HISTORY
of
ITALIAN ART

HISTORY
of
ITALIAN ART

VOLUME TWO

Translated by Claire Dorey

POLITY PRESS

English translation © Polity Press 1994

First published in Italy as *Storia dell'Arte Italiana* © Giulio Einaudi Editore, 1979.

This translation first published in 1994 by Polity Press in association with
Blackwell Publishers Ltd.
First published in paperback 1996.

Editorial office:
Polity Press
65 Bridge Street
Cambridge CB2 1UR, UK

Marketing and production:
Blackwell Publishers Ltd
108 Cowley Road
Oxford OX4 1JF, UK

Published in the USA by
Blackwell Publishers Inc.
238 Main Street
Cambridge, MA 02142, USA

ISBN 0–7456–0694–6 (vol. I) ISBN 0–7456–1754–9 (vol. I, pbk)
ISBN 0–7456–0695–4 (vol. II) ISBN 0–7456–1755–7 (vol. II, pbk)
ISBN 0–7456–1364–0 (2-vol. set) ISBN 0–7456–1819–7 (2-vol. set, pbk)

A CIP catalogue record for this book is available
from the British Library and from the Library of Congress.

Typeset in 10½ on 12 pt Sabon
by Graphicraft Typesetters Ltd., Hong Kong
Printed in Great Britain by Hartnolls Ltd, Bodmin, Cornwall

This book is printed on acid-free paper.

Contents

———— ∞∞∞ ————

Illustrations

Publisher's Note

In this edition references to English-language sources have been given where possible. In some foreign works not readily available in English, references to the Italian editions used by the authors have been retained.

ONE

The Periodization of the History of Italian Art

GIOVANNI PREVITALI

Periodization

THE first question a historian finds he must address as soon as he chooses a topic for research is that of where his narrative should begin and end and what subdivisions to make. In fact the different solutions one may adopt with regard to periodization imply different definitions of the subject under study.

In our case, it is clear that the historical subject defined by the two words 'Italian art' entails different periodizations depending upon what meanings we wish to attribute to that noun and that adjective. If by 'art' we mean some eternal category of the human spirit, it may seem invalid – an insult to the universality of art, even – to wonder when a particular artistic output with national characteristics began and ended. Similarly, if by 'Italian' we mean everything that has taken place within a given geographical area known as Italy, obviously the question of when Italian art began is synonymous with the question of when anything that could be called art first appeared within that territory; equally – given that there exists today a country called Italy which produces works of art – our destination is always inevitably going to be the present day. For as long as there have been people living on Italian soil, and for as long as they remain, Italian art has existed and will continue to exist.

This may seem to be the simplest solution and is therefore one which is often adopted, even by the anti-idealist camp, since it gives

the illusion of resting on objective, physical bases (the history of
Italian art as the history of a certain quantity of material within
well-defined geographical borders). But in reality this answer, obvious
as it may seem, causes more problems than it solves. If we look at
it carefully, it works only if both terms, 'art' and 'Italian', are kept
as empty vessels, and all it does is to shift the debate to another area
– that of geography. Instead of asking ourselves, for example, what
characterizes the particular artistic output known as Italian art and
makes it so distinctive at different times, all we have done is delineate
the area which can geographically (or politically) be defined as Italy.
And maybe we could deal with difficult cases in chapters on Italian
art outside Italy (although this would still beg the question of what
it might then be that makes it 'Italian art') and on 'foreign' art in
Italy. But the truth is that we have no choice but to find an alter-
native.

Whatever one chooses to understand by the expression 'Italian
art' will entail a particular choice of periodization, and vice versa.
General historicism may believe the problem can be avoided by
endlessly referring back to earlier origins, but history is the story of
objects, of whole entities which can be defined by describing their
structures. Only a historical description of the distinctive character-
istics of Italian art can provide us with both a definition and the key
to solving the riddle of its origins, by which we mean the riddle of
how it began and, of course, how it continued. In fact the first
people to reflect upon the works that made up what will later come
to be called Italian art, like Dante Alighieri and Giovanni Villani,
Lorenzo Ghiberti and Giorgio Vasari, did not feel the slightest ob-
ligation to go back to the beginnings of art, but only as far as a
precise moment in the country's history, to the generation of Guido
Guinizelli and Guido Cavalcanti, Cimabue, Oderisi, Giotto and
Franco Bolognese, Nicola Pisano and Arnolfo. If we take two separ-
ate points in this evolution (comparing, say, Giotto with Botticelli,
or Pontormo with Pietro da Cortona, or Palladio with Juvarra) it is
easy to ask, ironically and rhetorically, what sense there can be in
defining them all as equally 'Italian'. It is just as easy to play the
philological trick of setting the synchronic and the diachronic against
each other to find that in any form of art defined as 'Italian' there
are closer affinities and similarities with parallel contemporary 'for-
eign' traditions than with other later 'Italian' movements. Roberto
Longhi used one particular set of circumstances to demonstrate,
amusingly, the 'German-ness' of Aspertini and the 'Italian-ness' of
Hans Holbein.[1] Still, only a blind man could deny the existence of

cultural traditions which are geographically localized and linked to each other and which are instrumental in establishing lasting states of consciousness, modes of behaviour, solidarity and debate.

The historian's task is not to define constant and immutable characteristics but to trace common and recognizable threads of continuity. In other words, when we acknowledge that Italian art has changed through time we are not denying its existence. Of course, just as historical objects come to be so they can pass away. A tradition can peter out – usually as a result of some catastrophic event. As we shall see at the end of this essay, we do indeed have a problem with the continuation of a history of Italian art following an event that was catastrophic in its way – the development since the First World War of the international avant-garde art market. But it would seem generally reasonable to assume, as a working hypothesis, that there certainly were, at least in the past, within a territory only sometimes and to some extent identifiable with the Italian republic of today, various 'Italian arts' or 'Italian art forms', and we must obviously seek to analyse to what degree these are consistent and ongoing. But it is equally reasonable not to exclude, at least in the early stages, the possibility that these various art forms may be linked to each other. Which means, for the purposes of periodization, that we should not confine ourselves to the question of the beginnings (and possibly the end) of Italian art, but rather broaden our scope to cover the internal spatial and temporal divisions of our chosen historiographical subject. And of course even here we are not faced with finding an answer from scratch. Observers of the life of Italian art have for centuries been aware that the output from certain communities in the peninsula was different from that beyond the Alps (and, for that matter, from that of the opposite shores of the Mediterranean), and they have also occasionally pointed out noticeable variations in the quality and characteristics of this output.

To return to our examples, Villani, writing at the beginning of the fifteenth century, had already discerned three different phases in Florentine painting of the previous century, and Vasari's division of art history into 'three parts, which we may call periods', proposed in the mid-sixteenth century, is still famous. In the late eighteenth century, at one of the most lucid moments of Italian cultural self-knowledge, Luigi Lanzi mapped out in his *History of Painting in Italy* a complete geography of 'schools of painting', and these too do not all begin and end at the same date, and are also internally divided into periods. The plotting of hiccups and digressions important enough to be, as he put it, epoch-making did not prevent Lanzi

from considering the art produced before and after the change he was observing as equally Italian (or Florentine, or Venetian), or from taking into account defections from one school to another, exchanges and similarities which make his work a history of schools which, though different from each other, are all, in their different ways, 'Italian'.[2]

So by putting the problem in terms of content (or of form, which in the case of the figurative arts is more or less the same thing) we come to our first logical conclusion: that the internal subdivision of a historical narrative can never conform to mechanical grids of measurement (centuries, decades, generations and so on) which only occasionally and exceptionally correspond to objectively identifiable changes, and which are flawed in that their false objectivity leads us to endorse meaningless divisions because we are too lazy to make more meaningful ones of our own, and accept the distortions we can see for fear of introducing the possibility of other less obvious distortions. Looking at history through the mathematical grid of the centuries is like looking at a landscape through rippled glass. The whole may not change much, but we can be sure that every single detail is distorted.

History of 'Italian' art or of art 'in Italy'?

What we have said still cannot answer another possible objection: given that the main problem would appear to boil down to establishing a continuity between various art forms within our national territory, would it not then be more accurate, and less open to charges of nationalism, to speak not of 'Italian' art but simply of art 'in Italy'? This question has been asked before and not just by art historians (Giuliano Procacci entitled his brilliant synthesis *Storia degli italiani* (*The History of the Italian People*); and yet it is interesting to observe here that, although he does not talk about 'Italy' at a time when the Italian state did not yet exist, he does talk about 'Italians' and not 'Italic peoples'), and the question was answered in precisely that way by one of the least successful of the many collaborative works produced during the art publishing boom.[3] But this solution seems to me to be one which largely reintroduces, with only a token caution, the hypothesis we began with (that all the art produced in Italy from its beginnings to the present day is 'Italian') and, like that first solution, it is tainted by abstraction and therefore also by positivism and idealism.

In fact, in so far as it is an attempt to cause a coherent historical object to be endowed with systematic autonomy which can be studied in itself and in its development, a form of words like this dissolves on first contact. One has only to consider that 'art in Italy' means everything, including the palaeolithic rock paintings at Colle di Tenda and the Greek metopes at Selinunte, Trajan's Column and the Arch of Constantine, the Byzantine mosaics at Ravenna and the Arab art in Sicily, all of which have their identity within quite different systems and complexes, and which not only implicate fairly vast areas beyond the peninsula, but actually have their sources of movement and cohesion in those foreign parts. Besides, though they may have produced many masterpieces, these manifestations cannot easily be linked to one another or placed in sequences that might at some point converge, by some route or other, however tortuous, into something that could be defined as 'Italian art'. It should hardly be necessary to add, for the sake of clarity, that what we are talking about here is not quality, but survival and continuity. For various reasons, many species which were healthy and not qualitatively inferior to those which survived have, for various reasons, disappeared. It would be inaccurate to call them the ancestors of those which – by other paths and through favourable circumstances – are with us today. The Selinunte metopes, the Ravenna mosaics, the Romanesque of Padua are sublime episodes in the history of humanity, but they have no part to play in the history of Italian art in the sixth century BC, or in the sixth century AD, or in the twelfth century, but only from the eighteenth century when Italians of the decadent movement rediscovered them and reintegrated them into their own national consciousness.

'Italian' art in reality and in the Italian consciousness

'National consciousness' is a phrase which is bound to appear suspect in the current climate of progressive Italian culture, seriously exposing whoever uses it to charges of idealist or even Fascist sentiments. However, something similar to what this phrase describes has existed, and we may even ask with good reason whether the problem of the awareness that people in the past had of the distinctiveness of Italian art is really without relevance to this question. It is true that idealist Italian culture confused the question of its own perception of this distinctiveness with the question of its existence, and took the birth of an embryonic body of art criticism within the

context of Italian vernacular literature (Dante, Villani, Cennini) as conclusive evidence;[4] it is in fact essential to recognize that we cannot in principle overlook the possibility that in the figurative arts, as well as in other fields, the Italians may have been able to believe themselves to be something which in fact they have never been; and that foreigners (perhaps under their influence) were also taken in; and that this supposed self-awareness may, when all is said and done, turn out to be mere self-delusion. Italians (and outsiders) have certainly 'mystified' their own history; but does this observation mean that we can conclude that their history therefore has no distinctive characteristics and does not constitute a history? Is the flourishing of this 'false consciousness' over seven glorious centuries not itself actually a 'characterizing' basic fact of history which must be carefully considered?

So, to begin our discussion, when and how did this 'false consciousness' come about, and what are its essential characteristics? It arose first and foremost from the idea that the Italians, and in particular the Tuscans and the Florentines, were the instigators of the late thirteenth-century renewal which led to an irreversible break from the 'dark time' of the Middle Ages; then from the conviction that the Italians were somehow predestined for this role by virtue of being the 'natural' heirs to the ancients. While these two factors are both at work throughout the critical tradition, they must be kept distinct precisely because of the different levels of 'ideologizing' behind them (because the first refers to a historical fact and the second appeals to an anthropological concept).[5]

The first theme, which entailed the definition of an 'in-between age' as a logical consequence of the revival of classical models at the hands of the humanists, stamped itself upon the 'modern' consciousness of the Florentines, and therefore upon the minds of the swelling ranks of 'Italians' in the fourteenth and fifteenth centuries, and then gradually (particularly following the watershed of the Counter-Reformation) lost importance. During the seventeenth century the ancient/modern dichotomy became more radical (seeking to identify the semantic field of the term 'modern' with that of today's word 'contemporary'), and the closing bracket of the 'medieval' parenthesis was naturally shifted so as to include the fourteenth and fifteenth centuries in the darkness of barbarism. In this situation the determined, though limited, efforts of the culture of the Enlightenment, in Italy as elsewhere, to recover the sense of distinctions to be made within that dark parenthesis managed to make much less of an impression on the collective consciousness than did the

next wave, which came in the age of the Restoration and buried all such erudite and intellectual subtleties under a tide of general 'continuity'. A whole phalanx of historians, scholars and Catholic propagandists (Seroux d'Agincourt, Artaud de Montor, Paillot de Montabert, Montalembert, Overbeck, Jean François Rio; and in Italy, following the example of Filippo Buonarroti: Laderchi, Minardi, Marchesi, Facciolati Sergi, Selvatico) now rushed to build bridges 'across' the Middle Ages (which were therefore presented as having 'preserved' the 'purest' of the ancient traditions) so as to link the ancient (classical, but more importantly early Christian) world smoothly with the modern world of the Restoration of monarchy and Catholicism. We are all aware of how far this historiographical trend spread and how long it has lasted, even to this day, as it seeks to deny the 'catastrophic' nature of the events surrounding the fall of the Roman Empire, the barbarian invasions, the long period of Lombard, Frankish and Byzantine rule, and thereby enhances the ever bright and providential role of Christian Rome in inheriting and continuing the work of imperial Rome which provided cultural unity for the West. It was at the time of the Counter-Reformation that any sign, any relic of evidence of the continuity between the late ancient world and modern times came to be preserved, restored and revered. The papacy, the monastic orders and the artists' guilds were invoked from time to time, often with a complete lack of sensitivity to the difference between formal or institutional continuity and real continuity, as evidence that when the Florentines of the late thirteenth and early fourteenth century congratulated themselves (with all due respect to dear old Dante) on the progress they had made, they did not really know what they were talking about, and that the humanists had been even wider of the mark in claiming there were positive models to be reconquered in classical culture. The second theme, the idea of the classical inheritance, went on, through the course of the country's history, to gather ever greater (rhetorical) importance, in even more marked contrast to the real situation (from the 'prehumanists' of the second half of the fourteenth century, to the humanists of the fifteenth and sixteenth centuries, to the seventeenth-century antiquarians, and finally on to the archaeologists and professors of Italy at the Unification and since), and after a certain point, actually worked to the detriment of the first theme. In fact in the course of the nineteenth century, while every aspect of the Middle Ages was being comprehensively re-evaluated north of the Alps, mainly in Germany, but also in France and England, the nationalistic but subordinate culture of the Italians sought to make

some contribution to the partition of these new historiographical territories, by abandoning its embattled defence of that distinctiveness which seemed to consist precisely in having left behind those centuries which previously seemed barbaric and which now appeared to be so rich in historiographical raw materials.

The degree of compromise between classical and romantic camps which characterizes Italian culture in the first half of the nineteenth century (an example is Manzoni's rejection of Sismondi's 'historiographical proposal')[6] meant that classical, early Christian and medieval art could all be heaped into one incoherent jumble, since all were the glories of Italy and equally representative of the virtues of the race. Then, in the first half of the twentieth century, nationalist competitiveness did the rest, persuading every student of the kingdom of Italy to believe that he had done his patriotic duty every time he managed to push back by a couple of years or a couple of metres, in any direction, the boundaries of his national art. The history of artistic production on the national territory was now seen, even by the best of them, as a linear process drawing in everything it meets in its path: 'this book does not ask that we consult it but that we read it. And may it instruct anyone who does not know that Italy has always risen upwards and that it is her destiny to rise',[7] booms the preface to one of the best products of that school of historiography.

At this point it becomes more difficult to preserve the necessary sang-froid to distinguish between what, within our own current sensitivities or consciousness, comes from a continuity which is, so to speak, legitimate, and what derives instead from ideas made up since the 'united national consciousness' took hold.

Medieval art and Italian art

It is also at this point that it becomes very important for an art historian who also happens to be Italian, to address other opinions. We shall then realize that modern historiography (not just in the history of art or just in the history of Italy), despite its polemics and occasional backsliding, tends increasingly to recognize, as is logical, that the period we still call the Middle Ages is anything but unified either chronologically or topographically. And for the purposes of what particularly interests us here (the non-continuity between classical art, medieval art on Italian territory, and Italian art) it is important to point out, firstly, that there is no longer any reason to

doubt that a qualitative leap, seen on a structural level before the cultural level, occurred in the passage from late antiquity to the beginning of the Middle Ages proper (in particular, as far as Italy is concerned, the literally catastrophic nature of the Byzantine wars of reconquest in the sixth century). Secondly, an inverse tendency in a positive direction is generally agreed to begin no earlier than four centuries later (the year 1000). Thirdly, it is accepted – though through clenched teeth by some – that Romance (i.e. Romanesque and Gothic) western art is substantially original and cannot be traced back to models in either classical or Byzantine art. Fourthly, it is usually recognized, by art historians as much as by historians of other aspects of medieval life, that apart from understandable overlappings in contact areas, odd enclaves, and more or less obvious cases of export, Italy is divided, at the level of the Apennines, by an easily discernible cultural divide (coinciding with a linguistic boundary that can still be observed), so that from the eighth to the thirteenth centuries almost all of northern Italy is involved with what happens in the 'Romance' area, while Venice, Aquileia, the Exarchate and the whole of central and southern Italy (except for the period of Arab rule in Sicily) come within the sphere of influence of eastern and Byzantine art.

These, very roughly, are the observations which form the still valid basis of the traditional thesis (see Dante and Vasari) whereby, compared with the above-mentioned events, what happened in Tuscany with Maragarito, Nicola, Arnolfo and Giotto (together with the literary developments of Guittone, Cavalcanti and Dante) represents a new and original synthesis, built upon elements taken from different moments in past tradition (classical, early Christian and Romanesque–Gothic) and from both cultural areas (Romance and Byzantine), and that therefore this moment and no other, give or take a decade, should be taken as the moment when the history of 'Italian' art began. And this is the solution still adopted by the most authoritative non-Italian guide to the history of art, the series edited for Pelican by Nikolaus Pevsner, which gives Italian art separate treatment from the volume devoted to *Art and Architecture in Italy: 1250–1400* (J. White) up to the one on *Art and Architecture in Italy: 1600–1750* (R. Wittkower).

There is in fact another, less crude and more subtly insidious 'ideological' element, derived from our consciousness as 'modern' Italians, which we must identify and isolate if we wish to ensure that it does not unconsciously deform the objective reconstruction of the facts.

The process which led, from the late seventeenth century onwards, to the formation of a collective consciousness among the Italian ruling classes, and therefore to the constitution of a single state, on the one hand dissolved local territorial units, allowing truly national (and possibly nationalistic) trends of thought to flourish for the first time, but on the other hand, by partly making up for the time lost during the long seventeenth–eighteenth century crisis, it made the Italians culturally more 'European' and therefore, in some sense, less 'Italian'. We are not concerned here with looking, even briefly, at the causes and stages of this recent history, except to remember that this was when the northern element of the Italian ruling classes, who felt themselves to be somehow the 'direct heirs' of the prosperous and still un-Italianized peoples of the thirteenth century, gained their dominant economic importance and their political and ideological prominence.

The fact that Piedmontese, Lombards and Emilians rose to become leaders of the country (the whole country) was bound to make a deep impression on the collective consciousness, even the limited sector concerned with the artistic past. Anyone who grew up in the shadow of Romanesque cathedrals and *broletti* (Lombard public buildings) would in fact find it difficult to accept them as part of 'another' history, although not really bound to them as to elements of a cultural tradition, but rather as one is attached to natural features and elements, like the mountains and lakes, the landscape. That this basic fact should have later found expression even until recent years in the tendency of critics to sing the praises of a kind of meta-historic (or prehistoric) 'northern-ness' can be seen as a backward and 'provincial' episode, but it is nonetheless symptomatic of a misunderstanding that is rooted deep in a real historical process.[8]

According to this new and updated 'revisionist' tendency of traditional periodization, the central role is no longer played by the universal mediator of Rome; the northern plain instead comes to play an equal, and maybe even a dominant role in the life of western society (or else it is seen to be 'unjustly' subordinate, which comes to practically the same thing). With this aim in mind, even if we accept the break between the ancient and modern worlds, and thereby distance ourselves from nationalistic and Catholic 'Romanism', the most modern component of post-Unification Italian culture, we can go back to the mythical watershed of the year 1000 (the eighteenth-century Jesuit Saverio Bettinelli's 'resurgence of Italy in studies, art and mores after the year 1000')[9] to include the northern Romanesque

in a more modern and updated *risorgimento*. And in support of this backdating we can invoke the discovery that economic history also traces the first signs of agricultural recovery to around the year 1000. So pushing back the date of the beginning of the history of Italian art, with the advantage of not excluding the pre-Renaissance glories of the Po valley, could also have the no less important advantage of better synchronizing events in the history of art with those of civic, political and above all economic life.

The periodization of history and the periodization of the history of art

This last consideration compels us to pause for a moment before we go on, over a point of method which it will be useful to this discussion to clarify.

Ever since the great formalists of the early twentieth century (Berenson and Siren, Roger Fry and Clive Bell, Focillon and Longhi) launched their brilliant campaigns to rout the ranks of the erudite and the aesthetes, and Heinrich Wolfflin in his *Kunstgeschichtliche Grundbegriffe* codified the principle that 'Naturally, in the course of time, art manifests very various contents, but that does not determine the variation in its appearance', insisting that 'speech itself changes as well as grammar and syntax. Not only that it is differently pronounced in different places . . . but it has absolutely its own development, and the most powerful individual talent has only been able to win from it a definite form of expression which does not rise very far above general possibilities',[10] the fact that the rationale for the periodization of the history of art had to be found exclusively within and through 'stylistic data' (equated, rather far-fetchedly, with 'linguistic data') and its divisions must correspond to 'stylistic divisions', and that, ideally, periods and 'historical styles' must coincide, has become the established wisdom, and is still a basic principle taken for granted and undisputed even by the most recent theorists on the subject.[11] In this regard, it must be acknowledged that the iconological polemics of Panofsky and Meiss and the sociological polemics of Antal and Hauser have been almost without consequence. These scholars should be credited instead with the very important merit of having tried to respond to the real demands of historical thought where the formalists preferred to fight shy: the demand for a tighter bond between the different historical sequences themselves and between them and the general development of human civilization.

The reader will observe that in the course of the following discussion, as we seek a rationale for the periodization of Italian art which is based on a description of artistic production, we shall often bring to bear evaluations and adopt descriptive and critical categories which refer not just to so-called works of figurative art, nor, in fact, just to art in its broader sense.

The concepts which we have to work with – tradition, continuity, change, hiatus, interruption, differentiation, dynamism, stagnation, etc. – are concepts shared by all historical sciences whether they deal with art, or with the history of politics, institutions or economics. I am convinced that if we want to find some common ground for discussion with scholars of other disciplines, bearing in mind possible connections between the development of the arts and of other historical sequences, it is precisely to this kind of concept that we must turn; although this does not mean we have to be prepared to accept, as some would like, that we can escape the consequences of ignoring that dimension which is specific to artistic production and which we have come to sum up in the concept of 'style'.[12]

If it is in fact true that stylistic concepts are ambiguous and multifunctional and do not readily lend themselves to interpretation as more general indicators of the social dynamic (style as style – as the young Gombrich observed in a justly famous review – 'expresses' nothing precise)[13] they do not thereby lose their validity as instruments for the interpretation of artistic phenomena, and as an indispensable means to precisely identifying the connections which really exist between the various products, both of a topographical nature (via exchange) and a chronological one (via revival and derivation).

In other words, by consciously choosing to go back to describing artistic modes and forms and works of art on the basis of how they are similar to all other products of labour instead of by how they differ, in order to find a common ground for comparison (and, in particular, common points of reference for periodization), we are not saying we can never go back, once this has been achieved, to that specific level of so-called figurativity in order to reassess the repercussions of the more general dynamic of historico-social evolution within it. The temporary and methodologically justifiable decision not to use a particular distinction must not become an excuse for obliteration of that distinction, or for collapsing the separate levels, or for indiscriminate application to all other levels of the divisions identified on a structural level.

When studying the origins of Italian art, therefore, our primary concern is not with seeing whether and when a style such as, say,

a 'classicizing' (or a 'Gothic' or a 'proto-perspectival') style first appears on Italian soil, nor with deducing, once we have equated this new style with the concept of Italian art, that it is at that point, where it appears for the first time, that the break with the Middle Ages occurred, and going on to check whether there are similar signs at that point of renewal in other historical sequences (literature, music, philosophy, agricultural, commercial and political history, etc.). What we are interested in showing is, for now, something more basic: that is not so much the nature and meaning of a particular 'stylistic' change, but simply the fact that it exists, and that it does not stand in isolation, but accompanies a whole phenomenology of changes, often of very different kinds, but all equally indicative of a new social dynamic manifesting itself. In this regard, the classicism of Nicola Pisano and Arnolfo is not the only important indicator of what was happening in Italian society in the last thirty years of the thirteenth century; we should also look at the neo-Hellenism of the 'San Martino master' and Cimabue, the 'French' Gothic of Giovanni Pisano, and Giotto's three-dimensionality, and even the unprecedented profusion of contemporary output from the second-rate workshops, such as the Berlinghieri in Lucca, or that of the 'Maddalena Master' in Florence. On the art-historical side, we can already see signs of this sudden growth in the increase of works showing varying degrees of Byzantine influence which can be observed a generation or two before the time of the canonical 'fathers of Italian art', for example the activity of artists like Margarito, Coppo di Marcovaldo, the 'Santa Chiara Master', Giunta Pisano, etc., and there is no need at this stage to find a unifying characteristic for all these phenomena except precisely the fact that they are all in some way 'new' compared with the past. On this same level, the linguistic or literary historian should also be able to observe that after 'an exceptionally long twilight phase', it is 'suddenly, in the course of the thirteenth century' that we have 'a resolving crisis of extreme violence',[14] although we need not therefore assume any particularly close direct relationship of either give or take between literary and figurative production. And if we confine ourselves to architecture and sculpture, fresco and goldsmith's work as products, valuing them in essentially economic terms, we will have no difficulty in accepting along with economic historians the coining of the gold florin by the Commune of Florence (1252) as a symbolic date for central Italian beginnings, or in going back even further, for the case of the north in our quest for an upturn after the crisis of the early Middle Ages, to a date which allows us to reclaim the

great sculptors of the previous century, Wiligelmo and Antelami. On
the level of the increase in volume and in the rate of innovation, the
gap between the beginnings of economic recovery (usually put at
about the year 1000) and artistic renewal can be greatly reduced, if
not completely closed. In other words, if we want to draw com-
parisons with other historical sequences by looking at the directions
that the general development of society is taking, we will find it
essential to go back to purely quantitative and dynamic concepts.
Thus it will be possible to read the contemporary resurgence of both
Romance language and literature and Latin and vernacular writing,
and both the spread of the protohumanism of the *dictatores* and the
Aristotelianism of the doctors as part of the same clue.[15] But is it
really legitimate to adopt the point to which we have reduced the
various historic sequences (in this case the 'take-off' point of the
year 1000) as a watershed which holds good for them all? When we
ask ourselves what the best starting point would be for a history of
Italian art we have to go back to a specific 'linguistic' level. The
remobilizing of a dynamic of production and consumption on Ital-
ian soil, to include the production and consumption of works of art,
in perfect parallel and comparable, even synonymous, with the dy-
namic of the economy, is one thing; but the cumulative effect of this
dynamic on a qualitative level, sufficient to bring about a break with
a long-standing figurative tradition and the adoption of new solu-
tions which are not comparable, on a specific linguistic level, with
what went before, is quite another thing. It is one thing to import
works of art, or even to produce works that resemble imported
works, but quite another to produce original work of one's own.
And it is one thing to recognize that works of art, in so far as they
are products of human labour, are 'products like any others', in the
sense that they are subject, like any others, to market forces, but
quite another to believe that they are products just like any others.

The beginning of Italian art history:
the early Trecento

Let us now return to the point from which we digressed, to the
question of whether or not we should take the Romanesque art of
the Po valley as a starting point for the development of Italian art,
and let us see how we may answer it.

The twelfth and thirteenth centuries witnessed the confrontation
of two worlds within Italian territories, two artistic viewpoints which,

although they derive in part from the same origins, are in reality deeply opposed: that of western Romanic art and that of the eastern Byzantine tradition. The western and central areas of the north (corresponding roughly to Piedmont, Lombardy and Emilia) were consistently involved in the developments of the Romance world. Certainly, if we look towards the Veneto and Romagna, we are in the frontier zone of the Byzantine sphere: but the role of this zone in exchanges is not as a mediator but as a party to the suit, on the side of France and Germany.

Italian art was actually born in another frontier zone, Tuscany, and it first saw the light of day at the moment when the new solution of synthesis between classical-Byzantine continuity and barbarian-Gothic innovation was reached. The rationalist Florentine solution (which is both neoclassical and Gothic and finds its synthesis in the three-dimensionality and spatial quality of Giotto) is the formula which launches a new tradition, already in some way 'Italian'.

So we cannot really speak of Italian art proper until the time when Giotto and the artists of his generation put forward their ideas, just as we cannot talk about an Italian literary language before Dante and his generation (despite the undeniable vitality of the spoken Romance language of northern Italy). Changing art form again, this original synthesis of different traditions also characterizes in those same years the emergence of 'Gothic' architecture in central Italy or, in yet another different field, the birth of the *ars nova* in music.

> Just as the Dantean *stil novo* contrasts, even in its in musical aspects, with the Provençal lyric, from which it is nonetheless derived, as something absolutely new and autonomous, and is fundamentally different too from the German *Minnesang*, so too do the Tuscan cathedrals of Siena, Orvieto and Florence contrast with the German and French Gothic cathedrals. They are Gothic churches, but it is a Gothic *sui generis*, far removed from the French spirit,

as a great historian has written, and being bilingual, he was well qualified to make the comparison.[16]

So what cultural history, and the history of art in particular can tell us – and there is nothing in economic history to contradict them – is that the revolutionary moment of greatest vitality, expansion and dynamism must have come somewhere between 1290 and 1320. These were three fortunate decades for the country's history – not only in art history – when some areas of central Italy, Florence first

among them, found themselves playing the role of vanguard in an absolute sense and for the benefit of the whole western world. And it should not matter much if this is where the conservative historiographical tradition mentioned earlier thinks it can find suitable grounds for its ultimate proof of Roman primacy. We are no longer dealing with the early Middle Ages, where the scarcity of available data in some sense actually facilitates the building of rather unlikely bridges (which are sometimes founded on something as tenuous as changing the date of a single work);[17] here there is no shortage of historical, economic and art-historical data, all of which converge to show irrefutably that the centre of innovation, the great commercial, banking, and manufacturing metropolis at the time was Florence and not Rome, where the papacy confined itself to making the products of the Tuscan city work to its own political and religious ends. First Cimabue, then Arnolfo and Giotto were called to the service of the popes because local artists alone were unable to satisfy their requirements. Jacopo Torriti, Cavallini, Conxolus, and Giovanni di Cosma, serve to prove not that Italian art was reborn out of the medieval Roman tradition but – a fact certainly not without interest – that Rome was quickly conquered by the new figurative language which had evolved in Florence.[18]

The extent and quality of this phenomenon, although clear in outline to economic historians for some time (it should hardly be necessary to recall here the data relating to demography, manufacturing production, financial investment, construction), are not readily accepted in all their enormity by art historians, who are still widely conditioned, if they are conservatives, by the myth of Renaissance perfection, and if they are 'progressive' by the mercenary instinct orienting current research and preferences away from the exhausted seams of the 'primitives' towards later centuries (from the seventeenth to nineteenth), which are better sources of available material.[19] Even though Roberto Longhi (who certainly knew his seventeenth century) liked to define the fourteenth as 'the greatest century of Italian art', it is only very recently that research has begun to provide detailed evidence of the truth of this and thrown light on the heavy imbalance between the situation in the early years of the century and that of the entire period which followed.

Positivist-inspired historiography, which unwittingly laboured under a mechanical concept of historical time, once sought to distribute surviving works evenly over the whole available chronological expanse, starting from the undemonstrated and even unspoken premise that artistic production tends naturally to occur in uniform density.

But systematic and analytical historical research conducted in recent years on ever larger sections of surviving fourteenth-century artistic output shows this chronological layout to be unfounded, and instead documents just how unequal is the distribution of output both chronologically and topographically. Let us look, to begin with, at purely quantitative considerations: although it has long been acknowledged that production fell off, in the course of the century, in certain important centres (Genoa, Pisa, Rome) and halted completely in another (Rimini), only now that autonomous production in other 'minor' centres such as Lucca, Arezzo and Pistoia, Volterra, Orvieto, Assisi, Spoleto, Gubbio and L'Aquila etc. at the beginning of the period in question has been recognized, can we at last fully measure the significant effect of the impoverishment caused by the gradual concentration of production in the future 'capitals' (Florence, Siena, Perugia). We can in fact begin to perceive a transition from a phase of production that was extremely rich, varied and diffuse, to one that was more restricted and concentrated.[20]

But we must look at the specific, qualitative level too. It is a fact that most of the 'masterpieces' of fourteenth-century art (fresco cycles by Giotto, Simone Martini, Pietro Lorenzetti in the basilica at Assisi, Buffalmacco in the Camposanto at Pisa, 'Barna' at San Gimignano) are undergoing substantial backdatings, and the same fate seems to await whole clusters of works which make up the catalogues of first-rate personalities such as the 'Master of the Codice di San Giorgio' and the 'Daddesco Master' in Florence, or 'Dalmasio' and 'Pseudo-Jacopino' from Bologna, after what happened to the 'Figline Master', who has gone from 'Orcagnesque' to 'Giottesque', with a chronological leap backwards of about half a century. This seems to suggest that most of the more sensational fourteenth-century stylistic 'inventions' of a truly artistic nature are going to be traced back to the turn of the century and the years immediately following it.

We can if we wish find further evidence in the recent re-evaluations of early datings which had until recently seemed surprising if not quite unacceptable, on account of the 'incredible' modernity of their stylistic features. Take the portrait of Bruno Beccuti in Santa Maria Maggiore in Florence, held to be a fifteenth-century work because of its strong naturalism but in fact most probably painted between 1317 and 1323 by Tino di Camaino; or the tomb of St Simeon by Marco Romano in Venice, from around 1317, which was judged in the past to be contemporary with Matteo Raverti because of the maturity of its Gothic naturalism, when in fact it connects very well with other works which are also extraordinarily

'fifteenth-century' but which date from the early fourteenth century, for example the famous full-length portrait known as *Ranieri del Porrina* at the Duomo in Casole d'Elsa. We have already mentioned how hard critics find it to place the plastic feel of the 'Figline Master' (it is almost like that of Piero della Francesca, Giovanni di Francesco, or the 'Pratovecchi Master' before their time) somewhere in the thirteenth or fourteenth centuries. All these works 'anticipate' (like Giotto's 'perspective' and 'foreshortening') future developments whose real significance we would do well to understand.

The beginning of Italian art history: interrupted development

Art historians usually tend, precisely because they are vaguely aware that the analysis should be conducted on two levels, to introduce a strange optical distortion whereby, on precisely this 'qualitative' level, the importance of an artist is measured according to how long the style he engendered survived (in such cases we talk about a 'wide following', an 'experiment which inspires several decades of development' and so on; the opposite effect is labelled 'fruitless', 'without consequence' and so on), when in fact, strictly speaking, the artist has, after his death, little or no responsibility for his 'following'. In fact, the lengthy survival of a style, far from being attributable to the merits of its founder, can only indicate a lack of will or ability to innovate on the part of his followers, and it is therefore likely that, far from being a sign of some sort of posthumous power of a great personality, it is a symptom of a weakening of the social dynamic, a crisis of stagnation, a depression. Culture is a living thing, and rapidly renews itself when society is dynamic; in such circumstances artists themselves go through rapid changes, adopting a succession of different 'styles': as did Nicola Pisano and Giotto in the years which concern us, and Bellini, Titian and Caravaggio in later periods. If economic and social dynamism remain ebullient after the death of the master, however great he is, he will be 'superseded' (as in the Bellini–Giorgione–Titian sequence); the lengthy dominance of a style will therefore, on the contrary, be very likely to signify stagnation. We can see this immediately in the way 'Giottism' was perpetuated in Florence almost until the beginning of the fifteenth century, and later how Titian's painterliness was kept alive in Venice, or Reni's idealism in Bologna for nearly the whole of the seventeenth century.

This insight may mean that the way the art of the early fourteenth century seems to us to be ahead of its time is perhaps just another symptom of 'interrupted development', as though the ideas which had been left half-finished almost a century earlier could not be successfully picked up until the fifteenth century in Florence.

Once we have duly reaffirmed the absolute originality of the renewal of representational form that took place in Florence and Tuscany between the thirteenth and fourteenth centuries, and noted the exceptional energy and speed of the first overwhelming explosion of new artistic concepts which saw Arnolfo (in Rome, Florence and Orvieto), Giovanni Pisano (in Pisa, Genoa, Pistoia, Perugia and Siena), Giotto (at Assisi, Rome, Rimini, Padua, Naples, Bologna and Milan), and then their first followers: the Sienese, Memmo di Filippuccio (at Pisa and San Gimignano), Tino di Camaino (at Pisa, Florence, Siena and Naples), Pietro and Ambrogio Lorenzetti and Simone Martini (in Assisi, Orvieto and Naples as well as Siena), and then Pietro Cavallini (at Rome and Naples), Buffalmacco (at Pisa, Arezzo and Bologna), and the Umbrians, the Riminese and the other northerners from Bologna and Lombardy, between them convert nearly the whole peninsula with the sole exception of Piedmont, a few areas of Lombardy, the city of Venice and the far south to the new language, in a burst of energy, in the space of no more than thirty years; once we have noted all this we must immediately add that this conquest soon turned out to be incomplete, not so much in that it failed to reach the 'natural frontiers' of Italy, but in that it lacked depth and solidity. The process of assimilation turned out to be far from easy, full of returns to the past. Even in the centres where the new artistic doctrines had sunk in deepest, Florence and Siena, it is not difficult to spot the thirteenth-century substratum resurfacing in many artists. In particular the irrationality, imaginative impressionism, and fragmentary naturalism of the language of French Gothic continues to appear in Italy and in Florence itself for a long time as a possible alternative to the rigorous structuring of bodies and spaces and the rational narrative logic proposed by the giants of the heroic generation.

1348: the crisis of the mid-century

These are perhaps the most important symptoms which allow us to recognize, in artistic production as well as in other areas, the warning signs of the ruinous mid-century crisis which culminated in the macabre triumph of the Black Death of 1348, and which had clearly

been emerging since the 1330s, first as a crisis of productivity then as a political and financial crisis.[21]

Can 1348 be taken as a point for the periodization of art history too, and if so, in what sense? The problem of a correlation between art-historical periodization and general periodization, first encountered when we were looking at their beginnings, now crops up again in rather the opposite sense. In the first case, there was a well-established tradition in a specific context which saw a qualitative leap at the end of the thirteenth century in Tuscany, and which seemed to be contradicted, at least in part, by the inclination of some economic historians to go back further to the first symptoms of a resurgence of agriculture, in around the year 1000. Here, conversely, a catastrophic division on a structural level does not appear to be so instantly recognizable in the specific context, where in fact we see a substantial continuity of debate over the same ideas for the whole of the rest of the century. And it must be said that even attempts by excellent historians of Florentine art (from Antal to Meiss to Boskovits) who have tried so desperately hard to find a positive interpretation for the mid-century changes of style are not entirely convincing, being as they are so obviously influenced from the outset by what is known (from non-specific sources) about Florentine society at the time of the Black Death.[22] The main change to be found in Florentine artistic production around the middle of the century is the fact – and this is no paradox – that there is precious little change; or to be more precise, that there is a remarkable slowing of the rate of change. The culture which had been the principal constant force for innovation serving the whole of Italy, and even the whole of Europe, now appeared to be closing in on itself to contemplate its own recent glorious tradition. The last fifty years begin to take on the mythological hues of a golden age. The changes we can see on the level of style are typical of an attempt to preserve tradition: the rigidifying of figurative formulae, mechanization of processes of production, iconographic repetition or fixed figurative topoi, almost perfect replicas of works from the golden age. This is the case with the workshops of Taddeo Gaddi and Orcagna, Andrea Bonaiuti and Niccolo Gerini in Florence, and Segna di Bonaventura, 'Bartolomeo Bulgarini', Andrea Vanni, Giacomo di Mino del Pellicciaio and Bartolo di Fredi in Siena.

It seems to me that the idea of 1348 as a chronological pivot came from comparisons with the general dynamic of social facts, and not purely from looking at artistic forms, and this would best explain errors such as the dating of the *Trionfo della Morte* in the Pisa

Camposanto to the second half of the century (because of its 'plague' theme), when it has been convincingly demonstrated that it belongs instead to the 1330s;[23] or the interpretation in mystical neo-medieval terms of the spread of a new subject like the *Madonna dell'Umiltà*:[24] as though coming down from her throne to sit on earth, in a flowery meadow or on a cushion might not rather mean that the mother of God is coming closer, in an 'affable' and cordial sense, to the world of men in a way that is not theological and neo-mystical, but quite secular and profane, although certainly not 'popular'. As such, the subject fits perfectly as a logical development in the trend of secular realism begun by Giotto and followed through, in this case, particularly by Simone Martini – a trend which, as we shall see in a moment, was well able to forge a path for itself quite independently of the turning point of the Black Death, and not so much because of the premature academic defensiveness of the above-mentioned artists as because of the decisive influence in Florence itself of an artist who came from outside, Giovanni da Milano. It was in fact his influence on painters such as Puccio di Simone and Giotto's own nephew, Giottino, which made the greatest contribution to keeping alive the new line of development begun at the start of the century and not allowing it to become embalmed.[25]

The fact that the innovation was non-local in origin and that it in fact came from Lombardy is of no mean importance. It serves to demonstrate that, alongside the mid-century division (which in this century more than any other, therefore, represents a real turning point in art history as in other areas), a reversal of roles also took place, whereby the Po valley, which had been converted to the new Tuscan art less than half a century earlier, though admittedly with great enthusiasm (it is the literary focus of Dionisotti which reminds us that the figurative Tuscanization of the north preceded its linguistic counterpart),[26] took over the leading role. It now becomes more important to recall, rather than any drop in production or social crisis in Florence, the fact that 'the Po Valley never experienced the great secular crisis which hit the countryside throughout Europe from the first decade of the fourteenth century', and that it managed instead to show an unusual capacity to 'resist the long crisis of the fourteenth century and so prolong its exceptional demographic and economic expansion until the end of the fifteenth century'.[27] This is tantamount to saying that the self-criticism which has, since Toesca's book was published in 1912,[28] but particularly in the second part of the twentieth century, caused Italian historiography to integrate, reproportion and correct the Tuscanocentric point of view of Vasari

(and in this respect the much more traditionalist historiography of the Germans and, especially, the English, did not follow the Italian example) enables us, among other things, to synchronize better the known facts (leaving aside the Black Death) about economic and social events in different parts of the peninsula. In so doing, we reinforce the idea that the 'Italianization' of the Po valley from the fourteenth to the sixteenth centuries is an absolutely crucial event in the history of Italian art, to which the northern artists fully belong from this moment on. The naturalistic and expressionistic past continues to resurface occasionally, as a substratum, but from now on it will always be subordinate to the new linguistic structures. The leading figures of 'Lombard' culture will not be those who refuse to take part in this new integration by continuing to speak their own dialects, but precisely those like Giovanni di Milano and Tommaso di Modena, and later Foppa and Bramantino, Correggio and Parmigianino, Lorenzo Lotto and Savoldo, and later still Annibale Carracci (leaving aside all the Venetians for now), who, while all very different from each other (despite the common ancestry that some would like to believe they shared), each made their own contribution to the unified and ever-changing phenomenon we call the history of Italian art.

The graphs for the development of artistic production in central and northern Italy are distinguished thus: central Italy shows a rapid surge followed by a slowing after the 1330s, then almost grinds to a halt after 1348 (it is strange to find anyone still saying that in the 'terrible epidemic', 'no famous architects, painters or sculptors lost their lives'[29] – unless we wish to exclude from among the 'famous' Andrea da Pontedera, Pietro and Ambrogio Lorenzetti, Bernardo Daddi, Maso di Banco, Francesco Traini: records for all of these artists, as for so many others, stop significantly in 1348; or are we actually waiting for death certificates to be unearthed?), and thereafter a recovery, slow at first but becoming ever brisker from the 1370s onwards; the graph for the north shows a healthy and continuous rise, which proceeds without major disturbances once it is past the stylistic updating which the thirteenth century brought. The two lines tend to converge in the last thirty years of the fourteenth century, when it looks for a long while as though the new variation on the modern language which the Po valley played such an important part in formulating, the so-called 'courtly', or 'international Gothic' style, will win the day in Tuscany, as in the rest of Europe (Starnina's activity in Florence, Ghiberti's early period, Lorenzo Monaco, Gentile da Fabriano, Masolino).

The pattern of these two graphs is so closely paralleled by the graphs of the corresponding economic areas, that even the 'exceptions' which we can identify stand out clearly *as* exceptions requiring detailed explanation in order to be understood.

Of particular note here in northern Italy is the eccentric case of Venice, which had already passed its peak of power in the thirteenth century, and had achieved this by concentrating its efforts entirely in the direction of the Eastern Empire. At the time when the wave of innovation from Tuscany was invading northern Italy, Venice took up a conservative position as it struggled to break away from the Byzantine culture in which it had been playing a starring role for more than a century. The fact that the paintings in the Scrovegni Chapel made its closest mainland rival, Padua, the exuberant standard-bearer of all that was newest, cannot have helped Venice to accept these innovations sympathetically. Thus, of the two variants on the new language, the Giottesque and the Gothic, Venice seems be inclining cautiously towards the second, absorbing it slowly via its Emilian variant (Paolo Veneziano, Lorenzo Veneziano).

Still, the process seems to have been quite straightforward nonetheless, becoming more and more established as the century goes on and finally taking shape at a rate of development which, apart from its slow start, was eventually not very different from that of other northern Italian cities; in fact Venice manages to tune in with the others by the end of the century and contribute an authentic voice of its own to the grand chorus of 'International Gothic' (Niccolo di Pietro, Jacobello del Fiore).[30]

In central Italy, where even the major centres (not just Florence and Siena but Pisa, Perugia and Rome as well) were caught up in the crisis of the recession, the most notable exception is that of Orvieto, which apparently survived the mid-century intact and where in fact the 1360s seemed to provide the school of painting with an expansionist force which had previously eluded it (Ugolino di Prete Ilario, Piero di Puccio, Cola Petruccioli). The explanation for this is perhaps to be found in the decision by Cardinal Albornoz, a legate assigned to the 'reconquest' of the Papal States, to establish his court there, thus temporarily (1354–67) giving it a political, and thereby an economic and cultural importance such as it had never known. This suggests Orvieto as the first example of a phenomenon recurring elsewhere in the history of Italian art, whereby, in a situation of general decline, the centres which manage to stay relatively prosperous acquire, by contrast, much greater positive prominence and therefore act as a magnetic force for attracting artists and also, to

a variable extent depending on the phenomenon in question, as a cultural model and guiding direction.

Hard times and investment in culture

What has been observed so far must in fact have brought us to a point where, from the art-historical angle, we can take up a position in the famous debate over the periodization of the 'Renaissance' which has been brewing among scholars particularly since the 1950s,[31] and we can say that, contrary to a widely held view of the matter, it would not be at all incompatible with the current state of our knowledge of the condition of artistic production in central Italy at that time to backdate the moment of the greatest impulse of growth as well as the clearest break with the past from the beginning of the fifteenth century to the end of the thirteenth, as certain economic historians have proposed. It must always be remembered of course that there are fundamental differences in the way these two historical sequences unfold; essentially there is a greater emphasis on the short and medium term (in the context of the length of human generations) in the art-historical sequence, and on the longer term (particularly for its fundamental basis of production: agriculture) for the economic sequence, and this difference will translate into different plottings of the watershed or take-off point. But this does not amount to a denial of the substantial correspondence between the phenomena, nor does it throw us back on to that last resort of determinism, the 'overwrought theory of cultural lags'.[32]

We have still to discuss how we should explain the so-called 'early Renaissance', and therefore the phase of stylistic renewal which began in Florence in the first three decades of the fifteenth century and spread all over Italy in a kind of repetition and consolidation of the first early fourteenth-century Tuscan wave.

If what we have said is true, it should be possible to use the same line of argument to try and find an answer to what we might call 'Lopez's paradox', taking the name from the economic historian who made explicit, as far as the Renaissance goes, the contradiction between the two different historiographical traditions (cultural and economic history).

Lopez's line of argument is well known, and can be summarized thus: there is a correspondence between the time of greatest economic growth (the 'commercial revolution' of the Middle Ages) and a period of great artistic flowering (Romanesque and Gothic),

but the Renaissance, the greatest development in western artistic civilization, coincides with a period of economic depression. We must therefore acknowledge, firstly, that the two sequences of phenomena, even over the long term, do not necessarily develop in parallel, and secondly that the relationship between economy and culture can take many different and contradictory forms even to the point of having cultural growth in a situation of social stagnation or even outright decline. In particular, Lopez tries to explain the superiority of 'Renaissance' artistic production (i.e. fifteenth and sixteenth century) by suggesting that during this period a poorer society was investing proportionately more in culture and art.

It seems to me that, even without going into an assessment of the objections economic historians (Cipolla, Romano) have raised to the theory of a Renaissance depression, Lopez's reasoning is ruined in part by his acceptance as indisputable presuppositions of two prejudices, and because they are both from a field unfamiliar to him, that of the historiography of art, they demand that we in turn should answer them.[33] The first, which goes back to Vasarian apologetics, is the idea that artistic progress moves ever onwards through a series of stages from Giotto to Masaccio to Michelangelo, each successive stage being absolutely qualitatively superior to the previous one. This concept served Vasari admirably in support of his thesis, which was to demonstrate the superiority of contemporary artistic production (in which he had a vested interest) over that of all previous eras, but which subsequently gained even greater strength from the other prejudice, of a naturalistic character, whereby, as we have already seen, styles (here equated with biological species) are considered better and healthier the longer they survive. So that, here too, relative stasis (such as the persistence of 'Mannerism' in painting and sculpture and, above all, of the 'classical style' in architecture) has been seen as a positive indicator of vitality instead of as a sign of a lack of renewal of production and therefore of stagnation, as would have been more correct.

Once we have rejected all attempts to judge the artistic products of a period with hindsight, instead of through its own optic, and learned to read the 'economic' significance of artistic facts correctly, there seems to be no reason why we should not call the artistic production of, say, the sixteenth century as a whole 'inferior' (let us suppose for a moment that it is) to that of the thirteenth or fourteenth century, or vice versa. In other words, it is methodologically incorrect to suppose *a priori* that the (relative) economic 'depression' of the fifteenth and sixteenth centuries was not accompanied by a (relative)

artistic 'depression' which still of course produced Masaccio and Giovanni Bellini, Michelangelo and Titian, among others. But this does not mean that we have to imagine a system of investment in culture which turns the way the two levels relate on its head, so that a 'less' developed economy would be balanced, almost in compensation (or as a consolation) by a 'more' developed art.

At first glance there would still appear to be some strength in the aged Luzzatto's conclusion that 'the old position of monopoly was gone, and the old power of expansion was enfeebled. To this extent, undoubtedly, it is proper to speak of Italian economic decline. But to use the word "decline" in the further sense, of an absolute fall in the volume and value of production and exchange, would be wholly unjustified.'[34] This conclusion has more recently been reinforced by the work of Ruggiero Romano, who has pertinently recalled the negligible importance which the avant-garde sectors (manufacture, international trade), the historians' favourite indicators, had in the economy as a whole at the time; although it may be appropriate to remember, for the sake of our own immediate interest here, that artistic production itself, at least that part of it which can be classed as luxury consumer goods, seems to be very closely linked to precisely those forefront sectors.

These references to the ongoing debate between economic historians help us to understand that if we want to progress from a discussion of method (which can be usefully kept on the level of paradox) to a discussion of merit, we must simply acknowledge that our current knowledge does not allow us to give reliable answers. Analysis of the significance, in economic terms, of artistic production, is in particularly short supply. Even the quantitative data which we could use (what quantity of art has survived, its cost and the cost of those works which have not survived as given in contracts, the dimensions of buildings, the spread of the city) have hitherto been evaluated in a wholly impressionistic way, without any kind of serious scientific processing. In these circumstances, it is difficult to maintain that the fifteenth century invested more in works of art, either in absolute figures or in percentage terms, than the fourteenth century, just as it is difficult to make the opposite claim. What is certain is that in many, if not all cases money was invested in art in a different way.

One way of seeing this is the difference in the geographical siting of the most important churches (the Duomo in Milan, the Certosa in Pavia; in Florence the greatest task is to try to finish off the Duomo, begun in the late thirteenth century), and in the slowing up

of building development in so many centres of population (Volterra, San Gimignano, Orvieto, Spoleto, Gubbio etc.) which still have a largely 'medieval', or rather 'fourteenth-century', character to this day, and not without reason, though this was accompanied by an impressive revival of residential construction (especially for the ruling classes) in other cities (Florence, Siena, Venice, Ferrara). In a different sector, the widespread popularity of cut gems and small items for private collectors generally towards the end of the century meant that there was a 'hoarding effect' which has often been pointed out. It is still hard to say whether the Strozzi Palace cost more in real terms than the Palazzo Vecchio, and whether the Medici Palace was a greater financial strain than the Peruzzi houses, or whether Lorenzo de' Medici and his kind invested more or less money in jewels and precious stones than the early fourteenth-century Florentine or Bolognese merchants spent on ecclesiastical goldsmithery and miniatures either directly or through the religious orders. All we can say for now is the opposite: that the different geographical distribution and the different nature (for example the greater 'secularity' so often referred to) of fifteenth-century works of art postulate a different system of investment distribution in the sector, and it will take a whole series of investigations to establish its workings. As for the problem of ascertaining whether the bulk of investment was proportionately rather than absolutely higher, this is a delightfully historical-economic question, which requires a general and comparative analysis of all sectors of the economy and the relationships between them, such as I fear is still far from any conclusion. But even once we have all the answers an in-depth study of public and private balance sheets in the course of the period in question can provide, it is hard to believe that, in every case, these will take on the theoretical importance which Lopez seems to wish to give them. Besides, Lopez is quite prepared to bring into the debate, alongside the economic data, arguments of a 'superstructural' nature. He insists, for example, on the closed and essentially aristocratic nature of Renaissance society, and underlines the lack of optimism in the prevailing ideology, seeking therein indirect confirmation of his 'depression' thesis:

> The moods of the Renaissance are so many and so various that they seem almost to defy definition. That is exactly why the Renaissance looks so modern to us – it was almost as rich and diversified as the contemporary scene. One important modern trait, however, was lacking. Most of its exponents had little faith and little interest in progress for the whole human race. Indeed this idea seems to be germane to

economic expansion. The religious ideal of progress of mankind from the City of Man towards the City of God hardly survived the end of the commercial revolution and the failure of social revolts in the fourteenth century. In the later period, even the most pious men tended to exclude forever from the City of God the infidel, the heretic and frequently all but a handful of Catholic ascetics or Protestant militant men predestined for salvation. The secular ideal of the progress of mankind through the diffusion of decency and learning was seldom emphasised before the late sixteenth century, when economic stagnation began at last to be broken. In between there were nearly two hundred years – the core of the Renaissance – during which any hope for progress was generally held out not to the vulgar masses but to individual members of a small élite, not to the unredeemable 'barbarians' but to the best representatives of chosen peoples.[35]

I do not mean to sound sceptical about the ability of 'intellectuals' (writers and, from this period onwards, certain artists also) to take on board the aspirations and feelings of the whole of society (in fact my real feeling is one of caution in the face of monolithic concepts, even when dealing with societies of the past), but I have the impression that, if investment in culture at this period had really been greater in absolute terms, or even only in relative terms, than in the past, the ideologies embodied in works of literature and art would have shown more obvious signs of optimism ('progressivist').

The late Gothic revival

All this was to show that in the last analysis the unfolding of the historical process described by the economic historians (Sapori, Lopez, Miskimin) can be applied even better than they themselves would dare to imagine, though with the provisos already mentioned, to the history of art. In fact, for the late Gothic revival, as for the period covering the second half of the thirteenth century and ending with the fourteenth-century renewal, the qualitative leap on the specific level of style is preceded by about thirty years (1380–1410) of general renewal in the dynamic of innovation.

If indeed we have suggested that the cessation of production in some centres in the mid-fourteenth century, the reduction of production in other centres, and the conservatism of Florentine art in the years 1348–70 should be read as signs of recession, we are obliged to see developments in Tuscany over the next thirty years as quite the reverse, as signs of relative renewal.

There was a new flourishing of artistic activity in relatively minor centres, which began to produce personalities of considerable talent: in Arezzo there was Spinello, whose fresh narrative and inter-city style of career (Pisa, Florence, Siena) anticipate the new breed of 'international' artist; Orvieto in turn exported painters like Piero di Puccio (to Pisa, Cetona, Perugia) and Cola Petruccioli (to Perugia); in Volterra there was Francesco Neri; Giuliano di Simone and Puccinelli in Lucca; in Pistoia, Giovanni di Bartolomeo Cristiani, and even Montepulciano had its own Pietro di Domenico.[36] The 'export' of talent and works of art from minor centres to major ones suggests that the major centres were more readily disposed to give work to outsiders, a point which seems to be confirmed by the activity of non-Italian artists such as Pietro di Giovanni Tedesco or the Portuguese Alvaro Pirez in Tuscany.

Another sign was the revival of grand public projects in the big cities, from Orsanmichele to the Loggia dei Lanzi, and the baptistery doors and dome in Florence, from the Loggia di Piazza to the Fonte Gaia in Siena; and this also seems to be a sign of greater availability of funds for works of art. Moreover, even at the level of 'popular output there seems to be a perceptible increase in both the quality and the quantity of works produced by minor artists, often anonymous but occasionally having a certain personality of their own (for example Cenni di Francesco, Lorenzo di Bicci, Michele da Firenze, Giovanni di Marco).

It should be noted that here, as in the Byzantinizing output of the thirteenth century, the renewal is manifest above all as a revitalizing of traditional stylistic movements. The old artists were the first to benefit from the new influx of investment. In Florence Alberto Arnoldi in the Loggia del Bigallo, Giovanni Fetti at Orsanmichele, Jacopo di Piero Guidi and Giovanni d'Ambrogio in the Loggia dei Lanzi, worked diligently, but on entirely traditional lines;[37] the same is true of Siena, where the artists collaborating on the Loggia di Piazza, Bartolomeo di Tommé and Mariano d'Agnolo Romanelli, derive their ideas from Nicola Pisano.[38] And things are more or less the same in painting as in sculpture. In Florence both Nardo di Cione and Agnolo Gaddi and Niccolo di Pietro Gerini were trying, albeit in different ways, to be Giottesque; and the Sienese painters Taddeo di Bartolo, Gregorio di Cecco and Benedetto di Bindo can all be considered, at least in intention, as 'Martiniesque'.

For the younger generation it was becoming more and more common for artists to look beyond the walls of their city (take the Sienese artists Martino di Bartolomeo, Lorenzo Monaco and

Domenico di Niccolo dei Cori, thinking also of Jacopo della Quercia, Gherardo Starnina, Lorenzo Ghiberti). In fact some of them even seem to have gone on 'cultural updating' tours outside their territories – an important sign of how far Florence and Tuscany had fallen behind in the past thirty years.

It is only from this point that economic renewal also expresses itself in indigenous stylistic innovations which are truly original. At this point the trend is reversed again, and Florence moves from importing artistic ideas to exporting them (with Filippo Brunelleschi, Nanni di Banco, Masaccio, Donatello, Michelozzo, Luca della Robbia). This is, once again, an exclusively Florentine phenomenon, which once again, for at least the next twenty years, as in the early fourteenth century, radically distinguished developments in Florence and Tuscany from what was happening in northern Italy, where International Gothic was still flourishing, and in Lombardy (with Michelino da Besozzo, Jacopino da Tradate and the Zavattari), or in the Veneto (Jacobello del Fiore, Giambono, Jacopo Bellini and Antonio Vivarini) or in Emilia (Giovanni da Modena, Michele di Matteo), and even from developments in the Marches (where the Sanseverino brothers prospered), Umbria, where Bartolomeo di Tommaso distorted the courtly refined style of the Lombards to express a violent, neo-medieval religiosity, and in southern Italy.[39]

The 'early Renaissance' in Florence

The competition in 1401 for the baptistery doors in Florence, with the official participation of a whole group of important artists (expanded, after the event, to include Donatello for greater effect), seems like a good starting point, also being a new century, for a new era. However, judging by the panel which found most favour, the one by Ghiberti, and by the point of stylistic development we can imagine the other competitors whose work we know (Jacopo della Quercia, Francesco di Valdambrino, Niccolo Lamberti) had arrived at by that date, the artistic situation it reflects is consistent with the context we have described, where 'Gothic' trends were being revived both in their traditional and in their newer, 'international' forms. The one exception is the panel by Filippo di ser Brunelleschi. The drastic, radical innovation of his relief compared to that of the winner and to any contemporary work of sculpture has not, in my opinion, been fully appreciated. This is not because of any 'classical' elements it contains. The cult of the antique is not by this point

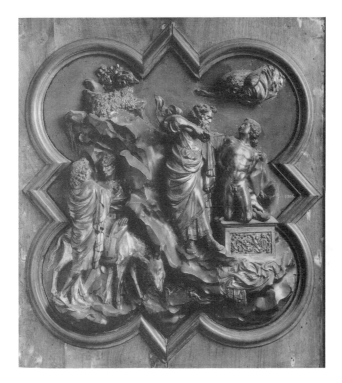

Plate 1 LORENZO GHIBERTI, *The Sacrifice of Isaac*, 1401, Museo Nazionale del Bargello, Florence.

Brunelleschi's monopoly, and classical quotations are to be found in contemporary work by other, more 'traditional' artists, from Giovanni d'Ambrogio to Ghiberti himself. And these artists were in fact at least as popular with the humanists as Brunelleschi. The really basic difference consists in the fact that Ghiberti's relief is to be read as one would a page of writing, from left to right, whereas Brunelleschi's needs to be seen in depth, as a whole. This is why Filippo developed his narrative in the opposite direction from a line of writing (which both his learned contemporaries and we feel to be the 'normal' direction): he wanted to break that mental habit and force us to look in a different way, into depth. Brunelleschi's relief is in fact, like Giotto's paintings, a unified spatial box in which a dramatic action takes place, and it already has perspective. At a time when the 'International Gothic' style reigned supreme this idea was too much against the tide to be accepted; and in fact it was only slowly,

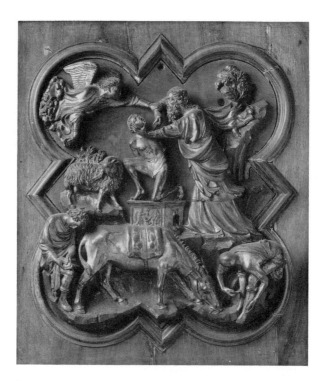

Plate 2 FILIPPO BRUNELLESCHI, *The Sacrifice of Isaac*, 1401, Museo
Nazionale del Bargello, Florence.

through the work of a whole flock of followers educated and in-
structed by Brunelleschi, that the idea gained strength. But there is
no doubt that, on a 'linguistic' level, this was the turning point, the
watershed.

Thus one could see the Florentine 'Renaissance' on a cultural level
as the fruition of a gradual renewal after a period of decline, and on
the specific level of the 'figurative' arts it would be characterized by
the discovery of perspective.

This first statement may prompt objections from anyone who
nurses doubts about the idea that there is a substantial parallel to be
drawn between the graphs of economic history and art history, namely
that the moderate and partial renewal of the late fourteenth century
seems rather an inadequate springboard for an artistic revolution
such as that of the Renaissance. We know, for example, that the
population of the city, though on the increase since its collapse at
the time of the Black Death, never again reached its former size,

and in fact began to shrink again after 1420; we know also from a political point of view that the unfortunate war with Lucca in the early 1430s is seen as the point when the internal balance of the Florentine ruling class was upset,[40] and we shall soon see that Cosimo de' Medici's accession (1434) has some retrograde effect even on the figurative arts. To counter this objection, we must first of all insist on a methodological point of the utmost importance; and this is the irreducible difference between the long-term periods of economic and demographic history and the short-term periods of cultural history which are linked to people's memories within the compass of a generation at most. Whereas most people do not perceive the deep currents of economic and social development, everyone has a psychological awareness of the 'current trend', and this works either negatively or positively, as a multiplication factor determining cultural output. The fact that today, with hindsight, we can clearly see the fragility of the Florentine recovery between 1370 and 1430 does not mean that this is how it appeared to people at the time. The current situation may have been the only visible reality for the artists, and for the first time in memory, it was a reality to get excited about, seeming to promise a tangible return to the golden age of the early fourteenth century, when the city numbered nearly a hundred thousand inhabitants, and Giotto was busy building walls to hold at least twice that many. In the sphere of political literature, Baron has rightly highlighted the psychological value of the successful resistance Florence kept up between 1390 and 1402 against the expansionist policies of Gian Galeazzo Visconti; and we should not forget that, very soon afterwards an age-old dream of the Florentines came true with the conquest of Pisa (1406).

My second statement, regarding the value of the discovery of perspective as a dividing-line in defining the new art of the Renaissance (and of Italy), is opposed, as we know, by a more eclectic historiographical tradition, which tends to put other factors alongside this one: classicism, worldliness, realism (individual portraits, anatomy). We can quickly put aside worldliness, which is not a feature of Florentine art at this time (after all Filippo di ser Brunelleschi's sculptures and Masaccio's paintings all have religious subjects, and the first sculpture on an 'antique' topic by Donatello[41] was not until the end of the 1430s), and that leaves classicism and realism. It would be absurd to deny the importance of these factors, but we must see what specific features of 'Renaissance' classicism and realism distinguish them from similar vigorous trends which are certainly to be found in ancient and medieval art. Erwin Panofsky, the greatest

student of the problem of the classical tradition, has claimed that what marks out the Renaissance proper (as opposed to medieval 'renascences') is the process of reintegrating the classical subject with classical style, and therefore in the bridging of the gap between literary and figurative movements in the classical tradition.[42] In the period we are looking at here, there is no such process at work yet, for the reason already adduced that there are no classical subjects whatsoever. Nevertheless classicism is present, a classicism of style, not of content, which takes visual metaphor to the limit (Nanni di Banco, Donatello, Michelozzo), substituting prophets for ancient philosophers, and cherubim for cupids.[43] The function of this classicism is the evocation of its models, but more one of 'realism' (see Masaccio, Donatello). And so we come to realism. There is no doubt that this Renaissance 'realism', which includes naturalistic features resurrected from certain periods of antique art (particularly the Republican or Antonine portrait, though passing over real Augustan classicism; imperial sarcophagi), is different from any previous kind. Commentators have always agreed on this, and it has given rise to the now famous distinction between analytical or surface realism and synthetic or structural realism. What is it, then, that makes the realism of the early Florentine Renaissance a realism 'of structure' compared with northern realism (for example that of Sluter)? What else can it be besides the fact that it is perspectively conceived? And what is anatomy, that quest for a stable geometrical structure underlying the visible appearance of flesh, drapery, hair, in this early phase (we are still a long way from Leonardo!) if not a search for a more solid basis for the perspectival placing (or fore-shortening) of the human figure?

Perspective is, therefore, the only characteristic of the new Florentine art which unifies all its other features and co-ordinates and subordinates them into a coherent figurative system which differs from the traditional one (or from all except, to some extent, the Giottesque tradition). This is why, from this point until the end of the century, the history of Italian art, as it becomes stronger and more firmly established, runs parallel with the history of the spread of perspectival vision.

The discovery of perspective therefore allows the new modern language, Italian and Giottesque, to absorb into itself the ancient, classical, Graeco-Roman and early Christian language, rather than the reverse. It is this discovery, with its unified basis, which prevents a split in the figurative arts similar to the literary schism which separated the vernacular from humanist Latin. This is also why,

from this point until the end of the century, the history of the language of Italian art as it becomes stronger and more firmly established, runs parallel with the spread of perspectival vision rather than with the proliferation of classical subjects and naturalistic style. Particularly along the 'Umbrian way' observed by Roberto Longhi (originally as early as 1914),[44] this spread followed the movements of Piero della Francesca: Bonfigli and Caporali (and later Perugino, Bramante and Raphael) in Umbria; Cossa, Tura, Marco Zoppo (and later Ercole de' Roberti, Costa, Francia) in Ferrara and Bologna; and Giovanni Bellini, Carpaccio, Cima da Conegliano and Bastiano (and later Giorgione, Titian) in Venice. But it also reached central Italy (Antoniazzo Romano), the south (Antonello da Messina) and Lombardy (Foppa, Butinone, Zenale, Luini, Bramantino).

A Renaissance of the antique?

By the same token, we should ask what we can keep of the traditional concept of re-naissance, or new birth, and what exactly it was that was reborn at the beginning of the Quattrocento. The traditional answer, which has been reinforced quite recently by a great scholar of art, is well known: 'despite the "neo-Gothic" or "anti-classical" movements – which must be viewed not just as a potential starting point for Mannerism but also as an effective and necessary prelude to the classic high Renaissance – the Italian Quattrocento was and is a "renaissance of antiquity".'[45] It cannot be denied that an unprecedented effort was made throughout the fifteenth century to rebuild the classical tradition from scratch, so to speak; but this is really the history of what happened later, and some of the northern centres (Padua, Mantua, Venice) may have played a greater part in it than Florence itself. When the process began, with the Florentines, what was generally envisaged was not the highly improbable rebirth of the Roman republic of 1,500 years earlier, but the rebirth of a relatively more recent republic, which they had experienced at first hand, the Florentine republic, which was no more than a century old, the same city which at a time when it was extraordinarily powerful had built the Palazzo Vecchio, the Bargello and the city walls, and given life and work to the great Dante, Giotto and Andrea da Pontedera, who had yet to be surpassed.

Revivals, even copies from Giotto and Andrea Pisano were just as common in those years linking the two centuries as references to examples of ancient art,[46] and it is no accident, in my opinion, that there has always been argument over the extent to which the Duomo

is 'antique' or 'Arnolfian'. There was always a strong sense of this specific modern tradition in Florence, from Filippo Villani and Cino Rinuccini to Matteo Palmieri who, in the 1430s, spoke of painting 'before Giotto' as being 'the lifeless mistress of laughable figures; it was resurrected by him and sustained by his followers to be handed on to others', and sculpture and architecture 'had long been full of amazing stupidities', but 'in our time' have 'risen again, brought back to the light' and 'made perfect';[47] what is important here is to notice how 'our time', for the figurative arts, begins precisely with Giotto.

The answer to the problem posed at the beginning of this section must therefore be that to whatever extent the early Florentine Renaissance was in fact a 're-birth', a conscious renewal and revival, its aim was to be what it was, above all: a rebirth of the original Florentine (and Italian) art.[48] We can then retain the old saying, in another, metaphorical sense, that it seemed to be, and to some extent really was, a new departure from that same rational basis.

The turn of neo-feudalism: Cosimo and Piero de' Medici

It was observed from the time of the first studies, and has almost become a commonplace, that the works of the generation of artists born at the end of the fourteenth century, Filippo Brunelleschi, Donatello, Michelozzo, Luca della Robbia, Masaccio (but also 'non-Renaissance' artists such as Ghiberti and Masolino) cannot be compared in terms of their originality and innovative force with the work of the next generation – Filippo Lippi, Bernardo Rossellino, Domenico di Michelino, Benozzo Gozzoli and Andrea del Castagno. This observation led George Kubler, in a brilliant typology of the artists based on their biographies, to use Brunelleschi, Masaccio and Donatello as examples of the category of 'precursors', or 'men whose powers of invention find a proper entrance no more often than once every few centuries, when new domains of knowledge are opened through their efforts', 'such men prefigure in the work of a few years the series that several generations will slowly and laboriously evolve'; and it was Longhi's famous and masterly analysis of which parts of the Uffizi *St Anne* were Masolino's and which Masaccio's that compelled him to advance a rather similar theory: 'as often happens in early genius, Masaccio seems to give a hint of every possible direction his formal thought might take, which will later be fully worked out by others.'[49]

I have already explained how we should interpret this kind of observation in our reading of the social dynamic. There is a slower rate of innovation, a lack of public interest in welcoming new things, and relative stagnation. Therefore we can certainly see Brunelleschi, Donatello and Masaccio as geniuses, but we must also more importantly acknowledge the prudence of their colleagues, followers and clients.

So from the 1430s onwards the history of 100 years earlier repeats itself: as the tide of innovation ebbs we see a largely conservative culture being established where, as in Giovanni da Milano's day, the most important new influences will once again come from outside (Domenico Veneziano, Piero della Francesca) and will be understood only by a few (Maestro di Pratovecchio, Baldovinetti). The only noticeable difference is that this drive for innovation turned out to be much weaker than the fourteenth-century one. While the careers of the great fourteenth-century artists (Giotto, the Lorenzettis, Tino di Camaino, Simone Martini) were, after all, constantly on the up, and their main problem seems to have been how to invent new modes of organization and style in order to meet the barrage of demand, when we look at the lives and works of the great Florentines of the early Renaissance we cannot escape the impression that the society which had been dynamic enough to produce them did not have enough to sustain them. Progress was slow on buildings designed by Filippo Brunelleschi, and they were left unfinished for lack of funds, while Cosimo preferred Michelozzo's idea for a palace to Brunelleschi's because it was less sumptuous;[50] Masaccio clearly lived a miserable existence, Donatello had to step up his production of low-cost semi-popular work (terracottas, stuccoes, papier-mâché) substantially in order to make a living, and finally had to emigrate to the richer markets of the north of Italy. Nor should we overlook the great success enjoyed in Florence itself, even long after Masaccio's death in 1428(?), by traditional works by older artists (Giovanni di Marco, Bicci di Lorenzo, Mariotto di Nardo, Rossello di Jacopo) and, moving on through the century, the persistent popularity, at least with a less discerning clientele, of decidedly conservative artists, from Mariotto di Cristofano to Paolo Schiavo and Andrea di Giusto, Francesco di Antonio, Pier Francesco Fiorentino and Neri di Bicci. Nor does the story of the great survivors of the first generation, on either a human or an artistic level, seem to contradict this interpretation. Take Donatello's dramatic struggle, his frantic experimentation, or, by way of complete contrast, the measured neo-medieval formula, so consciously 'reactionary', seen in some later works by

Fra Angelico. The fact that in 1459, in his frescoes for Piero de' Medici, Benozzo Gozzoli went back to the 1423 model of Gentile da Fabriano, has rightly been seen by Gombrich as 'quite in keeping with what we know of the taste of the rich Florentines after the middle of the century'. The generation to which Piero belonged 'sought contact with the aristocratic style of living they knew from their customers in Burgundy and France'. In other words, this was a change of tack, veering towards neo-feudalism, apparently turning its back quite deliberately on the rationalist 'bourgeois' values which the main leaders of the 'heroic' generation had stood for. This accords perfectly with the conclusion Antal reached in his famous study, regarding the period immediately prior to this:

> In general the later Albizzi period, from about 1430–1440, was marked by an intensification of the aristocratizing late Gothic – that is, by a formal continuation and accentuation of the style of Lorenzo Monaco and Gentile of the tens and twenties of the fourteenth century . . . So there now arose a very marked 'influence' of the International Gothic style, more intense than in Lorenzo Monaco and particularly manifest in its Franco-Burgundian mould. This accentuation, of course, was only possible since this specially aristocratizing current adopted much of the detailed realism of the French-courtly and of Gentile's art, but fundamentally little of the naturalistic achievements of upper-bourgeois art.[51]

At this point it should perhaps be added that, in this late phase, it was not only aristocratic tendencies which found expression through late Gothic stylistic formulae, but also their complete opposite, down-market, populist tendencies.

But although the International Gothic revival which struck Antal and Gombrich is certainly the clearest indication of interrupted development in the early Renaissance, there is another aspect to the situation which we ought to pause over for a moment: namely that it was also here, and only here, that the new plastic and perspectival art begun by Filippo and his friends, began, with younger followers like Lippi and Andrea del Castagno, to take on some of its typically 'humanist' characteristics (classical, esoteric, neo-Platonic subjects, and 'proto-Mannerist' stylistic traits). It is no coincidence that the famous early lunette by Filippo Lippi, usually seen as his most 'Masaccesque' work, is also the one which, in its tension between realist intention and abstract effect, already foreshadows the 'dream-world' which that wildest of Mannerists, Jacopo da Pontormo, was to evoke.

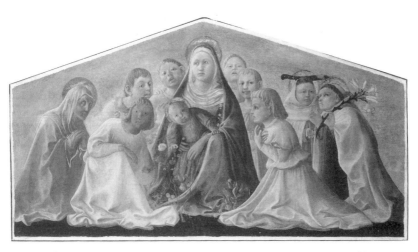

Plate 3 FILIPPO LIPPI, *Madonna of Humility*, c.1432, Castello
Sforzesco, Milan.

In the second half of the century there is every sign that, as a
group, artists in Florence were suffering from underemployment. As
for that great survivor from the heroic generation, Donatello, a
prodigal son who had returned home, it was absolutely essential
that he should not be left idle, so he was given a sort of state
commission, the San Lorenzo pulpits.[52] It has also been noted that,
during this period, the number of drawings which were preserved
grew out of all proportion, and

> not just because we are already seeing . . . early examples of collect-
> ing, but because of real hyperactivity in the drawing sector . . . In this
> huge mass of drawings the vast majority are by Florentines because
> of their marked predilection for the form of drawing . . . a choice
> which must have found support in the neo-Platonic theory of Ficinian
> circles with their preference for ideas over realities.[53]

This hyperactivity could also be due to the relative decrease in big
commissions for public display, and the increased importance of
private commissions from intellectuals, and with a combination of
these two factors the preparatory process of practice, study and
publicity (of which drawings are an instrument) became slower,
more complex and structured.

The difficulty of discussing, and therefore of periodizing, the art-
ists who, in Alberti's view in 1436 'should not be slighted in favour
of anyone famous or of long-standing in these arts',[54] together with

the refined, aristocratic and decadent 'crisis culture' which evolved in Florence in the second half of the century, is reaffirmed by repeated proposals for revising the starting date of the Italian 'Renaissance', even to the extent of delaying it until 1453, 'when Constantinople fell to the Turks, or 1454, when that ominous event cowed the Italian states into forming an uneasy league',[55] thus linking the idea of Renaissance itself to a moment of purely defensive reaction when the crisis of stagnation had already had time to show itself extensively both on a political level, with Cosimo's seizure of power, and on an artistic level where, as we have just seen, there was a 'neo-feudal' reaction sponsored by the brother of the father of the state, Piero the Gouty, at least from the 1440s onwards. We should also backdate to this point the rigidifying of social relations which forced the artists to construct for themselves, as a means to taking their place (albeit a marginal and precarious place) among the ruling classes, or at least somewhere in the upper echelons of society, a theory of the nobility of the arts, which is simply the ideological expression of the transformation of the artist from manual worker to 'intellectual'.

And this is perhaps the firmest basis for a definition of what 'humanism' might mean for the figurative arts, a better basis than the 'reintegration of classical subject with classical style' (which, given the literary culture of the time, begins to look more like the inevitable consequence of the closing of the gap between artists and scholars). It is highly symptomatic of this change that among the front lines of casualties in the process of 'intellectualization' we find so many examples (from Filippo Brunelleschi to Ghiberti, Leonardo and Michelangelo) of sons (sometimes illegitimate) of representatives of the middle class who saw artistic activity, however brilliantly pursued, as ultimately a backward step on the social ladder. This polemic 'did not intend to overcome the age-old opposition between the mechanical and liberal arts' but rather to distance the 'figurative arts' from the world of manual labour, as has now been clarified,[56] and seen from this angle, the wealth of literature arguing the nobility of the graphic arts seems to me to provide, over its three centuries of development, emphatic indirect confirmation of the profound process of social readjustment which it expresses.[57]

The moment of balance: Piero della Francesca

From the point of view of the question we are addressing, the problem of periodization, we must once again acknowledge that,

whereas the crisis of positive development, the phase of expansion, can be registered on a stylistic level by a clean break, an innovation, a precisely identifiable qualitative leap at its beginning, the crisis of stagnation, or even recession, shows in a much more ambiguous way that is much harder to place chronologically. This is quite understandable, given that the dynamic push, even as it subsides, still gives just as much support, almost by force of inertia, to whatever tendencies are already in motion, regardless of when they began; thus 'innovative' movements seek quite simply to survive, becoming 'conservative' themselves, albeit in a different way. Alternatives become less drastically opposed, and there is widespread interest in trying to achieve balance, order, synthesis. In the art of the Quattrocento in central Italy the genius interpreting this concern was Piero della Francesca.[58] For example it is quite clear that compared with the sacrilegious content of the realism of a Donatello or a Masaccio, what Piero is working on, with the thoroughly modern tools of Brunelleschian perspective, is actually an inverted process of sacred restoration. The ceremony and solemnity of the processions in the Arezzo frescoes, the stillness imposed on the figures in the limpid air by their perspective, the impression which Piero can give with almost physical intensity that every element, every gesture is subject to a rule which governs the whole, is already a radical departure from the earthy aggression of the crowds in the Carmine (which Piero studied so closely) as they take to the streets of Florence. Take another work painted at the same time as (or straight after) the Arezzo frescoes: the *Resurrection* which Piero painted for his home town, Borgo San Sepolcro, on the borders of Tuscany and Umbria.

The work is profoundly new in every detail and yet consciously reabsorbs into itself a whole series of traditional features (which, I might add, has led some critics to drag in Byzantium as usual): the composition is lifted from the fourteenth-century panel adorning the high altar of the Duomo in Borgo; the symbolism, referring to the passage from winter to spring (bare landscape to the left, blooming to the right) and from night to day (the sleepers below, the light of dawn in the sky), is the ancient symbolism of all agrarian civilizations; furthermore, the perspective itself is used only to emphasize the imposing sacred presence of the risen Christ: the horizon is in fact placed relatively low (level with the edge of the tomb) and the central axis coincides exactly with the figure of Jesus, making him a kind of pillar around which the other elements of the composition are organized.

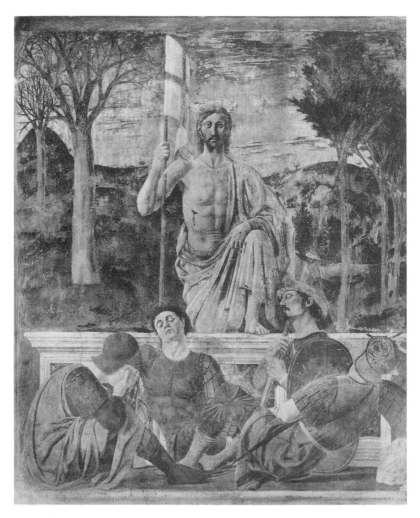

Plate 4　PIERO DELLA FRANCESCA, *Resurrection*, *c*.1460, Borgo
Sansepolcro, Pinacoteca Comunale.
Photo: Archivi Alinari.

I think that in order to account for this peculiar position Piero
adopted in relation to tradition, beyond the description sketched out
here, we must, in the final analysis, move away from the artistic
superstructure to look instead at economic structures. What we will
find, ultimately, is that Masaccio had the newly expanding business
and manufacturing world of early fifteenth-century Florence behind

him, whereas Piero's background was the agricultural and patriarchal world of Umbria.

As is logical, the validity of making this link with the basic economic structure of the different regions of Italy becomes clearer the less we consider the individual style of a single artist and the more we take a general view of the forms of expression adopted by whole groups of artists. Just referring briefly to Piero's following, it is not hard to see that the more progressive features of his style were not brought to fruition either by his 'peasant' followers in Umbria and the Marches, or by the aristocrats of Ferrara, but only by Antonello ('in Sicily only one town, Messina . . . possessed . . . a definite middle class')[59] and, more importantly, by the Venetians, who were lucky enough to live in the richest business and banking centre in Italy.

One characteristic of Piero della Francesca's art which should nonetheless not be overlooked is that it came free of any precise connection with any of the urban traditions. He worked mainly for the small courts of central and northern Italy, Rimini, Urbino, Ferrara, and managed, with his use of perspective, to synthesize the plasticity of the Florentines with the chromatic tradition of northern late Gothic (which had come to him mostly through Domenico Veneziano), and to offer learned men from various regions of Italy a universal solution to the problem of figurative language. In the wake of Alberti's theorizing he was the embodiment, even in the eyes of the humanists, of the new kind of intellectual artist. In this sense he was the only real precursor for the art of the so-called 'high Renaissance', which was both classical and Italian *par excellence*: the art of Bramante and Raphael.

The Renaissance outside Florence

While this, roughly, is the story of what happened in the home of the new style, Filippo Brunelleschi's Florence, things moved at a different pace in other parts of the peninsula: in the rest of central and southern Italy we can talk about a fairly homogeneous process of evolution in which the slow spread of Renaissance innovations and their adaptation to traditional realities provides an extraordinary phenomenology of brilliant 'reactionary' versions of that culture, clearly perceived as too advanced for the expectations and demands of the various local markets (take for example Siena and Giovanni di Paolo, Sassetta, Vecchietta and Neroccio;[60] Camerino and Boccati or Girolamo di Giovanni;[61] Perugia and Bonfigli or Caporali;

Antoniazzi's Rome[62] or the 'San Severino Master' in Naples);[63] in northern Italy, alongside similar phenomena which can generally be seen as a reconquest of all that fertile territory which sustained the luxuriant growth of International Gothic (not just Ferrara, with Galasso, Bono, Francesco Pelosio and later Cosimo Tura; but also Modena with degli Erri, Cristoforo da Lendinara, Bartolomeo Bonascia; Verona with Francesco dai Libri and Benaglio, and Cremona with the Bembo family),[64] we can also see other phenomena working to develop the more innovative possibilities provided by Renaissance ideas about investigating, conquering and rationalizing the reality of nature. The fact that in the second half of the century northern Italy was once again strong enough to take a leading role in the development of Italian art is a sure sign, from our point of view, that the rich farming centres of the Po valley with the manufacturing and commercial activity attached to them, provided a whole new network of firm support for a varied and high-quality art scene. Moreover, the fluctuations in the relative importance of the north versus central southern Italy in the forty years following the Treaty of Lodi (1457) was not something that influenced only the figurative arts, if Peter Burke can deduce from a few statistics on the make-up of the Renaissance elite that 'after two essentially Florentine generations ... of the 85 members of the creative élite born between 1460 and 1479, only 21 were Tuscans', and this is out of a 'sample' which privileges the 'creativity' of the Tuscans more or less *a priori* and according to tradition.[65] Unlike the situation in the second half of the fourteenth century, when the north made a comeback, largely thanks to the cities of Lombardy and Emilia (Milan, Modena, Bologna) and the greatest contribution in the Veneto came from the inland cities (especially Verona and Padua), in the fifteenth century 'remake', the role of undisputed star fell, as has always rightly been acknowledged, to the city of Venice. The importance of this total reversal for the history of Italian art is impossible to overstate.

The old Venice, holed up in its lagoon, a border territory that looked to the sea and the east, was shaken during the fourteenth and fifteenth centuries by political upheavals on a large scale (to the west the establishment of the *signorie* of the inland states: the Carraresi in Padua, Scaligeri in Verona, Visconti in Milan; and to the east the advancing Turks), and, as we know, it undertook the conquest of the mainland; in 1402 Bassano was annexed, in 1404 Vicenza, the following year Padua and Verona, and in 1441, with the Treaty of Cremona, the territories of Peschiera, Brescia, Bergamo and part of

the territory of Cremona. But the great era of Venetian art began after the period of conquest ended, with the Treaty of Lodi (1454) and the removal of the Doge Francesco Foscari (1457).

In fact it is impossible to place the qualitative leap in Venetian artistic output any earlier than the 1460s, with Giovanni Bellini as its leader.[66] Until then, neither the Bellini workshop nor the rival Vivarini workshop had gone beyond a process of filtering and re-working Florentine innovations, quite similar to the process going on in other parts of northern Italy (for example in Pisanello's work at Mantua and Verona).[67] The same is true of sculpture, which stayed with late Gothic forms until Antonio Rizzo and Pietro Lombardo's works of the 1470s,[68] and architecture, where we have to wait until Mauro Codussi's San Michele in Isola (1469).[69]

We know what the cultural experiences were which opened Giovanni Bellini's eyes and turned him into the greatest exponent of the new art of perspective: Donatello's work in Padua (1443–53) and Venice (1453–6), and his knowledge of the works of Piero della Francesca. There is no need to recall this well-known chapter in art history except to highlight the different, almost opposite effect that the same experiences had on Andrea Mantegna on the one hand (he had in fact, at a very early age, been the first to engage with the Florentine innovations) for whom the robes of a humanist seem tailor-made, and on Giovanni Bellini, who was quite different and rather greater.[70]

In works such as the *Pietà* now in the Brera or the Polyptych of *St Vincent Ferrer* we can already see the pictorial revolution carried to its ultimate conclusion, where it is not line and foreshortening but perspective and light and colour which lead to a new vision of man in nature, or, to be more precise, man in the country. Humanizing the sacred subject is something quite different from dressing it up in ancient costumes: his saints, his Madonna and Christ himself are men and women, not heroes and heroines; foreshortening and per-spective are neither used to show off intellectual ability, nor as winks and nods to the initiated; rather they are means of presenting more clearly and faithfully how man and nature are bound together as one.

This was the beginning of a new chapter in the history of Italian art, in which Venice rose to become capital of the region and could even entertain ambitions of contending with Florence for national primacy. It was Giovanni Bellini who led the process of change with confident authority for a span of forty years (until he was directly succeeded by the young Titian, passing over the 'humanist' Giorgione);

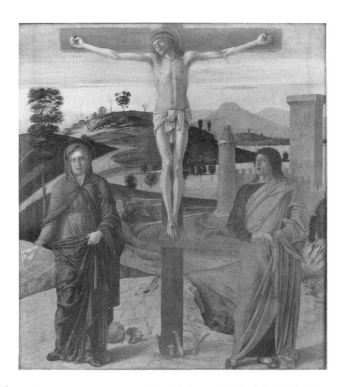

Plate 5 GIOVANNI BELLINI, *Crucifixion*, *c*.1470, Musée du Louvre.
© Cliché Musées Nationaux, Paris.
Photo: Réunion des Musées Nationaux.

whether training his squad of workshop hands (who were authorized
to sign in his name: Niccolo Rondinelli, Lattanzio da Rimini, Marco
Bello, Rocco Marconi, Bartolomeo Veneto, Francesco Bissolo),[71] or
standing as an essential term of comparison for every artist from
Venice or inland who wished to call himself modern (just think of
the names from Venice: Vittore Carpaccio, Cima da Conegliano,
Lazzaro Bastiani, Marco Basaiti, Benedetto Diana; from Vicenza,
Giovanni Buonconsiglio and Bartolomeo Montagna; from Verona:
Michele da Verona and Francesco Morone).[72] This then was the
Venice, dominated by Giovanni Bellini, which witnessed in around
1475 the definitive 'Italianization' of the greatest southern painter,
the half-Flemish Antonello da Messina.[73] The new importance of
landscape in sacred scenes (rural, out-of-town landscape) and the
new success of the portrait, not the old heraldic, numismatic and
celebratory version, but the three-quarters view, real though not

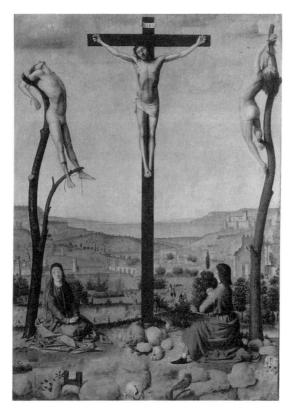

Plate 6 ANTONELLO DA MESSINA, *Crucifixion*, 1475, Antwerp, Koninklijk Museum voor schone kunsten.

realistic, individual though not psychological – these are the clearest signs of the new 'Italianism' in Venetian art. The links between this change and the new land-based and farming interests of the Venetian ruling class have already been pointed out, and it is also quite clear that Venice took on its new role of model and guide in the eyes of the other still important cities of the Veneto as a direct consequence of its emergence as the political capital, indicating its growing wealth both in relative, and probably at the time in absolute, terms.

Venice and Florence

Whereas a comparison in time with the situation in the fourteenth-century Veneto shows Venice itself pulling ahead of the inland cities,

a synchronic comparison with the situation in the other main centre of cultural development, Florence under Lorenzo the Magnificent, also highlights differences beyond their common 'modernity' which some have seen as irreconcilable.

To look first at what they have in common, we must take note of the substantial progress made in both geographical areas by the 'humanist' process, the intellectualization of the artist, and the rationalization, secularization (and to some degree profanization), and privatization of the work of art. It has recently been re-emphasized how quantitatively limited this process was, bearing in mind that the majority of works were still religious both in subject and function, and would be for some time to come;[74] but this must not be allowed to obscure the qualitative leap inherent in the reversal of the relationship between the two sectors; whereas in the Middle Ages, when an artist was called upon to portray a profane subject, he would dress it in sacred clothing, now the opposite was happening; the private sector became the guiding force for the public religious sector too. Portraits, architectural and landscape backgrounds, objects, all take on an importance of their own which is reflected even in paintings for altarpieces; saints are portrayed as lords or rich merchants, prophets as ancient philosophers; explicit representations of everyday life or love scenes are relatively rare, but even theophany becomes a family gathering, a *sacra conversazione*, and there are pronounced erotic undertones in the elegance and physical beauty of many young saints, and even in the announcing angel and his reluctant lady.

But it would not be hard to shift the emphasis to the differences which separate the sophisticated 'humanism' of the Florentines from its much simpler and more relaxed Venetian version. Florence nurtured the hothouse culture of the court of Lorenzo the Magnificent and Verrocchio's workshop (Botticelli, Perugino, Leonardo, Lorenzo di Credi),[75] embodied in a secular painting with a 'classical' subject like the *Birth of Venus*, rising from such an improbable sea, and ultimately so un-'antique'; in Venice even subjects for private paintings were for the most part religious, but a Madonna and Child by Giovanni Bellini or Cima da Conegliano is more Hellenistic and more natural than anything by Ghirlandaio or Botticelli. And the traditional contrast between the abstract, intellectual *disegno* of the Florentines and the (sensual?) colour of the Venetians cannot be without some significance on a social level. The impression we get is that these two interpretations of humanism reflect differing breadths of support from within society, deriving in turn from the difference

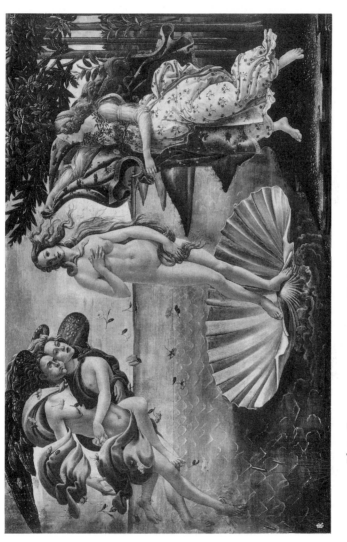

Plate 7 SANDRO BOTTICELLI, *Birth of Venus*, *c*.1485, Uffizi, Florence.
Photo: Archivi Alinari.

in how secure the ruling classes were in both places. Moreover, before the end of the century the precariousness of the position held by the Florentine ruling class was to be shown by the interlude of Savonarola's whinging republic (1494–8),[76] while its Venetian counterpart would show its resilience by surviving the Agnadello crisis a decade later (1509–17).[77]

Northern Renaissance and 'premature classicism'

Any picture of the 'humanist' unification of the figurative language of Italy – at least at the level of works produced for the ruling classes – in the last quarter of the fifteenth century, must include the vast Po valley area, including the part which did not fall under Venetian rule. Whereas the Veneto certainly played its part, by 'converting' Vincenzo Foppa and Ambrogio da Fossano if nothing else, we must not forget the influence of the other modernizing trends coming from the previously 'Italianized' northern centres, Ferrara (with Tura, Cossa, Ercole de' Roberti), Padua (with Squarcione, Donatello and Bellano), Mantua (with Mantegna, Riccio and l'Antico) as well as directly from central Italy. The perspective which found favour here was not the clear, relaxed Piero della Francesca–Giovanni Bellini line, but the ostentatious, obsessive, virtuoso version by Mantegna (Girolamo da Cremona) and more particularly Bramante. Sculptors such as Mantegazza and Amadeo and painters like Butinone, Zenale and even the great Bramantino came closer to the new figurative language of the Tuscans and humanists via the complex route which apparently seeks to deny as it embraces them the values of 'bourgeois' rationality on which it is founded.[78]

We have seen that the two lines of development in the artistic production of central and northern Italy have, despite the decisive exchanges and role reversals, followed quite different paths up to this point; in these late years of the fifteenth century they begin to converge until the so-called 'premature classical' phase and later the Raphaelesque classical phase, when a stylistic formula of truly national currency was to be coined for the first time.

What modern critics have now agreed to call 'premature classicism' – after Longhi – had already been discussed by Vasari in his introduction to the third part of the *Lives*, defining its distinguishing trait as 'a harmonious blending of colours' and pointing out that it was 'first observable in Francia of Bologna and Pietro Perugino. The people, when they beheld the new and living beauty, ran madly to

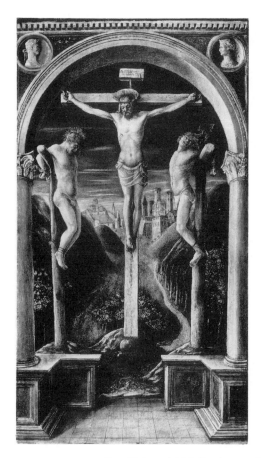

Plate 8 VINCENZO FOPPA, *Crucifixion*, 1456, Bergamo, Accademia
Carrara.
Photo: Archivi Alinari.

see it.'[79] Here we should notice that for the first time Vasari is
yoking together as innovators a northern artist and a central Italian
(non-Tuscan) artist, and he almost seems to be conceding the primacy
of the former; it is actually hard to say whether the rich melting-pot
is dominated by its northern ingredients (from Flanders, Ferrara, the
Veneto: Hans Memling, Lorenzo Costa, Vittore Carpaccio) or by the
central Italian elements which Perugino, who started out as a fol-
lower of Piero and spent time in Verrocchio's workshop in Florence,
may have brought to it. This form of didactic, elementary classicism
certainly seems to have managed to give around twenty years of

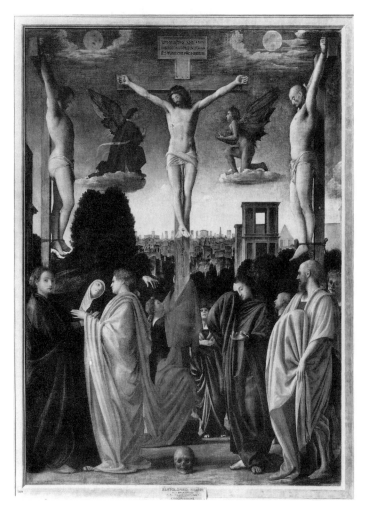

Plate 9 BRAMANTINO, *Crucifixion*, c.1515, Brera, Milan.
Photo: Archivi Alinari.

satisfaction to 'progressive' art lovers as well as to a general public who still liked the symmetry of polyptychs and the diligence of the Flemish painters: to humanists and churchgoers alike. This was a compromise formula if ever there was one, but it was still something new, and at one point around the turn of the century it was followed by major and minor artists working on both sides of the Apennines, but especially in Umbria (Lo Spagna, Pier Matteo

d'Amelia, Tiberio d'Assisi, Matteo Balducci), Lazio (Antonio da Viterbo, known as Pastura, Bernardino Pinturicchio), Tuscany (Leonardo da Vinci, Lorenzo di Credi, Mariotto Albertinelli, Fra Bartolomeo), Emilia-Romagna (Gian Battista Bertucci), Venice (Carpaccio, Giorgione, Tullio Lombardo), Ferrara (Lorenzo Costa, Garofalo), Cremona (Boccaccio Boccaccino), and Lodi (Albertino Piazza), whereas in Milan a similar solution (though on largely local naturalistic lines) was made successful by Ambrogio da Fossano known as Borgognone.[80]

1492

The flowering of this particular phase in the evolution of the language of Italian art coincides almost to the year with the point traditionally taken, at least on an institutional level, as the watershed between the study of 'modern history' and 'medieval history': 1492, the discovery of America and the death of Lorenzo the Magnificent, or 1494, the year when Charles VIII's troops invaded Italy (a date which Lopez would like to take as the starting point for his 'mature' Renaissance).[81] This coincidence is easier to state than to explain.

What we have here is a critical point which is generally agreed to exist, but for which various different, even contradictory meanings are found. Was it the beginning of an age of catastrophe, as political historians (from Guicciardini onwards) see it, or the start of the greatest flowering of the Renaissance, as art historians from Vasari onwards, saw it, the beginning of the 'third style, which I will call the modern', culminating, twenty years later, in the 'golden age' ('for thus we may call, in view of the virtuous men and noble works of art, the happy age of Leo X', 1513–21).[82]

Even taking into account the obvious apologetic content of Vasari's exposition (he was defending the court, because Leo X was a Medici, and corporate interests, by hailing the superiority of the artists of the 'third age') a problem remains. We are looking, objectively, at the greatest divergence between political and cultural events that had so far occurred in the history of Italy. This is the problem de Sanctis expressed in moralistic terms when he said that 'Charles VIII rode into Italy and conquered it "with chalk". He found a people who called him a barbarian; a people in the full rigour of its intellectual forces but empty of soul and weak of fibre';[83] but he was painting a general and realistic picture when he emphasized the relative continuity, compared to the Quattrocento, of the formation process of

a real Italian language, 'an artificial and purely literary creation' linked to the fact that 'the bourgeoisie (we would say: new aristo-cracy) wanted its own language.' So we are at the point of greatest divergence, but it is the maturing of a long process, which could be said to have begun in Florence with the 'humanist' but also 'neo-feudal' reaction of the 1530s. The art historian who has sketched the 'classic' picture of the 'classic art of the Renaissance', Burckhardt's pupil Heinrich Wolfflin, has been chided for making 'the Quattrocento, the whole of the Quattrocento, a necessary prelude to the Cinquecento',[84] and even though criticism since then has cor-rectly identified the vital importance of the Piero della Francesca–Giovanni Bellini–Bramante–Raphael succession, and has produced a successful critique of the Swiss scholar's positivist evolutionism ('artistic development is no different from that of plants'), the basic continuity of the process as a whole has not been seriously disputed. From the moment perspective was discovered none of the changes which can be identified on a stylistic level and which I have de-scribed at some length, can claim to be signs of some radical depar-ture or reversal of trend. They are always new versions or new developments, further explorations, elaborations, exporting and broadening ideas that had been around for more than a century.

So there is continuity, but certainly not stagnation: the rate of styl-istic innovation rose again, especially in northern Italy in the second half of the Quattrocento, to a high level and, as we have seen, it did not really slow down in line with the supposed watershed of 1492–4. The observations of art historians therefore tend to confirm the opinion of political historians who seek nowadays to reappraise its epoch-making importance and to see it as no more than an early, albeit a very visible, sign of the fragility of the political system of the Italian states. This is another fact which finds no contradiction in a study of the characteristics of the art produced, or at least of that produced for the ruling groups in those states. The very ease with which this culture, in its various forms, could be transferred, even by the fifteenth century, from city to city and from court to court, until the final magnificent transplanting to Rome of its Urbino variety under Julius II della Rovere (1503–13), shows ultimately that its roots did not go deep.

Nor, apparently, did the loss of political equilibrium, and the wars which followed, cause any noticeable slowing in artistic production in Italy in the years immediately afterwards; at least in the main centres. In Milan the generations move on from Foppa to Bramantino and Boltraffio, Cesare da Sesto and Luini; in Venice from Carpaccio to

Giorgione and Titian; in Florence from Botticelli and Filippino to Fra Bartolomeo, Albertinelli, Franciabigio; in Rome from Pinturicchio to Raphael. In fact at the turn of the century we can see an acceleration which was to culminate in the birth of the 'modern manner' and which again, as at the beginning of the fifteenth century, managed for at least twenty years to create a radical distinction between innovative and traditionalist artists in Italy. There was a repeat of that phenomenon which so often accompanies any sudden change, an abrupt conversion of the type of product leading to a break in the stylistic development of artists who find themselves, by virtue of their generation, living through the change. For connoisseurs, this makes it difficult to link the two severed stumps, to find a way back from 'modern' production to what went before the change. Think of Luini's first paintings from the Veneto, or Lorenzo Lotto and Palma Vecchio's early 'perspective' works, Correggio's early 'Mantegnesque' work, Rustici's early 'Filippinesque' work, and although we cannot identify the young Michelangelo's 'Ghirlandaiesque' paintings, think of the huge gulf between the first documented sculptures (the stylistically 'Ferrarese' statuettes for the arch of San Domenico in Bologna) and the 1504 *David*, not to mention the *Doni Tondo* (*c*.1506), or the difference between Bramante in Lombardy and Bramante in Rome, and finally the most striking, though well-rehearsed, example of the transformation of Raphael from 'Peruginesque' to 'Michelangelesque' and, one might say, 'Titianesque'.[85]

In Julius II's Rome (1503–13) the situation in Filippo Brunelleschi's Florence seems to repeat itself. Through a series of extraordinary initiatives, political circumstances created a sort of euphoric climate in a city whose very function was artificially exalted. Julius II della Rovere 'not only dreamed of creating a national, authoritarian monarchy under the Papacy, but aimed at a "renovatio imperii" (revival of empire) in which the pope would also be emperor; just as Augustus, Tiberius or Trajan had been Emperors and pontifices maximi. Julius II would be the new Julius Caesar.'[86] This is the moment when the papacy, with its allies in the world of high finance (Agostino Chigi), actually practises the same 'worldly rationalism' as the bourgeoisie.[87] In the face of the traumatic invasion of the peninsula by foreign armies, it was the source of a fit of national consciousness ('Barbarians out!'); in this campaign the 'Latin-ness' of the humanists does not seek to deny the claims of a more recent 'vernacular' tradition, and Bramante can admire the buildings of imperial Rome and simultaneously declare himself, as Gaspare Visconti tells us, 'an ardent partisan of Dante'. The world of the

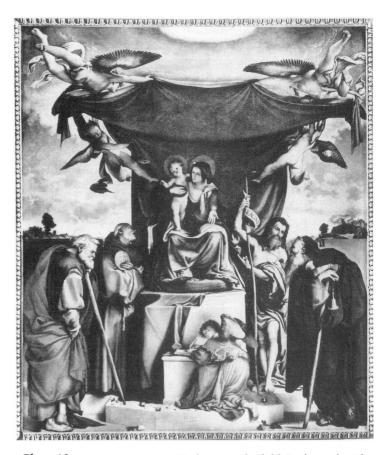

Plate 10 LORENZO LOTTO, *Madonna and Child Enthroned with Saints John, Bernardino, John the Baptist and Antony Abbot*, 1521, Church of San Bernardino, Bergamo.
Photo: Archivi Alinari.

papal court, and the flurry of activity that it brought to the city of Rome (the state's income doubled between 1492 and 1525),[88] provided the socio-economic support for the art of the 'mature Renaissance'. Raphael and his workshop,[89] which attracted artists from every part of Italy, local ones (Giulio Romano), artists from the north (Giovanni da Udine, Polidoro da Caravaggio, Marcantonio of Bologna), Tuscany (the Florentines Giovan Francesco Penni, Lorenzetto, Perin del Vaga; and Vincenzo Tamagni from San Gimignano), and even from abroad (Berruguete, Machuca, Marcillat),

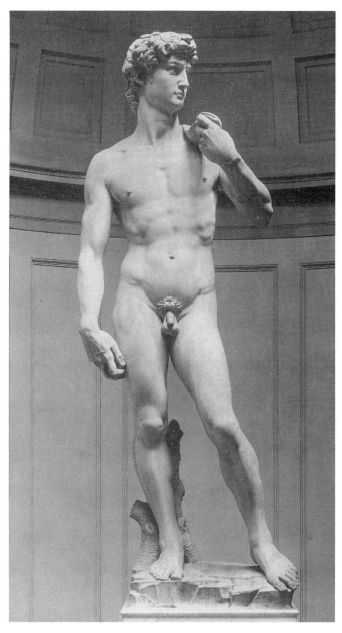

Plate 11 MICHELANGELO, *David*, 1501–4, Galleria dell'Accademia,
Florence.
Photo: Archivi Alinari.

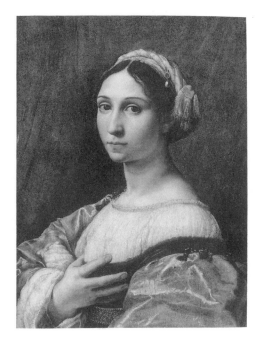

Plate 12 RAPHAEL, *Portrait of a Young Woman*, Musée des Beaux-Arts, Strasbourg.

set the tone for this phase of Italian art, and even tended, following the lead of Michelangelo the 'sculptor', to reabsorb the tradition of the Veneto (Titian, Dosso, Sebastiano del Piombo). The outcome of this intellectual adventure is well known: in 1520 Raphael died young, and the sack of Rome in 1527 scattered the artists, and thus helped to spread the modern manner (its 'nationalistic' charge having by now been defused and reduced to a polyvalent *koine*) throughout Italy and Europe. Polidoro went to Naples and Messina, Machuca and Berruguete to Spain, Rosso Fiorentino, Rustici and Cellini to France, and so on.

1527

1527, the year of Machiavelli's death, the sack of Rome, and a new outbreak of the plague, 'used to be entered in old-fashioned manuals as marking the death of the Italian Renaissance at the murderous

hands of transalpine Protestants'; this – as Lopez says – 'seems too much, but', he goes on, 'we may adopt that date, 1527, as the end of maturity and the beginning of old age.'[90] In reality the 1520s as a whole can be seen as catastrophic even by the standards of the time. In 1525 there was the Battle of Pavia, in 1526 the siege of Milan, in 1527 the sack of Rome, 1528 the siege of Naples and 1529 the siege of Florence. We have mentioned the plague: 'in the third decade of the Cinquecento the "vicious circle" of poor harvests–famine–epidemic'[91] drew tighter in Italy; in Venice 1528 and 1529 were the years of the 'great famine'; 'never in Christendom had such a desolate spectacle of ruin been seen', wrote the English ambassadors passing through Lombardy.[92] However we know that it is never difficult for a social historian who, for some reason, wants to paint a picture of 'hard times', to compile a pretty thick catalogue of war, pestilence and want, and that these pictures of catastrophe did not always entail any interruption or slowing down, or even change in the nature of artistic output. Is this true of the 1527–30 crisis or were things different? What do we learn from studying the art-historical sequence of events?

We do know that the so-called 'classic moment' of the Renaissance in Florence, Rome and, albeit more slowly, Venice came to an end around that time, while so-called 'Mannerism' spread and became more established as a common language, at least on a certain level.

The 'epigonic' nature of this style, a symptom of decadence and, in a more modern term, of crisis, has always been recognized and is nowadays a cliché. Even recently Peter Burke commented on the deliberately out-of-place triglyphs in the Palazzo del Tè by Giulio Romano, saying:

> this kind of deliberate rule-breaking, not uncommon in the 1520s and 1530s, implies spectators who are educated enough to know what the rules are, to entertain certain visual expectations, and receive a shock when those expectations are falsified; to enjoy the sensation of shock, perhaps because long familiarity with the rules has made them rather blasé. Mannerist architecture is thus allusive architecture. In literature, the anti-Petrarchism of Aretino and Berni is equally allusive. To enjoy their parodies the reader must have some familiarity with Petrarch and his fifteenth century imitators, a familiarity which breeds, if not contempt, at least boredom.[93]

So what we are seeing is a challenge to the rules from below, which transgresses them but largely takes them for granted and in violating

them actually reinforces them, never dreaming of replacing them with others: their 'freedom', as the incomparable Vasari wrote, 'while outside the rules, was guided by them . . . not incompatible with order and correctness'.[94] And Roberto Longhi, while refusing to 'draw up artistic horoscopes as it is fashionable to do nowadays, from various events and calamities of the time', came to see Mannerism as a sign of the 'desperate "vitality" of a crisis'.[95] Without attempting to address here the weighty question of the origins, function and significance of 'Mannerism' which, as we know, has provoked endless debate,[96] let us stick to a few solid facts which may be relevant to our task.

Firstly, the so-called Mannerist style emerged at the same time as, or rather is actually part of the modern manner, as an internal and only partially alternative variant, and its father and undisputed star is the Michelangelo of the *Battle of Cascina*, the *Doni Tondo* and the Sistine chapel ceiling (1508–12).[97] Born in 1475, Michelangelo is in fact the oldest of the whole rank of 'moderns'; Bernardino Luini, Gaudenzio Ferrari (born around 1480–5), Pordenone (born around 1483), Jacopo Sansovino (1486), Andrea del Sarto (1486), Berruguete (*c.*1486), Beccafumi (*c.*1486), though all slightly younger than Raphael (1483), were the same age as Titian (*c.*1487) and older than Correggio (1489). Secondly, Mannerist tendencies began to dominate only from the second decade of the century (in Florence itself, during the lifetime of Fra Bartolomeo, who was a year younger than Michelangelo, the 'classical' style found more favour), and are found in a group of artists born in the 1490s – Giulio Romano (1492), Baccio Bandinelli (1493), Pontormo (1494), Rosso Fiorentino (1495) – or slightly later – Polidoro da Caravaggio (*c.*1500), Perino del Vaga (1500), Benvenuto Cellini (1501), Camillo Boccaccino (1501), Giulio Campi (1502), Bronzino (1503), Parmigianino (1503), Primaticcio (1504).[98]

Compared with the older generation, this group had what we might call an advantage: never in the whole span of their careers did they have to make radical 'changes of output'. Once he had formulated his style from the relatively late works of Raphael, Giulio Romano was able to go on using it, via a series of gradual, untraumatic modifications, throughout his life, and in fact even after his death (in 1546) it retained its validity at the hands of Rinaldo Mantovano; Pontormo was already fully formed in his *Storie di Giuseppe Ebreo* from around 1518, and his manner is followed through without becoming too rigid well into the second half of the century by the faithful Bronzino (whose work was in turn continued

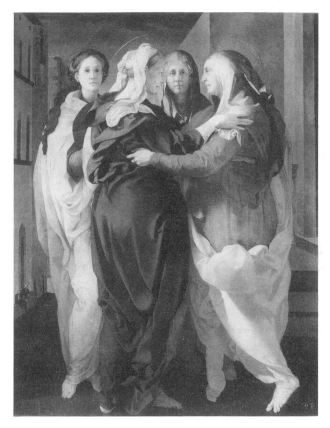

Plate 13 JACOPO PONTORMO, *Visitation*, *c.*1528, Carmignano, Pieve.
Photo: Archivi Alinari.

by Alessandro Allori, who died in 1607!); Rosso is already perfectly recognizable in his Uffizi panel (commissioned in 1518) as the painter of Fontainebleau (1532–7). With successive generations there is even more remarkable continuity in the various lines of stylistic development which can be traced back to the 'Manner'. Beginning in the north of Italy, let us just remember that Correggio's style still held good almost into the 1470s through the work of Mazzola-Bedoli,[99] Parmigianino, Primaticcio, Gandini del Grano; take the survival of Romanino's style, through Callisto Piazza, to almost the same date; the undimmed supremacy of Titian over all Venetian painting (including its down-market exploitation by the workshop of Tintoretto,

who died in 1594); in central Italy we have already mentioned the Pontormo–Bronzino–Allori dynasty, but we could add to it the parallel succession of Perino del Vaga–Francesco Salviati (which takes us at least up to 1563); up to his death (around the middle of the century), Beccafumi (and in Parma his follower Michelangelo Anselmi) carried on a manner which was still 'in the making' in the *Trinità* triptych of 1513, but was already formed by the following year in his painting of the stigmatization of St Catherine;[100] in Rome Michelangelo's dominance is upheld well into the second half of the century (when Sebastiano del Piombo died in 1547 his reformed style was continued until 1580 by Girolamo Siciolante) by Daniele da Volterra (died 1566) and Marcello Venusti (died 1579); in southern Italy (around Gaeta–Naples–Salerno) Andrea Sabatini, having settled for the style of Raphael's Logge from around 1518, never saw any need to change, and even after his death (1530) works of the same genre went on being produced (particularly by Giovan Filippo Criscuolo) and found a good market almost into the 1570s; in Calabria and Sicily traces of Polidoro (who died in Messina in 1546) provided a living for several generations of artists almost into the next century (from Marco Cardisco and Pietro Negroni to Mariano and Antonello Riccio, from Silvestro Buono and Deodato Guinaccia).[101]

These examples could easily be added to, but even this many should be sufficient evidence of how the rate of stylistic change, still very high during the second decade of the century, subsequently tailed off.

The same, therefore, goes for the second and third decades of the sixteenth century as for the fourth and fifth decades of the fourteenth, that the difference is that nothing changes much. And we could interpret this symptom in the same way as before: as confirmation of a deeper, structural crisis of stagnation, if not recession. This is the real significance of the 'consolidation' of Mannerism from the 1530s onwards which German critics have seen as the phase of 'mature Mannerism'.[102] There is no intrinsic contradiction with our interpretation of the historical process in the fact that it was precisely during this period that the spiritual preoccupations of the religious reformers began to find expression in the figurative arts (in works by Michelangelo and Sebastiano del Piombo in Rome, Silvestro Buono in Naples, etc.). A drop in the rate of change clearly does not necessarily mean that development grinds to a halt. In fact economic historians note the 'trend going into reverse' in the years 1529–34 and a 'confident recovery' only around 1575.[103]

1563

As the main event of the religious, political and social history of the century, the Reformation cannot be left out of the picture when we are seeking to periodize the next chronological phase of the Cinquecento; but the range of dates proposed shows that what is at work here is in fact a gradual and continuous process of transformation, which it is hard to break down much further with any precision, precisely because the main break had already happened. Once upon a time, when 'Mannerism' had not yet been invented (people talked, instead, about 'late-Renaissance'),[104] the decree of the Council of Trent on sacred images (3 December 1563), the death of Michelangelo (14 July 1564) and the publication of Gilio's *Dialogues* (1564) were made to synchronize with the direct passage from Renaissance to baroque.[105] Nowadays some historians go back to 1541–2, when the failure of the conference of Regensburg was followed by the institution of the Holy Office and any remaining dream of reconciliation in Germany or Italy was crushed,[106] while some go back only to 1599, when the Treaty of Cateau-Cambrésis left Italy under Spanish control, and religious control found one of its most efficient instruments in Paul IV's Index of prohibited books.[107] This date would seem to synchronize the calculations of political and religious historians with those of economic historians, although Fernand Braudel talks of a slight improvement in the economic trend in the years 1539–59, followed by a general recession lasting until 1575, whereas Carlo Cipolla dated his 'Indian summer of the Italian economy' back to 1550.[108]

At the time of this 1559 landmark (the beginning of a period of peace and at the same time – according to Braudel – of an unfavourable economic trend) the art-historical situation is recorded in the exceptional testimony of Giorgio Vasari's *Vite* in their two editions of 1550 and 1568.

The history of the first half of the century as we have roughly outlined it here found its classic historiographical organization in the first edition of Vasari's work, to which we are still greatly indebted. As everyone knows, this book transformed the uneven complexity of Tuscan and Italian art history, in a manner that now seems obviously contrived, into a linear process culminating in the work of Michelangelo and Vasari himself. The artists were presented and then assessed for the contribution they made to the single process of perfecting ways of representing nature. This gave rise to the historiographical tradition which sees the whole development of

Italian art from Cimabue to Michelangelo as sustained by a constant
and vigorous drive towards realism, suggesting a direction of develop-
ment which nowadays inevitably seems to contradict what we know
about the growing process of 'refeudalization' in Italian society. The
changes Vasari made in the 1568 edition clearly reveal that the con-
sequences of the period of upheaval, the final retreat of the Renais-
sance elite, and the gathering strength of the Counter-Reformation
are fully felt in the art-producing world only after 1550, but these
factors also herald the first successes of a new generation of artists
commanding great respect, who were born in the years of the great
crisis, between 1524 and 1529: Alessandro Vittorio, Paolo Veronese,
Antonio Campi, Bartolomeo Passerotti, Pellegrino Tibaldi, Giam-
bologna, Sofonisba Anguisciola, Girolamo Muziano, Federico Barocci,
and Taddeo Zuccari,[109] not to mention those Vasari leaves out, of
whom the most important of all is the great portrait painter of the
middle class in Bergamo, Giovan Battista Moroni.

Although there is no violent break with the past, what the activity
of these artists really shows is a process of innovation which, though
initially very restricted, did gather strength noisily and violently
from the 1570s onwards. There are new movements in style, the
'sweet smooth style' of the Zuccari brothers, Federico Barocci's
'cangiantismo', or subtle colour effects, which initially worked to-
gether with the more traditional forms of the modern manner and
ultimately, by the last quarter of the century, supplanted them. From
another angle, and again as in the second half of the previous two
centuries, there was also a shifting of the centre of innovation from
central to northern Italy. Let us look again for a moment at the list
of prominent artists above, and notice how many of them are
northerners. A sign of this role reversal can be seen, as usual, in
Florence itself, where the 'avant-garde' position in the second half of
the century is held by the group of painters who had gone over to
the 'style of the Veneto' under the influence of Santi di Tito. At the
end of the century, from the 1580s onwards, there even seems to
be the beginning of a more radical reversal of the trend, with Italy
embracing and spreading an artistic movement from beyond the
Alps (with the neo-Parmesan Mannerism of Goltzius, Spranger,
Cornelis van Haarlem) instead of vice versa.[110]

It is essential to take careful account of the richness of sixteenth-
century artistic production after Vasari if we wish to keep in perspec-
tive what at first sight might again appear to be an incomprehensible
contradiction between the main outlines of the picture painted by
economic historians and the traditional view of the history of culture;

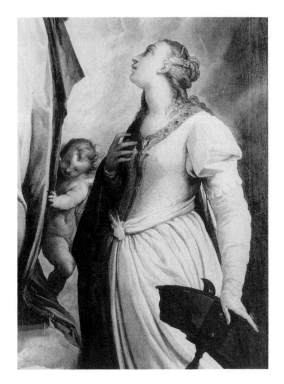

Plate 14 FEDERICO ZUCCARI(?), *Madonna in Glory with Saints John the Baptist and Catherine of Alexandria*, detail, *c*.1565, Museo Diocesano, Cortona.
Photo: Soprintendenza per i Beni Artistici e Storici, Milan.

it is a similar divergence, though the opposite way round, to that which we had to consider at the flowering of the 'early Renaissance'. For economic historians, in fact, 'between 1550 and 1620 the picture becomes rosy again. The general tendency is once again towards expansion. This is the Indian summer of the Italian economy: there is tendential increase in population, production, consumption, investment, nominal prices and salaries';[111]

> certainly . . . during the whole century . . . (and with particular intensity and speed between 1560 and 1590) the great Italian cities managed to rise to very high levels in European traffic (in every sense of the word), particularly in the sectors of luxury products and that most prestigious of trades: money. This also allowed the smaller centres

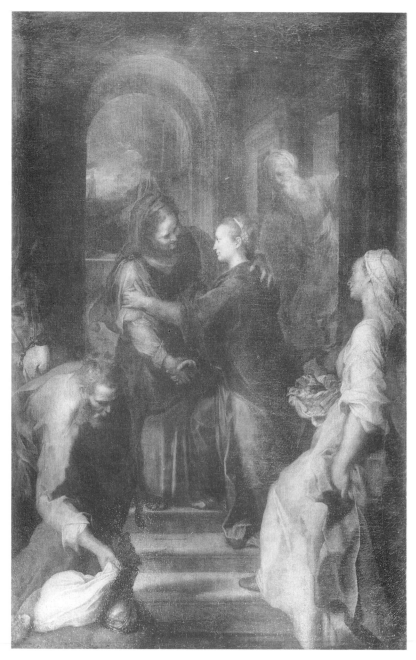

Plate 15 FEDERICO BAROCCI, *Visitation*, 1583–6, Chiesa Nuova,
Cappella Pozzomiglio, Rome.
Photo: Archivi Alinari.

– which naturally gravitate around large cities – to take advantage of the situation.[112]

Development of the luxury goods sector (of which art was already a part) is advancing and the construction industry is booming: 'wherever one follows the phenomenon, one notices feverish activity in construction, not only of large buildings (churches, palaces, castles, villas), but of urban housing in general: in Rome, Venice, Naples, Milan.'[113] An 'optimistic' picture (though with the proviso, which is not of direct interest to us here, that sometimes there was a failure to adapt, which would form the basis for the subsequent collapse) which it is hard to reconcile with the traditional view of the second half of the Cinquecento as the 'age of the Counter-Reformation', in which an 'unstoppable process involving the whole of Italian society' was set in motion, an age of civil, moral and artistic decadence which moved the writers of the old handbooks to pass directly (making short work of the 'transition') from the age of Raphael to the era of Annibale Carracci, whom Bellori saw as the person through whom 'the declining and extinguished art was reforged.'[114]

If we go back and make a measured assessment of the renewal of artistic production which took place in the second half of the century the process of historical evolution makes better long-term sense, taking shape as the simultaneous coexistence (and this should not come as too much of a surprise) in a phase of economic (and demographic, agricultural, manufacturing and artistic) expansion, of a process of renewal and reconversion of production alongside a process of political regression. This process has its roots way back in the fifteenth century, but it reaches its peak in the second half of the sixteenth, when we can see the ruling classes disposing of greater wealth and yet finally closing in on themselves (there is very clear evidence of this in the widespread dissemination of theories of noble breeding).[115] Faced with a situation which gives him unhoped-for opportunities and yet seeks to implicate him in a kind of politics which can only be to his long-term detriment, the artist's position is an ambivalent one. The tastes and interests of the class to which the producers belonged and the class for which the product was destined began to diverge. What pleases the family no longer pleases the patrons and, conversely, unless suitably modified, it is hard for a fashionable product to become accepted by the less elevated but no less important circuit of commissions from the middle classes. Artists (even the greatest of them) tended to produce different products for different destinations: we have a 'court' Vasari (at the Palazzo

Vecchio), a 'family' Vasari (in his houses in Florence and Arezzo) and a 'church' Vasari (in his *Crucifixion* for Cardinal Seripando); an 'allegorical' Zuccari (in the dome for the Duomo in Florence) and a 'realistic' Zuccari (in the life drawings made at Vallombrosa)[116] and so on. The range of possible solutions is of course not infinite; but it is still quite broad, and freedom of choice is facilitated (unlike other arts which make use of words) by the natural ambiguity of the figurative medium. Veronese's replies[117] to the Venetian Inquisition are the most famous example of the clever quibbles an artist could resort to in order to defend his own margin of autonomy.

Having said this, one should not underestimate the place the Counter-Reformation movement found for itself in this divergence between economic expansion and refeudalization, using the arts as effective instruments of persuasion. This happened quite independently of its intentions – about which I hope one is entitled to one's own opinion – and there is no need to see every Polish canon who collected relics as a 'progressive' sign of religious and civil commitment,[118] simply by channelling vast amounts of capital into the sector and arousing the interests of much broader social strata than the aristocratic feudal elite. In terms of quantity the effort to restore, rebuild and relaunch the public artistic heritage of a religious nature, which took place in the years between 1560 and about 1600, is probably unrivalled anywhere else in Italian history (except perhaps if we go back to the golden age between 1270 and 1320, when the churches of the mendicant orders were being built all over Italy).

Nearly every single church in every city in Italy underwent radical refurbishment at least, if not total reconstruction, during this period. In every confraternity an oratory was either built, restored or painted with entirely new frescoes. Even when artists were working to serve this grandiose movement of ideological reconquest they managed, as artists, to express different attitudes. There is sufficient evidence of this in the fact that artists as diverse as Scipione Pulzone, Bartolomeo Cesi, Domenico Passignano, Jacopo Ligozzi, Guglielmo Caccia known as Moncalvo, Marco Pino, Giovanni de' Vecchi, Giuseppe Valeriani and Domenikos Theotokopulos known as El Greco, have each in turn, and always with some good reason, been put forward as typical examples of the art of the Counter-Reformation.[119]

1600. Caravaggio and naturalism

Once more, as at the end of the thirteenth and fourteenth centuries, quantitative expansion resolved itself, at a certain point, in a

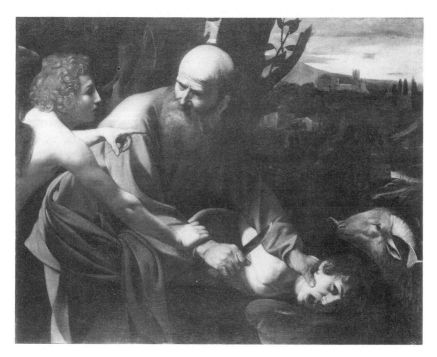

Plate 16 CARAVAGGIO, *The Sacrifice of Isaac*, Uffizi, Florence.
Photo: Archivi Alinari.

qualitative leap which can be perceived on a stylistic level, and this
sounded the death knell for Mannerism. But first, as before, the
whole of artistic production in all its various aspects seemed to be
filled with renewed vitality. The same drive towards expansion which,
when the time came, would support the production of styles that
were new (Annibale Carracci) or revolutionary (Caravaggio) mean-
while guaranteed a second youth for the old styles: the 'Baroccesque'
style found keen followers from Siena (Francesco Vanni, Ventura
Salimbeni)[120] to Naples (Girolamo Imparato, Giovan Vincenzo
Forli)[121] and in Rome itself it was adopted by young painters who
would subsequently convert to a Caravaggesque naturalism (Orazio
Gentileschi, Giovanni Baglione); the 'sweet smooth manner' origi-
nated by Correggio and Zuccari underwent unforeseen developments
at the hands of very talented artists like Alessandro Casolani from
Siena, Bartolomeo Cesi from Bologna, the Piedmontese Guglielmo
Caccia known as Moncalvo; the 'reform' in Tuscany and Veneto

lined up its new devotees (Cigoli, Passignano) alongside its old champions (Santi di Tito, Empoli) pushing its outposts as far as Naples and beyond (Giovanni Balducci, Fabrizio Santafede); and even Parma's most outrageous Mannerism made, through Bartolomeo Spranger, an unexpected and glorious comeback (Raffaellino da Reggio, Francesco Curia). Unlike the earlier situations, however, this time the centre of innovation, which in the time of the Medici popes had already looked set to shift from the banks of the Arno to the banks of the Tiber, now finally came to settle in the papal city. Similarly, in the north, Milan and the Po valley seemed set to challenge the primacy of Venice. It is no coincidence that the artists whose names justly sum up the qualitative leap of the late sixteenth century should, as has been convincingly demonstrated,[122] have been from such wholly 'Lombard', northern backgrounds: Annibale Carracci and Michelangelo da Caravaggio.

1620. The seventeenth-century crisis

Economic historians see no problem in calling the period from about 1620 to 1730 one of 'general crisis' and 'recession' in the European economy; they also agree in seeing Italy as the worst-hit victim of the crisis.

'At the beginning of the seventeenth century, Italy – or more exactly Northern and Central Italy – was still one of the most advanced of the industrial areas of Western Europe with an exceptionally high standard of living. By the end of this century Italy had become an economically backward and depressed area';[123] 'The case of Italy is typical in that it transformed itself from the most urbanized and industrialized country of Europe into a typical backward peasant area';[124] 'The last years of the sixteenth century and the beginning of the seventeenth are still a period of ardent vitality for the Italian economy, especially in the cities. But this was a final phase of euphoria, followed quickly by a recession which eventually relegated Italy to a marginal role in the European scene.'[125] Guido Quazza entitled a collection of his essays *Decadenza italiana nella storia europea* (Italian decline in European history).[126] And yet the word 'decadence' went out of fashion with art historians in the late nineteenth and early twentieth century (with 'reappraisals' of barbarian art, Mannerism and Baroque) and has, with the passage of time, actually become taboo. By contrast the word 'crisis' has enjoyed much favour (with a new, positive nuance) so that nowadays

it is difficult to find a single point in history or even a single artist of whom it cannot be said, with ill-concealed satisfaction, that it or he represents a moment of crisis, or is in crisis, and so on. Although, quite frankly, it is hard to see what a 'deep crisis' which was 'prolonged' and 'without positive issue' could lead to apart from something that is, one way or another, very close to what was once meant by the term 'decadence'.

It cannot be denied that, at first glance, just going by the current thinking on seventeenth-century art, this is not another of those glaring contradictions between the socio-economic facts and the cultural facts which so delight many idealist historians, and which the ingenious theory of 'investment in culture' has recently been devised to resolve.

In fact it is well known that from the late seventeenth century onwards an impressive body of study has sought to free almost every aspect of seventeenth-century artistic production from the accusations of the Enlightenment, and to reclaim its validity and greatness, both naturalistic and baroque, from set-design to the lesser arts.

Caravaggio's naturalistic revolution goes hand in hand with the reform of the Carracci, which often takes on an even more rousing tone, with all its cohorts of great and nearly great Emilian painters: Guido Reni, Domenichino, Lanfranco, Guercino, Albani, Algardi etc. Venetian painting (which was always great, right up to Tintoretto and Palma Giovane) was nevertheless 'renewed' under the influence of three immigrants (Lys, Fetti and Strozzi). The Lombards, with the Procaccini brothers, Morazzone and Cerano, carried on the strong naturalistic tradition, and the necessity of serving Borromeo's religious apologetics and propaganda seems to have done them nothing but good. The Florentines, besides having had their own worthy 'reformation' ahead of the Bolognese, were later able to make an unusually balanced synthesis between the values of their tradition of draughtsmanship and the new naturalism. Naples welcomed with open arms the innovations brought by the refugee Caravaggio, and there are those who actually see it as the avant-garde for the whole of Europe (a position it would then maintain for the rest of the century, until Solimena and ... Giambattista Vico). And there is more to come, because around 1630 came the explosion of the great new European style, the baroque, taking in Bernini and Borromini in Rome, Baldassare Longhena in Venice, Cosimo Fanzago in Naples, and only slightly slower off the mark, Guarini and Juvarra in Piedmont. A rosy picture, a general 'rediscovery', within which distinctions

must sooner or later be made. Indeed, it seems to me that it is one thing to re-evaluate the first great 'seventeenth-century' generation, the anti-Mannerist reflections of Annibale Carracci and his pupils (Domenichino, Guido Reni), the drastic naturalistic (anti-humanist) ideas of Caravaggio and his immediate followers both in Italy (Gentileschi, Saraceni, Borgianni, Serodine) and abroad (Elsheimer, Ter Brugghen, Honthorst, Valentin), and the generation immediately following, to which nearly all the great artists of the 'baroque' generation belong (Mochi, Lanfranco, Fetti, Guercino, Bernini),[127] but it is quite another thing to try and extend the same verdict of excellence to almost every aspect of later work, for all kinds of reasons, including the pressure of the profit motive.

Studies of the seventeenth century are certainly throwing light on the figures of a whole series of competent artists whose work shows that Italy was still productive in this sector, and moreover that Italians continued to observe, suffer, reflect and struggle even in the midst of the crisis they were living through. And the artistic results of their observations, struggles and reflections are clearly, besides being perfectly valid in themselves, a unique source for acquiring a detailed knowledge of the manifold ways in which the decadence of the age found expression. But of course this is to assume that there was 'decadence'. And of course, there are certain essential provisos. First and foremost, there was still an impressive volume of works of art of real quality being produced (in some cases, as we know was true in Holland, there was probably even quite a marked surplus of production). Secondly, within the general decline of the economy, the luxury goods sector (aimed at the privileged classes and the export market) must have been relatively less hard hit by the recession. Thirdly, the onus of this crisis was unevenly distributed, not just socially but geographically, and this allowed some areas to remain relatively immune, and limited but definite phenomena of euphoria to occur.

Although the seventeenth-century crisis was not comparable, either in extent or character, to those which had gone before, it is not impossible to apply the argument we have already used in other cases to that of 'baroque' Italy: a recession crisis, a loss of momentum and a reduced capacity for innovation do not necessarily mean a sudden drop in the average quality of work produced, still less a complete standstill.

But having established and premised all this, I believe it may be possible to find, even within this very impressive batch of artistic production, signs of Italian 'decline'. The first sign can be identified

Plate 17 FRANCESCO MOCHI, *Annunciation*, 1608, Museo dell'Opera
del Duomo, Orvieto.
Photo: Archivi Alinari.

with certainty in the further concentration of production into a few 'capitals' (Milan, Venice, Bologna, Florence, Genoa, Rome, Naples, Messina, Palermo) and the accelerated process of provincialization in minor urban centres (including cities which had still been quite important in the sixteenth century: Mantua, Cremona, Modena, Parma, Ferrara, Verona, Ravenna, Siena, L'Aquila, Gaeta); the second clue is that Italian art lost its expansive force and its role as a leading light for the rest of Europe.

The best confirmation of the first point is the withdrawal into provincialism of local cultures, and the self-appointment of 'schools' of art; and it is symptomatic that, precisely at the moment when they are defining themselves conceptually, and beginning to take early 'administrative' measures for ensuring their own survival (written propaganda, academies), Lanzi was compelled to record their loss of momentum.[128] Whereas he still feels the need to add a new (fourth or fifth) 'era' to the Florentine, Roman, Neapolitan, Venetian, Cremonese, Milanese, Bolognese and Genoese schools, he does not deem it necessary for the Sienese, Mantuan, Modenese, Parmesan and Ferrarese schools, but instead merely notes that academies were founded to revive the art which had fallen into decline.

As for our second point, if we just reflect that, whereas the sixteenth century was still – on a European scale – an 'Italian' century in which the best among foreign artists (even Flemish ones) were those who best assimilated what they knew of the great modern manner of Lombardy, Veneto or Tuscany and Rome, the same cannot be said of the seventeenth century. The last style to originate in Italy and penetrate the whole of Europe was Caravaggio's naturalism (of which Elsheimer and Rembrandt, Ter Brugghen, Honthorst and Vermeer, La Tour and Le Nain, Velazquez and Ribera are all direct tributaries by different routes),[129] which Italy found it hard to assimilate – a tell-tale sign – and tended to misunderstand.

The subsequent spread of baroque (Roman, Genoese, Neapolitan) met, as we know, with considerable difficulties precisely in the new states which had taken over the leading role in development (France, England) and thus in some ways came to represent the 'conservative' style of the 'marginal' areas (Spain, central and southern Italy, Austria and Germany). It is not entirely legitimate, in any case, to credit Italy with having invented it, given the precedent set by Rubens.

Furthermore, seventeenth-century Italy showed plenty of signs of a reversal of trend, so that it was now the turn of Italian artists and collectors to watch new developments beyond the Alps with interest. Rembrandt's etchings were studied by Stefano della Bella and

Castiglione; Genoese nobles had their portraits painted by Rubens and Van Dyck; the Messina collector Antonio Ruffo bought paintings by Rembrandt; Cosimo III collected Dutch paintings. 'Rembrandt-style' portraits proliferated; the Dutch painter Van Laer invented a new genre, the *bambocciata*, which enjoyed resounding success for all the humanists and academicians could say; Albani established himself by inventing a formula, the small engraving of a genre scene with a classical subject, a typical compromise with the northern tradition. This meant that a whole slice of the market (and its most modern sector, the one with most future), the market for art for 'private display', had slipped through the fingers of Italian artists, who were now forced to imitate foreign products in 'genre' painting (portraits, still lifes, *bambocciate* and landscapes), without great success.

'1630, or baroque'?

But one could point out that we are again judging as decadent the period which coincides with the great 'Baroque flowering' which Giuliano Briganti, in a rightly famous essay which gives its title to this section, saw as beginning in 1630. In presenting this idea, Briganti was thinking particularly of the work of the painter Pietro da Cortona,[130] but if we look instead at architecture, the picture is not very different; Anthony Blunt wrote in 1973 that 'Baroque suddenly burst upon the world in the second and third decades of the seventeenth century, and by the sixth decade it had already used up nearly all its resources.'[131]

However, by applying the same criterion of interpretation previously exercised elsewhere to this case and, without allowing ourselves to be distracted by naturalistic metaphors for the blossoming, flowering and vigorous propagation and survival of the baroque style, and taking a long cold look at the dynamics of the facts and their likely significance, I think it must be concluded that, whereas during the 1620s and 1630s Italian society (in this case, Roman society) was still able to come up with innovative solutions (which made other styles, even those of recent origin, like Carracci's and Caravaggio's, seem outmoded), this capacity must have been lost in the years that followed, ensuring the 'conservation' (i.e. 'vigorous propagation and survival') of the last style to arrive in the phase of expansion, which was of course the baroque.

This is to see baroque not, as was once believed, as the art of decline or as an expression of the corruption in Italian society; its

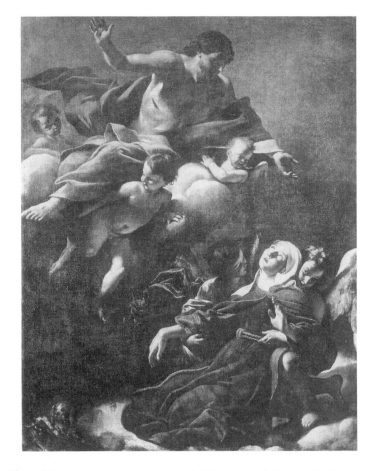

Plate 18 GIOVANNI LANFRANCO, *St Margaret of Cortona in Ecstasy*, 1621, Palazzo Pitti, Florence.
Photo: Archivi Alinari.

emergence while the sixteenth-century wave was still rolling (preserved in Rome, and with greater psychological relief for being opposed, for a good few years to come) was the ultimate proof of its capacity for expansion, and its long survival was one sign of the subsequent crisis of stagnation.

However, this interpretation of the baroque phenomenon necessitates a closer look at its 'starting point'. Should we see Briganti's suggestion of 1630, and Blunt's 1620–30 as points of origin or of full expression?

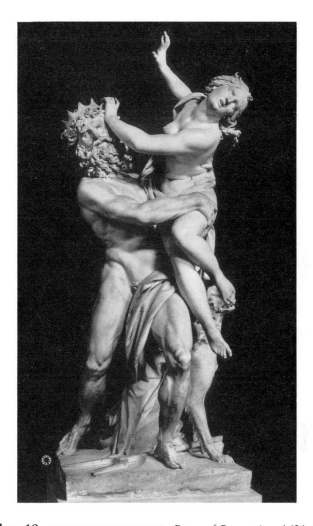

Plate 19 GIANLORENZO BERNINI, *Rape of Proserpine*, 1621–2,
Borghese Gallery, Rome.
Photo: Archivi Alinari.

I think it is significant that it should be architectural history, the
history of the activity requiring the greatest co-ordination of effort
and concentration of investment, and therefore usually, compared
with its sister arts, a slower and less sensitive indicator of trends in
motion,[132] that seeks to backdate the take-off point for Baroque by
a decade.

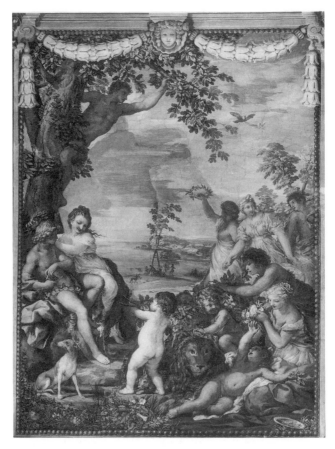

Plate 20 PIETRO DA CORTONA, *The Age of Gold*, 1637, Palazzo
Pitti, Florence.
Photo: Archivi Alinari.

If we move across to painting and sculpture we cannot deny that
by 1620 it is already possible to perceive tendencies that are not so
much pre-baroque, as has been claimed, but fully baroque in every
sense. Even without going back to late sixteenth-century precursors
of the style (Cigoli's 1597 *Martirio di santo Stefano*, or Annibale
Carracci's frescoes in the Farnese Palace, 1595–1604) and without
choosing to place too great an emphasis (as would be quite legit-
imate) on the fact that these preludes were immediately exploited in
an already fully baroque manner by Peter Paul Rubens (in Italy

between 1600 and 1607) at least from 1605 onwards,[133] and if we therefore decide to confine ourselves to examples from Italy (and particularly from Rome), it is enough to recall that Borgianni, who painted, among other things, the dizzying and miraculistic *Apparizione della Vergine a san Francesco* at Sezze (1608), died in 1616 and that similar paintings by Lanfranco (the *Annunciation* in San Carlo ai Catinari, the *Ecstasy of St Margaret* in the Pitti Palace) date from the second decade of the century, Mochi's Orvieto *Annunciation* is from 1603–5, and his Farnese knights in Piacenza (perhaps the most 'baroque' of the whole seventeenth century) are from 1612–25, that Bernini carved his *Neptune* (Victoria and Albert Museum) and his *Rape of Proserpine* (Galleria Borghese) in the very early 1620s, that Guercino's *Aurora* is from 1621, that Fetti died in 1624, that Van Dyck was active in Italy from 1621 to 1627, and so on.[134] It is an impressive collection of examples, which seem to me to justify back-dating the moment of innovative discovery, the qualitative leap, at least to the beginning of the second decade, if not the middle of the first.

The crisis of the seventeenth century: Rome and southern Italy

We can see that once the first seventeenth-century generation, fol-lowed by the generation of Caravaggio's disciples and the Carraccis' pupils, and then by the only slightly younger breed born at the end of the century (Bernini, Borromini, Pietro da Cortona) all ran out of steam, there was a period of relative stasis visible, indirectly as usual, in the problems facing 'connoisseurs'. Whereas no student of art history would mistake a 1270 work for one from 1320, or a 1470 work for one from 1520, nor even a 1570 work for one from 1620, even well-trained connoisseurs have often been plagued with reasonable doubts over the dating of works from between 1630 and 1680, and I do not think this is for the reason usually given that this is a 'less studied' period.

More directly, the tendency towards stagnation can be observed in two phenomena which, despite often considerable local differ-ences, can be taken as being fairly generalized in the middle of the period. One is the way the established styles persist so tenaciously, as we have already seen, and the other is the strongly retrospective, nostalgic, even 'reactionary' nature of the 'new' styles which take root from the 1630s onwards.

As regards the first observation, we have seen how, at least in Rome, this includes the so-called 'triumph of baroque', except that we should consider how Bernini's style, already fully worked out by the end of 1620 (the baldacchino in St Peter's of 1624–33) could continue to dominate, without any noticeable development until the 1680s, through the work of pupils who, though talented, saw no reason to introduce any but the smallest variations: Ercole Ferrata (1610–86), Antonio Raggi (1624–86), Domenico Guidi (1625–1701), Melchiorre Cafà (1635–67) among them; and how the same thing happens with Pietro da Cortona, whose style was already complete in the Barberini Palace *Triumph* (1633–9), but who got away with using the same style until his death (1669), a style which was again stretched and made to last longer with only incidental variations by remarkably talented artists: Guidubaldo Abbatini (1605?–56), Salvi Castellucci (1608–72), Lazzari Baldi (1623–1703), Francesco Allegrini (1624–79), Guglielmo Cortese (1627–79), Ciro Ferri (1628?–89).[135] A further sign of this loyal fondness of public and patrons alike for well-established styles is to be seen in the surprising ability of a few robust old men born at the end of the sixteenth century to keep a grasp of the situation until the end of the seventeenth: Bernini in Rome, who died at eighty-two, Longhena in Venice, who was eighty-four, Fanzago in Naples, who was eighty-seven, and Silvani in Florence, who was ninety-six.

As regards the second observation, the matter of (retrospective) 'invention', Wittkower again talks of a 'reversal of values' for Rome in the 1640s a 'return to a dry and archaizing Bolognese manner', a 'radical archaism', recalling the work of Giovan Battista Salvi known as Sassoferrato (1609–85), Gian Domenico Cerrini (1609–81), Giacinto Gimignani (1611–81), Francesco Romanelli (1610?–62);[136] I would add to these Francesco Cozza (1605–82) and, without false modesty, the acknowledged leader of this retrospective movement, Charles Nicolas Poussin (1594–1665), the stoical spokesman for the disappointment of the humanist 'antiquarians' with the way the situation was developing.

If we shift our gaze from that great centre of original achievement, papal Rome, and look at other regional capitals, the phenomenon is even more noticeable. At the beginning of the seventeenth century Venice was still an artistic metropolis of some importance, where there was also room for artists from outside (in fact the best of them), who brought with them the culture of Rome (Carlo Saraceni, 1579–1620; Johann Liss, 1595?–1629?), the Tuscanized Rubens (Domenico Fetti, 1589–1623), Milan–Genoa (Bernardo Strozzi, 1581–1644) and

later still – on the rebound – the Tuscan reform (Sebastiano Mazzoni, 1611–78). But the truly local forces give expression to a decidedly conservative culture, whether in the way Tintoretto's exploits were perpetuated for so long in the work of Jacopo Palma Giovane (1544–1628), Sante Peranda (1566–1638) and Francesco Mafei (1600?–60), or in the more interesting fact that Padovanino's (1588–1648) anti-Mannerist reflections, comparable in some ways to Carracci's work in Rome, were already taking on the archaizing tones which form a logical precedent for the endeavours of his pupils Pietro della Vecchia (1603–78), Giulio Carpioni (1611–74), Francesco Ruschi (1610?–61), Pietro Liberi (1614–87), which were paralleled by the neo-Venetian movement which was also then afoot in Rome (Sacchi, Testa, Mola, Poussin, etc.).[137] The canonical models of Giorgione and Titian must have had the same meaning for this group of painters as Palladio did for the Venetian architects: the only example of 'baroque' to be quoted is in fact the exceptional case of Santa Maria della Salute (1631–87) by Baldassare Longhena (1598–1682).

Even more obvious is the loss of momentum in the Bolognese school, which had nonetheless played a leading role on the Roman scene with Annibale, Guido, Domenichino and Algardi. The generation of painters born between 1570 and 1580, Mastelletta (1575–1655), Alessandro Tiarini (1577–1668), Giacomo Cavedoni (1577–1660) and Lorenzo Garbieri (1580–1654), was still able to express a very rich and varied culture; but Reni's return to Rome (1612) left the atmosphere drained of energy, as is clearly demonstrated by the fact that his late style marked even the younger painters, Francesco Gassi (1588–1649), Giovanni Andrea Sirani (1610–70), Simone Cantarini (1612–48), and became 'an inexorable law during the thirties'. Nor can Guercino's classicizing about-turn, even though, as we have seen, it coincided with what was going on in Rome, be seen as any contradiction of this, any more than the long favour enjoyed by Albani's mythological engravings (he died in 1660). In this context the most interesting experiments were Cantarini's, who, without straying too far from Reni's orthodoxy, tried out naturalistic approaches and transparent light effects that are almost Gentileschian, and which for such a late date smack unmistakably of nostalgia and archaism, in rather the same way as what Francesco Cozza, Cerrini and Sassoferrato were doing in Rome at the same period.[138]

On to Milan, where the 'Manzonian' plague of 1630 is generally taken as a sign of the 'end of the first and greatest phase of Milanese Seicento painting'.[139] Here too, as in Bologna, there is no comparison to be made between the generation born between 1570 and

1580 – Morazzone (1573–1626), Giulio Cesare Procaccini (1574–1625) and Cerano (1575–1632) – who with their bizarre style, a mixture of Calvaert, Spranger and Cavalier d'Arpino, were still able to contribute a healthy variant with an authentic Lombard ring to it to the international flowering of the extreme Mannerism of Haarlem and Prague, among whom even Caravaggesque naturalism found a rough but intelligent continuity in Tanzio da Varallo (1575?–1635), and the following generation, of whom only Daniele Crespi (1598?–1630), with his Counter-Reformation naturalism, was able to keep up the high standards,[140] and whose outstanding personality, who managed to cross the ridge of the 1630s, Francesco del Cairo (1607–65), has rightly been referred to for some time as one of the great painters of corruption and decline.[141]

The picture we get from the main artistic centres of northern Italy is therefore one of a progressive loss of innovative momentum from the beginning of the seventeenth century, leading to outright stagnation in the 1630s; and if we examined the minor centres more closely, the situation would certainly not look any better.

Would it be crude determinism to recall at this point that 'in the first half of the century the northern regions, directly affected by the Thirty Years War and struck down by the 1630 epidemic, lost more than one-fifth of their population'?[142]

The crisis of the seventeenth century: the Genoese 'exception'

Until now our overview of artistic decline in northern Italy in the first half of the seventeenth century has not mentioned the city of Genoa, which is, to some extent, in a class of its own. There are objective reasons for this, as we shall soon see, but it is mostly for reasons of historiographical interpretation. Genoa has been held up as a model case, and as positive confirmation of the economic harm done by the politics of 'investment in culture' practised by the Italian ruling class. Lopez began to wonder rhetorically, 'how could we explain . . . the artistic obscurity of the business metropolis that was Genoa?' and Hobsbawm had to acknowledge that 'philistine historians were welcome to observe that the only major city state which never produced any art worth mentioning, Genoa, maintained its commerce and finance better than the rest.'[143]

First of all we must establish what we mean by the ideas of

'artistic obscurity' and of never having produced 'any art worth mentioning'. Certainly no one would wish to deny that from the end of the thirteenth century onwards (with Manfredino da Pistoia and the 'Santa Maria di Castello Master'), through the fourteenth century (the tomb of Margherita di Lussemburgo by Giovanni Pisano, Bartolomeo da Camogli, Taddeo di Bartolo), and then best of all in the fifteenth century (Donato de' Bardi, Vincenzo Foppa, Carlo Braccesco, Domenico Gagini) and sixteenth century (Giulio Romano, Perino del Vaga, Giovannangelo Montorsoli, Galeazzo Alessi), the Genoese were able to engage some very respectable masters; and if the ideas actually allude to the fact that works by local artists tended on average to be of inferior quality to that of the 'foreigners', one would have to point out that, by the same token, other 'artistically obscure' cities would have to include Rome, where the scant supply of local artists listed with parochial pride by Bellori (Cavallini, Paolo Romano, Giulio Romano, Andrea Sacchi)[144] is even more disproportionately outweighed by the rest of the art produced there. Nor is it clear how these distinctions between indigenous production, production by outsiders and imported products could be relevant to the problem of unproductive investment in culture, since whether imported or home-produced, whether by citizens or by immigrants, the works of art are there, and must therefore have commanded adequate investment. Judging by the results, this investment must have been sufficient, even by the end of the sixteenth century, and – unlike the rest of Italy – throughout the seventeenth century, to sustain alongside the work of other illustrious immigrants, the development of one of the most lively and original local schools of the seventeenth century.

With regard to the first part of this question, it is worth recalling that the Sienese artists Pietro Sorri (1556–1622), Francesco Vanni (1563–1619) and Ventura Salimbeni (1567–1613), the Lucchese artist Benedetto Brandimarte (documented 1588–92), the Pisan Aurelio Lomi (1566–1622), the Bolognese-Milanese Giulio Cesare Procaccini (1570–1625, in Genoa 1618) were all active in Genoa, and that the Flemish painters Peter Paul Rubens (1577–1640, in Genoa 1607), Cornelis de Wael (1592–1667, at the head of the strong Flemish presence in Genoa), Antonie Van Dyck (1599–1641, in Genoa 1621–2 and 1626–7) and the Spanish painter Velazquez (1599–1660, in Genoa 1629) all visited the city.

Addressing the other side of the question, that of how, alongside the prolonged activity of some excellent masters of the generation born in the 1560s (Lazzaro Tavarone, 1556?–1641; Bernardo Castello,

1557–1629; Giovan Battista Paggi, 1554–1627), Genoa was, throughout the first half of the seventeenth century, host to a whole blossoming group of painters whose dates of birth (unlike Bologna and Milan, where the most important artists were all, or almost all, born in the seventies) are spread at pretty regular intervals between 1580 and 1610: Bernardo Strozzi (1581–1644), Andrea Ansaldo (1584–1638), Domenico Fiasella (1589–1669), Luciano Borzone (1590–1645), Giovanni Andrea de' Ferrari (1598?–1669), Gioacchino Assereto (1600–49), Orazio de' Ferrari (1606–57), Giovanni Benedetto Castiglione (1610?–65). The general picture shows the moment of greatest flowering to have been delayed, but the moment of crisis to have been likewise postponed. The crisis also seems to have been less keenly felt, although Genoa, in common with Rome, Venice and Bologna, predictably produced an artist who would mark the second half of the 1630s as a period of 'archaizing innovation': Pellegro Piola (1617–40). Then, after the moment of deepest depression, there seems to be an excellent recovery, based to some extent on Roman baroque models, but with a strong flavour of originality, which was similarly sustained right up to the brink of the eighteenth century through artists whose dates of birth are again spread with remarkable regularity between 1620 and 1650: Pierre Puget (1622–94, in Genoa from 1661 to 1667), Silvestro Chiesa (1623–57), Valerio Castello (1624–59), Domenico Piola (1627–1703), Filippo Parodi (1630–1702), Bartolomeo Biscaino (1632–57), Giovan Battista Gaulli (1639–1709), Gregorio de' Ferrari (1647–1726). On the whole (despite the ravages of the plague of 1657 which claimed Orazio de' Ferrari, Silvestro Chiesa and Bartolomeo Biscaino) this is an unusually bright picture compared with the general scene, and is certainly no worse (at least as far as indigenous production is concerned) than the situation in the sixteenth century.[145]

Far from being an exception in the sense originally intended – an oasis of wealth because of cutbacks in investment in art – Genoa therefore appears to be quite the opposite, excellent proof of what was already known about the sustained prosperity of the ruling class amid the general crisis of the seventeenth century and proof, if we needed it, that even in a specific case the graphs of economic prosperity and artistic production run parallel. This artistic production, as we have mentioned, had many qualities (such as its pronounced internationalism and the way it opened up the local market to foreign artists) which would endear it to the leanings of an oligarchy which owed the survival of its own extraordinary wealth to its ability to stay in touch with the international world of finance.[146]

The crisis of the seventeenth century: Florence, Naples and the south

In central Italy Florence stood as the classic case of a conservative culture. This is not really so much a question of failure to rise on the tide of the sixteenth-century Indian summer, to breathe life into a generation of artists of comparable quality to those produced by the other provincial capitals; in fact Cristofano Allori (1577–1621), Pietro Tacca (1577–1621), Matteo Rosselli (1578–1650), Gherardo Silvani (1579–1675) and Giovanni da San Giovanni (1590–1636) were all highly respected professionals. It is more because of the way in which these artists went back to the culture of the earlier generation and passed that culture on with only a few minor variations to the next generation. Silvani kept architecture in the furrow ploughed by Buontalenti (1536–1608); Pietro Tacca drove sculpture in the same rut carved by Giambologna (1529–1608); Cristofano Allori and Matteo Rosselli followed the moderate Venetianizing picturesqueness of Cigoli (1559–1613), and so on. Here too, from the 1630s onwards, anything new takes on a marked retrospective character, whether it is Lorenzo Lippi (1606–65) re-evoking the clean Bronzinesque naturalism of Santi di Tito Titi (1536–1603), or the child prodigy Carlo Dolci (1616–86) trying, with pious intent, to translate Caravaggio's modern naturalism into Flemish diligence, with dazzling effects of deathly, waxen, almost surreal clarity. A general tone of contrite sentimentality is common to the works of the young painters born at the beginning of the next century, Francesco Furini (1604–49), Felice Riposo (1605–69?), Cecco Bravo (1607–61) and Orazio Fidani (1610?–68?), who managed to give figurative shape to the devotions and peccadilloes of a scholarly, sleepy, sceptical and bigoted province, still convinced deep down of its own invincible perfection. Seventeenth-century Florence reeked of boudoir and confessional, death and decay, and its artists give us a sense of the stench; this certainly makes them great, but should we not call decadent the society to which they are witness? This is an atmosphere in which real innovation can come only from outside, and its greatest sons were in fact those who were able to look beyond the city walls; among its artists the most important was Stefano della Bella (1610–64), the engraver, who like Genoa's Castiglione benefited greatly from his study of Rembrandt's etchings.[147]

We have already seen how Rome weathered the crisis of depression better than other places, and in fact at first gained greater

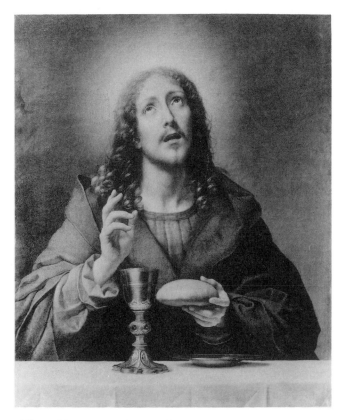

Plate 21 CARLO DOLCI, *Christ Giving Blessings*, c.1665,
Gemäldegalerie Alte Meister, Staatliche Kunstsammlungen, Dresden.

prominence from the adverse pressure. Only in the 1660s did the decline of the papal capital become clear for all to see.

The case of Naples is rather similar; the great artistic flowering of the last quarter of the Cinquecento seems to have continued, although with gradually slowing momentum, well into the next century, until the Masaniello rebellion (1647–8) or even right up to the plague of 1656.

But in Naples too the symptoms of stagnation can be clearly read. The last great renewal was brought about, with the encouraging influence of Caravaggio's activity there (1606–8), by Battistello Caracciolo (1570?–1637) and Jusepe Ribera (1591–1652), bolstered

by the naturalized neo-Mannerism of Stanzioni (1586–1656) and Spinelli (?–1647?), which bear comparison with the rather similar formulae adopted at the same period by Lombards (Procaccini, Morazzone, Cerano), Genoese (Strozzi, Ansaldo, Assereto) and also, somewhat later, by the Florentines (Furini, Pignoni, Cecco Bravo). In the years following 1620 not only do we see no great innovations to compare with those mentioned above; what we notice is in fact the surprising durability of styles which originated in the sixteenth century: Fabrizio Santafede (1560?–1634), Bernardino Azzolino (1572?–1645) and even Belisario Corenzio (1560–1648) still enjoying remarkable success without any change of style. The young artists Andrea Vaccaro (1604–70), Pacecco de Rosa (1607–56), Francesco Guarino (1611–54) and Bernardo Cavallino (1616–56) carry on, with minimal variation, the stylistic movements begun by Stanzione or Ribera (as in the work of Francesco Fracanzano, 1612–57).[148]

It would not be difficult to prove that other major ports in southern Italy were also still able, in the first half of the seventeenth century, to produce independently intelligent works of art, for example those by the Messinese painters Alonso Rodriguez (1578–1648), Domenico Maroli (1612?–76) and Giovan Battista Quagliata (1603–73), or Mario Minniti (1577–1640) from Syracuse, Pietro Novelli (1603–74) from Palermo or Andrea Carreca from Trapani (?–1677), all artists who were perfectly capable of making the most of the news brought to the island by Caravaggio (1609–10) or Van Dyck (1624) of innovations in Naples, Rome or Flanders.[149] However, for the purposes of this argument we may, if we spend too long enumerating the many noble episodes which are still woven into the history of Italian art at this period, run the risk of masking the general outline of the phenomenon and the basic fact that nowhere in Italy, north or south, does the second half of the century even remotely compare to the first half, although for Rome and the south the point of greatest weakness seems to have been somewhat delayed, as was the subsequent recovery in the eighteenth century.

1748: late baroque survival and eighteenth century 'recovery'

After the great depression of the seventeenth century the position of Italy in the European scene changed radically, and consequently the terms of the question of periodization as they relate to the history of art are also altered. From being a central point of reference for

European economics and politics, Italy withdraws to the sidelines as a marginal and dependent element, so that even when a different shift of emphasis from the seventeenth century brought recovery to the north of Italy first and then central southern Italy, it arrived in the wake of a more widespread sudden take-off of European economic development. From being at the centre of the system, a point from which innovation radiated outwards, Italy gradually retreated, during the eighteenth century, into a secondary and eventually subordinate role.[150]

The main consequence of this on a cultural level was to open up dramatically for the first time the contradiction between Italian-ness and modernity which was later to become a permanent inheritance of Italian history. The implication of this for the question of periodization is that, from this point onwards, there are ever more striking contrasts between new outside factors originating in distant contexts which some of the more advanced groups manage to tune in to, and the objective, internal situation to which the vast majority of the population continues to refer and which in the end even the avant-garde movements find they cannot ignore.

An example of the kind of new contradictions which the historiography of art must address from this point onwards, is again the once classic, and oft-quoted, volume by Rudolf Wittkower in the series edited by Nikolaus Pevsner, who chose to take his account up to 'around 1750', a cut-off point that squares with the 1748 Treaty of Aix-la-Chapelle, that familiar date usually taken as the starting point of the new, more modern eighteenth century, which brought a widespread recovery even to Italy and, in some states (Lombardy, Parma, Tuscany, Naples), saw the beginning of the Enlightenment-inspired reform movement.

This was therefore a decision to abandon the narration of the story of Italian art precisely at the point when it was emerging from a long period of stagnation and finding it must start seriously taking stock of its own incipient backwardness. Such a choice takes a conservative view, as it tends to see the history of eighteenth-century art in Italy essentially in terms of the survival and progressive exhaustion of the seventeenth-century tradition and, as such, Italians are bound to feel it to be a deeply unjust choice, particularly with regard to those artists (Ceruti, Traversi, Pietro Longhi, Canaletto, Bellotto, etc.) who managed, against all odds, to be modern; but it is a choice that is also bound to appear both consistent and historically justified.[151]

There is no denying that what we are seeing here is a divergence

of the paths of socio-economic and artistic development which it is hard to ascribe, as we did in similar cases already encountered, to mere optical distortions of one or another historiographical tradition.

Whereas in the first thirty years of the eighteenth century when the country was still only caught up to a very limited extent in the recovery trend, Italian artists showed further remarkable capacity for renewal, and their output seemed to be expanding, the recovery of the second half of the century no longer seems to entail a corresponding increase in either the quantity or quality of artistic activity as a direct consequence.

Though Pellegrini and Ricco could still teach de Troy, André Van Loo and François Lemoyne a thing or two, and Quentin de La Tour could learn from Rosalba Carriera, Hubert Robert from Pannini, and even Greuze from Cignaroli, it is quite obvious, with all due respect to current Venetian critics, that the Guardi brothers could no longer teach anyone anything. And this argument holds not just for Venice (which is nonetheless certainly the most striking example) but also, with superficial variations, for the other urban centres of Genoa, Bologna, Florence and Naples, where the generation born after the mid-seventeenth century does not really bear comparison with the previous generation. I do not think that it can just be a matter of taste or reputation or outdated historiography when all, or nearly all, the famous names which sum up Italian eighteenth-century art (from Solimena to Amigoni and Sebastiano Ricci, Bologna's Crespi to Pellegrini and Rosalba Carriera, Raguzzini to Fuga and Vanvitelli, Carlevaris to Tiepolo and Canaletto) are those of artists born before the century began![152] Let us acknowledge the possibility that a re-evaluation of neo-classical and 'romantic' art in Italy will add other names to those of Appiani and Sabatelli, Felice Giani and Camuccini, Canova and Ceracchi, Valadier and Poccianti, Bartolini and Jappelli, but I do not think it is possible to imagine a time when, personal tastes aside, the combined weight of these artists could tip the balance back their way.[153] There is a real divergence, then, in the trends shown by the graphs of economic and social history and the history of art, which can be explained only by taking into consideration the new position of Italy in relation to Europe, and thus bearing in mind that the process of recovery took hold first in England and France, and in Italy only marginally, and mostly in the north, so that it was, so to speak, absorbed into that process. This explains why, despite the economic and political recovery, the reforms and so on (which by themselves form a group of facts whose relevance is dubious), Italy had less importance in the European market (including the art

market) at the end of the process than it had had to begin with, and why Italian artists, who were still respected mentors in the first thirty years of the eighteenth century, had to sprint hard in the 1790s to catch up with events beyond the Alps.

Italy and Europe: art theory

An indirect but valid indication of how the situation had changed has been found in the reversal of roles regarding theoretical thought in the arts: 'In the eighteenth century', writes Wittkower, 'the relationship between Italy and the other nations was for the first time reversed: English and French treatises appeared in Italian translations . . . Not only Roman but Italian supremacy had seen its day. France and, as the century advanced, England, assumed the leading roles'; a fact which the German scholar feels to be in contrast to the actual state of artistic production: 'It is all the more surprising that never before had Italian art attracted so many foreigners . . . It is equally surprising that never before were Italian artists a similar international success . . .'[154] But a historian cannot be content with surprise; he must follow up his wonderment with an explanation which makes coherent sense of the apparent contradiction and explains for the case in point why the 'old hands' of Italy, the 'virtuosi', who were unable to give any theoretical account of what they were doing, gained such widespread approval.

Clearly an adequate answer can be found only in a detailed working history of eighteenth-century art which makes distinctions both chronological (between the two halves of the century) and spatial (between areas of strong development, England and France, and other areas which like Italy are relatively peripheral: Spain, Germany, Slavic countries), as well as possibly making qualitative distinctions (about different kinds of Italian art and the audience for which it was destined). However, we can begin by stating one generally valid point: the marked internationalism of artistic production in the eighteenth century which so benefited Italian artists is a sure sign that a circuit of foreign patronage existed to provide them with indispensable economic support largely independent of the support they had at home.

What happened in the eighteenth century was in fact a veritable brain-drain which, far from contradicting what we know about the gradual widening of the gap between economic conditions in Italy and those in Europe, is actually a typical example of that growing

distance. As twentieth-century Europeans know from direct experience, this phenomenon may momentarily satisfy the pride and economic aspirations of those directly involved, but it never fails to make its very negative consequences felt within the next few generations. So we should not be surprised if, in the course of the eighteenth century, Italian artists often produce their best work when they are set in a foreign context (Giaquinto and Tiepolo in Madrid, Gregorio Guglielmi at Schönbrunn, Pietro Rotari and the architects Rinaldi and Quarenghi in Russia, etc.), or when at any rate they are working for foreign patrons (the series of 'English' portraits by Batoni or the works by Venetian painters for Consul Smith being just two of the best-known examples).[155] Nor should we be amazed that the history of European art henceforth follows a path that is largely, if not entirely, uninfluenced by anything that happens in Italy. With hindsight, we can even see it as quite inevitable that those last brilliant generations of late baroque virtuosi should have had no clear awareness of the gravity of the crisis they found themselves living through: it is significant that of all the artist-writers the eighteenth century is rightly famous for (Falconet and Liotard, Hogarth and Reynolds, Jean François Blondel and Ledoux) none of them was born in Italy, and that the only artist who managed, by virtue of his European intellect, to salvage the Italian tradition was the Romanized Saxon, Antonio Raffaello Mengs.

Italian artists and the 'Dutch' tradition

As the gap between Italy and Europe widened, it became more difficult for an artist born in Italy to reconcile his own Italian-ness with modernity, and his relationship with local tradition became more problematic. It was thus all the more important to arm oneself with the necessary intellectual equipment to look at such a complex and varied tradition and see what could still be salvaged for the purposes of a 'modern' statement. Even if, by the eighteenth century, the problem had not yet come to be the central obsession it became in later centuries, it is nonetheless already evident, and it can help us to pick out the few real 'intellectuals' from among the many competent artisans. For in the age of international Enlightenment, as in the age of international humanism, the artist was now held to be an 'intellectual'.

This is not to say that, in the eighteenth century, the terms of the problem had changed radically from the choice artists had faced in

the late sixteenth century between the humanist tradition and the new naturalism. What changed was the respective emphasis specific to the two traditions. Whereas, in artistic terms, Italy and Holland enjoyed roughly equal prestige in the mid-seventeenth century, there is no doubt that the following century saw the formal solutions which had already been established in seventeenth-century bourgeois Holland eventually permeating almost every aspect of the new European art.

The most obvious symptom of this process has already been observed, particularly in the two principal countries but consequently in the others as well, in the importance and prestige now given to artistic genres which were previously considered quite minor and subordinate: the still life, the genre scene, the 'conversation piece', the landscape, and above all the portrait, which became the real star of the show in the history of eighteenth-century art at the hands of an extraordinary succession of talented artists, some famous or very famous (Fra Galgario, Rosalba Carriera, Quentin de La Tour, Pompeo Batoni, Perronneau, Reynolds, Gainsborough, Houdon, Goya, David), others less so (Ghezzi, Aved, Liotard, Alessandro Longhi, Roslin, Duplessis, Zoffany, Wright of Derby, Vincent, Vigée-Lebrun, Chinard, etc.) scattered all over Europe.

The most dynamic sectors in Italy too came to be those which forged the closest links with what was going on in Europe; the liveliest centres were those which mainly produced works for tourism and export (Venice, Rome, Florence, Naples), and the more genuinely modern artists, capable of debating on equal terms and making an original contribution to developments in Europe, are found to be less likely to be working in the traditional sector of learned art (in which Church, governments and academies tended to concentrate their efforts and support) than in marginal sectors without that special protection, which were more sensitive to market forces: portraiture, landscape, and the genre scene.

But even in the privileged sphere of 'history painting' the Italian idealistic tradition actually had to come to terms with its great adversary just as it seemed to be winning over foreign artists. Take the way Greuze sets 'acts', 'movements' and 'action' reminiscent of Domenichino within bourgeois interiors, in paintings for private houses that are basically very Dutch, or, jumping to the end of the process, think of the brilliant way David brings a Carracci–Poussin 'istoria' up to date by going back through northern interpretations of Italian art (Claude Lorrain, Philippe de Champaigne) to the origin of the modern naturalistic tradition (Caravaggio, Valentin), arriving

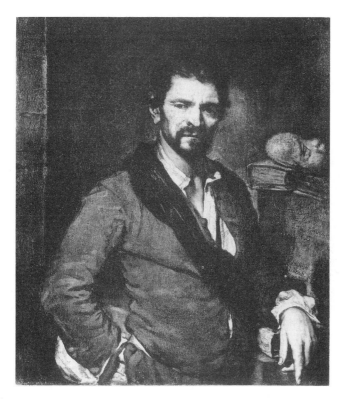

Plate 22 FRA GALGARIO, *Portrait of Francesco Bruntino (in egestate natus, picture ac liborum amator)*, 1737, Accademia Carrara, Bergamo.
Photo: Archivi Alinari.

ultimately at something that has little or nothing in common with everything we have experienced in Roman or Italian history. However paradoxical this may sound to French ears, David's works (and later, even more so, those of Ingres), seem, to Italian eyes, in their 'values', their themes, their analytical clarity, terribly 'northern', or, one could say, Dutch.

We really ought to ask ourselves whether it was not Italian art, but a few northern Italian artists, who had shown the way early on for this process of rehabilitation of the seventeenth-century naturalistic tradition as a basis for modern, bourgeois development.

Among those painters must have been, first and foremost, Fra Galgario, whose ruthless portraiture seems to be a rethinking of

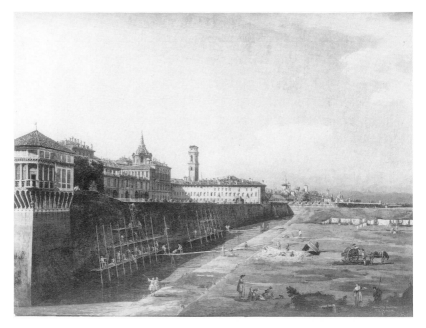

Plate 23 BERNARDO BELLOTTO, *View of Turin*, detail, Galleria
Sabauda, Turin.
Photo: Archivi Alinari.

the great colourist tradition of northern Italy (Titian, Moroni) in
the light of its Dutch counterpart (Rembrandt); a little later, still in
Lombardy, Ceruti, whose portraits of 'ordinary unhappy men, with-
out comment, but large as life'[156] (poverty being the hidden side of
the coin of the agricultural rationalization of the Po valley!) cannot
be explained away by linking them to seventeenth-century prints of
'crafts and trades', when they are clearly a revival of the serious
naturalism of Michiel Sweerts and the French Le Nain brothers (and
also, if so, of their Piedmontese counterpart, Giovenale Boetto). Then
there is Canaletto, who freely synthesizes the Italian tradition of
stage design with the northern tradition of view-painting (Berckheyde,
Van Wittel, Carlevaris), and even more importantly Bellotto, for
whom the only painter of interest in the whole of Italian art seems
to be the *quadratura* painter who worked with the *bamboccianti*, that
'portraitist' of buildings and Roman and Neapolitan ruins, Viviano
Codazzi, whereas he draws deeply on Dutch art by Philips Koninck,
Van der Heyden, Berckheyde; and, on some reflection, even Pietro

Longhi's ironic interiors surely owe more to Dutch bourgeois pre-cedents than to anything in the Italian tradition, and Pietro Rotari's well-turned half-figures are modelled as much on the Dutch, 'Vermeerian' optical realism of the painter Jean-Etienne Liotard from Geneva as on the naturalized and archaizing classicism of Domeni-chino and Sassoferrato; while the 'Roman' painter Antonio Raffaello Mengs, at least in his marvellous portraits, was modern and European precisely because he was able to reincarnate Italian models in a transparent clarity which comes from the Dutch tradition.[157]

Must we then deduce from this that for the first time in its history Italy's most modern artists are also those who are least typically 'Italian'? It would be nice to be able to apply to them the words written with other categories of intellectuals in mind, that 'the closer they came to being really European, the more they found themselves to be Italian as well, where being Italian meant most importantly becoming conscious of how far behind Italy was and how essential it was to make up the lost ground.'[158]

1789

After all we have said it is obvious that there can be no fixing a date for the end of this process, in the case of Italy, without reference to Europe and, more precisely, to France.

Despite the reasonable and predictable objections that have been raised against taking the date of the French Revolution, 1789, as a landmark in the periodization of the history of art, it is still on the whole impressive to observe how closely the outbreak of the Great Revolution coincides with the stylistic turning point, which should properly be called neoclassicism (it being essential to avoid confu-sion with the legacy of seventeenth-century classicism). The fact is that no one would wish to date it any further back than the 1770s (the death of Louis XV in 1774 is the date of choice) when the work of Ledoux established the new style of architecture, or the early 1780s, when David finally found his true vocation.[159] But this problem, this 'stylistic gap', of qualitative innovation coming after a general revitalizing surge of production is one that we have already met, but which unfortunately no longer concerns Italy, where the new style now comes from outside, a few years later, just ahead of Napoleon's army (1795–6, 1800), bringing changes of varying degrees of intelligence depending on the local situation.

Once written, even this chapter did not turn out to be such an unpleasant episode in the history of Italian art; what we can expect

to see from now on are the mechanisms of retranslation, misunderstanding and ideal backdating with which the new perspective was received in its day in the Marches, Umbria, Lazio and southern Italy, at work more often than the confident and sympathetic acceptance it found in Venice.

This said, it seems understandable that the exhaustion of the eighteenth-century momentum within the country and the crisis of the Restoration should have exerted a greater periodizing, punctuating force in Italy than did the arrival from outside of the new neoclassicism.

While the violent annexation of the country by the French only accelerated the process of Italy's integration into Europe that was already under way, the subsequent return of the old fragmentation, the loss of influence by the intellectual elite of the Enlightenment, the depressed state of farming, the most basic sector of the economy, and the related political protectionism of the individual states, all helped to isolate the country from the rest of Europe and imprison it within its own provincialism. In the neoclassical age, the Italian states may no longer have been producing the dominant personalities of Europe's artistic culture, but they nevertheless remained largely in harmony with it, in sculpture (from Ceracchi to Canova and Bartolini), painting (Appiani, Giana, Giuseppe Velasquez, Camuccini) and architecture (Valadier, Poccianti, Jappelli), and this obviously ceased to be the case in the next era, apart from exceptional instances confined exclusively to the Lombardy–Piedmont area, which was already beginning to emerge as 'not only the most economically advanced nucleus in the peninsula, but also the driving and determining centre of the national movement in the Risorgimento'[160] (for example the engineer Antonelli, the landscape and portrait artist Piccio, and the engraver Gonin).

1815

Because of these unavoidable comparisons (with England, France and Germany) Italy found itself, from the second decade of the nineteenth century onwards, in a state of dislocation between the mind of the country, involved with the international problems of the day, and its disabled body handicapped by its lack of political unity and its economic backwardness ... a country with an agrarian economy in which social relations are much closer to the patriarchal unity of the feudal aristocracy than to democratic individualism ... forced to test its ideology against every aspect of industrial civilization when it has

not even reached the necessary first condition for development, the political unification of the national market.[161]

With things as they stood, it is no surprise that even the 'mind' of the country, and that tiny part of it represented by its artists, began to show signs of considerable confusion. In fact everything became more difficult, from the question of response to innovations from distant and foreign social and cultural contexts, to that of the relationship with tradition. There was a conscious and deliberate drive to bring the country up to date with events abroad, particularly in Paris, but *what* should an artist then be admiring or imitating in Paris – Courbet or Rosa Bonheur, Manet or Bonnat? – very few knew; reference was made to a 'national' tradition, but as to what this should be identified with, whether it meant medieval literature, Quattrocento drawing or seventeenth-century history painting, still remained to be decided. In any case, the few positive examples available serve to show that the two problems are contemporaneous, and that an artist who could successfully identify the modern strand in foreign art would be able to recreate a healthy breeding line within the national tradition, or conversely, that only by keeping strong links with local tradition would it be possible, from this firm background, to stand comparison with foreign art without risk of losing one's cultural identity.

In a period of such dull seclusion perhaps the healthiest specimen was the thoroughly Lombard example of Giovan Battista Carnovali (il Piccio) (1804–74),[162] and his quiet determination, amid so much noisy 'romantic' debate, to go back through the unpretentious teachings of Giuseppe Diotti (1779–1846) to Appiani and, through him, to the late seventeenth-century pictorial softness of Francesco del Cairo and Nuvoloni, and further back still to the 'bourgeois' version of Titian's portraiture represented by the work of his fellow Lombard Moroni, and back to Luini's *sfumato*; from all these he gleaned his tracts of dazzling, misty landscape worthy of Gainsborough, his heartfelt portraits, painted with a mixture of tenderness and freedom comparable to the less 'Napoleonic' Gros and almost to Delacroix; he sought to discover for himself with fine independence, although within the context of the dominant French culture, a corresponding direction in painting that would be intimate, anti-rhetorical, 'pre-romantic' perhaps, with a turn of mind not very different from (and just as valid as) the line which would later, in the 1870s, lead the much younger and more civilized Auguste Renoir to rediscover Perronneau, Saint-Aubin and Fragonard.

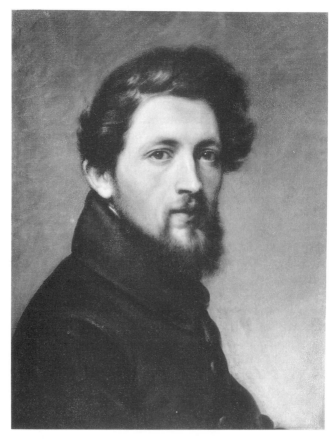

Plate 24 GIOVANNI CARNOVALI, *Self-Portrait*, Uffizi, Florence.
Photo: Archivi Alinari.

Italy and France: the gap widens and narrows again: 1870

As it is neither possible nor methodologically justifiable for the structural reasons already mentioned to see the question of the periodization of Italian art in the nineteenth century, as many would like to, in perfect isolation, almost as though it were 'anthropologically' a different culture rather than an internal division within a European culture which was now more closely united than ever before, precious data such as the strength of links with the centre (or centres)

where innovation originated, the speed of communication, and above all the differences in these data measured in years become more important in allowing us to make useful comments. It would in fact be safe to assume that the longest delays correspond to the phases when Italian society was most cut off from European society, and the smaller gaps to the periods of closest integration.

The comparison, obviously, should be made between the individual artistic output of different geographical areas. I am sure that some 'comparative history' with other areas on the periphery of the main zone of development (which had now expanded since the previous century to include Germany), from Spain in the west to Hungary, Poland and Russia in the east, could help in more accurately reassessing a number of artistic phenomena, particularly in central and southern Italy.

However, taking the most advanced groups, those at the head of the avant-garde movement, and with far the liveliest centre at this point being Paris with its realism and its Impressionists, the area has already been explored in some famous pages by Roberto Longhi on *L'Impressionismo e il gusto degli italiani*. What is of greatest interest here for us is to note that while Longhi observes a 'cultural lag of about a quarter of a century'[163] in the 1850s, at the time of visits to Paris by Domenico Morelli (1826–1901), Saverio Altamura (1826–97) and Serafino de' Tivoli (1826–92), still measuring the 'usual twenty years' in 1870, when the only exponent of the 'realist' movement cited by Adriano Cecioni (1836–86) was Courbet, he sees this gap diminishing rapidly during the following decade (Zandomeneghi's visit to Paris in 1874, Diego Martelli's lecture on the Impressionists in 1879).[164]

Drawing the same comparison, but focusing on the area of Lombardy and Piedmont instead of on the Macchiaioli and the central southern area, we see the same tendency, even though the gap is smaller: in the 1850s the innovative Fontanesi (1818–82) visited Paris and took on board Corot (1796–1875), Théodore Rousseau (1812–67) and Daubigny (1817–78), members of what is generally known as the 'generation of 1830',[165] and works from the 1810s and 1820s by French painters who were not from the extreme avant-garde, such as Drolling (1752–1817), Horace Vernet (1789–1863), Paul Delaroche (1797–1856) were still, in the middle of the century, the unsurpassed models for the 'Brera Masters', Hayez (1791–1882), Inganni (1807–80), Cornienti (1816–60), Girolamo Induno (1825–90), etc.;[166] here too the gap tends to narrow visibly from 1870 onwards (in Turin, Enrico Reycend exhibited for the first time in

1873) until it almost disappears in the 1880s, when 'before the turn of futurism, Italian 'Divisionism' (pointillism) was also European.'[167] And it is significant that it should be a Lombard–Piedmontese movement, such as Divisionism, which confirms the reconnection of Italy to Europe at the same time as it shows the supremacy achieved within the country by the dominant northern groups.

1895–1918: the plunge into 'modernity'

How much sense does it make to take the glorious dates of the Risorgimento, the landmarks of national unification, from the campaign of the Thousand (1860) to the establishment of Rome as capital (1870), as valid points in the periodization of the history of artistic production?

It seems obvious that such sensational events must have had some effect on art history, even if the most immediate and directly observable effects seem mostly negative: the disappearance of the old political capitals, relegating a whole group of traditional cultural centres (Parma, Naples, Palermo, Florence) to the level of provinces (as happened to Lucca, Venice, Genoa), the appearance of monumental public commissions, mostly serving to reinforce the more academic artistic movements, and the urban demolition programmes both in the temporary capital (Florence 1865–70) and in the permanent one.[168] It would be a few years before any positive consequences were seen, such as a closer and readier assimilation of innovations from beyond the Alps. On a stylistic level, after the faint rumbles of the 1870s, the first concrete signs of modernization came in the following decade, when Divisionism took hold at the first Triennale exhibition at the Brera (1891: Segantini, *Le due madri*; Previati, *Maternité*; Morbelli, *Alba*), and the arrival of *Japonisme* in Italy as elsewhere; later at the start of the twentieth century, the exhibition of decorative arts in Turin (1902) would provide proof that at least the best part of Italian architectural and figurative culture was now in tune with European movements, from the English Liberty style to the Austrian Secession.[169]

Looking at the dynamics of style, it seems sensible on the whole to conclude once again that the facts of art co-ordinate much less easily with events in the history of politics and institutions than with the generally less well-known events of economic history. In fact it is the economic historians who discern, from 1861 to 1894, an almost 'autonomous' period of strenuous efforts to make economic unity follow on from political unification, and only in later years

with the great leap of industrialization do they see a process of rapid transformation of the country's economic structure.

The scissor action of the economic situation (the crisis in agricultural production combined with the launch of new industry) can also help us to understand why losing the status of political capitals really spelled doom for the southern cities, while some of the northern ones (Genoa, Turin, Milan), which were on the way to becoming industrial centres, enjoy a kind of second youth.[170]

Giuseppe Pellizza da Volpedo's *Quarto stato*, painted between 1896 and 1901, would seem to possess all the right qualifications, including artistic ones, for symbolizing this stage of national development when the growing influence of socialism is the clearest sign that Italy is moving into a role in the modern world.[171] It was in fact only after political unification had sunk in and had time to produce an effect on the economic plane, with the creation of a single national market, that Italy fully entered into modern (i.e. capitalist) logic and that the modes of distribution of information and works of art, and eventually the general dynamic of the artistic product, underwent profound changes as a result. Social cohesion within individual centres slackened in favour of links across wider horizons between small groups. The mutual isolation of the social classes increased, and the market became more and more differentiated across horizontal stratifications instead of by location. The dialectic of avant-garde movements emerged, and historiography must replace the idea of 'schools' with the idea of 'movements'.

The turbulent years from the economic bottleneck of 1907–8 up to the outbreak of the 1914–18 war were still intense years for Italian art, with the plunge into modernity laying the foundations for all subsequent development. Futurism in painting has an official date of birth, the 1910 *Manifesto dei pittori futuristi* (Manifesto of the futurist painters, signed by Umberto Boccioni, Carlo Carrà, Luigi Russolo, Giacomo Balla and Gino Severini), but on a strictly figurative level it does not settle into a consistently new linguistic form until a few years later, and even then it seems, admittedly, very like a local variant of French cubism with local colour provided by its thoroughly 'northern industrial' programmatic intention to express the new dynamism of modern society. And it was in Paris again, at the same period, that the Levantine Giorgio de Chirico invented his modern formula for showing the other, 'old-fashioned', mythological and non-contemporary face, of Italy.

The difficulties faced by critics in attempting to define the geographical origins of innovation, and the arguments over precedence

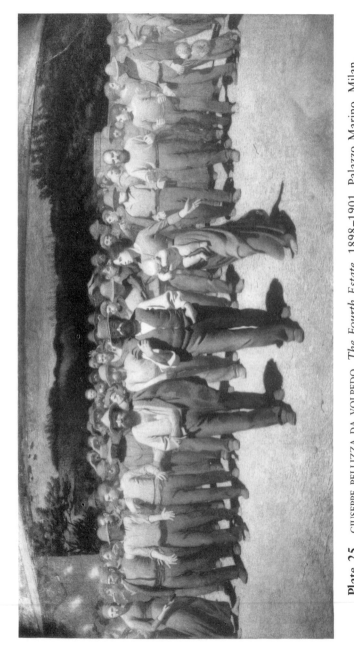

Plate 25 GIUSEPPE PELLIZZA DA VOLPEDO, *The Fourth Estate*, 1898–1901, Palazzo Marino, Milan.

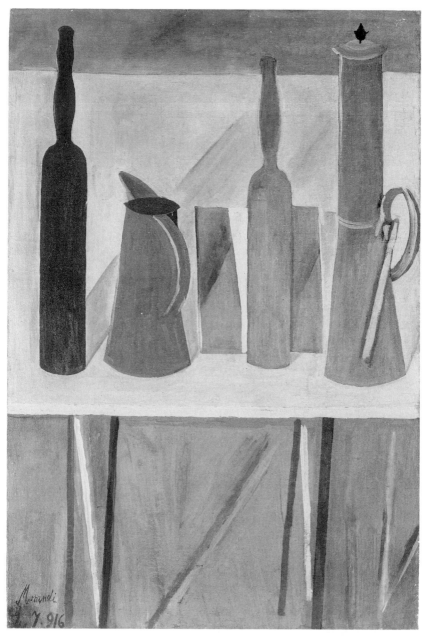

Plate 26 GIORGIO MORANDI, *Still Life*, 1916, Museum of Modern
Art, New York; acquired through the Lillie P. Bliss Bequest.

which rage over a question of a few years and sometimes even of months (defining 'pre'-cubist, futurist, metaphysical, dadaist or surrealist works), confirm the basic fact of interest here: the new and closer connection between avant-garde sectors in the Italian art world and those in the international art world. There are famous extreme examples of total integration, up to and including emigration (Cappiello, Severini, Modigliani, Magnelli), but in all other painters (from Soffici to Sironi, from Casorati to Arturo Martini, from Morandi to de Pisis, etc.) there is such constant attention, and so many contacts and links that any history of Italian art written nowadays would also have to be at least a history of European art, albeit in foreshortening, and, a history of world art.[172]

NOTES

1 R. Longhi, 'Arte italiana e arte tedesca', in *Romanità e Germanesimo* (Florence, 1941), pp. 209–39.

2 F. Villani, *De origine civitatis Florentiae et eiusdem famosis civibus* (c.1400), in K. Frey, *Il libro di A. Billi* (Berlin, 1892), pp. 73–5; G. Vasari, *Le vite de' piu eccellenti architetti, pittori e scultori italiani da Cimabue insino a' tempi nostri descritte in lingua toscana da Giorgio Vasari pittore aretino, con una sua utile e necessaria introduzione a le arti loro* (Florence, 1550; translated as *Lives of the Painters, Sculptors and Architects*, 4 vols, London, 1963); L. Lanzi, *Storia pittorica della Italia. Dal risorgimento delle belle arti fin presso al fine del XVIII secolo* (Bassano, 1795–6; translated as *The History of Painting in Italy*, London, 1847).

3 G. Procacci, *Storia degli italiani* (Bari, 1968; translated as *History of the Italian People*, London, 1970); C. L. Ragghianti and others, *L'arte in Italia* (Rome, 1969).

4 J. von Schlosser, *Die Kunstliteratur* (Vienna, 1924); L. Venturi, *Storia della critica d'arte* (Florence, 1948).

5 Cf. G. C. Argan entry under *Arte*, in *Enciclopedia del Novecento*, vol. I (Rome, 1976), pp. 255–80 (268–70).

6 G. Bollati, 'L'italiano', in *Storia d'Italia Einaudi*, vol. I (Turin, 1972), p. 991.

7 A. della Seta, *Italia antica, dalla caverna preistorica al palazzo imperiale* (Bergamo, 1921), preface to the 2nd edn (1928).

8 F. Arcangeli, *Natura ed espressione nell'arte Emiliana*, exhibition catalogue (Bologna, 1970).

9 S. Bettinelli, *Risorgimento d'Italia, negli studi, nelle arti, e ne' costumi dopo il Mille* (Bassano, 1786).

10 H. Wolfflin, *Kunstgeschichtliche Grundbegriffe* (Munich, 1915; 6th edn, Munich, 1923), p. 241 (translated as *Principles of Art History.*

The Problem of the Development of Style in Later Art, New York, 1950).

11 H. W. Janson, 'Criteria of Periodization in the History of European Art', *New Literary History: A Journal of Theory and Interpretation* (published by the University of Virginia), 1, no. 2 (1970), pp. 115, 22; cf. also *Sixteen Studies* (New York, 1971), pp. 331–6.

12 G. Kubler, *The Shape of Time. Remarks on the History of Things* (New Haven, 1962).

13 E. H. Gombrich, 'Wertprobleme und mittelalterliche Kunst', *Kritische Berichte zur kunstgeschichtlichen Literatur*, 6 (1937), pp. 3–4; cf. G. Previtali, 'Ernst H. Gombrich, conservatore viennese', *Paragone*, 41 (July 1968), pp. 22–40 (28–9); A. Hauser *Sozialgeschichte der Kunst und Literatur* (Munich, 1951; translated as *The Social History of Art*, London, 1951); E. H. Gombrich, review of the English edition, *Art Bulletin* (March 1953). But bear in mind that in subsequent works (*Philosophie der Kunstgeschichte*, Munich, 1958; *Der Manierismus. Die Krise der Renaissance und der Ursprung der modernen Kunst*, Munich, 1964 (translated as *Mannerism*, London, 1965); *Soziologie der Kunst*, Munich, 1974 (translated as *The Sociology of Art*, London, 1982)) Hauser indirectly answers, mostly satisfactorily, many of Gombrich's principal observations.

14 C. Dionisotti, *Geografia e storia della letteratura italiana* (Turin, 1967), p. 77

15 P. O. Kristeller, *Renaissance Thought: The Classic, Scholastic and Humanistic Strains* (New York, 1961); *idem, Renaissance Thought, II: Papers on Humanism and the Arts* (New York, 1965).

16 J. von Schlosser, *Die Kunst des Mittelalters* (Berlin, 1923).

17 See the moving to the eighth century of the panel in Santa Maria in Trastevere (C. Bertelli, *La Madonna di Santa Maria in Trastevere*, Rome, 1961); the dating to the sixth century, originally proposed by C. Brandi, is now reconfirmed by M. Andaloro, 'La datazione della tavola di Santa Maria in Trastevere', *Rivista dell'Istituto Nazionale di Archeologia e Storia dell'Arte*, n.s., 19–20, 1972–3 (Rome, 1975), pp. 139–215.

18 F. Zeri, 'Un frammento su tavola di Pietro Cavallini', in *Diari di lavoro 2* (Turin, 1976), p. 6, goes so far as to describe the historiographical trend which supports the innovative role of Florentine culture, even compared to Rome, as a 'sad episode of cultural hooliganism'.

19 R. Davidson, *Geschichte von Florenz* (Berlin, 1896–1927); F. Antal, *Florentine Painting and its Social Background. The Bourgeois Republic before Cosimo de' Medici's Advent to Power: XIV and Early XV Centuries* (London, 1947); H. A. Miskimin, *The Economy of Early Renaissance Europe, 1300–1460* (Englewood Cliffs, N.J., 1969).

20 There is no room to mention each individual contribution to this trend of study; they can mostly be found quoted in L. Bellosi, 'Moda e cronologia', I: 'Gli affreschi della basilica inferiore di Assisi', and II:

'Per la pittura di primo Trecento', *Prospettiva*, 10 (July 1977), pp. 21–31, and 11 (October 1977), pp. 12–26.

21 E. Fiumi, 'Fioritura e decadenza dell 'economia fiorentina', *Archivio Storico Italiano*, 115 (1957), disp. 4, pp. 385–439, and 117 (1959), disp. 4, pp. 427–502; R. Romano, 'La Storia economica. Dal secolo XIV al Settecento', in *Storia d'Italia Einaudi* (1972–6), vol. II, 2, pp. 1813–931. There is no point in pressing the point of getting the crisis dated 'to the year', even symbolically. There were 'scientific' predictions of the Black Death, and a few particularly sensitive artists show obvious signs of a 'crisis' even before 1348 (Ambrogio Lorenzetti).

22 Antal, *Florentine Painting*; M. Meiss, *Painting in Florence and Siena after the Black Death. The Arts, Religion and Society in the Mid-Fourteenth Century* (Princeton, 1951, 2nd edn, 1964); M. Boskovits, *Pittura fiorentina alla vigilia del Rinascimento, 1370–1400* (Florence, 1975).

23 L. Bellosi, *Buffalmacco e il Trionfo della Morte* (Turin, 1974).

24 Meiss, *Painting*, ch. 6.

25 R. Longhi, 'Fatti di Masolino e di Masaccio', *Critica d'Arte*, 25–6 (July–December 1940), pp. 180–1 (also in *Opere complete*, vol. VIII, i (Florence, 1975), pp. 46–7).

26 Dionisotti, *Geografia*, pp. 91–2.

27 R. Zangheri 'The historical relationship between agricultural and economic development in Italy', in *Agrarian Change and Economic Development*, ed. E. L. Jones and S. J. Woolf (1969).

28 P. Toesca, *La pittura e la miniatura della Lombardia. Dai piu antichi monumenti alla metà del Quattrocento* (1912), ed. E. Castelnuovo (Turin, 1966).

29 P. Renucci, 'La Cultura', in *Storia d'Italia Einaudi*, vol. II, 2 (Turin, 1974), p. 1143.

30 R. Pallucchini, *La pittura veneziana del Trecento* (Venice and Rome, 1964); W. Wolters, *La Scultura veneziana gotica (1300–1460)* (Venice, 1976); I do not think therefore that it can be said that Venice was 'until the end of the fourteenth century a cultural appendage of the Eastern Roman Empire', as F. Zeri did in 'La percezione visiva dell'Italia e degli italiani nella storia della pittura', in *Storia d'Italia Einaudi*, vol. VI (Turin, 1976), p. 65.

31 W. K. Ferguson, *The Renaissance in Historical Thought* (Cambridge, Mass., 1948); D. Cantimori, 'La periodizzazione dell'età del Rinascimento' (1955), in *Studi di storia* (Turin, 1959), pp. 340–65; 'Il problema rinascimentale proposto da Armando Sapori' (1957), ibid., pp. 366–98; C. Angeleri, *Interpreti dell'Umanesimo e del Rinascimento* (Milan, 1965).

32 R. S. Lopez, 'Hard Times and Investment in Culture', in *The Renaissance: Six Essays* (New York 1953; 2nd edn, 1962), p. 42.

33 R. S. Lopez and H. A. Miskimin, 'The Economic Depression of the Renaissance', *Economic History Review*, 14, 3 (1962); C. M. Cipolla,

R. S. Lopez and H. A. Miskimin, 'Economic Depression of the Ren-
aissance?', ibid., vol. 16, 3 (1964); R. Romano, *Tra due crisi: l'Italia
del Rinascimento* (Turin, 1971).

34 G. Luzzatto, *An Economic History of Italy from the Fall of the Roman
Empire to the Beginning of the Sixteenth Century* (London, 1961).

35 Lopez, 'Hard Times', p. 47.

36 R. Longhi, 'Tracciato orvietano', *Paragone*, 149 (May 1962), pp. 3–
14; L. Bellosi, 'Da Spinello Aretino a Lorenzo Monaco', ibid., 187
(September 1965), pp. 18–43; G. Previtali, 'Affreschi di Cola
Petruccioli', ibid., 193 (March 1966), pp. 33–43; Boskovits, *Pittura
fiorentina*.

37 G. Kreytenberg, 'Giovanni Fetti und die Porta dei Canonici des
florentiner Domes', *Mitteilungen des Kunsthistorischen Institutes in
Florenz*, 20, 2 (1976), pp. 127–58; *idem*, 'Die trecenteske Dekoration
der Stirnwand im Oratorio del Bigallo', ibid., 20, 3 (1976), pp. 397–
403; *idem*, 'Zwei Marienstatuen über der Porta dei Cornacchini des
florentiner Domes', *Pantheon*, 34, 3 (1976), pp. 183–90; *idem*, 'Tre
cicli di Apostoli nell'antica facciata del Duomo fiorentino', *Antichità
Viva*, 1 (1977); *idem*, 'Alberto Arnoldi e i rilievi della Loggia del
Bigallo a Firenze', *Prospettiva*, 11 (October 1977), pp. 27–33.

38 Various authors, *Jacopo della Quercia nell'arte del suo tempo*,
exhibition catalogue (Siena, 1975); *Jacopo della Quercia fra Gotico
e Rinascimento*, Documents of the Congress of Study organized by
G. Chelazzi Dini (Siena, 1977).

39 Toesca, *La pittura e la miniatura*; B. Toscano, 'Bartolomeo di
Tommaso e Nicola da Siena', *Commentari*, vol. 15, 1–2 (1964), pp.
37–51; L. Castelfranchi Vegas, *Il gotico internazionale in Italia* (Rome,
1966).

40 H. Baron, *The Crisis of the Early Italian Renaissance, Civic Humanism
and Republican Liberty in an Age of Classicism and Tyranny* (1955;
2nd edn, Princeton, 1966).

41 The so-called *Atys-Amorino* in the Museo Nazionale del Bargello in
Florence; see H. W. Janson, *The Sculpture of Donatello* (Princeton,
1957; 2nd edn, 1963), pp. 143–7.

42 E. Panofsky, *Renaissance and Renascences in Western Art* (Stockholm,
1960).

43 J. Pope-Hennessy, *Italian Renaissance Sculpture* (London, 1958); *idem*,
Essays on Italian Sculpture (London and New York, 1968), pp. 22–
64; *idem*, 'The Madonna Reliefs of Donatello', *Apollo* (March 1976),
pp. 172–91.

44 R. Longhi, 'Piero della Francesca e lo sviluppo della pittura vene-
ziana', *L'Arte*, 17 (1914), pp. 198–221 (also in *Scritti qiovanili 1912–
1922*, Florence, 1961, pp. 61–106).

45 Panofsky, *Renaissance and Renascences in Western Art*.

46 M. Boskovits, '"Giotto born again", Beiträge zu den Quellen
Masaccios', *Zeitschrift für Kunstgeschichte* (1966), pp. 51–66 (figs

1–4, nn. 1–6); G. Previtali, *Giotto e la sua bottega* (Milan, 1967; 2nd edn, 1974), p. 383.

47 Matteo Palmieri, *Della vita civile* (1439), ed. F. Battaglia (Bologna, 1944), p. 36.

48 It is of particular significance here that even a work by Masaccio such as the *Madonna del sollecito* for Cardinal Casini (now in the Palazzo Vecchio) should be a revival, even in its technical aspects, of thirteenth–fourteenth-century tradition. See R. Longhi, 'Recupero di un Masaccio', *Paragone*, 5 (May 1950), pp. 3–5 (also in *Opere complete*, VIII, i (Florence, 1975), pp. 71–3).

49 Kubler, *The Shape*, pp. 89–90; R. Longhi, 'Fatti di Masolino e di Masaccio', *Critica d'Arte* (July–December 1940), pp. 153–4 (also in *Opere complete*, VIII, i, pp. 13–14).

50 E. H. Gombrich, 'The Early Medici as Patrons of Art', in *Italian Renaissance Studies: A Tribute to the late Cecilia M. Ady* (London, 1960); see also *Norm and Form. Studies in the art of the Renaissance* (London, 1966), pp. 35–7.

51 Ibid.; Antal, *Florentine Painting*, pp. 332–3.

52 Vespasiano da Risticci, *Vite di uomini illustri del secolo XV* (c.1485) (Milan, 1951), p. 418: 'because in those days the art of the sculptors had come rather to a state where they were little used, Cosimo, in order that Donatello should not be idle, allocated him some bronze pulpits for San Lorenzo.' Cf. G. Previtali, 'Una data per il problema dei pulpiti di San Lorenzo', *Paragone*, 133 (January 1961), pp. 48–56.

53 G. Romano, 'Disegno', in *Enciclopedia Feltrinelli Fischer, Arte 2*, I (1971), pp. 143–4.

54 Leon Battista Alberti, *Della pittura* (1436), ed. L. Mallé (Florence, 1950), p. 54 (translated as *On Painting*, tr. and ed. J. R. Spencer, London, 1956).

55 R. S. Lopez, *The Three Ages of the Italian Renaissance* (Charlottesville, 1970), p. 7; M. P. Gilmore, *The World of Humanism (1453–1517)* (New York, 1952; 2nd edn, 1962).

56 C. Luporini, *La mente di Leonardo* (Florence, 1953); Paolo Rossi, *Technology and the Arts in the Early Modern Era* (New York, 1970), p. 29.

57 F. Bologna, *Dalle arti minori all'industrial design. Storia di un'ideologia* (Bari, 1972).

58 R. Longhi, *Piero della Francesca* (Milan, 1927; 3rd edn, Florence, 1962).

59 Luzzatto, *Economic History of Italy*.

60 J. Pope-Hennessy, *Sienese Quattrocento Painting* (London, 1947); A. Graziani, 'Il Maestro dell'Osservanza', *Proporzioni*, 2 (Florence, 1948), pp. 75–88; C. Brandi, *Quattrocentisti senesi* (Milan, 1949); E. Sandberg Vavala, *Sienese Studies* (Florence, 1952), pp. 226–350;

E. Carli, *Sassetta e il Maestro dell'Osservanza* (Milan, 1957); *idem, I pittori senesi* (Siena, 1971).

61 M. Bacci, 'Il punto su Giovanni Boccati', *Paragone*, 231 (May 1969), pp. 15–33, and 233 (July 1969), pp. 3–21; A. Paolucci, *Per Girolamo di Giovanni da Camerino*, ibid., 239 (January 1970), pp. 23–41; P. Zampetti, *Giovanni Boccati* (Milan, 1971).

62 R. Longhi, 'In favore di Antoniazzo Romano', *Vita Artistica* (1927), pp. 226–33; F. Negri Arnoldi, 'Madonne giovanili di Antoniazzo Romano', *Commentari*, vol. 16, 3–4 (1964), pp. 202–12; *idem*, 'Maturità di Antoniazzo', ibid., vol. 16, 3–4 (1965), pp. 225–44.

63 F. Bologna, 'Il polittico di San Severino Apostolo del Norico', *Paragone*, 61 (January 1955), pp. 3–17; F. Zeri, 'Altri due pannelli del polittico di San Severino', ibid., pp. 18–21.

64 B. Berenson, *Italian Pictures of the Renaissance. A List of the Principal Artists and their Works, Central Italian and Northern Italian Schools* (London, 1968); R. Longhi, *Officina ferrarese 1934 seguita dagli Ampliamenti 1940 and dai Nuovi Ampliamenti 1940–55* (Florence, 1956); *idem*, 'Una cornice per Bonfacio Bembo', *Paragone*, 87 (March 1957) (also in *Opere complete*, VI, Florence, 1973, pp. 251–60).

65 P. Burke, *Tradition and Innovation in Renaissance Italy. A Sociological Approach* (London, 1974), p. 325.

66 C. Gamba, *Giovanni Bellini* (Milan, 1937); R. Longhi, *Viatico per cinque secole di pittura veneziana* (Florence, 1946), pp. 12–13, 56; R. Pallucchini, *Giovanni Bellini*, exhibition catalogue (Venice 1949).

67 L. Magagnato, *Da Altichiero a Pisanello*, exhibition catalogue (Verona, 1958); O. Pacht, 'The Limbourgs and Pisanello', *Gazette des Beaux-Arts*, 62 (1963), pp. 109–22; G. Paccagnini, *Pisanello alla corte dei Gonzaga*, exhibition catalogue (Mantua, 1972).

68 Wolters, *Scultura veneziana*; Pope-Hennessy, *Italian Renaissance Sculpture*.

69 L. H. Heydenreich, 'The Quattrocento', in *Architecture in Italy 1400–1600* (Harmondsworth, 1974), pp. 3–146 (83–95).

70 G. Fiocco, *L'arte di Andrea Mantegna* (Bologna, 1926; 2nd edn, Venice, 1959); R. Longhi, 'Lettera pittorica a Giuseppe Fiocco', *Vita Artistica* (1926), pp. 127–39, 147–9 (also in *Opere complete*, II, Florence, 1967, pp. 77–98); E. Camesasca, *Mantegna* (Milan, 1964).

71 F. Gibbons, 'Practices in Giovanni Bellini's Workshop', *Pantheon*, 3 (1965), pp. 146–55.

72 B. Berenson, *Italian Pictures, Venetian School* (London, 1957); Longhi, *Viatico*, pp. 13–17; L. Puppi and collaborators, *Maestri della pittura veronese* (Verona, 1974), pp. 91–200.

73 M. Rostworowski, 'Trois tableaux d'Antonello da Messina', *Koninklijk Museum voor Schone Kunsten, Antwerpen, Jaarboeck* (1964), pp. 53–88; N. J. Little, 'A Note on the Date of the London "St Jerome in his

Study" by Antonello da Messina', *Arte Veneta*, 30 (1976), pp. 154–7.

74 Burke, *Tradition*, p. 333.

75 F. Zeri, 'Il Maestro dell'Annunciazione Gardner', *Bollettino d'Arte del Ministero della Pubblica Istruzione* (April–June 1953), pp. 125–249; A. Chastel, *Art et humanisme à Florence au temps de Laurent le Magnifique. Etudes sur la Renaissance et l'Humanisme platonicien* (Paris, 1959); *idem, Renaissance méridionale* (Paris, 1965).

76 D. Weinstein, *Savonarola and Florence. Prophecy and Patriotism in the Renaissance* (Princeton, 1970).

77 A. Ventura, *Nobiltà e popolo nella società veneta del '400 e '500* (Bari, 1964).

78 W. Suida, *Bramante pittore e il Bramantino* (Milan, 1953); R. Longhi and others, *Arte lombarda dai Visconti agli Sforza*, exhibition catalogue (Milan, 1958), pp. xxx–xxxvii, 89–159; L. Bellosi, 'Una "Flagellazione" del Bramante a Perugia', *Prospettiva*, 9 (April 1977), pp. 61–88.

79 Vasari, *Lives*, preface to the third part; R. Longhi, *Viatico*, pp. 19–21.

80 Berenson, *Central Italian and North Italian Schools*; A. Puerari, *Boccaccino* (Milan, 1957); E. Carli, *Il Pintoricchio* (Milan, 1960); S. Zamboni, *Pittori di Ercole I d'Este, Giovan Francesco Maineri, Lazzaro Grimaldi, Domenico Panetti, Michele Coltellini* (Ferrara, 1975).

81 Lopez, *The Three Ages*, pp. 7 and 33.

82 F. Guicciardini, *Storia d'Italia* (Florence, 1561), ch. 9 (translated as *The History of Italy*, New York, 1969); Vasari, *Lives*.

83 F. de Sanctis, *Storia della letteratura italiana* (Naples, 1870), ch. 12; ed. N. Gallo (Turin, 1958, p. 451); translated as *History of Italian Literature* (London, 1930).

84 S. Bottari, foreword to Italian translation of H. Wolfflin, *Classic Art* (Oxford, 1980; originally published Munich, 1899).

85 Luini: A. Ottino della Chiesa, *Bernardino Luini* (Novara, 1956), pp. 128–30. Lotto: B. Berenson, *Lorenzo Lotto* (London, 1956); F. Zeri, 'Il capitolo bramantesco di Giovanni Buonconsiglio', in *Diari di lavoro 2* (Turin, 1976), pp. 58–70; V. Sgarbi, 'Pier Maria Pennacchi e Lorenzo Lotto', *Prospettiva*, 10 (July 1977), pp. 39–50. Palma Vecchio: G. Mariacher, *Palma il Vecchio* (Milan, 1968), pp. 14–15, 94 (he does believe the signature is authentic). Correggio: A. E. Popham, *Correggio's Drawings* (London, 1957); R. Longhi, 'Le fasi del Correggio giovine e l'esigenza del suo viaggio romano', *Paragone*, 101 (May 1958), pp. 34–53 (also in *Cinquecento classico e Cinquecento manieristico 1951–1970* (Florence, 1976), pp. 61–78). Rustici: M. G. Ciardi Dupre, 'Giovan Francesco Rustici, *Paragone*, 157 (January 1963), pp. 29–50; J. Pope-Hennessy, 'Some newly acquired Italian

Sculptures', *Victoria and Albert Museum Yearbook*, 4 (1974), pp. 11–47 (21–37). Michelangelo: R. Longhi, 'Due proposte per Michelangelo giovine', *Paragone*, 101 (May 1958), pp. 59–64 (also in *Cinquecento classico*, pp. 5–9); M. Lisner, *Il Crocifisso di Michelangelo in Santo Spirito a Firenze* (Munich, 1964); A. Parronchi, *Opere giovanili di Michelangelo* (Florence, 1968) (all these writings show above all how difficult it is to trace back from the Michelangelo we know to his early works). Raphael: R. Longhi, 'Percorso di Raffaello giovine', *Paragone*, 65 (May 1955), pp. 8–23 (also in *Cinquecento classico*, pp. 11–23).

86 A. Bruschi, *Bramante*, 2nd edn (London, 1977).

87 F. Antal, *Raphael between Classicism and Mannerism. Four Lectures on 16th and 17th Century Painting in Central Italy* (1934–5).

88 F. Braudel, 'L'Italia fuori d'Italia. Due secoli e tre Italie', in *Storia d'Italia Einaudi*, vol. II, 2 (Turin, 1974), p. 2134.

89 N. Dacos, *Le Logge di Raffaello. Maestro e bottega di fronte all'antico* (Rome, 1977).

90 Lopez, *The Three Ages*, pp. 7 and 54.

91 B. Geremek, 'Il pauperismo nell'età preindustriale (secoli XIV–XVIII)', in *Storia d'Italia Einaudi*, vol. V, 1 (Turin, 1973), pp. 685–6.

92 C. M. Cipolla (ed.), *Storia dell'economia italiana. Saggi di storia economica*, vol. I (Turin, 1959), p. 17.

93 Burke, *Tradition*, p. 332.

94 Vasari, *Lives*, preface to part III.

95 R. Longhi, 'Ricordo dei manieristi', *L'Approdo*, vol. 2, 1 (January–March 1953), pp. 55–9 (also in *Opere complete*, VIII, 2 (Florence, 1976), pp. 85–7).

96 G. Weise, *Il manierismo: bilancio critico del problema stilistico e culturale* (Florence, 1971); T. Klaniczay, *La crise de la Renaissance et le maniérisme* (Budapest, 1970); E. Nyholm, *Arte e teoria del Manierismo, I: Ars Naturans* (Odense, 1977).

97 G. Briganti, *Il manierismo e Pellegrino Tibaldi* (Rome, 1945); *idem*, *La maniera italiana* (Rome and Dresden, 1961; translated as *Italian Mannerism*, London, 1961); S. J. Freedberg, *Painting of the High Renaissance in Rome and Florence* (Cambridge, Mass., 1961); *idem*, *Painting in Italy 1500 to 1600* (Harmondsworth, 1971); J. Pope-Hennessy, *Italian High Renaissance and Baroque Sculpture* (London, 1963); J. S. Ackerman, *The Architecture of Michelangelo* (London, 1961; 3rd edn, 1966).

98 See the bibliography quoted in Freedberg, *Painting in Italy*, and add: for Michelangelo: P. dal Poggetto, 'I disegni murali di Michelangiolo scoperti sotto la Sagrestia Nuova', *Prospettiva*, 5 (April 1976), pp. 11–45; *idem*, 'Nuovo contributo michelangiolesco, I: Disegni murali architettonici nell'abside della Sagrestia Nuova', ibid., 6 (July 1976), pp. 30–45; *idem*, 'Nuovo contributo michelangiolesco, II: Disegni

murali di figura nell'abside della Sagrestia Nuova', ibid., 8 (January 1977), pp. 18–24. For Raphael: K. Oberhuber, *Raphaels Zeichnungen, Abteilung IX, Entwürfe zu Werken Raphaels und seiner Schule im Vatikan 1511–12 bis 1520* (Berlin, 1972); Dacos, *Le Logge.* For Titian: R. Pallucchini, *Tiziano* (Florence, 1969); H. E. Wethey, *The Painting of Titian. The religious Paintings* (London, 1969); *idem, The Painting of Titian. The Portraits* (London, 1971). For Pontormo: J. Cox Rearick, *The Drawings of Pontormo* (Cambridge, Mass., 1964). For Polidoro: A. Marabottini, *Polidoro da Caravaggio* (Rome, 1969); G. Chelazzi Dini and M. G. Ciardi Dupre, 'Polidoro Caldara da Caravaggio, in *I Pittori bergamaschi dal XIII al XIX secolo,* vol. II (Bergamo, 1976), pp. 257–375.

99 E. Borea, entry on 'Bedoli, Girolamo, detto il Massola', in *Dizionario biografico degli italiani,* vol. VII (Rome, 1965), pp. 523–6.

100 D. Sanminiatelli, *Domenico Beccafumi* (Milan, 1967), figs 1 and 7.

101 G. Previtali, *La pittura del Cinquecento a Napoli e nel vicereame* (Turin, 1978).

102 N. Pevsner, *Die italienische Malerei vom Ende der Renaissance bis zum ausgehenden Rokoko* (Wildpark-Potsdam, 1924), p. 40; Weise, *Il manierismo,* p. 199.

103 Braudel, *L'Italia,* p. 2136.

104 H. Voss, *Die Malerei der Spätrenaissance in Rom und Florenz* (Berlin, 1920).

105 E. Male, *L'Art religieux après le Concile de Trente: étude sur l'iconographie de la fin du XVIe siècle, du XVIIe siècle, du XVIIIe siècle, Italie, France, Espagne, Flandres* (Paris, 1932; see English edition, *Religious Art from the Twelfth to the Eighteenth Century,* Princeton, 1982).

106 Procacci, *Storia degli italiani,* vol. I, p. 166.

107 Lopez, *The Three Ages,* pp. 7 and 70.

108 Braudel, *L'Italia,* p. 2136; *Storia dell'economia,* p. 17.

109 See the bibliography provided in Freedberg, *Painting in Italy,* and add to it: for Barocci: A. Emiliani, *Mostra di Federico Barocci,* exhibition catalogue (Bologna, 1975); E. Borea, 'La mostra di Federico Barocci', *Prospettiva,* 4 (January 1976), pp. 55–61. For Taddeo Zuccari: J. A. Gere, *Taddeo Zuccaro: His Development studied in his Drawings* (London, 1969).

110 See for example the case of Raffaellino Motta da Reggio at Caprarola (I. Faldi, *Gli affreschi del Palazzo Farnese di Caprarola,* Milan, 1962) or the case of Francesco Curia at Naples (Previtali, *La pittura del Cinquecento,* pp. 106–9).

111 Cipolla, *Storia dell'economia,* pp. 17–18.

112 Romano, *Storia dell'economia,* p. 1897.

113 Ibid., p. 1892.

114 F. Zeri, *Pittura e contriforma. L'"arte senza tempo' di Scipione da Gaeta* (Turin, 1957); G. P. Bellori, *Le vite de' pittori, scultori e*

architetti moderni (1672; translated as *Lives of Annibale and Agostino Carracci*, Pennsylvania, 1968), p. 6.

115 Procacci, *Storia*, vol. I, pp. 175–6; M. Berengo, *Nobili e mercanti nella Lucca del Cinquecento* (Turin, 1965), pp. 252–7; Ventura, *Nobiltà e popolo*, pp. 275–330; Bologna, *Dalle arti minori*.

116 D. Heikamp, 'Federico Zuccari a Firenze (1575–1579)', *Paragone*, 205 (March 1967), pp. 44–68 and 207 (May 1967), pp. 3–34; 'A Florence la maison de Vasari', *L'Oeil*, 137 (1966), p. 2; L. Berti, *La casa del Vasari in Arezzo* (Florence, 1955); G. Previtali, 'La pittura napoletana dalla venuta del Vasari (1544) a quella di Teodoro Fiammingo (1574)', in *Storia di Napoli*, vol. V (Naples 1972), pp. 847–50; A. M. Giusti, 'Restauri nella casa del Vasari', *Prospettiva*, 9 (April 1977), pp. 78–9.

117 P. Caliari, *Paolo Veronese, sua vita e sue opere* (Rome, 1888), pp. 102–5.

118 C. Bertelli, 'Di un cardinale dell'Impero e di un canonico in Santa Maria in Trastevere', *Paragone*, 327 (May 1977), pp. 94–7 and 107.

119 Zeri, *Pittura*; A. Graziani, 'Bartolomeo Cesi', *Critica d'Arte* (April–December 1939), pp. 54–95; M. Bacci, 'Jacopo Ligozzi e la sua posizione nella pittura fiorentina', *Proporzioni*, 4 (1963), pp. 46–84; A. Griseri, 'Un poeta del controriforma in Piemonte', *Paragone*, 173 (May 1964), pp. 17–28; A. Truffa and G. Romano, *Guglielmo Caccia detto il Moncalvo nel quarto centenario della nascita 1568–1625* (Asti, 1968); E. Borea, 'Grazia e furia in Marco Pino', *Paragone*, 151 (July 1962), pp. 24–52; P. Pirri, *Giuseppe Valeriano S.I. architetto e pittore 1542–1596* (Rome, 1970).

120 P. A. Riedl, *Disegni dei barocceschi senesi (Francesco Vanni e Ventura Salimbeni)*, exhibition catalogue (Florence, 1976); cf. review by A. Bagnoli and D. Capresi Gambelli, *Prospettiva*, 9 (April 1977), pp. 82–6.

121 Previtali, *La pittura del Cinquecento*, pp. 111–19.

122 R. Longhi, 'Momenti della pittura bolognese', *L'Archiginnasio*, 30, 1–3 (1935); also in *Opere complete*, vol. VI (Florence, 1973), pp. 198–201; *idem*, 'Quesiti caravaggeschi, II: I precedenti', *Pinacotheca*, 5–6 (March–June 1929), pp. 258–320; also in *Opere complete*, vol. IV (Florence, 1968); pp. 97–143. An updated summary of the debate relating to the two artists can be found in the Borea edition of Bellori, *Le Vite*, pp. 31–45, 211–36.

123 C. Cipolla, 'The Decline of Italy: The case of a Fully Matured Economy', in The *Economic History Review*, series II, 5 (1952), pp. 178–87.

124 E. J. Hobsbawm, 'The General Crisis in the European Economy in the 17th Century', *Past and Present*, 5 and 6 (1954).

125 A. Bellettini, 'La popolazione italiana dall'inizio dell'età volgare ai giorni nostri. Valutazioni e tendenze', in *Storia d'Italia Einaudi*, vol. V, 1 (Turin, 1973), pp. 489–532 (512).

126 G. Quazza, *La decadenza italiana nella storia europea. Saggi sul Sei–Settecento* (Turin, 1971). Cf. Procacci, *Storia*, I, pp. 232–4.

127 As it would be impossible to list here even the main texts of this impressive tradition of study, I shall mention merely the bibliographies in R. Wittkower, *Art and Architecture in Italy: 1600 to 1750* (Harmondsworth, 1958; 2nd edn, 1965) and E. Borea in P. Bellori, *Le vite de' pittori, scultori e architetti moderni*, edition with commentary (Turin, 1976), pp. xci–cxxii, critically discussed in the notes.

128 Lanzi, *Storia pittorica, passim*.

129 E. Borea, 'La diffusione del naturalismo in Europa', *I Maestri del Colore*, 265 (1968).

130 G. Briganti, 'Milleseicento ossia il barocco', *Paragone*, 13 (January 1951), pp. 8–17; idem, *Pietro da Cortona o della pittura barocca* (Florence, 1962).

131 A. Blunt, *Some Uses and Misuses of the Terms Baroque and Rococo as applied to Architecture* (London, 1973).

132 Naturally if we extend our survey from constructed architecture to architecture that was merely projected the gap tends to close, although this does not give sufficient cause to adopt the opposite attitude which says that 'architectural change precedes the related changes which correspond to it in the thought of a period and its social structure' (E. Kaufmann, *Architecture in the Age of Reason. Baroque and Post-Baroque in England, Italy and France* (Cambridge, Mass., 1955).

133 G. Chelazzi Dini, 'Aggiunte e precisazioni al Cigoli e alla sua cerchia', *Paragone*, 167 (November 1963), pp. 51–65; D. Posner, *Annibale Carracci. A Study in the Reform of Italian Painting around 1500* (London, 1971); A. W. A. Boschloo, *Annibale Carracci in Bologna. Visible Reality in Art after the Council of Trent* (The Hague, 1974); M. Jaffé, *Rubens and Italy* (Oxford, 1977).

134 R. Wittkower, *Gian Lorenzo Bernini. The Sculptor of the Roman Baroque* (London, 1955); idem, *Art and Architecture in Italy*.

135 See the bibliography quoted in Wittkower, *Art and Architecture*, and see also: A. Griseri, 'Due dipinti di Lazzaro Baldi a Granada', *Paragone*, 153 (September 1962), pp. 37–9; V. Casale, G. Falcidia, F. Pansecchi and B. Toscano, *Pittura del Seicento e del Settecento. Ricerche in Umbria*, I (Treviso, 1976); G. di Domenico Cortese, 'Francesco Allegrini pittore di battaglie', *Quaderni dell'Istituto di storia dell'arte* (Facoltà di Lettere, Messina, 1975), 1, pp. 31–7; C. Zappia, *Il volto ufficiale di Francesco Allegrini*, ibid., 2 (1976), pp. 37–47; F. Zeri, 'Francesco Allegrini: gli affreschi del Sant'Uffizio', *Antologia di Belle Arti*, 3 (September 1977), pp. 266–70.

136 Wittkower, *Art and Architecture*, p. 322; also: F. Mace de Lepinay, 'Archaïsme et purisme au XVIIe siècle: les tableaux de Sassoferrato à S. Pietro de Pérouse', *Revue de l'Art*, 31 (1976), pp. 38–56; E. Borea, Gian Domenico Cerrini. Opere e documenti, *Prospettiva*, 12 (January 1978), pp. 4–24.

137 As well as the bibliography given in Wittkower, *Art and Architecture*, see also here A. Sutherland Harris, *Andrea Sacchi. Complete Edition of the Paintings with a Critical Catalogue* (Oxford, 1977).

138 Wittkower, *Art and Architecture*, pp. 322ff; on painting in Bologna from the second half of the seventeenth century to the nineteenth century see R. Roli, *Pittura bolognese 1650–1800, dal Cignani ai Gandolfi* (Bologna, 1977).

139 Wittkower, *Art and Architecture*, p. 104.

140 Apart from the bibliography given in Wittkower, see also here Various authors, *Il Seicento lombardo*, exhibition catalogue (Milan, 1973); G. Pizzigoni, 'Inediti di Tanzio da Varallo', *Prospettiva*, 11 (October 1977), pp. 58–62.

141 G. Testori, 'Su Francesco del Cairo', *Paragone*, 27 (March 1952), pp. 24–43; this interpretation has since been applied too many times, with irrelevant variations to inappropriate subjects, but here it is perfectly apposite.

142 Bellettini, La popolazione', p. 513.

143 Lopez, *Hard Times*, p. 30; Hobsbawm, *The General Crisis*, p. 24.

144 Bellori, Vita di Andrea Sacchi', in *Le vite*, pp. 535–6.

145 The same picture emerges from the more recent overview of Genoese painting by: Various authors, *La pittura a Genova e in Liguria dagli inizi al Cinquecento* (Genoa, 1970), and *La pittura a Genova e in Liguria dal Seicento al primo Novecento* (Genoa, 1971).

146 As Wittkower, *Art and Architecture*, pp. 84–6 and 293–6, rightly says. See also Quazza, *La decadenza*, pp. 203–15, which refers mostly, however, to the period which followed.

147 The most up-to-date summary of seventeenth-century Florentine painting is to be found in E. Borea, *La Quadreria di Don Lorenzo de' Medici*, exhibition catalogue (Poggio a Caiano, 1977). Among earlier writings it is worth remembering F. Sricchia, 'Lorenzo Lippi nello svolgimento della pittura fiorentina della prima metà del Seicento', *Proporzioni*, 4 (1963), pp. 242–63, and M. Gregori, *70 pitture e sculture del '600 e '700 fiorentino*, exhibition catalogue (Florence, 1965). The piece by C. del Bravo, 'Carlo Dolci devoto del naturale', *Paragone*, 163 (July 1963), pp. 32–41, is unintentionally revealing.

148 The most recent overall treatment of seventeenth-century Neapolitan painting is by R. Causa in *Storia di Napoli*, vol. V, 2 (Naples, 1972), pp. 915–1055, and of its architecture A. Blunt, *Neapolitan Baroque and Rococo Architecture* (London, 1975). Also: A. Spinosa, 'Cosimo Fanzago, lombardo a Napoli', *Prospettiva*, 7 (October 1976), pp. 10–26; Various authors, *Mostra didattica di Carlo Sellitto primo caravaggesco napoletano* (Naples, 1977); V. Pacelli, 'New Documents concerning Caravaggio in Naples', *Burlington Magazine* (December 1977), pp. 811–29.

149 The state of study relating to southern Italy (with the sole exception of Naples, to some extent) and Sicily is, for the seventeenth century

as for other periods, a long way short of what it should be, to the point where one may search in vain for a proper treatment, or even a passing mention, of the artists I have mentioned in the often quoted, and otherwise very up-to-date survey by Wittkower. See the recent summary by E. Natoli in the commentary to A. Mongitore, *Memorie dei pittori, scultori, architetti, artefici in cera siciliani* (Palermo, 1977), and see also: F. Negri Arnoldi, 'I "Cinque sensi" di Caccamo e l'attività siciliana di Giovanni van Houbracken, *Bollettino d'arte del Ministero della Pubblica Istruzione*, 2–3 (April–September 1968), pp. 138–44; *idem*, 'Alonzo Rodriguez: un caravag-gesco contestato', *Prospettiva*, 9 (April 1977), pp. 17–37.

150 Bellettini, 'La popolazione', pp. 515–16.

151 Wittkower, *Art and Architecture*; A. Caracciolo, 'La storia economica', in *Storia d'Italia Einaudi*, vol. III (Turin, 1973), pp. 511–693 (particularly pp. 516 and 532).

152 Apart from the bibliography given in Wittkower, *Art and Architecture*, see also: G. Testori, *Fra Galgario* (Turin, 1970); M. A. Pavone, *Paolo de Majo. Pittura e devozione a Napoli nel secolo dei 'lumi'* (Naples, 1977); Various authors, *Luigi Vanvitelli* (Naples, 1973); P. Carreras, *Studi su Luigi Vanvitelli* (Florence, 1977); Various authors, *Piranèse et les français 1740–1790*, exhibition catalogue (Rome, 1976).

153 The process of re-evaluating the art of the neo-classical period in Italy as elsewhere is, as we know, in full swing; I shall therefore just give a few essential references: H. Honour, *Neo-classicism* (Harmondsworth, 1968); Various authors, *The Age of Neo-classicism*, exhibition catalogue (London, 1972); G. Hubert, *La sculpture dans l'Italie napoléonienne* (Paris, 1964); *idem*, *Les Sculpteurs italiens en France sous la révolution, l'empire et la restauration 1790–1830* (Paris, 1964); Various authors, *1770–1860. Pittura neoclassica e romantica in Liguria*, exhibition catalogue (Genoa, 1975); Various authors, *Mostra dei Meastri di Brera (1776–1859)*, exhibition catalogue (Milan, 1975); Various authors, *Pelagio Palagi artista e collezionista*, exhibition catalogue (Bologna, 1976); Various authors, *Pasquale Poccianti architetto, 1774–1858. Studi e ricerche nel secondo centenario della nascita* (Florence, 1974); Various authors, *Lorenzo Bartolini. Mostra delle attività di tutela*, exhibition catalogue (Prato, 1978).

154 Wittkower, *Art and Architecture*, p. 368.

155 F. Haskell, *Patrons and Painters. A Study in the Relations between Italian Art and Society in the Age of the Baroque* (London, 1963), pp. 169–202 and 276–316.

156 R. Longhi, 'Dal Moroni al Ceruti', in *I pittori della realtà in Lombardia*, exhibition catalogue (Milan, 1953), p. xvii.

157 On the importance of the Dutch tradition in the history of eighteenth- and nineteenth-century painting in Europe see L. Malvano, 'Naturalismo e realismo', in *Enciclopedia Feltrinelli Fischer, Arte 2*, II (Milan, 1971), pp. 353–441; A. G. H. Bachrach, *'Shock of Recognition'. The*

Landscape of English Romanticism and the Dutch Seventeenth-Century School, exhibition catalogue (The Hague and London, 1971); P. ten Doesschate Chu, *French Realism and the Dutch Masters. The Influence of Dutch Seventeenth-Century Painting on the Development of French Painting between 1830 and 1870* (Utrecht, 1974).

158 Procacci, *Storia degli italiani*, II, pp. 274–5.

159 See, for example, G. C. Argan, *L'arte moderna 1770–1970* (Florence, 1970), and P. Rosenberg et al., *De David à Delacroix. La peinture française de 1774 à 1830*, exhibition catalogue (Paris, 1974).

160 A. Caracciolo, 'La storia economica', in *Storia d'Italia Einaudi*, vol. III, pp. 511–693 (582).

161 G. Bollati, *L'Italiano*, ibid., vol. I, pp. 951–1022 (1000).

162 C. Maltese, *Storia dell'arte in Italia 1785–1943* (Turin, 1960); M. Valsecchi, F. Rossi and B. Lorenzelli, *Il Piccio e artisti bergamaschi del suo tempo*, exhibition catalogue (Bergamo, 1974).

163 R. Longhi, preface, with a report on Impressionism and the tastes of the Italians, in the Italian edition of J. Rewald, *Storia dell'impressionismo* (Florence, 1949), pp. vii–xxix (xi) (translated as *History of Impressionism*, London, 1973).

164 Longhi, preface to Rewald, *Storia dell'Impressionismo*, pp. xiii–xviii. See also D. Durbe et al., *I macchiaioli*, exhibition catalogue (Florence, 1976).

165 A. Griseri, *Il paesaggio nella pittura piemontese dell'Ottocento* (Milan, 1967), p. 12.

166 Various authors, *Mostra dei maestri di Brera (1776–1859)*, exhibition catalogue (Milan, 1975).

167 R. Longhi, 'Ricordo di Enrico Reycend', *Paragone*, 27 (March 1952), pp. 43–55; *idem*, 'Avvertenze per il lettore', in *Scritti giovanili, 1912–1922*, vol. I (Florence, 1961), p. ix. For Reycend, as generally for pictorial culture in Turin at the time, the most fitting comparison is possibly with the situation in a large and cultured provincial centre like Lyon, rather than directly with Paris.

168 Maltese, *Storia*, pp. 216–77; G. Falcidia and B. Toscano, 'Aspetti dell'arte dell'Ottocento, in F. Negri Arnoldi, *Storia dell'arte*, vol. III (Milan, 1968), pp. 417–522.

169 I. Cremona, *Il tempo dell'Art Nouveau. 'Modern' style, Sezession, Jugendstil, Arts and Crafts, Floreale, Liberty* (Florence, 1964), pp. 161–79; G. and R. Fanelli, *Il tessuto moderno. Disegno, moda, architettura, 1890–1940* (Florence, 1976), pp. 126–9.

170 G. Luzzatto, *L'economia italiana dal 1861 al 1914*, vol. I: *1861–1894* (Milan, 1963); A. Gerschenkron, *Continuity in History and other Essays* (Cambridge, Mass., 1968).

171 G. Pellizza da Volpedo, *Il quarto stato*, ed. A. Scotti, preface by M. Rosci (Milan, 1976).

172 This is the logic informing recent treatments of the subject: from the wide overview in fourteen volumes by F. Russoli and others, *L'arte*

moderna (Milan, 1967), to the volume by Argan, *L'arte moderna 1770–1970*. This does not mean of course that it is impossible that even from this viewpoint there can be any useful exploration of many aspects of 'local' culture; attempts to do this have been made, among others by: P. Fossati, *L'immagine sospesa. Pittura e scultura astratte in Italia (1934–40)* (Turin, 1971); C. de Seta, *La cultura architettonica in Italia fra le due guerre* (Bari, 1972; 2nd edn, 1978); F. Tempesti, *Arte dell'Italia fascista* (Milan, 1976).

The Iconography of Italian Art 1100–1500: An Approach

SALVATORE SETTIS

> Inscribe in any place the name of God
> and set opposite to it his image: you will
> see which will be held in greater reverence.
> Leonardo[1]

'Pictura loquitur'

BETWEEN the beginning of the eighth century and the middle of the ninth, a violent furore swept back and forth through the territory of the Eastern Empire. As a contemporary source relates, whole cities and multitudes of people were constantly agitating on one side or the other of the image controversy;[2] and the struggle of the iconoclasts with their adversaries went beyond the boundaries of mere theological disputation to involve everyone, and at times took on the colours of harsh intolerance and cruel persecution with no holds barred.

It has always been the custom, and certainly still is today, to destroy images of a vanquished foe, or of an enemy one is still fighting: how many times had the *damnatio memoriae* not fallen on the once glorious statues of the emperors of Rome? And the fall of paganism had certainly spelled doom, either through neglect or deliberate effort, for the statues of the dispossessed gods.[3] But in the Byzantine world, for the first and perhaps the only time, it was

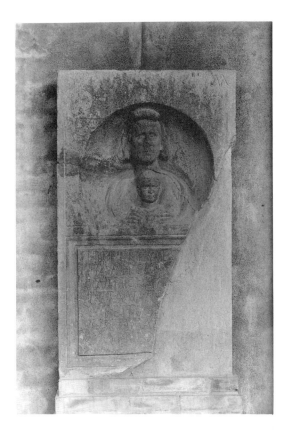

Plate 27 Workshop of Aquileia, Mother and child grave stele, first half of the third century, Museo Nazionale, Aquileia.

actually the images of the dominant religion which were being destroyed: pious sovereigns and patriarchs and bishops who uttered the holy names of Christ and Mary with more than a ritual reverence, furiously attacked their images, wrenching them from the walls of their churches. Thus with a force and passion, which surviving texts can only partly convey, did a particularly keen sensitivity towards the world of painted and sculpted figures take on form and consciousness, since to destroy them and fight them with the flourishes of rhetoric and the weapons of theology was surely to treat them as *living* enemies.[4]

Monks who still wished to gather around walls covered with holy

Plate 28 Roman mosaicist(?), *Madonna with Child*, *c.*820, Cappella della Colonna, Santa Prassede, Rome.
Photo: Archivi Alinari.

images were thunderously accused of idolatry by the new theologians: the adoration given to icons, as material objects, was diverted from its true and only object, which is God; the multiplying of images in order to worship them was like multiplying gods and was a return to the errors and wretchedness of the gentiles. Another theme is bound up with this one, like a tangled web of contradictions: one objection is that images, however skilfully they may be painted, will always be inadequate representations of God and the saints. But it is precisely the insistence on this inadequacy, supported by the radical prohibition of images in Exodus 20.4 and other quotations from the Bible and the Fathers of the Church, which reveals, by its almost obsessive reiteration, a fear that icons might, by the quality of the drawing and the brilliance of their colours, attract all the attention of the faithful: and that their great beauty, which actually made them seem *too much* like real beings, might draw to the images themselves the admiration and homage which belonged to God alone.

The verisimilitude topos, of the life infused into the statue by the artist, which had been a constant theme throughout the classical world, is still very important to the Byzantines: in fact, without apparently noticing the stylistic gap between ancient art and their own, they repeated it for Zeuxis exactly as for the icons. In as many variations as the artifice of rigid rhetoric would allow, this topos is passed down among learned men as though by the force of its own inertia: but in popular culture it is naturally translated into a wealth of legends about statues that come to life,[5] which become confused with traditional stories of automata, the pride of the imperial court; and furthermore, in endowing statues with the magic power to move inert matter, they end up by investing them with demonic possession, behind which the defeated gods of Olympus are still at work. This is the idea, rather than any dumbstruck awe of a 'barbarian', behind the declaration of the crusader Robert de Clari, who visited the Hippodrome of Constantinople in 1204 and saw all the bronze statues which were still there as a host of automata 'with broken clockwork'.[6] A kind of homespun euhemerism has turned demons into machines.

The 'causes' of iconoclasm, which have been investigated with endearing simplicity, as distinct from its 'effects', must certainly be religious and political and social and economic and military and due – why not? – to Arab or Jewish 'influences'. But the whole movement, in the continuous debate which follows its changing fortunes through all the struggles and ruptures, revolves around the irremediable conflict

between an ultimately Graeco-Roman cultural tradition, which demanded as 'lifelike' an image as possible, and the fear that icons might take on breath and movement in the eyes of the faithful, and stand, as a work of the devil, between God and the people, and between the emperor and the people.

Whether as inadequate copies of a living supernatural reality, or as objects too alive in themselves, sacred images were to be destroyed. But the relationship, analysed so many times, between the invisible blueprint (God and the saints) and their tangible icons disguises the real root of the problem: the figures painted by the artist's hand and filled by him with so much beauty and ornament *involve the senses* in adoration, and prayer becomes a carnal act. With sharp 'pedagogical' intuition, St Cyril (fourth century) had written that images, like parables, have the advantage of presenting the force of their meaning 'to the sight of the eyes and the touch of the hand'. But icon-worshippers sought the right to 'embrace them, kiss them and love them'; phrases like this recur dozens of times with a kind of excited sensual emphasis in statements by the Fathers of the Second Nicene Council (787); a contemporary western observer was therefore justified in speaking of *amplectibilis adoratio* (embraceable adoration).[7] We can now understand the strange punishment inflicted in 766 on monks who were unshakeable worshippers and defenders of images: they were made to parade in the Hippodrome, each one holding the hand of a woman.[8] Whoever devised this strange procession no doubt had in mind a passage from the Epistle of St Paul to the Galatians (5.19): 'The works of the flesh are manifest, which are these; Adultery, fornication, uncleanness, lasciviousness, *idolatry*.' To adore an image is to yield to the senses: therefore the holy chastity of the monk, having already been profaned, can be derided by forcing it into contact with the flesh of woman.

The responses of the icon-worshippers were no less rich in arguments and quotations. Basing themselves on long tradition, they affirmed the legitimacy of worshipping images, since the worship passes from the images to the prototype, to God himself. This key argument was rephrased dozens of times, and always rejected by the iconoclasts: however, by stating the problem in terms of a relationship between *prototype* and *copy* (= the icon), it shifts our attention fatally on to the channel between the two, the artist who must somehow copy the prototype. This point is so delicate that it is hard to find it explicitly formulated: but it could not be evaded. The arguments put up to counter it follow two directions which are

only apparently divergent: the first (which is firmly rooted in pre-iconoclastic times) is the attempt to identify, by constructing ficti-tious traditions, acheiropoetic (αχειροποίητοι) icons, painted not by the hand of man, but where the divine image has been miraculously imprinted on to matter.[9] The human mediator is thus eliminated: the dark horse of the artist's fallibility is ruled out, and the icon *must* resemble the prototype.

The second counter-argument is found most clearly formulated in the proceedings of the Second Nicene Council, which re-established for ever the worship of images: '*Non est imaginum structura pictorum inventio, sed ecclesiae catholicae probata legislatio et traditio . . . con-silium et traditio ista non est pictoris (eius enim sola ars est), verum ordinatio et dispositio patrum sanctorum*'.[10] The painter's only province is *ars* – artistic skill – while the Church, by tradition going back to the Fathers, controls the *structura* of icons, that is their *ordinatio et dispositio*, their iconography. The problem of likeness to a reality that is beyond the senses is thus solved by moving it to the background and hiding it behind the indisputable seal of the Church's authority as guardian of tradition and as the operative hierarchy.[11]

None of these answers, nor any of the metaphors by which they were sometimes bolstered, could be understood without reference to the living presence of classical culture. Behind the phrase 'from pro-totype to copy' lies firstly the experience of the monastic *scriptoria* and the problem of fidelity to the original text being copied, but surely too, on a more specifically iconographic level, there is an awareness of the practice of copying the *nobilia opera* of the mas-ters, to which statues and texts bore and still bear constant witness.

Moreover, such a rigid distinction between the painter (whose sole province is *ars*, or technical skill) and the ecclesiastical patron, who has total control over iconographical *inventio*, which must, however, always be taken from tradition, not only reflects the custom of the time, but also presupposes the *real* existence of an iconographical tradition which had modelled itself expressly on the art of the late Roman Empire, adapting its forms to the new Chris-tian themes.[12]

The power of images lies in what they can suggest without words; as Erasmus put it, 'we often see much more in images than we could understand from written things.'[13] And so, in looking at art that had radically reworked its forms and styles to suit the needs of imperial propaganda,[14] only an openly hostile disposition would think of looking *inside* the iconography, of 'taking it apart' and asking *why*:

therefore we find the fullest account of the range of themes and schemes in ancient imperial iconography in St Gregory of Nazianzus's speech against Julian the Apostate. 'Emperors do not only love the *reality* of the exploits of which they are so proud; they also love to see them *portrayed*; thus they hope to be better and more perfectly venerated.'[15]

The conflict between pagans and Christians, and the problem of the worship of imperial images, had thus made people aware of the propagandist nature of imperial art by showing that behind the figures (or schemes and themes) was a highly structured social hierarchy of relationships which the images served to mediate. But the new Christian Empire had already, with Constantine, cut at the roots of hostility towards the veneration of sovereigns: 'peer of the Apostles' and defender of the faith, the emperor could, through his portraits, still be the object of ritual public professions of loyalty and devotion. It is very relevant that the iconoclasts aimed their revolt *only* against religious images, while portraits of the emperor and paintings of profane subjects such as circus and hunting scenes, always arranged around the figure of the ruler, were still being produced.[16] The conclusion that the iconoclast emperors were opposed to religious images in order that their own figurative propaganda should have greater prominence may seem rather too obvious, but it is certainly not the whole story. Moreover, the defenders of images used the veneration of imperial portraits as an argument in their favour, since here too the homage paid to the inert matter 'really' reaches the living person of the ruler.[17] The *intention* of the imperial subject, or of the icon-worshipper, is therefore the only crucial point: kneeling before the portrait of his sovereign, a Byzantine merchant could imagine himself performing, with no lesser reverence, the ceremonial gestures laid down, in the inaccessible palace, by the ritual of the court; so to embrace the image of a saint, of the Virgin or of Christ is in fact to try and penetrate with the flesh and the senses into the sphere of the divine.

The movement against *sacred* images cannot be put down to unrefined emperor worship: it was the result of very close attention paid to the response of the senses of the beholder of an image, as product of human *techne*, and the theologians voiced this concern with argument and language. But the different treatment given to the themes of imperial art makes it clear that we are witnessing here, for the first time, the consummation of a total divorce between *sacred art* and *profane art*. The ancient aspiration towards verisimilitude, which in the one case can win merit for the artist who calmly

perpetuates the old traditions of the pagan rulers, can, in the other context, be blasphemous idolatry. The distinction between sacred and profane disjoints the relationship with the classical models: and doubts about orthodoxy interfere not only with the activity of the painter but also, more seriously, with the senses of the beholder.

The dramatic dichotomy between complete *amplectibilis adoratio* and the stern refusal to allow any sensuous mediation between man and God could of course be avoided. The attribution of artistic activity to St Luke the Evangelist is along these lines: how could the inspired author of the gospel have deviated from the truth in painting the Virgin? Through the two aspects of the figure of Luke, *text* and *image* were placed in parallel, and an argument, used in ancient times, and surely one of the most commonly recurring topics in the unfolding of western culture, was brought back into play: *ut pictura poesis*, poems are just like pictures. From the Renaissance onwards, the Horatian simile (*Ars poetica*, 361) was used to tackle the question of how to codify the status of art, and eventually came to refer to the degrees and forms of the imitation of nature, tracing a line between painting and poetry which is sometimes one of kinship and sometimes a dividing line, and sometimes takes on the characteristics of a debate as to the superiority of the one over the other.[18]

But when the Church found it necessary to speculate about the use of images in the context of pagan religion, the comparison between image and written word had to operate entirely at the level of *meaning*. The *locus classicus* is a letter from St Gregory the Great written in October 600 to Bishop Serenus of Marseille: thus with the full authority of a pope the principle was asserted that '*praecipue gentibus pro lectione picture est*' (painting is chiefly for teaching the people): since

> painting fulfils for the ignorant the same role as writing has for those who can read; in painting the ignorant can see examples to be emulated, and those who do not know how to read *can read*; and images have been put in churches not to be worshipped, but solely and exclusively to instruct the minds of the unlearned.[19]

This point of view was naturally taken up in the East by the supporters of images, especially by St John of Damascus.[20] But St Gregory the Great drew his doctrine on images from the living, secular presence of the Roman world: in relating the life of the third-century emperor, Maximinus of Thrace, the *Storia Augusta* had told how, having victoriously completed his campaign in Germany, he

'ordered that the exploits of that war be painted on some panels, which were hung before the Curia, *ut facta eius pictura loqueretur'* (that the painting should speak his deeds). *Pictura loquitur* – painting speaks: and in fact, after his death, the Senate ordered that the panels be taken down from the wall and burned.[21] Once again, the destruction of an image is the clearest proof of its value as a direct, *speaking* visual message. This was why, in Roman courts, orators had learned to be silent every so often, relying on specially painted images to move the judge's feelings, believing that 'a dumb effigy can speak (*locuturam*) better in their favour than any oration', as Quintilian writes.[22]

Even more richly articulate than the letter from St Gregory the Great is one of the formulations of the Second Council of Nicaea, where the distinction is made between two different uses of images, *ad salutationem* and *ad memoriam*; both, it adds, are equally necessary.[23] In both cases, the bridge between the beholder and the figure is the senses, which allow recognition of the *exemplum* in the picture which is to be followed: as though by way of an answer to those who had seen an *opus carnis* (a work of the flesh) akin to lust in the cult of images, the examples cited are the story of the chastity of Joseph, the continence of Susanna, and thirdly St John the Baptist dressed in camel skin, eating wild honey and pointing to Christ suffering for the sins of the world. Looking at these painted stories, the faithful could not fail to learn from them the lessons of continence and penitence; and all the saints point, like the Baptist, to the greatest example, Christ himself.

As it happened, a deep crisis forced each side in the controversy to formulate its arguments more deliberately and explicitly. By setting sacred and profane, visible and invisible, pagan and Christian against each other so bluntly and rigorously, the iconoclast controversy established a permanent rift between East and West. At the same time the opposition of *memoria* to *salutatio* as alternative functions (or benefits) of the image provided an extraordinarily lucid definition of the two poles of every possible emotional response by the beholder of an icon, describing them in highly ritualized terms. This opposition is in turn founded upon another opposition between the *representative* image (relating to *salutatio*) and the *narrative* image (for *memoria*), and ultimately involves two different dimensions of time for the beholder, the first, in the *salutatio* icon, being a point in time, whereas for an image from which we are to reconstruct (or read) the memory of events and sacred texts, time must stretch in a linear path as the eye wanders over the painting.

'Secundum typicam figuram'

Religious geography ignores landscape and defies history. The fabric of valleys, mountains and rivers, passes and bridges, the ship on the sea, are all link points along the line of the journey towards the holy place. Cities and castles can act as reference points or stopping places; but a map showing the precise lie of the land is not only 'technically' impossible, it is not even desirable. What does it matter how wide the river is? Few even counted the days spent on the road.

On a very well-trodden path like the journey to Rome or Compostela, the twists of the itinerary seem to be held together less by an organized sequence of roads and expectations, than by an individual tension within the traveller who is moving above all towards a privileged encounter with the sacred, in search of his own salvation. Though elevated in collective pilgrimages to mark feasts, and later for indulgences and jubilees, the journey has always, even when made by a solitary pilgrim, had a somehow choral dimension: to tread the path others have trodden and still others will tread is to throw one's own fate and one's own hope in with those of one's fellows. Equally, in the great holy cities like Rome or Jerusalem, the guides would enjoin pilgrims to visit the numerous sites of visions and miracles, passing over the whole complex fabric of the city, with all its life, its passions and sufferings, inventing a new artificial topography of very scattered features, almost like a net placed over the real city and marked here and there by knots for sites, the blinkered vision of the sacred.

And yet, this sacred geography which seems to destroy and contradict reality has a reality of its own; since the *peregrinus* is not only the pilgrim who moves 'beyond his homeland' (Dante), but every Christian, since we are by definition strangers in the world: this is the fate marked out for us by God's words to Abraham: 'Leave your country . . . for the land I will show you' (Genesis, 12.1). Therefore, in this constant quest for salvation, the place where the pilgrim encounters the sacred is by its very nature indefinable, *its real* history is irrelevant to it. What is important is that tradition should confirm the sacredness of place, the more *intense* presence of the divine, with authority, always relying on basic stories which need no verification, episodes from the life of Christ or one of the saints.

Faith in the omnipresence of a God outside space and time is thus wedded, paradoxically, to the quest for some privileged contact with him *located* in a sacred *event*. It matters little that the choice of

location and/or event may be more or less arbitrary: the function of the holy place is fully expressed in the simple fact that pilgrims flock there. So this distillation of the sacred at a few privileged points is a determining factor in giving a collective and 'technical' dimension to devotion; and if it is the sum of pilgrims which makes a certain place sacred, on a personal level an individual's faith in the efficacy of his or her encounter with the divine is based partly precisely on the journey made to reach the place, the time and effort and emotion that went into it. Monte Mario, a landmark for Rome-bound pilgrims from the north, thus becomes *Mons Gaudii*; and the joy of reaching the holy city prefigures the perpetual bliss of entering the celestial Jerusalem, a pilgrim no longer.

As pilgrimage is to home life, so feast days are to work days, and the short pilgrimage of going to church in one's town or village is not just a break, but a real gateway to a dimension that was thought of and characterized as 'different'. For while the turreted city that is the cathedral, standing in contrast to the lord's palace or the town hall, is often seen as an image of the City of God, a more common and direct contrast is made between the works of the world and the practice of piety.

As the place designated for collective devotional practice, the church – with its hoard of relics, its precious little treasures, its architectural forms – is not a mere theatre for ceremonies and rites, but must offer an image of divine rhythm which both clashes and harmonizes with man's rhythm in his everyday life. So the faithful may salute, or greet the relics and images, in an instant encounter that can be awakened simply by the sound of a bell, but this is just one aspect of their relationship with the church, which is above all a *place of memory*.[24]

Recording how the Greek Simonides discovered the principle that the keenest of our senses is sight, Cicero shows how well founded is the belief that images have more power over the memory than words; this, he says, is why any discourse heard with the ears will remain more easily in the mind if it is also conveyed through the eyes. The whole of ancient wisdom as it relates to memory and all the mnemotechnics it produced are founded on this simple observation.[25] The author of the *Rhetorica ad Herennium* insists on the necessity of 'assisting the memory by using emotional triggers' (Yates), anchoring what we wish to remember firmly to striking and unusual images; since, as he says, the more closely things resemble our everyday life the more they imperceptibly slip from our memory; the things that stick best are those which are *'egregie turpe, inhonestum,*

inusitatum, magnum, incredibile, ridiculum' (3.22) (exceptionally ugly, unsightly, unusual, large, incredible or ridiculous). The whole ancient 'art of memory' is aimed at cultivating artificial memory, which first anchors the things it wishes to remember to *signa*, as Quintilian calls them, suggesting particularly *imagines vel simulacra*, and secondly places these *signa* in areas of memory *quae vel finguntur vel sumuntur*, either taken from real life or imagined, in either case holding them in the mind (*Institutio oratoria*, XI.2, 19.21). These images are filed away in real or imagined places, 'compartments' which we picture in order to tie to them the things we wish to remember.

However, the statues and porticoes which the ancient treatises on the art of memory advised their students and readers to plant firmly in the memory were a little too like the marble statues and porticoes among which their readers moved. If the earliest 'art of memory', possibly first systematized by Simonides of Ceos in the early fifth century BC, chose its location within the network of urban monuments, it was because these monuments had been designed, more and more consciously, to contain statues and paintings and reliefs which by their position and interrelation were supposed to make passers-by remember the mythical or historical events in the life of the city, and later of the empire and the ruler's family.

The *Rhetorica ad Herennium*, thought to be by Cicero, and closely related to the authentic treatise *De inventione* – was the basis for medieval speculation about the art of memory, as Yates demonstrates very well. Albertus Magnus and St Thomas Aquinas, the greatest authorities on the medieval *ars memorativa*, took this as their basic text, showing clearly how the pivotal point of artificial memory has shifted from rhetoric to ethics. Memory is part of the virtue of prudence, and as it seeks above all to commit to itself 'things relating to salvation and damnation, articles of faith, the roads through virtue to heaven or through vice to hell', it should be practised mainly in 'solemn and rare' places. And then, surely, 'the best kind of building in which to form places in the memory could be a church' (Yates). Once again, artificial memory stores its archives in existing buildings designed for a purpose that is at least partly analogous to its own aims. There is a common thread, which Frances Yates has brought to light, linking the *ars memorativa* of Albertus Magnus and Aquinas to the mnemotechnic of pagan antiquity; another thread links the decoration for figures in ancient buildings with the decoration for figures in medieval churches. These two threads are closely interwoven, and reinforced by two common and

complementary principles: that sight is the dominant sense, and that in order to remember (or cause others to remember) things better, one must invent (or paint or sculpt) *figures* that define, guide and dictate what is recalled.

Ostrich eggs, meteorites, unicorn's horns, gryphon's claws, mammoth's tusks and stuffed crocodiles were, and sometimes still are, hung for all to wonder at in medieval churches, which must have been rather like early natural history museums.[26] Here the faithful could then find curious and unusual things they did not have at home, evoking fabulous or exotic creatures, and from them derive, if not teaching, then at least some sense of wonder. Where possible, ancient sculptures were lined up inside or around the church, or even put up on the walls: sarcophagi, capitals, architraves and Roman heads and busts were jumbled in with the medieval murals and carvings.[27] The church was seen as a repository of human knowledge which could reproduce within a limited space the rich variety of the 'outside' world; natural history and profane history were gathered into the compass of sacred history. And the *vana curiositas* towards nature which St Augustine so deplored could be usefully reclaimed by translating knowledge and 'facts' on to a strictly ethical plane: like the animals of the *Physiologus* and the many *Bestiaries* derived from it, the oddities exhibited in the churches became a starting point for moral interpretation.

Why ostrich eggs? Because, as Gulielmus Durandus explains in the *Rationale divinorum officiorum* (*c*.1295),

> some say that the ostrich, as being a forgetful bird, leaveth her eggs in the dust: and at length, when she beholdeth a certain star, returneth to them and cheereth them by her presence. Therefore the eggs of ostriches are hung in churches to signify that man, being left of God on account of his sins, if at length he be illuminated by the Divine Light, remembereth his faults and returneth to him. As it is written in Luke that after Peter had denied Christ, the 'Lord turned and looked upon Peter.' (22.61–2)[28]

Mirabilia turn into *exempla*; and the gaze of the faithful settling on the ostrich egg hung in the church may lead them to repentance and salvation.

To make itself into a visible framework for a concept of the world which takes everything back to the individual and collective problem of salvation, the church must first of all become distinct from every other building by its form and position within the urban fabric; secondly it must be decorated with images '*in ornamentis ecclesiae*

et memoria rerum gestarum' (for the decoration of the church and the memory of past deeds).[29] In order for such *litterae laicorum* (lay literature) effectively to reach its audience in accordance with the teaching of St Gregory the Great, it must reflect the doctrine of the Church faithfully, and the artists must keep to that doctrine by repeating approved formulae. Therefore the work of the painter will simply be '*secundum typicam figuram desuper oleum fundere*' (to pour his paint from above on to a stereotyped figure).[30]

The extraordinary uniformity of religious iconography is not the result of the promulgation of detailed and binding rules (such as those laid down to govern church rites), nor of any 'official' code. And yet iconography is not just a science that has been constructed retrospectively from the extensive baggage of surviving images by cataloguing the attributes and formulae of themes and events, in the same way as a lexicon of Homer breaks the poet's language down into individual words in order to isolate the epithets for a river and the exploits of a hero.

The constant dependence of painters and sculptors on commissions from church patrons or from patrons controlled by members of the clergy, ensuring the didactic purpose of the *ornamenta ecclesiae*, explains how, even within the wide variety of available themes and schemes, the images of Christ and the saints are always portrayed *secundum typicam figuram*. It was not only the artists who saw to the circulation of these *typi*, learning as they did from each other or from pattern-books, but the patrons too, in their desire to make the story comprehensible to the *laici*, and the illiterate.

'Litterae laicorum'

'Sometimes a door, a façade, or an entire church displays a symbolic meaning which is quite unrelated to religion, even hostile to the Church . . . In the Middle Ages thought written in stone, the architectural book, enjoyed privileges which can be closely compared to our own free press: it is "free architecture" ' (Victor Hugo, 1832).[31] This view of medieval sculpture was an important factor in the gradual return to studying the decorative heritage of our cathedrals which took place during the nineteenth century: and yet it is completely false. The sculpture of the architrave of the vestibule in the Duomo in Cremona, dominated by the motionless figure of Bishop Sicard,[32] is like a distillation, in an image full of silent authority, of the prelate's influence on the decoration of *his* cathedral.

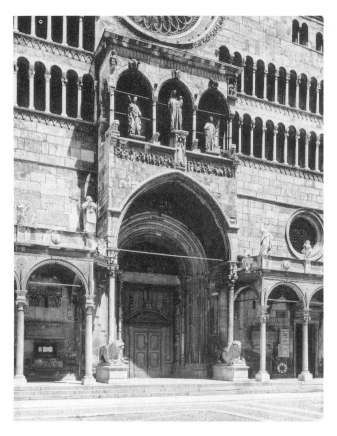

Plate 29 Lombard sculptors, Main portal, beginning of thirteenth
century, Cremona Cathedral.
Photo: Archivi Alinari.

Sicard (*c*.1155–1215), bishop of Cremona from 1185 until his
death, is one of the very few figures who left in his writings any
detailed evidence of his interest in images: a considerable proportion
of his treatise on liturgy, the *Mitralis*, is devoted to the decoration
of churches, with particular emphasis on sculpture.[33] He explains that
sculptures 'are not only made as *ornatus ecclesiarum*, but also be-
cause they are the *litterae laicorum* (literature of the lay people), in
so far as they serve to commemorate past matters (stories and
visions), and to give information about present matters (the virtues
and vices) and future matters (punishment and reward)' (*Patrologia
Latina*, CCXIII, 40A–B).

What we seem to have here is a rough summary of the decorative schemes for all sacred buildings: Bible stories, visions like the tree of Jesse or the Apocalypse, Virtues and Vices, Hell and Heaven. But why – here and often elsewhere – so much emphasis on memory? In her concern for the spiritual welfare of her people, the Church seems afraid that the faithful might forget the great truths of the faith. She is perhaps conscious of the gulf between the rhythms of everyday life with its basic problems of work, food, sickness, and the future prospect of eternal life. The gulf between this apparently merely contingent dimension, which is the only dimension the people experience daily in the flesh, and a world beyond on which man depends without ever seeing it, is as wide as the gulf between all their little houses and the great cathedrals of stone; and the gulf can be bridged only by constant remembrance of the sacred, as it was revealed in the past and for the future. In their appeal to the senses, images serve this purpose better than words.

Even as they approach the church the faithful must notice straight away the sudden passage from the world to the sacred space: not just the architecture, but the sculptural decoration of the façade, and especially the entrance door should express this. Sicard of Cremona (c. 21 B) states simply that the Church door *is* Christ, illustrating this with a passage from St John's gospel: 'I am the way. Anyone who enters through me will be saved' (10.9); so, the door of the Church is also *porta coeli* – the gate of heaven.[34] The architrave, the tympanum and occasionally a more complex prothyrum are often organized around this basic idea; occasionally, the panels of the door itself are part of the same scheme.

Two sets of bronze doors by Bonanno Pisano, one at Monreale, dated 1186 and one in Pisa, probably later, display an iconographic scheme which is very similar, and yet quite differently articulated[35] (see figures 1 and 2). The direction in which they are to be read is the same in both cases, with the doors closed: from the first panel at the bottom left it proceeds as a line of writing would, through the four panels of the first row, and then again from left to right in all the other rows. But the Monreale doors are much bigger, and leave room for a much longer cycle: the five lower rows are devoted to the Old Testament and the five upper ones to the New Testament, whereas in Pisa the panels are arranged in only five rows, entirely dedicated to the life of Christ. However, the need to give a comprehensive view of religious history centred on the life of Jesus is met in both cases: in Monreale, out of twenty Old Testament panels, seven are devoted to the story of Adam and Eve, and another seven

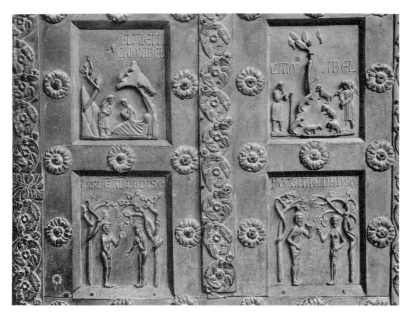

Plate 30 BONANNO PISANO, Bronze door (detail), 1186, Monreale
Duomo.
Photo: Archivi Alinari.

to seven pairs of prophets; in Pisa, twelve prophets in a paradise of palm trees occupy the band at the bottom of the doors, their mere presence recalling the way the whole of the Old Covenant was driving towards the coming of the Messiah; and we are reminded of the Fall by a sequence of slender figures contained – without any narrative connection – under the hill which the Magi are crossing on horseback. At the top of both sets of doors, though in reverse order, the concluding themes of the two programmes are the same: Christ and Mary in the glory of Heaven.

The two series of Gospel stories differ principally in the displacement of two scenes. In Monreale the *Presentation in the Temple* comes after the *Massacre of the Innocents–Flight into Egypt* pair: but the Massacre and the Flight are found only in St Matthew, and the Presentation only in St Luke, making the order of events a matter for discretion, which could be put to the artist in different ways by different patrons. It is more difficult to explain why in Monreale the *Transfiguration* comes after the *Entry into Jerusalem*, whereas the

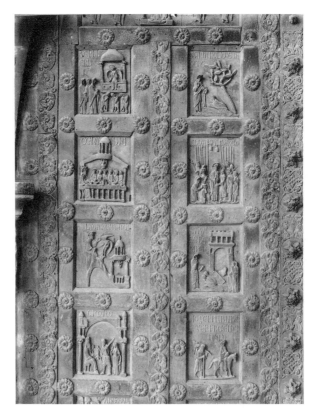

Plate 31 BONANNO PISANO, Bronze door (detail), 1186, Monreale
Duomo.
Photo: Archivi Alinari.

synoptic gospels agree in placing it earlier (the *Raising of Lazarus*,
which is found only in St John, can be positioned more 'freely'):
probably the panel was installed in the wrong place.

As well as the narrative being differently arranged, there are fur-
ther differences in the last two rows. In Pisa the *Last Supper* runs
on into the *Washing of Feet*, and more importantly still the *As-
cension* is flanked by the *Dormition of the Virgin*, more rigorously
consistent with the top sections of the doors where the glory of Jesus
is next to the glory of his mother. At Monreale, these two scenes
(nos 13 and 20 in figures 1 and 2) are missing; the *Noli me tangere*
and the *Emmaus* (nos 18a–b), which replace them, are positioned

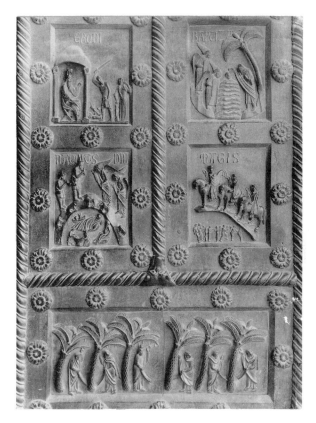

Plate 32 BONANNO PISANO, Bronze door (detail), after 1186, Pisa
Cathedral.
Photo: Archivi Alinari.

between the *Women at the Tomb* and the *Ascension*, and thus en-
large upon the narrative of events following the *Resurrection*, with
a more markedly 'Christocentric' twist, which cannot have been a
decision by Bonanno acting as theologian, but must be a response
to some instruction by the patron. Similarly, in a pious sermon or
text, certain episodes from the gospels could be brought to the at-
tention of the faithful in preference to others.

These differences in the programme are made all the more signifi-
cant by the great similarity in the iconography of the scenes the two
doors share in common, since the patron always dictates the themes
to be portrayed and their interrelation within the programme; whereas

Pisa Monreale

Figures 1 and 2 The doors by Bonanno Pisano

Subjects of the reliefs:

I–IV Animals

A Creation of Adam	N Abraham, Isaac, Jacob	10 Transfiguration
B Creation of Eve		11 Raising of Lazarus
C Adam and Eve in Eden	O–T Twelve prophets	12 Entry into Jerusalem
D The fall		13 Washing of feet
E The punishment	1 Annunciation	14 Last Supper
F The subordination of woman to man	2 Visitation	15 The kiss of Judas
	3 Nativity	16 Crucifixion
G The motherhood of Eve	4 The Magi	17 Descent into limbo
H Cain and Abel	5 Presentation in the Temple	18 Resurrection
I The fratricide		18a *Noli me tangere*
J Noah's ark	6 Flight into Egypt	18b Emmaus
K Noah plants the vine	7 Massacre of the Innocents	19 Ascension
L Abraham and the three angels		20 Dormition of the Virgin
	8 Baptism	21 Christ in glory
M The sacrifice of Isaac	9 Temptation	22 Mary in glory

the choice of iconography, so long as it does not involve any shift of meaning which might have some theological implication, is more easily left to the artist.

We cannot compare the 'abridged' account of the *Fall* in the Pisa doors with the more extended version in Monreale; however, if we look closely at the choice of scenes in Pisa, we can see more clearly, by contrast, the degree of special attention given to the theme of the *Labours of the Ancestors* at Monreale; it is in fact the angel himself, brandishing the flaming sword in his right hand, who offers the spade to Adam and Eve dressed, as in Genesis (3.21), in *tunicae pelliceae* (clothes made of skins). But in the following scene the couple have abandoned this primitive clothing and are already wearing normal dress belted in at the waist: 'Eva serve a Ada(m)' (Eve serves Adam) by bringing him food while he works in the fields, proclaims the vernacular caption; and when '*Eva ienui(t) Cain Abel*' (Eve bore Cain and Abel), and nurses one of the two children, Adam holds the other in his arms. The Bible tale is thus embellished, as in the Byzantine tradition, with details from 'everyday life': but if the woman bringing food to her husband in the field was (and still is) a common experience of peasant life, the birth of Cain and Abel reproduces, with only minor alterations, the iconographic scheme of a *Nativity*, of which it is supposed to be an antiphrastic *figure*. *Ave*, the angel's greeting, is simply the name *Eva* backwards, and in giving birth to the Redeemer, Mary atoned for Eve's fault and vanquished the serpent: '*per feminam peccatum oritur, per feminam eradicatur*' (St Augustine) (sin came into the world through woman and through woman was cast out).[36]

The scene of the *Annunciation* is portrayed in both doors with exactly the same iconography, but in Pisa it is made more dramatic by the more sharply creased drapery and the greater tension in the faces and gestures; there is the same architecture forming a canopy in the background, detached from its support like the spiral vase which follows the caption to one side. The same tendency is even more obvious in the *Massacre of the Innocents*, which at Pisa springs to life in the arm of a murderer raised to strike, in the mutilated bodies of the babies and in the same more nonchalant attitude of Herod, sitting with his legs crossed. But in at least one instance Bonanno reserves the more dramatic scheme for Monreale: in the *Last Supper*, where it is not just St John who leans against the figure of Christ, but Judas too, almost throwing himself on the table, ready to reveal himself as the traitor. So the tendency towards more highly dramatic forms – which cannot by itself be used either as a criterion

for deciding which door predates the other nor as an indication of a development in Bonanno's work – does indicate, precisely because it emerges only occasionally, that greater room for manoeuvre has been left to the artist, who has been asked to reproduce the same story but can still choose where to put it and can make the stress fall on the figures he chooses.

But such rich decoration for doors was a very rare privilege. Much more often, a simple wooden door marked the entrance to a church; and all around it, on the façade and elsewhere too of course, were ranks and sometimes hosts of animals and monsters of all kinds. It is certainly pointless to try and seek a precise meaning for each of them in the hope of constructing some kind of hidden grammar of symbols; it is equally pointless to claim that the great bestiary of the cathedrals can be dismissed *en bloc* as mere ornament. As always, we must instead make the distinction between the introduction of a theme or motif (usually quite conscious and meaningful) and the tradition which follows on, which can be merely repetitive.

An architrave in the Church of San Giovanni at Campiglia Marittima portrays a classical subject, 'Meleager hunting the wild boar', though this is not, as has been believed, an ancient sarcophagus, but a medieval 'copy'.[37] Here, the imitation of the antique serves principally to draw attention to the decorative value of the relief; but if we look at it in the context of the numerous other boar hunts which decorate medieval churches, perhaps we will find ourselves unable to explain them either as 'action shots' of hunts which really took place or, when the hunter is Meleager, as reminders of a classical myth. The introduction of the boar hunt within the ornamental repertoire of churches is probably due to Psalm 80.13: 'The boar out of the wood doth waste it.' The boar which ravaged the vineyard of the Lord is the devil; the hunter who kills him, then, is Christ or one of his followers, depending on who the Psalm is addressed to: 'Look down from heaven, and behold, and visit this vine; and the vineyard which thy right hand hath planted.' Whoever built the Church of San Giovanni *may* have been using the hunting scene with Meleager to create a more elegant and complex way of expressing the same idea.

The violent conflict between men and beasts recurs amazingly often in churches: combat with a lion is probably its commonest form. Here too the existence of ancient models and the many variations on the theme seem at first glance to suggest that it is merely decorative, but in an early and famous example on the façade of the Pisa Duomo, an inscription establishes the direct and quite

conscious link with Psalm 21.22, '*Salva me de ore leonis et a cornibus unicornium humilitatem meam*' (Save me from the lion's mouth, and my humbleness from the unicorn's horns). As the man is pursued by the lion, or some gentle animal (a deer for example) chased and killed by wild beasts, as the vineyard is ravaged by the wild boar, so the Christian in the world is assailed by his own passions and the temptations of the devil, and can find refuge only in church. The material church is a 'figure' of the spiritual Church. This seems to be the basic idea which gave rise to those hundreds of beasts swarming over doorways and capitals, stretching across floors with a variety that certainly lends itself to natural 'decorative' exuberance, and the twisting and intertwining of wild beasts with tame animals, hunters with their prey, mermaids and unicorns, symbolize the powerful intrusion into the church space of the demonic world seeking to make itself felt.

It is far harder to find precise interpretations within the general meaning for these tangles of beasts and monsters than for scenes – whether sacred or profane – played out by humans. The two lions on the pulpit at Barga are a good expression of this difficult and often ambiguous kind of meaning: the lion on the right is standing over a man who is thrusting a dagger into his body, and we can imagine him addressing the Psalmist's prayer to his Lord; the lion on the left is fighting with a dragon, a constant symbol of the devil, and would seem here to represent a 'positive' force. It is pointless to seek omnivalent explanations in the texts, given that only Sicard gives the two interpretations *together*: the lion as Christ and the lion as the devil.[38] It is rather the *function* of these lions, supporting as they do the columns of a pulpit, which seems to give them both an equally demonic significance, echoing Psalm 90.13 *Super aspidem et basiliscum ambulabis: et conculcabis leonem et draconem* (you will walk on the asp and the basilisk, and you will trample the lion and the dragon). The stories of Christ and the symbols of the Evangelists on the pulpit, together with the priest who climbs it, 'trample' the lion-demons; and the fact that one of them is fighting the dragon may indicate the disarray and division among the forces of evil. Only the context in which beasts and monsters are found can thus (and certainly not in all cases) provide the key to the right reading. In the contemporary pulpit at Volterra, the meaning of these fierce column-supports is further clarified: one of them, its monstrous figure of an anthropomorphized bull evoking the ancient river god Achelous, could not fail to remind the beholder, with its wrinkled and horned gorgon face, of the familiar image of the devil.

Plate 33 LUCCHESE(?) sculptor, Pulpit, second half of twelfth
century, San Cristofano, Barga.
Photo: Archivi Alinari.

Ingrediens templum, refer ad sublimia vultum (when you enter the
temple, raise your face to the heights), exhorts the inscription over
a French doorway,[39] making explicit for once in words what is implicit
in the sculptures over every doorway. And at the moment of entry
into church, the faithful are often met by figures presenting, in vari-
ous combinations, an image of Christ's *adventus*, thus marking the
entrance to the church and the beginning of the liturgical year by
the same sign. Theologians distinguished between an *adventus in
humilitate*, a coming in humbleness (which could be signalled by an

Plate 34 NICCOLO and assistants, Main portal of Ferrara Cathedral,
showing lunette with St George.
Photo: Archivi Alinari.

Annunciation or a *Nativity*), and an *adventus in maiestate*, a coming
in majesty, to which the *Resurrection*, the *Ascension*, the *Apoca-
lyptic Vision* and the *Last Judgement* all belong; the memory or the
hope of these, in the rite of Mass as in the decoration of the church,
was supposed to bring about an *advent* in the minds of the faithful.[40]

In the vestibule of the Duomo in Ferrara, which was completed in
two phases between 1135 and the beginning of the fourteenth cen-
tury, there are two different groups of themes which overlap and
interlace without clashing and, as in the Barga pulpit, the lions stand
side by side as by weight-bearing telamones. The lunette is filled by
the figure of the patron saint of the cathedral church, St George,
shown, according to ever popular iconographical tradition, killing
the dragon. The struggle of man against the devil, transported into
a sphere of chivalrous elegance, is thus played out by a figure who
cannot fail to triumph; the defeat of evil is guaranteed. On the

architrave, eight small arches, which look as though they are derived from the lid of an ancient sarcophagus, contain episodes from the life of Jesus, corresponding, surely not by chance, to occasions which revealed his divinity: the *Visitation of St Elizabeth*, who, filled with the Holy Spirit, recognized the divine presence in Mary's womb (Luke 1.41–45); the *Adoration of the Shepherds* and then of the *Magi*, to whom the divinity of the newborn child had been revealed by the angel and by the star (Luke 2.9 and Matthew 2.2); the *Presentation in the Temple*, when old Simeon recognized the Messiah and recited the '*Nunc dimittis*' (Luke 2.25–35); the *Flight into Egypt*, which God willed in order that the prophecy of Hosea should be fulfilled: *Ex Aegypto vocavi filium meum* (Out of Egypt I have called my son) (Matthew 2.13–15); and finally the *Baptism*, when the spirit came down upon Jesus and declared him to be the Son of God (Matthew 3.16–17). The *Annunciation* is missing from this series: it should go at the beginning, but it is portrayed with extraordinary emphasis, by placing Mary on the right hand side and Gabriel on the left in the splays of the doorway, right next to the capitals supporting the architrave, and the scrolls in their hands bear the gospel words: *Ave Maria* and *Ecce ancilla domini* (Behold the handmaid of the Lord).

Another four solemn figures, two on each side, bear four scrolls: these are the prophets Jeremiah, Daniel, Isaiah and Ezekiel, proclaiming the coming of the Redeemer. But the words which the scroll-bubbles put in their unmoving mouths are not taken from the Bible. The only literal quotation is in fact the sentence from Isaiah (7.4), often repeated as the most explicit of the prophecies: *Ecce virgo concipiet, et pariet filium, et vocabitur nomen eius Emmanuel* (Behold, a virgin shall conceive and bear a son and his name shall be called Emmanuel). Given still greater authority by being quoted in St Matthew (1.23), this one sentence made its way intact to the Ferrara doorway. On Daniel's scroll, however, the words of the prophet are curiously prefixed by the request: 'Say, holy Daniel, what you know of Christ', and the reply is: 'When he comes the anointing of the holy of holies will cease.' This 'question and answer', which obviously does not come from the Bible, can leave no doubt: the Ferrara prophets are performing a sacred drama from their stage of stone. And the text which Daniel solemnly displays on his scroll is copied to the letter from a sermon, falsely attributed to St Augustine, which was often read out in the Middle Ages in a 'dramatized' form, as the sixth lesson of the Christmas Office[41] and was like a parade of prophets, each in turn questioned by the officiant, and each proclaiming his own witness to the coming of the Redeemer, in the face

of the stubborn incredulity of the Jews. In the same sermon we find the words of Isaiah, as in the Bible and at Ferrara, and those of Daniel, which are very freely adapted from Daniel 9.24; we must therefore assume that Jeremiah's scroll, mutilated by an early 'restoration', bore, after the only legible word, *Ecce*, a text similar to that of the pseudo-Augustinian sermon, taken in fact not from Jeremiah but from Baruch (3.36): *Hic est (or Ecce) Deus noster, et non aestimabitur alius absque illo* (or *adversus eum*) (This is our God, no other can compare with him).

The fourth Ferrara prophet, Ezekiel, is not found in the *In Natali Domini* sermon, but appears in later variations on the same text;[42] the words *Vidi portam in domo Domini clausam* (I saw the door of the house of the Lord closed), adapted from Ezekiel (44.1–2), refer (according to a traditional exegesis which goes back to St Jerome's commentary in *Patrologia Latina*, XXV, 428) to the gate of Paradise, closed to the prophets and the Old Testament faithful until it was reopened to man by the work on earth of the Son of God in shedding his own blood. Thus Ezekiel's testimony is almost in opposition to the others, which are all 'open' towards the Redemption, recalling the condition of the Old Covenant, the House of the Lord closed to all. But the *porta in domo Domini* is also the door of the Duomo (= *Domus*), the House of the Lord, which is thereby compared to Paradise; every member of the faithful who passes through that now open door must know from the mouths of the prophets that if he reaches that happy state it will only be through the passion of Jesus. The door of the church is therefore the *porta coeli*.

This iconographical programme reaches its conclusion on the arch, with an *Agnus Dei*, flanked by St John the Baptist (on the right) and St John the Evangelist: it is the Evangelist, in fact, who recounts the scene in which the Baptist greeted Christ: 'Ecce Agnus Dei' (Behold the Lamb of God) (John 1.29). *Revelation* is the theme of the Ferrara doorway; the order of 'historical' reading goes from the splays (Prophets, Annunciation) to the architrave (Visitation through to Baptism) to the arch (the two Johns and the *Agnus Dei*). The *porta in domo Domini* can now open, because the son of God became a lamb, and St George in combat with the dragon-demon can be confident – like every Christian – of the infinite fruits of the Incarnation.

The teachings and Passion of Jesus are completely absent from the Ferrara doorway; and when, almost two centuries later, it was raised to a high aedicule with a pediment, the subject chosen for its sculptural decoration was another *adventus* of Christ, the *Last Judgement*. Surrounding Christ in his almond-shaped *mandorla*,[43] flanked

Plate 35 Workshop of the Po region, Aedicule with pediment,
second half of thirteenth–early fourteenth century, Ferrara Cathedral.
Photo: Archivi Alinari.

by angels bearing the symbols of the Passion and, as in a Crucifix-
ion, by Mary and John, thronging the slopes of the tympanum are
crowds of apostles and angels bearing scrolls to crown him *Rex
tremendae maiestatis*. In the spandrels of the ogival arches, four
corpses rise from their lidless tombs. In the frieze, the three angels
in the centre (two sounding the trump of Judgement, and the third,
St Michael, weighing souls in his balance and deciding their fate)
separate the damned (to the left of the Christ-judge) from the cho-
sen. In the adjoining lunettes, to the right of Christ, in Paradise,
Abraham solemnly welcomes to his bosom the souls of the blessed

(Luke 16.2); on the left is a turbulent hell. Thus around the door of the church a whole sermon is displayed in the stone, its two poles, the hope of salvation and inexorable judgement, separated by time and style, overlap without clashing to form one discourse.[44]

A *Last Judgement* also adorns the internal façade of the Church of Sant'Angelo in Formis (not far from Capua), linked to a long cycle of frescoes (variously dated between the late eleventh century and the early thirteenth) which covers the walls of the three naves and apses. Here Christ is enthroned in the central *mandorla*, which stretches across two of the five bands into which the composition is divided. Trumpeting angels fill the uppermost band, but here too, as at Ferrara, they are immediately above the *Resurrection of the Dead*, who are struggling out of four fluted sarcophagi, since it is at the sound of those horns that *mortui resurgent incorrupti* (1 Corinthians 15.52). The angels in the second row and the seated apostles in the third row hold court around the Judge, whose verdicts are delivered by the scrolls of the three angels directly above the entrance door. To the right of Christ, '*Venite benedicti patris mei, percipite regnum*' (Come you blessed of my father, see the kingdom), and to the left '*Ite maledicti in ignem aeternum*' (Go accursed into the eternal fire) (these are quotations from memory, slightly modified, from Matthew 25.34–41), and in the centre the longest legend, of which the only legible words ('*tempus amplius non erit*', there will be no more time) are taken from Revelation 10.6. On either side, the fourth row contains the chosen (on the right hand of Christ and of those entering the church) and the damned (on the left), and corresponding with these two groups in the bottom row are heaven and hell.[45]

There is at least a century and a half separating the *Last Judgement* in Sant'Angelo from the one in Ferrara, but they also use different media (the painting on wet plaster, the sculpture in stone) and show a deep divergence of style and cultural tradition (see figures 3 and 4). The Gothic niche in Ferrara is close to contemporary examples from France, and has been attributed to French masters; the frescoes in Sant'Angelo are obviously in the Byzantine mould. It is therefore even more striking how close, even substantially similar, the two iconographical programmes are, despite having to fit into such different frameworks as a galleried and irregularly shaped prothyrum niche and the smooth internal façade of a church. A comparison of the two diagrams shows how they share the same order: the angels and apostles at Christ's side (in Ferrara on the slopes of the pediment), the judged below him; heaven and hell, which at Sant'Angelo are placed much further down, are in adjoining lunettes at Ferrara. The

Plate 36 Workshop from Campania, *Last Judgement*,
late eleventh century(?), Sant'Angelo in Formis, Capua.

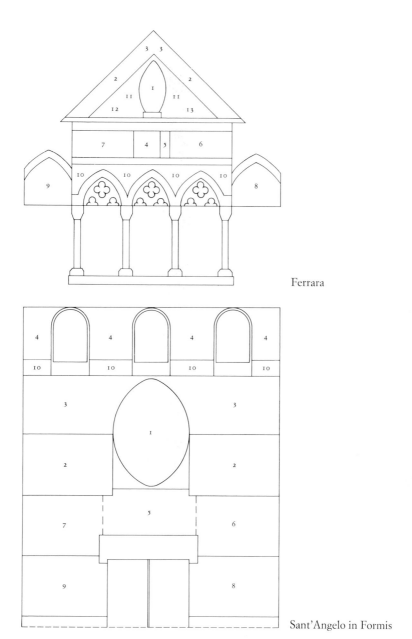

Ferrara

Sant'Angelo in Formis

Figures 3 and 4 The Last Judgement

1	Christ-Judge	7	The chosen
2	Apostles	8	Hell
3	Angels	9	Heaven
4	Angels with trumpets	10	Resurrection of the dead
5	Angels of judgement	11	Angels with symbols of the Passion
6	The damned	12–13	Mary and John

'active' angels, trumpeting and judging, are grouped together under the *mandorla* at Ferrara, and the job of separating the damned from the chosen is given to St Michael alone with his scales, whereas at Sant'Angelo the four trumpeters fill the spaces between the windows, and St Michael is replaced by the three angels with scrolls displaying warnings, more for the benefit of the faithful passing through the door than for the souls in judgement. This distribution of angels constitutes the main difference between the schemes: the *Resurrection of the Body*, which must be kept close to the trumpeting angels, is low down in Ferrara and high up at Sant'Angelo.

Just as the three scroll-bearing angels *equal* the soul-weighing St Michael at Ferrara, so the Heaven/palm-tree garden at Sant'Angelo *equals* the bosom of Abraham, both being alternative *signifiers* of the same *signified*. So as well as differences of style and chronology, we twice see the same idea expressed differently: only the angels and the figures of Mary and John beside the Redeemer at Ferrara, evoking the memory of the Passion to justify both the rewards and the punishments, introduce a substantially different theme, combining the Byzantine scheme of the *Deësis* (St John and the Madonna interceding with the Christ-judge) with the wholly 'western' presence of the angels bearing symbols of the Passion.[46]

Thus Christ's *adventus in maiestate* can, without changing its meaning, embrace the interior or the exterior of the entrance door of a church; as they look up, *ad sublimia*, the teaching which comes across to the faithful is the same. At Sant'Angelo, as at Ferrara, the *Last Judgement* is a natural link in a whole programme which reminds us of Salvation: at Ferrara, it is Revelation and the *adventus in humilitate* (the Lamb of God), at Sant'Angelo, a rich display of frescoed figures portraying and recounting the Old and New Testaments all around the walls of the old Benedictine church.

'Everything written about me in the law of Moses, in the Prophets and the Psalms, must be fulfilled': these words of Jesus's at the end of the gospel of St Luke (22.44) inform all the *typological* systems of the Middle Ages. The Old Testament was to be read as a prefiguration of the New, the New Covenant as a fulfilment of the Old: '*cum in vetere novus lateat, et in novo vetus pateat*' (since the new is hidden in the old, and the old is revealed in the new) (St Augustine).[47] Therefore the books of the Old Testament were seen, even when they had no explicitly prophetic content, as a great reservoir of *types* or prefigurations of events in the Gospel. The biography of Christ, now central to the whole of human existence, casts its net over the ancient sacred history of the people of Israel and transforms

events into *figures* of the life of Jesus, thus salvaging them whole – though with some adjustments – for the only 'historical' dimension acknowledged as valid: the story of the Redemption. By comparing his three days in the tomb to the three days Jonah spent in the belly of the whale (Matthew 12.40), Jesus seemed to be endorsing this use of the Old Testament. Thus Sicard could say, comparing the prophets to the apostles: '*Illi viderunt in nocte, vos in die; illi in figura, vos in veritate*' (they saw in the dark, you see by day; they saw things figuratively, you see them in truth) (c. 193c). David killing Goliath with the sword prefigures Christ defeating the devil with his cross (cc. 313c and 319a), the creation of Eve from the rib of Adam prefigures the birth of the Church from Christ's side (cc. 325c and 327b). This is why Bonanno's doors in Pisa show the prophets, ranked together as though to guarantee and guard the sacred narrative, numbering twelve like the apostles.

Apostles and prophets often line up in two mirror-image groups; sometimes they hold a conversation amongst themselves, which emerges from the scroll-bubbles and which consists variously of verses from the Old and New Testaments and articles from the *Credo*. In the main doorway of the baptistery in Parma, Antelami repeated this theme in a particularly elegant structure: the twelve apostles are holding twelve medallions with the busts of twelve prophets, almost like *imagines clipeatae* (portrait shields) handed down from generation to generation in age-long reverence finally to rest with the friends of Jesus, since the practice of lining the walls of the ancient libraries with bronze medallions showing the portraits of philosophers and poets (and later, patriarchs and religious writers) had been transferred to Christian churches, as in the Roman Basilica of Santa Croce in Jerusalem.[48] So, if an apostle is seen holding a medallion with the bust of a prophet, it underlines the link between them, leading to Christ, their common goal, as well as the historical distance between them. The apostles at Parma are like readers in a library who instead of taking the scriptures of the prophets down from the shelves, have instead taken their portraits down from the walls.

From the moment the Word was made flesh, the New Covenant began for man, and the coming of the Messiah not only divides human history, but as a symbol of contradiction, divides the followers of Christ for ever from the Jews. The irreconcilable conflict between Jews and Christians raises a kind of wall between the books of the Old Testament and those of the New, and whenever a decorative programme contains both they are never presented as a *historical* sequence of events, but rather by drawing parallels and

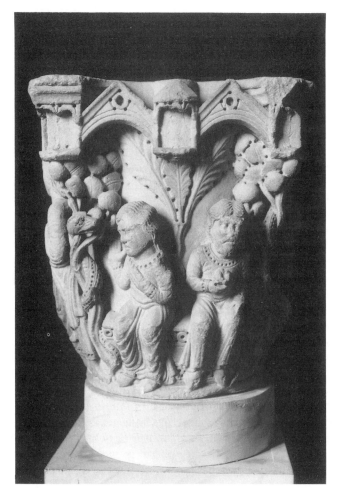

Plate 37 BENEDETTO ANTELAMI, *The Temptation of Eve*, detail of a
capital, National Museum of Antiquities, Parma.

contrasts between them. It was originally the daily practice of the
liturgy which suggested this interweaving of words and deeds into
the common dimension of the story of the Redemption. A reference
to original sin, which was a *felix culpa* (happy fault) if it was the
reason Jesus came to live on earth among men, therefore becomes
more like a foretaste of the coming of the Messiah: and Adam takes
his rightful place, at the head of the prophets, in the office of the

Figure 5 Sant'Angelo in Formis. Itinerary for reading the frescoes of the New Testament

Nativity.[49] In his sin the Redemption is already foreshadowed, and Christ is *novus Adam*: Bonanno Pisano's panel juxtaposing the Magi with Original Sin is thus in line with liturgical experience.

At Sant'Angelo in Formis, the stories from the Old Testament, which have only been partially preserved, fill the aisles, beginning near the right-hand apsidiole and ending near the left-hand one; in the central nave, on the walls supported by columns, we have instead the *Life of Jesus*, in sixty frames progressing from the *Annunciation* to the *Ascension*, beginning and ending near the apse (see figures 5, 6 and 7). So the visitor wishing to read the sequence of frescoes 'in order' must go up and down the length of the church at least five times, moving between the *Christ in Majesty* in the apse to the *Last Judgement* on the internal façade. It is from just such a journey that we get a really clear picture of the difference of 'rank' between the Old and New Testament, reflected in the greater importance of the central nave compared with the aisles; at the same time, the prophets

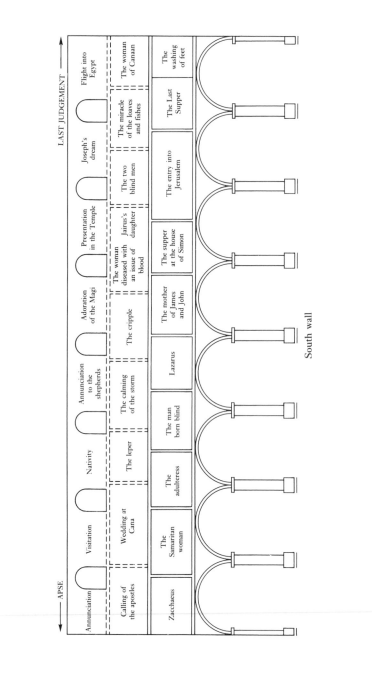

APSE

LAST JUDGEMENT →

Annunciation | Visitation | Nativity | Annunciation to the shepherds | Adoration of the Magi | Presentation in the Temple | Joseph's dream | Flight into Egypt

Calling of the apostles | Wedding at Cana | The leper | The calming of the storm | The cripple | The woman diseased with an issue of blood | Jairus's daughter | The two blind men | The miracle of the loaves and fishes | The woman of Canaan

Zacchaeus | The Samaritan woman | The adulteress | The man born blind | Lazarus | The mother of James and John | The supper at the house of Simon | The entry into Jerusalem | The Last Supper | The washing of feet

South wall

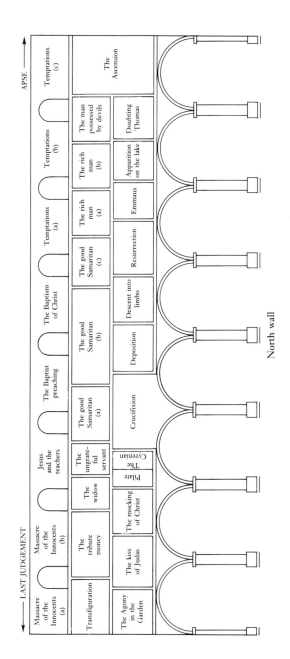

Figures 6 and 7 Sant'Angelo in Formis. Subjects of the decoration of the central nave

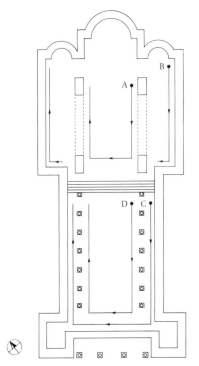

Figure 8 Monreale, Duomo. Itinerary for reading of the wall mosaics.
A, B, C: New Testament; D: Old Testament

and Sibyls ranged in the spandrels of the arches display scrolls bearing legends proclaiming in every detail the life and death of the Messiah: for example, beside the *Crucifixion*, Solomon announces: '*morte turpissima condempnemus eum*' (let us condemn him to a most shameful death) (Wisdom 2.20), and Hosea says, '*ero mors tua o mors, morsus tuus ero*' (O death, I will be thy death, hell I will be thy bite) (Hosea 13.14).

The splendid mosaics in the Duomo in Monreale divide the Old and New Testaments from each other in a different way, devoting the central nave to the former, and the transept to the latter; the aisles contain 'minor' events from the life of Jesus, arranged in a chronological order which overlaps with the order in the transept; the choir chapels contain the stories of St Peter and St Paul in parallel (see figure 8). The internal façade has no independent subject, but continues and connects the narratives of the central nave.[50]

By ensuring, here as elsewhere, that the 'systematic' visitor follows a complicated route, whoever mapped out the iconography of Monreale seems to have also had in mind a more subtle and intermittent system of dual references 'by association': for example, it can be no accident that the scene of *Noah's Ark and the Animals Disembarking after the Flood* is matched by the scene of *Jesus saving Peter from the Waves* in the aisle: the ark and the boat are both 'figures' for the Church.

There are not many programmes of comparable breadth to the schemes at Monreale or Sant'Angelo. Most of the time, the bishop or abbot who commissioned a cycle of biblical stories had much less space and money at his disposal. The *choice* of scenes to be portrayed therefore became important, crucial in fact, and if in even a long cycle like the one at Monreale the Old Testament ends with the story of Jacob, sometimes much larger sections had to be drastically cut from the programme. This choice is *always* conditioned by the necessity of putting the main emphasis on the life of Jesus, organizing the portrayal around one or more meaningful *itineraries*. It is not possible to identify any general 'rules' either for the choice or for the itinerary: the freedom to construct a discourse through images is as great as the freedom of a theologian or preacher to draw as much as they wished from the bottomless well of the Bible. Therefore the composition of sacred narratives on the walls of churches tells as varied and interesting story as the pages of the *Patrologia Latina*, so richly embroidered with references. *Typological* juxtaposition, resemblance by *association*, and reference to the *liturgical calendar* are the principal criteria (though probably not the only ones) which seem to inform these choices.

Only rarely, we may suppose, did the patron's instructions go beyond the choice and mutual relationship of the subjects to describe in detail the way in which they were to be addressed, i.e. what *iconographical scheme* to adopt. There was an unwritten contract between bishop, artist and churchgoer that these images should be easily comprehensible. Therefore there was no need to insist that scenes so often portrayed must be portrayed according to conventional schemes, whereas there had always been the widest scope for some degree of variation (within a range of forms which may or may not allow for differences in style), leaving certain essential features unchanged. It is difficult to describe in words which these features were, just as it is difficult to say which features remain the same when an expression changes from happy to sad, or a face grows from childhood to adulthood.[51]

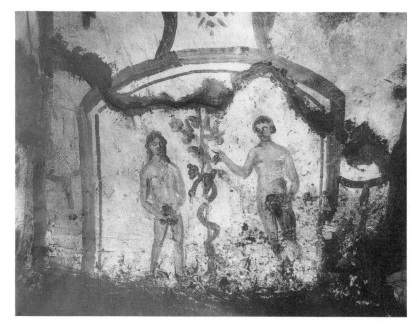

Plate 38 Roman painter, *The Original Sin*, fourth century AD, Catacomba dei Santi Pietro e Marcellino, Rome.

The iconographical scheme for the *Fall*, surely one of the most frequently portrayed scenes, seems to have been firmly established by the time of early Christian art, and endlessly repeated for centuries thereafter. Adam and Eve stand either side of the tree, around which the Serpent is entwined. Among the thousands of images showing this scene it is however possible to find a few which deviate from this basic scheme. For example, in a capital in the Duomo at Parma, Antelami shows Adam and Eve elegantly dressed in long tunics with sleeves sitting on a bench near the Tree of Knowledge: while Eve, her hand cupped to her ear, listens to the voice of the serpent, Adam sits apart from her, holding a flower in his hand, like a nobleman in his garden. But in the next scene the sin has been committed, and four apples have been plucked from the tree (one in the mouth of the serpent, one each held by Adam and Eve, and a fourth that Eve is offering to Adam).[52]

The rich clothes of Adam and Eve suggest the direct influence of liturgical drama; in the semi-liturgical performances which took place

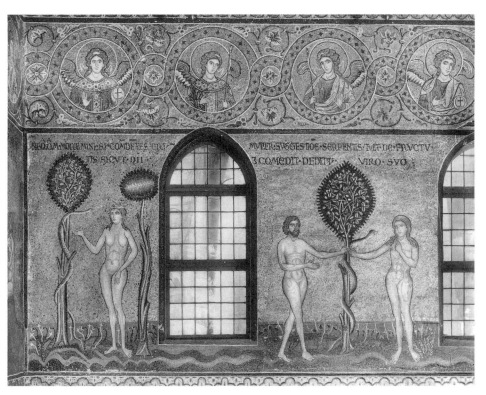

Plate 39 Local mosaicists of the Byzantine School, *The Original Sin*,
twelfth–thirteenth century, Monreale Duomo.
Photo: Archivi Alinari.

near the church, from which 'God' entered and exited in priestly
vestments, Adam and Eve were naturally not portrayed naked, even
before the Fall, but richly dressed – Adam in a *tunica rubea* (red tunic),
Eve in a *tunica rubea et pallio serico albo* (red tunic and white silk
cloak); this Eve in Parma would have addressed Adam, as in one of
these texts, 'Adam, bel sire' (Adam, fair lord).[53] However, despite an
exception such as this, which is rare if not completely isolated, the
representation of the *Fall* in Christian iconography remained virtu-
ally unchanged, and is thus an example of a 'fixed' scheme.

Other stories show situations which are to some extent 'inter-
changeable': the *Wedding at Cana*, the *Supper at the House of Simon*,
the *Last Supper*, the *Road to Emmaus* – all of them set around a

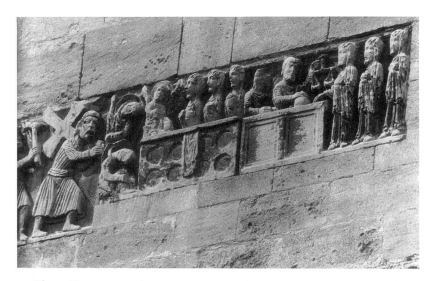

Plate 40 Provençal sculptor, *The Purchase of the Ointments and the Three Marys at the Grave*, *c*.1150, Beaucaire Parish Church.

dinner table – suggest a *common* gestural repertoire which can be effortlessly transferred from one to another. The *Resurrection* is a special case: the traditional iconography, as we might call it, right through the fourteenth century, follows the Bible very closely, not showing the moment when Jesus rose from the tomb, but only the scene in which the women who had gone there with their ointments found the empty tomb and the presiding angel and the discarded funeral shroud. However, in the *Raising of Lazarus*, an equally widespread tradition showed Jesus's miraculously raised friend emerging from his tomb still swathed in his winding sheet; the resurrection of the dead, as represented in the *Last Judgement*, has them rising suddenly, naked, from their open tombs. The differences between these schemes are fully justified, since each of them corresponds to a different episode, and yet the closeness of the underlying theme (Resurrection), and the custom of projecting Christ's Resurrection on to the resurrection of his faithful eventually contaminated the different schemes: there is no other explanation for the radical change in the iconography of the Resurrection (see p. 244).

A capital in the Museo Civico in Modena shows two closely connected scenes: the Marys going to buy spices to anoint the body

of Christ, as recounted in St Mark (16.1), and the Marys at the tomb. This iconography is very closely dependent on French models like the Beaucaire frieze; the emphasis placed on the scene of the purchase of spices in these two reliefs certainly derives from sacred drama: the conversation of the Marys with the haggling shopkeeper had become a kind of little 'comic' insert in the Easter stories.[54] But the sculptor at Modena has removed the angel, and shown Mary Magdalen throwing herself dramatically against the empty tomb, from which the edge of the shroud protrudes. Thus the two sides of the capital portray two sides of the sacred drama, 'comedy' and 'tragedy'; and comparison with what is surely its French model proves, despite the radical iconographic innovation of the weeping Magdalen, a process of 'repetition' in the handing down of schemes which can nevertheless, occasionally and gradually, incorporate *internal* changes.

Only rarely (for example, in the cloister of Sant'Orso at Aosta) are a series of capitals arranged to form a series of reliefs which follow a complete iconographic programme; more often, one isolated capital or a small group of them function more as a 'quotation' from a Bible story: *'capitella ... sunt verba sacrae Scripturae'* (capitals are the *words* of Holy Scripture), as Sicard explains (c. 22c). But even a brief 'quotation' from a single episode of the Gospel could provide something more than just a reminder of an event: a sermon by St Bernard points to the women's purchases of the spices as a model for the Christian soul, which should revive itself with a spiritual tonic whenever it feels itself losing faith.[55] Even when it is not spread across a complete programme, the holy book can – in sermon or capital – offer an *exemplum* to Christians.

Even the floor which the faithful walked on as they moved about the church was often adorned with figures. Desiderio di Montecassino, who was very attentive to the beauty and dignity of his abbey church (eleventh century), 'could not find anyone in Italy with these skills, and sent for Greek and Saracen men to decorate the floor of the church with inlaid marble and various paintings, which we call mosaic work'.[56]

Although it marked the route from the door (and the outside world) to the altar, a mosaic floor, which the Benedictine abbot felt to be so indispensable, was also the lowliest part of the church: a regulation of the Digest (in force at least until the time of St Charles Borromeo) strictly forbade the carving or painting on floors of the image of Christ. Psalm 118.25 *Adhaesit pavimento anima mea* (my soul hath cleaved to the ground) suggested a direct symbolic equation between the floor and *humilitas*; but this 'humility' could be

understood in other senses than the moral one. In contrast to the nobility of frescoes and sculptures relating the deeds of Jesus, the floor mosaic, where only episodes from the Old Testament could be placed, had to use motifs which could be characterized as *praeambula fidei*, or *praeparatio evangelica* (prefaces to faith or evangelical preparation).[57] The compulsory exclusion of any explicit portrayal of episodes from the Gospel ruled out the 'sublime style', and obliged the mosaic floor to present its subject in a 'humble style', though this also encouraged the artist to look further afield for material for his composition, which he could organize more freely.

Unique among the many floor mosaics in Italy in that it is almost perfectly preserved, the floor of the Duomo in Otranto, laid between 1163 and 1165 by a priest named Pantaleone, can still reveal the intricacies of a programme that unfolds gradually, written in a kind of *vernacular*.

A great tree stretches from the door to the sanctuary, and acts as a route-finder along the length of the nave. But only at the end, when we recognize Adam and Eve beside us, with the serpent between them, can we confidently identify the tree as the Tree of Knowledge. With its great branches stretching to the sides from its base and covering the whole floor, it is thus the Tree of Eden which serves as a framework for Pantaleone's discourse and that of his Archbishop Jonathan, who commissioned the mosaic, as is stated in four inscriptions. But the successive elements of the discourse must be discovered one by one in the great decorative tapestry, which scatters leaves and flowers like playing-card pips among highly coloured, sometimes monstrous fauna: ostriches, fish, dragons, and centaurs with up to three heads. Alexander the Great attempting to reach heaven with a throne supported by two gryphons is one of the first *exempla*, taken from profane 'history' and introducing the theme of pride; it is then immediately taken up, on the other side of the tree, by the Tower of Babel, the same subject echoed within the context of the Bible.

The building of the ark and the Flood, which immediately follows and occupies an entire band of the mosaic, shows the divine presence more directly, in the hand of God reaching towards a gigantic Moses: in the Flood and the ark they show the certainty of retribution and the hope of salvation at the same time, like two sides of the same coin.

Hanging freely among the branches in three rows of four are the medallions of the Months, which seem to interrupt an otherwise entirely religious picture, with their purely agricultural and

astrological view of the calendar. But this is not just a break, nor is the interpolation of zodiac signs and peasants ploughing, sowing and reaping gratuitous: *'pavimentum, quod pedibus calcatur, vulgus est, cuius laboribus ecclesia sustentatur'* (the floor, which is walked on by feet, is the common people by whose labours the church is sustained) (Sicard, *Mitralis* 20a). The efforts of the *vulgus*, who construct a cycle around the earth as constant and incontrovertible as the wheel of the stars, thus signify man in his humble everyday role, which the Church absorbs and makes her own. By making it fit the context of a sermon interwoven with moral *exempla*, the humdrum rhythm of man is offered and presented, without the intermediary of the liturgical calendar, as God's rhythm.

Beside the tree as it thins out towards the top, after the Months, are, on the left, the other trees of Eden, and on the right, in contrast, scattered about in no particular order, the figures of King Arthur first astride a ram(?), then in combat with the Cat of Lausanne, Cain and Abel presenting God with their gifts, and then confronting each other in the dramatic scene of the first fratricide. Thus an almost contemporary piece of history is once again set against a Bible story; since *exempla* can be drawn from the sacred well or the profane with equal validity. To make the discourse even more charged with meaning, the figures of Adam and Eve being banished by the Angel (going from Eden to a world which includes the death of Abel and of King Arthur) are placed directly above the figure of the Good Thief, who is waiting at the closed gate to be the first among the redeemed souls to enter the Kingdom of Heaven. Crime and punishment are shown, but always find immediate reflection in the hope of salvation, a thread which culminates in the curved space of the apse, dominated by the figure of Samson wrestling with the lion and Jonah emerging after three days from the belly of the whale: both *figurae* of Christ conquering death, harrowing hell and rising.[58]

So by tracing his path through the all-embracing branches of the Tree, in a world dominated by sin, Pantaleone is not recounting the Bible: he is *choosing* a few episodes from it, presenting them with no respect for the order of events as laid down by the holy books, and the force of his *exempla* gains strength from their juxtaposition to profane subjects (such as Alexander or Arthur).

All the most important themes (with the sole exception of the Tower of Babel) are accompanied, and therefore signposted, by inscriptions (*Alexander rex, Rex Arturus, Noe, Abel, Cayn, Eva, Adam, Sanson, Ionas propheta*, the names of the months . . .), certainly intended as a guide to the mosaic, but for whom? Not just for the

illiterate masses, who would have been unable to make out the Latin Bible quotations in the chips of the mosaic (nor, in a contemporary mosaic in nearby Brindisi, the French of the *chansons de geste*);[59] nor was it just for the clergy, who would have been able to recognize Noah or Alexander without reading their names. Running along the barrier of progressive illiteracy separating the different strata of the population from one another, these inscriptions, enclosing as they do only some of the myriad figures in the mosaic, trace around those few images a kind of verbal halo which indicates, for the benefit of clergy and people alike, their greater weight of significance; almost like arrows showing the route around the discourse.

Painting and writing are thus opposite poles of the same message, from the same source – the ecclesiastical patron – which *appears* to have been sent in two versions to a learned and an illiterate audience; but in reality the message can only really occupy the whole of its space if the letters *also* address the people and the figures *also* speak to the clergy; 'poles with a kind of electricity of meaning between them' (Butor).[60] The *Exultet* rolls, used during the Easter liturgy, are an eloquent example of this same line which both divides and links: they were meant to be held by the officiant over a high lectern, and unrolled as the reading proceeded, and are richly decorated with figures running in the *opposite direction* to the writing, so that as the priest reads the people meanwhile look at the pictures.[61]

So the stories painted in churches, which pass from the eyes to the memory of the faithful as instruction and admonition, are not just *litterae laicorum*, but also speak to the senses of the most educated, enlivening with colours and faces the bare words of the sacred texts; while the inscriptions which accompany them, referring those who cannot read back to the greater learning of the clerics, constantly emphasize that in order properly to read and understand these images that are so richly displayed and animated they will always need the intermediary of the ecclesiastical culture. From commission to 'authentic' interpretation the circle revolves around the image; the 'monopoly' of the Church, understood as a whole, is absolute.

'Ut populus ad ecclesiam trahatur'

The moment the churchgoer crosses the threshold of the church he sees the apse, framing the high altar, the focal point of the rite, the goal of a journey organized around memories of sacred history,

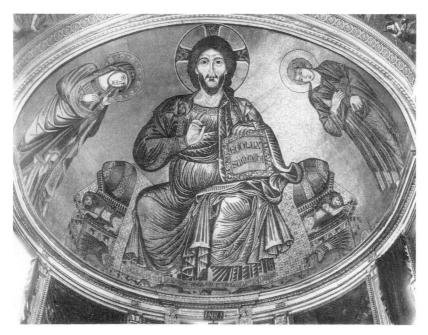

Plate 41 FRANCESCO, CIMABUE and assistants, *Christ in Glory with Mary and St John the Evangelist,* apse mosaic, 1302–3, Pisa Cathedral.
Photo: Archivi Alinari.

condensed and as it were translated into a liturgical dimension. *Christ in Majesty,* sometimes in the Byzantine form of the *Pantocrator,* sometimes in the form of an apocalyptic vision or sitting in judgement, is therefore an appropriate subject for the apse.

The mosaic in the apse of the Duomo in Pisa was the work of eighteen craftsmen (plus another six assistants) over a little less than a year, under the guidance of two different master-craftsmen in two successive phases;[62] thus there was not even the constant presence of the same *magister* to ensure continuity and unity of meaning in the most important decoration in the cathedral; not for a single day did Francesco and Cimabue work together, and Turetto was the only *pictor* from the original team that Cimabue kept on in the second (see figure 9). Moreover, one of the figures (the Madonna) seems to have been finished much later, in 1321, by another master. From the few surviving accounts books recording names and salaries and dates, it is unclear who prepared the overall design of the mosaic (it was

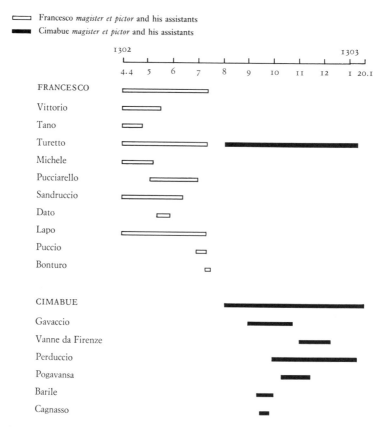

☐ Francesco *magister et pictor* and his assistants
■ Cimabue *magister et pictor* and his assistants

Figure 9 Daily sections of work (*giornate*) on the apse mosaic in the Duomo at Pisa (4 April 1302–20 January 1303)

presumably the first of the two *magistri*, Francesco), but the continuity of the work and the connection of meaning between the figures was ensured by its commissioners, '*Uguiccio Grunei et Jacobus Murcij positi et constituti a Communi et pro Communi pisano super fieri faciendo* Maiestatem *super altare maioris ecclesie pisane civitatis*' (U.G. and J.M. appointed and constituted by and for the Commune of Pisa over the commissioning of a *Maestà* to go over the high altar in the church of the city of Pisa).

In this *Maestà* in Pisa, which subsequent restorations, always under Church supervision, have, if anything, made even more 'collective' and functional to the image of the cathedral and its liturgy, Christ, shown giving a blessing from his enormous throne supported by

pairs of winged dragons and lions, tramples underfoot an asp and a basilisk. Immediately above, the edge of his robe, draped in wide swathes, hangs down low enough for us to read the caption embroidered on it (*'super aspidem et basiliscum ambulabis, et conculcabis leonem et draconem'* – you shall walk on the asp and the basilisk, and you shall trample the lion and the dragon): so not just the words, but the whole figure of Christ and his throne transcribe Psalm 90.13 on to the gilded glory of the apse.

But the theophany we see here is not that of the burning visions of Isaiah and Ezekiel or the Apocalypse; Christ does not appear in the *mandorla*, surrounded by the Tetramorph, the Evangelists or by a court of angels. The book which his left hand holds open to the eyes of the faithful shows in huge letters the beginning of a verse from the gospel of St John: *'Ego sum lux mu(n)di'* (I am the light of the world) (8.12);[63] and therefore, by varying the normal scheme of the *deësis*, which has the suppliant Madonna and St John the Baptist beside the *Christ in Majesty*, here it is St John the Evangelist who is closest to the throne of God. As when they are placed either side of a *Crucifixion*, the mother and the beloved disciple accompany a Christ who is not sitting in judgement, but is king and *lux mundi*; and his celestial triumph is founded on the memory of the Passion. The novelty of this scheme explains a certain awkwardness of gesture: Mary with her hands held as though to illustrate speech;[64] John holding in both hands the closed book of his gospel. The isolation of the figures and their preoccupied, detached air, as players in a scene that is not in the sacred texts nor in traditional iconography, can help to explain the sharp differences of opinion among critics, some of whom see St John (the only figure to have been studied, since it is entirely by Cimabue) as a 'great masterpiece' (Battisti), and others as 'of no interest whatsoever' (Nicholson).

That Mary and John should be able to change from the grieving figures at the foot of the cross to companions in Christ's glory, is not some gratuitous compositional novelty: the paradox of the cross is precisely that it is a sign at one and the same time both of the most cruel and infamous suffering and of the highest point in the entire course of human history. Therefore the *lignum Crucis* (wood of the Cross) is a symbol of triumph, the turning point in every human event, the linchpin of the faith and the liturgy. And beside the Christ enthroned in the golden heaven of the apse, the Madonna gestures intercession, while John bears silent witness with the book he wrote.

Even in the turmoil of the iconoclast controversies, the cross – the crowning glory not only of Calvary but of the altar – retained all its

value both on a strictly liturgical level and as the seal of the divine investiture of the *basileus*. Paradoxically, the *Libri carolini* are in agreement on this point, did they but know it, with the views of their opponents in the controversy.[65] *Crucis mysterium, Crucis vexillum* (the mystery of the Cross, the standard of the Cross): this symbol, which embodies and commemorates the Incarnation, Passion and Redemption, could put the demons to flight and break down the gates of hell as no image could. In defiance of the value-systems of pagan society, in the first few centuries the cross had already attained the value and weight of a symbol; an acknowledgement and declaration of faith, 'magical' protection from the devil and from evil. But the crucified Christ had taken longer to find his place in the naked symbolism of the cross: the total absence of prototypes in Roman art made it even harder to cross that narrow bridge towards the representation of a scene that could be evoked in words in the liturgy or in the gospel, but which had not yet found the right language for translation into an image without losing the full significance of its meaning. Therefore the crucifixion could be represented by symbols, just by the sign of the cross or, better still, by alluding to the Passion through the image of the Lamb.

It may have been a theological debate which finally brought about the inclusion of the crucifix in the repertoire of Christian art. The Monophysites denied the human nature of Christ; a doctrine which called itself Docetism taught that the son of God had only taken on the appearance (δοκέω) of human nature, as *putative*, and therefore his passion and death were not suffered by the living body of a man. The Council '*in Trullo*' (692), rejecting the representation of the Lamb as a 'shadow' or 'emblem' of Jesus, decided that

> in order to make his perfection clear to all eyes even through painting . . . Christ our God must be portrayed in human form . . . so that all the sublimity of the Word may be contemplated through his humility. *The painter must take us by the hand*, and lead us to remember Jesus as living flesh and bone, who dies for our salvation and by his passion wins the redemption of the world.[66]

This was just before the wave of iconoclasm: the appeal to the evocative force of images and to the role of the painter seems sufficient justification for the theologians' concern. In 726, a revolt brought down the crucifix which stood at the entrance to the imperial palace; but at Nicaea, in the Church of the Dormition, the figure of the Virgin in the apsidal mosaic was destroyed and replaced by a monumental cross.[67] The cross-emblem was defended and pro-

mulgated; the crucifix, telling of the passion and sufferings of the flesh in the body of Jesus, was rejected.

The painted cross is certainly one of the most unusual forms representing the crucifix, and is entirely peculiar to Italy.[68] The oldest known and dated example is from 1138, but the origins of the form must surely be rather older. These crosses, often very large, were meant (particularly in the Tuscany–Umbria area, and especially at Pisa and Lucca) to be hung from the apsidal beam, or more often on the iconostasis, which until the fourteenth century still sectioned off the choir in most Italian churches. '*Crux triumphalis in plerisque locis in medio ecclesiae ponitur* [in many places a triumphal cross is placed in the midst of the church], in order that the faithful should pay homage to it as *arbor salutifera* [tree of our redemption] and *signum victoriae* [sign of victory]: and that we should never forget the love of God, who, to redeem his servants, gave his only son, that we might imitate him Crucified.'[69] A cross signed by the Lucchese painter Berlinghiero Berlinghieri, in around 1220–30, shows the figure of Christ standing nobly upright against the wood of his agony, clad in a rich green loin-cloth. From four nails drip symmetrical flames of blood, but the jewelled halo around his head defines him more as *triumphans* than as *patiens* (suffering); and his side is not yet pierced. The development from the older convention – Jesus alive on the cross, with head erect and eyes open – to the other convention of the dead Christ with his head bowed and his eyes closed, his body bent in a last spasm of agony, which was already beginning to appear by the middle of the twelfth century, took nearly a century longer to appear in the Italian painted cross. This one discrepancy serves to show the central importance of painted crosses in the furnishing of churches and in the devotion of all churchgoers; it is more difficult to introduce significant iconographic innovations in images which meet the strongest and deepest needs of the faithful.

Beneath the lean body of the crucified Christ flourished a frilly passementerie of carefully decorated ribbons; and Christ is not really hanging from those nails: he is rather opening his arms in triumph to receive them. But the panel does not merely reproduce the instrument of torture, nor does the gold and blue colouring merely consign it to a triumphal and celestial dimension. At the extremities and the sides, it has grown geometrical excrescences: the top moulding or cymatium showing the *Ascension* (the uppermost part of which, with the bust of Christ, is now mutilated); the ends of the cross-piece bear the symbols of the Evangelists; the *Denial of Peter*, either side

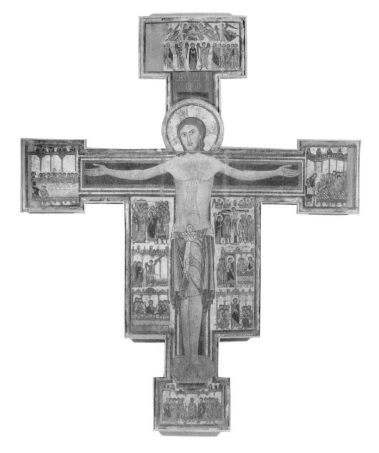

Plate 42 Master from Pisa, Painted cross, *c*.1200, Museo Nazionale
di San Matteo, Pisa.

of the foot-rest; and finally, beside the crucified Christ, the weeping
figures of Mary and John stand out from an abstract little green
meadow.

The Pisans showed a particular tendency to enlarge the space of
the painted cross, populating it with other scenes: *Cross* no.15 in the
Museo di San Matteo crowds into the two spaces beside Christ and
the four extremities of the panel ten episodes from Scripture, from
the *Last Supper* to the *Pentecost*. Resting his stern gaze upon the
faithful, showing no sign of pain, this Christ *triumphans* is thus also
docens (teaching): from the very wood of his agony, with detailed

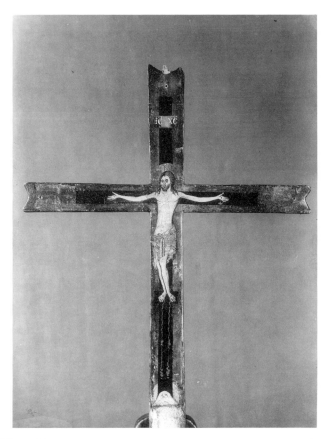

Plate 43 GIUNTA PISANO, Painted cross, recto, second half of
thirteenth century, Fondazione Giorgio Cini, Gallerie di Palazzo Cini,
Venice.

and didactic calligraphic formality he tells of his own passion and
glory.

It may have been Giunta Pisano who introduced the dead Christ
to the painted cross (we know of an example 1236 which has been
lost). A processional cross attributed to him shows the transition
between the two types: Jesus is shown on one side alive and upright,
while on the reverse his head is bowed and his eyes are closed in the
stillness of death; the iconographic innovation has taken place on
the less important side. But, more importantly, Giunta has radically
transformed the type of the painted cross itself. In his late cross of

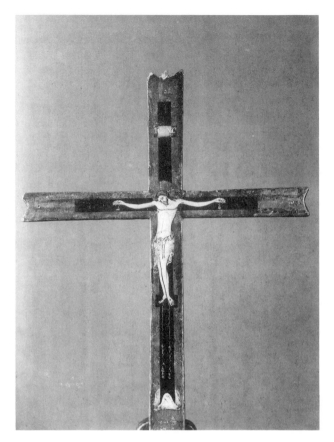

Plate 44 GIUNTA PISANO, Painted cross, verso, second half of thirteenth century, Fondazione Giorgio Cini, Gallerie di Palazzo Cini, Venice.

San Domenico in Bologna, the structured geometry of the 'Pisan' template is preserved, becoming in fact more rigorous in the structure of the decoration, with its rounded ends which close off the border-band so neatly; but the surrounding figures have all but disappeared. In the cymatium panel, which may once have been topped by a half-circle with a miniature *Ascension*, the mocking *titulus* takes up three lines; the panels at the ends of the cross-piece contain the half-figures of Mary grieving and St John the Evangelist, portrayed in the 'Syrian' pose, showing the red and jewelled book he was to write.[70] This idea, that the Crucifixion foreshadows his future function as witness and narrator of the sacred event, was to be taken

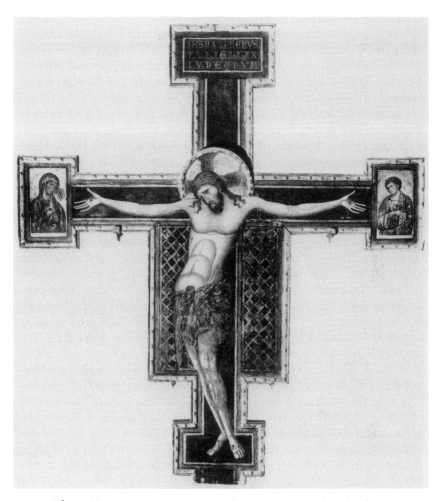

Plate 45 GIUNTA PISANO, Painted cross, *c*.1250, Church of San
Domenico, Bologna.

up more fully by Cimabue in the apse of the cathedral at Pisa: but
here it functions not as prolepsis, but as a badge.

By deliberately reducing the figures of the mourners to conven-
tional, allusive reminders of a more detailed Crucifixion, Giunta
Pisano dramatically isolated the crucified Christ; the tense, trans-
fixed body is arched; death has hollowed out a whole anatomy of
suffering there. Taking the faithful 'by the hand', Giunta does not
invite them to follow the stations of the cross via a series of detailed

panels; he puts before them the visible signs of torment, and thereby the humanity of Christ. Not without a keen self-consciousness did the painter's brush sign his name in a 'ringing' (Brandi) rhyme at the foot of the cross: '*cuius* docta *manus me pinxit Iuncta pisanus*' (Giunta Pisano whose *learned* hand painted me).[71] Nicola Pisano was to sign himself *docta manus* in the baptistery pulpit, and another Pisan sculptor, Biduino, had also proclaimed himself *doctus* half a century earlier, in his signature on the architrave of San Casciano near Pisa.

If this refers, as seems likely, to *doctrina antiquitatis* (knowledge of antiquity), Cimabue would have had more reason than Giunta to boast at the foot of a Crucifix. The one in Santa Croce in Florence is clearly derived from Giunta's model, which had come to be seen as a measure of 'classical' perfection; but its use of colour and shadow stirs the body of the Redeemer into motion, despite the conventional and obligatory posture. The loin-cloth has become light and transparent, hiding as little as possible of the body, which has taken on so much more life, animating Giunta's polished outline with internal relief and vivid muscular tension. The stiffness of the artificially geometric epigastric arch and the six divisions of the stomach has suddenly been wiped out, to reveal a more 'real' and moving anatomy behind the representative convention, and so the faithful can, under the painter's guidance, relive the suffering and death of Christ even more vividly. Even the blood no longer falls in curving trickles: it falls straight down from the nails, discovering the law of gravity.

Along this path of growing 'realism', the emotions of the faithful are one sure and constant pole of reference. Gulielmus Durandus, a Frenchman who lived in Italy from his student days in Bologna until his death (1296), momentarily makes this intention explicit in a passage from the *Rationale Divinorum Officiorum*, a widely distributed treatise on liturgy, which has yet to be fully appreciated for its significance in many areas including iconography.

Why is the church a collecting point for curiosities and treasures (ostrich eggs for example), where they are exhibited to the faithful? Durandus replies (I, 3.43): '*ut populus ad ecclesiam trahatur, et magis afficiatur*' (that the people may be drawn to church, and have their minds the more affected). *Afficio* means 'to affect', but also 'to move, involve (emotionally)'; Durandus's words can be applied to other *ornamenta ecclesiae*: for example, if heaven and hell are portrayed in churches, it is in order to arouse in the faithful the joy of future reward (*delectatio praemiorum*) and the fear of punishment (*formido poenarum*: I, 3–21).

The other pole to which every image must refer is the acknow-

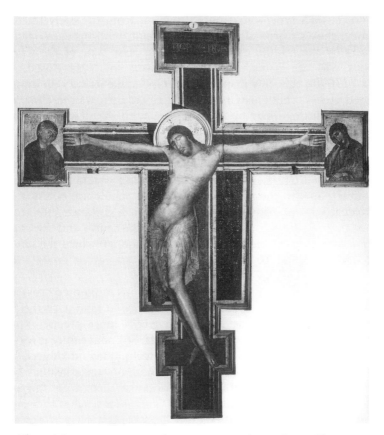

Plate 46 CIMABUE, Painted cross, *c.*1280, Santa Croce, Florence.
Photo: Archivi Alinari.

ledged power of a tradition made authoritative and compelling pre-
cisely by the repetition of the same figures. The expectations of the
'public' thus move on two planes which are only apparently diver-
gent: on the one hand, a cult image, precisely because it is an object
of devotion which takes a substantial part of its value from its part
in a tradition, must adapt to images of the same type which have
gone before it; on the other hand, every innovation which arouses
emotional shocks can stimulate new interest in a figure or theme
which mere repetition might leave blurred and meaningless. So the
painter must strike an ever-shifting balance between tradition and
innovation to induce the eye of the beholder to *stay longer* over a
'new' image; and yet he will innovate gradually, and always *within*

the established type. *Cross* no.15 in Pisa, from the early thirteenth century, shows Christ alive and triumphant, with his eyes open; but already by the middle of the century the new type of the *Christus patiens* was appearing, with head bowed and eyes closed. Only after 1236 did this new iconographic type make its way up on to the painted crosses, but this *Cross* no.15 already shows the *Crucifixion* among the little scenes by Christ's side with the new iconography. Scaled down in size and importance compared with the gigantic figure which takes up most of the panel, a side panel can more easily be the *first* site for innovation. The contrast between the large and small crucified Christs that the people of Pisa would see painted on the same panel in the Church of the Holy Sepulchre, is less a clash between two 'opposite' iconographies than a distance (hierarchical rather than a chronological one) between the centre and the margin, the *salutatio* and the *memoria*. The cult image, to which the *salutatio* belongs, is slower to innovate than the narrative image, which appeals to *memoria*.

Typological and iconographical innovations in painted crosses can be justified only by a gradual preponderance in favour of the 'new' type; but perhaps we may be able to give a more precise explanation. In the *Legenda maior sancti Francisci*, St Bonaventure gives some valuable information about the prayer techniques introduced by St Francis with his first followers, who had no ecclesiastical books from which to take their prayers and organize them according to the canonical hours. But instead of books St Francis teaches them to use the *liber Crucis Christi* (the book of Christ's cross), to pray *mentaliter potius quam vocaliter* (in the mind more than out loud), before the crucifix, in fixed contemplation: *continuatis aspectibus*.[72]

Prayer is a meditation on the Passion of Christ, *mediated by the image* of him crucified: by privileging vision over words, the time spent contemplating the image is calculated in terms of emotional response, corresponding to and dictating the time of prayer. St Francis thus oriented everyone's devotion towards Christ's humanity, and particularly towards the cross;[73] without directly inspiring any specific crucifix, he changed the whole attitude towards an iconographic type, which prolonged contemplation, as advocated by the new devotional practice, and invited painters to rethink. Tommaso da Celano calls St Francis *novus evangelista*, so important and new was his message: and in fact in the iconography he was immediately given unusual attributes: a book (like an evangelist) and, for the first time, a crucifix.[74] His faithful conformity to Christ is stamped upon him by the stigmata, which nail him to the cross with his unattainable

model, *Christo iam cruci confixus*:[75] it is not enough to crucify the soul – the flesh too must be visibly crucified.

This would explain the 'variant' which takes place at the foot of the crosses painted from around 1260 onwards, but found only in Umbria and Tuscany: bowing at the feet of Christ, a tiny St Francis meditates on the Passion which he shows to the faithful in his own wounded hands.[76] Thus breaking down all historical barriers, the saint of Assisi enters the space of the cross to share in the grief of Mary and John, and thereby attracts the Crucifixion back towards his and our own vivid experience, making it something contemporary.

However, St Francis was not the first person to occupy this highly privileged position. His friend and successor, Brother Elias, who built the basilica at Assisi, got there before him. In the lost *Crucifix* painted and signed in 1236 by Giunta Pisano for the lower basilica in Assisi, a *Christus patiens*, one of the very earliest if not the first of its kind, also bore, on the foot-support, the image of Brother Elias kneeling in prayer and the legend '*Frater Helias fieri fecit. Iesu Christe pie miserere precantis Helie. Iuncta Pisanus me pinxit* A.D. *MCCXXXVI*' (Commissioned by Brother Elias. Jesus Christ have mercy on the praying Elias. Giunta Pisano painted me in 1236). The powerful general of the Franciscan order was thus placing himself in the foreground as the devout patron at the foot of the cross, in the attitude that was to become common for St Francis: this is how he is shown in a seventeenth-century print, which at least gives us the posture of this lost image;[77] the iconographic fidelity of the print seems to be proved by the 'Armenian' cap – Salimbene de Adam testifies that Brother Elias did use one.[78] We do not know what reaction this intrusion of a living person on the cross would have provoked; certainly one of the principal charges against Brother Elias which led to his downfall, exile and excommunication was his *carnalitas*, his life of luxury, an excessive sense of his own worth and the dignity of his position.[79] As almost the only holder of the secret of the stigmata until the death of St Francis, it was he who made known *at the same time* the death of the saint and the extraordinary divine imprint: from the foot of the crucifix, Elias is thus trying to usurp the whole of Francis's inheritance. This is probably why the foot-panel of the cross with his 'portrait'(?) and inscription were covered up, just as in the new *Vita* by St Bonaventure, which never mentions Elias, this former friend of St Francis's, who had been 'like a mother' to him (according to Tommaso da Celano), is sentenced to *damnatio memoriae*. Only in 1624, when the cross was dropped and broken, did the legend and the face of Brother Elias see the light

of day again.[80] Elias's desire for legitimacy and glory, which even today strikes us as worldly, disrupted the historical sequence; at the foot of the cross, Elias precedes Francis.

'Tempus veritatis'

Copying does not come naturally. Only in a very few periods of human history have artists turned to past works with the *intention* of reproducing them, of 'disappearing' behind the model and reducing their own *ars* to their ability to repeat it with the greatest possible fidelity. In ancient Greece and Rome copy workshops operated widely, for the first time in western history and, because the general consensus and the gradual emergence of an early historiography of art gave rise to an image of *classical* art which had reached unsurpassable perfection, it was this art that had to be copied. In response to the demands of a market which wanted to savour at close range an echo of the immortal works of Polyclitus and Apelles, sculptors and painters became copyists; but the 'end of antiquity', which brought respect for the originals, also brought an end to the practice of copying.

In the Middle Ages, copying a model because it was classic was unthinkable. This was certainly not the relationship between Cimabue's *Crucifix* and Giunta's: despite typological and iconographic similarities, we can be sure that Cimabue knew he was creating an entirely new work, as indeed he was. Like all artists, he had to use his art 'within' an approved *type*, the type established by Giunta, which could only gradually be modified; but he was not copying a *model*. And when in 1396 P. P. Vergerio wrote that the painters of his time *solius Ioti exemplaria sequuntur* (follow only the examples of Giotto)[81] he was talking about stylistic and iconographic dependence on the master, appreciation and study of his works, not the proliferation of *copies* in the proper sense (made with the express intention that they should be recognized as copies).

Medieval 'copies' do exist, however; they were inspired not by admiration for an artist's style, but by devotion to a particular sacred image. When popular piety and reputation attach memory and belief in miraculous intervention to a cult image, it is not so much the saint of that name who is invested with that memory and belief in the hopes and prayers of the cult, but the tangible likeness which has 'worked' the miracle and may work others, mediating *palpably* and, as it were, gathering into itself the desires, prayers and

imploring gazes of the faithful. The pressing need for the sacred is still anchored to material things. The devotions (and images) of the Madonnas of Lourdes, Pompeii and Syracuse are recent, living examples, each with its own separate history, even though everyone knows that there is only one Madonna in heaven. By being linked to a *place* of worship and to foundation stories and legends of devotion and miracles, a saint assumes (or can assume) characteristic forms which are indissolubly linked to that particular image of them, which acts moreover as a guarantee of the holiness of the place and of its working order as a privileged theatre of divine intervention, of miracles. The worship of relics refocuses on sacred images which can actually *produce* relics by bleeding or weeping.

The Holy Face of Lucca[82] is a crucifix which owed most of its enormous reputation in the Middle Ages to the legend that claimed it was carved by the hands of Nicodemus, who helped Joseph of Arimathea to lay Jesus in the tomb. It is not, therefore, an acheiropoetic image, nor one from the brush of Luke the Evangelist, but the next best thing. It is certainly not the only crucifix dressed in the Syrian *colobium* known in the West; but as this iconographic type became rarer and rare, and the statue in Lucca certainly became more and more unusual, so its reputation grew, making it more 'unique' and distinctive. Despite its renown all over Europe, the *Holy Face* did not influence the evolution of the crucifix even in the area immediately around Lucca. Conversely, the desire of pilgrims to have copies of this particular miraculous image had to be met; and it could not be met by a 'normal' crucifix (like those by Giunta Pisano, or, in Lucca itself, Berlinghieri), but only by actual *reproductions*, of variable fidelity, naturally, but recognizable as copies of the cross in Lucca. These copies, which date back to the beginning of the twelfth century, were made in their hundreds all over Europe. Without ever replacing the current model for the crucifix or even influencing it, they became a kind of parallel development. They would always be entitled *Holy Face* or *Holy Face of Lucca*, a name which is *never* applied to a 'normal' crucifix. The name, the place and the iconographic type form one unit, guaranteeing even in the copy some glimmer of the sacred *aura* which is universally attributed to the original.[83] The most faithful, and the most likely to be actual 'copies' now that we can compare them with photographs, are of course those made in closest proximity to the original (for example the one in the church of San Rocco in the Piazza dei Cavalieri in Pisa); the greater the distance, the less chance there would be of verifying, and the less important the model becomes. Space and time

Plate 47 *The Holy Face*, twelfth century(?), Lucca Duomo.
Photo: Archivi Alinari.

can even strip the image-copy of its meaning, while still keeping intact its 'magic' ability to work miracles. In the late fourteenth century in Flanders a copy of the *Holy Face* was venerated and credited with miracles, but no one could remember what it represented. The long, sleeved robe made it hard to recognize it as a crucified Christ, since the Redeemer was always depicted wearing a loincloth, and it really looked more like a woman; but there had to be some explanation for the beard. And so the legend grew up of a

woman saint who, wishing to preserve her virginity at any cost against the wishes of her father, who had promised her to a king of Sicily, was given a thick beard by God which covered her face and made her no longer desirable; but her father was angered and had her crucified. This *Virgo fortis* was given no less than twenty *different* names in the different countries of Europe (from Sankt Wilgefortis and Kümmernis in Germany to Sainte Débarras in France) and took her place in the *Martyrologium Romanum* in 1583, where she remained, enjoying wide popular devotion all over Europe (except in Italy) until the last century.[84] Emptied of its original meaning, the image produced a new meaning for itself, which was both 'popular' and 'false', and coexisted with the 'true' and 'learned' meaning (which persisted in Italy and elsewhere). This dual development can be described by the linguistic term *allotrope* (for example the Latin word *bestia* gives the two Italian words 'bestia' and 'biscia'): the phonetic changes can be compared to iconographical changes (for example, the more feminine details in the dress of Sankt Wilgefortis).

As in the history of a text, the history of images can *also* proceed by 'mechanical' repetitions. A commentary by St Augustine on a passage from the Bible can be transcribed word for word (with or without mistakes, with or without acknowledging the source), or it can provide a starting point for a new interpretation: in both cases it is an invitation to read the relevant Bible passage for oneself. Commentary, narrative, and liturgical and dramatic elaboration thus leave a deposit on the sacred text, connected with it but increasingly difficult to get past; but only very rarely is there a radical move to go back to the Bible directly, skipping over the intervening centuries. The images which adorn churches are self-perpetuating, whether they transcribe faithfully or, with varying degrees of wisdom, change what went before. Between the late twelfth century and the early thirteenth, the problem of the function of sacred art was explicitly and very sensitively addressed, and the need to renew its models was deliberately stated.

In a key contribution to the controversy between the Cistercians and Cluniacs, the *Apologia* directed at Guillaume de Saint-Thierry, St Bernard of Clairvaux stated for the first time the need for a clear distinction between the decorative programmes of cathedrals and those of monastic churches.[85] Bishops must address both *sapientes* and *insipientes*, but monks need not. The uneducated masses are *insipientes*, incapable of leading purely spiritual lives; therefore the *devotio carnalis populi* (the devotion of the fleshly people) must be excited, as bishops wisely do, by *corporalibus ornamentis* (fleshly

adornments). Monks, who have removed themselves from the people and rejected the world of the senses (all five of them are listed, beginning of course with sight), should not have need of such things. And yet look at all the *curiosae depictiones* in the monastery churches! What are all those impure apes, fierce lions, monstrous centaurs, semi-human figures and spotted tigers doing there? *Ridicula monstruositas*, which is however somehow *deformis formositas ac formosa deformitas* (a distorted beauty and a beautiful distortion): such a wide variety of animals and monsters, that *even* the monks felt the desire to spend all day contemplating one by one the painted and carved figures: *ut magis legere libeat in marmoribus quam in codicibus* (that it pleased them better to read marble than manuscripts); and the Bible and laws of God are left aside! But why does all this happen? It is greed (*avaritia*) which is made the slave of idols (*idolorum servitus*), filling the church with *curiosae* images in order to interest the faithful and make them give donations and offerings.

The monks of Cluny are the main target of this memorable invective, although his condemnation of the excessive encyclopaedic nature of the Romanesque churches is arguably even more radical.

> He cannot have been blind to the profound religious meditations to which other clerics of his time were led by many of the images he included in his denunciation ... he realised that under the impact of a rapidly expanding secular culture, the spiritual ideas which had given rise to these symbols were in danger of being obscured and degraded.

This 'eruption of the sensual world' could lead the beholder *towards* the world instead of *away* from it.[86] It is particularly the monks, we understand, whom St Bernard is chastising – echoing St Augustine – for their *vana curiositas* towards the *curiosae depictiones*, which inevitably attract the attention (*aspectus*) of the faithful, disturbing their emotional involvement (*affectus*) in the liturgy. In the aristocratic isolation of the entirely *spiritual* monk, prayer should not need the intermediary of the senses; of these two sides of *devotio*, *aspectus* and *affectus*, the monk should seek to cultivate only the second, the people both. For the *simplices, insipientes* worshippers, *affectus* is reached via *aspectus*.

At the general chapter of 1134, the Cistercians decided to ban rich illuminations from their manuscripts; but the ban was promptly disregarded.[87] However, as an eloquent document of the views of someone extraordinarily sensitive to the problems facing the Church in his time, the words of St Bernard give an early sign of the deep

crisis in the relationship between the universe of images and the system of demands (by the Church) and expectations (of the faithful). The whole picture was beginning to crack: new models must be found. The general direction would not, in the end, be the one suggested by St Bernard.

Perhaps Sicard, bishop of Cremona, was really thinking of the *insipientes* among his flock when he suggested how to capture the imagination of the faithful. 'Why are sculptures in high relief, apparently emerging from the wall? Because in this way the examples they give become so vividly present and familiar to the faithful as to penetrate them *naturally*, leading them to perform all kinds of virtuous, deeds.'[88]

The dominant role of sculpture, as compared to painting, in the early Italian Duecento has often been acknowledged and confirmed; in E. H. Gombrich's words, 'it could be argued that, at first, sculpture was more pliable to these new demands (i.e. to the "dramatic evocation" of events) than painting was'.[89] The passage from Sicard's *Mitralis* shows how a bishop could be fully aware of the more 'realistic' nature of sculpture provided by its third dimension.

A comparison between St Bernard (*c.*1091–1153) and St Francis (1182–1226) gives the best indication of the direction in which Italian art was to move. Both expound and recommend the *inner* dimension of prayer; both set the written word (the prayer book) against the painted or carven image. But, for St Bernard, the inner *affectus* should be achieved only *codicibus, non marmoribus*, from books and not from statues. For St Francis that prayer which is *mentalis potius quam vocalis* should be aroused by the constant 'reading' of the *liber Crucis*. Both men are addressing their companions in the religious life; but Bernard's monks live apart from the people, whereas Francis's friars, seek to mingle with them. Bernard is writing to an abbot, and speaking for the monks of the whole of Christendom; if he has a renewal of sacred art in mind, it is with the monasteries as outposts of a more austere spirituality. Francis is speaking for everyone, going back to the vernacular, preaching to the people in their own language; in order to make the mystery of the Nativity more real, he put the Child (possibly, though we cannot be sure, a real live baby) in the Crib at Greccio between a *real* ox and a *real* ass. As a witness and a spur to his own people, he does not scorn their carnal needs: out of their need for *corporalia ornamenta* he seeks to arouse in them a more ardent devotion. Shifting the emphasis of prayer from the book to the image, he overthrows the privilege of the literate, and brings the *insipientes* closer to Christ.

This was the trend that was to emerge victorious. In St Thomas Aquinas's *Summa Theologica* he touched briefly on images in churches, and gives three reasons for justifying them: '1. *ad instructionem rudium* (for the instruction of the ignorant); 2. *ut incarnationis mysterium et sanctorum exempla magis in* memoria *nostra maneant* (so that the mystery of the incarnation and the examples of the saints may remain longer in our *memory*); 3. *ad excitandum devotionis affectum* (in order to arouse the mood of devotion)'.[90] The first two points take up recurring themes: the didactic function of images, *libri laicorum*, their role in recalling sacred events to all minds (not just those of the learned); but the appeal to the *affectus* had possibly never taken its place among the other reasons until now, on the same level as the others in a doctrinal exposition. The great Dominican father thus sets the seal of approval, by this cold enumeration of the *raisons d'être* of images, on a change that St Francis had accelerated and made people generally aware of.

In the *Rationale divinorum officiorum*, Gulielmus Durandus is even more explicit: '*pictura . . . plus videtur movere animum quam scriptura*' (paintings appear to move the mind more than descriptions); and he adds that in fact, when we go to church we do not show such *reverentia* to books as to images and pictures (I, 3.4). Quoting, shortly afterwards, two lines from Horace's *Ars poetica* (9–10): '*pictoribus atque poetis Quidlibet audendi semper fuit aequa potestas*' (painters and poets have always had equal power to dare whatever they please), Durandus consciously takes up the old theme of *ut pictura poesis*, and interweaves it with a different theme, the freedom of the painter: the stories of the Old and New Testaments are, he says, painted *pro voluntate pictorum* (after the fancy of the painter) (I, 3.22). In a telling slip of the pen, some manuscripts of the *Rationale* have *addendi* instead of *audendi*, and the freedom of painters and poets is thus confined to their ability to 'add' whatever they want to the language, which is otherwise static. But, from the preface to his book onwards, Durandus had shown the way forward, and not just for painters: 'Furthermore, the symbolism which existeth in things and offices ecclesiastical is often not seen . . . *tum quia figurae recesserunt, et est tempus hodie veritatis* (because figures have departed, and now is the time of truth) (*Proemium*, 5). So the time for figures and symbols is past, and truth must take their place, narrated and represented directly. The written word and the painted image are – as Horace's words suggest – equally called to this new truth; but painting is more attractive and more moving than writing. They can recount and recall, but most importantly images must arouse emotions and involve the beholder.

Greccio was not the first place the ass appeared on the sacred stage. In twelfth-century France, the *Procession of the Prophets*, a semi-liturgical dramatic play, had already been enlivened by the introduction of a *live* donkey, as a mount for the prophet Balaam. The success of this innovation can be judged by the fact that the whole play soon came to be known as the *Procession de l'âne*, although the donkey appeared only for a few minutes.[91] The intrusion of everyday life into the sacred, which was eventually to triumph everywhere under the influence of the Franciscans, entailed a radical upheaval in the modes and forms of sacred iconography. The gold background, which Byzantine tradition never forsook, was to emerge defeated and banished, since the works of Jesus and the saints could be depicted as happening on earth, and if the sky is to be shown in a painting, abstract gold leaf – which is, *figuraliter*, light – must make way for the blue of the atmosphere, and for clouds. As they departed further from what we would call the hieratic stillness of the icons, the main figures of the sacred story would begin to move like men and women, and take on flesh and feelings. The new problem constantly to be tackled would thus be how to obey the new demands of this *tempus veritatis* without dropping from a 'sublime' style to a 'humble' style. The encroachment of the ordinary – the donkey – must be rescued from this danger by a new stylistic dignity. And so the growing tendency towards story-telling, with ever more 'minute' details, is bound up with another tendency towards freeing the painted figures from the bondage of outline, making them more sculptural and 'alive' and, like Sicard's reliefs, apparently standing out from the wall. This dual development was to be for ever associated with the name of Giotto.

The life of St Francis, immediately recognized as exemplary, asked, indeed demanded some record. In the reredos by the Lucchese painter Bonaventura Berlinghieri at Pescia (San Francesco), dated 1235 (a panel of similar structure from 1228, which was at San Miniato al Tedesco, is documented but has been lost), the stern figure of St Francis holding his book as a *novus evangelista* showing the wounds in his hands has a border, as in the outer panel of a painted cross, containing six scenes (the *Stigmata*, the *Preaching to the Birds*, the *Healing of a Young Girl* on the left, and on the right the *Miracles* of the *Cripples*, the *Lame* and the *Possessed*), and above them are two angels on either side of the halo. The panel's shape, culminating in a pediment, is quite new; the scenes at the sides seem to resurrect the custom found in Roman votive reliefs (for example in Mithraic works) of accompanying the venerated image with biographical 'flashbacks'; in later examples, the lateral vignettes proliferate: the

Plate 48 BONAVENTURA BERLINGHIERI, *St Francis and Scenes from his Life*, 1235, San Francesco, Pescia.
Photo: Archivi Alinari.

panel in Santa Croce in Florence has twenty.[92] The new simplicity of Franciscan churches, along the lines suggested by St Bernard, prohibited rich and imposing mosaic or fresco decoration of the apse, and so tended to privilege the form of the altarpiece, which had a direct but 'flexible' relationship with the altar: its position could be changed, and it could be carried in processions. The gradual disappearance of the iconostasis is thus balanced by a huge increase in the number of altarpieces, over a wide range of types and forms.[93]

With the greatest possible dignity a kind of sacred topicality now entered into painting. Alongside the solemn effigy of the saint which

asks for reverence and *salutatio* from a distance, we find vignettes from his life, meant to be seen from close up; like the *Fioretti* these call to mind (*memoria*) with simplicity and in detail his words and deeds, and put the encounter with the fiery seraph on the same level as the encounter with the birds. In all the scenes, characters who are mute, as a painting must be, express feelings and passions by their gestures; the inner turmoil of the possessed, the saint's desire for the stigmata, the amazement of his friends as they witness the miracles, all animate their outlines against a background of abstract houses and mountains. But standing before the picture, the beholder is not mute: he can translate the phrases of this gestural language into emotions and words.

The resolutions resulting from the general chapter of the Franciscan order held at Narbonne in 1260 and presided over by St Bonaventure adopted a 'rigorist' stance over the question of images, echoing the position of St Bernard: they condemned *curiositas* and *superfluitas* in painting and sculpture, forbade (though with some significant exceptions) stained-glass windows portraying stories and *tabulae sumptuosae seu curiosae* (sumptuous or curious panel) over the altar or elsewhere.[94] This was of course to ensure that the rule of poverty was not contravened; but the other reason concerns *curiositas*, which was not to be encouraged, as St Bernard had stated earlier. There can be no doubt that the intention of the new general, St Bonaventure, and the other Franciscans who convened at Narbonne was drastically to restrict the figurative decoration of their churches, bearing in mind among other things Brother Elias's excesses; it is equally certain that these rules were not observed, least of all in Italy. But within these same almost 'iconophobic' rules of 1260 are clues to a rather opposite tendency: narrative stained-glass windows are forbidden *in general*, but it is suggested that the main window (behind the high altar) should show the crucified Christ *or* the Virgin, St Francis and St Anthony. The image of the Madonna has become an alternative to that of the crucified Christ, and the two saints of the order are given an almost equal position alongside the two main themes.[95] The new devotion to the Mother of Jesus, which of course goes back to St Francis, is thus mixed with a kind of Franciscan 'patriotism'.

The apsidal mosaic in Santa Maria Maggiore, the work of Jacopo Torriti commissioned by the Franciscan pope Nicholas IV (1288–92), is devoted to the *Dormition* and *Coronation of the Virgin*. Byzantine tradition gave pride of place in the cupola to the *Pantocrator* and left the sanctuary for Mariological themes; but this mosaic of

Nicholas IV's seems directly inspired by the new position the Madonna had assumed in devotion and worship since the time of St Francis: St Francis and St Anthony on either side of the double throne set the seal on the wholly Franciscan character of this image. In the same spirit of 'patriotism', Nicholas V also inserted the figures of the two saints of his order in the mosaics of the Lateran.[96] From 'poor' panel-paintings, St Francis has entered the glory of the apse; the papal city continues to use more 'representative' forms and decorations.

The *Maestà* painted by Duccio for the Duomo in Siena (1308–1311) marks the high point in the development of the altarpiece centred around the Madonna by the size and the quality of the work.[97] The huge figure of the Virgin in the centre, flanked by triple ranks of angels and saints, is not only holding the Child on her lap and showing him to the faithful; she has become a kind of magnetic pole of reference for the whole of religious history. As a kind of commentary on the scene of her motherhood, the predella tells the story, through a series of panels interspersed with prophets, of the childhood of Christ: but on the reverse of the ancona the story continues up to the Emmaus episode, though giving particular and unusual prominence to the Crucifixion, which is the central scene and also the largest. Thus as the Childhood cycle is a 'commentary' on the Motherhood of Mary, the public life of Jesus is crowned by the Passion: but this theme occupies the less important side of the panel. The predominantly 'representative' image (facing the people) and the predominantly narrative cycle (behind the altar) are back to back; the predella acts as the hinge between them, and thereby determines the order of the narrative (from bottom to top) on the second side.[98]

Such a reversal of priorities would never have been possible without the new emphasis on the veneration of Mary; but it cannot be explained so simply. From 1260 onwards, after Montaperti, Siena had been the first city in Europe to put itself under the protection of the Madonna by public decree; and the inscription traced by Duccio's brush runs *Mater Sancta Dei sis causa Senis requiei – Sis Ducio vita te quia pinxit ita* (Holy Mother of God, be the cause of peace in Siena – Be life to Duccio because he painted you thus). The painter appears in person, asking *vita* of the Mother of God *because* he was able to paint her in this way; but the accent is stronger still on the city. If the very title of *Maestà* itself can pass from the Redeemer to the Madonna, it is because of the *political* meaning which was now attached to the figure of Mary *as well as* the religious meaning. Therefore the choice of saints surrounding her is made according

Plate 49 DUCCIO DI BUONINSEGNA, *Maestà*, 1308–11, Museo dell'Opera del Duomo, Siena.
Photo: Archivi Alinari.

Plate 50 DUCCIO DI BUONINSEGNA, *Maestà*, reverse, Museo dell'Opera del Duomo, Siena. Photo: Archivi Alinari.

to a deliberately and exclusively Sienese point of view – labelled by name in little captions, the four tutelary saints of Siena (Ansano, Savino, Crescenzio and Vittore) are depicted kneeling, thus placing them on a higher level even than the pairs of Peter and Paul, John the Baptist and John the Evangelist, Catherine of Alexandria and Agnes.

The influence of the secular has privileged the image of glory over the image of piety; 'religious immediacy' (affecting both subject and iconography) has given way to *political* immediacy (determining the measurements and positioning of the painting, its dedication, and its protective value).

Simone Martini's *Maestà* (1315), four years on, presents an image rephrased in more explicitly political and ceremonial terms. After the precedent set by Duccio, the subject demanded a much larger space and a central position. This may *also* help to explain the passage of the theme from panel painting to fresco. This new *Maestà* was painted not for a church, but for the Palazzo del Comune, where a panel painting would have been out of place, being too closely associated with its usual function (in the context of worship) and with its usual place (in church). The *Civitas Virginis* (city of the Virgin) thus calls more openly upon its patroness in the Council Chamber of the Palazzo Pubblico, surrounding her with the same saints who were with her in the Duomo, under a wide canopy held up by eight saints. Amidst angels and apostles, raised on a wide dais, the Madonna is seated on a Gothic throne, clad in attire that could have been borrowed from an Angevin court wardrobe, displaying the Child, who stands on her lap, as he did in French art at the end of the previous century. From *regina coeli*, as she still was in the Duomo, bringing down her blessing on the city from her gold background, Mary has become an earthly queen, *involved* in the Consistory of the Commune.[99] The change of *place*, far more than the *iconographic* changes, shifts the meaning of this *Maestà* on to openly secular territory.

The sacred image has become more open to the many different demands made upon it; and it comes down among men to take on their clothing and their problems. The beholder of the Pescia panel draws closer to count the birds perched on the hill and in the trees, and in the wounds of Francis weeps for the sufferings of Jesus. The *Madonna in Maestà* in the Palazzo Pubblico in Siena presents the mother who had protected and would always protect Siena against Florence and Pisa and Lucca to the beholder in a blaze of earthly glory; the image-presence prevails over the image-story, but it lays

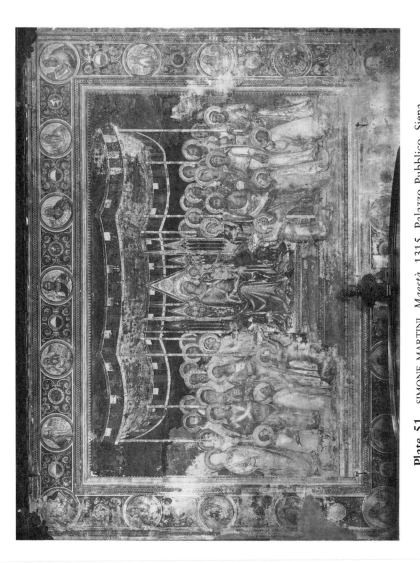

Plate 51 SIMONE MARTINI, *Maestà*, 1315, Palazzo Pubblico, Siena. Photo: Archivi Alinari.

itself open to a largely profane *salutatio* which is most distinctively marked by civic (*comunale*) passion.

The friar of San Gimignano who wrote, before 1335, the *Meditationes Vitae Christi* moved on quite a different plane. Developing the devotional techniques suggested by St Francis, he sought to transport the reader on to the Gospel stage; he therefore recounts at length, in the most minute detail, the life of Jesus, and 'knows a host of things of which Mark and Matthew seem quite unaware'.[100] Falsely attributed to St Bonaventure, and therefore credited with greater authority particularly in circles influenced by Franciscan preachers, this book was to become 'the fifth gospel, the last of the Apocrypha . . . a summary of medieval spirituality, a manual of Christian iconography, one of the principal sources of the mysteries'.[101] A 'book of painting' which does not proclaim itself as such, but takes details and information from images, giving the reader, be he painter or patron, two or more versions of the same scene, and suggesting new combinations, teaching and showing more than the gospel. You wish to describe (or depict) the Crucifixion? You must begin by nailing Jesus to the cross. *Diligenter attende* (attend carefully): one ladder behind and another in front, and the *malefici* (which is to be understood as a description both of a moral state and of a physiognomy) climbing up with hammers and nails. *Conspice nunc bene singula* (now observe everything closely): Jesus going up, embracing his fate, hanging from the nails by the weight of his body, bleeding, suffering and dying; close by, his Mother watching and grieving (pp. 112ff). *Conspice, vide*: the beholder is called upon to enter the scene, to share the pain of Christ and Mary, letting it in through his gaze; but he can make this journey only if he is led by the hand into the world of the 'everyday' workings of sacred history, where it is legitimate to seek (and to supply) details of what food the angels brought Jesus in the desert, which hand was nailed first, and to hear the sound of the nails and the tearing of the flesh. With even greater emotional intensity, another Franciscan, Jacopone da Todi, developed the whole of his hymn from a few words of St John's gospel (19.25: 'Stabat iuxta crucem mater ejus'):

Stabat mater dolorosa	(The sorrowing mother stood
iuxta crucem lacrimosa . . .	weeping by the cross . . .
quae moerebat et dolebat	she mourned and suffered
et tremebat dum videbat	and trembled as she *saw*
nati poenas incliti.	the pain of her glorious son.)

But most importantly:

> *Quis est homo qui non fleret* (Who is there who would not
> weep
> *Matrem Christi si videret* to *see* the Mother of Christ in
> *in tanto supplicio?* such torment?)

The Crucifixion is relived through the suffering of the Mother of Jesus who *sees* her Son in such atrocious agony; and who would not suffer to *see* him?

The Madonna offers herself as an intermediary in a profound emotional participation, which could become identification, involving all the senses of the *carnales* masses, beginning with sight. Crucifixion with Christ by the power of mental ardour was the privilege of the heroic virtue of Francis, and yet a *visible* apparition of the crucified Christ or the seraph and a perceptible sign of the stigmata were still needed. One step below this, it is possible to 'see' with the eyes of the mind the scenes of the Passion, to relive them, by contemplating them using powerful inner visualization; it is easier (and more common) to do it by reading the Gospel, still easier when the imagination is assisted by a text such as these *Meditationes*, with all the details it gives, and easier still when it is the sight of the eyes which directly 'assists' or awakens the eyes of the mind. The aim is the same: to lose oneself in the sacred scene or in Christ; it is the *method* which changes, with the alchemy of 'carnality' and 'spirituality'.

Exempla were on the increase. Was the fifth Gospel written by the author of the *Meditationes vitae Christi*, or did St Francis write it by the life he lived? But every saint can become, if not a *novus evangelista*, at least an example. From the thirteenth century on, it was not just the images of saints that were increasingly depicted, but most particularly their *stories*. The *Golden Legend* of Jacopo da Varagine (Varazze), a Dominican and bishop of Genoa from 1292 until his death (1298) is to the lives of the saints what the *Meditationes* are to the life of Christ – perhaps even something more – collecting and organizing lives, stories, episodes, miracles, words and deeds from the huge wealth of material provided by hagiographers. It is familiar with the images, and takes details and information from them, which it then recommends to anyone wishing to paint new images. Following the cohort of the saints, the reader moves from far-off pagan antiquity to his own time, from the remotest regions to his own city; he sees kings and popes, monks and knights, woodcutters and hermits file past as in a mirror. Through these *Lives*,

'history and geography were seen through its perspective glass . . .
a little vague and misshapen, as on an old map; nonetheless, it was
an image of reality'.[102] Iconography kept up with this new wave of
interest in hagiography, and vernacular versions of the Latin original
spread the influence of the Dominican bishop's book even further
among painters and patrons. The people no longer understood the
Latin of church rites; and the 'Cantico di frate Sole', although of
course not counting itself within the liturgical 'genre', had provided
evidence of the need to communicate thoughts and reflections which
still resembled prayer in the vernacular. Iconography must also now
refer to a *sermo quotidianus*, or invent one: this is another meaning
of *tempus veritatis*.

Saints were also on the increase. Their *stories* (in successive scenes),
or their images alone, reintroduce the distinction/contrast between
memoria and *salutatio*. Particularly from the fourteenth century
onwards, the concern to distinguish one from the other took shape,
and translated itself into a new vocabulary of attributes, with the
aim of *differentiating* between the saints to whom they refer from
one another. 'Many of the objects in old paintings were words':[103]
the lamb identifies St Agnes, a reference to her name; the pilgrim's
costume St James, a reference to the pilgrimage to Compostela; the
gridiron St Laurence, since this was the instrument of his martyr-
dom.[104] In the last case, which is certainly the commonest, the at-
tribute contains the narration of an event (the martyrdom) in a
nutshell, *condensing* it without a full explanation; it recalls it with-
out recounting it, it is a 'hieroglyph'. Thus the potentially *more*
arbitrary nature of this new sign language becomes clear. The sword
could be an excellent attribute for St Peter, since everyone remem-
bers the episode in the garden on the Mount of Olives, when he cut
off the ear of Malchus, and the words of Jesus (John 18.11); but
universal custom, and specific pressure from Rome, gives him the
symbolic keys of primacy to hold, and the sword is *never* used for
him, only for St Paul, whose execution it recalls. Since St Peter and
St Paul are grouped together in the liturgical calendar and often
depicted as a pair, we still refer to these attributes today in order to
recognize and distinguish between them.

Through one set of specifications after another, the vocabulary of
images is constantly enriched and made more complex: single figures
of saints come to be identified by their attributes (pointer-words),
narratives are enlivened by an increasingly mobile repertoire of ges-
tures; the relationships between one character and another, between
the centre and the edge, between foreground and background,

are tried out in different ways. The further iconography moves away from the formulaic and towards the experimental, the more questions painters, patrons and the public will ask about meaning as a *function* of its value as a message, along with a growing awareness that a shift of iconography entails (or may entail) a shift of meaning. But at the source of this development is the desire to make sacred stories, as Sicard advocated, *naturaliter insitae* (naturally placed) for the faithful, making them *egredi de parietibus* (come out of the wall).

Sculpture obviously led the way. The pulpit which the people of Pisa wanted to build in their baptistery was completed in 1260 (the year of Montaperti) by the *docta manus* of Nicola Pisano, who, Vasari tells us, 'applied such diligence in imitating that style, and other excellent sculptures on the other antique sarcophagi, that before long he was considered the best sculptor of his time'. He was *doctus* therefore because he was a shrewd and skilled imitator of the antique, just as a century earlier Biduina of Pisa had been *doctus* in his antique-style design for a burial chest in the architrave of San Casciano and in his copy of an entire Roman sarcophagus, strigilled and decorated with lions. But Nicola, before being 'Pisano', was *de Apulia*, as the documents tell us;[105] and the argument constructed by Bertaux (1904) to show his dependence on models elaborated in Frederick II's Apulia is still very persuasive, despite the interminable quibbles of the critics.[106]

Following the example of the Roman statues the art of Frederick's court required dignified clothing, laurel wreaths, and the lost *ars* of carving faces which had nobility and strength in their rich heads of hair and their flowing beards. A 'classical' Capuan bust sought to assign to Pier delle Vigne, or whoever it was of, a common set of intentions and celebrity shared with the ancient Romans; but this meant detaching him from his own age and freezing him within a kind of ceremonial classicism.

The Pisa which summoned and welcomed Nicola de Apulia had been meditating upon Roman antiquity for more than a century, though always reflecting it in its own great civic pride.[107] The great ornamental vase which must already have stood on the steps of the Duomo was not just an ordinary trophy or curiosity, but the 'talent of the Emperor Caesar', given to Pisa because that was where 'all the tributes and taxes which the kings and nations and peoples of the world rendered . . . to the Roman Empire were brought by sea' (G. Villani); they were all weighed in Pisa, before being sent to Rome, it seems. Pisa – the new Rome – did not collect any old antiques; instead it was looking for its own past in those Roman

Plate 52 NICOLA PISANO, *Presentation in the Temple*, detail from the
pulpit, 1260, Pisa Baptistery.
Photo: Archivi Alinari.

marbles, in order to justify its present and its future. The sarcophagi
which Nicola saw around the Cathedral were *exhibited* there, as proof
of the *Romanitas Pisana* they displayed; by their very rarity and
antiquity, they bestowed upon the personages buried in them (Beatrice
of Tuscany, Gregory VIII . . .) a seal of earthly glory. The crowds of
figures carved in the marble by the Romans, telling in solemn and
dramatic tone the dead fables of the ancients, offered a repertoire of
patterns and gestures which could instantly enrich the language of
the art of telling stories through images. Vasari was well aware that
this was what made Nicola Pisano revise his art.

 In the baptistery pulpit, the relief of the *Presentation in the
Temple* takes up an obvious, well-rehearsed theme, but regenerates
it radically from within. The architecture in the background acts
merely as a framework, a canopy: the sculptor's real interest is
focused wholly on the human figures, and the altar, the traditional
focus of the scene, has become a slender column. The four main

figures from St Luke's text (2.22–38) are no longer alone: with St
Joseph carrying the doves and Mary, Simeon and Anna, comes a
small crowd of spectators at the sacred drama, the scene of the
recognition of Jesus as the Messiah. Anna is still holding her scroll,
which defines her as a prophetess, but her face hollowed by age and
long self-denial, at last rewarded by meeting the Messiah, is raised
dramatically heavenwards; this and the other old woman's face,
which looks out from behind St Joseph, are both derived from
Phaedra's nurse in the Roman sarcophagus of the Countess Beatrice.
Simeon, who holds the Child, also has a kind of double in the very
solemn figure of an old man entering from the right into the relief,
supported by a boy, and taken from the 'talent of the Pisans'; in the
words of the liturgy of the Purification and the gospel of pseudo-
Matthew: '*senex puerum portabat; puer autem senem regebat*' (the
old man carried the child, but the child was lord over the old man'.
Nicola Pisano does not take 'quotations' from antique sculptures;
his hand is *docta* because he knows how to look to antique statues
and other sources for new formulae and gestures and schemes which
will answer the convergent demands of a portrayal which has suf-
ficient relief to 'stand out from the wall' and which makes a deep
impression on the beholder by showing the characters in the sacred
scene experiencing emotional passions and tensions with which
he or she can identify. In the abundant and well-ordered drapery,
the wise heads leaning to one side, the movement, almost arching,
of bodies, no critic's filter could tell the 'Gothic' apart from the
'antique', since what Nicola has shopped for in Roman art is not a
model of classicism, but a vocabulary of truth. And this he found,
since it was what he was looking for.

In the relief of the *Crucifixion*, the still standard convention
placing Mary and John on either side of the cross is abandoned: the
mourners are *all* on the Saviour's right, and on the left, damned as
in a *Judgement*, are *all* the Jews and gentiles; at the top right, an
angel is pushing the Church towards Christ, and on the left another
angel is driving away the synagogue. Turning towards Christ, who
is still in the throes of impending death, the mourners map out a
whole hierarchy of pathos: the three women in the second row,
raising tortured expressions to the sky, St John with a grimace of
pain fixed on his features, his arms hugging his body, Mary sup-
ported by two holy women. This theme is taken from the apocry-
pha, and was soon to become standard practice everywhere,
popularized by painters and by the *Meditationes vitae Christi*; but
the Pisa relief is probably still the most dramatic swooning of Mary

Plate 53 NICOLA PISANO, *Crucifixion*, detail from the pulpit, 1260,
Pisa Baptistery.
Photo: Archivi Alinari.

in Italian art; in the next pulpit in Siena the Madonna is again
falling into the arms of the holy women, and in a more 'naturalistic'
way, but to less violent effect. *Stabat Mater*, the Gospel suggests: but
to imagine that sorrow, to identify with it, to weep one's own tears
with those of Mary, was to take the austere and merely adumbrated
sorrow of the gospel text into an entirely human, physical dimen-
sion, where mothers cannot bear to watch the suffering and death
of their sons. The tendency towards emotional identification in the
scene depicted brings about a heightening of tension: the climax of
Iacopone's text (*dolorosa/lacrimosa/moerebat/dolebat/tremebat/
supplicio*) is echoed, in Nicola Pisano's relief, by the *hyperbole* of the
body of Mary bent double: 'sometimes not only the truth, but some-
thing beyond the truth, is told' (Boccaccio, *Decameron*, I, 6.23).

The body of the crucified Christ is more 'real'. Familiarity with
the ancient sculptors had helped to give vigour and flesh-and-bone
plasticity to a body which is no longer, like Giunta's, elongated and

stretched in Byzantine spiritual exhaustion. The proportions of the body have changed, and one leg is crossed over the other, because now just one nail is fixed through both feet: this dying Jesus carries greater weight, and therefore greater truth, although the right side is still curved in the Byzantine manner. In the same pulpit Nicola Pisano has taken a further step; he is more 'daring' or inventive, as is often the case, towards the edges than at the centre. The small panel, or gospel cover displayed by the *Faith*-angel on the left contains a miniature *Crucifixion* showing just Longinus (with the lance) and Stephaton (with the sponge) on either side of a Christ who is almost falling off the cross, dragged down by the weight of a body no longer sustained by life. The arms are stretched right out, the head is completely collapsed on to the chest, and the knees, freed from their 'Byzantine curve' really do seem to *egredi de pariete*.[108]

Moving 'from scripture to representation . . . with the help of the objective physicality of the sister art' – sculpture – Giotto marked the last phase in the development of the Italian painted cross.[109] The *Crucifix* in Santa Maria Novella inherits the Giuntesque shape, but enlarges it at the foot, which contains the trapezoidal mountain of Calvary lying over the skull of Adam. The body of Jesus in painting has become as heavy as any real corpse, and the lifeless and bloody hands hang down, whereas Cimabue still showed them with open palms, their rigidity dictated not by death but by convention. The crucified Christ has become more prominent, standing out from the support of the cross and there is an attempt to make his knees project as they would in a sculpture; also, in acquiring more anatomical 'realism', the proportions have been radically altered: the head-to-body ratio is no longer seven (as in Cimabue) but six.

In the *Crucifixion* in the Scrovegni Chapel, the hieroglyph of Golgotha, now a geometrical cylinder, supports an even more lifeless Christ emaciated by death; his hair falls even more dishevelled on to his face, his legs are even further apart, and gain further sculptural relief thereby. All around him, there is a strong contrast between the indifference of the soldiers who are sharing out the clothes (while the centurion who became a saint – marked out by his halo – points in vain to Christ) and the violent emotion of the mourners. Mary is swooning, supported here by St John as well as the others, and has therefore become almost a second focus of the composition; Mary Magdalen, with her long hair hanging loose around her shoulders, has left the group of holy women to embrace the cross. The symbolic representations of the Church and the Synagogue have disappeared; this *meditatio passionis Christi* suggests the

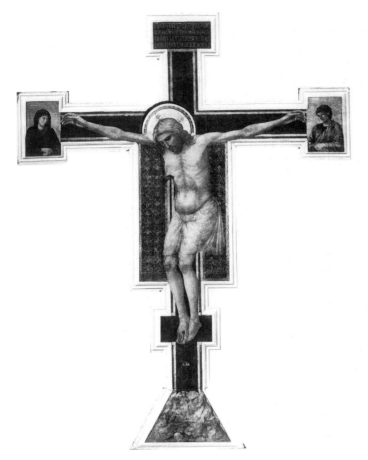

Plate 54 GIOTTO, Painted cross, *c.*1290, Santa Maria Novella,
Florence.
Photo: Archivi Alinari.

dramatic contrast between the sinning persecutors and the faithful
mourners; the centurion pointing to the cross and especially the
Magdalen embracing the feet of Christ, serve to show eloquently
how the sinner can be redeemed. The path to emotional identifica-
tion has become a dual process: first with the pain of the Madonna,
the mother without sin, the unattainable example, and then with the
more carnal and more accessible compassion of the redeemed sinner,
Mary Magdalen.

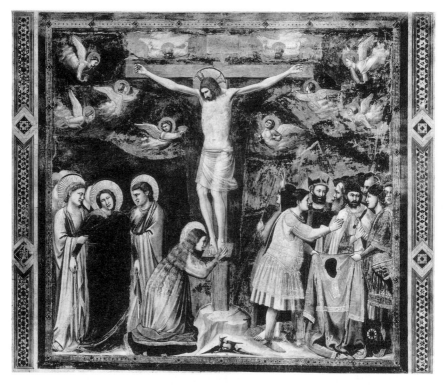

Plate 55 GIOTTO, *Crucifixion*, *c.*1304–15, Scrovegni Chapel, Padua.
Photo: Archivi Alinari.

So it is Giotto who is 'the sovereign master of painting in his time, and the one who drew each *figure* and *action* most *naturally*' (G. Villani). As he consults and integrates the dictionary of painting and sculpture, the lessons of Nicola Pisano and the authority of the antique, Giotto is not translating his figures from Greek into vernacular Italian, but creating his *own* vernacular and, with great intelligence and organizational power, promulgating it as the new language for painting. To draw a figure naturally is to give it weight and volume; to endow even the contrast between the clothes of the mourners and those of the soldiers with a moral tension culminating in the discarded robe of Jesus which is to be shared out, drawing living human presences with real *gravitas*, like geometric solids. Drawing actions naturally means the swooning of the Madonna, the Magdalen rushing to the foot of the cross, the heated argument

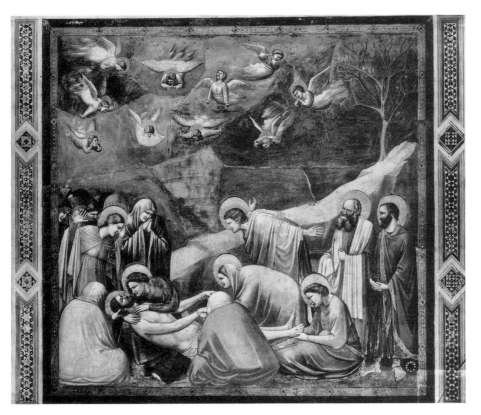

Plate 56 GIOTTO, *Deposition*, *c.*1304–15, Scrovegni Chapel, Padua.
Photo: Archivi Alinari.

among the soldiers over the holy garment. The fingers of Christ on the cross are contracted, closed over the nails in his hands – more 'real' than in the Santa Maria Novella *Crucifix*; the hands of the other characters are hidden, except where their gestures are significant. The Madonna's hands hang limply, while the soldiers are gesticulating in disagreement, their hands crossing and fighting over garment and knife. The gestural language makes the actions 'natural' as it narrates and depicts them.

Sorrow demands new formulae. The Scrovegni chapel *Deposition* draws up around the body of Jesus a varied and accomplished repertoire of gestures, ranging from discomfort to desperation,[110] which extends from the crowd of mourners to the angels in the sky. With

their backs to the audience, two women in full cloaks present themselves to us as more direct visual channels for us to 'enter' the picture by, for us to touch the body of Christ, along with the holy women. An abstract corridor of mountainside, as in an icon, topped with a bare tree, gives greater relief to the pose of the main figure of the panel, St John, who stands with his arms violently thrown back, his mouth half open as though in mid-cry. The pose is taken from the wide vocabulary of *Pathosformeln* or 'pathos formulae'[111] developed by the artists of classical antiquity and popularized in the sarcophagi showing the myth of Meleager. Nicola Pisano had already drawn from this source in the Siena pulpit; Giotto and his followers were to reintroduce it in the *Crucifixion* and *Massacre of the Innocents* in the lower church in Assisi.

Thus in 1381–2 Filippo Villani could quite calmly justify the absolute excellence of Giotto compared with 'ancient' painters precisely because the figures he painted 'appear to perform actions and movements so exactly as to seem from a little way off actually speaking, weeping, rejoicing and doing other things' and 'seem to the beholder to live and breathe'; and therefore *'liniamentis naturae conveniunt'* (agree with the lineaments of nature). The painter thus reduces natural realism to *liniamenta*, as is the nature of the brush, but he never silences it:

> not without pleasure for him who beholds and praises the talent and skill of the artist. Many people judge – and not foolishly indeed – that painters are of a talent no lower than those whom the liberal arts have rendered *magistri*, since these latter may learn by means of study and instruction written rules of their arts, while the painters derive such rules as they find in their art only from a profound natural talent and a tenacious memory.[112]

Standing in opposition to the *praecepta scripturis demandata* of the liberal arts, therefore, are such unwritten precepts as painters *in arte sentiant*. Without ever entering the system of the liberal arts, painting achieved sufficient dignity to rival poetry. Once just a quotation from Horace, *'ut pictura poesis'* now became the theme and measure of broad debate.[113]

And of course the attention drawn by the likes of Villani to the lack of written rules for painters served to highlight the gap and to move someone to fill it. In Leon Battista Alberti's *De pictura* (1435–6), Giotto's *Navicella* (which was at St Peter's in the Vatican) is held up as a model for every painter wishing to express the different human passions through faces and bodies, and through

Figure 10

the movement and gestures of figures. Giotto's place here is no accident, no gratuitous choice of a merely 'excellent' painter; if Alberti singles him out as an example, it is because he intelligently and rightly sees in Giotto's art unwritten rules, *praecepta scripturis non demandata*, which are nonetheless capable not just of animating, but of *organizing* interrelated images. For Alberti (with Giotto in mind) the greatest work of a painter is not an isolated figure, however grand (*colossus*), but his *historiae* (narratives), which are composed of many *corpora* (individual figures), composed in their turn of *membra* (limbs), each of which is made up of *superficies* (surfaces). The art of the *compositio* of a painted *historia* is thus the same as that which the schools of rhetoric taught for good prose (see figure 10).[114] Setting out these rules with an elegance and clarity which a treatise by Giotto could never have had, Alberti thus revealed, tearing down the screen which hid the painter's workshop, the process, the construction of his *historiae* as the sum of bodies moved by gestures and expressions, according to the (declared) principle of *variatio* and the (undeclared) principles of co-ordination and subordination, since in painting, he adds, '*et corporum et colorum varietas amoena est*' (variety of bodies and colours is pleasing).

The relationship between *membro* (limb, of the human figure) and *frase* (a sentence, of prose) gives sufficient indication of how important the different gestures of the figures were to the aims of the composition and to its readability, its *historia*: since the application of a rhetorical model itself implies that the purpose of the painted image is to persuade the audience. So we may see the work of the painter as 'montage', within the *historia* being narrated, of the individual *corpora* (bodies) – not too many though, he adds: no more than nine or ten to a scene! – with limbs in different poses, articulated

on different planes (*superficies*). The very close comparison with the rules codified by the rhetoricians suggests that painting is a language of its own.

But the *copia et varietas rerum* (plentiful variety) that Alberti recommends to the painter demanded a wider and more deftly inter-related repertoire of figures and gestures, and these new demands revived the classical vocabulary, which could never have been learned from cold marble statues alone. The complete absence of paintings from antiquity explains why it was the sculptors who first turned to classical art for new formulae to persuade the observer and awaken more 'real' emotions. In their response to the same demands, the painters lagged behind, but because they were treading a path where others had gone before they quickly made up for lost time, and took on the same models as sculpture – where gesture and relief work as one – embracing them *en bloc*. So, in order to 'take all figures and movements *from nature*', the painter too must make the figures seem *prominentes et de pariete egredientes* (having relief and standing out from the wall), and they must appear to the faithful to be *naturaliter insitae* (naturally positioned). So the painter will use relief to make gesture more effective, and gesture to make his relief convincing. Imitation of classical models and faithfulness to nature become con-fused, and the painter who constructs his own *historiae* with such wisdom therefore does so really, in Alberti's words, 'the *longer* to hold the eyes of learned and unlearned alike with some pleasure and a stirring of the spirit' (*ut oculos docti atque indocti spectatoris* diutius *quadam cum* voluptate *et animi* motu *detineat*). The length of time spent observing must increase both for the educated and the simple, who will now be brought closer together by the emotional impact the images generate; because with their richness and variety and relief, the images now bestow truth, and therefore also pleasure and emotion.

'Non tener pur ad un loco la mente'

It was only a few years since Filippo Villani had peremptorily stated that for painters there are no *praecepta scripturis demandata* (principles laid down in the literature), and Cennino Cennini the painter was already working on his *Libro dell'arte* (*Craftsman's Handbook*): 'to minister to all those who wish to enter the profes-sion I will make note of what was taught me', and of course he too

traced back to Giotto not only his own personal development (via Agnolo and Taddeo Gaddi), but also credits him with having 'changed the profession of painting from Greek back into Latin, and brought it up to date'.[115] For the first time, the word 'modern', which had already been used in opposition to 'ancient' in the language of theology and liturgy, is here applied to contemporary art, with an explicit contrast to the kind that went 'before'; since 'Greek' means 'Byzantine', 'rimutare' (to change back) painting into Latin means to lead it back to the nobility and vigour of *classical* art. The *modern* language therefore means the ancient language rediscovered and *perfected*: and this is why the art of Giotto is, for Cennino, 'compiuta'[116] (fulfilled, finished). As best he can, with the humble linguistic means at his disposal whenever he digresses from shop talk, Cennino declares that with Giotto painting was *reborn*. And therefore 'it justly deserves to be enthroned next to theory and to be crowned with poetry.'

There is, however, no point in scanning the pages of his *Handbook* for those unwritten rules of painting which Alberti, who saw the painter as orator, called *compositio*. Cennini transcribed and collected strictly technical recipes and directions on how to mix colours and prepare panels and draw with a pen. Nobody – and here Filippo Villani was right – would have thought of setting down in writing instructions on how to arrange your figures to give *effect* to the *historia*.

From a passage of Dante's *Purgatorio* we know at least how a sequence of *historiae* could be read. When Dante arrives on the first terrace (of pride), he is attracted by the reliefs ('intagli') carved all around the embankment. These carvings are recounted in detail, in a long description (X.28 onwards), and depict Gabriel's annunciation to Mary, David and the Ark of the Covenant, and the Clemency of Trajan. In order to 'read' each *historia*, Dante first of all moves closer ('e fe' mi presso / accio che fosse a li occhi miei disposta', 'I drew near to it that I might have it before my eyes') and examines it carefully. The work is so lifelike (as evoked by the verisimilitude topos: 'la natura li avrebbe scorno', 'nature would be put to shame there') that the poet-spectator is compelled not only to observe the 'atti' (bearing) of the figures depicted, but also to imagine their conversation. The angel

> dinanzi a noi pareva si verace
> quivi intagliato *in un atto* soave
> che non pareva immagine che tace.

Giurato si saria ch'el disse 'Ave!'
perche iv'era imaginata quella
ch'ad aprir l'alto amor volse la chiave;

e avea *in atto impressa* esta favella
'Ecce ancilla Dei'. (37–44)

(appeared before us so truly graven there in a gracious *attitude* that
it did not seem a silent image. One would have sworn he said 'Ave',
for she was imaged there who turned the key to open the supreme
love, and *in her bearing she had this word imprinted*: 'Ecce ancilla
Dei'.) (adapted from the translation by J. D. Sinclair, Oxford, 1971)

'Naturally', by the force of the impression they make upon the
pilgrim through Purgatory, these two sacred speech-bubbles waft
from the mouths of Gabriel and Mary, taken – naturally – from the
Gospel: for the image, though it cannot speak, still moves the ob-
server's memory to eloquence. It is the *bearing*, the positioning of
the figure and the gesture, which suggests the 'favella' – the word –
('imprinted in her bearing', precisely; the meaning is enclosed in the
iconographic stereotype; if we spot an 'announcing angel' we also
know exactly what he is 'saying'). Furthermore, the figures 'speak'
in so far as there is a system of relationships between them: Gabriel
is saying 'Ave' *because* he is standing before the Madonna (41).
Vision enters into conflict with hearing, which refuses to register
these words (see line 60), which nonetheless resound in the memory.

But to 'read' the *historiae* in order one must have a method or a
guide. Dante tarries too long over this Annunciation, and Virgil, the
good master, directs him elsewhere: 'Non tener pur ad un loco la
mente' (46) ('Do not keep thy mind on only one part'). Obediently,
Dante turns his gaze to the other 'intagli' with the stories of David
and Trajan. But Virgil's exhortation was not, as at other times, that
he should hurry on, but precisely that he should look carefully and
methodically, 'keeping his mind' on the images in the *historiae*
arranged around him, and not just on one of them. Only after
individually examining all three of them will Dante be able to grasp
their real meaning, the link which binds them: they are all 'l'imagini
di tante umilitadi' (98), *exempla* of humility to be used by the re-
pentant proud souls. It is important to shift the gaze and the atten-
tion from one 'intaglio' to another in order to read, behind the
individual stories, the overall sense of an 'iconographic scheme' of
which God himself is the 'craftsman'. But it is Dante who imagines
them and describes them, and he has portrayed himself as the naive
and ignorant audience, in order to leave to Virgil – as so many

'maestri' in the churches must have done – the job of showing people how to look at the figures. In taking upon himself the role of spectator, Dante can also describe the effect of these *exempla* on the souls being purged. By proposing that purification may take place through the contemplation of images, he is establishing their profound didactic potency, tying it to the 'realism' of the style and to their ability to read it – by which he means the ability to turn the mind from one *historia* to the next in order to grasp the connections. It is ultimately by their appeal to the senses that Dante describes the impact of the images on the observer, who is forced to bring to mind the words that the figures seem to be saying. The corporeality of the carved figures and the voice that seems to emanate from them thus rivet the senses and the attention not only of the *carnalis populus* (those clothed in flesh) but also of the disembodied souls.

Ordering the *historiae* therefore means not only choosing and arranging them in sequence according to their significance, but also seeking to control their *effect* by structuring the way they relate to each other (see figures 11, 12 and 13). The precision of Giotto's geometry in the Scrovegni chapel (*c.*1303–5) is much more than an 'example'. The asymmetry between the south wall which is punctuated by six windows) and the north wall which has no windows, is resolved by the invention of a well-adapted decorative scheme which uses the windows as a basic unit of measurement, making the window height equal to two panels, thus establishing the size and number of scenes in the two main tiers. Where there are no windows the squares are divided from each other by long bands, different from one tier to the next, which open out in the middle into quatrefoil lunettes depicting minor scenes, and in the bottom tier there are two mock veined marble panels to every block in the higher tiers, and these panels serve mainly to establish the principle of the division of the surfaces *per quadrate* (into squares), subject to a plan which demands the subordination of parts to the whole. Neither the frame borders of each panel (punctuated by rhombuses) nor the bands with the quatrefoil scenes can isolate the *historiae* from each other; rather, by structuring the available space according to strict rules, they indicate unequivocally the precise distribution of the components (pictorial or otherwise) within a scheme which is significant *in itself*. And though it was still the custom to accompany pictorial cycles with painted *tituli* (in verse or not, as the case may be) to explain the subject,[117] Giotto entrusted an arguably similar didactic function to the scansion built into the architecture, using it to point out not individual themes but the connections between them.

Figures 11 and 12 Scrovegni Chapel, Padua: the sequence of stories of the life of Christ on the south and north walls

Figure 13 Scrovegni Chapel, Padua: the sequence of stories of the life of Christ on the arch of the iconostasis

There is architecture within the panels:[118] the roof over the *Nativity* and the *Magi*, the classicizing arches and columns of the Temple from which Jesus drives out the money-changers, to the open loggias where the *Wedding at Cana* and the *Last Supper*, *Washing of the Feet* and *Pentecost* take place. Where there is no architecture, the stage is set by wings of mountains at the sides (as in the *Baptism*), or elsewhere; only in the *Payment of Judas*, the *Crucifixion* and the *Ascension* are there so many people present that the setting is characterized in any way. These 'sets' are not just a frame for the figures: by enclosing the space of the action, they base the narrative in a unified and coherent time and place which also dictate the co-ordinates of the memory. Where the architecture covers only part of the panel, it is arranged so as to make clear some distinction between the actors in the scene and the spectators (as in the *Nativity*); when it covers the whole space, it is closely functional to the distribution of the figures (as in *Jesus among the Doctors*).

The historical sequence of events determines the observer's itinerary. The life of Christ is divided on two levels, the first from the *Nativity* to the *Expulsion of the Money-changers from the Temple*, the second from the *Last Supper* to the *Pentecost*, so that the emphasis on the Passion (second level) is equal to the emphasis on the

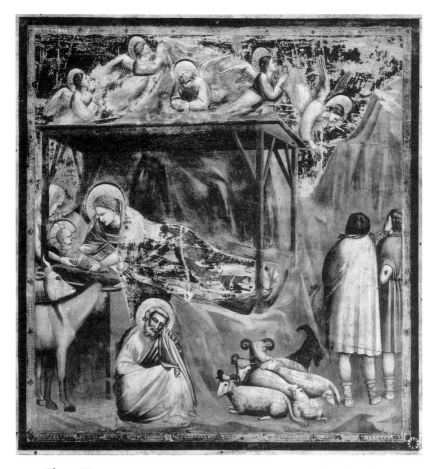

Plate 57 GIOTTO, *Nativity*, *c*.1304–15, Scrovegni Chapel, Padua.
Photo: Archivi Alinari.

whole of the rest of Jesus's life. Dividing the Gospel story into two
'chapters' and putting them on two different levels in strict geometri-
cal divisions gives a series of vertical associations, each pairing an
episode from Jesus's life before the Passion with an episode from the
Passion. These pairs are linked not just by the 'necessity' of the
structure, but more especially by connections which are sometimes
thematic, sometimes visual, and sometimes both at the same time.[119]
For example, on the north wall, the first four panels (two above and
two below) are linked horizontally by the repetition of the architecture

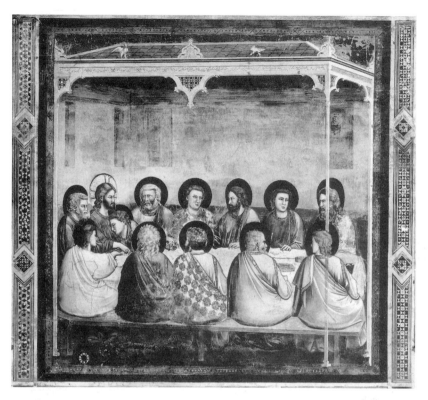

Plate 58 GIOTTO, *Last Supper*, *c*.1304–15, Scrovegni Chapel, Padua.
Photo: Archivi Alinari.

(two scenes with the stable roof, two scenes with the gallery of the Upper Room), which makes clear the close continuity between the scenes and the unity of place. But further still, in both the *Nativity* and the *Last Supper* Jesus is placed at the left-hand edge of the panel; turning towards him tenderly we have first the Madonna, then St John. The repetition of the gesture of tenderness, at the beginning of his life and the beginning of the Passion, stresses, in the very contrast it makes between the two ages of Jesus, his destiny from the first to redeem through pain and death: the visual connection thus establishes a thematic link also. The panels of the following pair are visually structured around two genuflections: above, the first of the Wise Men kneels in a gesture of offering and devotion to kiss the swaddled child; below, the adult Jesus stoops to wash the

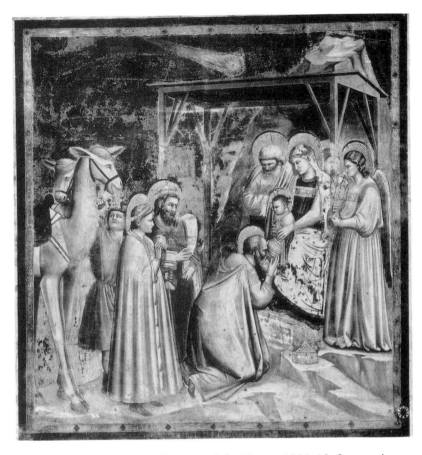

Plate 59 GIOTTO, *Adoration of the Magi, c.*1304–15, Scrovegni
Chapel, Padua.
Photo: Archivi Alinari.

feet of Peter and the apostles. The continuity between these two
stories and those which precede them horizontally, shown by the
repetition of the architecture, underlines the internal (vertical) con-
trast, thereby accentuating and exalting the Washing of the Feet: the
man whom the kings of the earth acknowledged and worshipped in
swaddling clothes is humble even to do this.

Here then, and in every other case, the accent falls on the scene in
the lower band (which is also the most visible): since the whole of
Christ's life works towards the Passion, prior events are presented,

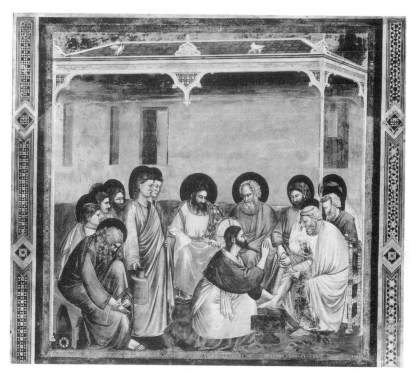

Plate 60 GIOTTO, *Washing of the Feet*, c.1304–15, Scrovegni
Chapel, Padua.
Photo: Archivi Alinari.

either by analogy or by contrast, as *prefigurations*, and organized
around the soteriological role of the protagonist. The itinerary of the
visitor, who is supposed to follow the scenes in their chronological
order, walking up and down the chapel, is thus not the painter's
only concern: knowing that, when one is close up, the eye inevitably
wanders from the panel one is observing to those around it, Giotto
has set up additional links on a vertical plane. The frame of reference
is still the 'typology' which reconciled the Old Testament with the
New around the Redemption, but the new concordances are all
within the life of the Messiah; similarly, the Peruzzi chapel offers
another set of concordances between the life of the two St Johns,
Baptist and Evangelist.[120]

In the last pair of panels on the north wall, we have the *Massacre
of the Innocents* above the *Flagellation* and *Mocking of Christ*: the

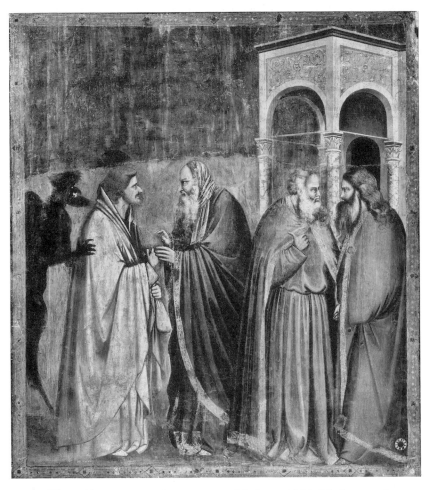

Plate 61 GIOTTO, *The Payment of Judas*, *c*.1304–15, Scrovegni
Chapel, Padua.
Photo: Archivi Alinari.

Innocent whom the soldiers of Herod could not find begins here
to shed his own blood. The incredibly densely packed scene of the
Massacre is dominated by the central figure of the ruthless assassin
who seems to rise up from the pile of babies already killed, ready
to plunge his sword into the body of another, whose mother is hold-
ing him back, though in vain. From a high balcony, which resembles

a corner pulpit from a church, a crowned Herod looks down, his hand stretched out to command the slaughter; on the other side, the dense group of grieving mothers is placed against an octagonal building which brings to mind the typology of the baptistery: baptism in water is thus equated with baptism in blood. These 'wings' on the set of the tragic stage are two pieces of architecture which together contrast the earthly power of a king against the redeeming power of martyrdom and grace; around them throng two groups who overlap at the centre: behind the 'principal' murderer is another, who is holding a child by the arm and killing it; but most of what is happening behind the foreground is hidden, and the effect remains 'suspended'. Reproducing the same scene at Assisi, Giotto(?) and his followers made the two groups 'slide sideways', so that of the two soldiers, 'the one holding the child in the air by the arm, previously half-hidden, is now fully visible. Moreover, the two figures have swapped clothes (the characteristic hood) and sword-grips.'[121] The fresco-painters at Assisi surround Herod with dignitaries on the balcony, and instead of contrasting it with a 'baptistery', they have a concise anthology of houses and towers; there are also armed men standing still, on foot and on horseback; in the two corners, there are many more *pietà* groups, and one mother is repeating St John's gesture of extreme desperation from the Padua *Deposition*, taken in turn from the Roman sarcophagi.

The use Giotto and/or his followers made at Assisi of the Paduan frame, which they took as a model, reveals how the scene is structured through overlapping wings, calculated on an architectural basis. It thus becomes clear that the spatial depth suggested by a carefully measured positioning of volumes was something that could be *read* and explored in all its potential. This construction, which uses volume to suggest not only relief against the background and overlapping planes, benefits from the wide use Giotto makes, at Padua and elsewhere, of figures seen from behind.[122] The small panel painting of the *Pentecost*, now in London, picks up the Paduan idea of the open gallery beneath which the apostles receive the flames of the Spirit; but a balustrade of inlaid marble, barred by a low studded door, isolates and encloses the main figures of the sacred scene: and the three windows in the back wall are also shut. With its obvious play on inclusion and exclusion, the architecture defines the levels of presence of the characters *in* the painting: three spectators stand *outside*, two of them symmetrically inclined towards the centre, looking at one another, their heads brushing against the edge of the balustrade; the third, solemnly draped, looks on, drawing his head

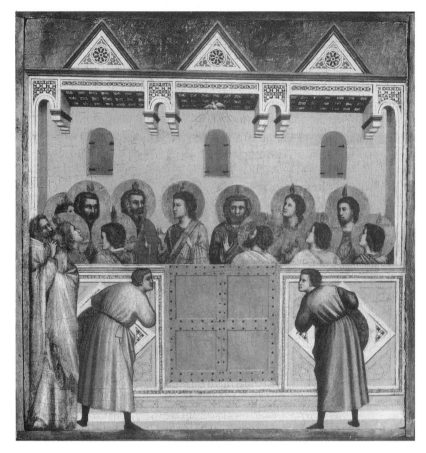

Plate 62 Ascribed to GIOTTO, *Pentecost*, *c.*1310–15, reproduced by
courtesy of the Trustees of the National Gallery, London.

close to the haloed head of the apostles, and stands in front of the
pilaster which frames them. Conforming to iconographic tradition,[123]
the *gentes* who marvel at hearing the apostles suddenly speaking
every language (Acts 2.7–13) are concisely represented here. But,
by turning their backs to the 'audience', the two figures beside the
closed door force the viewer not only to 'shift' the house in which
the Spirit is descending even further into the background; their very
anonymity, further enhanced by their symmetrical disposition (the
same cartoon seems to have been reversed and used again) makes

the two 'gentiles' watching the Pentecost *from within* the picture similar in some way to the churchgoer looking at the panel over an altar. They are seeing the sacred event *from outside*: but their measured amazement is only the first step towards a deeper involvement and understanding; the solemn, silent witness who draws his right hand from his rich cloak and raises it to his chin in a meditative gesture suggests, as well as amazement, some reflection on the Pentecost. The figure seen from behind, precisely because he is watching the sacred event from within the painting, to some extent 'comes out' of the picture, or invites the beholder to enter in; he builds a bridge between the holy protagonists and the anonymous multitude of the faithful.

The *Last Judgement*, which takes up the internal façade of the Scrovegni Chapel, is another, differently 'pasted-up' version of the same elements which comprised the corresponding programmes at Sant'Angelo in Formis and Ferrara, also repeating a model which seems already to have taken form in the Carolingian cycle of Müstair (Grisons).[124] It is in the lowest (and most visible) band that the programme becomes most complex and populated with new presences: hell catalogues a variety of punishments and damned souls, and a prominent hanged Judas; beside the cross supported by angels, Enrico Scrovegni is kneeling to present the Madonna with the chapel he wished to dedicate to her. Opposite, in the arch of the rood screen, beneath an *Annunciation* divided into two frames, Giotto inserted two scenes which tie in with the scansion of the side bands: a *Visitation* and, with most unusual iconographic importance, unparalleled elsewhere, the scene where Judas is paid by the priests for betraying Jesus (the imagined conversation is that of Matthew 26.15: 'Quid vultis mihi dare, et ego vobis eum tradam? At illi constituerunt ei triginta argenteos' (What will you give me, if I hand him over to you? And they gave him thirty pieces of silver). This Judas, *mercator pessimus*, who sells his Master for financial gain is thus placed exactly opposite the scene in which Judas hangs himself for shame; and the *only* time the devil, who is *never* seen in the cycles on the side walls (there are no *Temptations of Jesus*), appears is next to Judas with the bag of money in his hand: 'intravit autem Satanas in Iudam' (but Satan entered Judas) (Luke 22.3). Among the devils which populate hell, some of the damned are also clutching bulging purses: in fact avarice generally (and its retribution) has a special place in the iconographic programme of the chapel.

In Dante's *Inferno* the usurers also refused to be separated from their purses, which are labelled with their respective coats of arms:

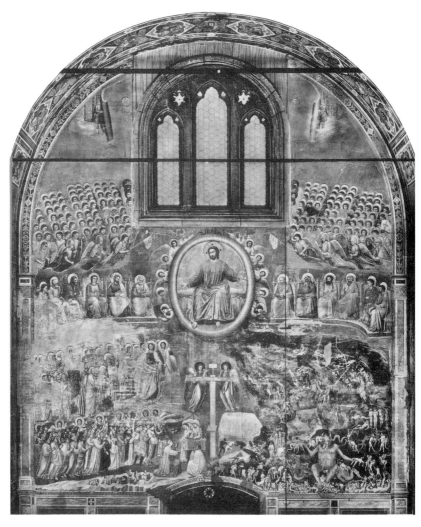

Plate 63a GIOTTO, *Last Judgement*, c.1304–15, Scrovegni Chapel, Padua.
Photo: Archivi Alinari.

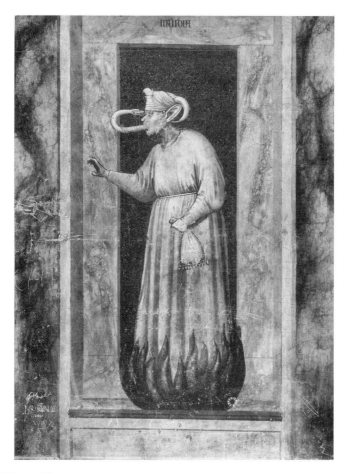

Plate 63b GIOTTO, *Envy*, detail from *Last Judgement*, Scrovegni
Chapel, Padua.
Photo: Archivi Alinari.

among others the 'scrofa azzurra e grossa' (fat blue sow) on a white
background denotes Rinaldo Scrovegni, the famous usurer (*Inferno*,
XVII. 64–75), father of Enrico. The sumptuous chapel offered by
Enrico Scrovegni to the Madonna can thus be partly interpreted as
expiation for the usury so widely practised in his family,[125] which must
have encouraged the dedication to Mary and suggested a few of the
figures, but is *not* the key to an understanding of the entire icono-
graphic programme. Presented not in the dimensions of one of the

damned but the size of an angel, and in a pious pose, in the most central position above the entrance door, Enrico Scrovegni thus distanced himself from avarice and usury, family vices from which he seeks to declare himself immune; even though it was family money that paid for the chapel (and Giotto's work). But the gesture of devotion actually translates into iconographic self-glorification: the patron not only violates the theological picture by placing himself right in the middle of a *Last Judgement*, but, by having himself painted to the right of the divine Judge, and contrasting himself with the avaricious who are punished in the horrors of hell, he is expressing much more than just the hope of his own salvation.

This arrogant epiphany of the commissioning patron could not go unnoticed: on 9 January 1305 the brothers of the neighbouring Eremitani (Augustinian friars) made a strong protest against Enrico Scrovegni's building and its decoration which, they claimed, were a source of '*grave scandalum, damnum, preiudicium et iniuria*'. In fact, the patron had wanted to go beyond the concessions granted by the bishop and transform the chapel into a proper church, open to the public, '*et alia multa quae ibi facta sunt potius ad pompam, et ad vanam gloriam et quaestum quam ad Dei laudem, gloriam et honorem*'[126] (and many other things which are done there more for show and for vainglory and profit than for the praise, glory and honour of God). *Quaestus* properly means 'profit, gain': in transforming a private chapel into a public display of pious generosity, Enrico Scrovegni is turning his gift to the Madonna into an instrument of personal and family propaganda, as part of his clever strategy of marriage alliances and ecclesiastical friendships, in vying with the Carraresi for a primacy which would ultimately lead him to the *signoria*.

So a 'total' reading of the chapel which Giotto frescoed would have to operate on several levels, none of which can really subordinate the others to the point of providing an explanation by itself. The actors on this Paduan stage are the *nobilis et potens Miles D. Henricus Scrovignus Magnificus civis Paduae* – described by his contemporary Giovanni da Nono as a hypocrite and a swindler[127] – the bishops Ottobono dei Raggi (up to 31 March 1302) and then Pagano della Torre, the Augustinian friars of the Eremitani sited near the Arena, and a painter from outside, Giotto. The audience is the city. Scrovegni has bought a large piece of land from Manfredo Dalesmanini (the contract still exists, dated 3 February 1300), and is adapting the existing buildings to form a sumptuous palace: it will of course be a family residence, but also a display of wealth, a

statement and an imposing image of his social status and his political capacities and aspirations. He wishes to attach to it '*unam parvam ecclesiam in modum quasi cujusdam oratorii, pro se, uxore, matre et familia tantum*' (a small church rather in the manner of some sort of oratory, for himself, his wife, mother and family only). The friars of the nearby Eremite monastery are not opposed to the project, reassured by the totally private nature of the *oratorium*, since there will, as the bishop's permission assures them, be no *concursus populi* there. The chapel's architecture is modest, as the agreement and prudence dictate; but for the decoration of the interior two well-chosen artists are called in from outside: Giovanni Pisano and Giotto. At the back of the apse, on the same axis as the entrance door and the high altar, the founder and commissioner of the chapel at least plans to erect his own tomb. In line with the prevailing current cult of Mary, the chapel is dedicated to the Madonna of Charity and/or the Annunciation; the first title certainly alludes to the contrast with the usury practised by his father: '*pro eripienda patris anima a poenis purgationis et illius expianda peccata*' (in order to rescue his father's soul from the pains of purgation and atone for his sins).[128] Enrico Scrovegni seems really to have abandoned the practice of usury between 1297 and 1300,[129] and the salvation of his father's soul must have been at least as much of a concern to him as his own public image as a rich *cavaliere*: therefore the chapel must be not just a votive offering but a manifesto.

Since the interior decoration *must*, in marked contrast to the simple exterior, be extremely sumptuous, the walls will be covered in frescoes; the chosen theme, a Christological cycle accompanied by a Mariological cycle, is quite an obvious choice in itself; less obvious is the iconographic programme, which selects and inserts each scene within a complex system of interrelations whose meaning, on a properly theological plane, can be understood only by finding the parallel or thread (not the 'source') in the texts of a contemporary preacher, perhaps. The help or advice of a cleric must have been enlisted at this stage (not necessarily, and certainly not merely as a guide) to assist the painter's choices. It was certainly the patron's idea to insert references to himself and his family into this wide network which links across the walls from one frame to the next: the two Judases who face each other and condemn the vice which Enrico has renounced; and the image of the patron himself, standing opposite the place where his tomb will stand, giving new dignity and prestige to this new Scrovegni. When the frescoes are ready, in all their radiance, the *oratorium* is opened to the public, breaking the agreement

made with the bishop, and immediately becomes not a private place of devotion, but something like a palace chapel; and the *concursus populi* is encouraged by the ringing of the bells (because the chapel has a belfry too). The friars protest, but in vain. A bull has already been drawn up by Pope Benedict XI of Treviso, calling Enrico Scrovegni *familiaris noster,* dispensing indulgences to anyone visiting the chapel;[130] and while the friars try vainly to have it closed down, Scrovegni obtains hangings and carpets from the Church of St Mark (the chapel of the Doge's palace) on loan from the Maggior Consiglio of Venice (16 March 1305) to make the ceremony of consecration more solemn (and more sumptuous). Devotion to the Madonna and the Passion of Christ, atonement for his own and his family's sins, the display of generosity, the exhibition of a structured public image are all interwoven not 'around' but *into* Giotto's frescoes.

If there were any truth in the (uncertain) attribution to Giotto of a canzone against poverty,[131] we could stress in the painter's own words the positive value of wealth, provided one is not greedy, and transcribe here his harsh condemnation of poverty, which everyone praises, while at the same time 'they think and do all they can to get out of it', with a 'hypocrisy' that 'spoils the world'. Whether or not they are by Giotto, these lines betray an openly mercenary moral sense, which Giotto may well have shared, not just because he often practised usury,[132] but more in view of the use he made of his own art, turning it into a workshop system which employed a team of carefully chosen collaborators to spread the Giotto 'trademark' much further than would have been possible for one man on his own.[133] But in setting up a workshop (which means distributing and organizing labour) one is also of course setting up a school (which means spreading compositional models and stylistic choices); and from then on it is the school which ensures the development of the painter's immediate reputation, making him the undisputed *maestro.*

But Enrico Scrovegni's painter is the same man as the painter at Assisi. This patron laid claim to a role hitherto reserved for bishops, abbots and sovereigns. The invasion of the devotional scene by the merchant middle class is complete; and despite a strictly orthodox iconographic programme and the sanction of a papal bull, the progress from a private commission (not of a painting, but an entire church!) to a public purpose still gives *grave scandalum.* The painter at Padua is the painter at Assisi. And had St Francis not once been a merchant? In the pauper saint's biography we see reflected a clear example of the relationship between the growth of the merchant class

and the success of the mendicant orders: opposite but complementary sides of the same coin. The rise of the merchants disrupted the vision of the *ordines* of society, which had changed from being simply a division (and description) of the world and become more and more sacred, taking on the appearance of a divine plan, in which the distinctions between the various *ordines* were as important as the definition of the hierarchical relationships which bound them in a close-knit system. Therefore, even knights were part of the *ordo*, but merchants were not: 'free from personal ties, free from the services imposed by fief-holding, manipulating money without working; they disturb the conformist system of ethics which was insensitive to the new market economy', and 'did not constitute an *ordo*'.[134] In the antithesis between wealth and poverty, the central problem is always the same: and so now in the hierarchy of sins, pride gives way to avarice.[135] However, in the series of didactic images of contrasting vices and virtues which decorate the dado panels in the Scrovegni Chapel, *Avaritia* is not shown, and *Charitas* is opposed instead by *Invidia*, which thus makes its first appearance in a painted cycle of vices and virtues. But the iconography of this vice, which the inscription above it explicitly identifies as *Invidia*, is constructed from attributes which are almost all taken from the iconography of *Avaritia* (the hand clutching the purse, the long ears, the horns . . .).[136] So it is the name, rather than the vice which has disappeared from the cycle, and the figure of *Invidia* also squeezes in the figure of avarice, with an important change of meaning; in the chapel of the usurer's son turned generous benefactor to the Virgin and the city, the shift from *Avaritia* to *Invidia* suggests that the figure should be characterized instead as 'envy of riches'. And so the personifications in the dado, placed in a more abstractly and statically didactic dimension by their treatment in *grisaille* (which contrasts sharply with the brilliant colours in the gospel scenes above) put in a more abstractly and statically didactic dimension, are also nevertheless linked to the others by direct references: the hanged body of *Desperatio* corresponds to the hanged Judas. In the figure of *Invidia* and the despairing fate of Judas it is not the amassing of wealth that is condemned, but the damaging greed that is never satisfied: precisely as in 'Giotto's' canzone. That the hugely wealthy Enrico Scrovegni, no longer a usurer, gave generously of what he had, without avarice and without envy, is still to be seen in his chapel.

If a merchant can be included in a *Last Judgement*, saved in advance, then the present has intruded into the painting, and the divisions between the sacred and the profane are blurred and

violated. It was easier for the living to enter into this new kind of painting which seems to 'stand out from the wall'. Franco Sacchetti, the story-writer (1332–1400), put the problem of *Dipinture de' Beati* (paintings of the elect) in a letter to Jacopo del Conte of Perugia,[137] protesting at the number of these 'upstart saints' who were understandably 'making people lose faith in the old ones'. And everyone was inventing their own saints: 'the Dominicans have beatified Villana, who was my neighbour, a young Florentine woman; she looked just like anyone else, and they are already celebrating her.' We might say that the 'aura' of sanctity had been lost. Faith had slipped away and self-interest prevailed: Urban V was already being venerated as among the blessed, although no one had yet beatified him; there was already a picture of him in the baptistery in Florence, but it must have been painted by someone who 'owed him a favour'. Urban V is the pope of whom Petrarch wrote (*Senili*, XIII, 13) that 'in order to please men, he displeased Christ, Peter and all the saints.' When he returned to Rome, it was around him that all those who wished the papacy to be brought back to Italy focused their hopes, and later their disappointment when he left Rome to go back to Avignon. The vicissitudes of his reputation are linked to the different phases of his attempts to 'please men'. Sanctity had become temporalized; and Sacchetti was right to deplore the homage rendered to Urban V:[138] the French pope was only beatified by Pius IX in 1870. It is against these popular devotions which pervert the 'old' religious practices, bringing current affairs to the altar, that Sacchetti is protesting. But the old devotion to the *Holy Face* also seems to him to be superstitious and irrational: 'if people hang votive pictures from it, I think it must be because his face is so frightening'; and 'who could say it is the image of Our Lord?' Jesus surely did not have, as the Lucca crucifix has, those 'rolled-back, terrified eyes'. So in what direction should devotion be moving?

In the *Regola del governo di cura familiare* (Rules Governing the Care of the Family) written by Blessed Giovanni Dominici in around 1400 at the request of Bartolomea Obizi, wife of Antonio Alberti (cousin of Leon Battista), the 'first little rule' for the 'nurture of God's children' is

> to have *paintings in the house* of holy children or young virgins, in which your child, while still a babe in arms, will take delight, *as like by like enraptured*, with actions and signs pleasing to infants. And as I say of painting, so it is of sculpture also. The Virgin Mary with the Child in her arms and a bird or a pomegranate in her hand is a good

idea. A good figure would be Jesus at the breast, or Jesus asleep on his Mother's lap; Jesus standing politely before her, Jesus trimming and Mary sewing the trimmed edge. Thus may the child *see itself reflected* in the Holy Baptist, dressed in camel skins, going into the desert as a young child, joking with the birds, sucking the honeyed leaves, sleeping on the ground. It would do no harm to see paintings of Jesus and the Baptist, or Jesus and the Evangelist together as small children; the massacre of the innocents, in order to instil fear of weapons and soldiers.[139]

Images too were on the increase. The 'little rules' of this tiny treatise on iconography for children can be projected on to the adult context. One little holy picture is not enough, but they should 'with many paintings almost make a temple within the house'. In laying hold of sacred iconography and bringing it within the walls of their homes, lay patrons were avoiding any kind of ecclesiastical filter between themselves and the painters. But if we transfer the rules which the Blessed Dominici more explicitly lists for children into everyone's houses and rooms, then we will ourselves be taking on the same repertoire of themes and, more importantly, the same general attitude as church paintings. *Ad excitandum devotionis affectum* (to excite the mood of devotion) the faithful (adults and their children) must *see themselves reflected* in the pictures they are observing, 'as like by like enraptured', and glean from them instructions on how to behave from them. But in order for the painting to be 'like' the observer, the figures must be constructed with 'actions and signs' (gestures and attributes) which are 'pleasing', i.e. which delight and foster the impression of 'likeness'. The *exemplum* has become a *mirror*: the appeal to the senses was the foundation, and now the evocation of events and feelings through images has found its cornerstone in the observer's *emotional identification*; and it is towards this identification that the painter must work to compose the figures in the picture, along with their 'actions and signs'.

'Come pintor che con essemplo pinga'

In an art which has no written *praecepta*, what is the role of the master? As often happens, the simplest way to answer this question is, in some sense, to turn it around, rephrasing it from the follower's point of view: what (and from whom) should a painter learn? Cennini's *Handbook*, and other similar works, imparted a wealth of technical instruction which should certainly have been part of any

apprenticeship. But to reduce a painter's training to this would be like giving a description of a medieval school which concentrated solely on how to sharpen the quill, dip it in the ink and guide it across the paper or parchment. Let us stay with this parallel for a moment, though it is in many ways inappropriate: the painter's work certainly has a much greater 'technical' dimension (in the sense we have just used it) than the writer's, and yet the analogy certainly does not end here. The new painter does not just learn how to mix colours, but also (and at the same time, of course) the correct way to do this or that figure or scene, in accordance with the dictates of the usual current market demands. 'The artist like the writer needs a vocabulary before he can set about copying reality.'[140] Sometimes a poet, in order to describe a sunset or a warrior, finds it easier (or more effective) to transcribe whole (or to rework) a formula which others have used before him, borrowing not 'words', but the actual order and metre in which words are arranged; and sometimes a painter translates into his own painting (and into his style) iconographic formulae which others have already used; he still needs 'words', that is basic iconographic units with which to reproduce or compose types, schemes and formulae. The custom of exporting from a model compositional formulae of varying sizes, which of course still goes on nowadays, could pass relatively unnoticed when each painting was firmly attached to one particular place, and a comparison between different paintings was practically impossible, unless one had the patience to copy them down on a sketch pad. The ordinary visitor never did any such thing; and the artist, who on the contrary probably did go around sketching, did so precisely in order to use these sketches later in his own workshop.

The repetition of a limited number of iconographical types, with few variants (for example the *Madonna and Child*, the *Crucifixion*, the *Judgement*) is commonly perceived even by the most inattentive visitor to churches and museums. *Iconographic tradition*, which explains this continuity of types, at the same time guarantees the continuity of the meanings which are closely bound to each iconographic type (or scheme). As in language, we can be reasonably sure that a word means the same thing in the thirteenth century as in the eighteenth century (as today), simply because it has continued to be used and understood. The same can be said of a painting, which is not just a collection of images, but something which mediates, through those images, a social relationship between people which someone has tried to translate into a message. However, language belongs *to everyone*, and painting does not; language is above all a spoken

thing, and therefore writing is (and used to be far more) a filter of social exclusion and selection distinguished to some extent by the sound and meaning of written words; whereas painted figures do not just filter, but actually *are* the language. *Ut pictura poesis*, not *ut pictura verbum*: and since the reality which word and figure strive to reproduce is the same reality, in the figure the two dimensions (written and spoken) which verbal language allows us to distinguish between are brought together. Therefore cultural and social elites have always had much greater control over communication through images than through words; conversely, a system of communication through images has a much greater area of intelligibility than any language of words, both because it has a more direct relationship with visible reality (compare, for example, the relationship to a *real* woman of an image of a woman and the various words for 'woman'), and because the relatively low number of producers of images (artists and patrons) restricts the formation of indigenous variants (an isolated valley may 'produce' its own dialect, but call in painters and sculptors from outside). The paradox of iconographic language is that, from a relatively very small number of intended recipients, it eventually reaches a relatively very large audience.

So to learn the art of painting one must also learn its language, because every request of the commissioner must be translated and articulated through that language. One must also learn the 'stories' to be painted: because, as Vitruvius had already warned architects, 'you must always be able to explain the reason why the figures are depicted, if someone asks' (*De architectura*, I. 1.5). The artist must represent the plot of these stories through images (types and schemes) which – like words – have not been invented on the spur of the moment, but dredged from the deposits of memory or from a pattern-book (and only in so far as they belong to a language can they be understood). The artist must choose and compose the figures which the pattern-book or the memory suggests according to a series of interrelations, 'tailoring' them according to the thread of the story to be related, the size of the wall to be frescoed, 'pasting them up' according to approved schemes, or attempting to introduce new ones.

Iconographic tradition thus resembles (though it is disorienting to point out the similarities instead of the differences) manuscript tradition; perhaps not so much the tradition of a classic and un-assailable text, such as Homer, where the best copyist is the most diligent one, who adds nothing and omits nothing, but rather the tradition of 'popular' texts, like the *Romanzo di Alessandro* or the

Physiologus, or certain lives of the saints, which even the most learned and/or imaginative copyists were unable to transcribe without enriching them with new stories, changing the order of the different parts, or colouring them with a new finish of their own. Therefore critical editing becomes an impossible task as the list of variants swells, and philologists find themselves having to divide the manuscript tradition not into 'branches' but into a number of different readings; but with so much 'editorial' freedom to make changes while copying, every manuscript *is* arguably (and potentially) a new reading. Is this plagiarism? Of course not. Only in 1791, and in Paris, naturally, did there begin to be talk of authors' rights, for literary works; but even today there is enshrined in practice a fundamental difference between a literary work and a painting: one may not copy the *plot* of a novel (even using different words to narrate it) without infringing the author's rights, but one is allowed to reproduce the general look of a painting (the arrangement and interrelation of the figures) provided that one does not copy the style. Picasso can copy Van Gogh, providing his picture is recognizably a Picasso; if instead it was entirely and solely like a Van Gogh it would be a fake.

In iconographic tradition the repetition of a type or a scheme is therefore not a *copy* (the copies of the *Holy Face* are devotional copies); instead it defines that language of images for which artists could find no dictionaries or written rules, and which was kept instead, as Filippo Villani says, in their *tenax memoria*, a memory which must also be shared in common with their audience; if not, whom would the figures be addressing? Common to the artist, his patron and his audience, the system of relationships between images and meanings is, thus, a *code* which must in principle be understood by everyone. Only within a whole system supported by memory, and against a background of images which repeat time-honoured types and schemes, is it possible for Giotto, for example, to play with freer invention, articulating gestures and compositions in a new way, still speaking the same language, and yet making it more rich and flexible, renewing it from within.

If we borrow some of the criteria and methods of textual philology, we can recognize 'lines of tradition', and distinguish derivations and variants. The cycle of paintings (preserved now only in seventeenth-century copies) depicting the lives of the apostles Peter and Paul in the portico of the old basilica of St Peter's in Rome gave birth to a whole progeny of iconographies, especially as the fame and authority of the place where they were located itself suggested

them as models for other painters. In the *Crucifixion of St Peter*, the Vatican painting showed the cross upside down with the saint in the centre, between two groups of figures, each grouped around a monument of imperial Rome: on the right, a sort of obelisk which must be the so-called *Terebinthum*, and three haloed figures, one of whom is leaning on a shield; on the left, a kind of pyramid, probably the *Meta Romuli*, with two spectators looking out from behind it, while another little group is gathered in front of it. In a fresco at San Piero a Grado near Pisa and in an Italian manuscript now in Hamburg we find the same scene, with some notable variations (particularly in the page of manuscript, where it is confused with other scenes); but we can recognize the strong Roman model particularly because we can again see the two small figures peeping out from behind the *Meta Romuli*.[141] The recurrence of this *lectio difficilior* indicates the possible archetype and identifies a line of tradition.

In order for a painter to remember things so accurately, even the best memory was not enough on its own. Among the practical advice dispensed by Cennino Cennini to those wishing to learn art, he recommends that they go around 'to churches and chapels', taking care to bring along 'a pouch made of pasteboard or just thin wood . . . this is good for you to keep your drawings in, and likewise to hold the paper on for drawing.' It is better always to 'go out alone, or in such company as will be inclined to do as you do, and not apt to disturb you', like other painters; to choose carefully which stories and figures to copy, and to work with the very greatest diligence, crossing out and starting again if necessary, until 'your figure agrees in proportion with the model' (chs 29–30). Cennino is not putting forward his *own* rules here, but is simply describing a universal practice. The painter's apprenticeship includes the preparation and collection of a repertoire of models, taken from earlier art: 'album pages' which are both a stylistic exercise and a 'lexical' record of iconographic types and conventions, 'figures' and 'stories'. Whether isolated or kept in books, these drawings should be part of every painter's equipment, naturally passing from one to another as necessary, and yet always remaining functional objects, not works of art, strictly professional notebooks. This is why there are so few examples of them surviving from before the Quattrocento.[142]

Coming to us from an age when there was no other known method for reproducing images, these drawings provide us with a kind of trail of clues to medieval tradition.[143] Of course, only very rarely were copies made of whole cycles of paintings: the parchment scroll

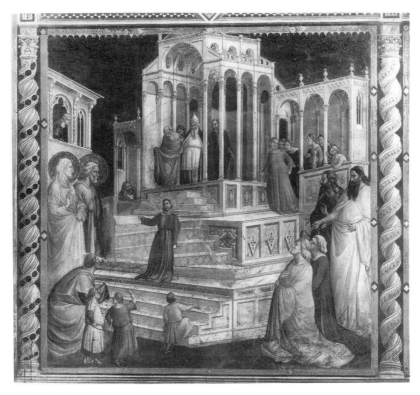

Plate 64 TADDEO GADDI, *Presentation of the Virgin*, 1332–8,
Baroncelli Chapel, Santa Croce, Florence.
Photo: Archivi Alinari.

on to which the paintings from the ceiling of Sant'Eusebio at Vercelli,
painted at least a hundred years earlier, were diligently transcribed
in the first half of the thirteenth century, is quite exceptional; as two
pairs of couplets at the beginning and end explain, the *longa vetustas*
(great age) of the paintings has taken its toll, and the drawings on
the scroll were to be used as a guide for repainting them (*ut renovetur
novitas*).[144]

More often the drawing would be of a whole 'story', as Cennini
indicates, in order to assimilate a composition which was considered
exemplary, or which a painter wished to declare as his model. One
case of this kind is the drawing in the Louvre which reproduces the
Presentation of the Virgin by Taddeo Gaddi from the Baroncelli

Chapel in Santa Croce with remarkable fidelity. It is not a 'preparatory drawing' by the painter himself, but, by its very detailed accuracy without alterations or deviations, a copy by a painter whom we can well imagine at work in front of the fresco, resting his paper on his 'case of wood'. The desire to assimilate and reproduce the tricky architectural perspective, which achieves 'the maximum obliqueness and complication'[145] for the time, is sufficient to explain the copyist's great diligence; the placing and blocking of the figures, as well as their proportional relationships, are based precisely on that architecture, which thus determines the iconography, and this is also the *innovation* which makes Gaddi's fresco a challenge and a model. This drawing may therefore well be the intermediate stage between Gaddi's *Presentation* and the one in the Rinuccini Chapel, again in Santa Croce: compared with the model (which there was evidently no compunction about reproducing only a few yards away), the new version had to be adapted to a more vertical format, and therefore the architecture is stretched upwards, making it more 'Gothic', and more figures are crowded in, their symmetrical arrangement made rather more complicated by organizing them into lateral groups. Moving around the same church, the painter of the Rinuccini Chapel probably started by recopying *to the letter* from Taddeo Gaddi the scene which he had been called in to depict, and then reproduced it in his own fresco with iconographical *variations*, and naturally in his own style.

But in most cases we find that in almost all the painters' sketchbooks

> whole compositions are lacking. Even where the artist is working from examples that can be reconstructed . . . or from known examples there is no question of his taking over the entire composition . . . The figures . . . inhabit the no-man's land between one work of art and another . . . In this way the artist keeps at his disposal a number of entities which, according to the requirements of the work in hand, he can bring together into a compositional whole. This combining process takes place on the panel or wall itself . . . The figure or group (. . . or parts of figures: full-length busts, lower limbs, leg positions or gestures . . .) forms the entity which we can call the smallest possible artistic unit used by the medieval artist.[146]

For example, a sheet from the Uffizi sketchbook already discussed (*c.*1400)[147] gathers together, jumbled up in no particular order, no fewer than twelve different drawings, with nothing that necessarily links them to one another: from a complete *Resurrection* to a lone

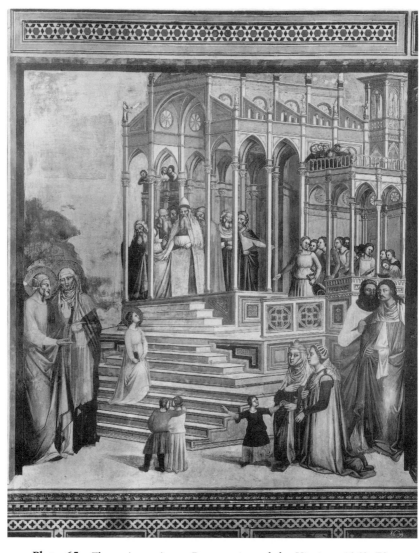

Plate 65 Florentine painter, *Presentation of the Virgin*, *c.*1360–70,
Rinuccini Chapel, Santa Croce, Florence.
Photo: Archivi Alinari.

peasant shouldering his spade, from St Catherine of Alexandria to a flagellated Christ without persecutors or pillar. But these are 're-corded and ready for use' (for insertion, on a wall or in a painting, within a complete *Flagellation*). In this 'travel sketchbook', an artist has made notes for later use of the schemes and themes he came across on the way.

The drawing which the painter gleans from his wanderings through churches and chapels, from frescoed walls and paintings, in order to transfer it later from his 'pouch' into his own reservoir of ideas and models is thus an 'example'. At the end of the *Purgatorio* (canto XXXII), Dante tells us that he was unable to listen to the song of the twenty-four elders near the 'stripped tree' of the Earthly Paradise, because he was overcome by its sweetness; nor – he adds – can he tell how he fell asleep: and who could?

> S'io potessi *ritrar* come assonnaro
> li occhi spietati udendo di Siringa
> li occhi a cui pur vegghiar costò si caro,
>
> *come pintor che con essemplo pinga*
> *disegnerei* com'io m'addormentai
> ma qual vuol sia, che l'assonnar ben finga. (64–9)

> (If I could *portray* how the pitiless eyes [of Argus], hearing the Syrinx, were put to sleep, those eyes whose watchfulness cost so dear, *I would draw as a painter paints from a model* how I fell asleep, but let anyone who can *reproduce* sleep do so.)

Since the divine *melius scitur nesciendo* (is known better by not knowing), the poet can tell of his experience (which is in fact ineffable) only by constant recourse to the rhetorical device of aposiopesis (or *reticentia*). To 'draw' how he fell asleep would be better than telling it in words: but, even if he were a painter, he would still need and does not have an adequate *essemplo*. For Dante to paint his dream he needs a model, a painting of the sleep of Argus; and the lack of an *essemplo* restricts the painter's space. Moreover, it is to mythological themes and to classical art that we are now looking for *essempli*; the existing language is no longer sufficient for these prodigious events and extraordinary passions.

Of course we do not know when, 'considering the excellence of this work which greatly delighted him',[148] the wandering artists began to add drawings of ancient sculptures to their sketchbooks. Nicola Pisano must have done it, if he was using the Pisa sarcophagi as

essempli; but the earliest surviving example is the famous sketch-
book in the Ambrosiana, which may have passed from Gentile da
Fabriano's workshop to Pisanello's: drawings made from sarcophagi
alternate in these pages with angels, madonnas, apostles, copies from
Giotto, Altichiero, Donatello.[149] From the pool of antiquity, as from
paintings by the masters, the artist drew material for his patternbook
of *essempli*.

In the same period, Donatello did not just study sarcophagi, but
talked about them to friends and colleagues, and became an enthu-
siastic 'propagandist' for them. Vasari's anecdote about him and
Brunelleschi[150] is echoed and supported by the brisk words of two
letters from one of Donatello's assistants, Nanni di Miniato, to Matteo
Strozzi, dated 1428 and 1430:

> I advise you that there are two small tombs between Pisa and Lucca,
> one at San Frediano near Lucca with the story of Bacchus, and the
> other near the hill at S. Giuliano in a church called Vicopelago . . . with
> sprites on it . . . According to Donato they are favoured works . . .
> Donato has praised them as good things.[151]

People went *looking* for antique models, with burning determina-
tion; sarcophagi which seem to us to be dull and mass-produced,
like the one in Cortona, aroused new enthusiasm, because the move-
ment of the figures, their nudity, the wide, 'hyperbolic' gestures,
which seem to reflect a world of primordial tensions and passions,
made those damaged reliefs seem animated by living 'sprites'.

Thus was the lexicon of painting composed, by amassing the
essempli which all the painters took from churches and chapels, and
later from antique sarcophagi as well, and which the greater artists
enhanced and renewed. We cannot expect ever to find it set down
as a firm set of rules, listing formulae for each story, and stories for
each formula. Western art has never had a 'book of painting' like the
one on Mount Athos:[152] the frozen language spoken by the 'models'
from frescoes and paintings was always warmed by the breath of a
keen yearning towards truth to nature, found in the movement and
freedom of the poses of antique sculptures.

But how does the painter address the theme dictated by his com-
mission? The growth of the merchant class led to a sudden increase
in the demand for images which usually repeat a few 'central' sub-
jects, such as the Madonna and Child or the Annunciation. The
proliferation of orders for the same sort of images naturally led to
'competition' between artists, which is also reflected in the way

they *intentionally* took their different places on the pay scale. But competition between artists works through a constant quest for new inventions (which can only in the most abstract sense be divided into stylistic and iconographic innovations) which modify current conventions, making them more *real*. This quest moves in three directions: a) variations *within* a type, by adding or subtracting attributes, peripheral characters, breaking up or rearranging the composition (a different positioning of the same figures), or by increasing or reducing the emotional charge; b) creation of new *types*, responding to the same subject by substituting equivalent schemes; c) introduction or reintroduction of entirely new or unusual or rare themes, which are narrated by adapting current conventions, or which stimulate the invention of new conventions. Even the partial adjustment of a convention can in principle be a step towards the 'real', and in fact, if it is taken up and repeated by others, it creates a new convention. The proliferation of demand thus leads to a wider diversity in religious iconography.

When presented with the theme dictated by his patron, an artist must have ready (in the workshop's 'drawing case') more than one possible solution to choose from. This is why the Uffizi sketchbook has made notes for six *different* Madonna and Child groups, as well as three Virgins Annunciate and three announcing angels (only in one case do two adjoining pages form a complete *Annunciation*). And this is why in a single page in the Louvre, which has been attributed to Tommaso da Modena, three *different* Annunciations are crowded in with other figures: in the first, Gabriel is kneeling slightly, raising his right arm and turning his head upwards towards a seated Madonna, who has her arms crossed on her breast in a gesture of acceptance and humility which must have been absolutely standard, since in all three variants it is exactly the same. But in the second the Angel is standing, with Mary kneeling before a lectern on which an open book is lying; in the third, both are kneeling, the Angel with a slender heraldic lily in his left hand, and Mary's kneeler has grown into a canopied throne and a fretted reading stand, both set in perspective.[153]

From a sermon by the impassioned fifteenth-century preacher, Fra Roberto Caracciolo of Lecce, we can gather a kind of 'catalogue' of Mary's emotional reactions to the news of the Incarnation: 'conturbatio, cogitatio, interrogatio, humiliatio, meritatio'; for each of these it is easy to find an equivalent in contemporary painting.[154] We can distil, from sermons, stories, letters and poems, a whole implicit 'book of painting' on the subject, collecting the *praecepta* which have

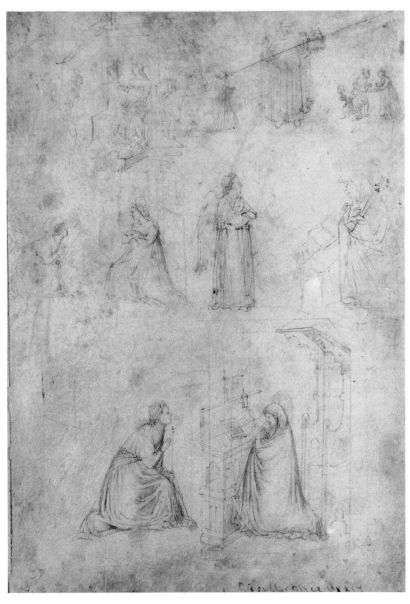

Plate 66 Attributed to TOMMASO DA MODENA, page of drawings,
c.1360–80, from Cabinet des Dessins, Musée du Louvre. © Cliché
Musées Nationaux, Paris.
Photo: Réunion des Musées Nationaux.

not been handed down by specially written books, gleaning them instead from the testimony of religious and lay people. And it would be a useful catalogue, although the more one sought to reduce it to a fictitious unity, the more artificial it would become. People's perception of images and their discussions about them certainly deposited a whole 'iconographic consciousness' which sometimes translated (as in Fra Roberto of Lecce's sermon) into explicit categorization, although it never became a 'system'. So iconography and its innovations work in equilibrium between absolute singleness (in principle) of the general trend and the plurality of variations *within* it, which can lead to the invention of new variants: but the boundary which cannot be overstepped is that of orthodoxy and decorum, which tradition itself establishes and maps out.

Soon after 1340, on commission from a patron whom we cannot identify with certainty, Ambrogio Lorenzetti and his assistants began painting, in the oratory of San Galgano a Montesiepi, a small cycle of frescoes, including, on either side of the window above the altar, an *Annunciation*.[155] Now that it has been so carefully taken down and restored, we can read this painting in four successive states: the first is the sinopia, showing in broad, confident lines the figure of Gabriel kneeling, holding out a palm towards the Madonna, while another figure, standing, stops on the threshold of a door behind them. On the other side, Mary is so overcome by the Annunciation that she has collapsed to the floor in dishevelled clothes, clutching at a column and hardly daring to turn her tense and frightened face towards the angel. Superimposing on the gospel text a legend which was alive in the Holy Land (Borsook was able to quote the account given by a Tuscan pilgrim in 1346–50, Fra Niccolo da Poggibonsi), we have here for the first and only time in Italian art, a portrayal of the terror which struck the Virgin when she saw Gabriel; pilgrims to the Holy Land were shown 'the column which St Mary held on to for fear when the angel announced to her'. This 'fear' is not found in Fra Roberto of Lecce's classification: the furthest that contemporary Sienese painting gets is the *conturbatio* of the Virgin (of which there are famous examples): the portrayal at Montesiepi is, therefore, an experiment.

When the fresco colours were painted on to this splendid sinopia, the general outlines of the composition were respected; only the lone figure of the spectator behind the angel was excluded, and the door shown closed (the second stage). However, not long afterwards, the frightened Mary was carefully eliminated and replaced (perhaps by Pietro Lorenzetti) with the canonical image of the Madonna humbly

accepting her destiny as mother of the Word, crossing her hands on her breast, with a no more than preoccupied expression on her face (third stage). Later, behind the announcing angel was added, on the dry plaster, the kneeling figure of the patron, most probably an ecclesiastic (fourth stage).

This fresco thus tells us the whole of its history, from the boldness of the painter who transported the figure of Mary from the atmosphere of *humilitas* to an earthly, human terror, until the 'normalizing' intervention of a patron who wished the figure of the Annunciate Mary to be restored to full orthodoxy. This is not to say that Ambrogio Lorenzetti was actually heterodox: his innovation is soundly based on a legend rooted in the pious accounts of pilgrims returning from Palestine; but it was without precedent in the strict iconographic lexicon. Of the three changes made to the sinopia, we can confidently ascribe the last to the patron, and perhaps to a *second* patron, if we find it hard to believe the original patron would have been so lacking in foresight as not to have told the painter right from the start that he wished to see his own devout image behind the angel. The first patron must be responsible for the disappearance of the onlooker in the doorway, lost in the transition from sinopia to fresco, although it is clear that, at this stage, the 'frightened Mary' had been acceptable to the patron, and was in fact painted on the fresco. So this change, which is the most radical alteration, can be attributed in all likelihood to the transfer from a first to a second commissioning patron; one naturally assumes a change of abbot at the Cistercian monastery of San Galgano.

Thus Ambrogio Lorenzetti's innovation is an iconographic invention which never became a convention (and therefore still seems to us extraordinary, superbly isolated): but for that precise reason it bears very important witness to the quest for new iconographic schemes which *can* affect the existing common language, either enriching it or changing it profoundly. In the lexicon of Christian iconography Mary's swooning at the foot of the cross was accepted (albeit toned down from Nicola Pisano's hyperbolic experiment); her fear in the presence of the announcing angel was not. Convention overcame experiment, because the terrified retreat of the Virgin, a forced and exaggerated version of the *turbatio* of which Luke speaks (1.29; cf. 1.30: 'ne timeas, Maria', do not be afraid, Mary), would have gone against the whole of the Mariological cult, which centred around the perfection of grace in the person of the Mother of the Word made flesh.[156] A fourteenth-century manuscript of the *Meditationes vitae Christi* (in the vernacular) shows in two successive illuminations the

perturbation of the Madonna and her acceptance; the instructions written for the illuminator *before* the drawings were made show the different meanings of the two iconographies: in the first, the sudden appearance of the 'angel giving the message', in the second 'how Mary accepts', with her hands crossed on her breast.[157]

The rule of *decorum* (in the sense of measure in the expression of passions) can thus be invoked to lower the threshold of these figurative hyperboles. In his treatise on painting, Leonardo described 'an angel, who looked as though in announcing he wanted to chase Our Lady out of the room, with movements showing as much insult as one would reserve for one's worst enemy, and Our Lady looked as though she was ready to throw herself out of a window in desperation.'[158] But the measure which Leonardo is recommending to painters is not shared by everyone; the example he recalls so vividly and disapprovingly is a painting of his own time, which could easily be an *Annunciation* like the one (now in the Louvre) painted in the late Quattrocento by the Milanese artist Carlo Braccesco, where the Angel is plunging obliquely down towards a highly gilded Madonna in a black cloak, who has just leapt up from the kneeler and grabbed a column, showing a fear that is rather ceremonial and full of studied elegance.[159] Fifty years on, in the first edition of the *Vite* (1550), Vasari seems to reverse Leonardo's opinion: if he gives 'special' praise to an *Annunciation* by Giotto at the Badia in Florence, it is precisely because 'he has represented with extraordinary truth the fear and astonishment of the Virgin Mary, who, in her terror at the salutation of Gabriel, seems ready to run away'.[160] The little that remains of this scene, which has recently been taken down and restored,[161] suggests that Vasari, in describing the poses of the figures, must have overstated the case, exaggerating its 'expressiveness': contrary to Leonardo's opinion, the liveliness of movement which gives the impression that the Madonna is about to escape, is for Vasari a great artistic merit. The quest for new formulae is increasingly matched by fresh debate among painters (and their patrons) as to what is permissible and what is not; as to the identification of 'movements in keeping with what is happening in the mind' (Leonardo);[162] and basically as to the make-up and the limits of pictorial language, from the gestures of individual figures to the *compositio* of the whole.

Iconographic (and stylistic) change is thus founded on the interaction between experiment and convention: new types and schemes are grafted on to the established lexicon, which necessarily continues and ensures continuity of tradition; the introduction of a certain number of new types and schemes is partly balanced by the gradual

abandonment of a certain number of conventions which thus 'drop out' of current usage. The grafting of new types and schemes may or may not succeed every time it is attempted; therefore we can distinguish clearly between the experiments which were 'rejected' (like the terror of the Annunciate Mary) and those which were instead absorbed into the lexicon of usage (like the swooning of the *Mater dolorosa*). The great tree of iconography has its barren branches, but not always for lack of 'artistic' vigour.

Even more dramatic emphasis had been placed on the sorrow of the Virgin at her Son's death by the great German mystical tradition: because the passions of all men are reflected especially in Mary, woman and mother; and from the eyes to the heart of the faithful her *conturbatio* and *lamentatio* cause deep-seated emotions to resonate, and lead to meditation, which becomes a devout exercise, a prayer on the Incarnation of the Word and his Passion. As early as the first years of the fourteenth century, there was a rapid evolution in *Deposition from the Cross* scenes, isolating and detaching the *Lamentation of Mary over her dead Son*, and then transferring the lifeless body of Jesus on to his Mother's lap, to form that intensely, painfully dramatic group which would later take the name of *Pietà* in Italian. It was north of the Alps that the first statues of the *Pietà* were created and exhibited; in these, the stiff and lifeless body of Christ stretched out in Mary's lap shows wounds deeper than those seen on the cross. Behind this new iconographic scheme, we can see the shadow of the most common image in Christian art, the Madonna and Child: therefore the *Pietà* (though we should call it by its German name, *Vesperbild*, since in the *Breviary* the hour of Vespers corresponds to the descent from the cross) contains a parallel – implicit and inevitable – between Childhood and Passion; it brings together and fuses the themes of motherhood and death; in the sorrow, in the lap of the mother it discovers and presents a framework and model, the most effective mirror in which to relive and imitate the passion of Jesus.

Italian sculptors were unable to find adequate versions of this theme: and yet the new devotion was spreading more quickly than the relevant iconography and demanded that a solution be found. This is why, between 1370–80 and the middle of the following century, dozens of *Pietà* by German sculptors appeared in Italy, bringing their own direct, 'anti-classical' expressiveness into the same churches as the growing new tendency towards the rediscovery of classicism – which is partly a balance of elements.[163] The mendicant orders (and particularly the Dominicans) seem to have played the

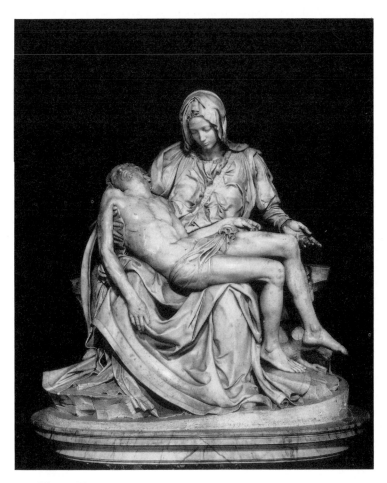

Plate 67 MICHELANGELO, *Pietà*, *c*.1499, St Peter's, Rome.
Photo: Archivi Alinari.

most important role in the spread of these statues in Italy, where the
theme is gradually assimilated and reworked by local artists along
lines of development whose direction is sufficiently clearly illustrated
by Michelangelo's early *Pietà*. Jesus's body is no longer gaunt and
tense, like a wooden crucifix figure without its cross, stretched out
straight in the Madonna's lap; it has lost its *rigor mortis*, and sags
gently, still and naked, and its softness and suppleness make a better
composition with the complexly draped figure of the mother. The

energetic, 'primitive' expressionism of the German models has been absorbed into a formula which subordinates pathos to the balance between elements, without ever losing or toning down the pathos. A subject missing from the gospel and the official worship of the Church thus found its place in the iconographic system; the Italian version represents a development towards a more 'balanced' and 'natural' form.

A quite opposite process, in some ways, can be seen during the thirteenth and fourteenth centuries, in the transition from one formula to another in the iconography of the Resurrection. The older convention, taken literally from the text of the gospels, portrayed the subject only indirectly, showing the empty tomb at the moment when the holy women arrived, with the angel sitting on it saying to the Marys, 'Do not be afraid: he is risen'; often the soldiers, who had fainted with terror, were included (Matthew 28.1–6). Then, particularly in the thirteenth and fourteenth centuries, this old iconography gradually gave way to the new, which was overwhelmingly dominated by the actual figure of the Risen Christ, who now emerges from the tomb with one foot on the edge, wielding a banner with a cross (as in the fresco by Piero della Francesca at Borgo San Sepolcro), and later in fact he is more and more often seen rising in mid-air, floating weightlessly over the uncovered tomb. Both innovations emerged from processes of iconographic *contaminatio* with analogous scenes. The direct portrayal of Jesus's Resurrection, an obvious idea for the new art which was trying to bring 'immediacy' to sacred events, was suggested by other subjects in the iconographic repertoire, such as the raising of Lazarus and more especially the resurrection of the dead in *Last Judgement* cycles; particularly since what happened to Lazarus demonstrated Christ's power over life and death, prefiguring his own destiny; and the Resurrection of Christ is also seen as the ultimate guarantee of the final resurrection of *all men*. In iconography, on the other hand, it seems to have been from the resurrection of *all men* that Jesus's own was drawn.

In a similar development (arising from scenes like those described above), *contaminatio* with other miracles, the Transfiguration and the Ascension, led to the peculiarly Italian iconography of the Risen Christ in mid-air, compressing into a compact sequence, with three violations of the law of gravity, three moments in which his divine nature was revealed with the most striking clarity. A fourteenth-century Florentine illumination shows the double iconography: beneath the soaring Christ gapes the empty tomb on which a white angel is seated, addressing the astounded Marys. At the foot of the

tomb are three sleeping soldiers: as is often the case, the holy terror of the guards put to flight by the mere sight of the angel (as in St Matthew's account) is transformed into a kind of benign siesta; in the eighteenth century, Juan de Ayala protested against this image which, he said, insulted the discipline of the Roman army.[164] But in the Florentine illumination none of the figures (including the angel and the Marys) seems to notice that Jesus is actually there above them: the two iconographical schemes, the old and the new, have been juxtaposed, not amalgamated, and each character has kept his or her own gestures; the old scheme, *without* the risen Christ, still survives, but at the cost of contamination by the new scheme, and is thus about to be abandoned for ever. Visibly removing the risen Christ not only *out of* the tomb, but *above* it, Italian tradition is showing a development back towards a less 'natural' form, giving 'effect' priority over verisimilitude. The *Pietà* scene was wholly absorbed within a dimension of tense, everyday humanity; the Resurrection is pushed into an exclusively divine atmosphere, dominated by the uniqueness and awesomeness of the miracle: a vision which the gospels do not describe and which points with triumphal solemnity towards the power of the one who can break down the doors of death and hell. The human and the divine are separated and distanced from one another: the leap from everyday experience (for example death and suffering) to the hope of the divine tends to lengthen the distance between the two poles which Christ's dual nature had sought to unite.

From the great pool of the closed chapter of antiquity which artists now wished not so much to bring to life again as to *perpetuate* in a fine contest of effects, came not only dramatic gestures and flowing drapery, but also the exalted idea of *perfection* in art. Thus, every attempt to portray Zeus was put in the shade, once and for all, by the great statue Phidias placed in the temple at Olympia: after such a *perfect* achievement, the image of the god can be repeated or varied, but not bettered. In the late first century AD, Dio Chrysostom gave the clearest expression to this idea when he put into Phidias's mouth, in a speech made at Olympia, the deepest reasons for his work (*why* Zeus was made *like that*); and naturally he had to deny the topos whereby Phidias had been inspired by Homer; instead he carved him 'as it was possible for a rational mortal to carve with an act of intelligence a divine nature which was not compressible within material limits . . . seeking to bring down into human form all the divine powers which men attribute to that nature'.[165] The *theme* seeks its *perfect* form; in Phidias, Zeus found his.

The problem of adequately portraying celestial prototypes, which was hotly debated during the iconoclast controversies, was still an undercurrent in the development of Christian art, and translates, on the most basic level, into the orthodox view of images, which means a more or less adequate representation of the sacred texts and teaching of the Church. But for this very reason, Christian iconography overflows with the whole potential leaning of every theme towards its perfect form, the form which recounts the 'story' and/or expresses the theological significance of an image better than any other. Therefore the filling of artists' sketchbooks with antique formulae and schemes did bring a sudden enrichment of their skimpy lexical baggage; but it encouraged them to compress those formulae into Christian themes, unhinging the rules of the game and forcing every subject to be measured against a wider range of potential iconographies. A greater *demand* for sacred images was met by a wider *supply* of iconographic formulae. The proliferation of figurative topoi which crowded into the sketchbooks and into painters' memories led to a greater diversity in religious iconography. There was more room for experiment, and there was strong emphasis and pressure from the movement towards profane themes (such as the classical myths themselves), with the result that not just gestures, but subjects too, could be derived from sarcophagi. But the same topoi circulate from the Christian theme to the mythical theme, thus creating a vocabulary which is no longer tailored only to Christian art, but is potentially open and adaptable to every human experience or discourse.

The theme seeks its perfect form: for Leonardo, the *Annunciation* found perfect form in Mary's *humiliatio* and therefore, of course, in Leonardo's *Annunciation*. But the leaning towards perfect form is potentially suicidal: because beyond perfection there is no further development. In his elegant closing address at the Twentieth Congress of the History of Art (New York, 1961),[166] Sir Kenneth Clark put forward his own interpretation: 'the invention of a memorable image, united with a satisfying combination of forms, is an unusual, almost miraculous, event', which distils and fixes a 'motive', or a 'point where form and subject fuse, which includes a recurring theme or model, and for the most part also the notion that this recurring theme expresses an idea'. But when this *perfect* point of fusion is reached, development is arrested; the 'motive' no longer interests creative artists, and consequently the subject itself as such also dies. With the *Madonna del granduca*, for example, Raphael reached the highest possible perfection of the theme of Madonna and Child, and

therefore 'closed the door on this subject forever'. The term 'motive' which Clark introduces, comprises a reading on three levels: in Raphael's *Madonna*, the primary subject (a woman with a child), the secondary subject (the Madonna and Child), and the formal equilibrium of the figures; but if these three elements are in reality indivisible, it is because 'ever since the image formed itself in the painter's mind, they have been united and controlled *by some ancient recurring pattern*, which was come perfectly to express an idea' (p. 192). The miraculous contraction of these elements is thus matched by the perfection of the 'motive' relative to the 'idea'; and this in turn by the inevitable death of the theme. For Kenneth Clark as for Walter Pater, figurative art 'aspires to the condition of music', which is conceived as the condition of a potentially indeterminate relationship between form and sense; in the great symphonic fabric of western art, 'motive' therefore, as Clark expressly states, stands for the equivalent of a Wagnerian leitmotiv; whereas the 'ancient recurring pattern', or the 'idea' to which the motive seeks to adapt itself in order to attain its perfect form is nothing but an archetype in an explicitly Jungian sense (pp. 204ff), which inherits the full Platonic leaning towards a world of ideas beyond the senses.

Iconographies do not thrive on the emergence of innate archetypes; a theme does not lapse and die from having finally fitted itself to that archetype. It is historical memory (by nature variable) which acts as a filter, and sometimes points to a particularly well-developed iconographic formula and (provisionally) classifies it as 'perfect'. We have learned from the ancients that art reaches a peak and then wanes; the idea of perfection is itself a topos. We could rally round this concept not only Clark's inspired reflections, but a vast crop of texts and musings by artists and critics, and 'commonsense opinions' from everyone; because it is true that these 'perfect iconographies' are laid out, splendid and eternal, in our historical memory. There is only one *Discus-Thrower*, the one by Myron; plenty of versions of the *Last Supper* have been painted, but none of them is like Leonardo's. Not that after Leonardo the subject dies out; but everyone who thinks of the *Last Supper* thinks first and foremost of that version, perfect offspring not of a world of archetypes but of a historical memory conditioned by Leonardo's reputation, by discussions and anecdotes relating to the work, by the problems involved in preserving it, the vast number of copies, imitations and reproductions made of it, which make his Supper unique, unrepeatable, a perpetual *model*. This is why Luis Buñuel, when he wanted to parody the Last Supper in the beggars' banquet in *Viridiana* (1961), arranged

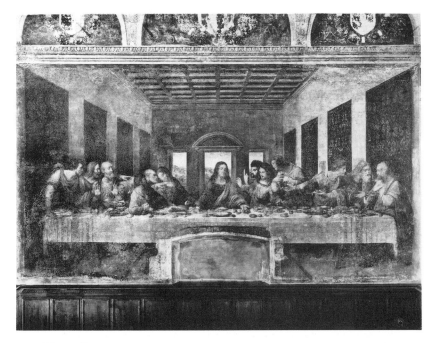

Plate 68 LEONARDO DA VINCI, *Last Supper*, 1495–8, Santa Maria
delle Grazie, Milan.
Photo: Archivi Alinari.

his characters like Leonardo's (prompting the predictably inane
accusations of sacrilege); Robert Altman did the same thing in *Mash*
a few years later in a ludicrous soldiers' dinner around a failed
suicide; and only later did the iconographic scheme 'return', in the
cinema, to its original theme, Christ and the apostles, in Norman
Jewison's *Jesus Christ Superstar*. In all three films, the characters
gradually adopt, at a certain moment, the poses which Leonardo
enshrined and made 'definitive' (since in our memory, through the
painting at Milan, they identify the Last Supper as a 'real' scene);
then they hold it for a moment, to allow the audience to recognize
the reference to Leonardo's model: this use of an iconographic allu-
sion to give a precise meaning compels the cinema to abandon for
a moment its greatest advantage over painting, that of motion.

This case of iconographic tradition being passed from painting to
cinema teaches us a number of things. First, that the iconographic

scheme – however well developed – can become a binding norm; secondly, that it is gestures, not clothing, which 'make' the scheme; thirdly, that parody (when possible, and when recognizable) identifies and marks out a scheme which is supposed to be universally known (explicitly designating as a scheme, so to speak). More bluntly, 'Jesus Christ Superstar' sits in a field with his disciples, re-enacting Leonardo's gestures (without the table); the iconography of that Supper has become a norm, a gospel: the exact repetition of the gestures assures the audience that this *really is* the Last Supper, the 'real' thing.

Through a tradition which is still with us, the lexicon of painting (as opposed to verbal communication, spoken or written) claims to be 'universal'; and since it must tell its stories through gesture, like a sign-language for the deaf, it aspires to a 'perfection' which consists in offering the most efficient form for each 'story'. In a letter from Leonardo Bruni to those who commissioned Ghiberti's doors (which came to be called the *Porte del Paradiso*) and entrusted him (Bruni) with the job of devising the iconographic programme and therefore the *selection* of twenty stories from the Old Testament, he wrote that the 'stories'

> have two main requirements: one is that they must be *illustrious*, the other is that they must be *significant*. I call those stories illustrious which can feed the eye with variety of design, and those significant which are important enough to be worthy of *memory* . . . It is essential that whoever draws them be well versed in each story, so that they will put the right *characters* and *gestures* in . . . But I would really like to be in contact with him to make sure he understands each meaning which the story *carries*.[167]

It is thus the 'story' itself which entails and dictates both the composition and the 'right' gestures if it is to be 'illustrious and significant', and take its place in the programmatic invention with 'every meaning it carries'. The space in which the image *must* fall is thus dictated by the two opposite poles of the senses and the memory.

Within the scope allowed by the patrons (the Old Testament), Bruni clearly marks out a space for himself and for the artist: for himself he reserves the choice of times and the 'instruction' of the artist as to 'each meaning', while Ghiberti's job is to translate that meaning into appropriately posed figures. Whoever takes on the invention must have a biblical and theological background; the artist must bring to bear his lexicon of gesture. And Bruni, in wishing to be in contact with Ghiberti to suggest and control the meaning, is

making himself available on the same lines as Ceraunia, wife of
Namatius, bishop of Clermont (fifth century), who, as Gregory of
Tours relates, would sit in the church built by her husband, *'legens
historias antiquas actionis, pictoribus indicans, quae in parietibus
fingere deberent'* (reading stories of ancient deeds, indicating to the
painters what they should depict on the walls).[168]

But the reason no one denied Giotto credit for having begun to
bring art back to nature was precisely because he had refused to
settle for the lexicon he had learned from his masters. Frederick II,
keen to learn the origins of language, had had children raised – so
Salimbene de Adam recounts – by mute nurses on a desert island;
Leonardo claims that Giotto 'born in mountain solitudes . . . began
by drawing on the rocks the movements of the goats which he was
tending'. And so the great new challenge to the artist was the direct
observation of the truth of nature, which *must* open the magic doors
beyond which the conventions of art have hitherto concealed the
infinite variety of the world. This is why room must be found in that
'pouch' recommended by Cennini for other drawings; Leonardo's
precept is to

> often amuse yourself when you take a walk for recreation, in watch-
> ing and taking note of the attitudes and actions of men as they talk
> and dispute or laugh and come to blows with one another, both their
> actions and those of bystanders who either intervene or stand looking
> on at these things, noting these down with rapid strokes in this way

> in a little pocket book, which you ought always to carry with
> you . . . And let this be of tinted paper so that it may not be rubbed
> out . . . but preserved with the utmost diligence, for there is such an
> infinite number of forms and actions of things, that *memory is in-
> capable of preserving them*; and therefore you should keep those as
> your patterns and *teachers*.[169]

This was how Giotto, the painter with no masters, had (according
to Leonardo) ingenuously taken as a model the 'movements of the
goats', nature without nurture; repudiating the filter of the estab-
lished iconographic language, the painter (Leonardo) will now draw
only *from life* the 'movements' of men.

NOTES

1 Leonardo da Vinci, *Das Buch von der Malerei* (Treatise on painting),
 ed. H. Ludwig, I (Vienna, 1882), p. 32, para. 19. Cf. *The Notebooks
 of Leonardo*, ed. E. MacCurdy (London, 1938), from which trans-
 lations are taken where available.

2 Cf. the words of the patriarch of Constantinople Germanus I (early
 eighth century), in Migne, *Patrologia Graeca*, XCVIII, 164ff.

3 Cf. T. Buddensieg, 'Gregory the Great, the Destroyer of Pagan Idols',
 Journal of the Warburg and Courtauld Institutes, 28 (1965), pp. 44ff.

4 *Iconoclasm. Papers given at the Ninth Spring Symposium of Byzantine
 Studies* (University of Birmingham, 1975), ed. A. Bryer and J. Herrin
 (Birmingham, 1977). Cf. P. Miquel, in *Dictionnaire de spiritualité*, VII
 (1971), cc. 1503ff.

5 C. Mango, 'Antique Statuary and Byzantine Beholder', *Dumbarton
 Oaks Papers*, 17 (1963), pp. 55ff.

6 A. Esch, in *Archiv für Kulturgeschichte*, 51 (1969), pp. 33ff.

7 *Libri Carolini (Monumenta Germaniae Historica*, Legum sectio III:
 Concilia, vol. II, supplement, ed. H. Bastgen (Hanover and Leipzig,
 1924), p. 140, line 34.

8 Mango, in *Iconoclasm*, p. 4, quotes this episode without comment.

9 E. Kitzinger, 'The Cult of Images before Iconoclasm', *Dumbarton Oaks
 Papers*, 8 (1954), pp. 83–150, particularly pp. 112ff.

10 I have taken the remainder from the Latin version in Mansi, *Concilia*,
 XIII, p. 672. (The structure of images is not the invention of painters,
 but the approved legislation and tradition of the Catholic church . . .
 this judgement and tradition is not the painter's job (for his only
 concern is with his craft), but the ordinance and disposition of the
 holy fathers.)

11 For the 'western' attitude to the question of images, see especially
 S. Gero, 'The Libri Carolini and the Image Controversy', *Greek
 Orthodox Theological Review*, 18 (1973), pp. 7–34.

12 A. Grabar, *Christian Iconography. A Study of its Origins* (Princeton,
 1968).

13 Erasmus, *Epistolae*, ed. P. S. Allen, I (Oxford, 1906), p. 1391.

14 R. Brilliant, *Gesture and Rank in Roman Art* (New Haven, 1963).

15 Migne, *Patrologia Graeca*, XXXV, 605c.

16 L. W. Barnard, *The Graeco-Roman and Oriental Background of the
 Iconoclastic Controversy* (Leiden, 1974), p. 68.

17 For example in the Second Nicene Council: Mansi, *Concilia*, XII,
 p. 1068; XIII, pp. 57ff.

18 R. W. Lee, *Ut pictura poesis* (New York, 1967).

19 Cf. J. Kollwitz, 'Bild und Bildertheologie im Mittelalter', in *Das
 Gottesbild im Abendland*, ed. G. Howe (Berlin, 1957), pp. 109–38,
 especially p. 109.

20 Migne, *Patrologia Graeca*, XCIV, 1284c.
21 Scriptores historiae Augustae, *Maximini duo*, XII, 10–11. The same sort of thing is to be found in a letter from Lucius Verus, brother of Marcus Aurelius, to the Praeceptor Fronto (Fronto, *Epistole*, II.3A.436).
22 *Institutio Oratoria*, VI.1.32.
23 Mansi, *Concilia*, XIII, pp. 720–2.
24 G. Schreiber, *Die Sakrallandschaft des Abendlandes* (Düsseldorf, 1937); B. de Gaiffier, 'Pélérinages et culte des saints', in *Etudes critiques d'hagiographie et d'iconologie* (Brussels, 1967), pp. 31ff.
25 F. A. Yates, *The Art of Memory* (Harmondsworth, 1969).
26 J. Sauer, *Symbolik des Kirchengebäudes und seiner Ausstattung in der Auffassung des Mittelalters*, 2nd edn (Freiburg im Breisgau, 1924), pp. 209ff. Crocodiles in churches today: Santa Maria delle Grazie (Mantua), Ardesio (Bergamo), Oiron (Deux-Sèvres).
27 A. Esch, *Spolien*. 'Zur Wiederverwendung antiker Baustücke und Skulpturen in mittelalterlichen Italien', *Archiv für Kulturgeschichte*, 51 (1969), pp. 1–64.
28 *Rationale divinorum officiorum*, I.3.42–3. This quotation is from the Venice edition of 1582, p. 12v; translated as *The Symbolism of Churches and Church Ornaments* (London, 1893), p. 67.
29 *Libri Carolini*, p. 3.
30 Ibid., p. 29.
31 E. Male, *Religious Art of the Thirteenth Century* (London, 1949), talks about the important influence of this passage on French culture, and particularly on Viollet-le-Duc.
32 A. Puerari, *Il Duomo di Cremona* (Milan, 1971), p. 102
33 Migne, *Patrologia Latina*, CCXIII. Cf. P. G. Ficker, *Der Mitralis des Sicardus nach seiner Bedeutung für die Ikonographie des Mittelalters* (Leipzig, 1889).
34 Cf. the texts cited by F. X. Kraus, *Geschichte der christlichen Kunst*, II, 1 (Freiburg im Breisgau, 1897), p. 366.
35 A. Boeckler, *Die Bronzetüren des Bonannus von Pisa und des Barisanus von Trani* (Berlin, 1953).
36 *Serm. CXXX*, I (Migne, *Patrologia Latina*, XXXVII, 1984). For more on this rich theme, see E. Guldan, *Eva und Maria. Eine Antithese als Bildmotiv* (Graz and Cologne, 1966).
37 P. Bacci, 'La Pieve di S. Giovanni a Campiglia Marittima', *L'Arte*, 7 (1910), p. 7: 'the marble lid of a pagan sarcophagus lid used as an epistyle'.
38 Ficker, *Der Mitralis*, pp. 59ff.
39 E. Male, *L'Art religieux du XIIe siècle en France*, 2nd edn (Paris, 1924), p. 378. (For English version see the compilation *Religious Art from the Twelfth to the Eighteenth Century*, Princeton, 1982.)
40 Cf. Ficker, *Der Mitralis*, p. 45.

41 M. Sepet, 'Les Prophètes du Christ. Etude sur les origines du théâtre au Moyen-Age', *Bibliothèque de l'Ecole des Chartes'*, 28 (1867), pp. 1ff (in four instalments). The credit for using this sermon to explain the scrolls of the prophets at Ferrara, Cremona and other churches in Italy should go entirely to J. Durand, 'Monuments figurés du Moyen-Age exécutés d'après des textes liturgiques', *Bulletin Monumental*, 54 (1888), pp. 521ff.

42 Sepet, 'Les Prophètes du Christ', *Bibliothèque de l'Ecole des Chartes*, 38 (1877), p. 410.

43 O. Brendel, 'Origin and Meaning of the Mandorla', *Gazette des Beaux-Arts*, 6th series, 25 (1944), pp. 5–24.

44 Cf. also below, p. 219.

45 O. Morisani, *Gli affreschi di Sant'Angelo in Formis* (Naples, 1962); A. Moppert-Schmidt, *Die Fresken von Sant'Angelo in Formis* (Zurich, 1967). For their chronology, cf. W. Paeseler's discussion in *Actes du XXIIe Congrès International d'Histoire de l'Art* (Budapest, 1972), pp. 259ff.

46 Male, *L'Art religieux du XIIe siècle*, p. 408.

47 *Quaestio in Exodum 73.*

48 G. Matthiae, *Gli affreschi medievali di Santa Croce in Gerusalemme* (Rome, 1968), p. 3; cf. A. Grabar, 'L'imago clipeata chrétienne', in *L'Art de la fin de l'antiquité et du Moyen Age*, I (Paris, 1968), pp. 607ff; S. Settis, in *Athenaeum*, 50 (1972), pp. 237ff and H. Lavagne, in *Présence de Virgile* (Paris, 1978), pp. 142–6.

49 Sepet, 'Les prophètes du Christ', *Bibliothèque de l'Ecole des Chartes*, 39 (1868), pp. 108 and *passim*.

50 E. Kitzinger, *The Mosaics of Monreale* (Palermo, 1960).

51 E. H. Gombrich, 'The mask and the face: the perception of physiognomic likeness in life and art', in E. H. Gombrich, J. Hochberg and M. Black, *Art, Perception and Reality* (Baltimore, 1972), pp. 1–46.

52 G. de Francovich, *Benedetto Antelami architetto e scultore e l'arte del suo tempo* (Milan, 1952), pp. 151ff.

53 Cf. L. R. Muir, *Liturgy and Drama in the Anglo-Norman Adam* (Oxford, 1973), especially pp. 34ff and 47ff.

54 Male, *L'Art religieux du XIIe siècle*, pp. 135ff; de Francovich, *Benedetto Antelami*, p. 67.

55 Migne, *Patrologia Latina*, CLXXXIII, 284d; cf. de Francovich, *Benedetto Antelami*.

56 Amatus, *Storia dei Normanni* (Rome, 1935), III, 52 ('non trova en Ytalie homes de cet art, manda . . . pour homes grex et sarrasin, pour aorner le pavement de l'églize de marmoirte entaillié et diverses paintures; laquelle nous clamons opere de mosy').

57 Sauer, *Symbolik des Kirchengebäudes*, p. 299. For the Digest's veto, see E. Muntz, *Etudes iconographiques et archéologiques sur le Moyen-Age* (Paris, 1887), p. 47.

58 C. Settis-Frugoni, 'Per una lettura del mosaico pavimentale della cattedrale di Otranto', *Bollettino dell'Istituto Storico Italiano per il Medio Evo*, 80 (1968), pp. 213–56; ibid., 82 (1970), pp. 243–70 and in *Storiografia e storia. Studi in onore di E. Dupré Theseider* (Rome, 1974), II, pp. 651–9; W. Haug, *Das Mosaik von Otranto* (Wiesbaden, 1977).

59 R. Lejeune and J. Stiennon, *La Légende de Roland dans l'art du Moyen-Age* (Brussels, 1966), vol. I, pp. 97–102.

60 M. Butor, *Les mots dans la peinture* (Geneva, 1969).

61 M. Avery, *The Exultet Rolls of South Italy* (Princeton, 1936); G. Cavallo, *Rotuli di Exultet dell'Italia Meridionale* (Bari, 1973).

62 G. Trenta, *I mosaici del Duomo di Pisa e i loro autori* (Florence, 1896).

63 Cf. C. Capizzi, *Pantokrator (Saggio d'esegesi letterario-iconografico)* (Rome, 1964), particularly pp. 191ff. Cf. the review of this book by K. Wessel, *Byzantinische Zeitschrift*, 58 (1965), pp. 141–7.

64 For example E. Sandberg-Vivala, *La croce dipinta italiana* (Verona, 1929), p. 144, figure 105, and p. 544, figure 366. Cf. more generally R. Berger, *Die Darstellung des thronenden Christus in der romanischen Kunst* (Reutlingen, 1926), pp. 126–59.

65 Gero, 'The Libri Carolini', pp. 16ff.

66 P. Thoby, *Le Crucifix dès origines au Concile de Trente* (Paris, 1959), pp. 18ff.

67 P. A. Underwood, 'The Evidence of Restoration in the Sanctuary Mosaics of the Church of the Dormition in Nicaea', *Dumbarton Oaks Papers*, 13 (1959), pp. 135–43.

68 Sandberg-Vivala's work, *La croce dipinta*, is of fundamental importance.

69 G. Durandus, *Rationale divinorum officiorum*, I, i, para. 41; English translation, p. 28.

70 For this iconography, Sandberg-Vivala, *La croce dipinta*, p. 135.

71 C. Brandi, 'Il crocifisso di Giunta Pisano in San Domenico a Bologna', *L'Arte*, 39 (1936), pp. 71-91.

72 IV, 3 (1923, p. 33). Cf. the subject index in T. Desbonnets and D. Vorreux, *St-François d'Assise* (Paris, 1968), pp. 1508 and 1531, 'Croix'.

73 E. Delaruelle, *La Piété populaire au Moyen-Age* (Turin, 1975), pp. 229ff; cf. pp. 27ff on the crucifix in popular devotion before the eleventh century.

74 Ibid., p. 269.

75 St Bonaventure, *Legenda maior*, XIV, 1, p. 148.

76 Sandberg-Vivala, *La croce dipinta*, pp. 823ff; see the analytical scheme on pp. 880ff, final column.

77 Reproduced in L. de Chérancé, *Saint François d'Assise* (Paris, 1885), p. 152.

78 B. Kleinschmidt, *Die Basilika S. Francesco in Assisi* (Berlin, 1925), vol. I, pp. 14ff, note.

79 R. B. Brooke, *Early Franciscan Government. Elias to Bonaventure* (Cambridge, Mass., 1959); G. Barone, 'Frate Elia', *Bollettino dell'Istituto Storico Italiano per il Medio Evo*, 85 (1974–5; in fact 1978), pp. 89–144.

80 L. Wadding, *Annales Ordinis Minorum*, II (Rome, 1723), p. 397.

81 Cf. M. Baxandall, *Giotto and the Orators. Humanist Observers of Painting in Italy and the Discovery of Pictorial Composition, 1350–1450* (Oxford, 1971), p. 43.

82 Cf. especially for what follows here, G. Schnurer and J. M. Ritz, *St Kümmernis und Volto Santo* (Düsseldorf, 1934).

83 The term 'aura' is taken from W. Benjamin, *L'opera d'arte nell'epoca della sua riproducibilità tecnica. Arte e società di massa* (Turin, 1966).

84 As well as the full documentation gathered by Schnurer and Ritz see also some later contributions: those written before 1969 are collected in R. Van Doren, in *Biblioteca Sanctorum*, XII (1969), cc. 1094–9, s.v. Wilgefortis.

85 *Apol.*, ch. XII (ed. J. Leclercq and H. Rochiis, Rome, 1963, in vol. III of the *Opere* of St Bernard; English translation and commentary by M. Casey and foreword by J. Leclercq, Spencer, Mass., 1970). Cf. P. Michiel, *Formosa deformitas. Bewaltigungsformen des Hässlichen in mittelalterlicher Literatur* (Bonn, 1976), particularly pp. 156ff; M. Schapiro, *Romanesque Art* (New York, 1977), pp. 6ff. An anonymous text, also certainly by St Bernard, of similar content (thirteenth century) tries to suggest what themes may be used to decorate a church: cf. L. Delisle, *Mélanges de paléographie et de bibliographie* (Paris, 1880), pp. 205–7. Cf. also Sauer, *Symbolik*, p. 280, for the contrast between *curiositas* and *devotio* in a similar context, though much later (Rumpler, Abbot of Formbach, early sixteenth century).

86 F. Klingender, *Animals in Art and Thought to the End of the Middle Ages* (London, 1971), pp. 334ff.

87 A.-M. Armand, *St Bernard et le renouveau de l'iconographie au XIIe siècle* (Paris, 1944), p. 25.

88 *Mitralis*, ch. 12, in Migne, *Patrologia Latina*, CCXIII, 44b. It seems to me to be necessary for the understanding of this text to correct *ipsorum* to *ipsarum* at the end of the quotation.

89 *Means and Ends. Reflections on the History of the Fresco Painting* (London, 1976), p. 34.

90 Sauer, *Symbolik*, p. 279.

91 Sepet, *Les prophètes du Christ*, pp. 211ff.

92 G. Kaftal, *Iconography of the Saints in Tuscan Painting* (Florence, 1952), pp. 385ff. For the framing with biographical scenes and its history, B. Schweitzer, in *Jahrbuch des deutschen archaeologischen Instituts*, 46 (1931), pp. 228–46; cf. E. B. Garrison, *Italian Romanesque Panel Painting. An Illustrated Index* (Florence, 1949), particularly pp. 149 and 153.

93 H. Hager, *Die Anfänge des italienischen Altarbildes* (Munich, 1962).
94 H. Thode, *Franz von Assisi und die Anfänge der Kunst der Renaissance in Italien* (Vienna, 1934), p. 585.
95 Hager, *Die Anfänge*, p. 163.
96 Ibid., pp. 18ff.
97 Ibid., particularly pp. 146ff.
98 Cf. A. Preiser, *Die Entstehung und die Entwicklung der Predella in der italienischen Malerei* (Hildesheim and New York, 1973), especially pp. 72ff.
99 R. Jaques, 'Die Ikonographie der Madonna in trono in der Malerei des Dugento', *Mitteilungen des kunsthistorischen Instituts in Florenz*, 5 (1937–40), particularly pp. 45ff.
100 L. Gillet, *Histoire artistique des ordres mendiants* (Paris, 1912), p. 120. Information about the author and the state of research in M. J. Stallings, *Meditaciones de passione Christi* (Washington DC, 1965), from which the following quotations and page reference are taken.
101 Cf. I. Ragusa and R. B. Green, *Meditations on the Life of Christ* (Princeton, 1961), p. xxii (this volume contains the precious illustrations from the MS Paris, ital. 115, which has the vernacular translation of the *Meditationes*, with English translation).
102 Male, *Religious Art*.
103 Butor, *Les mots dans la peinture*, p. 51.
104 For origins of these three attributes, see H. Delehaye, *Cinq leçons sur la méthode hagiographique* (Brussels, 1934), p. 130.
105 J. Poeschke, *Die Sieneser Domkanzel des Nicola Pisanus* (Berlin and New York, 1973), particularly pp. 67–72.
106 *L'art dans l'Italie méridionale* (Paris, 1904), vol. II, pp. 787ff. Cf. F. Bologna, *I pittori alla corte angionia di Napoli, 1266–1414* (Rome, 1969), pp. 34ff.
107 For the following, M. Seidel, 'Studien zur Antikenrezeption Nicola Pisanos', *Mitteilungen des kunsthistorischen Instituts in Florenz*, 25 (1975), pp. 307–92.
108 Cf. M. Lisner, *Holzkruzifixe in Florenz und in der Toskana* (Munich, 1970), pp. 16ff.
109 G. Previtali, *Giotto e la sua bottega*, 2nd edn (Milan, 1974), p. 65.
110 M. Barasch, *Gestures of Despair in Medieval and Early Renaissance Art* (New York, 1976), pp. 69ff.
111 Aby Warburg was the first to speak of *Pathosformeln*: cf. E. H. Gombrich, *Aby Warburg. An Intellectual Biography* (London, 1970).
112 M. Baxandall, *Giotto*, pp. 146ff (text) and 70ff (translation and commentary).
113 R. W. Lee, *Ut pictura poesis*.
114 Baxandall, *Giotto*, particularly pp. 130ff, is fundamental here.
115 Ed. D. V. Thompson Jr (New Haven, 1932), p. 2.
116 E. Panofsky, *Renaissance and Renascences in Western Art*, provides

an excellent frame of reference and interpretation (for 'modern' see pp. 50ff). But to introduce and employ the term 'modern' I rather think one should inevitably refer to the theological context – cf. E. Goessman, *Antiqui und Moderni im Mittelalter* (Paderborn, 1974); for now let us simply refer to Geert Groote and the *devotio moderna*.

117 J. von Schlosser, *La letteratura artistica*, 3rd edn (Florence, 1977), pp. 35–40.

118 W. Euler, *Die Architekturdarstellung in der Arena-Kapelle* (Berne, 1967).

119 M. Alpatov, 'The Parallelism of Giotto's Paduan Frescoes', *Art Bulletin*, 29 (1947), pp. 149–54. Cf. also M. von Nagy, *Die Wandbilder der Scrovegni-Kapelle zu Padua: Giottos Verhältnis zu seinen Quellen* (Basle, 1962); J. H. Stubblebine, *Giotto. The Arena Chapel Frescoes* (London, 1969); on the quatrefoil medallions, A. Bertini, in *Giotto e il suo tempo* (Rome, 1971), pp. 143–7; on the frames, R. Mioli Toulmin, ibid., pp. 177–89, and cf. A. L. Prosdocimi, ibid., pp. 135–42. Also, B. Cole, *Giotto and Florentine Painting. 1280–1375* (New York, 1976), pp. 63–95.

120 F. Bologna, *Novità su Giotto* (Turin, 1969), particularly pp. 51ff.

121 Previtali, *Giotto*, p. 99.

122 M. Koch, *Die Rückenfigur im Bild. Von der Antike bis zu Giotto* (Recklinghausen, 1965).

123 S. Seeliger, *Pfingsten. Die Ausgiessung des Heiligen Geistes am fünfzigsten Tage nach Ostern* (Düsseldorf, 1959), particularly p. 12 and table IV.

124 B. Brenk, *Tradition und Neuerung in der christlichen Kunst des erstens Jahrtausends. Studien zur Geschichte des Weltgerichtsbildes* (Vienna, 1966), pp. 118 and 136ff.

125 Cf. especially U. Schlegel, 'On the Picture Program of the Arena Chapel', in Stubblebine, *Giotto*, pp. 182–202.

126 O. Ronchi, 'Un documento inedito del 9 gennaio 1305 intorno alla Cappella degli Scrovegni', *Atti e Memorie dell'Accademia Patavina*, n.s., 52, 2 (1936), pp. 205–11.

127 J. K. Hyde, *Padua in the Age of Dante* (New York, 1966), pp. 101ff. See this book for information on the political activities and ambitions of Enrico Scrovegni.

128 Scardeone, *De antiquitate urbis Patavii* (Basle, 1560), p. 322.

129 Hyde, *Padua*, pp. 188ff; for his accession to the rank of *cavaliere*, p. 101.

130 C. Grandjean, *Le Registre de Benoît XI* (Paris, 1905), n. 435; cf. n. 126.

131 Previtali, *Giotto*, pp. 144ff (text of the canzone also found here).

132 F. Antal, *Florentine Painting and its Social Background. The Bourgeois Republic before Cosimo de' Medici's Advent to Power: XIV and Early XV Centuries* (London, 1947).

133 Previtali, *Giotto*, particularly p. 73.

134 M.-D. Chenu, *Nature, Man and Society in the Twelfth Century* (Chicago, 1968), p. 226.

135 L. K. Little, 'Pride Goes before Avarice: Social Change and the Vices in Latin Christendom', *American Historical Review*, 76 (1971), pp. 16–49; for the iconography, the observations of C. Settis Frugoni, *Historia Alexandri elevati per griphos ad aerem. Origine, iconografia e fortuna di un tema* (Rome, 1973), pp. 332ff; also L. K. Little, *Religious Poverty and the Profit Economy in Medieval Europe* (London, 1978).

136 S. Pfeiffenberger, *The Iconology of Giotto's Virtues and Vices at Padua*, degree thesis (Bryn Mawr, Pa., 1966), particularly ch. 5, pp. 45ff.

137 In F. Sacchetti, *Opere*, vol. II (Bari, 1938), pp. 99ff. Cf. Kaftal, *Iconography of the Saints*, pp. xxxff.

138 Cf. N. del Re and C. Moccheggiani Carpano, 'Urbano V', in *Bibliotheca Sanctorum*, XII (Rome, 1969), cc. 844–7. There exist a few representations of Urban V beatified, from the fourteenth century and the fifteenth: cf. also Kaftal, *Iconography*, cc. 993ff; *idem*, *Iconography of the Saints in Central and South Italian Schools of Painting* (Florence, 1965), c.1108; *idem*, *Iconography of the Saints in the Painting of North East Italy* (Florence, 1978), cc. 1005–9.

139 Florence, 1860, p. 131.

140 E. H. Gombrich, *Art and Illusion* (London, 1960).

141 J. T. Wollesen, *Die Fresken von San Piero a Grado bei Pisa* (Bad Oeynhausen, 1977), particularly pp. 60ff.

142 R. W. Scheller, *A Survey of Medieval Model Books* (Haarlem, 1963).

143 J. Schlosser, 'Zur Kenntnis der künstlerischen Überlieferung des späten Mittelalters', *Jahrbuch der kunsthistorischen Sammlungen in Wien*, 23 (1903), pp. 279–338.

144 C. Cipolla, 'La pergamena rappresentante le antiche pitture della basilica di Sant'Eusebio in Vercelli', in *Miscellanea di Storia Italiana della Deputazione di Storia Patria per la Lombardia*, 3rd series, VI (Turin, 1899).

145 Panofsky, *Renaissance and Renascences in Western Art*, p. 165; cf. also p. 187 (for the later relationship with the Limbourgs).

146 Scheller, *A Survey*, pp. 14ff.

147 U. Jenni, *Das Skizzenbuch der internationalen Gotik in den Uffizien. Der Übergang vom Musterbuch zum Skizzenbuch* (Vienna, 1976), particularly pp. 28ff and 41ff.

148 G. Vasari, *Lives*, part II: 'Life of Nicola Pisano', p. 40.

149 B. Degenhart and A. Schmitt, 'Gentile da Fabriano in Rom und die Anfänge des Antikenstudiums', *Münchner Jahrbuch der bildenden Kunst*, 3 (1960), pp. 59–151.

150 See above, vol. I, p. 123. For the sarcophagus, see A. Minto, in *Rivista d'arte*, 16 (1950), pp. 1ff.

151 This quotation merges different passages from the two letters, without of course altering their meaning. The letters have been published

by C. von Fabriczy, in *Jahrbuch der preussischen Kunstsammlungen*, 27 (1906), pp. 74ff. Probably the sarcophagi stayed where they were; only for the Bacchic one has identification been attempted (cf. F. Matz, *Die Dionysischen Sarkophage*, II (Berlin, 1968), n. 90).

152 Cf. P. Hetherington, *The 'Painter's Manual' of Dionysius of Fourna* (London, 1974).

153 Jenni, *Das Skizzenbuch*, figure 113.

154 M. Baxandall, *Painting and Experience in Fifteenth Century Italy* (Oxford, 1972), pp. 49ff.

155 E. Borsook, *Gli affreschi di Montesiepi* (Florence, 1969), particularly pp. 27–32; M. Meiss, *Frescoes from Florence* (London, 1969), pp. 60–5. For the iconography of the Annunciation, most recently D. Denny, *The Annunciation from the Right from Early Christian Times to the Sixteenth Century* (New York and London, 1977).

156 M. E. Gossmann, *Die Verkündigung an Maria im dogmatischen Verständnis des Mittelalters* (Munich, 1957) for texts on Mary's fear at the announcement, particularly Origen (p. 13), Nicholas of Lyra (fourteenth century, p. 241), the *Meditationes vitae Christi* (p. 223); cf. also pp. 243 and 253.

157 I. Ragusa and R. B. Green, *Meditations on the Life of Christ. An Illustrated Manuscript of the Fourteenth Century* (Princeton, 1961), pp. 17ff.

158 *Das Buch von der Malerei* (Treatise on Painting), ed. H. Ludwig (Vienna, 1882), I, pp. 112ff, para. 58. Cf. C. Pedretti, *Leonardo da Vinci on Painting. A Lost Book (Libro A)* (Berkeley and Los Angeles, 1964), p. 115.

159 *Arte lombarda dai Visconti agli Sforza* (Milan, 1958), p. 120 and colour plate.

160 *Lives*, part I, vol. I, 'Life of Giotto'.

161 U. Procacci, in *Omaggio a Giotto* (Florence, 1967), pp. 12–14. It is not certain whether the fresco is really by Giotto; but this does not affect our appreciation of the text from Vasari.

162 *Trattato*, I, p. 34, para. 20.

163 G. W. Korte, 'Deutsche Vesperbild in Italien', *Kunstgeschichtliches Jahrbuch der Bibliotheca Hertziana*, 1 (1937), pp. 1–138.

164 L. Réau, *Iconographie de l'art chrétien*, II, 2 (Paris, 1957), p. 548. For iconographies of the Resurrection cf. particularly the full study by H. Schrade, *Die Auferstehung Christi* (Berlin, 1932).

165 S. Ferri, 'Il discorso di Fidia in Dione Crisostomo', in *Opuscula* (Florence, 1962), pp. 165–91, particularly p. 169.

166 'Motives', in *Studies in Western Art. Acts of the XX International Congress of the History of Art*, IV (Princeton, 1963), pp. 189–205.

167 R. Krautheimer, *Lorenzo Ghiberti*, II, 2nd edn (Princeton, 1970), p. 372, doc. 52 (1424).

168 *Historia Francorum*, II, 17.

169 *Trattato*, I, pp. 210ff, para. 173.

The History of Art and the Forms of Religious Life

BRUNO TOSCANO

The dimension of Christian art

IN the history of a country such as Italy, even after the second millennium of Christianity, the phrase 'religious life' has occupied such a large place so rich in meaning as to ensure from the outset that any attempt to think of it simply as one side of some kind of bipolar treatment, such as the title of this chapter – necessarily very limited in scope – would seem to promise, will at best be schematic and generalized.

It would be no exaggeration to state that many of the main strands of artistic activity in the Italian peninsula appear to form part of a religious project. It is quite appropriate that an important branch of art history should have taken the name of Christian archaeology, since the majority of evidence from the early centuries of the new era is found in the buildings and artefacts of the Christian cult. But the observation can be extended, although not quite so comprehensively, to cover the whole of the Middle Ages.

Medieval contributions to the buildings and layout of Rome and the region, or at least those which left the most lasting impression on the history of artistic activity and related fields, more or less directly reflect initiatives which are specific to the religious sphere, in the most general sense of the expression in its most general sense. Among the legacies in architecture, sculpture, painting, and the so-called minor arts from those centuries, examples of an ecclesiastical

or funereal nature easily outnumber the rest. Only rarely do we come across important evidence which cannot be identified with one of the new types of sacred building, whether basilica, church, the martyry with *confessio*, the baptistery church or chapel, or with artefacts whose origin is directly related to these buildings. Moreover, because of the frequent incidence of continuity between one monument and the next, often indicating continuity of worship, it is quite common to find remains of the structure and decorative components of previous buildings incorporated within the new ones. If we widen our discussion to the urban and regional scene, our conclusions are the same. One cannot understand the medieval dynamic of the urban fabric and the territorial order without careful consideration of the evolving power of the bishops, the chapters, the monastic orders and, by the end of the era, the mendicant orders. The walled city, particularly the episcopal city of central southern Italy, is largely the result of the adjustments, tensions and rifts in the fabric of Rome, particularly in the later centuries of the Middle Ages, caused by the activity of those various bodies, either by agreement with the local authorities or otherwise. The infiltration of the inland valleys, plateaux and mountains of the Apennines, where people clung more fiercely to pre-Christian cults and beliefs, introduced factors of transformation and evolution to the region and laid the foundations for the establishment of an ever denser network of religious buildings and settlements, and this context gave artistic activity a powerful boost. The 'Christian occupation of the land'[1] developed with the spread of the practice of eremitic living in solitary caves, in a *laura* or in the first coenobitic communities, and intensified further as the penetration of the monastic orders and diocesan organizations evolved to form a network of abbeys, parishes and dependent churches, which provided a stable base for patterns of settlement in the regions which are still emerging today.

This does not mean that everything – and there was much – achieved by the independent actions of the lay bodies in the medieval process of transforming the cities and the land should be relegated to a subordinate role: monarchs, dukes, senior officials, lay aristocracy, urban and rural communities and eventually the free Communes clearly all competed with equal determination in initiating and regulating this dynamic; but it should be stressed that the religious drive found so many ways of manifesting itself that it can quite legitimately be seen as omnipresent.

The extraordinary programme of church decoration went on incessantly, everywhere, employing workers skilled in a very wide

range of techniques: sculpture, particularly for façades, often form-
ing whole cycles with complex iconographies; frescoed wall paint-
ing, which reached its peak of popularity both in frequency and
extent in the fourteenth and fifteenth centuries, particularly in cer-
tain regions (Tuscany for example), and not only on interior walls,
though for obvious reasons surviving evidence of fresco painting is
almost exclusively from interior works; floor and wall mosaic, stained
glass, woodwork of different kinds for doors and choir stalls, metal-
work; furnishings rich with marble, goldsmithery, glass, china, ivory,
textiles and leather; liturgical manuscripts, among which the *rotuli*
(scrolls) best exemplify the intention of communicating the contents
of Scripture through illumination.

The way was paved for this grandiose elaboration of Christian art
by a process of spreading and propagating the thematic substance of
the Scriptures, which further intensified in the later centuries of the
Middle Ages; it was not just the Scriptures which were spread in this
way, but also legendaries and passionaries of the saints and martyrs,
meditations on the life of Christ, treatises on the virtues and vices,
bestiaries and even profane medieval cycles. The vivid mythology of
the *Legenda aurea* (Golden Legend) or the narrative register of the
Legenda maior of St Francis by St Bonaventure seem purpose-built
– as did the subtle allegorical tone of the *Speculum humanae
salvationis* in France – for translation into figurative terms.

The ever-growing importance of the papacy as the modern age
began, with the burgeoning influence of the Roman Church and its
local sections, and the more widespread and intense activity of the
mendicant orders and, later, of the new orders which arose from the
Catholic Reformation and the Counter-Reformation all worked to
complete and transform the sacred buildings and bestow on them
the features that nowadays compose their complex appearance.

Obviously, in the two-thousand-year process which went into
forming this complex face, the nature of this religious force was far
from consistent, carrying with it movements and pressures of differ-
ent kinds: social, political, economic and cultural. In the develop-
ment of this great tradition the religious sphere of action is almost
boundless. Besides being 'theology', illustration of the gospels and
lives of the saints, the representation of the sacred is an expression
of life which vividly reflects its various conditions, the make-up of
its social organizations, cultural characteristics and psychological
undercurrents. Take for example the huge iconographical legacy
relating to the lives of the saints, disseminated through illuminated
manuscripts, mural cycles and removable retables. Together with

literary texts of a similar nature this is primary source material for hagiographical research, but the value of both resources goes even further: far wider meanings can be extracted from them, for example, by studying the origins of the legends or by observing recurrent motifs and themes. 'If there are so many hanged men, suicides and convicts and so many kidnappers in literature, then they must also have existed in real life, or in people's minds', as Leclerc said;[2] and this observation, which is not as self-evident as might appear, can easily be applied to figured texts as well as written ones.

Concerning correspondences between art and religious ideas

It is well known that the study of great cultural transformations has often been bound up with the study of changes in religious spirit, almost to the point of their being interchangeable. Tackling the problem of how to interpret the passage from one era to the next was one of the commonest procedures in the historiography of the second half of the nineteenth century and the first half of the twentieth. The favourite theme, the passage from the Middle Ages to the Renaissance provided scholars of such different backgrounds as H. Thode and K. Burdach, H. Baron and A. Chastel, with the best possible opportunity for introducing, always differently argued, the theme of religious ideas as an essential factor in the transformation leading to the Renaissance.[3] Burckhardt's clear relief-portrait of Renaissance civilization, which gave greatest prominence to secular, aesthetic and philological concerns, while perfect in itself, came to seem increasingly limited; it could have been given a quite different emphasis by underlining additional, or quite different elements. Let us look, for example, at a typical religious factor, the influence of the message of St Francis. Even though it has been subjected to so much scrutiny and pruned of its rhetorical and dogmatic elements, Franciscan 'humanism' opened up extraordinary possibilities for reconnecting religion with nature, and is still appreciated in its full value as the dawn of a new age: this despite the fact that it has been rightly pointed out that the ideal of poverty was already losing ground by the time of the early humanism of the fourteenth century, re-emerging only at periods of crisis and in disastrous situations, and at other times remaining confined to the margins of institutions in Church and society. However, it is important to emphasize here that the radically new ways of living out Franciscan sensibilities and

ideals are still (particularly in the centuries of the Middle Ages and the Renaissance) fundamental to an understanding of the overall historical dynamic, including aspects relating to the rise and change of artistic forms.[4]

But this does not mean we can proceed by drawing automatic analogies between the expressive tendencies of individual artists or groups or schools and the various branches of Franciscan ideology which established themselves after papal intervention had relaxed the strictness of the rule concerning poverty. What is known about the artistic ideas of the Conventuals and Spirituals or of other more radical dissident movements can give only a general indication as to what influence the Franciscans may have exerted over the builders and decorators of their churches and monasteries; and the same is true later on for the Regular Observants.[5] The extraordinary variety of expression in the sacred art of their buildings in the fourteenth and fifteenth century, particularly in central and northern Italy, ranging from moderate ecstatic pietism to vehement religious passion, would foil any attempt to hold the religious ideas of one or another of the Franciscan offshoots responsible in some way for the stylistic intonation of those works.[6] Similarly it is not sufficient to observe that one of the most remarkable unknown Umbrian artists of the first half of the fourteenth century worked mainly for the Augustinian order, and then decide that the informality of his patrons had something to do with his distinctive expressive style of characterization, pathetic and grotesque by turns, which is so different from the more controlled pathos of the Master of the 'Romitorio di Campello' (a Spirituals' refuge?) or the unruffled sweetness of the masters originally from Assisi who worked with Puccio Capanna.[7]

Today we can draw a kind of linguistic map of fourteenth-century painting, rich with different variants corresponding to small localities situated in between the better-known areas such as Orvieto, Assisi, Perugia, Spoleto, Gubbio, Fabriano, Arezzo, Florence, Siena, Pistoia, Pisa, Lucca and so on. Those places may have been better known, but they were still too condensed compared with the flexible topography of local idioms. The connoisseurs are to be congratulated for the resulting picture, which is still being worked out. Historical research has found valid reasons for the origins and offshoots of styles and the complex interrelationships of schools and workshops, and will soon provide facts relating to religious society which will be most useful in providing a proper framework within which to view the changing picture of artistic expression if they give us greater confidence to override generalized classifications and abstract

analogies and throw more light on what we might call medium- to small-scale situations, to reveal at least some threads in the religious, socio-political and cultural fabric which often weaves itself within even a limited field of mentality and behaviour. The search for connections therefore has to contend with a very complex order of considerations, full of internal divisions and real or apparent contradictions. And we shall get nowhere unless we decide to mistrust results which square perfectly simply because they can never go beyond the general: starting with two-horse syntheses of the Cimabue–Jacopone, or Giotto–St Francis kind and so on, to equally schematic and unlikely antitheses such as the same Giotto–St Francis association from an antiphrastic approach.[8]

An example of systems of influence

Staying for a moment with this theme of the relationships between the particularly influential religious orders and the stylistic movements of a given period, if the idea is to evaluate in sufficient detail the ways in which external forces exerted pressure on the expressive will of the artists and the effects of that pressure, we must first and foremost bear in mind that its angle of incidence often depends on the fact that the religious sphere from which these forces emanate is also 'transmitting' to the social, economic and cultural spheres. Consequently, a balanced appraisal of the phenomenon can be achieved only by close examination of the specific ways in which such a complex influence is exerted in a given area, of the position of the artist in the social context – which is often, as we have said, a microcontext – and finally of the cultural character of the phenomenon, which also dictates its tendency to consensus, passivity or resistance.

If we take a good example, we can try to get a clearer idea of what at least some of the threads of a similar investigation would be.

Some aspects of paintings of sacred subjects that are classed as extreme Gothic are striking by the quite frequent recurrence, in fairly large centres in different geographical areas, of characteristic expressions which are so marked as to be easily classifiable. Boldly unrealistic concepts of space, recurring graphic accentuation, the tendency to amplify the most 'disturbing' physiognomies and anecdotes all lead towards a strongly emotive rendition of biblical and hagiographical narratives, and their didactic and exemplary value tends to be suggested in tones of gloom and excitement simultaneously. This movement in sacred painting was almost entirely

confined to the first half of the fifteenth century, and to Emilia, the
Marches and Umbria, and had as its champions Jacopo di Paolo
and Giovanni da Modena, the itinerant painters Antonio Alberti and
Bartolomeo di Tommaso, and the still unnamed masters of the Rocca
di Vignola and the Sagra di Carpi.[9] Their works show another face
of late Gothic painting, that 'courtly art' *par excellence*, which
tended to turn a sacred theme into a worldly spectacle; here there is
no brilliance, no lyrical evasiveness, but 'commitment' to the pur-
pose of translating eschatological admonishments, calls to repentance
and salvation, and the exploits of Christ, the devil and the saints
into figures charged with humour and drama. Such intense involve-
ment vividly recalls aspects of violent expressiveness, again religious,
to be found in the same regions in the previous century.[10]

There is a strong and justifiable temptation to imagine some in-
trinsic influences from the respective religious environments at work
behind the blatant increase of specific content in the sacred theme,
for example in Modena and Bologna, Camerino and Terni. But the
known facts about at least one exponent of this culture – which has
been shrewdly defined as 'full of nostalgia for ancient fables, to the
point of reviving them in cycles full of figurations, and yet open too
to the dramatic senses of a new harsher and harder-fought life of
vested interests, customs and classes' – and about the social and
religious realities he faced again seem to suggest that we should go
back and look at a small group of phenomena, which relates the
term 'environment' to a much more specific situation in a limited area
rather than to an all-embracing ideological and cultural 'system'.

In the case of Bartolomeo di Tommaso, whose work has unmis-
takable nuances of expression as well as a constant psychic tension,
our aim will therefore be to define the social and cultural context
within which his language earned approval or, more importantly,
actually received positive encouragement.[11]

One thing we know is that Bartolomeo's father, Tommaso
Pucciarelli, was a skilled shoemaker in Foligno. But the 'leather
road', which was the artery for one of the fastest-growing industrial
and commercial activities of the fifteenth century, passed not through
Foligno but through the nearby Marches. The painter's long stay in
the Marches during his youth and his relationship with Olivuccio di
Ciccarello, who seems to have been his first master, seem from the
surviving documents to be closely related to his father's work, as the
latter toiled between Foligno and Ancona with leather, alum and
'Grecian wadding'. In 1425, when he was fifteen, Bartolomeo wit-
nessed a series of documents involving *sutores* (seamsters), in one

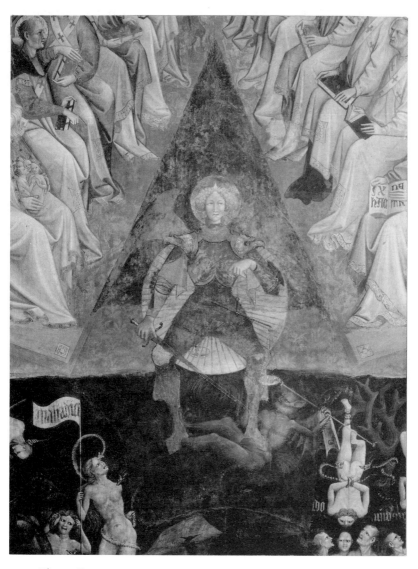

Plate 69 GIOVANNI DA MODENA, *Judgement*, detail, *c.*1410–15, Museo di San Petronio, Bologna.

Plate 70 BARTOLOMEO DI TOMMASO, *Judgement*, detail, San
Francesco, Terni.
Photo: Archivi Alinari.

case with Olivuccio and one of his pupils in front of his shop: there
is no better way to get an idea of the thoroughly craftsmanlike
training of a provincial painter, even one who was destined for
employment in the Vatican and the Campidoglio, than to observe
this fellowship of painters, apprentices and exponents of the *arte
calçolariorum*. The existence of a cultural understanding between
father and son can now be traced by reference to a recently discov-
ered fact of the painter's early training: the triptych in the church of
San Salvatore in Foligno has now been dated to before December
1432, which coincides with the date of Sassetta's *Madonna of
the Snows*. Bearing in mind that the relationship between the two
paintings is beyond doubt, Bartolomeo's encounter with the Sienese
painter's work must have taken place the previous year, when

Plate 71 BARTOLOMEO DI TOMMASO, *Hell*, detail, *c.*1450, San
Francesco, Terni.
Photo: Archivi Alinari.

Sassetta's painting was probably already on view; and since it seems
that Bartolomeo's father still had his son in tow at that point, we
can deduce that the painter was trained in Tuscany, taking advantage
of his father's need to travel on business: Tommaso may even have
gone to the capital of the hide and leather industry, Pisa, which can
be reached by two different routes – either through Arezzo or through
Siena.

 This is all that was known until now about the painter's early
background and the opportunities for training it could effectively
provide. But what else can we now unearth about the specific social,
religious and cultural context to which Bartolomeo's unusual modes
of expression refer?

 In his book on the relationship between painters and humanist
circles, Baxandall observes that the work of Pisanello 'sometimes

Plate 72 BARTOLOMEO DI TOMMASO, *Madonna of Loreto and St Anthony of Padua*, Pinacoteca Comunale, Foligno.

has the character of contriving a series of cues for standard humanist responses – Mongols and birds for variety, whole menageries for decorative itemizing, flashy foreshortenings for *ars*, snakes and gibbets for the (Aristotelian) principle of pleasurable recognition (of base objects)'.[12] Of course Bartolomeo did not have Guarino and Facio to turn to; but the 'hieroglyphic symbolism'[13] through which he renders his obsessive sense of the numinous, his gloomy mysticism loaded with obscure signs and exaggerated effects may also have been meant for someone in mind whose expectations must be met, someone to 'contrive cues' for.

In the agreement drawn up to decide the decorative scheme for San Giuliano at Fano the documents from 1434 establish that Bartolomeo would be given the bulk of the work only if the samples pleased the bishop, the Franciscan preacher at San Francesco, the

patroness and two experts. Five judges then, four of whom belonged
to the ordinary, normal world. The person whose presence should
be stressed here and seems to be stressed in the document (*'venerabile
patre magistro Johanne de Montebodio lectore s. Francisci de Fano'*)
is the Franciscan preacher. There is no doubt that it was his opinion
which really counted. We possibly tend to forget how densely the
first half of the fifteenth century is populated not only by humanists
but also by the 'glorious succession of Franciscan Observant preachers',
which included characters such as Bernardino da Siena, Giovanni da
Capistrano and Giacomo della Marca. There is surely no need to
point out that their impact on everyday life and on their dual targets,
the local centres of power and, through preaching, the masses, was
far greater than the influence of the 'orators' and learned men. The
Regular Observance of the time was heading a widespread and radical
movement aimed at influencing public life as well as the private
sphere, fanning out from central Italy to beyond the Alps and finding
probably its most spectacular expression in the preaching of Giacomo
della Marca, who was always to be found in every town square of
mid-Europe giving the Communes their statutes, imposing reconcili-
ations, punishments and fines, and confronting heretics and Jews.[14]

Bartolomeo di Tommaso's twenty documented years of activity
are full of encounters with the Franciscan family. We have already
mentioned the friar who was in charge of the Fano frescoes; Barto-
lomeo's patrons at Cesena, Cascia and Terni were also Franciscan,
and in the case of Terni, Monaldo Paradisi's links with the Obser-
vance seem to have been very strong. But the fresco from Santa
Caterina di Foligno also presents a Franciscan theme and the same
must be said of the Camerino triptych. Careful observation shows
that in these and in further important stages of Bartolomeo's artistic
development, the sphere of events – often dark and turbulent events
– in which the painter worked was dominated by the presence of
Giacomo della Marca. In the years around 1425, when Bartolomeo
was in Ancona, the friar was busy there and in other cities in the
Marches, energetically settling controversies, overseeing the actions
of the Communes, stirring the people up against the Fraticelli whose
stronghold at Maiolati was destroyed in 1428. When the painter
first returned home (*c.*1432), Giacomo was away preaching in
Hungary, Dalmatia and Bosnia; but when Bartolomeo again became
a resident of Ancona, he turned up in the Marches again (1441), and
when Bartolomeo went back to Foligno for good we find Giacomo
there again making his presence felt in the decisions of the Com-
mune and promoting the *Santissima Unione* whose statutes bear the

painter's signature along with those of the heads of families.[15] It could be very interesting to investigate the personality of Monaldo Paradisi who, as the main representative of his family, must be identified as the person who commissioned the chapel at San Francesco di Terni, where Bartolomeo painted his famous frescoes. Local sources show that Paradisi was a staunch supporter of the statutes proposed by Giacomo della Marca, who was preaching at Terni in 1444 – possibly when the decoration of the chapel was already being planned.[16] So at almost every stage of his life Bartolomeo found himself within earshot of the solemn and fervent Franciscan; this close contact may even mean that the placing of the name of Jesus high on the cymatium of the Camerino triptych somehow relates to a favourite theme of Giacomo's sermons; or that the Franciscan saint gesticulating from behind the parapet of a pulpit in the 1449 fresco at Foligno is a portrait not of St Anthony of Padua, as is usually claimed, but of the impulsive friar who had preached just four years earlier in the main square of Foligno.

The oratory of San Bernardino, which has been defined as 'a meeting of themes from the great tradition of Franciscan speculation and essential motifs from the new humanist culture',[17] seems very far removed from the sermons of Giacomo della Marca. It is not for us to define Giacomo's distance from the 'new age', but we can assume that the archaic didactic symbolism and Joachimite eschatology of his sermons must be considered in the same cultural context of irreducible foreignness to the Renaissance as the art of Bartolomeo di Tommaso. Perhaps the painter hoped that his work would come across to its intended audience and critics as 'inflamed and incisive' like the sermons of the Franciscan.[18]

I would not have restated this possibly too detailed exposition of a subject which I have already gone into elsewhere if I did not still think it was one of those unusual cases where a few favourable conditions combine to throw sufficient light on the nature and circumstances of the relationship between an artist and the forms of religious life with which he comes into contact. In this case, our satisfactory knowledge of the painter's surviving *corpus* and the world he worked in, the good crop of documents relating to him and, in particular, the availability of evidence closely pertinent to his social background, his movements, his patrons and their social and religious backgrounds, all seem to admit pieces of clear evidence at least, if not of certainty, which may possibly serve as clues to studying other similar situations. In fact, the expression of religious feeling in central Italy, particularly in the years from 1420 to 1460,

constitutes a unique phenomenon with its own peculiar features, which have increasingly been the subject of specialist study in recent years.[19] There seems to be a preponderance of influence from the Observance Franciscans in these manifestations, which works by insinuating itself into all expressions of individual and social life, or as Ghinato has written: 'both in the greatest problems of the general life of the Church, state and city and in the tiny problems at home, in small businesses and in personal relationships'.[20] The power of this influence lay mostly in popular preaching, which at this time was almost entirely in the hands of the Observants, and was an exceptionally important sign of the exercise of power which gave rise to a great mass movement in the religious and civil spheres, which in turn had a profound influence on patrons and artists, and especially on those working in Franciscan churches in proven contact with the most popular Observance preachers. What the preacher had to offer artists, who mingled with the people of God, conscious of being 'agents for showing common men who cannot read the miraculous things achieved by virtue and in virtue of Holy faith'[21] and thus themselves engaged in 'silent preaching' (*muta praedicatio*), was not only theological doctrine and moral precepts but a rich range of expressive nuances to arouse edification, terror, laughter and tears. Just as in some of the most notable examples of contemporary preaching – for instance in the case of Giacomo della Marca – the content of the sermons seems perfectly consistent with the typical mentalities, interests and problems of the time, and relies on techniques and tones still openly medieval in their use of the old *artes concionandi* (arts of preaching) and typically scholastic schemes,[22] so equally do some contemporary painters – for example Bartolomeo di Tommaso – in aspiring to heavily charged expressiveness and grandiose form, still use a duly harsher and exaggerated version of the late Gothic linear canon, which appeared to have run out of steam in the 1440s and 1450s.

This is the picture we get of a strongly distinctive period and environment typified by the forms it used for propagating the ideals of religious life and of the way those ideals were able to penetrate right to the heart of the imaginative and formative faculties of the artists. Although this intense relationship has not received the attention that has made the pairing of Savonarola with Botticelli or even with Fra Bartolomeo so famous, and although we cannot back it up with literary evidence as in the case of Francesco Panigarola and Ambrogio Figino, it nonetheless seems clear that circumstances were favourable to the consolidation of the relationship and to its visible consequences,

from evidence as concrete as that adduced in the case of fourteenth-century painting to establish the existence of 'affinities' between Jacopo Passavanti and Andrea Orcagna, or between Simone Fidati and Taddeo Gaddi, and even between Domenico Cavalca and Giotto.

To sum up our chosen example, the most interesting thing to emerge, in my opinion, is not just the unusually generous opportunity which it affords to observe clear evidence of how a certain style of preaching could be a forceful instrument of religious propaganda used to influence the society to which the artist belonged, nor, taken to its furthest implications, can it be used to try and draw up a kind of table of concordances between the patterns of San Giacomo della Marca's religious rhetoric and the cast of Bartolomeo di Tommaso's style. But in studying the circumstances, we find that this was a case where events combined in such a way that the people and groups for whom the work of art was intended confronted the artist very force-fully with the problem of what was expected of him, so that what we see is them 'meeting half-way', full of expectations and eagerness to get it right, at a place where religious, ethical, political, social and cultural forces as well as artistic ones all converge.[23]

Religious experts in action

However, it is unlikely that the forcefield in which the artist moves always exerts quite such a strong influence. A. Hauser's caution over a possible link between Pontormo's retreat to the Carthusian monastery at Galluzzo and the artistic 'crisis' in the Certosa frescoes seems well justified.[24] If we reflect upon Pontormo's personality and consider, for example, that the early 1520s were years of upheaval almost everywhere, we should wonder whether it is possible to see as an important motive force what seems, without details of time and place, to be a uniform religious climate – unless we once again put all our money on the theory of post-plague reflections. Similarly, if we explore the later part of the century, as we shall see more clearly later on, the unfocused idea of the 'Counter-Reformation climate' as a motivating force is insufficient evidence for the detection of its possible effect on stylistic processes.[25]

Looking at how the theoreticians of religious art were growing in number to include some very important figures, who made it their business to spell out to artists the 'qualities they must show to Christians',[26] it is tempting to credit them with greater influence than they would have had in other circumstances. For example, it is still

Plate 73 PONTORMO, *Resurrection*, *c*.1523–5, Certosa di Galluzzo,
Florence.
Photo: Archivi Alinari.

hard to see what the stylistic response might be that would square
comfortably with the 'cosa nova e bella' (fine new style) drafted by
Gilio[27] in contrast not just to Michelangelo, but also to Sebastiano
del Piombo and Siciolante. It was in fact simply an abstraction (but
does the idea of the 'mixed painter' have any greater substance?),
seasoned with barren and monotonously pathetic descriptions, which
left no demonstrable trace on the living body of art. In fact it is
significant that Lomazzo, who actually understood art much better
than the Monsignor from Fabriano, confines himself in the most
obviously Counter-Reformationist part of his *Trattato*, to giving
iconographical recipe hints, and hardly ever suggests expressive so-
lutions.[28] But on the whole, as we observe the proliferation of this
kind of writing during the second half of the sixteenth century, with

Gilio, Molano, Carlo Borromeo, Paleotti and Comanini, all fairly closely connected to the Tridentine decrees and the statements of the provincial Councils etc., we are left asking a number of questions of direct relevance to the theme addressed in this essay, which should not be seen as a study of treatises on religious art.[29] All that interests us here is to highlight the importance of one problem which is vital to our theme: how far can we take the idea that those stipulations against malpractice, all those principles and guidelines, necessarily entail their own poetics, or mark out a concept of style and a recognizable standard of good taste; and then, once those qualities were established, how far could we credit them with the ability not just to shackle religious images to respect for dogma, historical truth and morality, but also to influence so radically the formal world of the artists. In advocating the carving of an image of Christ 'afflicted, bleeding, spat upon, shaved, deformed, bruised and ugly, such as no longer to resemble the form of a man',[30] Gilio is probably not holding up a recognizable model, nor does he seem to be delivering some kind of neo-medieval manifesto; and the hypothesis that St Charles's *Instructiones* was actually 'outlining his own architectural poetics' is still debatable.[31] I do not see how such works as these could be included in the artists' perception as pressures, ideas and concrete influences on their formal imagination.[32]

In a searching review of the theoretical literature of the Catholic Reformation concerning the figurative arts, one of the most diligent scholars of sixteenth-century religious life, P. Prodi, has included a study of some recent work by art historians on the subject. Regarding the decree on sacred images given out by the Council of Trent in 1563, Prodi delivers a quite different judgement from that given by F. Zeri in his famous essay on Pulzone, when he denies that the decree, which was 'general and without the direct effect usually ascribed to it', can be considered as the starting point of a long process of repression of artistic freedom culminating in the oleographic anonymity of modern 'religious art'.[33] Equally interesting is his scepticism – already perceptible in a piece by Schlosser – as to the real penetrative force of a text like Gilio's, which far from being a 'new chapter in the history of art criticism', is better understood as an episode of minor importance in the tradition of treatise-writing as a whole.[34] The ultimate aim of Zeri's book is to endorse a monolithic definition of Counter-Reformation art, which is in fact a complex historical phenomenon best served by those exemplary treatments which 'display a basic interest in capturing, within the Italian Church, those currents in spirituality, and in theological, cultural and

Plate 74 FEDERICO ZUCCARI, *Ordination of San Giacinto*, 1600, Santa Sabina, Rome. Photo: Archivi Alinari.

disciplinary background which were manifest in very different ways in the regions and dioceses of Italy'.[35] We shall return later to the appropriateness of research conducted on these lines. But it is important to observe at this point that at least over the important question of evaluating the influence of rules and precepts on the artistic changes which followed the Catholic Reformation, the differences between these two scholars are not always insuperable, despite their divergent viewpoints. When Zeri acknowledges that a 'gradual bending of pictorial form to the demands of the subject in religious paintings, the escape of the subject from its condition as simply a pretext in works of art painted for devotional purposes, are noticeable very early on in the sixteenth century' and goes on to give examples which confirm that 'the ideas of a Fra Bartolomeo or a Mariotto Albertinelli are almost half a century ahead of developments that are usually imputed to the Counter-Reformation', he allows us to grasp how important features of Italian religious painting were sometimes totally independent of the processes whereby religious art is regulated and theorized.[36]

Of course, Fra Bartolomeo, Mariotto and Sebastiano del Piombo were living within complex realities which cannot be reduced to the zeal of ecclesiastics and liturgists. But let us observe these clerics and other figures of similar rank, not committed this time to giving out general instructions, but exchanging opinions and doubts as to how the Assumption should be portrayed in a large altarpiece intended to be placed in San Silvestro al Quirinale. The Bandini patrons – one of whom was a prelate – wished to consult Silvio Antoniano, who was not yet a cardinal, and Gabriele Paleotti, who also sought the opinion of Sigonio, who was also on hand when he was working on his *Discorso intorno alle immagini sacre e profane* published the previous year. The correspondence, brought to light by P. Prodi, took place in April 1583, probably just before work began on the great slate altarpiece by Scipione Pulzone (1585), considered to be one of the most important works for understanding 'Counter-Reformation' religious painting.[37]

None of the thematic components of the subject escapes the attention of these learned men: the ascension of the Virgin 'in body and soul'; the 'attendance of Angels', and thus far there is no room for uncertainty; more problematic however are the juxtaposition of the Assumption with the gathering of the apostles at the tomb, two notoriously asynchronous events, the type of tomb (should it be in the centre, in an ahistorical sarcophagus, 'o pur nel fianco, et nel masso d'una rupe viva?' – or at the side, cut out of a sheer cliff?),

Plate 75 FRA BARTOLOMEO DELLA PORTA, *God the Father with Mary Magdalene and St Catherine of Siena*, 1509, Pinacoteca, Lucca.
Photo: Archivi Alinari.

the Virgin's age (should she be sixty or thirty-three?), and the number of apostles, as some had already died.

Clearly there was no shortage of issues for debate, but a particularly tricky question was that of accepting a synoptic presentation of the Assumption and the apostles. On this point Antoniano seems

to have been attracted at first by the most drastic solution but im-
mediately realized that 'without apostles, the painting would seem
too bare' and eventually allowed them into the vision, confident that
the effect of the picture will be to suggest the correct interpretation
of two different times ('and the painting will almost suggest that the
tomb was found empty, since the Madonna has been assumed into
Heaven'), provided, however, that the apostles show no sign of
watching the Virgin ascend, given that the Scriptures do not say that
the Virgin was visible. For his part, Sigonio – and it seems as though
Paleotti agreed with him – went even further: his proposal was that
some of the apostles should be looking at the entombment and
others towards the Virgin, who may have been made visible by the
grace of the Holy Spirit.

Antoniano may have passed on the outcome of this consultation
to the Bandini and there is much to suggest that they in turn in-
formed Pulzone. But can we suppose that these preliminaries had
any real effect? Not only do they lack any rigid, let alone binding,
content; what is striking is in fact how flexible and interchangeable
the proposals were, almost always keeping a tone of quite open
possibilism. On the whole, with the Bandini wishing to keep to 'the
historical truth and precise representation of the great mystery',[38] the
answer is that where Scripture is silent or reticent there is no alter-
native but to follow tradition or, as we have seen, to trust that the
painting will have the right effect. As for Pulzone's great altarpiece,
it shows the Virgin looking rather young, the tomb in the shape of
a sarcophagus and centrally positioned, and the apostles numbering
twelve. And it is true that they do not give the impression that they
have noticed the miraculous ascension, but rather seem to be con-
ferring gravely – almost in imitation of the three experts – over the
empty tomb; but one would hesitate to attribute their behaviour,
which is itself not entirely unambiguous, to the vague ideas referred
to above, particularly if we bear in mind another solemn *Assump-
tion* painted at the same period by Ludovico Carracci in Bologna
under Cardinal Paleotti himself, where a clear majority of the apostles
are raising their eyes on high and enjoying the full vision.[39]

There are precious few opportunities for studying documents tes-
tifying to the debate that preceded the painting of such a represent-
ative work, and therefore few chances to interpret them. In pausing
so long over this example, I did not intend to minimize the general
force of influence and control exercised over artists by the ecclesias-
tical authorities in the post-Conciliar era – though perhaps less ener-
getically under Gregory XIII himself.[40] However, I think this episode

Plate 76 LUDOVICO CARRACCI, *Assumption of the Virgin, c.*1586–7,
North Carolina Museum of Art, Raleigh; gift of Mrs J. L. Dorminy,
in memory of her husband.

does justify the suggestion that we should not attribute the uniform
and inflexible conditioning of the artist's will to eminent Counter-
Reformation scholars and theoreticians without careful verification.[41]
 Similar caution is also appropriate when examining a case where
the pope himself commissions a work and personally takes part in

Plate 77 FEDERICO BAROCCI, *Institution of the Eucharist*,
1605–8, Santa Maria sopra Minerva, Rome.
Photo: Archivi Alinari.

its planning. One particularly well-documented example is the case
concerning Clement VIII's commission to Federico Barocci for the
Institution of the Eucharist for the Aldobrandini Chapel in the Church
of Santa Maria sopra Minerva in Rome. The letters from the Duke
of Urbino, who acted as an intermediary with the artist, and better
still the very detailed letters from his agents in Rome give us a
chance to follow at close hand the early stages of the planning of
this important piece during the years 1603–4, and clarify Clement
VIII's role in its execution.[42]

The pope realized that the subject he wanted would require a
different space from the rather tall narrow area above the altar.
On this point he not only declared himself prepared to be guided
by Barocci's judgement, but actually allowed the painter to choose

between that subject and another quite different one, a Madonna and Child with Saints Clement and Hippolytus, his patron saints. The duke told his own agent that Barocci 'chose the Supper, and decided on it because it had been His Holiness's first intention and also perhaps because he realized that nothing would be gained, as regards the narrowness of the space, by choosing the other subject that had been proposed'.[43] From this formulation, putting the two reasons which he inverts for diplomatic reasons back into their proper order, it transpires that the final decision rested with the painter and that the real reasons for the choice are artistic ones. The pope then carefully studied the two drawings Barocci sent and chose one, which probably corresponds to one now in a private collection in England.[44]

However, the pope advised two changes and 'the better to impart his meaning' he gave the Urbino agent a sheet with a 'sketch by a young man'. With the help of this sketch, which Barocci was never shown 'in order not to give him any more trouble than he already has', Clement described in detail the two changes, and 'it really seemed [the agent tells us] that he said and did it reluctantly': he would like to see Christ's hand more detached from his breast so as to express more clearly the act of communion, and he would also like to see the addition of some 'lighting' to show that the Institution took place at night.[45] We know that Barocci reacted to this by complaining to the duke that a nocturnal setting presented further problems and therefore would take longer to complete. But it was certainly not for this reason that Clement never saw the finished painting; it was simply the painter's usual slow progress.

Here again we may wonder whether the influential patron, with his constant involvement in the preparatory stages of the painting and his stated requirements, managed to exercise any substantial control over the artist's expressive will. The answer is perhaps to be found in the beautiful passage Bellori devotes to the *Institution of the Eucharist*. Particularly prominent therein is his admiration for the 'interior of the cenacle bathed in dusky, nocturnal distant light' and, generally, for the superb pictorial effects Barroci had achieved by judiciously including a candle-butt, a torch and a candlestick.[46]

Of course the artist's religiosity, which A. Emiliani rightly emphasizes, is beyond dispute.[47] For this precise reason, it is important to make a distinction between religious feeling that is personally experienced and not merely responsive to contemporary religious ideals, and a forced devotionalism imposed from outside. But we should also remember that there is a third possibility, which we have already tried to point out in an example drawn from the 1440s and 1450s:

the idea of a convergence of circumstances consistent enough to be considered less an external force acting on the artist's consciousness than as a key component of his personality. Such a deeply felt religious impulse, then, combines with ethical and social pressures and the pressure of preaching, and is perceived as a much more effectively persuasive model for pictorial discourse than any dogmatic tenet or iconographical prescription.

Religious art history, art history, and history

Our study of the religious motive loses none of its impetus when faced with the fact that, in the second half of the fifteenth century, the development of the Christian ideal, rather than simply manifesting the effects of a renewed burst of faith, suffered a really serious change which, explicitly or otherwise, shook the doctrinal premises and the unique and privileged image of Christianity itself. It was the moment when the spread of neo-Platonic thought and a renewed interest in ancient religions, particularly in hermeticism, encouraged the search for 'ideas common to all religions' and favoured the propagation of the idea of 'constant revelation as old as humanity, progressing slowly but surely'.[48]

Against the background of this revelation which has unhaltingly followed and enlightened the march of humanity, the Christian hero becomes the modern and 'perfect' incarnation of religious ideas that humanity has always cultivated in other forms and in distant ages. There were at least two important consequences of this, which characterize the art of the late fifteenth century. On the one hand, this harmony between ancient and modern, between pagan mythology and Christian hagiography, between the wisdom of the ancients and Christian revelation, gave rise to more cultured and intellectually complex religious art, which was theological and philosophical at the same time, able to take in past and present in its wide compass. On the other hand, the ancient world began to seem less distant, and the new attention paid to the main features of its civilization, including those relating to religious ideas, tended to humanize that civilization and make it more relevant. In an important passage in his *Botticelli's Mythologies*, E. H. Gombrich rightly placed this second consequence in close relationship with the emergence of a secular art revived by intense intellectual fervour and enriched by far-reaching projections, and he underlined the 'fact that such high and inspiring thoughts could be translated into pictorial terms outside the range of religious

iconography'. What happened was that 'the highest aspirations of the human mind were opened up to non-religious art. What we witness is not the birth of secular art – that had existed and flourished throughout the Middle Ages – but the opening up, to secular art, of emotional spheres which had hitherto been the preserve of religious worship.'[49] We can only point out once again that the causes which helped to change the face of secular art also influenced the sensibilities at work in addressing sacred themes. So what Gombrich defines as the 'transformation of the classical symbols in the solvent of neo-Platonic thought'[50] would involve the development of all art, religious or otherwise, so radically as even to take in the Michelangelesque concept of the sacred.

What we would like to see emerging more clearly from this set of themes, which we have referred to only briefly here, are the probably insurmountable difficulties we face if we seek to reduce such broad and complex material to the terms of a simple interaction between religious life and artistic activity. It is now clear that the stakes of the game are much higher and that 'religious ideal', 'religious feeling', 'religious life' and other similar phrases have such rich implications, beyond their direct meaning, that they can even cover salient features of individual experience and social life. If the dynamics of cultural movements and of religious ideas often cross paths, and if religious organization and the social order influence each other to the point of having structures and attitudes in common, if religious and economic thought show close links, and if individual and collective psychology are really so often at one with the world of religious images, then accepting the comparison between religious life and artistic activity offers the best means of testing the assertion that the history of art is 'a history in its own right' covering a field of interest which includes, as straightforward history does, nothing more or less than what is 'proper to man, depends on man, serves man, expresses man, and signifies the presence, activity, tastes and ways of being of man'.[51]

Thus conceived, art history takes on the same mandate as history, to break out of the isolation of the discipline and make use of the findings and methods of disciplines such as geography, economics, sociology and psychology.[52] If the history of art figures in the history of religious life, then this is a perfect opportunity to justify the demand for this kind of expansion and to expose, in the very clearest light, the 'structures' and 'trends' which excite greater enthusiasm in the historians who seek to go beyond the idea that the actions of individual personalities could have played the decisive role, and to

animate the simple mechanics of events with complex motivations. It would be difficult to think of any subject which lends itself better to an interpretation based on the dialectic between long-term features and the trends or shorter-term processes, which often contradict each other, than the history of religion: a good example is easily found in the eremitic and monastic 'secessions' and the recurrent, mostly passing, phases of resistance in the name of the 'Spiritual', 'Observant' and so on towards the essentially static temporal nature of the actions of the Church and the religious orders.

So it seems that the art historian has no other solution. If he believes he must define himself as one, he should reject the logic of 'specializations' and recognize that his proper title is, in fact, that of historian. If he takes an interest in the relationship between what happens in art and in religious life, he should know that just by making that link he would get a view of the whole picture of man's ways of being in society.

Put like this, our objective seems impossibly difficult: it is understandably intimidating to realize that the ultimate consequences of such an idea for someone who has been looking at the works of art of a particular period, is that they must now turn their attention to all the other relevant historical sequences. But it is doubtful whether an art historian with such a boundlessly 'omnivorous' appetite has ever existed, and whether the most convincing examples of wide-ranging multidisciplinary methodology that have appeared in art history of recent years have actually produced their best results by taking this model to its logical conclusion. I would say that the most valuable findings have been achieved when a study of artistic expressions or an attempt to explain processes of transformation in style has in fact been very selective, within the context of an admirable desire for breadth, real selectiveness, either by focusing on particular factors of influence – social and economic contexts, institutions, religious life, cultural movements and mentality – obviously whichever of these were seen to be the most powerfully conditioning at the time, but not always and in every case the same ones; or by rigorously narrowing the field of observation to a particular milieu, considered in its specific components over a short period.

The examples proposed by F. Antal to show the positive results achieved by co-operation between art history and other historical sciences correspond to this description.[53] There is a significantly diverse range of interests among the scholars he mentions, such as R. Krautheimer, M. Schapiro, M. Meiss, E. H. Gombrich, A. Blunt, F. Saxl, E. Wind, and in the pieces in his collection the linking

factors are, variously, religious life, institutions and thought, social and political conditions, literary and philosophical concepts, mentality and taste. We could add to this list famous essays such as E. Panofsky's *Suger*, M. Baxandall's *Giotto and the Orators* and Antal's own book on Hogarth, stressing their common ability to avoid schematic gereralizations in linking themes and their convincing balance in observing relationships between the different spheres. These are precisely the qualities which have been pointed out, not without reason, as being only inconsistently present in some of the more ambitious theses which set out to show precise symmetries and recurring correspondences between artistic forms and the composition of society: for example A. von Martin's work on the Renaissance as appraised by A. Chastel; and E. H. Gombrich's appraisal of A. Hauser's *Social History*.[54]

In addressing the question of links between the history of art and religious life we must take account of the positive and negative aspects which have emerged from these other attempts. There should be little comfort in hiding behind a binomial title such as 'religious life and society' or 'religious life and collective psychology' or even 'artistic activity and religious life'. The atmosphere is still too rarefied. It immediately becomes necessary to add some further specification responding to the questions of where, when and in what particular conditions. And our findings will probably be all the more reliable the more circumscribed we keep the area under study, how well defined our period – with good reason – and how carefully we distinguish among the specific conditions of the world we are observing.

This deliberate narrowing of perspective does not of course mean we are indifferent to longer-term and geographically wider realities; in fact we must stay closely tuned to them, without ever confusing them with variously adjusted representations of the presumed spirit of the age, understood as a quite abstract category or a schematic denominator of civilization or society, which leads to the idea that, as D. Cantimori observes, 'the typological notion ultimately coincides with the notion of style.'[55] This observation could equally be applied to all general definitions of the 'spirit of the age', such as Renaissance, Mannerism etc., used as universal keys. For the sake of our discussion, however, one of the most important examples is the case of baroque, since its stylistic territory, notoriously difficult to define, has often been connected with that crucial phase in the history of Catholicism, also treacherously difficult to define, the Counter-Reformation.

The artistic sequence known as baroque and the historical se-
quence known as Counter-Reformation, both noticeably distinctive
in their stylistic connotations, their conceptual content and their
chronological duration, have long been associated together, at least
since W. Weisbach's celebrated essay and subsequent attempts by
scholars such as N. Pevsner, K. M. Swoboda, V. L. Tapié and P.
Francastel to link them. To pause for a moment over the general
problems raised by studies based on this sort of premise, it is imme-
diately evident that even if one of the two sequences shows an ill-
defined conceptual area beyond the terminology, this will greatly
detract from the plausibility of any system of interrelations which
may be proposed.[56] Even without wishing to insist on the persistent
difficulties in delimiting the kind of artistic phenomena which may
be referred to as 'baroque', we must take account of the unfavour-
able reception with which scholars of religious history greeted the
use of the term 'Counter-Reformation' in the sense it is often used
in art-historical studies, which they say is lacking both in precision
and definition. If, as has been observed, the Counter-Reformation
'is still conceived of as a monolithic solid block, almost solely char-
acterized by the triumphant struggle against Protestantism, without
nuances allowing us to see different turbulences and currents of
spiritual life or chronological or geographical differentiations with-
in the main body',[57] then it becomes ever less likely that we will
grasp the relationship between the formal processes of religious art
and the changes in religious thought and life; unless we settle for a
kind of meta-history, or a clever rhetorical tissue of causes, effects
and correspondences which is concerned to protect itself from the
dangers of 'non-reducibility' which arise when the analytical phases
of research show up fragmentary and contradictory phenomena in
historical events.[58] These phenomena crop up more and more often
in the necessary shift of viewpoint from ecclesiastical history to reli-
gious history, which is more naturally open to the many aspects of
the human and social picture.

For over half a century, some of the consistently typical tendencies
emerging from the most advanced historical research have been to
reject the division of history into periods which are entirely artificial
integral entities, and syntheses which aim to define whole eras, and
to value those elements of the historical picture which are the hard-
est to schematize, often because they are linked to the unexpressed
aspirations or leanings, often confused and contradictory, of groups
and minorities within society. In an early piece which threw light on
the rich and composite picture of the Reformation in France, L.

Febvre stressed with particular incisiveness how important it was to expose 'the great tide of different tendencies and aspirations which can only occasionally be expressed with precision but which are not any the less important for that in guiding human works and actions' behind the screen of the generalizing formulae.[59] It is to be hoped that in the study of the Counter-Reformation also the 'great tide' will continue to attract more of the attention it deserves.

After the many attempts – some of which are still valid – that have been made at identifying connections and parallels between artistic expression and religious movements in the Catholic world of the second half of the sixteenth century, the remarks of a historian like D. Cantimori come across as a lucid appeal to reason which may disorientate but which it would be imprudent to underestimate for its topicality; in an unfinished essay – the last thing he wrote – concerning the use of the term 'Counter-Reformation' he said:

> like the terms 'Renaissance' or 'baroque' or other similar terms, which are merely arbitrary abstractions referring to or derived from general tendencies and concepts of history and the world, which do not correspond to complex sets of particular facts and conscious actions, nor to long-term phenomena, they are not useful in interpreting, studying, comprehending and understanding historically sequences of events, nor in exactly qualifying periods of whatever chronological duration, nor in understanding factual situations whether they be general, particular, or individual or biographical.[60]

Moreover, as an equally negative consequence, 'the use of these inappropriate instruments often deters the historian from suggesting the most fertile and useful directions for research and the collection and organization of documentable and carefully weighed facts, and from coming to any precise conclusion.'[61] And again:

> these are schemes of classification with hindsight, idealizations and abstractions invented on a general polemico-philosophical basis. The persistence of such schemes, as with their various use from various points of view or the lazy acceptance of them, cannot (or at least should not) distract the attention of students of history from facts which are reliable because they have been gleaned from a wide and varied range of documents which is precise even though incomplete, and should not lead them into debates over general periodization and concepts, instead of towards the collection and augmenting of the documentary corpus itself.[62]

Anyone who understands that the history of art runs exactly the same risks and that the passionate warning sounded by Febvre and

Cantimori is perfectly tailored to our subject will not complain at so many extended quotations.

Meanwhile, it is fundamentally important to exclude from the conceptual territory generically occupied by the term 'Counter-Reformation' all those phenomena which, aside from their internal differentiations, can be regrouped under the heading of Catholic Reformation. H. Jedin formulated the distinction with extreme clarity: 'the Catholic Reformation is the Church's appraisal of itself by the yardstick of an ideal of Catholic life attainable through internal renewal; the Counter-Reformation is the self-affirmation of the Church in its struggle against Protestantism.'[63] Within this distinction is implicit the idea that both movements contain a rich range of variants, for example with regard to the relationships between the hierarchy and the religious system, the characteristics of single societies, or psychological attitudes and how these and other factors were differentiated over time; and these variants dictate that our study of connections should be a more subtle investigation, tirelessly keeping its object in focus. Once the distinction between Catholic Reformation and Counter-Reformation has been introduced, the art historian who seeks to attempt a relevant reading of changes in style cannot but take into consideration those findings of historical research which make it possible to find in phenomena features both of unity and of multiplicity. The task is certainly not to record passively, but to check, integrate, and if necessary give prominence to the fact that the dynamic of artistic expression can frustrate the desire for too consistent or detailed symmetries.

Moreover, it is the same need to distinguish and specify, emerging with growing insistence in the historical research of the last few decades, which justifies the necessity for art historians too of equipping themselves with instruments capable of handling ambiguities, contradictions and diversity. In the case of the sixteenth century, the art historian must take account of the composite nature of the Catholic Reformation, and notice phenomena within it which are diverse or ambiguously concomitant, or which produce undue dislocation in historical placing. The facets we must focus on naturally include, as early as the time of Julius II, and Leo X with the Fifth Lateran Council, a reaffirmation, though with new implications: after Luther, the establishment of the two poles of Protestant and Catholic Reformation – the latter with new objectives and new emphases – and all the variously nuanced positions in between, even as to whether or not it was appropriate to convene the Council; then the emerging tendencies within the Tridentine assize, which saw

the convening of the Council either as the decisive moment for the ideals of renewal and reform to gain ground or as essentially the most effective instrument for the total rejection of Protestantism and for a new Catholic victory; then the ambiguous post-Conciliar phase, which saw the albeit brief prevalence of the reforming tendency, after which, with a progressive strengthening from the 1580s onwards of the repressive and intransigent currents and what can be seen as the real beginning of the chapter of the Counter-Reformation; and finally, the crisis of the Counter-Reformation, coinciding roughly with the beginning of the pontificate of Urban VIII, which should be understood as the weakening of the more properly religious motives and the ascendancy of more properly political ones.[64] It is true that the debate over the internal chronology of these events, and whether and to what extent some of them should be considered as part of the Catholic Reformation or as part of the Counter-Reformation, is still open;[65] but this detracts nothing from the evidence that if art history wishes to try and discover associations and harmonies between religious history and changes in form, it must engage with the complex tapestry of characters and happenings and not with a set of improbably homogeneous definitions.[66]

Art, the Church and groups

At the risk of unbalancing this discussion by devoting so much space to the sixteenth and seventeenth centuries, it is important to try and draw further material for scrutiny from those two centuries. Moreover, it is acknowledged that they offer more data of particular relevance to the question we are addressing here than other periods.

A plot as rich with contrasts as the historians of religious life paint the era of the Catholic Reformation and the Counter-Reformation[67] has its natural corollary in the need, which has also been stated many times in the last few decades, for a study of religious life to be geographically differentiated, first and foremost. This need is greater than ever in research relating to Italy, where there is no point of reference which the presence of a homogeneous political structure can, in some cases, provide. The findings which have so far emerged particularly from French and Italian studies have unanimously shown the importance of specific research into the real situations in individual dioceses, where it is nearly always possible to find a fairly sharply defined picture, which is of essential value if we wish to clarify the relationship between religious activity and other expressions of social and cultural life.

In their investigation of the religious history of the sixteenth century, scholars such as G. Alberigo, addressing 'smaller' realities and discovering new divisions, found it necessary to turn from the general scale of research into the 'Counter-Reformation' to the detailed scrutiny of, for example, the effective modes of application of Tridentine decrees in the Italian dioceses, and there is no reason why art historians should not, in their search for connections, correspondences and derivations, also accept the idea of the diocese, or even the parish as a cultural entity, when everything seems to indicate that in certain cases this was the current entity.[68] For example, it would seem essential to consider the particular religious climate in Brescia in the first half of the sixteenth century,[69] characterized by its movement towards devotion and piety and its local expressions of the spiritual and ecclesiastical life, which make this Lombard diocese an area of considerable significance in religious history even before the Council, if one is asking questions about the nature of the sober realism found in the sacred paintings of Moretto[70] as early as the 1530s and refusing to separate the problem from the study of the religious tones specific to the people and groups whose demands and expectations gave the painter's work its *raison d'être*. The outcome will not, or at least should not, be a mechanical equation between the religious climate in Brescia and Moretto's realism; but it will certainly throw light on the formation of a tone of expression in religious painting (which was, incidentally, destined to last) unmatched at the time anywhere else in Italy, let alone, as anyone can see, in Venice, to which state the diocese of Brescia belonged. The possibility that even within a parish there might have developed a specific territory of taste, manifesting itself in a certain continuity and consistency in activating artists of similar tendencies, has already been considered, for example, in the context of early seventeenth-century Rome, where, as A. Ottani Cavina observes, Santa Maria della Scala and San Lorenzo in Lucina, in contact with the Carmelites, threw out a similar commissioning policy in favour of painters of the Caravaggesque school.[71]

The dangers of corroborating phases of artificial and undemonstrable parallels will be more successfully avoided the more elements we have at our disposal to help us gain specific knowledge of individual situations. We can continue to follow the methods proposed by scholars of religious history – and therefore, I need hardly say, of social history – who rightly insist on the importance of addressing more analytically than ever areas of research which have not yet been sufficiently explored.[72] It is quite justifiable for a history of art

which is not meant to abide forever in the firmament of the 'great categories' and which is wary of solutions based on a kind of autonomous dynamic of forms, to concentrate on at least some of these areas. It is clearly an advantage for anyone undertaking a study of one or more artists active principally in the sacred buildings of the diocese to have the greatest possible wealth of data available on the social background, material conditions and cultural grounding of the bishops, the secular clergy and the laity (starting with those active in the confraternities) for whom the artist was working. Just as an example, the study of the artist–patron relationship (patron understood here collectively as well as individually) is bound to be vague and generic unless it explores the relationship between the cultural level of a member of the hierarchy or of a social group, and religious sentiment, or if it fails to devote enough attention to the cultural development of the clergy – for example to the fact that in the second half of the sixteenth century the spread of ideas of reform, new practices of devotion and piety, and the rise of seminaries, colleges and congregations introduced innovative factors into the training process of the diocesan clergy.[73]

There is a similar need for an appreciation of the real impact of the new orders and congregations which arose in the sixteenth century as the chief expression of the Catholic Reformation, from Capuchins to regular clerics, among whom we see the emergence of the Jesuits, the priests of the Congregation of the Oratory, the re-formed Carmelites of St Teresa, and the Ursulines. We need an evaluation which can see beyond brilliant but often ambiguous general definitions (the 'style of the Jesuits', the 'style of the Oratorians', and so on, now as outmoded as the definition of 'Benedictine art') and grasp which religious, social and cultural factors are specific to the individual foundations or relate to the places where they were instituted.[74]

An interesting case, referred to by M. Rosci, is the Church of Sant'Alessandro of the Barnabites in Milan, where the success of Moncalvo's 'academicizing and "morbidly" mysticizing' manner towards the end of the second decade of the seventeenth century appears to be related to cultural and religious tendencies specific to that church, which had become a characteristic centre of family power, both lay and ecclesiastical, dominated by Giovan Ambrogio Mazenta, architect and general of the order, and by his brothers.[75] We are not dealing then with the kind of relationship which can be observed on the rarefied plane of ideologies and general schemes: we are faced with a circumscribed and homogeneous world better suited

to nurturing particular religious stimuli, and whose cultural content seems much easier to grasp than those defined by concepts such as the 'age of Charles Borromeo' or 'the age of Federico'. To bring in another 'group' and its implications for this subject, it seems fully justified to pay careful attention, as L. Berti does, to the link between Santi di Tito and the lay congregation of contemplatives of St Thomas Aquinas with which the painter was associated.[76] It is to be hoped that specific research will be carried out on this circle, as well as on the circle of Sant'Alessandro in Milan, which will serve to show whether and how the specific religious atmosphere of the association, under the influence of the Dominicans of San Marco and linked with typically Florentine features of the Catholic Reformation, became a fertile ground for the birth of Santi di Tito's measuredly natural religious painting.

But there are grounds to suspect that there exists a kind of high-water mark for defining and describing the influence exerted by orders old and new, or by manifestations of Counter-Reformation thought in general. If we fail to acknowledge this, we will find that in one case after another the usefulness of our findings is dubious, for example if they lead us to conclude that Caravaggio showed a 'religiosity which may have been reformist, counter-reformist, Oratorian . . . or Augustinian'; C. Brandi certainly did not conceal his incredulity when he said this.[77] Similarly, it seems legitimate to demand concrete proof, as we feel like doing when we read that the origins of Caravaggesque 'realism' are to be found in the religious ethic of St Charles Borromeo, or that Federico Borromeo should be seen as a 'doctrinal source'[78] for Caravaggio as for the quieter Figino. It is still strongly desirable that this kind of research, on this or on other subjects, should be supported by proof and by specifications which can define as concretely as possible, beyond intuition as to what influences and associations were at work, the real areas and layers of interaction and of possible correspondence and consonance. Ideas such as those of W. Friedlander on the 'low Church' may prove useful here, although they could be taken further.[79] And, more generally, in E. Panofsky's studies, on subjects requiring constant appraisal of how far tendencies traceable to aspects of contemporary philosophical or religious thought penetrate the context of artistic activity, the picture brought into focus by his investigation appears to be complex, varied and full of contradictions.[80]

So too, doubtless very often, was the picture which seventeenth-century centres of painting, both large and small, reflect: so much so

that, returning to examples from Lombardy, we must appreciate R. Longhi's perplexity when he emphasized the difficulty of

> understanding how on earth, out of the funereal drabness of the painting of the first few decades . . . which, strangely enough, seemed to be harking back very belatedly to the first plague of 1577 (as horrifically recorded by St Charles), the second plague (Cardinal Federico's plague) brought a new docility in Lombard beauty without the need to rely on Cortona or the great Europeans who never painted for Milan.[81]

Longhi was not just revealing the presence of an element of disturbance (the painting of Carlo Francesco Nuvolone with all its charm) in the hallowed tone of Lombard painting from the first half of the seventeenth century, but he was also, though only in passing, showing the lack of correspondence between events and patterns of expression. No one would seek to deny the impact of events as crucial as the two tremendous epidemics, for this would amount to a denial of the whole historical scene, nor the exceptional role of the Borromeo brothers, which would amount to a denial of the immediate context of artistic activity. In a particular case where there really seems to have been a 'long-term relationship'[82] between artists and practitioners of religion, such as the one which developed in the second decade of the seventeenth century between Federico Borromeo and his colleagues on the one hand, and Cerano and Giulio Cesare Procaccini on the other, the hypothesis that artists were susceptible to such influences becomes quite substantially credible, even to the point where the shifting of the plane of expression, more noticeable at some times than at others, is caught up in and almost swallowed by the religious, cultural and psychological influences the artists undergo. In his analysis of a different context, F. Zeri demonstrated the enormously powerful influence wielded by a figure such as Cardinal Alessandro Farnese, and correctly assessed the significance of his relationship with Vignola and the other artists in his employ.[83] But many other examples could certainly be found of these encounters between artists and representatives of religious or secular patronage where credit and debit relations – and role-reversal is not ruled out – assume a totalizing dimension. Perhaps a less well-known case is that of Francesco Maria II della Rovere, who wished Federico Zuccari to paint a crucifix for him and did not stop at suggesting measurements, numbers of figures, type of landscape or establishing further elements of the iconographical solution (Christ

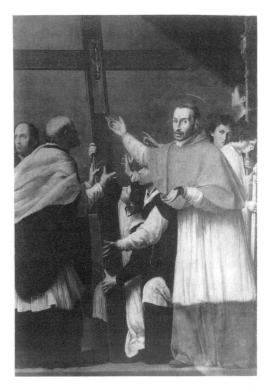

Plate 78 CARLO SARACENI, *San Carlo Takes the Holy Nail in Procession*, c.1619, San Lorenzo in Lucina, Rome.
Photo: Archivi Alinari.

must be 'close to death, but not yet dead') but actually went into the question of colours, raising doubts as to the appropriateness of using ultramarine blue 'since it is not used for flesh and there is little need for it in the landscape'.[84] But to return at last to Longhi's passage on Nuvolone, it would seem to imply that by concentrating on events and characters which we credit with sufficient force to direct the course of art and to call the tune to the artists, we do not necessarily guarantee greater understanding if we do not thoroughly check the many different levels of circumstance surrounding events, personalities and artists, in support of our idea.

It should be added that an investigation of the great personalities of the mystics, bishops and leading figures of faith and piety and the contribution they made to the creation of a new expressive climate

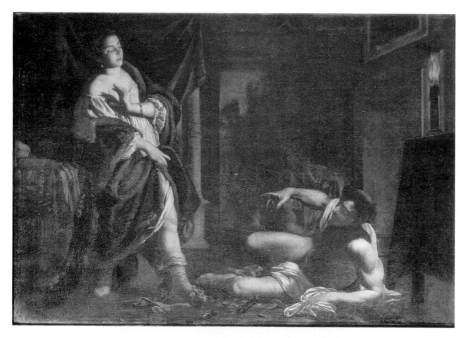

Plate 79 SIMON VOUET, *Temptation of St Francis*, 1624, San
Lorenzo in Lucina, Rome.
Photo: Archivi Alinari.

will not exhaust this field of research. The field should be widened
to try and establish what were the most common characteristics in
the religious and social life of the parishes and individual commu-
nities or groups of communities, including the average level of culture
among parishioners, the veneration of local saints, local devotional
practices, the real extent of penetration of hagiographical, liturgical
and devotional motifs through the dissemination of texts and printed
images and through ordinary preaching. The activity of the preachers,
whose importance in certain phases of history I have already tried
to show, merits special attention in view of the fact that the religious
and moral themes which recur systematically, even in the average
repertoire of sermons, and the rhetorical tools familiar to preachers
were surely capable of exercising a formative function and a trenchant
psychological effect in the most diverse social contexts, and were
even able to offer stylistic *exempla*, both elementary and complex
ones, to the Christian populace of which patrons and artists were
also members.[85]

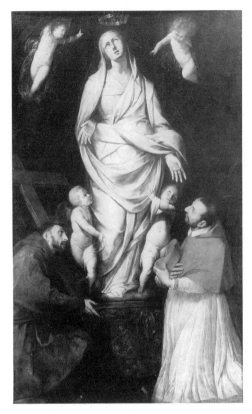

Plate 80 CERANO, *Madonna of San Celso with San Carlo Borromeo,*
c.1610, Galleria Sabauda, Turin.

In each of these themes, the aspects under study can be illum-
inated by observing whether the parishes (or other communities)
were located in cities or in the country, on the plains or in the
valleys, which were part of a coherent system of communication, or
else in mountain areas, which were more or less cut off but some-
times open to less reliable communication. One recent line of re-
search, which applied analytical procedures to this territory, has
demonstrated how the phenomenon of second jobs, common in
mountain areas where the economy is strictly seasonal, created the
basis for pockets of foreign culture to form which cannot be ex-
plained by geographical contiguity and which survived for centuries.

The shepherds-cum-customs officials of Nursino invoked Florentine saints, their churches used furnishings from Florence and their altars were graced by paintings of the same unexpected provenance.[86]

It would be unfair to see this desire to know more about these and other groups which managed, in an economic context that was certainly never affluent, to reconcile seasonal emigration with religious sentiment and artistic commissioning by the community, as irrelevant to the concerns of art history. But if we wish to know more we need documents providing information about their education, their psychology, their religious feeling and customs, and these are often scarce: something like Jacques Fournier's records for Montaillou or, from times closer to our own, the diary of the parish priest of Rumegies, which can certainly tell us more about the human environment than official documents such as statutes and constitutions, even registers.[87] The coexistence within one place or in neighbouring places of works consistent with local tradition alongside others which introduce imported forms, the close contiguity even in tiny areas of archaicizing forms of expression to others of a 'progressive' nature, and finally the different levels of religious feeling should all be observed and assessed to see how they relate to social and cultural characteristics, which often vary perceptibly on this same small scale.

It would surely be far from irrelevant, and would in fact complement the procedures of *connoisseurship*, to undertake an investigation on the same methodological lines as the research conducted in the 1960s and 1970s on sample territories in France, either on an iconographical basis, like the systematic research into Holy Souls altars in Provence in the fifteenth and sixteenth centuries, or more broadly based on religious history like the investigation centred, through a complex system of classification, on altarpieces in dioceses in Brittany, Aquitaine, Seine-et-Marne and Roussillon.[88]

In the second example, the survey was widened to include the demographical consistency of the settlements in which the sacred buildings housing these altarpieces were constructed, determining the socio-religious status of the building, the date of construction, the significance of its location in relation to communication networks and the geographical situation. It scrutinized the iconography of the painting, the materials used for the altar and the building compared with what materials and production methods were available locally, defined the characteristics of the style and investigated the commissioning to see what influence the life of the confraternities, the work of the missions, and bishops' visitations may have had on the execution of the works under study.

'Connoisseurship' and the sociology of religious art

But it is perhaps pointless to go on stressing the importance of these investigations (or to bemoan how rarely they are conducted in Italy) except to point out that well-co-ordinated study of the course of 'artistic activity' and the course of 'religious life', via the methods and themes which we have considered in this chapter, should not tend to transmute art history into a sociology of religious art. It would seem just as important to avoid this sort of consequence as it would to avoid the effects of scepticism about the influence of events, forces and social groupings intrinsic to religious life, not only on the artists' personal and social development but on their expressive options and behaviour and on supra-individual processes of stylistic transformation. This is the view that while there may be impulses from beyond the artists' universe, and that his surrounding environment in its various forms undoubtedly exerts its own pressures, in the end the artist is on his own. However, we cannot delude ourselves by thinking we can avoid this kind of attitude just by superimposing the role of 'sociologist of religious art' over our role of art historian. For the art historian, the first area of investigation remains the work of art, its structural reality and its specific language. Despite constant claims on him or her from the 'worlds' of other disciplines such as philosophical and religious thought, literary culture, psychology and social sciences, the art historian should not interpret the need for co-operation between the different sciences, though it is more keenly felt than ever, and rightly so, as a sign that one should still, in studying a work of art, privilege elements such as the subject or the topic, which, it is assumed, must always, regardless of the historical situation and the personality of the artist, reflect with axiomatic precision a given intellectual and social landscape.

Possibly through some kind of 'over-defensiveness' towards formalist methodology, or towards a methodology that is judged to be formalist, recent studies have felt obliged to neglect not only the territory opened up by Wolfflin and Riegl but also the areas closely linked to them discovered by Berenson and even Longhi. And yet there appears to be no good reason to believe that the *de facto* participation of the history of art with the assembled historical sciences would entail a methodology any different from those which give sufficient attention to reading and characterizing forms, unearth forgotten works, personalities, coteries or schools, and refine the tools for attribution.[89] Even if no one has yet managed to formulate

a 'theory of incompatibility' of one method with another, there is no denying that a kind of tacit 'process of elimination' is accepted, which makes it difficult to imagine a descendant of A. Warburg even pretending to be a meticulous *connoisseur*. In Italy, this unjustified conflict has become so prominent as to bring about situations where institutions of art history and their respective trends have no inter-communication, making it more difficult for new researchers to get a balanced grounding.

In 1949 F. Antal rightly observed that the close relationship with the historical disciplines achieved by the Vienna school and by A. Warburg had contributed greatly to 'opening the way to a deeper, richer and less nebulous study of the history of art'.[90] We need only add now that if the artistic factor is to be seen within a complex historical, political and social picture, and if this integration is to take its place as we would like it to, as a factor of great solidity and clarity, it is more important than ever not to break off contact with the whole fabric of artistic forms, which is practically inexhaustible and which could be still further enriched by finding new meaningful units which modify what we thought was a definitive image of a personality, a circle or a school. The picture we are trying to compose could become even more 'nebulous' if we concentrate exclusively on cultural, religious and psychological data and so on, in isolation from the subject or the material substance of a work of art, and if this concentration leads us in good faith to posit undemonstrable or improbable or incredible combinations of signs, psychological under-currents, intellectual enthusiasms, religious atmospheres or political implications. These risks increase when direct and reliable sources of information about the artists' mentality, their intellectual background and reading matter, their sense of the sacred and their opinions of current affairs are hard to come by or, worse still, non-existent. But even in cases where researchers have access to relevant documentary material, it could be vital to have a working knowledge of the stylistic fabric of the period and area in question comprising the greatest possible number of examples, and what opportunities are still open for identifying and attributing works, if we are to appraise with sufficient subtlety the real significance of 'external' influence on movements of style.

I say it *could* become a vital tool. In fact we are still a long way from the goal and the many possible digressions make it hard to see the way clear. It is significant that even a real expert in fourteenth-century Italian painting like M. Meiss, in attempting to find certain themes and characteristics present and on the increase in Florentine

and Sienese painting of the second half of that century, thus suppos-
edly showing them to be consequences of the tragic events of 1348,
should rely, at an important pivotal point of his argument, on a
work which soon afterwards turned out to be quite irrelevant to his
argument.[91] Meiss was describing the *Last Judgement* in the Pisa
Camposanto, which he, in common with other scholars, believed to
have been painted by Francesco Traini in around 1350, as a gloomy
portrayal of inexorable divine wrath, a description which contrasts
strangely with Longhi's reading, attributing the *Judgement* to a
Bolognese painter active in around 1360 and pointing out the gro-
tesque tone of the setting as though the terrible experience had not
been taken too seriously.[92] But it is not just a question of deciding
which of these two interpretations is the more appropriate. Accord-
ing to Meiss, the *Judgement* contains innovations of iconographicy
and expressive tone found only in the second half of the fourteenth
century. To be more precise, contrary to what we see in Giotto's
fresco in Padua and in examples of the same subject which are
chronologically closer to the Giotto model, the Pisa Christ is turned
only towards the damned, and the attitudes of the other main figures
are dependent on his terrifying act of sentencing; the Virgin, the
apostles and archangels are moved to pity, fear or impassive stern-
ness. A sound motivation for this unusual treatment of the *Judge-
ment* theme is to be found, according to Meiss, in the fact that the
fresco was painted in the context of the atmosphere immediately
following the plague of 1348, when the churches resounded with the
most vehement warnings from the preachers, and with prophecies of
further disasters on the way, and the 'Black Death' was brandished
in everyone's faces as a manifestation of divine wrath and a prefigu-
ration of the *Judgement*. L. Bellosi's lucid reconstruction of the person-
ality of Buonamico Buffalmacco has now convinced us all that the
Pisa *Judgement* and the other frescoes in the same group were painted
by Buffalmacco in around 1336, and we are forced to acknowledge
the fragility of the thesis advanced by Meiss in a book which is
nonetheless rich in insights.[93]

It was not my ulterior motive, in pausing over this example, to
belittle a scholar of great merit. But it was important to underline
how attempts to link certain thematic and expressive deviations with
trends that are supposedly dominated by particular manifestations
of social or religious psychology, are bound to run into trouble, not
just where the historical picture has not been explored rigorously
enough, but also, as was the case in the above example, where at
least two preliminary conditions have not been respected. Firstly, in

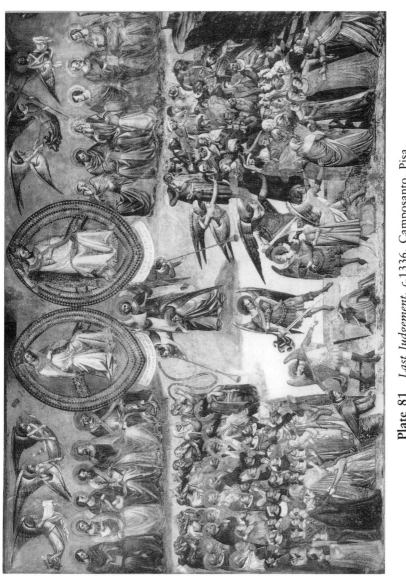

Plate 81 *Last Judgement*, c.1336, Camposanto, Pisa.

shrugging off the influence of a previously established theory, it has failed to grasp the 'objective' expressiveness in the pictorial text; it then failed to carry out in full that basic philological task which consists of checking the attribution, the dating and the placing of the work within a specific context of artistic activity. Has Meiss 'forced' his reading of the fresco? Was Longhi's reading more accurate? In any case, whether it is tragic or grotesque, the Pisa *Judgement* can no longer be associated with the turmoil of 1348. It is perhaps then appropriate to wonder whether we shall ever find an 'explanation' of the expressive tone of the fresco other than Bellosi's assertion that it is an instance of Giottesque dissidence: 'an expressionistic and Gothic trend which radiates out from its centre in Florence over the early decades of the century',[94] and of which Buffalmacco is a typical exponent.

NOTES

1 Jean Hubert's expression.
2 J. Leclerc, in *Studi medievali*, 3 (1968), p. 239 (review of B. de Gaiffier, *Etudes critiques d'agiographie et d'iconologie*, Brussels, 1967). Faced with the vast amount of material gathered in this erudite work of research, the reviewer underlined the necessity for a sociological and psychological interpretation of hagiographical literature. Cf. also J. Leclerc, 'Modern psychology and the interpretation of medieval texts', *Speculum*, 48 (1973), pp. 476ff. For the figurative hagiographical corpus a similar need was noticeable, particularly following the publication of the two monumental volumes by G. Kaftal, *Iconography of the Saints in Tuscan Painting* (Florence, 1952) and *Iconography of the Saints in Central and South Italian Schools of Painting* (Florence, 1965) (to which we now have the addition of a third volume which deals with north-west Italy).
3 Cf. also for Thode's and Burdach's position, A. Chastel, 'Art et religion dans la Renaissance italienne. Essai sur la méthode', *Bibliothèque d'Humanisme et Renaissance*, 7 (1945), particularly pp. 19–25; and see also above, n. 2.
4 For the influence of Franciscan ideas on the intellectual life of the fifteenth century and the changing fortunes of the ideal of poverty, the essay by H. Baron, 'Franciscan poverty and civic wealth as factors in the rise of humanistic thought', *Speculum*, 13 (1938), is still worth reading.
5 There is some significance in the way Meiss proceeds with caution when dealing with the Fraticelli: 'we can discern their influence upon painting, no less important because it is indirect and in a sense even

negative.' Cf. M. Meiss, *Painting in Florence and Siena after the Black Death* (1951), (New York, 1973), p. 82. There have been numerous attempts, particularly since the 1960s, to examine the points of interference between aspects of the Franciscan movement and artistic personalities and tendencies: see also below, n. 6.

It is worth recalling a very recent example to demonstrate how difficult it is to follow the method of associating images with the ideals of one or another religious movement. The hypothesis that one of the ways of depicting St Francis (as concept and as a figure) which was dear to the Spirituals and both *periculosum et stultum* (dangerous and foolish) in the eyes of the Conventual 'community' was as *alter Christus* contradicts the established fact that the seal of the custodian of the Sacred Convent actually bore a representation – the earliest known example of this iconography – of Francis as the second Christ. Cf. H. W. Van Os, 'St Francis of Assisi as a second Christ in early Italian painting', *Simiolus*, 7 (1975), p. 11, and see S. Gieben's observations on the relationship between E. Pasztor, *L'immagine di Cristo negli Spirituali* and the Third Congress of the International Society for Franciscan Studies, Assisi, 1975 (*Chi erano gli spirituali*, Documents of the Congress, Assisi, 1976, pp. 30 and 116–18).

6 See instead, for an attempt to implicate these themes in the changes of the late thirteenth century, E. Battisti, *Cimabue* (University Park, Pa., 1967); but cf. C. Volpe's position in his review of this monograph (in *Paragone*, 173, 1964, p. 70).

7 The so-called 'Master of the Blessed Clare', one of the painters active in the Cappella della Croce in the Augustinian women's convent of Santa Chiara at Montefalco, where he painted frescoes and panel paintings, is also found at work in the church of Sant'Agostino in the same city. The development of a Millard Meiss-type theme – art, religion, society – would in this case be much complicated by the interference of a lay patron who had clear links with the Augustinian order: the Frenchman Jean d'Amiel, rector of the duchy, portrayed at the feet of the cross in the Chapel of Santa Chiara. In order to show some stylistically very different aspects of fourteenth-century Umbrian painting, which are still contemporary with the Master of the Blessed Clare, I have chosen two unknown examples which seem to me particularly expressive, fragments of surviving frescoes in the church of the Franciscan ex-convent of Sant'Antonio, now called the Franciscan Romitorio or Hermitage at Pissignano (Campello sul Clitunno) and in one of the chapels of the hermitage of Sant'Onofrio at La Costa (Spoleto).

8 Before it took the form of a tentative approach towards ultradisciplinary expansion, reliance on pairings like these was one of the favourite *loci* of a school of criticism, not just of art literature, from the early years of the twentieth century, that was more or less directly descended from decadentism. Thus we see how Giotto, through his 'Canzone sopra la

povertà', destroyed the soul of Franciscanism ('l'âme de la légende'), how the entire della Robbia family was 'pénétrée de l'esprit franciscain' (did Ozanam not point out that a manuscript by Jacopone had belonged to Luca?), and how Ambrogio Lorenzetti and, better still, Sassetta were steeped as few others were in the odour of the *Fioretti* . . . All this and more can be found in L. Gillet's book, *Histoire artistique des ordres mendiants. Etude sur l'art religieux en Europe du XIIIe au XVIIe siècles* (Paris, 1912), a study which is in its way still attractive and full of meaning.

9 For these artists, the most recent contributions are those by C. L. Ragghianti, 'Il Maestro di Sant'Apollinare', *Critica d'Arte*, 39, 133 (1974), pp. 25–40 and 135, pp. 35–50; and S. Padovani, 'Pittori della corte estense nel primo Quattrocento', *Paragone*, 299 (1975), pp. 25–53, both containing ample surveys of previous writings on the subject. For Antonio Alberti and Giovanni da Modena the characterization by R. Longhi, *Officina ferrarese* (1934) (Florence, 1956), pp. 10–14 is still illuminating. Alberti's frescoes at Montone were published by F. Santi, 'Gli affreschi nell'abside di San Francesco a Montone', *Bollettino d'Arte*, 2 (1967). On Bartolomeo di Tommaso, the most significant contribution from our point of view is F. Zeri, 'Bartolomeo di Tommaso da Foligno', *Bollettino d'Arte*, 4–6 (1961), pp. 41–64; more recent research, full of new elements, is of an archivistic nature: cf. M. Sensi, 'Documenti su Bartolomeo di Tommaso da Foligno', *Paragone*, 325 (1977), pp. 103–55, where a bibliography of preceding contributions is also to be found.

10 Cf. R. Longhi, 'La mostra del Trecento bolognese', *Paragone*, 1 (1950), pp. 17–19: at the time when the first Gothic work was being done on San Petronio, Jacopo di Paolo and his companions 'went around initialling romantically some latest abbreviation of *Maestà*, Crucifixions or giant Saints, patron saints of journeys, exorcists of misfortune'. The quotation which follows in the text is taken from the same essay, p. 19.

11 On this topic I follow from this point, with a few variations, a previously published text: see B. Toscano, 'A proposito di Bartolomeo di Tommaso', *Paragone*, 325 (1977), pp. 81–5. For the world of the Quattrocento leatherworkers in Umbria (to which Bartolomeo's father belonged, see further on) the study by R. Pierotti, 'Aspetti del mercato e della produzione a Perugia fra la fine del secolo XIV e la prima metà del XV. La bottega di cuoiame di Niccolo di Martino di Pietro', *Bollettino di Storia Patria per l'Umbria*, 1 (1975), pp. 79–185; 1 (1976), pp. 1–131.

12 M. Baxandall, *Giotto and the Orators. Humanist Observers of Painting in Italy and the Discovery of Pictorial Composition, 1350–1450* (Oxford, 1971), p. 96.

13 The expression is F. Zeri's.

14 There have been recent studies of the influence of the preachers of the Observance in fifteenth-century society by A. Ghinato ('I Monti di

pietà in Umbria nell'età moderna', in *Atti del VII Convegno di studi umbri (Gubbio 1969)* (Perugia, 1972), pp. 475–517; 'La predicazione francescana nella vita religiosa e sociale del Quattrocento', *Picenum Seraphicum*, 10 (1973), pp. 24–98) and M. Sensi ('Predicazione itinerante a Foligno nel secolo XV', ibid., pp. 139–95, with an examination of the reforms from 1426 to 1500). More specifically, the work of Giacomo della Marca – which seems to address the whole range of human life, public and private, of institutions, groups and individuals – has been examined by: M. Faloci Pulignani, 'Per la storia di san Giacomo della Marca, *Miscellanea Francescana*, 4 (1889), pp. 65–78; G. Caselli, *Studi su san Giacomo della Marca* (Ascoli Piceno and Offida, 1926); A. Ghinato, 'Apostolato religioso e sociale di san Giacomo della Marca a Terni, *Archivum Franciscanum Historicum*', 49 (1956), pp. 106–42 and 352–90; D. Lasic, *De vita et operibus san Jacobi de Marchia* (Falconara Marittima, 1974); and see also the contributions made by G. Pagnani, in *Picenum Seraphicum* on the Franciscan who settled the borders between the castles of the Marches and Piceno (8, 1971, pp. 178–87; 10, 1973, pp. 219–26), brought peace to the Macerata mountain communities (6, 1969, pp. 72–90), and promoted unity between Ascoli and Fermo (8, 1970, pp. 209–11) and harmony between other Picene communities (8, 1971, pp. 178–87). See another issue of the same journal (9, 1971) for the Documents of the Fourth Congress of Study (Loreto, 25 April 1972) devoted to *I Monti di Pietà e la attività sociali dei Francescani nel Quattrocento*: see particularly A. Ghinato, 'I Monti di Pietà istituzione francescana', ibid., pp. 7–62, which also gives further bibliography.

15 B. Toscano, 'Bartolomeo di Tommaso e Nicola da Siena', *Commentari*, 15 (1964), pp. 37–51.

16 On Paradisi and his administrative activity in agreement with Giacomo della Marca see F. Angeloni, *Storia di Terni* (1641) (Pisa, 1878), pp. 213, 220 and 230–1; L. Silvestri, *Collezione di memorie storiche . . . della città di Terni dal 1387 al 1816*, ed. E. Ciocca, 2nd edn (Terni, 1977), pp. 82, 105, 106, 123 and 135; Ghinato, 'Apostolato religioso e sociale', pp. 142 and 387; *idem*, 'Primi tentativi per la fondazione di un Monte di Pietà a Terni (1464–1472)', *Archivum Franciscanum Historicum*, 50 (1957), particularly pp. 385–6 and 409–10; C. Pietrangeli, in *Strenna dei romanisti* (1973), p. 340.

17 E. Garin, 'Il francescanismo e le origini del Rinascimento', in *Filosofia e cultura in Umbria tra Medioevo e Rinascimento. Atti del IV Convegno di studi umbri (Gubbio 1966)* (Perugia, 1966), p. 123.

18 In the sermon entitled *De sancto Bernardino*; cf. D. Pacetii, 'Le prediche autografe di san Giacomo della Marca con un saggio delle medesime', *Archivum Franciscanum Historicum*, 35 (1942), pp, 296–327 and 26 (1943), pp. 75–97, Giacomo says of San Bernardino, his revered master: 'the words of the holy man are inflamed and incisive.' In the text I have transferred these characteristics to San Giacomo's own style of

oratory, because I do not think it is arbitrary to assume that he would
have attributed to San Bernardino the qualities to which he himself
aspired.

19 Proof of this, apart from the copious literature of course, is the increas-
ing number of congresses on this and related themes: the Spirituals, the
Fraticelli, the Clarenians, facts and figures of the Observance, fifteenth-
century Franciscan preaching, eschatological expectation, San Giacomo
in the Marches etc.

20 Ghinato, 'La predicazione francescana', p. 83. One of the strangest
figurative documents on the profound influence the Observance friars
had over the social fabric of the fifteenth century, through preaching
and concrete initiatives such as the *monti di pietà* (pawnshops), is to
be found in a woodcut showing the *Tabula della salute* by Marco da
Montegallo (Florence, 1494). Social action and theology share the same
scheme, centred around the image of the *Mons Pietatis* – and the earthly
destiny of the Christian and the salvation of the soul appear closely
linked. The depiction seems to be inspired by the gesture the Franciscan
preacher is making from the pulpit towards the whole of God's people,
depicted in its various social elements.

21 '. . . we are by the grace of God those who show etc. . . .' from the
Brief of the guild of Sienese painters in the year 1355 (cf. G. Milanesi,
Documenti per la storia dell'arte senese (Siena, 1854), I, pp. 1ff).

22 Ghinato, 'La predicazione francescana', p. 84; R. Lioi, 'Tecnica e
contenuto dei sermoni di san Giacomo della Marca', *Picenum Seraphi-
cum*, 10 (1973), particularly pp. 105–6 and 109–10. Corresponding
to the frequent use of medieval rhetorical devices is an interest, albeit
less well documented, in old *quaestiones* such as the *De sanguine Christi*,
'which must have caused him much displeasure' (Lioi). For the extent
of San Giacomo's literary and philosophical culture see Lioi's essay
'San Giacomo della Marca studioso di Dante', *Studi Francescani*, 61
(1964), and the contributions by G. Pagnani, D. Lasic and R. Lioi
at the Congress dedicated to *La libreria di san Giacomo della Marca*,
published in *Picenum Seraphicum*, 8 (1971). All we know about his
taste for the figurative arts is that he described as *pulcherrima* an illu-
minated bible which he owned (now in Naples, Biblioteca Nazionale,
ms VI A 5). The illuminations, which date from the end of the four-
teenth century or the early fifteenth, have been judged to be partly
central Italian with Bolognese influence and partly Bolognese (cf. *Mostra
storica nazionale della miniatura (Roma 1953)*, (Florence, 1953),
catalogue edited by G. Muzzioli, no. 193).

23 The ground of these 'affinities' between mystics, preachers and painters
has been repeatedly gone over by M. Meiss, who believed he had
discovered relationships of influence specific to the Florentine milieu
(for the examples quoted in the text see Meiss, *Painting*, pp. 26 and
84) and other networks specific to Siena: 'we feel their influence (i.e.
the influence of St Catherine, Giovanni dalle Celle, Colombini and

Passavanti) in the spiritual intensity of contemporary painting, in its reversion, not without ambivalence and conflict, from the natural and the human to the unnatural and the divine. The mystical rapture of Colombini and Catherine is more evident in the painting of Siena; in Florentine art there is more of Passavanti's grim penance, of his insistence upon the curative power of good works and participation in the rites of the Church' (pp. 89–90).

A few more specific observations may serve to show how substantially different the object of my own argument is. In the sermon *De sancto Bernardino*, published by D. Pacetti (cf. above, note 18), Giacomo della Marca sketches the ideal model of a preacher, much sought after in his time, whose main gift of inexorable anagogical power does not seek to enlighten a minority through subtle arguments, but can by his pathos excite a collective longing for salvation and set the whole of God's people aflame. The language used by this enthralling proselytizing style, full of apostrophe and invective, is a composite, even a hybrid, mixing pompous literary inflections with openly common flourishes, juxtaposing tones of ecstatic exaltation with red-blooded characterizations, and grandiloquent passages are often spiced with blatant solecisms. If there is any kind of binding agent in this kind of language, it is to be found in its tendency to excite emotion and to disturb by frequent recourse to bombast and hyperbole. There is a very significant quotation from Isidore: '*Doctrina sine iuvante gratia, quamvis infundatur auribus, tamen ad cor numquam descendit*' (Doctrine without the help of grace, however much it is poured into the ear, never reaches the heart). Let us look at some examples: '*iste annunctiator Evangelii pacis, qui descendit ab altitudine divine contemplationis per humilitatem deorsum ad scopandum immunditias, peccata populorum . . .*' (this messenger of the peace of the Gospel who humbly descends from the celestial heights of divine contemplation to sweep away the impurities and sins of the people . . .) (*De sancto Bernardino*); '*Virgines deflorantur, uxores et vidue violantur, horrenda homicidia, puerorum crudeles neces, dire carcerationes, tormenta crudelissima. Quidam suffocantur, quidam comburuntur, alii fame pereunt, alii in stercore proiciuntur. Aliis preciduntur membra, manus, lingua, et aliquando ipsimet eadem coguntur conmedere; alii precipitantur a turribus, alii in fluminibus et puteis, alii dantur canibus, alii relinquuntur lupis, alii assantur vivi. O divina ensis quid facis? Quid dormis? Quid taces? Non respicis ad tanta crudelia mala quod isti qui habitant in loro horroris et vaste solitudinis perpetrant et conmictunt?* La spada de quasu non taglia in frecta / né tardo, mai al parer de colui / che desiando o temendo l'aspecta' (Maidens are deflowered, wives and widows raped, horrible crimes are committed, cruel massacres of children, terrible incarcerations, the harshest tortures. People are smothered and burned, or starved or thrown in the sewer. Others are mutilated, their limbs, hands or tongues cut off, and they are even sometimes made to eat

them. Others again are thrown from towers, or into rivers or wells, fed to the dogs or left for the wolves, or burned alive. O sword of God, what are you? Why do you sleep? Why are you silent? Do you not see all these cruel ills perpetrated by those who live in this great place of horror and desolation? The sword from above never seems to fall fast to those who desire it, nor slowly to those who fear it) (*De partialitate*: cf. Lioi, 'San Giacomo della Marca', pp. 3–46, who, in discussing the picturesquely distorted quotations from Dante, speaks of 'adaptation, substitutions and omission of words with consequent change of meaning, rhyme and rhythm'). The same mixture of forms, again supported by fiery and 'impressive' rhetoric, is found in other compositions besides the sermons, such as the letter from San Giacomo to San Giovanni da Capestrano, published by N. Dal-Gal, in *Archivum Franciscanum Historicum*, 1 (1908), pp. 94–7 (but the date is 1455, not 1449, as Caselli and Pacetti have shown: cf. R. Lioi, in *Picenum Seraphicum*, 6, 1969, p. 114); the effect of urgent emotion relies on its paratactic structure, as in the following passage: '*O insania, et caeca invidia, et obstinata malitia membrorum Satanae, quae numquam desinit a via veritatis bonos pervertere, et in viam perditionis impellere, et vitam reproborum laudare, et magnificare, ut veniat super eos omnis sanguis, qui effusus est super terram a sanguine Abel iusti, usque ad sanguinem Zachariae filii Barachiae, ut Deus misericors et iustus non misereatur eis usque in sempiternum!*' (O folly and blind envy and stubborn malice of the followers of Satan, indefatigable in its attempts to distract the righteous from the way of truth and push them down the road to perdition, and in praising and exalting the lives of the unjust, may all the blood fall on them that has been shed on earth from the blood of that just man Abel to the blood of Zecariah son of Barachiah, and may the merciful and just God never have mercy on them for all eternity!)

These observations (though many more examples could be given) are not intended, as I have already mentioned in the text, to show precise analogies between forms of religious rhetoric and contemporary pictorial forms; rather they are meant to suggest that we might consider the hyper-expressive effects sought after in a certain kind of mid-century painting using a characteristic manipulation of the late Gothic repertoire, as being inseparable from a complex network of influences which in some cases is particularly compelling.

24 A. Hauser, *Mannerism. The Crisis of the Renaissance and the Origin of Modern Art*, 2 vols (London, 1965).

25 Cf F. Zeri's correct observations in *Pittura e Controriforma. L'arte senza tempo di Scipione da Gaeta* (Turin, 1957), pp. 26–7. In Male's classic work devoted to the art of the Counter-Reformation, *L'art religieux de la fin du XVIe siècle, du XVIIe siècle et du XVIIIe siècle. Etude sur l'iconographie après le Concile de Trente* (1932) (Paris, 1951), the author maintains a perfect consistency with the largely thematic and iconographic context he has set himself, as in his other works on medieval

art, and a generally good balance in presenting the relationship be-
tween the religious substratum and artistic activity.

26 G. A. Gilio, 'Dialogo . . . degli abusi de' pittori ecc.', in *Trattati d'arte
del Cinquecento tra manierismo e controriforma*, ed. P. Barocchi, II
(Bari, 1961), p. 41.

27 Gilio, 'Dialogo', p. 42.

28 G. P. Lomazzo, *Trattato dell'arte della pittura, scultura et architettura*,
particularly book VI, ch. 23 and book VII, chs 2–5 and 25; cf. *idem*,
Scritti sulle arti, ed. R. P. Ciardi, II (Florence, 1974).

29 For a full critical study specifically focused on Cinquecento treatises –
albeit from different points of view – see instead, among recent works,
the very careful notes by P. Barocchi in her edition of *Trattati d'arte
del Cinquecento*, 3 vols (Bari, 1960–2); P. Prodi, 'Ricerche sulla teorica
delle arti figurative nella Riforma cattolica', *Archivio Italiano per la
Storia della Pietà*, 4 (1962), pp. 123–88, with appended documents;
G. Scavizzi, La teologia cattolica e le immagini durante il XVI secolo',
Storia dell'Arte, 21 (1974), pp. 171–212. As Prodi's essay makes points
which go beyond his interest in the treatises, we shall return to it later.

30 Gilio, 'Dialogo', p. 40.

31 Barocchi, *Trattati d'arte del Cinquecento*, vol. III, p. 387. The question
of the influence of the *Instructiones* on Milanese architecture has
subsequently been addressed by other scholars and it is significant that
their evaluations are far from reaching a consensus: cf. M. L. Gatti
Perer, 'Le istruzioni di san Carlo e l'ispirazione classica nell'architettura
religiosa del Seicento in Lombardia', in *Il mito del classicismo nel
Seicento* (Messina and Florence, 1964); L. Grassi, *Le province del
Barocco e del Rococo* (Milan, 1966); M. Tafuri, *L'architettura
del Manierismo nel Cinquecento europeo* (Rome, 1966); A. Scotti,
'Architettura e riforma cattolica nella Milano di Carlo Borromeo',
L'Arte, 18–20 (1972). More recently M. L. Gatti Perer ('Cultura e
socialità dell'altare barocco nell'antica diocesi di Milano', *Arte
Lombarda*, 1975, pp. 11–66) has returned to the debate with an
analysis of the *Instructiones* which focuses on their suggestions of form
which are sometimes significant enough to constitute 'the beginning of
a long road which will lead to Borromini and Guarini, keen readers of
the *Instructiones*' (p. 16); but elsewhere (p. 18) she underlines the
almost boundless 'freedom of operation' which the Caroline rules
allow the working artist.

32 Barocchi, in *Trattati*, vol. II, p. 528, rightly defines Gilio as 'a non-
participant in the stylistic diatribes'; for the previous, and not always
compatible, opinions of Dejob, Weisbach, Schlosser, Lee, Grassi and
Zeri regarding the true importance of Gilio's ideas for artists, cf. ibid.,
particularly pp. 524–6. Later Prodi (*Ricerche*, p. 130), went much
further in playing down the importance of Gilio's work, which he sees
as a 'very modest little treatise', without 'proper theoretical backing',
which 'was not widely read'. In contrast, Zeri pointed out several cases

in some of the most important works of art from the period where
Gilio's formulae have left their mark: in the architecture of the Gesù
(*Pittura*, p. 40: 'The Church of the Gesù marks the clearly conscious
realization of the "measured mixture" Gilio recommended for paint-
ing'); but for a study of other cultural and religious sources for the
architecture of the Gesù cf. the more recent work by R. Wittkower and
J. S. Ackerman, *Baroque Art: The Jesuit Contribution, Papers of the
Congress* (New York, 1972), pp. 1–14 and 13–28 respectively); in
Valeriano and Pulzone's paintings for the Madonna della Strada Chapel
in the Gesù (p. 67: 'these constitute the most telling, rich and self-
conscious example of the "measured mixture" which Gilio recom-
mended as a remedy for the crisis in religious art'); and finally in the
Ordination of San Giacinto by Federico Zuccari in Santa Sabina (p.
46: 'the prescription of "measured mixture" is applied with rare mas-
tery'). But a reading of other passages of Zeri's very full essay leaves
one with the impression that the two standpoints are not always quite
opposite: 'Gilio's criticism of painters is purely practical and utilitar-
ian; it contains no interest in formal language or the "Idea"' (p. 25);
and even '[Gilio] judges the work by its "devotional" value; and with
a yardstick that ignores quality and the demands of style' (p. 26). How
can we then talk about his having such a great influence on artists?
A subtle explanation is to be found in another passage from Zeri
concerning the effects of the Tridentine decrees upon images: 'if the
directives they imparted are highly generalized, it is obvious that,
however vague and approximate they may be, the very fact that the
problem behind them had surfaced – the problem of the relationship
between art and its devotional function – sowed the seeds of a process
of self-interrogation and self-criticism, and of calculating and crystal-
lizing a set of rules' (p. 24). Even writings such as Gilio's could cer-
tainly trigger such processes, despite their lack of poetics or rather of
proposals for style which artists could recognize as such. Gilio's Christ
'aux outrages' is a generically archaic stereotype of 'Christian art',
which was successful until the time of Fra Angelico but also found in
devotional images (like the parchment Tesoro di Assisi); the 'neo-
medievalism' present in certain Cinquecento circles so precisely por-
trayed by Zeri (pp. 42ff) is in fact an important and multifaceted cultural
component, which left a wide trail of influences in the formal world
of the artists, and it is much more recognizable as a cultural component
of their work than of the wordy formulations of Gilio. If we find in
the *Vestizione di san Giacinto* a 'clearly Quattrocento flavour' (still
quoting Zeri, p. 46) and we see this work of Zuccari's as a 'bridge
between Ghirlandaio and Sassoferrato', this casting back function does
not necessarily imply any debt to Gilio. We may guess that the extent
of his knowledge of 'pre-Raphaelite' painters is very limited: in the
Dialogo the pet topos of the 'saintly' painter, such as Cavallini, Fra
Angelico, Fra Bartolomeo, Dürer etc. does not appear. Zuccari was

sensitive to many other voices and was quite capable of looking backwards, even as far as the Vele di Assisi.

33 Prodi, *Ricerche*, p. 130.

34 Ibid.; but cf. Zeri, *Pittura*, pp. 23–4 and cf. also above, n. 32.

35 Prodi, *Ricerche*, p. 133. This demand, inspired by worthy relativism, seems very different from E. Battisti's approach (cf. 'Il concetto di imitazione nel Cinquecento italiano', in *Rinascimento e Barocco* (Turin, 1960), p. 214), which is still based on a 'block' contrast, or on the hypothesis of an 'opposite concept of religious art: historicizing and popularizing in the north, with Nordic and Protestant influences; learned and allegorical in the south by reason of Renaissance intellectualism'.

36 Zeri, *Pittura*, pp. 27–8.

37 For this correspondence, see Prodi, *Ricerche*, appendix I; for the Pulzone altarpiece, see Zeri, *Pittura*, pp. 22 and 71. The painter is not named in the correspondence; perhaps his name had not yet been put forward for the commission.

38 Prodi, *Ricerche*, appendix I, p. 191.

39 This altarpiece, preserved in the North Carolina Museum of Art, Raleigh, belongs to the period 1585–8: see F. Arcangeli, 'Sugli inizii dei Carracci', *Paragone*, 79 (1956), pp. 43–4 (on the old copy in the Bologna Pinacoteca) and *idem*, *Natura ed espressione nell'arte bolognese-emiliana*, exhibition catalogue (Bologna, 1970), pp. 194–6. We have M. Pinnell ('Lodovico Carracci's *Assumption of the Virgin*', *North Carolina Museum of Art Bulletin*, vol. 1, 4–5 (1957–8), pp. 1–7) to thank for the iconological exploration of the painting, which identifies the sources of the most important details as the *Golden Legend*, Molano and Pierio Valeriano, via Paleotti. Pinnell's decoding gives the impression that the work is a learned exercise in religious erudition and forgets that it has another side: the passionate visionary and popularizing statement so acutely observed by F. Arcangeli and C. Gnudi in Ludovico's religious poetry (cf. Arcangeli, 'Sugli inizi', pp. 36ff; Gnudi, introduction to *Mostra dei Carracci*, exhibition catalogue (Bologna, 1956), pp. 29ff) and strongly present in the Raleigh painting also. Besides, we still need to clarify how the desire to fill the scene with allusions and symbols, some of which are not easy to interpret (a Jewish and a Roman tomb, the position of the figures of St Paul and St Peter, the book, the branch of 'paradise palm', the obelisk), sits with the requirement expressed in an important chapter of Paleotti's *Discorso* entitled 'On paintings which are obscure and difficult to understand' (book II, ch. 33, in *Trattati d'arte del Cinquecento*, vol. II, pp. 408ff), where among other things he says: 'it happens that every day we see in a number of places, especially in churches, paintings so obscure and ambiguous that whereas they should enlighten the intellect so as to excite devotion and pierce the heart, their obscurity confuses the mind and distracts it in a thousand directions at once, busying it with trying to work out what a particular figure is, and not without loss of devotion.

The mind then loses the shred of worthy thought it brought with it to church, and often mistakes one thing for another; so that instead of being instructed, one is left confused or mistaken'; and there are many other passages insisting on the need for clarity for the purposes of the 'universal' teaching role which the author assigned to painting (cf. P. Barocchi's note, p. 687). Ludovico himself, whose prime concern is with expressing religious feeling as human participation, does not apparently gain any particular advantage from this necessity of displaying symbolical relationships and allusions; and we should bear in mind that in a painting on the same subject, a later one (1601), in the church of the Corpus Domini in Bologna, where a few 'bits' of the Raleigh *Assumption* reappear, the group of apostles is arranged entirely differently. But what should most of all disturb anyone who sees the mark of Paleotti in the iconography of Ludovico's altarpiece is the complete absence of symbolic elements in the San Silvestro al Quirinale *Assumption* for which, as we have mentioned, we have documentary evidence that the Bolognese cardinal was consulted. Otherwise, if we had to conclude that what was true for Bologna was not true for Rome, we would encounter a new problem in crediting the prescriptions of theoreticians and experts on religious art with a degree of influence that they probably never enjoyed.

However, the question of Paleotti's influence on circles in Bologna gains substance and credibility from the remarkable personality of the author of the *Discorso* not just as an ecclesiastic but also as a man with a complex cultural background, who had documented contact with the art world in Bologna, from Agostino Carracci to the last exponents of local Mannerism: on this see Prodi, *Ricerche*, particularly pp. 142–5 and, for a complete picture, *Il cardinale Gabriele Paleotti (1522–1597)*, 2 vols (Rome, 1959, 1967), by the same author. A. Foratti (*I Carracci nella teoria e nell'arte*, Città di Castello, 1913) had already looked at the question which was in some sense evaded in R. Longhi's 'Momenti della pittura bolognese', *L'Archiginnasio*, vol. 30, 1–3 (1935), pp. 124ff, reprinted in *Da Cimabue a Morandi* (Milan, 1973), p. 210, where he looked at Ludovico, the personality most steeped in religiosity, within a dynamic of the formation and evolution of pictorial language towards the 'naturalism' of the Lombardy area; the idea that the movement of artistic sensitivity in that direction was countered by renewed religious sensitivity on a human scale particularly in northern Italian diocesan areas – continuing the ideals of the Catholic Reformation, as Prodi sees it, rather than the spirit of the Counter-Reformation tendencies, though the Counter-Reformation in fact tends to be the recurring landmark in studies of the art history of the period – this thesis is found in a well-known essay by A. Graziani ('Bartolomeo Cesi', *Critica d'Arte* (1939), pp. 54–95) and, more explicitly and diversely expressed, in Arcangeli's 'Sugli inizi', particularly pp. 36ff, and in the introduction by C. Gnudi to the catalogue of the

Carracci exhibition (cf. pp. 29ff) which we have also mentioned. Prodi reassociates himself with these last pieces (*Ricerche*, pp. 171ff), bolstering their salient points with pertinent observations on Paleotti's personality and religious circles in Bologna.

From these contributions and especially from the balanced account by Arcangeli ('Ludovico had enough depth not to be damaged by . . . the publication of the first two books of the *Discorso intorno alle immagini sacre e profane* by Cardinal Paleotti and actually to turn his reading of them and the general atmosphere emanating from the prelate into good, wholesome nourishment') it seems possible to draw the suggestion that we should address the question not in terms of the influence exerted by a religious figure over an artist but by concentrating our investigation instead on the way new upheavals and aspirations manifested themselves in certain circles – in the religious, social and cultural spheres – where both the religious representative and the artist become autonomous interpreters and models. In 1924 E. Panofsky wrote the following conclusion to his chapter on Mannerism in *Idea*: 'At odds with nature, the human mind fled to God, in that mood at once triumphant and insecure which is reflected in the sad yet proud faces and gestures of Mannerist portraits – and for which the Counter-Reformation, too, is only one expression among many' (New York, 1952, p. 99). The date of writing explains the absolutism of this passage. The main work still to be done is to find specific attributes and circumstances for these fluctuations of the 'human spirit'.

40 For a note on the dangers of ascribing the same features to all the post-Tridentine popes, see Prodi, *Ricerche*, p. 131, n. 2.

41 To go back to a distinction which E. H. Gombrich insisted on ('Aims and Limits of Iconology', in *Symbolic Images* (London, 1972), p. 1), we should emphasize that even the opinions and prescriptions of these learned men and theoreticians come into the category of 'verbal descriptions'. Bearing in mind that Gombrich was talking about literary texts given to artists for translation into images, there is relevance to this discussion in his observation that 'no verbal description can ever be as particularized as a picture must be. Hence any text will give plenty of scope to the artist's imagination.'

42 For this correspondence see G. Gronau, *Documenti artistici urbinati* (Florence, 1936), pp. 176–86.

43 Letter from Duke Francesco Maria II of Urbino, 27 August 1603, addressed to Giacomo Sorbolongo: see Gronau, *Documenti*, pp. 179–80.

44 See A. Emiliani, *Mostra di Federico Barocci*, exhibition catalogue (Bologna, 1975), pp. 221–5; reference should be made to the copious entries regarding the Minerva painting for all related matters. Regarding the objections raised by the pope towards the drawing showing 'the Devil speaking in Judas's ear' (as Bellori writes), Emiliani defines Barocci's idea as the fruit of the 'cultural opinion of several decades

earlier, which would probably enjoy very little further success in Rome'
(p. 224): this interpretation highlights the distance between Clement
VIII's circle and the now distant aspirations of the Catholic Reforma-
tion proper. It is worth remembering that it was from the Aldobrandini
pope's circle, as Prodi observes (*Ricerche*, p. 184), that a clear oppo-
sition had emerged to the repressive tendencies of the ageing Cardinal
Paleotti, who had changed since the days of the *Discorso*. As for
Barocci's drawing showing the 'devil' which Clement VIII rejected, it
should be noted that Bellori's account clashes with the letters brought
to light by Gronau concerning this episode.

45 Letters from Malatesta Malatesti to Duke Francesco Maria II from
 Rome, dated 22 November 1603 and 21 February 1604: cf. Gronau,
 Documenti, pp. 181 and 183.
46 G. P. Bellori, *Le vite de' pittori, scultori e architetti moderni* (Rome,
 1672) (new edn by E. Borea, Turin, 1976), p. 197.
47 Introduction to the catalogue of the *Mostra di Federico Barocci*, par-
 ticularly pp. xlviff.
48 E. Garin, *Medioevo e Rinascimento* (1954) (Rome and Bari, 1973),
 p. 274.
49 *Symbolic Images*, p. 64.
50 Ibid.
51 L. Febvre, *Studi su Riforma e Rinascimento e altri scritti su problemi
 di metodo e di geografia storica* (Turin, 1971), p. 557 (originally in
 Revue de Métaphysique et de Morale, 1949). For other connections
 quoted in the text, see R. H. Tawney, *Religion and the Rise of Capi-
 talism* (1926).
52 Febvre, *Studi*.
53 F. Antal, 'Remarks on the Method of Art History', *Burlington
 Magazine* (1949).
54 Chastel, *Art and Religion*, pp. 28ff; E. H. Gombrich, 'The Social History
 of Art', in *Meditations on a Hobby Horse and Other Essays* (London,
 1963), pp. 86–94 (originally in *Art Bulletin*, March 1953); for this
 review see the full commentary by E. Castelnuovo, 'Per una storia
 sociale dell'arte', I, *Paragone*, 313 (1976), pp. 17ff.
55 D. Cantimori, 'Il dibattito sul barocco', in *Storici e storia* (Turin, 1971),
 p. 620 (originally published in *Rivista Storica Italiana*, 72 (1960), pp.
 489–500). For the importance of ensuring that 'basic facts' do not
 degenerate into generalizing schemes, as particularly underlined in
 the writings of historians like J. Vicens Vives, T. C. Cochran, F. Braudel
 etc., see the full and detailed review by G. Barraclough, 'History', in
 *Tendances principales de la recherche dans les sciences sociales et
 humaines. Seconde partie: Sciences de l'art, Science juridique,
 Philosophie*, ed. Unesco (Paris and The Hague, 1977); also in *Main
 Trends in History* (New York, 1979), particularly chs 2 and 3.
56 Cantimori, 'Il dibattito sul barocco', on the Congress set up in 1960
 by the Accademia Nazionale dei Lincei (*Manierismo, Barocco, Rococo:*

concetti e termini, in the proceedings of which (Rome, 1962) the pieces by E. Raimondi, G. Getto, R. Wittkower and Cantimori himself offer important contributions to the problem we are looking at here); see also his observations on earlier contributions to the debate.

57 Prodi, *Ricerche*, p. 125. Of particular interest are Cantimori's remarks in 'Galileo e la crisi della Controriforma', in *Storici e storia*, pp. 657ff.

58 For similar problems of method Febvre, 'Le origini della Riforma in Francia e il problema delle cause della Riforma', in *Studi su Riforma e Rinascimento* (originally in *Revue Historique*, 161, 1929); and see Cantimori, 'Il dibattito', p. 619.

59 'Le origini della Riforma', p. 27.

60 Cf. p. 658 of Cantimori's essay referred to above, n. 57.

61 Ibid., pp. 658–9.

62 Ibid., p. 659.

63 H. Jedin, *Riforma cattolica o controriforma? Tentativo di chiarimento dei concetti con riflessioni sul Concilio di Trento* (1957) (Brescia, 1967), p. 52 (1st edn in German: Lucerne, 1946). In the discussion of problems relating to the relationship between Reformation, Counter-Reformation, Mannerism and Baroque, by A. Hauser in his volume on Mannerism (1st German edn 1964; cf. above, n. 24), the idea of the historical category of the Catholic Reformation, conspicuous by its absence, would have helped the author's thesis, which contrasts both with Pevsner's (that Mannerism has its roots in the Counter-Reformation) and Weisbach's (Mannerism 'stamped the mark of areligiosity'); for further confirmation, see: 'When the attempt is made by authors who grant Mannerism its true historical extent, that is to say, date it from Raphael's death, and still claim to trace it to the Counter-Reformation, it is disconcerting and unintelligible' (p. 67); and again: 'It can be assumed that the same spiritual excitement, the sense of crisis that in Germany led to the Reformation, led in Italy to corresponding phenomena in philosophy, science, art and literature without Luther's exercising any direct influence there' (p. 68); it is furthermore significant that, immediately after this, Hauser refuses to identify that 'excitement' with 'ideas anticipating the Counter-Reformation'. In fact, Jedin grasped certain specific features of that excitement on a religious level, clearly separate from what was later to become the Counter-Reformation. In the text just quoted from Hauser the possibility of correlations or parallels between Mannerism and the attitudes of the Counter-Reformation is put forward with a reserve and caution that it is harder to find in *The Social History of Art* (London, 1951), pp. 353ff. Jedin's definition of the Catholic Reformation was a fruitful one for G. Weise, *Il Manierismo. Bilancio critico del problema stilistico e culturale* (Florence, 1971) (cf. ch. 18, pp. 203–12) and, before him, for von Einem (ibid., p. 207).

64 The importance of these distinctions may be grasped particularly clearly in studies such as that by G. Alberigo, 'Studi e problemi relativi

all'applicazione del Concilio di Trento in Italia (1945–1958)', *Rivista Storica Italiana*', vol. 70, 11 (1958), particularly pp. 285 and 297 (indicating previous writings on the subject), and by Cantimori, 'Galileo', pp. 662–3.

65 Alberigo, 'Studi e problemi', p. 285.

66 For these reasons one hesitates to adopt the solution proposed by G. Weise, *Il Manierismo*, p. 212, whereby 'the real expression of the artistic ideals of the Counter-Reformation' is to be found in the 'realist movement' (ibid.) of Federico Zuccari and Santi di Tito.

67 Cf. again Cantimori, 'Galileo', pp. 628–9.

68 For these diocesan 'cultures' see the study by Alberigo, 'Studi e problemi', p. 264.

69 On the Brescia milieu before and after the Council see the remarks by Alberigo, 'Studi e problemi', p. 264, and the monographic writings recalled therein.

70 It is worth reading the passage devoted to Moretto by R. Longhi, in *I pittori della realtà in Lombardia*, exhibition catalogue (Milan, 1953), p. 17; in paintings like *Supper in the House of Simon* (Brescia, Santa Maria Calchera) Longhi saw 'a certain commitment to realism which is already specific, in its full sixteenth-century classicism and also in its sacred topic, to Lombard painting: a commitment which very quickly became impossible after the Council of Trent and forced his pupil Moroni from Bergamo to seek refuge in the only "reality" it was then possible to explore, that of the "portrait" '.

71 A. Ottani Cavina, 'Il tema sacro nel Caravaggio e nella cerchia caravaggesca. Indicazioni per il Bassetti', *Paragone*, 293 (1974), pp. 31 and 46, n. 5.

72 This need is raised in the studies of G. Le Bras: see for example 'Un programma: la geografia religiosa' (originally in *Annales d'histoire sociale 1945. Hommages à Marc Bloch*, I); and also *Etudes de sociologie religieuse*, 2 vols (Paris, 1955–6). For a later review of this avenue of socio-religious research, confined to the sixteenth and seventeenth centuries, but full of penetrating insights, see J. Delumeau, *Catholicism Between Luther and Voltaire* (London, 1977). Recent Italian studies on specific topics also show how useful a geographically differentiated investigation into religious life and its attitudes can be to art historians: see for example the collected essays of F. Chabod, together with their rich crop of documents, in the volume *Lo stato e la vita religiosa a Milano nell'epoca di Carlo V* (Turin, 1971), especially the chapter on the conditions of the clergy; M. Rosa, *Religione e società nel Mezzogiorno tra Cinque e Seicento* (Bari, 1976), especially the chapter 'Pietà mariana e devozione del Rosario nell'Italia del Cinque e Seicento'.

73 See Alberigo, 'Studi e problemi', pp. 288–9 on this subject. We should consider carefully the possibility that the artist takes account of the socio-cultural characteristics of the patron and the intended audience,

and that when this happens there may be some observable and possibly important variation, not so much in the quality as in the iconographical system and even in the tone of expression. Of possible examples, I would suggest some taken from the seventeenth-century material with which I have recently been directly involved. Giacinto Brandi 'behaves' differently when sending work to a provincial patron for a small Apennine community from the way he works when decorating the altar of a church in Rome: one gets the impression that he is manipulating his own penchant for characteristic pathos as appropriate. Even a provincial painter like G. Antonio Scaramuccia seems to be pressing different pedals, treating the same subject in such different ways, depending on whether it is destined for a country church or for the most influential religious house in the land.

74 Among 'religious styles', the one most often discussed has been the 'Jesuit style'. C. Galassi Paluzzi, *Storia segreta dello stile dei Gesuiti* (Rome, 1951), examined in a lively and well-attested review the earlier positions on the question, from K. Holl to Voss, Frey and Wolfflin, Dvořak and Male, Braun, Weisbach and Croce. The author's conclusions are largely in agreement with those of Dvořak, who naturally denied any possibility of identifying the art of the Counter-Reformation or baroque (at least as they are generally understood) with the 'Jesuit style', although he did credit the Jesuits with an exceptional role in promoting and directing, though not in 'regulating', ecclesiastical artistic activity (cf. particularly pp. 123–4 and 157–60). Since Galassi Paluzzi's monograph, the theme has been addressed from various angles, by P. Pirri, P. Moisy, F. de Dainville, J. Vallery-Radot and by a conference at Fordham University in New York, entitled *Baroque Art: The Jesuit Contribution*, the proceedings of which were published under the editorship of R. Wittkower and J. B. Jaffe (cf. above, n. 32). In H. Hibbard's contribution (' "*Ut Picturae Sermones*": The First Painted Decorations of the Gesù', pp. 29–50), he raises serious doubts about the possibility of making a case for the existence of 'Jesuit' taste, let alone style, at least before the end of the sixteenth century. A study of artists active in the Gesù confirms that 'stylistic unity was an ideal foreign to the Jesuits of the 1580s and 1590s.' According to Hibbard, the Society confined itself to organizing the painted decorative scheme within a general iconographical programme. In R. Wittkower's contribution ('Problems of the Theme', pp. 1–14) he recognizes the particular stamp of the Society only in the 'simplistic style' of the churches by Tristano. Even in the Society's early period, we cannot speak of consistent tastes, let alone specify consistent elements of continuity. The original appearance of the Gesù, with Muziano's *Circumcision* over the main altar, G. de Vecchi's *Doctors of the Church* in the spandrels, and the vault of the tribune still plainly plastered like that of the nave, without the mosaics which Cardinal Farnese planned for

its decoration, was still recognizable in the mid-seventeenth century. As we know, all this was radically altered by changes made in the second half of the century.

This subject raises a series of problems which emerge from our observations on the relationship between architecture and liturgy, and therefore on the religious implications of a sacred building and how those implications condition its formal elaboration. As an exemplary guide to these problems see R. Krautheimer's essay 'Introduction to an Iconography of Medieval Architecture', *Journal of the Warburg and Courtauld Institutes*, 4 (1940–1). The theme does not cease to be of interest after the Middle Ages, but the religious architecture of the modern age demands further distinctions. For example, in the style of buildings by Valeriano or Tristano we can see the effects of a particular religious concept covering worship and the liturgy, the Society's 'way of its own' (cf. P. Pirri, *Giovanni Tristano e i primordi della architettura gesuitica*, Rome, 1955, pp. 160ff), and it is certainly true that some typically seventeenth-century aspects of devotion such as the apparatus and machinery installed for the Forty Hours at the Gesù and at San Lorenzo in Damaso anticipated the illusionistic baroque of the Palazzo Barberini vault and those of the Gesù or St Peter's (cf. M. S. Weil, 'The Devotion of the Forty Hours and Roman Baroque Illusions', *Journal of the Warburg and Courtauld Institutes*, 37 (1974), pp. 218–48, where, among other things, he examines, in the way we have discussed, a 1633 drawing by Pietro da Cortona); but it would be inaccurate to say that the liturgy influences art in such cases, since it is more simply a matter of the influence of architectonic creations, albeit originally temporary ones, over 'stable' creations.

75 M. Rosci, 'Storia del popolo lombardo. Realtà di san Carlo e metafora aristocratica di Federico Borromeo', in *Il Seicento lombardo*, introduction to the exhibition catalogue (Milan, 1975), p. 54; A. Griseri, 'Un poeta della Controriforma in Piemonte', *Paragone*, 173 (1964), p. 25, had earlier noted that in 1619 Borsieri praised Caccia for painting 'to the great approval of the faithful, having a grace that easily impresses them'; Griseri observed that he 'stood, in Milan, between Sant'Alessandro (1609–13) and San Vittore al Corpo, and therefore not just in Piedmont, as an important "Catholic counter-figure" of Tuscan pictorial narrative'.

76 L. Berti, *Il Principe dello Studiolo. Francesco I dei Medici e la fine del Rinascimento fiorentino* (Florence, 1967), pp. 179 and 284; and cf. two paintings for this oratory by Cavalori and Santi di Tito: one from 1568 showing *I primi soci della Congregazione* (ibid., figure 170), and the other from *c.*1569 of *The Vision of St Thomas* (ibid., figure 177), two good examples of two different responses to the 'devotional' painting arising from the same social and religious environment of the noble 'contemplatives' of St Thomas. Berti sees that ' "pictorial reform" such as that of Santi di Tito was not really simply motivated by

piety' and that 'beyond the element of "humble devotion in the new age" there were other factors at work in Florence', both stylistic and cultural, as they were understood in those days. This once again reminds us not to follow the path of correlations and parallels unilaterally, even when certain movements appear particularly all-embracing. On these features of religious life in Florence and the 'reform' in painting cf. also M. Gregori, 'Note storiche sulla Lombardia tra Cinque e Seicento', in *Il Seicento lombardo*, p. 28.

77 C. Brandi, 'L'"episteme" caravaggesca', *Colloquio sul tema: Caravaggio e i caravaggeschi (1973)*, Accademia Nazionale dei Lincei, vol. 371, 205 (1974), p. 11. Although Brandi's contribution was inspired by a study by M. Calvesi ('Caravaggio o la ricerca della salvazione', *Storia dell'Arte*, 9–10 (1971), pp. 93–141), its pervasive scepticism can be extended generally to repeated attempts to correlate Caravaggio's language with the leanings of religious orders: the Oratorians, as proposed by P. Francastel, W. Friedlander and R. E. Spear; or the Augustinians, according to M. Calvesi's hypothesis and – more cautiously – that of A. Ottani Cavina. G. Cozzi had already cast doubt on whether any connection existed between Caravaggio and the circle surrounding the Oratory of St Philip Neri ('Intorno al cardinale Ottavio Paravicino, a monsignor Paolo Gualdo e a Michelangelo da Caravaggio', *Rivista Storica Italiana*, 78 (1961), pp. 53ff) with a consistent line of argument, later underpinned by F. Bologna ('Il Caravaggio nella cultura e nella società del suo tempo', *Colloquio sul tema*, pp. 158–9 and 175–6). Even the hypothetical affinity between Caravaggio's naturalism and the mysticism of St Ignatius seems tenuous in the light of Bologna's acute observations (pp. 164–5).

78 In particular, M. Calvesi's detailed iconological survey, 'Caravaggio o la ricerca', sought to demonstrate that 'Although I accept that Caravaggio's pauperism and populism may arise from other circles, particularly from the Oratorians, it is a special feature of the correspondence between his own religious sense and that of Borromeo' (p. 134). The relationship between Caravaggio and Borromeo extended, according to Calvesi, from the ethical and religious sphere to the cultural, and may even justify a kind of table of concordances between passages from the *De pictura sacra* and paintings by Caravaggio (pp. 130ff), based on the conviction that 'Federico Borromeo with his theological and antiquarian learning together with the young Caravaggio were very probably concerned with exploring this delicate cultural heritage, hovering between Orphism, gnosis and patristics, and were spurred to this as much by the residual actuality of the humanist culture of the Renaissance as by the ascetic desire to leave it behind' (p. 131).

79 W. Friedlander, *Caravaggio Studies* (Princeton, 1955), ch. 6.

80 In E. Panofsky's essay *Gothic Architecture and Scholasticism* (Latrobe, 1951) (see also P. Bourdieu's full 'Postface' to the Paris edition), there is still great importance attached to the attempt to project the influence

of St Thomas's thought on to the Gothic architects in such an articulate context as to promote it to the status of habit-forming force. Panofsky's thesis is strengthened by his clarity of expression and by his series of comparisons, as also by his focus on the specific combination of events, forces, and channels by which scholastic culture was transmitted. Among these the medium of liturgical and iconographical programmes, let alone any direct contact with the texts on the part of the artists, are of less striking significance than school, sermons and *disputationes de quolibet*, and finally the establishment of urban socioprofessional structures which were not bureaucratic and facilitated encounters between people of different classes and callings.

81 R. Longhi, 'Due esempi di Carlo Francesco Nuvolone', *Paragone*, 185 (1965), p. 45. Rosci, 'Storia del popolo lombardo', p. 49, gives a fitting appraisal of Longhi's position with regard to socio-religious implications in the history of art, and in particular the history of Lombard painting in the sixteenth and seventeenth centuries; a position determined 'by a just diffidence when faced with the abstract nominalism of *Kulturgeschichte*, or with the mechanical and pietistic interaction between the general letter of Counter-Reformation dictates and concrete phenomena of language and culture'.

82 Rosci, 'Storia del popolo lombardo', p. 56. The most emblematic work from this point of view is Cerano's *Madonna of San Celso with San Carlo Borromeo*, a painting in which the author's art seems to take second place to the 'objective' reproduction of the incumbent statue by 'San Carlo's sculptor', Annibale Fontana. The copying had obviously been agreed with the patron, who is not known but who was certainly from among those closest to Federico. The painting thus also celebrates St Charles in the image of the Virgin he is venerating, which he himself had commissioned and at whose feet he kneels, a 'modern' saint alongside the great 'ancient' saint. But the range of Federico's tastes, both in his years in Rome and in Milan, seems so vast as to defy any single definition: Federico Zuccari, Nebbia, Barocci, Moncalvo, Daniele Crespi and Giulio Cesare Procaccini, Cerano, Jan Brueghel and the Caravaggesque 'line' . . . For the *Madonna of San Celso* see *Mostra del Cerano*, exhibition catalogue ed. M. Rosci (Novara, 1964), pp. 63–4. Expressive tendencies traceable to the establishment of a close consensus between artist and customer are to be found in the paintings of Giulio and Antonio Campi for Carlo Borromeo, particularly in the devotional pictures for his chapel, for which see G. Bora's well-balanced study, 'La cultura figurativa a Milano, 1535–1565', in *Omaggio a Tiziano. La cultura artistica milanese nell'età di Carlo V*, exhibition catalogue (Milan, 1977).

83 Zeri, *Pittura*, pp. 38ff.

84 See the correspondence (from 1593) between Francesco Maria and Grazioso Graziosi, his ambassador, brought to light by Gronau, *Documenti*, pp. 225–7.

85 Besides the works mentioned above, n. 72, it is worth bearing in mind research such as that by A. Vecchi, *Il culto delle immagini nelle stampe popolari* (Florence, 1968), for the general problems he tackles. He sketches a very useful outline for future investigations, which one hopes will be conducted into the figurative traditions of individual societies and communities: for example, the distinction between images for veneration and images for devotion; the rise of the votive image over the self-dedicated statue and votive gifts; the concept of a 'devotional tradition'; the link between images of the miracle-working saint 'in action' and petitional prayer; the erratic and gradual intensifying of interest in cycles of Mary and the saints compared with cycles of the Eucharist, the cross and the divine image. For example, if by the eighteenth century 'the liturgy had to come to terms somewhat with popular devotional practices, turning to them for help, and to pay more attention to litanies of the saints . . .' and 'Masses ended with triduums, novenas and invocations to the saints; solemn Masses often become more like thanksgivings for help received from some local devotion' (p. 22), I wonder if this might not help to explain the way a tendency to portray hagiographical material in characterized and juxtaposed narrative forms of varying degrees of fluency resurfaced in painting, from the end of the seventeenth century, not just in minor centres. This can be seen in certain examples by Giuseppe and Pierleone Ghezzi, Giuseppe Passeri and – moving on in the eighteenth century – painters like Sebastiano Ceccarini, Placido Costanzi and, in his 'purist' devotional mood, Marco Benefial.

'But what has the history of worship to do with it? He can light his little candles as he pleases; I am writing about iconography and art': thus Adolfo Venturi scorned the harsh reviewer of his book *La Madonna. Svolgimento artistico della rappresentazione della Vergine*. B. Croce, who entered the debate with a résumé of previous contributions (in *Napoli Nobilissima*, 8 (1899), pp. 161–3 and 9 (1990), pp. 13–14, and then in *Problemi di estetica e contributi alla storia dell'estetica italiana* (Bari, 1910), pp. 265–72), wrote – and it is no longer possible to agree with him – that 'works of literature and art should be studied in monographs on individual works, individual authors or individual periods, or in the general framework of the history of literature and art. Other vertical or horizontal sections one may take no longer work in the interests of the history of art'; but he added that 'if, as in the present case [Venturi's *La Madonna*], they call our attention to the history of religion, we must deal with this history deliberately and pertinently, using appropriate methods; and not allow ourselves at will to declare the history of worship irrelevant' (p. 269). Staying with the same subject, we can see that this comment is still valid from the fact that in the most recent of the many books devoted to the Madonna which have appeared since Venturi's (M. Warner, *Alone of All Her Sex. The Myth and the Cult of the Virgin Mary*,

London, 1976), the art historian finds observations formulated 'by appropriate methods' which can throw light on the feelings which, again in Croce's words, the artist projects on to the image of the Virgin: 'a certain religious emotion (which always varies from artist to artist, according to his times and his environment); . . . a feminine erotic ideal; a moral ideal of maternity; an historical reconstruction, flattered by fantasy, of what the woman of Galilee, wife of a poor craftsman in Nazareth, would really be like in eighth century Rome' (p. 267).

There is striking evidence of the psychological effect of the preachers in the testimony relating to San Bernardino published by R. Livi, 'San Bernardino e le sue prediche secondo un ascoltatore pratese del 1424', *Bollettino Senese di Storia Patria*, 20 (1916), pp. 458–69. Sandro di Marco di Sandro dei Marcovaldi, 'an uneducated merchant' mingling with the crowd which heard San Bernardino preach for forty days in the Piazza di San Francesco in Prato, says, among other things, in a letter to his brother that the preacher seemed to him like 'a ghostly prophet and strong leader, armed with every weapon . . . And he seems like a St Paul for his doctrine and mastery, that never in our lifetime has anything like it been heard from a man with such eloquence to master Christian faith, to keep from sin and all wrongdoing . . .' As for the influence of religious oratory on artists, we have already looked at one specific case (pp. 271–4); the subject should clearly be tackled from the angle of the old assertion that religious painting and preaching shared the same aim of improving those *'qui litteras nesciunt'* – the illiterate (Gregory the Great; cf. for this and other such early testimony L. Gougaud, 'Muta praedicatio', *Revue Bénédictine*, vol. 42, 2 (1930), pp. 168–71). In later theoretical writing on religious art (cf. Gilio, Ammanati, Paleotti, etc.) the analogy is so close that many rules and regulations relating to art are actually calqued on rules and regulations for the religious orator, beginning with the ban on rhetoric rich in artifice which seeks only to demonstrate the preacher's virtuosity.

M. Baxandall, *Painting and Experience in Fifteenth Century Italy* (London, 1972), pp. 64ff, underlines another aspect of the influence of preaching on painting, that of gesture, giving the example of the raised hands of the six saints in Fra Angelico's *Coronation of the Virgin* in San Marco, Florence, as in an old rule of mime ('And when thou spekest of any holy matter or devotion to holde up the handes'). As far as I know, no study has yet been undertaken of iconographical borrowings from preaching, and more particularly from its more spectacular and terrorizing moments. It is not often pointed out that the well-known fresco by Giotto showing *St Francis and the Crowned Skeleton*, in the right transept of the lower basilica of San Francesco in Assisi, is a real reproduction of a disturbing 'dramatized' climax from the preaching of the mendicant orders. A little-known fresco in a church in the Apennines in the Marches, San Martino in Castel Sant'Angelo di Visso (cf. A. Fabbi, *Visso e le sue valli*, Spoleto, 1965,

pp. 143–4), with Christ carrying the cross surrounded by dozens of tools of trades which must not be carried on Sundays, acts as a propaganda manifesto for one of the most commonly recurring themes of popular preaching in the fifteenth century, and can also be found in contemporary frescoes in other regions. I am not convinced by the iconographical association J. Baltrusaitis (*Le Moyen Age fantastique. Antiquités et exotismes dans l'art gotique*, Paris, 1955) suggests between the Assisi fresco and a mural painting in Qizil, in central Asia, showing a dialogue between the monk and a skull (uncrowned). In any case, the association would not contradict the hypothesis of a reference to some preaching topos.

86 *Pittura del Seicento e del Settecento. Ricerche in Umbria*, I, conducted by V. Casale, G. Falcidia, F. Pansecchi, B. Toscano (Treviso, 1976), pp. 21 and 34.

87 E. Le Roy Ladurie, *Montaillou, village occitan de 1294 à 1324* (Paris, 1975); H. Platelle, *Journal d'un curé de campagne au XVIIe siècle* (Paris, 1965), cf. Delumeau, *Catholicism*.

88 G. and M. Vovelle, 'La mort et l'au-delà en Provence, d'après les autels des âmes du Purgatoire, XVe et XVIe siècles', *Annales ESC* (November–December 1969); on the second research topic, promoted by the Centre de Recherches sur la Civilisation de l'Europe Moderne and directed by V.-L. Tapié, cf. Delumeau, *Catholicism*. Among Italian initiatives, of which there have not been many, in which particular attention has been given in the study of an area of territory to the interaction between artistic, social and religious phenomena, it is worth recalling the exhibitions and related dossiers, edited by G. Romano, G. Gentile and others, on the Valle di Susa, Arone and Canale: cf. *Valle di Susa. Arte e storia dall'XI al XVIII secolo* (Turin, 1977); *Arona Sacra. L'epoca dei Borromeo* (Arona, 1977); *Vita religiosa a Canale. Documenti e testimonianze* (Canale, 1978).

89 Cf. the balanced opening page of Antal, 'Remarks', p. 204.

90 Ibid., p. 208.

91 *Painting in Florence*, pp. 76–7. Meiss returned to the subject and introduced corrections, including some relating to the chronology: cf. M. Meiss, 'Notable Disturbances in the Classification of Tuscan Trecento Paintings', *Burlington Magazine* (April 1971), pp. 178–87.

92 R. Longhi, 'La mostra del Trecento bolognese', *Paragone*, 5 (1950), pp. 12–13 and 32–5.

93 L. Bellosi, *Buffalmacco e il Trionfo della Morte* (Turin, 1974), particularly pp. 38ff.

94 Ibid., p. 98; see also pp. 73ff.

FOUR

Renaissance and Pseudo-Renaissance

FEDERICO ZERI

I T is well know that, in the terminology commonly adopted by historical science, 'Renaissance' is the only word (among those words which serve to denote one of the periods into which we have decided to divide the diachronic unfolding of the past) whose invention can be traced back, more or less directly, to the era which it describes. It was in fact the Italian humanists and scholars of the fifteenth century who first spoke of *rebirth* (rinascita), of a resurrection of cultural norms and modes from the ancient world, both Greek and Roman; they themselves perceived a definite break between their own concept of the world (and the cultural values implicit therein) and that which had prevailed for so long since the barbarian invasions and the end of the classical world, a collapse which they sought to identify as a complete break, quite sudden and clinical, rather than as a very complex transformation of social and economic reality, religious infrastructures and, finally, of that complex of intellectual form and the infinite manifestations connected with it to which the name of civilization is given. The supposed *end* of the ancient world was, in fact, a very long and multifarious evolution, which took place in very varied ways and aspects, according to the objective events which faced the various sections of the great union created around the Mediterranean and in western Europe by the Roman state; to the point where in certain areas of the Eastern Empire (especially those closest to its capital, Constantinople, and in Greece, which all remained exempt from Islamic secession) after the

deep crisis of the seventh and eighth centuries, the tradition of the ancient world, albeit with Greek and Christian characteristics, and with undeniable accretions, came back to a life not unlike the life of the empire which, when it was still whole, had been transformed by Constantine and his successors, who had stamped it with the marks of a state that was no longer authoritarian, as the principate had been since the time of Augustus onwards, but totalitarian, central-ized and free from any conditions or restraints. Anyway, despite its imperfections, the term 'Renaissance' has passed definitively into historiography, thanks to the obvious merits it has for the purposes of empirical research, although, like all given names, it carries the risk of simplifying a reality which is always made up of innumerable aspects which may even contradict each other, and which often cannot be reconciled to the profile of the historiographical term. There is a constant danger of transforming the latter into an entity with a subjective life of its own by reactively counterposing against it everything which happened on the synchronic plane, but which does not fit in with our mental patterns, and we must guard against this by bearing in mind the many territorial parcellings, infinite cultural traditions, variety of religious experiences, range of eco-nomic situations, imports of the barbarian settlers, differences be-tween political situations, and figurative remains from the past which characterized western Europe when, after the first millennium, the load-bearing platform of the economy shifted from the country to the city. We can in fact affirm that the Renaissance is the result of the resurgence of the urban economy which picked up, at different times and in different ways in individual areas, to emerge as nuclei distinct from the myriad splinters of self-sufficient agricultural micro-organisms into which the monolith of the late empire had been shattered.

The incorrect and unacceptable opposition between 'Renaissance' and 'Anti-Renaissance' goes back to a simplistic and rigid concep-tion of this varied and staggered reality; but, if we avoid that trap, we come up against the more serious problem of the chronological boundaries within which we are to fit the period of Renaissance and, within it, what place and meaning to give to the adjective 'Renaissance' when applied to artistic facts. Thanks to the insight of Erwin Panofsky, who clarified their standing and significance, the debate no longer includes the various succession of *renascences*, passing phases without lasting consequence, which occurred from the time of Charlemagne, and which were motivated by deliberate political propaganda rather than by the spontaneous energy of

cultural forces; there was no continuity of development, nor was there
that progression through a series of stages which, by contrast, char-
acterizes the true Renaissance, the roots of which were closely bound
up with the work of the humanists, and can be pinpointed to the
first half of the fourteenth century, if not even earlier (as far as Italy
was concerned) to the time of Frederick II, in other words even
before 1250. But we are not concerned here with discussing prob-
lems of dating; instead we must make clear how impossible it is
to make historiographical periodization coincide with art-historical
terminology, since it would involve putting figurative data from the
most widely different sources on a par. If by 'Renaissance' we mean
the return to the themes of classical antiquity (which in art boils
down to an interest in representing physical reality rather than the
metaphysical), it follows that, under this general heading such hetero-
geneous figures as Jan van Eyck and Pol de Limbourg, Andrea
Bonaiuti and Antonello da Messina, Ambrogio Lorenzetti and Nuno
Gonzalvez (to cite but a few examples of a boundless variety of
form) would, if we accepted the overlapping of historiographical
convention with artistic fact, come under one common heading. It
is therefore essential to decide whether there exists a 'Renaissance
style', and if so what are its characteristics and the boundaries of
its historical course. The answer to the first question is in the affirma-
tive; without broadening the context of the question to the whole of
Europe (which would involve many difficulties and complications)
we can state that in Italy a Renaissance style, unambiguous and
unmistakable, began in Florence in the first quarter of the fifteenth
century. It began when the exploration of space (that is of three-
dimensional representation) already seen in Giotto and his followers
(especially Taddeo Gaddi and Maso di Banco) passed from intuitive
and subjective experimentation to scientific systematization with the
help of Filippo Brunelleschi. An essential corollary to this research
into pictorial space is the study of the human body in its internal
structure, the expression of feelings and psychological impulses as
reflections of a genuine state of mind and not as norms dictated by
fashions or customs in social behaviour. Another corollary to this
state of mind is the absence of overabundant ornament, calligraphic
elements, or decorative motifs; ornament, where it exists at all, is
subordinate and limited to essentials. It is obvious that a style char-
acterized by such features does not overlap with the Renaissance
understood as a historical era; on the contrary, it was very restricted,
punctuated by a continual series of relapses into contradictory formal
idioms and elements of style which often deflected its essence and

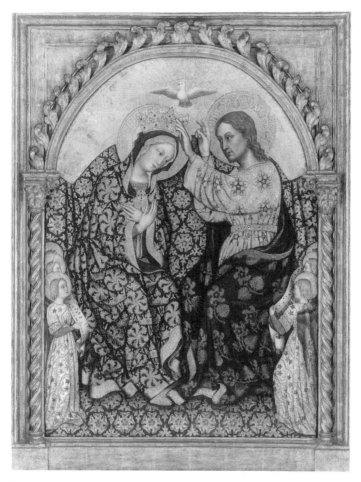

Plate 82　GENTILE DA FABRIANO, *Coronation of the Virgin*, J. Paul
Getty Museum, Malibu.

innermost meaning. In order to ascertain what the clearest aspects
of this style were, it would be as well to illustrate it with a choice
of images, as this would also serve to establish terms of comparison
with the many and various visual manifestations not of an 'Anti-
Renaissance' but rather of a 'Pseudo-Renaissance', or of a 'Shadow-
Renaissance' if we accept the very appropriate term coined by Roberto
Longhi.

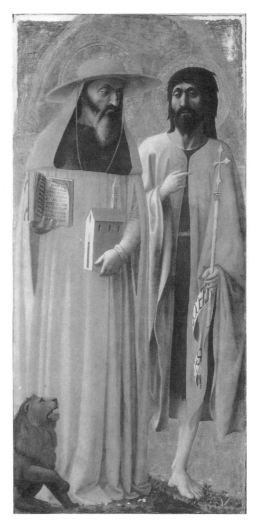

Plate 83 MASACCIO, *Saints John the Baptist and Jerome*, reproduced
by courtesy of the Trustees of the National Gallery, London.

A detail of the head of Christ in the *Coronation of the Virgin* by
Gentile da Fabriano beside a detail from Masaccio's *Saints John the
Baptist and Jerome* and a head from Nanni di Banco's *Quattro Santi
Incoronati* put into focus two different ways of perceiving (and
describing) objective reality, two different mental systems, from which
derive two quite distinct civilizations, in the figurative arts as in

other fields, despite the closeness of the dates of these three works, which cover no more than fifteen years between them. Nanni di Banco's carving dates in fact from about 1413, Gentile's panel was most probably begun around 1420, and Masaccio's tempera is part of the polyptych he executed with Masolino and others for the Basilica of Santa Maria Maggiore in Rome in 1428. In Gentile, the structure of the head is suggested only as a secondary concern by a description of the surface, in which all the elements (minutely observed) are placed on the same analytical plane, with no system of hierarchy subordinating one to another. It is true that there is some use of chiaroscuro in the plastic definition, but this is brought out by a vague luminosity rather than by light shining from a precise source; similarly the psychological expression of the Redeemer responds to a general social convention of benevolent courtesy, elicited more by external relationships than as an inner effect of the subordination of the body to the mind, as the effect of an authentic moral law. Of course the reproduction does not allow us to see clearly the technical aspect of these differences. Gentile's work is the result of a very complex and consummate mastery of his profession (in the spreading of colours with a pen nib, the elaborate tracings of the goldsmith's tools, and best of all the use of transparent coats and lacquers over the gold) and is matched in Masaccio by a use of equally clever technical means to the sole end of defining the plastic form, described with considered economy pared right down to essentials. The gold background contributes to this effect (although it was used by long tradition) in that it emphasizes the relief of the corporeal mass, over which the light, here modulated from one well-defined source and using chiaroscuro, lowers the external surface of a structure whose internal framework is known to the painter in all its joints and reflexes. There is something *extrovert* defining the psychological expression of Gentile's figure, while Masaccio's shows an *introverted* attitude, dictated by the force of a moral standard closed in on itself with inflections of grave, almost incommunicable asceticism, which other stars of the stylistic Renaissance (such as Donatello or Nanni di Banco) often took to peaks of rarefied, almost heroic sublimity. Bare and unadorned, these figures, which eschew the pretences, affectations or flourishes of passing fashion, are endowed with bodily weight, which allows them to stand their ground as stable and firmly based figures; and where the thematic demands of the narrative dictate architecture in the background or surrounding the figures, these are represented by a rigorously selected minimum, whittled down to essentials: in the Brancacci Chapel

frescoes in the Carmine in Florence, Masaccio is the first and earliest painter to discover the urban landscape, even in its most squalid and depressing aspects.

This 'first-person' Renaissance in the fields of painting and sculpture was sometimes undeniably and sometimes, as in Masaccio, only probably, tied to the study of the classical world through remains which were much more plentiful then than nowadays. In any case, one of the principal rules of narrative (either literary or figurative) of the ancient world is the principle of the *conclusion*, which says that the description of an event must have a beginning, an unfolding and an end. As for the human figure, now constructed from within, the study of bone structure and anatomy is the result of a fresh look at the large numbers of marble statues from the imperial Roman era found more or less all over Italy in the early fifteenth century; I say a fresh look, because quotations from ancient statues are recognizable even in many early fourteenth-century artists, but their acquaintance with these works did not stimulate those earlier artists to define scientific rules of universal validity or any mathematically precise models. Moreover, the profound morality, almost bordering on self-abnegation, of the committed revivers, must be traced back to the reading (or rereading) of Stoic texts or those by the propagators of Stoicism in Rome, and of the gospels (read at first hand without any post-Constantinian exegetic apparatus). As seems obvious, the *stylistic Renaissance* created an impulse to rationalize the ideas and themes which had already been around for a century at the time we tend to date the Renaissance when we are thinking of it as a historical period. This impulse is very clear in that linchpin of the true Renaissance, the quest for three-dimensional perspective and the establishing of scientific principles governing optics (as perspective was called during the period in question). Under the influence of wall paintings and mosaics from the Roman era (of great importance here was the *opus sectile* inlay work in the Basilica of Junius Bassus, transformed into the Church of Sant'Andrea Catabarbara, on the Esquiline in Rome) perspectival research aimed at defining the third dimension in painting had begun as far back as the thirteenth century with the Roman artists (particularly in the depiction of cornices, hanging arches and other decorative elements). But it was with Giotto and his first pupils (Taddeo Gaddi, Maso di Banco, Puccio Capanna) that the quest for perspective achieved such astonishingly precocious results. In certain episodes of Giotto's work, his three-dimensional representation borders on a scientific system: take the example of the two spaces with frescoed cages in the gable

wall of the Scrovegni Chapel in Padua. But in Padua Giotto also exemplifies a peculiar phenomenon which is similar in effect to certain mural paintings of the first century AD in Pompeii and Herculaneum and other cities buried by Vesuvius, especially in the decorations of the so-called 'fourth style'. There, if we examine the perspectival layout with the help of precise graphs, the plotting of the recession into the background seems to be governed by precise scientific principles, which would seem to imply awareness of a vanishing point, but only in the upper parts of the compositions, which seem elsewhere to proceed rather imprecisely and are left to intuition and a general overall impression.

A very similar phenomenon is found in the architectural backgrounds of some of the Scrovegni Chapel scenes; in paintings from the second half of the fourteenth century it is mostly in northern Italy (and especially at Padua and Verona, with Altichiero and his followers) that background buildings very often seem, in their upper sections, to be close to precise and very well worked-out rules of perspective. In Tuscany, before 1348, the followers of Giotto in Florence and Siena constantly ducked the task of rendering the third dimension on a two-dimensional surface: Taddeo Gaddi, Maso di Banco, Pietro and Ambrogio Lorenzetti all entrusted their exploration along these lines to experimental means, showing a very varied range of attempts such as, for example, the diminishing of points on a vertical axis, or what we might call 'fishbone' perspective, as in Ambrogio Lorenzetti. But elsewhere too, in central Italy in the first half of the fourteenth century (for example in the Marches) we find examples of a true spatial illusionism, sometimes executed not in fresco scenes but in the architectural frames enclosing them, on lateral walls, and hagiographical panels in which there is a commitment to adjusting painted corbels and cornices to the viewpoint of the observer, by playing with angles and even with the incidence of light. However, it was certainly Filippo Brunelleschi who discovered the scientific principles of spatial perspective in painting and pointed them out in his few paintings, unfortunately unknown to us, but described by the sources. The science of perspective now worked out and based on universal principles, which is the foundation for the genuine 'Renaissance style', is thus born of the rationalization and codification of ideas and tendencies which had already been in circulation in Italy from the earliest moments of the Renaissance as a cultural and historical period. And in the same space of time, anatomical research into the worlds of zoology and botany – so important to Donatello's bronze and marble sculpture – arrived at

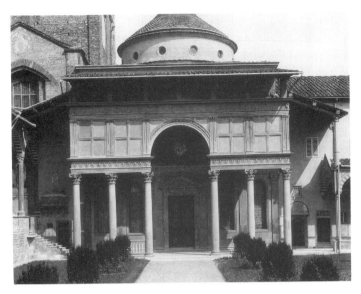

Plate 84 FILIPPO BRUNELLESCHI, Façade of the Pazzi Chapel, Santa
Croce cloister, Florence.
Photo: Archivi Alinari.

a similar point of evolution, all understood as part of the internal
structure of objective reality.

It was again Filippo Brunelleschi the architect who found, with
extraordinary intelligence, a whole series of solutions for 'rational-
ized space', lucidly articulated in the elements which define it, and
in which light (which enters the interior of the buildings in accur-
ately calculated quantities) contributes to the clarity with which the
observer perceives, at a glance, the mental principles which have
attended the birth of the structure. Brunelleschi was certainly stimu-
lated by his study of the architecture of ancient Rome; but (apart
from the fact that his creations are never cold attempts at imitation
or romantic poems on the theme of a dreamed-of golden age which
can never be repeated) it is a fact that research into the sources he
used is made very difficult, if not fruitless, by the fact that since
the fourteenth century a large number of buildings from the imperial
Roman era (particularly tombs along the consular roads around the
Urbs) have disappeared, and the stucco and marble facings, with
which many ruins were still covered when Brunelleschi saw them,
have been almost totally destroyed and eroded to the stonework.

This does not prevent us from identifying the first essence of Brunelleschian architecture as the logical concatenation of the various parts one to another, all interlinked with such consistent logic that if one of them (or even a part of one) is removed, the whole is thereby irremediably distorted and destroyed. In trying to describe the consequences of such determined rationality, of this archetype of true Renaissance architecture, we come up against grave difficulties implicit in the gap between project and execution, as execution was often deferred (because of the slowness of the work or for financial reasons) and entrusted to younger architects and was therefore subject to changes and revisions. This is for example what prevents us from properly understanding another 'founding father' of the architectural Renaissance, Leon Battista Alberti, whose buildings were too often executed by others or at least without his personal intervention to prevent his ideas being watered down by other ideas of quite different origins. The best-known case, and also the largest-scale, of this situation is the Tempio Malatestiano at Rimini, where Sigismondo Pandolfo Malatesta wished to rebuild, in a 'modern' manner, the former Church of San Francesco, transforming it into a monument to himself and Isotta degli Atti, adding complex astrologically symbolic embellishments to make a sort of memorial mausoleum to the seigneurial dynasty which Sigismondo happened to represent. Partly thanks to Matteo de' Pasti's architectural contribution, and also because of the relief decoration commissioned from Agostino di Duccio, the restored building is one of the richest and most important monuments of that 'Pseudo-Renaissance' which historiography still considers as a Renaissance masterpiece, in a confusion between facts of style and historical terminology. But to turn our attention to the few surviving architectural drawings of the fifteenth century, we come across examples of an identical cultural and intellectual position in a pure state, without the intervention of other parties and for which there can be no other explanation. The *Treatise on Architecture* by Antonio Averulino, known as Filarete, is a very significant example of this position; the various drawings which accompany the text constitute a practically inexhaustible collection of projects conceived by a mind rooted in the culture of sentiment (in this specific case of a courtly, noble and embellished variety) clothed in a Renaissance guise of surface elements gleaned from Brunelleschi, Alberti and an entirely superficial study of classical antiquity. Filarete specialized in structures which, like all products of an irrational and only apparently logical position, have no inner rationale. In the *Central Tower* of the fantastic ideal city, the number

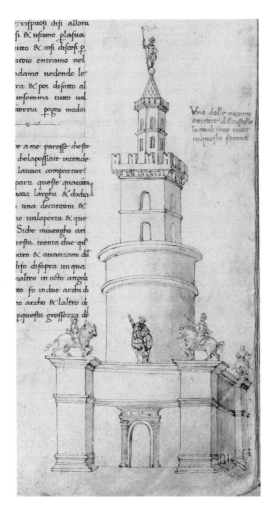

The handwritten text in the image reads (partially legible):

> rifpuofi difi allora
> fi & ufomo plafua
> tuto & cofi difcofi p
> atoto entramo nel
> damo vedendo le
> ra & poi difotto al
> infomma tuto vol
> torria pogni modo

> e a me pareffe chefte
> chelapoffiate intende
> lanuoi compartire
> parti quefte quaraia
> ioia larpha & dodia
> una decantoni &
> io tralaporta & que
> Siche miuengho an
> refta trenta due qu
> utro & auantami di
> lifo difopra un qua
> noltro in octo angoli
> to fo in due archi di
> io archo & laltro di
> pquefta groffezza di

> Vna dello auano
> entrate del cafteflo
> fecundi fono tute
> in quefta forma

Plate 85 IL FILARETE, *Entrance to a Fortress*, from *Treatise on Architecture*, 1460–5, Biblioteca Nazionale, Florence (Codice Magliabechiano XVII.30. fo. 42r).

of floors could be increased or decreased without altering the general effect. Elsewhere Filarete shows that he had seen, but not understood, the architecture of ancient Rome. *Entrance to a Fortress* follows a structure which, in the central cylinder set on a parallelepiped base, recalls, albeit vaguely and hazily, the Mausoleum of Hadrian. But this becomes a mere starting point for the upward growth of a

hybrid and irrational superstructure made up of the most disparate elements. The crenellated tower resting on the round drum derives from the Mausoleum, transformed into a fortified stronghold, the present-day Castel Sant'Angelo, which Filarete studied in this later form. But the classical connotations of the lower part – confined to the quite fortuitous addition of a series of equestrian statues at the corners – contrast strangely with the top of the bizarre structure, which resembles the Gothic bell-tower of the court church of Milan, San Gottardo.

In these drawings there is a complete absence of precise internal logic; and this is one of the basic characteristics of the Pseudo-Renaissance, which responds to sentimental rather than rational impulses, to the impetus of digressions of a kind which we would nowadays define as literary rather than functional, and to the development – never taken very far – of some idea drawn from rational models, as is the case for the archaeological connotations which crowd into Filarete's designs. The idea is then corrupted and applied without any precise objective. In the bronze doors for the Basilica of St Peter's in the Vatican, Filarete also outlines other phases in this same cast of mind. In the *Crucifixion of St Peter* (worked in perfect harmony with the other scenes and with the friezes which divide and close off the two doors) ancient Rome is represented through a close study of architecture, sculpture, clothes and uniforms. As a chronicler of coins, deep reliefs, ornamental vegetation and sarcophagi, Filarete deserves a special mention (not so different from the achievements of Pirro Ligorio a century later); but when it comes to rendering such an erudite heritage objectively, he lacks any power of synthesis, with the result that all the data are thrown together without any order of precedence. In other words, we have here the same criterion of indiscriminate accumulation and curiosity-shop display that informed the *Wunderkammern* which were to be found all over Europe at the time, and which showed a very different approach to the rigorous selection procedures which soon formed the basis of collections like those of Lorenzo de' Medici. In Florence, a tendency of this sort would – at least in the most cultivated circles – seem old-fashioned and vulgar, although there are plenty of examples, particularly in goldsmithery, of the tradition continuing through its links with the courtly culture of the fourteenth century. But the magnetic personality of Donatello, the new ideas of Brunelleschi and the movement towards a definition of form based on a new rationality, made themselves felt even among those at the forefront of the culture, who were nonetheless attached either by their education or by

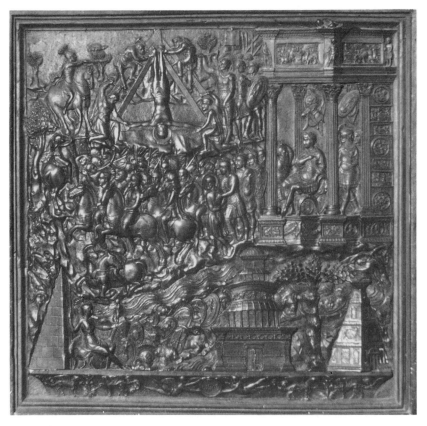

Plate 86 IL FILARETE, *Crucifixion of St Peter*, St Peter's, Rome.

their mental disposition to a pre-Renaissance figurative grammar. A compromise solution is thus found in Lorenzo Ghiberti (a figure of great importance in the development of a large number of Florentine sculptors and painters of later generations). In him we can clearly see the concern with defining space according to precise scientific rules and structuring the human body according to the universal principles of anatomy, particularly in his heads and busts. But his efforts are always impulsive and do not succeed in overcoming his innate, constitutional preference for solutions which rely on intonation and rhythm achieved by festoons of drapery: typical of this are the two bronze reliefs Ghiberti made between 1420 (apparently) and 1427 for the Siena Baptistery. In these the crucial element is still the

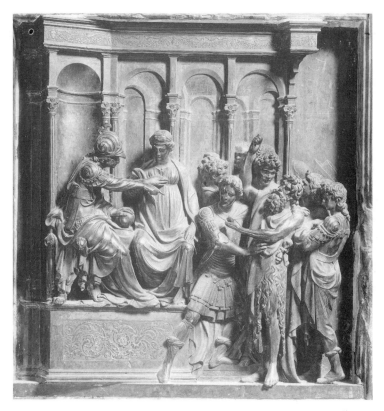

Plate 87 LORENZO GHIBERTI, *The Baptist before Herod*, Siena
Baptistery.
Photo: Archivi Alinari.

outline, that element of draughtsmanship which was soon to launch
a long tradition of Florentine painters and sculptors who let the
synthesis of relief and perspective found in Donatello, Brunelleschi
and Masaccio fade and almost disappear. So often artists from Flor-
ence or trained in Florence took with them to other centres in Italy
these characteristic solutions so reliant on *disegno*, outline and rhythm:
to cite but one example, the delicacy of Agostino di Duccio (whose
background is obscure and problematic) was active in Perugia and
Rimini, helping to create some of the most complete and varied
examples of Pseudo-Renaissance art. And it should be observed that
not even a direct knowledge of true Renaissance texts could trans-
form or divert the style of this kind of artist. Agostino di Duccio

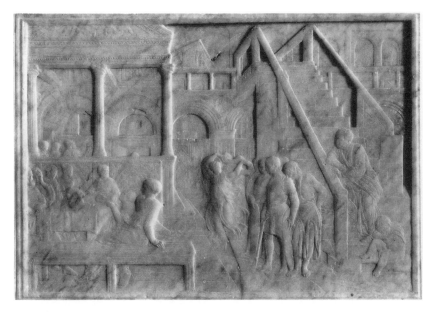

Plate 88 Master of the Barberini Panels, *Presentation of the Virgin*,
detail, Museum of Fine Arts, Boston.

certainly saw the works of Piero della Francesca, and the 'Master of
the Barberini Panels', an artist with a Florentine training in the style
of Filippo Lippi, regardless of whether he is identified as Giovanni
Angelo di Antonio, or, as is less likely, Fra Carnevale, must also
have seen Piero and even quoted from him, though without any real
effect on his stylistic formula. In a mature work such as the *Barberini
Panel* now in Boston, the greyhound in the foreground is lifted
wholesale from Piero's fresco in the Tempio Malatestiano with
Sigismondo Pandolfo Malatesta kneeling before St Sigismondo. But
this is a simple impromptu quotation from a figurative repertoire
which does not alter in the slightest the formula governing the com-
position: a formula of *disegno*, almost romantic in its elongated
distortion of the figures of the beggars, in which perspective plays a
subordinate, almost irrelevant role. If we compare a picture such as
this with Donatello's *Feast of Herod* we can measure the enormous
formal and moral gulf between these two completely irreconcilable
figurative worlds.

The cultural background of the Master of the Barberini Panels
derives in essence from Filippo Lippi, who was in fact the painter

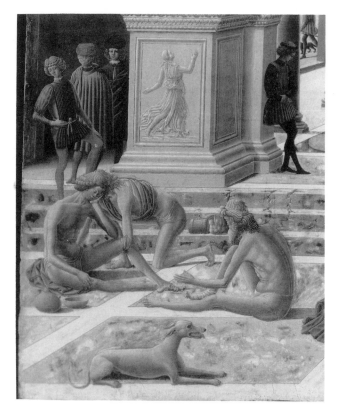

Plate 89 DONATELLO, *The Feast of Herod,* Musée des Beaux-Arts, Lille.

who opened the dichotomy which is characteristic of fifteenth-century Florence. In one of his early works, the *Confirmation of the Carmelite Order* of 1432 in the Carmine in Florence, he shows himself as a direct descendant of Masaccio in the way he takes up Masaccio's forceful definition of relief in a well-judged use of chiaroscuro (although the psychological rendering and definition of space are a little forced). But soon Lippi is building his images around *disegno*, although he remains caught between the two concerns of relief and rhythmic intonation. This path was followed to its conclusion by Lippi's most famous pupil, Alessandro Filipepi known as Botticelli, one of the great draughtsmen of all time, for

whom line woven into rhythm plays a decisive role. This development went hand in hand with the subjects of his pictures: Botticelli is in fact a faithful producer of allegorical, sometimes obscure literary themes (like his masterpiece, the *Primavera*) so beloved of the Florentine elite of the Medici with its fondness for neo-Platonic philosophy, allegory, and the revival of neo-pagan motifs, all of which contrast with the almost brutal immediacy with which Donatello and Masaccio had addressed the Florentine community, regardless of class or cultural background. It may seem false to label Botticelli's art as Pseudo-Renaissance; however, there is another case that may seem even more disconcerting where the Renaissance label, understood as a stylistic rather than as a historical phenomenon, is ultimately implausible, and this is the case of Paolo Uccello, usually considered to be one of the founding fathers of the new style, at least as generally understood. But we are forgetting that his reputation is based on works such as the three panels of the *Battle of San Romano* (Uffizi, Louvre and National Gallery in London), which were not completed before 1450, when the painter, born in 1397, was already over half a century old; other works from his brush which earned him his Renaissance reputation (such as the *Deluge* in the cloister of Santa Maria Novella) also date from around 1450. A large body of philological research has insisted, and still insists on denying that Uccello is the author of a rich group of panels, canvases and frescoes which goes under the provisional attribution to the 'Master of the Quarata Predella', 'Prato Master', or 'Karlsruhe Master', all hypothetical constructions which it has for some time been suggested should be incorporated into Uccello's catalogue. In fact we should add that it is only by acknowledging this provisional authorship as his that his later works can be properly evaluated. They are unparalleled examples of a frenetic, obsessive elaboration of one and only one of the items on which the complex formula of the founding fathers of the true Renaissance is based. Uccello's 'sweet perspective' is a pretext for research for its own sake, wrenched away from the perfectly homogeneous body of spatial clarity, definition of relief and psychological truth which in Masaccio or Donatello serve to enlighten man as to his own nature, helping him to understand his own essence and to free himself from metaphysical myths and social conventions. When seen as a mathematical exercise, exclusive and self-seeking, the quest for perspective produces images which are abstract and unreal, even dehumanizing. In the Karlsruhe *Nativity*, the palm tree is topped with a perfect arrangement of pointed leaves, clearly defined, but still and frozen, almost

Plate 90 PAOLO UCCELLO, *Nativity*, detail, Staatliche Kunsthalle, Karlsruhe.

as though made of beaten metal, just as the ox and ass (and even the sails of the ship on the horizon) skilfully positioned in the background suggest the toneless and rigid lifelessness of robots. In the same painting it should be noted how, alongside these attempts at mathematical structure, the Virgin is portrayed by a rigid, sharp profile, with unrealistic, calligraphic features: just as in many parts of the *Night Hunting Scene* in Oxford or in the three panels of the *Battle of San Romano* the protagonists pass nonchalantly from being perspectival axes (carefully disposed in order to suggest the depth of the third dimension) to being inlaid pieces in marquetry or some multicoloured mosaic, with faces seen from the side and outlined by a sharp, distinctive edge. In some cases (where we can assume the

influence of Donatello) Uccello describes the human face *alla moderna*, striving to follow the rules exemplified by Brunelleschi, Donatello and Masaccio, but fails to capture their essence. Typical of this (compared with certain excerpts from the *Deluge*) are the four so-called *Prophets* (more probably *Evangelists*) who appear within perfectly drawn lunettes at the four corners of the great clock on the internal façade of the Duomo. In one, the painter's intentions of rendering something of the Donatello model with a heroic emphasis are strangely let down by the perspectival process, which is applied according to separate elements, without a close awareness of the integrated structure of the skull and facial muscles and gives the whole a peculiar fracturing of planes, which remain disconnected, recalling certain fourth-century sculptures from post-Constantinian Rome (when the notion of anatomy and plasticity as being one was on the way out), which show two quite distinct compositional planes, one frontal, the other profile. Paolo Uccello's Pseudo-Renaissance is not, however, an isolated phenomenon; he interprets perspective with the same unilateral approach found in the way other followers of the founders of the Renaissance distorted the rich and integrated formal fabric of their models by extracting just one piece of data: Arcangelo di Cola took their chiaroscuro, Paolo Schiavo their monumentalism, Francesco di Antonio their moral impassiveness, to mention but a few. Of course, any great artistic personality and any genuinely innovative artistic movement will inspire these attitudes of mind. The incomplete way in which the original and authentic Renaissance in Florence was interpreted is not after all so different from what happened in Milan after Leonardo's arrival, or to the fortunes of the immediate followers of Raphael, or even finally to the rich variety of phases, all vaguely monotonous and incomplete, which comprise the spread of 'Caravaggism'. This is not to say that the meaning of the true Renaissance was lost in Florence; it was taken up in an extraordinary variety of ways and with a variety of formal and cultural accretions by Fra Angelico, by the sculpture of Luca della Robbia, Andrea del Castagno's Donatellesque revival, by Domenico Veneziano (another person whose background remains something of a mystery) and Piero della Francesca. Colour modulated by light now began to play a role in the definition of perspective; and it remains to be established how important in this respect was an awareness of Flemish pictorial texts, especially those of Jan van Eyck and Petrus Christus. But on this question there are too many gaps and too many works have been lost – particularly in the field of painting – for us to know accurately what happened in Florence

between 1430 and 1450; but in the second half of the century two things inspired the revival of Renaissance praxis with a new look. The first was a successful commitment to rationalizing the design solutions of Filippo Lippi and his followers, a commitment which led Piero and Antonio del Pollaiuolo (thanks also to their extraordinary knowledge of anatomy) to elevate *disegno* from the limitations of calligraphy and raise it to dizzy heights in a functional, or energetic, treatment.

The second factor was the achievement of the workshop of a painter who was also a sculptor, Andrea del Verrocchio, which produced several of the best reworkers (and sometimes popularizers) of the art of the true Renaissance. Verrocchio the sculptor was always concerned with placing the plastic form in its environment through a constant chiaroscuro modulation of the surfaces, defined by a close scientific study of objective reality. Often the real intentions of an artist are revealed in the lesser aspects or in the accessories of his production; framing elements for painters (where they have designed them themselves), pedestals for sculptors, mouldings and entablatures for architects. With Verrocchio, whose catalogue of undisputed works is very limited, a decorative work such as the tomb of Piero and Giovanni de' Medici, in the Old Sacristy at San Lorenzo in Florence, is rich in allusions. The lion's paws which support the porphyry sarcophagus, the acanthus scrolls (from Roman sources) which cover its corners, and even the piping along the edges and in the background grille are all rendered with a scientifically accurate realism, and animated by the constant variation of the chiaroscuro factor, which breathes everywhere like a breath of life. There is no room here to go into Verrocchio's relationship with other Florentine sculptors, such as Antonio and Bernardo Rossellino or Desiderio da Settignano; in any case, the importance of his role in the development of Renaissance rationalism is sufficiently clear from the fact that Leonardo da Vinci was trained in his workshop (where many of the most important members seem to have been agnostic in the matter of religion and uninhibited in their sexual relations). For Leonardo's Florentine period, a secondary and disputed painting is of great importance: on the reverse of the *Portrait of Ginevra Benci* the emblem of allegorical and heraldic motifs is a real masterpiece of optical insight, of absolute botanical and perspectival realism. The twigs of juniper, laurel and palm are executed with astonishing rational clarity; the depth of commitment which led to its execution can been clearly seen by comparing the anatomy of Leonardo's palm with the one painted by Paolo Uccello in the Karlsruhe *Nativity*. We

Plate 91 ANDREA VERROCCHIO, Tomb of Piero and Giovanni de'
Medici, detail, San Lorenzo, Florence.
Photo: Archivi Alinari.

also have Verrocchio to thank for the training of Pietro Perugino,
who absorbed Piero della Francesca's understanding of space, and in
turn helped along that veritable paragon of humanism and Renais-
sance personified, Raphael.

It was again in Verrocchio's workshop that another great artist
(often wrongly seen as a mere popularizer) learned his trade:
Domenico Ghirlandaio. In the dichotomy between false and true
Renaissance he occupies a very important position among the pro-
moters of rationalism; it was no accident that the phenomenon of
Michelangelo is traceable to him. And finally it is only proper to

Plate 92 LEONARDO DA VINCI, Emblem on the verso of *Portrait of Ginevra Benci*, *c*.1474, National Gallery of Art, Washington; Ailsa Mellon Bruce Fund.

point out that Ghirlandaio, who is a true starting point for High Renaissance art, possessed one of the very effective though unacknowledged components essential to Cosimo Rosselli, a second-rate painter who nonetheless taught Piero di Cosimo, another great leader of the line which took the original spirit of the founding fathers into the sixteenth century, breathing into it a new emphasis of lively and profound lyricism, thereby rescuing it from the academicism which was common currency in Florence from 1450 onwards. It must also be remembered that, after the collapse of the gloved rule of the Medici, under the Republic, which ended in 1530, the most genuinely *democratic* painter (often working towards a subtle revival going back to Masaccio) was Ridolfo, who was Domenico Ghirlandaio's son.

Although studies of Sienese art in the fifteenth century are still

incomplete, it is safe to assert that in Siena, apart from some isolated exceptions in the field of sculpture, the art of the period belongs to the cultural category we have defined as 'Pseudo-Renaissance'. The city had been in a phase of economic and political decadence since the 1348 epidemic (from which it never recovered), and its figurative artists kept it firmly rooted in its past glories. Reworkings of images created by Ambrogio Lorenzetti are found in one of the great local artists of the fifteenth century, Pietro di Giovanni Ambrosi, while another prominent figure, Giovanni di Paolo, merely heightened the superficial sensitivity with which he learned, at second hand, the repertoires of the traditional *Speculum naturae*, particularly in the version brought to the town by the visit of Gentile da Fabriano. Fifteenth-century Siena is a *hortus mirabilis* of feelings, enchantments and *frissons*; a series of irrational and fascinating motifs, very far removed from the rationalism of the Renaissance, but which sometimes (as in Neroccio di Bartolomeo, Francesco di Giorgio Martini and Matteo di Giovanni) stand out as the zenith in Italian painting of sensations, moods and emotional instincts. Matteo's *Madonna di Percena*, Neroccio's *Rapolano Altarpiece* (now in the National Gallery in Washington), and the glowing and jewel-like images of Benvenuto di Giovanni are (in their own very personal and varied ways) high points of visual communication entrusted to intuition and instinct rather than to rules and reason. This is not to say that the Sienese were unaware of the true Renaissance in Florence, right from its earliest manifestations; the greatest local artist of the fifteenth century, Stefano di Giovanni known as Sassetta, knew the work of Masaccio at least from the Brancacci Chapel frescoes in the Carmine, and made a precise quotation from them in a fragment of a large Crucifix painted in 1433 (Siena, Chigi-Saracini Collection). But this is just a quotation, nothing more; Sassetta's whole figurative code is oriented towards quite opposite styles to those of Masaccio. In the artist's masterpiece, the *Madonna of the Snows* painted between 1430 and 1432 for the Duomo at Siena (now in Florence, Palazzo Pitti, Contini Bonacossi Gift), the problem of the third dimension is addressed with a determination and variety worthy of Paolo Uccello; to this end, the whole of the great painting is crammed with artifice in the movements and positions of the figures: the figure of St Paul (top right) is a good example. The monumental image is shown in the act of displaying the Epistle to the Romans, armed with the iconographic attribute of the sword, both placed very prominently, simultaneously emphasizing the suggestion of spatial depth. In this detail, Sassetta has resorted to quite a figurative *tour*

Plate 93 SASSETTA, *Madonna of the Snows*, Palazzo Pitti, Florence;
donated by Contini Bonacossi.
Photo: Archivi Alinari.

de force, setting the sword horizontally (a choice unprecedented in
the iconography of the Apostle of the Gentiles); held suspended in
the right hand and leaning on the left wrist, the sword becomes the
bottom line of an imaginary parallelogram whose other sides are
the Epistle (orthogonal to the sword), the arms and the torso of
the saint. Underneath, a kneeling St Francis is similarly characterized
by gestures which serve to underline the three-dimensional effect: as
in the detail of the open book, which measures the distance between
the foreground and the middle ground. In the other great painter of
the same generation, Pietro di Giovanni Ambrosi, there appear simi-
lar effects, though not in the smaller pictures, where his awareness
and study of Florentine rational art sometimes leads him to a
definition of space which, though not quite scientific, nevertheless

Plate 94 PIETRO DI GIOVANNI AMBROSI, *Madonna*, fragment, Christian Museum, Esztergom, Hungary.

comes very close to the crux of the problem. But in the larger paintings and in his rendering of the human form, Ambrosi reveals himself as decidedly intuitive, as in the fragment from the Museum of Esztergom, possibly a remnant of a grandiose *Maestà*. The great fascination of this image is derived precisely from the fact that it is devoid of any internal structure or of any real or definite relationship between eyes, arched eyebrows, nose, mouth and cheeks; space in this painting, far from being polarized around one axis or one centre, instead seems fragmentary, composed of elements which have nothing except a system of almost symbolic allusion to link them. References to the landscapes of Sassetta's and Ambrosi's minds are found too in the next generation of Sienese painters, for example in Matteo di Giovanni, who in the various versions of his *Massacre of the*

Innocents (Siena, Sant'Agostino and Santa Maria dei Servi; Naples, National Gallery) declares a renewed interest in Florence (now studying Antonio and Piero del Pollaiuolo), but without straying from his usual inspiration or moving towards rationality.

As the Tuscan capital of fifteenth-century Pseudo-Renaissance (it was no coincidence that Siena moved straight on to Mannerism, via Domenico Beccafumi, without a break) Siena also demonstrates a strange phenomenon which causes serious problems for any rigid art-historical classification: there were artists who were rational and irrational at the same time, both scientific and intuitive, masters of reasoned perspective who remained ignorant of its premises. This is proved in at least two cases in two figures who dedicated themselves simultaneously to painting and sculpture, Lorenzo di Pietro known as il Vecchietta and Francesco di Giorgio Martini. In Vecchietta the painter, space and anatomy are reliant upon intuition and the figures are constructed of ductile material, subject to every sudden influence; quite the opposite of what is achieved in the works of Vecchietta the sculptor, especially in his very powerful bronzes, where the observation of space and anatomy is shrewdly subtle and accomplished. A similar phenomenon is to be found in Francesco di Giorgio's catalogue; in his paintings space and anatomy actually become a pretext for digression of a quite absurd nature, as in the lectern of the *Annunciation* in the Siena Pinacoteca, stretched and elongated as if by a distorting mirror. But as a sculptor Francesco di Giorgio is quite another matter; his work expresses Renaissance rationalism with impeccable logic, both in the rendering of space and in the definition of the human form, with that same rule of inexorable consistency found in Francesco di Giorgio the architect. This bivalency of some Sienese artists remains very problematic; perhaps the answer to the questions they pose lies in the fact that Siena possessed Donatellian models, and in the opportunity local sculptors therefore had to study them, absorb their structural principles and scientific basis, and find their innermost meaning. However, it is a problem which casts doubt on many art-historical certainties, just as studying the authentic Renaissance alongside the Pseudo-Renaissance throws deep shadows over the validity of some of the Marxist-derived schemes of interpretation regarding patrons and artists, and particularly how the social backgrounds of patrons affected the type of works they commissioned. It is beyond doubt that the formal rationalism of the Florentine Renaissance can be linked to the birth and growth of a bourgeois merchant class. The definition of universally valid rules governing space and perspective, the search for the

Plate 95 FRANCESCO DI GIORGIO MARTINI, *Annunciation*, Pinacoteca
Nazionale, Siena.
Photo: Soprintendenza per i Beni Artistici e Storici, Siena.

relationships between the different parts of the human body and its
proportions, and last but most importantly the problem of establish-
ing the precise parameters of the relationship between the individual
and his environment: these are all concerns which necessarily belong
to the same period, which faced the economic chain of cause and
effect rationally or, in short, replaced an economy based on outgoings

Plate 96 FRANCESCO DI GIORGIO MARTINI, *Flagellation*, Galleria
Nazionale dell'Umbria, Perugia.

with an economy based on income. But it is quite wrong, and flies
in the face of the evidence, to pass from these fixed points to a
rigidly determinist view of the role of the patron/artist relationship
in the link between style (of whatever kind) and consumers/patrons.
In reality the patrons saw little difference between the reasoned and
the unreasoned approach to form, or between *authentic Renaissance*
and *shadow Renaissance*, between science and intuition; they simply
took whatever was on offer at the time. In undertaking the recon-
struction – a gigantic project in those days – of the Church of San
Francesco in Rimini, Sigismondo Pandolfo Malatesta was quite happy
to employ Piero della Francesca alongside Agostino di Duccio; and
as for paintings, in 1454 he had commissioned from Filippo Lippi

a panel showing St Jerome which was probably meant for the chapel dedicated to this saint within the Temple.

Again, Federico da Montefeltro, who patronized two key figures of Renaissance rationalism, Luciano Laurana in architecture and Piero della Francesca in painting, did not hesitate, even for more important settings than his own residence, to use the services of someone like Giovanni Boccatis or the Master of the Barberini Panels, two painters who were very far removed from Renaissance rationalism: such cases are quite the norm, and a study of the archives of the middle class in Florence would bring quite a number to light. We can at best state that the true figurative culture of the Renaissance in Florence hardly penetrated (except intermittently) the smaller centres dominated by local lords, where culture was still bound up with the life of the court or the power of an elite without that intermediary layer between the lord and the people which could introduce new cultural interests and help to erode and supersede traditional networks of power. In centres in Umbria and the Marches similar situations gave rise to an exceptional variety of figurative discoveries, none of which could be termed Renaissance other than in a purely chronological sense. In Perugia, Domenico Veneziano and later Piero della Francesca passed through like shooting stars without lasting effect; local artists must have seen them as products of fashion or superficial typology, since their attitude was not in the least shaken by the presence of such a serious masterpiece of the new rationalism as Fra Angelico's polyptych (painted in 1437 for the local church of San Domenico). But stranger still is the case of another Umbrian centre, Foligno, where the great texts from Florence never found their way and where knowledge of figurative rationalism arrived at second or third hand. The *genius loci* who dictated the climate of figurative expression was Bartolomeo di Tommaso, a painter of very varied culture who fluctuated between his knowledge of the early Quattrocento in Emilia and its local version and, in his mature phase, his reading of the double polyptych by the Sienese Sassetta in the Church of San Francesco at Borgo San Sepolcro, although we cannot rule out the possibility that he made one or two forays towards Florence. Although the frescoes painted by Bartolomeo di Tommaso in the Church of San Francesco at Terni (around 1450) could be called many things, they are certainly not 'Renaissance'; it would be difficult to find an example of such obsessive and fantastic non-conformism or such unrealistic graphic characterization in any painting of the century. In the different sections which cover the walls of the Paradisi Chapel there are plenty

of nods and hints in the direction of plastic mass, chiaroscuro and anatomical realism; but they are all dissolved into a magma of fantasy which dilates, elongates, enlarges and exaggerates, showing allegiance only, and then only occasionally, to rhythmic cadence and calligraphic pedantry. We may well suspect that such a blaze of unrealistic passion in which the formal themes of the true Renaissance (actually very distant and blurred) are rejected, must mean that the painter knew about those themes through some intermediary, through Sassetta in fact, who had himself reworked those themes in a non-systematic vein. Bartolomeo di Tommaso also deserves a mention as one of the painters summoned by Nicholas V to decorate the papal apartments in the Vatican, and this is the same pope who patronized Fra Angelico in the same building – further proof of the lack of any connection between style and patronage, or between social status and preferred figurative language. So then, in a city like Foligno, a centre in an area predominantly supported by agriculture and without large commercial or banking businesses, it happens that the stylistic types expressed at the level of political power and the cultured class pass into the surrounding countryside unmediated and without intermediate stages. Although they may have been modified by various influences (ranging from the Florentine Benozzo Gozzoli to German engravings), Bartolomeo's forms are the same as those which appear, much pruned and reduced, in Matteo da Gualdo. In this distant country ancestor to Modigliani (grotesque rather than moving, and primitively monotonous) anatomical structures are achieved by *disegno* alone and subjected to fracture and distortion, so that the images are reduced to a kind of allusive shorthand. A similar approach is to be found in the Marches, for example in Ludovico Urbani of San Severino; in other centres in the Marches it may have been proved that true Renaissance figurative texts were known but failed to give rise to any following, as for example at Camerino, home to a circle of painters (partly influenced by Paduan fashions) who cannot possibly be described as using rational perspective, scientific anatomy, or rules of Stoical or evangelical ethics. In a cultural and intellectual climate of this kind covering a vast area from Atri to Terni and from Fabriano to Cesena, it is not surprising that archaic, outmoded figurative styles should have enjoyed a popularity that was as overdue as it was unexpected, thanks to a full-scale revival of sorts. The most symptomatic case of this syndrome is a panel by Francesco di Gentile da Fabriano which most probably belongs to the last decade of the fifteenth century (as suggested by the symbolic fruits and vegetables at the top, derived

from Carlo Crivelli). Breaking away for once from his usual practice
of dreamy and spineless rendering of the *modern* figurative reper-
toire (as he was aware of it through indirect channels, and certainly
not at first hand) the painter reassociated himself with Gentile da
Fabriano (in the tree full of red angels) and perhaps also with
Pisanello, in the section on the right with monkeys and deer, ob-
served in the manner of courtly zoography from a late fourteenth-
century pattern book. Everything is rendered in a pale, diaphanous,
fluid medium, where contrasts are kindled between rosy lacquers
and burnished gold. But to return to Foligno, where other aspects of
Bartolomeo di Tommaso's norm, or rather his lack of any real figu-
rative norm, find precise expression in the local artist and mentor of
the next generation. Niccolo di Liberatore, known as Alunno, taught
himself from the works left in Umbria (particularly at Montefalco)
by Benozzo Gozzoli, an intelligent popularizer of Fra Angelico's
repertoire. His mixture of Florentine realism (so to speak) and Foligno
expressionism translates into contortionism. Niccolo's figures writhe
and scream in the grip of uncontrolled emotions like the chorus in
a liturgical drama; often they are defined with an optical accuracy
that is as surprising as it is superficial, aided by technical tricks
which anticipate by several centuries the fakers and imitators of the
nineteenth and twentieth centuries. Despite his unusual intelligence,
Alunno is still an artist as actor, not personally involved in the
narrative he is trying to make us believe in: he stays in that limbo
of make-believe which is so utterly foreign to the 'first-person' Re-
naissance, which always bears the mark of the artist's direct involve-
ment in the figurative world in which he lives and suffers. In Rome,
where the arrival and activity of some of the most widely diverse
artists brought variety and even self-contradiction to the cultural
situation after 1450, the principal figure produced by the *authentic*
Renaissance was Antoniazzo, a great and noble painter sadly dimin-
ished by the flood of commissions he received, which forced him to
resort to the help of assistants and pupils who have obscured the
high quality of the catalogue of works that are genuinely by him.

Among the very many episodes which each in their own way
mark the diffusion and even distortion (albeit an inspired distortion)
in the second half of the fifteenth century of what the Florentines of
the first three decades had taught, a special corner must be reserved
for an obscure provincial painter active in many small centres in
the Umbria–Marches area, Bernardino di Mariotto da Perugia. If
we dissect the sources of his cultural influence it turns out to be
extremely broad, taking in painters from Perugia and Sanseverino,

ranging from Luca Signorelli to Carlo Crivelli; his whole repertoire of notes, themes and ideas comes across through a highly distinctive personal style, which strives to pass off as genuine the emotional, sorrowful and pathetic gestures performed by frail characters endowed with the exaggerated elegance so typical of provincial culture. The harmony between the *disegno*, adapted to the demands of the emotional and passionate (although delicately affectionate) tone, and the figurative register, which is so rigidly stylized by its very limited vocabulary, make Bernardino a forerunner, by more than four centuries, of the most important features of the comic strip, Walt Disney cartoons, and the mass production we have seen blossoming in the field of visual images.

What we nowadays call fifteenth-century Lombard art is in fact the figurative expression of many different cultural centres: Cremona, Pavia, Lodi, some of the valleys of the foothills of the Alps, and above all Milan. The state of our knowledge and philological analysis for this area is very patchy; however it has been proved that the basic developments took place in the capital of the duchy of Lombardy, Milan, although the formula which characterizes Lombard painting from the middle of the century onwards (and which constitutes its vital essence) was invented by a painter originally from Pavia and active in Genoa, Donato de' Bardi; after a debut which owed much to late fourteenth-century approaches, his painting was influenced most notably by his knowledge of Flemish art. It has become a commonplace to assert that the rational observation and description of light was to the Flemish painters of the first Renaissance generation what perspective was to the Florentines. Donato de' Bardi shows signs of the influence of Jan van Eyck, although some of his few surviving paintings suggest a knowledge of other important fifteenth-century Flemish painters. The *Madonna* in the Poldi-Pezzoli Museum, which is certainly by him, is in practice a translation into Italian of a Roger van der Weyden-type model: form is defined by the incidence of light, a concern which is passed on to Vincenzo Foppa. It is still too early to establish the date and the nature of the relationship between Donato and Foppa, but it is undeniable that Foppa must formerly have been exposed to a non-Lombard environment, probably a Paduan one, harmonizing the sombre humanist rulebook of Andrea Mantegna with Donato's interest in the relationship between form and light. Later Foppa was among the more intelligent observers of Donato Bramante (who came to Lombardy in the late 1470s), grafting on to the Lombard stem the iron rationalism of Piero della Francesca's perspectival space,

Plate 97 Attributed to VINCENZO FOPPA, *Flagellation*, by courtesy of
the Fogg Art Museum, Harvard University, Cambridge, Mass.; bequest
of Charles A. Loeser.

which Bramante had picked up where he was born and brought up,
in Urbino.

So with Vincenzo Foppa a new branch of Renaissance reason
took concrete form and, through the painters of Brescia and Cara-
vaggio, it was to win a determining role for Italian and European
painting; I say 'new' because form and light are no longer separated
by the membrane of *disegno* or relief; instead light is absorbed into
form and expressed like the glow from burning coals. Of course the
rational approach to the problem of space and three-dimensionality
did have its downside; the work of Bernardino Butinone is sustained
by a distinctive luminarism which beats down from outside on to
forms which are rendered by a formula that is personal rather than
scientifically valid. However, as far as perspective was concerned,

Plate 98 JACOPO BELLINI, *Pagan Temple*, Musée du Louvre. © Cliché
Musées Nationaux, Paris.
Photo. Réunion des Musées Nationaux.

Milan certainly still cultivated it with unwavering commitment. If
we compare a drawing from the Fogg Art Museum (sometimes
hypothetically attributed to Foppa, showing a scene of the *Flagellation
of Christ* reduced to its most basic terms in the furthest background)
with a sheet of Jacopo Bellini's (the Venetian painter who founded
the famous dynasty and died in 1470) we can clearly see the vast
gulf separating true Renaissance rationalism from the fabulous and
whimsical vision of an aestheticizing and superficial approach to
that same rationalism. As for the Lombard idea of light, it was
Leonardo da Vinci who best understood its value and its possibilities;
he came to Milan in 1482–3 and entered the service of Duke
Ludovico, and the painted works he managed to finish (and which
have reached us undamaged) are true miracles of balance between
Florentine form and Lombard form, between *disegno*, mass and light,

between optical and stylistic realism. The *Belle Ferronière* (Louvre) and the *Lady with an Ermine* (portrait of Cecilia Gallerani) (Cracow) even more than the two versions of the *Virgin of the Rocks* (Louvre and National Gallery, London) represent the peak of Renaissance rationalism, ahead of the works of the mature Raphael or the Sistine Chapel ceiling, neither of which are sustained by a cultural formula as rich and varied as the Milanese Leonardo. The effect on local painters who were attracted by this formula was disastrous; it is difficult to find an example of such partial, unilateral and badly fragmented adaptation as Leonardo's models were subjected to by Ambrogio de' Predis, Bernardino de' Conti, Marco d'Oggiono, Francesco Napolitano and others like them, all examples of intemperate reduction where a prototype that is strictly and lucidly restrained is reproduced with a complete lack of moderation. Those who remained committed to Foppa's authentic formula of luministic extraction, which they reworked along very original lines, were saved from the tendency to interpret Leonardo according to spur-of-the-moment intuition: they included the great Boltraffio, Bernardino Luini (in his way) and Bernardino Zenale. But there were those who remained quite immune from the Leonardo reflex: Foppa himself (who died between 1515 and 1516), Bergognone and, most importantly, one of the greatest exponents of the true Renaissance, Bartolomeo Suardi known as Bramantino. An architect and painter simultaneously, Suardi does not even seem to have noticed Leonardo's stay in Milan; he looked to Bramante and availed himself of the latter's perspectival and architectural expertise, interpreting it in uniquely original ways that were really ahead of his time. The true Renaissance ended in Lombardy with the enigmatic visions of Bramantino: figures seen as living architecture, while in the background the real architecture (often anticipating by many decades the local architecture of the late sixteenth century), play an almost metaphysically suggestive role.

The characteristic dichotomy in Italian Quattrocento art, that contrast between the styles of reason and fantasy, between scientific and intuitive perspective, between Renaissance and Pseudo-Renaissance, took on exceptional prominence in the Paduan environment, thanks to the unique convergence of artists from outside, especially from Florence, with local artists. Padua was the seat chosen by Cosimo de' Medici and by Palla Strozzi for their periods of exile (the first in 1433 and 1434 and the second from 1434 to his death in 1462), and this preference reveals the strong links which ran between the city in the Veneto and the cultural and economic centre of Tuscany.

From Florence to Padua came Donatello (who transferred there for ten years from 1443, leaving behind his masterpiece, the Altarpiece for the Church of the Santo) after Filippo Lippi (in 1434) and Paolo Uccello (maybe in 1445) had passed through. The style of the Renaissance was therefore well known in Padua, through Donatello, in its most authentic and complete form, in the solutions of *disegno* which Filippo Lippi was reaching at the time of his stay there, and, with Paolo Uccello, in the imaginative and unilateral interpretation of perspective understood as one isolated factor. It should be added that Padua (a flourishing centre of humanist studies) had always keenly encouraged the study of Roman antiquities, even in opposition to the Byzantine-oriented culture of Venice, whose dominance the Paduans resented; the presence of Palla Strozzi added a Hellenic orientation to the Paduans' genuine veneration for classical antiquity. From these beginnings there emerged in Padua two figurative factions which were diametrically opposed to one another and identifiable as the Mantegna school and the other stylistic strain, named after Francesco Squarcione: 'Squarcionism'. With Mantegna, the world which the humanists had yearned for, on the strength of the texts which had survived the deluge of the seventh and eighth centuries, appeared in the flesh in paintings endowed with all the features and principal schemes of the true Renaissance. The *Christ on the Tomb*, a work from the artist's mature period, is a marvellous example, modelled on a Roman marble statue and executed with impeccable knowledge of anatomy and perspective. The Redeemer opens his arms with the same gesture as Seneca's Hercules: in fact this picture gives us a vision which identifies Christ with Hercules, rather than as a Christian Jupiter.

As always with the authentic Renaissance, the technical factors should not be underestimated: clear and patient, Mantegna's pictorial material is, in its detailed and accurate definition, a match for his Flemish contemporaries, both in the figures and in the landscape, or in the sunset sky, which all chorus their contribution to the drama of the Redeemer. From his earliest works, Mantegna had shown incomparable commitment in his study of classical antiquity. In the lost frescoes of the Ovetari Chapel at the Church of the Eremitani in Padua (painted between 1448 and 1457) his knowledge of finds from the ancient world was astonishing; the painter here showed himself as a serious researcher of armour, costumes, architecture, and his efforts in the field of epigraphs earned him a dedication from Felice Feliciano in 1463 in the collection of ancient epigraphs now kept in the Biblioteca Capitolare in Verona. Supremely

Plate 99 ANDREA MANTEGNA, *Christ on the Tomb*, Statens Museum
for Kunst, Copenhagen.
Photo: Hans Petersen.

rational and informed by a classicism that he loved and lived authentically and not just as a sign of erudition, Mantegna's style elicited an important response, not in Padua but elsewhere: it is especially important as a key to explaining the conversion of painters in Verona who (in the light of the San Zeno altarpiece, displayed in 1459) moved from shadow-Renaissance styles to a far-reaching absolute rationalism which fostered the production of some of the greatest masterpieces of the first-person Renaissance.

The catalogues of Francesco Morone and Gerolamo dai Libri (two artists whom modern opinion has seriously underestimated) often provide moments of admirable equilibrium, where the inner rationalism with which they face the objective world does not exclude a heartfelt lyricism, which rises from an elegiac timbre to a range that is universal, almost cosmic. Looking across from images of this kind to those produced by the other Paduan current, that of 'Squarcionism', one is aware of the chasm separating two totally different and irreconcilable intellectual worlds. It is very hard to define the real personality of Squarcione, and it is still doubtful whether we should acknowledge him as a true artist or more of an impresario (often an unscrupulous one) who used his pupils by exploiting and borrowing their efforts for his own glorification; equally doubtful is the consistency of his stylistic development, as there is no continuity between his two surviving panel paintings, the de Lazzara polyptych (Padua, Museo) and the signed *Madonna* in the Berlin Dahlem Gallery. In the *Madonna*, the adaptation of Donatellian models seems to be quite clear and direct and can be pinned down to the study of one specific plaque by the great sculptor: the result is a translation reliant upon outline which is ultimately not very far removed from what Filippo Lippi was doing prior to 1445. But the most unusual aspect of Squarcione relates to his pupils, among whom we find on one side his adoptive son, Andrea Mantegna, a champion of the most inflexible rationalism of true Renaissance stamp, and on the other hand, a string of characters who rely entirely on imagination, on their own personal code, on a variant of expressionism based on line and texture. The dichotomy between *essential* and *superficial* Renaissance is thus found in the pupils of Squarcione, through styles which suggest that the determining force was the 'mind-set' of the individual rather than culture, education or social origins. Compared with the stern classicizing discipline of Mantegna and the supreme imperial dignity of his figures, the figurative world of Marco Zoppo of Bologna (who worked with Squarcione between 1452 and 1455) seems to belong to another era, or to some other civilization.

Plate 100 FRANCESCO SQUARCIONE, *Madonna and Child*,
Gemäldegalerie, Staatliche Museen Preussischer Kulturbesitz, Berlin.
Photo: Jorg P. Anders.

His forms emerge in a constant succession of stops and starts and
vacillations; the unreal brightness of his translucent chromatic pig-
ment gives his paintings the look of embossed and beaten metals,
with the holy figures held together by his tormented outline, which
describes vegetation, when it appears (as in his pen drawings) as dry
and scorched and twisted like varicose veins. In another great painter
who must have received his training from Squarcione, Cosimo Tura
from Ferrara, a similar concern recurs so persistently as to acquire
the force of a signature, jagged and cutting, reminiscent of the he-
raldic and courtly mythologies so beloved of the ducal court of
Ferrara where Tura was a favourite artist. The figurative culture of
Ferrara (where Piero della Francesca was also active) must later have

converted to the styles of the true Renaissance (while keeping its own very distinctive particular qualities) by the time of Francesco del Cossa and especially Ercole de' Roberti, using an extraordinary variety of imports from outside, including Andrea Mantegna. Another painter trained by Squarcione (cited in documents as working with him between 1441 and 1444) is Giovanni Francesco of Rimini. In his work we find none of the textural surrealism of the other Squarcionists, and the main source of influence is still his study of Filippo Lippi's Paduan works, as well as his later encounter with the panels and frescoes painted by Benozzo Gozzoli in Umbria, an area in which Giovanni Francesco was active for a long time. Highly stylized, stiffly and rigidly based like painted wooden sculptures, his figures are a Paduan offshoot on Umbria–Marches territory; one might say that they achieve a union, albeit entirely transitory and superficial, between rustic culture and the forms of high culture.

The constraints of space make it impossible for us to describe the individual aspects of the Pseudo-Renaissance in the various regions of Italy, the many local versions with their formulae dependent upon customs, cultural influences and economic and political situations. There was no true rationalism of form in Liguria after 1450, in Piedmont or in most of the kingdom of Naples. Surrealism was sometimes expressed with extraordinary force and with very high quality, as in the panel dated 1472 in the Duomo of Viterbo, which was certainly the work of Gerolamo da Cremona, a miniaturist and painter whose history is very complex and who seems to be adapting the styles of Andrea Mantegna so as to reclaim them for values of transfiguration and vision, not very different from the values of Marco Zoppo and the Ferraresi. But in the history of the 'invented' Renaissance a special chapter must be reserved for an area of culture which has not hitherto been singled out, let alone studied in its development; this is the area we may call 'Adriatic', as distinct from the culture of Venice and the Marches. Its geographical boundary to the north is the island of Arbe, and in the south the Tremiti islands, while it flourished to the east in centres such as Zadar, Sibenik, Trogir (Traù) and other places in Dalmatia, and to the west it stretches to Ancona. Its first roots can certainly be traced to Padua, and Squarcione also certainly contributed to its formation (at least to some extent); in any case, Donatello's Padua altarpiece is the basic text for the formula of the 'Adriatic' style; one of its greatest exponents worked with Donatello on it, the sculptor Niccolo di Giovanni, known as Niccolo Fiorentino. Other artists who made important contributions to this episode (such as the sculptors Giorgio da

Plate 101 GEROLAMO DA CREMONA, *Christ and Four Saints*, Viterbo
Cathedral.
Photo: Archivi Alinari.

Sebenico (Sibenik) and the Albanian Andreas Alexii) have not been
the subject of much accurate philological research in the last few
decades; better known instead are the figures of the Dalmatian painter
Giorgio Chiulinovic known as Schiavone (who was the son-in-law
of Giorgio da Sebenico) and, best known of all, that of the Venetian
Carlo Crivelli, who was in Zadar (Zara) in 1465. Besides him, the

formula of the 'Adriatic' style is represented by Nicola di Antonio from Ancona, while Giovanni da Traù, known as Giovanni Dalmata, spread certain features of the style in central Italy, particularly in Rome, after working in Hungary in 1481 in the pay of King Matthias Corvinus.

It is hard to decide whether the most notable achievements of this stylistic formula belong to the field of sculpture or of painting; in studying its remains in Dalmatia (such as the splendid ensemble of the Orsini Chapel in the Duomo at Traù) we are hindered by the lack of adequate photographic evidence while other texts (such as the works by Alessi in the Tremiti islands) are still awaiting detailed reconnaissance. No one is even certain of exactly when this extraordinary movement reached its peak of activity, but the point of greatest intensity seems to have come between 1460 (the year when Giorgio da Sebenico produced the doorway for Sant'Agostino in Ancona) and 1475 when he died. In the work of Carlo Crivelli who, on his return to Italy from Dalmatia, exhibited masterpieces like the Massa Fermana polyptych (1468) or the polyptych, now broken up, which used to be in Porto San Giorgio, we can see him turning towards a less intense and caustic style from the time of the ex-Fesch polyptych of 1472 (now broken up), which already showed a diminished forcefulness compared with his other great ensemble, now divided between Montefiore dell'Aso, the Brussels Museum and the National Gallery in London, which perhaps dates from around 1470–1, where the fury of fantasy and line is supreme. Nicola di Antonio also seems to have reached his peak in 1472 with the altarpiece now in Pittsburgh, previously in Ancona, in the Church of San Francesco delle Scale. Nicola belongs at the crossroads between Chiulinovic (who worked with Squarcione between 1456 and possibly 1459) and Bartolomeo di Tommaso of Foligno, and his paintings form the most extravagant and extraordinary side of desperation and violence of the pedantic and aristocratic version of Donatellism developed in the *Adriatic* area, a flare which was snuffed out without sparking any response.

The word 'Renaissance' can also be applied to Venice, in the case of Jacopo Bellini and the Vivarini family. But in fact Jacopo's intellectual and optical structures were always those he learned alongside Gentile da Fabriano; despite his attempt to grasp reasoned perspective, as many of his drawings show, in his hands it was wrenched from the ethical and naturalistic context and transformed into a pretext for unruly flourishes. This fantastic perspective (which sometimes makes Jacopo Bellini seem like a kind of Venetian Paolo Uccello)

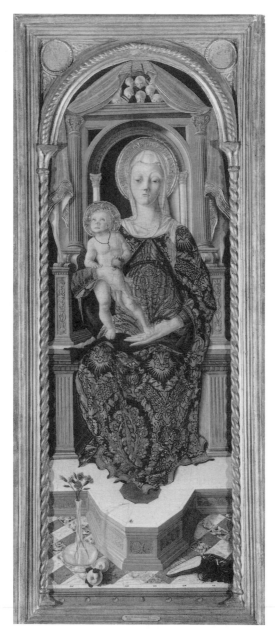

Plate 102 NICOLA DI ANTONIO, *Madonna and Child*, Minneapolis
Institute of Arts.

develops perfectly consistently with his interest in archaeology and humanism, and so, despite his close study of epigraphic characters, his Roman altars and tombstones are transformed into rare curiosities, just as antiquity enters the realm of *mirabilia* in the crude but evocative drawings of Ciriaco d'Ancona. The first of the three Vivarini, Antonio, also belongs to this band of Renaissance tendency, without ever going to the heart of the problematics of rationalism. Whether they are his work or from the hand of his brother-in-law, Giovanni d'Alemagna, the four *Stories of Sant'Apollonia* (Bergamo, Bassano and Washington) unfold within a setting of architectural flourishes, closer to the ideas of Filarete, Matteo de' Pasti or Jacopo Bellini than to the actual achievements of Filippo Brunelleschi or Leon Battista Alberti. But the figurative world of Antonio Vivarini emerges, to put it cinematically, in slow motion, with 'extras' who have a limited repertoire of gestures and emotions and move to very simple rhythms; when the narrative permits, some astonishing marvel takes centre stage, as in the beautiful *Story of St Peter of Verona*, which belongs to the Lafontaine Collection in Paris. If we wish to identify with some degree of authenticity the intentions and preferences of the Vivarini circle during this period, around 1450, it may help to look at a minor painter who developed alongside Antonio and who, despite his limited intellectual capacity and ability to express himself, is often livelier and more at ease. He is the author of a variety of panel paintings, the greatest of which are to be found in the *Story of Helen* in the Walters Art Gallery in Baltimore. Among them, the *Rape of Helen* shows a Temple of Venus where the altar (modelled on a pattern close to some of Jacopo Bellini's drawings) is placed inside a strange structure: a façade with an arched opening supported by pseudo-Corinthian columns, bounded by two classical pilaster strips with a back wall beyond, not unlike a wall in an early fifteenth-century church or chapel. There is no relation between the cylindrical altar and the floor, which recedes according to precisely defined perspective; the figures, despite their lively poses (see the lady on the right with arm bent and elbow protruding) are 'extras' without internal structure, mere components of a carefully portrayed scene, which is at its best in its fashions and hairstyles. Leaving aside the second Vivarini, Bartolomeo (who belongs to the minor strain of Squarcionism that was the Murano circle), we should underline the extraordinary variety which characterized the 'shadow-Renaissance' in the Veneto, Friuli, Istria and Dalmatia, which boasted a wide range of formulations (sometimes sophisticated, more often impoverished and toneless) which all relate to specific conjunctions between

Plate 103 Master of the Stories of HELEN, *Rape of Helen*, fifteenth
century, Walters Art Gallery, Baltimore.

figurative culture, political conditions and economic contexts. Never
in these episodes (which we can define as having local colour) do we
notice that special attitude in a chain of thought which inspires the
giant leap from imagination to reason, from the fragmentary to the
unified, or better still from dream to consciousness. In Venice this
passage was forged by Giovanni Bellini; it is probable, though not
certain, that it was Piero della Francesca who revealed perspective to
him, but it is certain that (after an early brush with para-Renais-
sance forms, as in the Birmingham *St Jerome*) Bellini absorbed the
essential facts of the art of Donatello and Andrea Mantegna. And
finally, it was the arrival of Antonello da Messina in Venice in 1475
which defined the terms of an equation between perspective, ana-
tomical structure and light which allowed Venetian painting to take
on such an important role in the context of visual perception in Italy
and in Europe. The essential question in Antonello's work is his
relationship with Flemish painting; where and when he may have
encountered it are still important unknowns in this set of problems,
although it now seems likely that the Messinese painter could have
seen paintings from northern Europe on two different occasions, the
second of which brought him into direct contact with the panel
paintings of Petrus Christus; and, as for the latter, the similarities
are such that it is difficult to decide (in a few cases, anyway, such
as the panel that was in Holford and is now in the Los Angeles

Plate 104 GIORGIONE, *Portrait of a Man*, San Diego Museum of Art, California; gift of Misses Anne R. and Amy Putnam.

County Museum) whether to point the finger of attribution towards Flanders or Italy, at Christus or Antonello. It was Antonello, the greatest exponent of figurative rationalism in the fifteenth century, who extended the range of Venetian painting: in his main follower in Venice, Jacometto, we see certain elements – facial descriptions, the relationship between form and light, the search for internal structure in the subject portrayed – which refer northwards, in the direction of the creator of Flemish painting, Jan van Eyck. In the wake of the 'Antonellesque' (or perhaps also 'Piero-esque') Giovanni Bellini, the last decade of the fifteenth century saw the rise of the unique phenomenon that is Giorgione, the most unusual of painters, who managed to marry rationally defined forms with themes borrowed from a humanist leaning towards the occult, an interest in the

Greek mysteries and logographs. But visual, pictorial rationalism had reached a point of technical and professional richness where it could afford to embrace all kinds of cultural and intellectual ideas without losing its direction.

I hope that this short and necessarily incomplete essay gives some idea of the difficult road which Renaissance rationalism had to travel, and also of the limited area in which it flourished, among digressions and mistranslations and a cultural and intellectual 'compost' which was ill-placed to understand its true meaning. I could have emphasized that the 'shadow-Renaissance' or Pseudo-Renaissance could also be defined as a grafting of Renaissance features on to a Gothic stem. In a way, this is true; but it is also true that the adjective 'Gothic' says both too much and too little. It is only valid as 'International Gothic', as a name for the cosmopolitan style which held sway in western Europe between the end of the fourteenth and the first decades of the fifteenth centuries (the length of its survival varying from one place or region to another). But it is meaningless to talk of 'Gothic' as a mode of expression in the figurative arts in the period leading up to the Renaissance (also taken in a very vague and general sense).

In reality, 'Gothic', so-called, is a general label applied to a myriad of artistic forms, cultural situations, figurative traditions, and formulae which reflect the fragmented state in which the territory of the Western Roman Empire (and the areas of central and northern Europe which were accultured by their conversion to Christianity) reached the threshold of the modern world. All these formulae are based on an imaginative interpretation of objective reality and its rendering in figurative terms; they follow an unpredictable and often tortuous course. By contrast, the thread of Renaissance artistic rationalism follows a consistent itinerary, even in its descendants. The Florentines, through Piero della Francesca and Raphael, are the original founders of a classicism which (despite temporary eclipses) is still alive today; the Lombards, through the Brescia School and Caravaggio, founded realism; and the Venetians, with Titian, launched the idea of painting as material and colour along a path which leads to Goya, the Impressionists and the dissolution of enclosed form. The events of the Pseudo-Renaissance, although rich and numerous, were meteoric, leaving no issue (except in some cases, though more in an intellectual than a formal sense, as antecedents of Mannerism).

Towards the Modern Manner: From Mantegna to Raphael

GIOVANNI ROMANO[*]

The Myth of Mantegna

APART from the solemn licence granted by Federico da Montefeltro in recognition of the talents of Luciano Laurana (10 June 1468) there is perhaps no public document in favour of a fifteenth-century artist which reaches such heights of magniloquence as the gift from Francesco Gonzaga to Andrea Mantegna, dated 4 February 1492:[1] it opens with a reminder of the Marquess of Mantua's long deliberations as to what would best guarantee him the praise of his future generations and above all the glory *'quae videtur esse quodam immortalitatis genus'* (which seems a sort of immortality), and goes on to dwell upon the most celebrated examples of artists whose virtuosity made their princely patrons famous:

* In the editing and publishing of these pages and their accompanying illustrations I have contracted debts of gratitude, which I wish to acknowledge here, to my friends Sandro Ballarin, Betty Bazzani, Sylvie Béguin, Luciano Bellosi, Andrea Buzzoni, Sandro Conti, Marta Cuoghi Costantini, Angela and Gianvittorio Dillon, Michela di Macco, Massimo Ferretti, Paolo Fossati, Mazzino Fossi, Michel Laclotte, Enrica Melossi, Enzo Mengaldo, Cristina Mundici, Francesco Negri Arnoldi, Sandra Pinto, Erich Schleier, Dandi Silvestri, Marco Tanzi and Bruno Toscano. The number of quotations is itself evidence of how much the publications of Carlo Dionisotti have meant in establishing the direction of research: this too is a great debt, which I willingly acknowledge publicly in the hope that I have not failed to honour it.

Hieronis namque Syracusarum regis phamam illustravit non mediocriter Archimedis summi architecti familiaritas. Inter praeclara Alexandri edicta illud maxime celebratur quo ab alio quam ab Appelle pingi, ab alio quam a Lysippo fingi se vetuit. Magno etiam decori fuit et gloriae Augusto quod Vitruvium Veronensem architectum suum tanta liberalitate persequutus sit (For the friendship of the great architect Archimedes won glory in no mean way for Hiero, the king of Syracuse. Among the most famous edicts of Alexander, the most celebrated is the one in which he forbids anyone but Apelles to paint him and anyone but Lysippus to make an image of him. And it was to the great dignity and glory of Augustus that he rewarded his architect Vitruvius with such generosity).

The *marchese* therefore wonders how he should reward the artist whose genius illuminates the Gonzaga court, '*Andream Mantiniam consumatissime virtutis virum, ex omnibus sine controversia qui picturam profitentur, quadam ingenii diversitate excellentem*' (a man of indisputably the most consummate skill of all who pursue painting, in which he shows excellent variety of genius), and the memory surfaces in his mind of the great works by the painter in the palace at Mantua: the chapel altarpiece, the family banqueting hall, the paintings of the *Triumphs of Caesar* '*prope vivis et spirantibus adhuc figuris . . . adeo ut nec repraesentari, sed fieri res videatur*' (with figures so nearly living and breathing that the thing seems not to be a representation but real); there is also the famous chapel painted by Mantegna for Innocent VIII in Rome: so many things that Francesco Gonzaga now has no hope of being able ever to find a fitting reward equal to the artist's merits.[2]

Then suddenly the document plummets from these heights of rhetoric and gets down to the economic practicalities of his gift of property: '*unam petiam terrae boschivae bubulcharum ducentarum sitam in territorio Scorzaroli in nemore venationis quae vulgariter dicitur*: El bosco de la captia . . .' (a small woodland site of two hundred bubulcae [bubulca = measure of land that a pair of oxen could plough in one day] in the Scorzaroli estate in hunting forest which is commonly known as the wood of the captive).

I do not think that Francesco Gonzaga personally wrote this ceremonious homage to the artistic genius, but the problem of the real author of the text is less interesting than the obvious importance of the document as the final touch in a systematic promotional campaign around the name of Mantegna. The possibility that the unknown author of the letter is the artist himself cannot be ruled out, but it is a fact that his impressive rise to the Parnassus of the

Quattrocento effectively elevated the court of Mantua, which was of ancient lineage but not very healthy economically, to above-average prominence. The model of cultural policy established by Lorenzo the Magnificent in Florence had been directly applied in Mantua, and we can trace it back at least as far as a letter from Luca Fancelli to Federico Gonzaga, Francesco's father, concerning an architectural drawing by Mantegna which could be useful in the family publicity campaign: 'come achade e spesso venire ambassadori e signori che per onorarli si cercha di mostrare loro opere stupendi, io haro adoncha questo disegno mirabile da poter mostrare'[3] (as it often happens that ambassadors and lords come visiting in whose honour we try to display marvellous works of art, I shall now have this remarkable drawing to show them). This was in 1472, when Mantegna was forty and probably already working on the Camera degli Sposi, the definitive statement of his chosen style and of his identification with the historical prestige of the Gonzaga family. The superhuman excellence of the painter later found its way even into legal documents: '*egregio viro Andrea Mantinia pictorum omnium famosissimo . . . viri ingenio et gratia praestantissimi . . . pictorum omnium re et fama facile princeps*' (to the illustrious Andrea Mantegna, the most famous of all painters, unsurpassed in genius and attainment, without rival among artists in fact and reputation alike) (4 November 1484); '*pictorum aetatis nostrae principe*' (the first of painters of our time) (31 August 1486).[4]

The effects were soon felt outside Mantua too, and the earliest evidence of this can be found in chapter 11 of Sannazzaro's *Arcadia*, when Ergasto offers the competitors as a prize 'un bel vaso di acero, ove per mano del padoano Mantegna, artefice sopra tutti gli altri accorto et ingegnosissimo, eran dipinte molte cose' (a fine vessel of maple wood with many things painted on it by the hand of Mantegna of Padua, a craftsman more skilled and ingenious than any other). The full description which follows seems more appropriate to a carved or engraved vase (like the *Gonzaga Vase* in the Galleria Estense at Modena), but of course Sannazzaro could not bring something made with such sophisticated technique into his rustic Arcadia. After Sannazzaro's quotation, which suggests that Mantegna was known and appreciated at the court of Naples,[5] comes his much more plausible inclusion in Giovanni Santi's *Cronaca*, from just before 1494 and therefore around the same time as Francesco Gonzaga's edict. Here the figure of the Gonzaga painter seems to overshadow all contemporary Italian masters: 'Andrea porta l'insegna' (Andrea the standard-bearer), with Leonardo, Botticelli, Perugino, Signorelli,

Ghirlandaio and even Filippino Lippi (in other words the new generation born around 1450) all trailing behind; 'de tucti i membri de tale arte / lo integro e chiaro corpo lui possede / piu che huom de Italia e dele externe parte' (of all the members of this guild, his figures are more whole and clear than those of any man in Italy or outside it).[6] In this hierarchy, which we now find debatable, Santi's old-fashioned tastes are certainly a factor, as is his belief that the basic principles of painting were still line and invention, areas where Mantegna was particularly gifted: 'vedrai che primamente lui si tiene / el gran disegno vero fondamento / dela pictura e in lui secondo viene / de inventione un lucido ornamento' (you will see that his first concern is that great drawing is the real foundation of painting and his second concern with a shining ornament of invention). The supraregional reputation of Mantegna is obviously bound up with the system of princely courts and their more selective collections, since his stay in Rome (1488–9) seems to have been much less significant. The painter himself does not seem to have been very keen on the place and, despite the statutory eulogies, his presence there does not seem to have had much effect.

By a series of fortunate historical coincidences Mantegna came to occupy an emblematic position among the leading figures in the passage from fifteenth to sixteenth century as a prime example of a court artist in the pay of a prince with a continuous run of commissions spanning the Gonzaga dynasty (Mantegna was painter first to Federico, then to Ludovico and lastly to Francesco Gonzaga). There is no equivalent to be found in Florence, for obvious reasons (from 1494 to at least 1512 it had nothing that could be called a court), nor can Rome, with a succession of such strongly contrasting popes as Alexander VI, Julius II and Leo X, provide a field of research where unforeseen variables are kept to a minimum. Venice, like Florence, is a law unto itself in this matter, and during the course of the fifteenth century the other Italian courts (Milan, Bologna, Urbino, Naples, to mention only some of larger ones) either suffered collapse (Bologna) or such radical problems that the continuity of their delicate and richly nuanced cultural evolution was interrupted. Ferrara, which managed to survive both French invasions and the unrestrained ambitions of Cesare Borgia and the pope, failed to emerge as an emblematic centre because until 1505 it was in the hands of an almost mythical and certainly very aged monarch: Ercole d'Este was a contemporary of Mantegna's, and never shook off the fact that he was a late son of Niccolo III (who was actually born in

the fourteenth century) and the last brother, after Lionello and Borso, to ascend a throne that had not been meant for him. In Mantua, on the other hand, Ercole's intelligent and determined daughter, Isabella d'Este, showed a clever sense of timing (at least until the first decade of the sixteenth century) in her orientation of cultural policy, which required her to play the role of promoter of every relevant innovation, reacting instantly whenever she heard about new happenings that had escaped her insatiable curiosity. The miraculous survival of the Gonzaga archive, and particularly of Isabella's correspondence, makes it possible to follow events almost day by day and to trace the development of a new critical consciousness of works of art; it was principally a triumph of the *literati*, but (as we have seen in the case of Giovanni Santi) it also fought its way into the world of the craftsmen and artists and from there overflowed into the less predictable territories of legal bureaucracy.

These external conditions, already highly favourable to Mantegna's progress, were further enhanced by his particularly distinctive humanist tendencies, in other words his strong secular and archaeological interest and his detachment, unusual for the time, from the more traditional religious art. Even today the Mantegna myth rests mainly on his non-religious works, and even the San Zeno altarpiece in Verona, in its adherence to Donatello's example, takes a conventional iconographic programme and adapts it to fit the formal and decorative ideas of an imagination whose first interest is archaeological. This choice of area allowed Mantegna a sphere of action which had long been forbidden territory for artists closely tied to sacred art, or art forcibly shaped by stylistic and devotional habits dictated by the expectations of an audience which was immediately present. The humanist painter, addressing an intellectual elite brought up on a common literary canon, goes beyond the traditional confines of his native land and reaches out towards quite distant cultural avant-gardes, which are less indebted to regional schools and professional guilds and an uncultured audience. It was not his draughtsmanship but his inexhaustible inventiveness (i.e. literary range) which ensured Mantegna's success as that precise moment of 'courtly culture', which literary historians have pinpointed between fifteenth-century humanism and high Renaissance, came to maturity and quickly burned out.[7] This label, now commonly used by literary scholars, can quite easily be transferred to the figurative context, with certain adjustments mainly for the different practical circumstances of figurative art and religious persuasion.

Mantegna and the 'antiquarians'

Looking back at Mantegna's rise to fame we come to the dedication
(1) dated 1463 and 1464 at the beginning of an important collection
of epigraphs by Felice Feliciano of which copies are kept in the
Biblioteca Capitolare in Verona (Cod. 269) and at the Biblioteca
Marciana in Venice (Cod. Lat. X, 196.3766):

> *Merenti. Pictorum principi ac unico lumini et cometae magnique ingenii*
> *viro Andreae Mantegnae Patavo amicorum splendori Felix Felicianus*
> *salutem. Felicis Feliciani Veronesis epigrammaton ex vetustissimis per*
> *ipsum fideliter lapidibus excriptorum ad splendidissimum virum*
> *Andream Mantegnam Patavum pictorem incomparabilem liber incipit*[8]
> (Felice Feliciano of Verona salutes the prince of painters and the sole
> light and star of great genius, Andrea Mantegna of Padua, a light to
> his friends. This is the beginning of Felice Feliciano's book of epigrams
> faithfully written down by him from very old stones for that most
> splendid man Andrea Mantegna of Padua the incomparable painter).

The affectionate pomposity suggests a close relationship between
Feliciano and the painter, as between contemporaries with interests
in common who found time for each other; we also know of a
sonnet from Feliciano to Mantegna 'godfather of the most reverend
cardinal of Mantua beseeching him to put in a good word for him
to the Monsignor in their high parliament'. The sonnet was written
in 1460, before either of the two friends was yet thirty, although
Mantegna could already boast of success with his masterpieces at
Padua and Verona, crowned by his recent admission to the Gonzaga
court. Mantegna's long and glorious career has often led people to
overlook the fact that the Gonzaga court painter matured and con-
solidated his art in the 1450s and that his most famous Mantuan
works, his *Triumphs* for Francesco Gonzaga and his paintings for
Isabella d'Este's *studiolo* are therefore the work of a man whose
figurative and archaeological competence has survived almost mira-
culously in very different times. In Mantua, at the heart of a very
biased and single-minded court which lacked the direct stimulus of
a university centre, it was inevitable that a painter should be out
of step, but even in Rome the situation already seems to have been
burdensome (and Mantegna seems to have suffered directly from
it).[9] We should reflect that the chapel of Innocent VIII in the Vatican
is entirely contemporary with Filippino Lippi's Carafa chapel in the
Roman Church of Santa Maria sopra Minerva, and was painted

only a few years after Ermolao Barbaro's edition of the *Castigationes Plinianae*: in the kaleidoscope of intersecting paths that was Rome, the diversity of stylistic disciplines (or indiscipline) and a strict and forthright philology which was also boundlessly inquiring tended to steer the boldest artists towards intellectual adventures that Mantegna would have been unable, and unwilling, to face.

Mantegna's archaeological background was not based on serious philology but on wide reading of texts that were not always reliable and on unscrupulous epigraphy, for example those collected by Feliciano and by his greatest patron, Giovanni Marcanova. This kind of epigraphic collection made do with copies and derivations, as well as direct surveys; it was evocative rather than stringently critical, and was even open to deliberate forgery, so great was its faith in its own antiquarian range and its own assumption that the present dressed up in ancient costume might be just as good as the real classical past (in Feliciano's collection there is no hierarchy of distinction between ancient epigraphs and modern creations in the same style). Mantegna identified with this daydream and, along with Feliciano and Giovanni Marcanova, played a leading role in a famous classicizing 'roadshow' in late September 1464: the three friends, together with a fourth person, the less well known Samuele da Tradate, set off on 23 September for a trip along the shores of Lake Garda in search of Roman remains, particularly inscriptions. Feliciano's account is often quoted, so we can confine our references to those passages which betray his deliberate distortion of the experience. The trip is organized *'sub imperio faceti viri Samuellis de Tridate. Consulibus viris primariis Andrea Mantegna Patavino et Joannes Antenoreo. Procurante Felice Feliciano'* (under the imperial command of that amusing man Samuele da Tradate. With those important men Andrea Mantegna and Giovanni Marcanova as consuls and Felice Feliciano as procurator). Having cast themselves in Romanized roles (with Samuele da Tradate as 'emperor' crowned with ivy, myrtle and other foliage) the friends explore the shores of the lake marvelling at the reminders of the Antonine emperors which fortune puts in their path; even their boat is disguised *'tapetibus et omnigenere ornamentorum . . . lauris et aliis frondibus nobilibus'* (with hangings and all kinds of ornaments . . . with laurels and other noble foliage) and our archaeologists keep their spirits up by singing *'semper ipso imperatore Samuelle citarizante et jubilante'* (with the Emperor Samuele himself playing the guitar and rejoicing). The trip ends with a prayer of thanks to the Virgin and Christ spoken *'summo tonanti'*, to underline yet again the equalizing of past and present.[10]

Of course this light-hearted testimony to the attitudes held by Mantegna, Feliciano and Marcanova towards the ancient world is taken from a magnificent manuscript at Treviso (Biblioteca Capitolare, Cod. I, 138), almost exclusively devoted to celebrating the figure of Ciriaco d'Ancona as a founding father of fifteenth-century archaeology, an unparalleled example of enthusiastic adherence to the classical past, particularly the Greek world. The manuscript dates from not long after the trip to Lake Garda and owes its existence to a commission from Samuele da Tradate himself as well as to Felice Feliciano's calligraphy, though we should add that when it was made Ciriaco had been dead for nearly ten years, and he had not died young.

The same revitalizing of the antique also produced Marcanova's iridescent Modena manuscript, dated 1465, which restores a very rich corpus of classical inscriptions, inserted after a series of drawings of antique remains that are hardly ruins at all but very much alive and largely untouched by the ravages of time and man.[11] This is how Mantegna, his friends and patrons liked to imagine the ancient world, still close and accessible: 'If fragments of holy antiquity and its broken ruins, why even its dust, inspire speechless admiration and delight in us when we observe them, how much more impressive would they be in their entirety?'[12] Isabella d'Este was to express the same enthusiasm and the same regret at having already passed the middle of life's journey without seeing Rome:

> Your ladyship may say: 'I have seen Rome'; I am afraid that you have seen it destroyed and ruined. But I have seen Genoa, Florence and Milan triumphant, which in our day are no less admirable. I do not wish to deny that I have the deepest desire to see Rome, not for the court and the different nations, for I could not see more of those than I have already seen, but to see the ancient remains and famous ruins of Rome and to contemplate what it must have been like when a victorious emperor held a triumph.[13]

The magnificence and presence of the past captured the imagination of the 'antiquarians' and the dilettanti and created a demand for a whole range not only of epigraphic inscriptions and literary quotations, but whole pattern-books of drawings in which the artist could find images of the most fabulous characters ever to have inhabited the classical world, amply documented by the sculptures discovered in the very fertile territory of Rome, Brescia, Verona, Padua and even in the Near East, which the Venetians had long been in the habit of happily plundering for ancient works of art. Obviously

Plate 105 Draughtsman of GIOVANNI MARCANOVA, *Triumph of a General*, 1465, from Giovanni Marcanova's *Collectio Antiquitatum*, Biblioteca Estense, Modena (cod. lat. L. 5.15 fo. 33r).

Mantegna was not immune to this traditional artistic practice, and in 1476 we find him engaged in seeking out particularly interesting graphic material.

> For many months [writes Angelo Tovaglia from Florence to Ludovico Gonzaga] I have with great diligence and study been trying and have asked others to try and get a book depicting ancient sculptures, mostly

of battles between centaurs, fauns and satyrs, and others with men and women on horseback and on foot, and other such things. And I especially wanted the centaurs because we already have some knowledge of those other subjects; in the course of my investigations many people have said that this book is in the possession of your Lordship, and this made me very happy as I have no doubt that you will oblige me . . . And because I know that these things are very precious and one does not send originals around, if you do have it, I should be grateful if it could be entrusted to Pietro Filippo or someone else to make a copy for me.[14]

Strangely, the volume of drawings was not to be found in Mantua, and Mantegna, when asked, replied rather vaguely that he had lent it to some other painter; at least this is what Ludovico Gonzaga told Tovaglia, perhaps in an attempt to protect a valuable heirloom, which he did not want devalued by excessive copying. Be that as it may, the centaurs eventually arrived in Florence and emerged triumphant in Botticelli's *Calumny of Apelles* for Antonio Segni (Florence, Uffizi). On close inspection the Botticelli *Calumny* itself comes into the category of archaeological evocations, being an attempt to recreate an ancient masterpiece by Apelles, described in detail by Lucian of Samosata.

Unfortunately we are not in a position to reconstruct the graphical background of Mantegna's workshop, but we can easily get some idea of it from a group of drawings in the Ambrosiana dating from before 1466, by an artist who was certainly indebted to Mantegna himself; similarly the so-called *Pattern-book of Mantegna's Drawings*, in Berlin, could simply be a fair copy of a random series of sketches from ancient works which were very faithful to a Mantegnesque model.[15] Their author seems very close in style to Bernardo Parentino, whose path in life seems to have crossed Mantegna's on several occasions and was almost a contemporary. As regards our focus of interest in this essay, an interesting link ties Parentino's contribution at Santa Giustina in Padua to the *Triumph of Caesar*, now in Hampton Court, and this has implications for the mystery surrounding the chronology of this famous Gonzaga masterpiece. The starting point is a fine drawing by Mantegna in the Albertina, which seems to derive directly from a relief from the time of Trajan on the Arch of Constantine in Rome. While keeping the mutilation of the emperor's left hand, the drawing in some parts modifies and elsewhere completes the theme of the ancient relief; in particular it underlines the dramatic and violent nature of the action by straining the caricature of the faces of the principal figures and

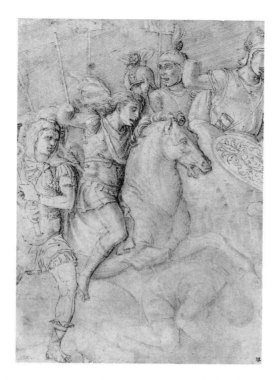

Plate 106 MANTEGNA, Drawing from the Arch of Constantine, 1488–9, Graphische Sammlung, Albertina, Vienna.

by letting their hair stream in the wind. Here again the slight distortion aims to bring back to life the ancient evidence which the sculptor has pent up. Mantegna's drawing, or another parallel version of it, was known to Parentino, who uses it as a basis for a fragment of polychrome relief in the Paduan cloister (in the scene of Benedict's investiture), finished after the fresco was removed to the Pinacoteca in Pavia with the Malaspina collection. However, the Paduan fresco and the Viennese drawing are distinguished by a fundamental difference, all the more significant since it is not based on any archaeological documentation: the standard-bearer on the left is wearing armour in the drawing, whereas in the fresco he is naked, apart from the strange little cape of lion's skin. The model for this detail is no longer the Vienna drawing, but instead the eighth canvas of the *Triumph of Caesar* at Hampton Court where the singularity of the

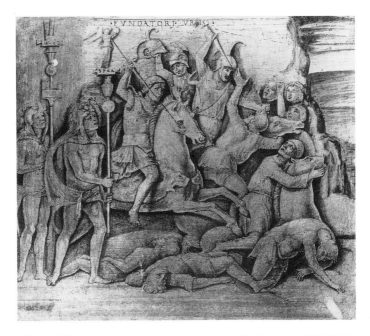

Plate 107 BERNARDINO PARENTINO, *Battle Scene*, 1495–1500, Pinacoteca Malaspina Pavia.

half-naked standard-bearer has recently raised many archaeological doubts. Since Parentino's fresco was certainly painted before 1498, this would give us some clue to the date before which the Mantegna must have been painted. Since the Mantegna drawing in Vienna must have been made in Rome, and therefore can have reached Mantua no earlier than 1488–9, we can dismiss with almost complete confidence the perplexing date of 1482 which the Santa Giustina frescoes have hitherto been lumbered with on the strength of Gerolamo da Potenza's *Elucidario*.[16]

In 1496 Isabella d'Este was most insistent that Parentino should be among those working on her *studiolo*, currently being fitted out under the personal supervision of the *marchesa* and her court painter. Aside from his probable contact with Mantegna in previous years, Isabella must have had precise information about what kind of work Parentino was doing in Padua through her intermediary, Simone da Pavia, then abbot of San Benedetto in Polirone, who until the year before had been abbot of Santa Giustina and probably

commissioned the frescoes.[17] It may have been Simone himself who described to Isabella the contents of those strange paintings at Padua, which presented the most charming ideas imaginable to the eyes and mind of the *marchesa*:

> many of Ovid's metamorphoses, poetic fables, stories from Valerius Maximus, Virgil, Horace and other Latin writers as well as Greeks, such as Homer, Hesiod and others ... towers, half-ruined antiques, amphitheatres, pyramids, obelisks with Egyptian writing, some intact but others eroded by time ... pictures of ancient tombs with urns and inscriptions some of which are complete and others imperfect, on others symbols, hieroglyphs, Egyptian lettering, other fragments of narrative pictures, fables, poetic fictions, wild places, Roman remains ... various triumphs and sacrifices and Roman antiques ... diverse trophies, symbols, hieroglyphs, figures, fables and poetic fictions, clever dicta and mottoes ...

Again this breathless description comes from Gerolamo da Potenza's *Elucidario*, which, considering the text is from 1609, follows very faithfully a style and set of terminologies close to the extraordinary example set by the *Hypnerotomachia Polyphili*, published by Aldus Manutius at the end of 1499. A comparison of the above passage with the anthology of architectural terms gathered together in the foreword to the reader at the beginning of the *Polyphilus* is sufficient evidence of this:

> If you wish to understand in brief what is contained in this work, let me tell you that Polyphilus tells how he saw in a dream amazing and ... ancient things worthy of memory. And all that he tells of having seen, he describes in every detail and in appropriate words ... pyramids, obelisks, great ruined buildings, different orders of columns with their dimensions, capitals, bases, epistyles or straight beams, curved architraves, or friezes, cornices and their decorations ... a magnificent door with its dimensions and decorations ... an excellent bath ... the queen's palace ... three gardens ... a brick peristyle ... a marvellous temple skilfully described ... a ruined temple ...

This seems less strange once Gerolamo da Potenza admits he has read *Polyphilus* (Marino too apparently read it with interest at the same period), but it is important to recognize the irresistible influence still exerted by the great antiquarian emporium Parentino had created for the brothers of Santa Giustina, more than a century after the frescoes were painted, and how Francesco Colonna's book

could quite appropriately be used as a guide to the paintings in the cloister.[18]

There is no need to recapitulate the copious writings demonstrating the relationship between the literary and figurative background of Francesco Colonna the 'antiquarian' and the similar experience of Feliciano and Mantegna, who were his exact contemporaries. It would be more rewarding to establish how much the hieroglyphic language of the *Polyphilus*, its exuberant inventiveness calqued on the objects he defined with 'appropriate words', his metaphorical zeal, which seems to fossilize gesture by its obsessive slow-motion descriptions and to bring the most improbable objects to life with demonic and disturbing vitality, have in common with the metaphorical-descriptive process of criticism, and how perfectly it works as a background to the works of Mantegna, having the same nucleus of invention and a similar reliance on emotion. Mantegna's world abounds with '*pugnacissime petre*' (hostile rocks) and, taking the rigorous interior of the San Zeno altarpiece, no one could deny the 'perfect and ambitious medal-encrusted beauty ... and the sustained symmetry of this building'; the capital atop the column, which links with the Vienna *St Sebastian*, should be listed among those 'rare in devising and in austere chiselling', while the amulet suspended in mid-air in the Louvre *Madonna della Vittoria* is obviously 'an unusual sprig of reddest coral'; finally, and more appropriately still, how else could the advancing crowds in the *Triumph of Caesar* be described than coming 'not at a run, but at a pace of triumphal procession'.[19] We shall not pursue this game of analogies; I think the few examples given here should suffice to confirm that the 'abundant imaginative discourse' of the *Polyphilus* is matched by Mantegna's richness of 'invention' and that both aim at evoking most imaginatively a classical universe bristling with difficult and impenetrable symbols, mysterious, though highly decorative, hieroglyphs, intersected by dangerously seductive digressions, almost a 'deep labyrinth in which entrance and exit are unknown'.[20]

The Triumph of Caesar

Towards the end of August 1486 Ercole d'Este, then a guest at the court of Mantua, broke off a trip on the Mincio to 'go and see the Triumphs of Caesar which Mantegna is painting and which pleased him greatly'.[21] It is believed that these *Triumphs* had only just been begun and the Duke of Ferrara possibly saw the cartoons rather

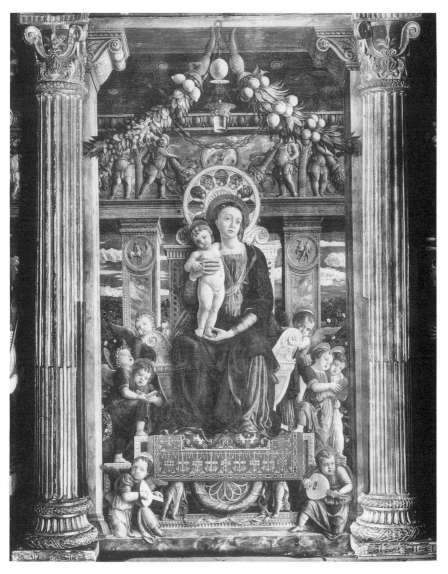

Plate 108 ANDREA MANTEGNA, *Madonna and Child with Angels*,
1459, San Zeno, Verona.
Photo: Archivi Alinari.

than the definitive version on canvas, now in Hampton Court; however, this was another success for Mantegna, possibly the greatest and most lasting of his career, and even reached the stern pages of Vasari without losing any of its lustre. Work proceeded slowly, as was the master's custom, and was suspended for months during his Roman interlude. From Rome Mantegna was concerned for the safe-keeping of the cycle, as a letter of 31 January 1489 shows ('. . . that they should not be spoiled because in truth I am not ashamed of having painted them, and I even hope to do some more'), and Francesco Gonzaga immediately assures him that 'all has been arranged for their safe-keeping'. The *marchese*'s reply, dated 23 February, also exhorts Mantegna to return

> for here too you have work to finish for us, especially the triumphs, which as you say are a worthy thing, and we should be very happy to see them finished . . . for though they are the work of your hands and your genius, we nevertheless glory to have them in the house, and this shall be a reminder of your faithfulness and virtue . . .

The boast of having given the commission sustained Francesco Gonzaga all his life, and no important visitor to Mantua could escape being shown Mantegna's *Triumph*: in 1492 the Venetian ambassador saw the 'painted room, the chapel, and Andrea Mantegna's work on the triumphs and other noble things of his', while in 1494 the great Giovanni de' Medici, the future Pope Leo X, paused before the 'chamber and the triumphs'. The political importance of the cycle was greatest during the Carnival of 1501, when six canvases from the *Triumph of Caesar* were exhibited as part of the sumptuous sets for a theatrical production. Interestingly, the letter from Sigismondo Cantelmo describing the event is addressed to the same Duke of Ferrara who fifteen years previously had visited the early sketches for the cycle; knowing full well how interested the d'Este court would be in the pomp and the particular antiquarian theme of the festivities, Cantelmo goes into some detail, as is necessary to describe

> the most gorgeous . . . sets worthy of comparison with any temporary theatre ancient or modern . . . It was rectangular, somewhat elongated in shape, the two opposite sides each having eight architraves with well-matched columns in proportion to the width and depth of the said arches, the bases and capitals most splendidly painted with the finest colours, and the decorative foliage evoked an eternal and delightful ancient building . . . Inside the prospect was of golden hangings

and some greenery as the text required, one of the sheets was decorated with the six paintings of Caesar's triumph by the hand of the extraordinary Mantegna... At the corner where one of the long sides met a short side were four very high columns with spherical bases supporting the four mainstays, and between them was a cave which appeared very natural though it was artificial; above it was a great sky glowing with various lights like the brightest stars with an artificial zodiac of signs, to the movement of which now the sun and now the moon revolved each in their houses; inside was a wheel of fortune with its tenses: I reign, I have reigned, I shall reign; in the middle stood the golden goddess holding a sceptre with a dolphin; around the stage on the low frontispiece were the triumphs of Petrarch again painted by the hand of Mantegna...

Few documents could better illustrate the almost imperceptible interweaving of medieval tradition, reconstructive archaeology and pompous ostentation so characteristic of the northern courts towards the end of the fifteenth century; only the description of the Paradiso festival at the Sforza court is as revealing, but being from 1490 it lacks the unmistakable Polifilesque colour which floods the vocabulary and syntax of Cantelmo's letter describing the festival itself: it is appropriate to remember that the *Polyphilus* had been published just over a year earlier.[22] The presence of the Petrarchan triumphs in contrast to the *Triumph of Caesar* points up the still ambivalent sensitivities of the taste of the Mantuan court, vacillating between archaeological reconstruction masquerading as antiquity and moral pantomime under the veil of a popular Petrarchan text;[23] but in the July of that same year, Bembo and Manutius were to publish the *Rime* in a philologically revised edition, marking the advent of a new image of Petrarch and also of a new type of reader, who while not completely irreconcilable with the *Triumph* was certainly irreconcilable with the *Hypnerotomachia*.

The fact that only six canvases were displayed at the 1501 Carnival may indicate that by that date only six had been finally delivered, but theoretically it is equally plausible that the six were chosen from the Hampton Court series, which now numbers a good nine pieces, to which may be added a drawing from Vienna – not original but certainly a very faithful reproduction – for a tenth canvas with the procession of senators (which was apparently never in fact painted). However, even from 1486 to 1501, this means the paintings represent precisely fifteen years' work, though looking at them one would not think so. Beyond their limited internal discrepancies, which Martindale has recently examined, the cycle seems to be very consistent, and in

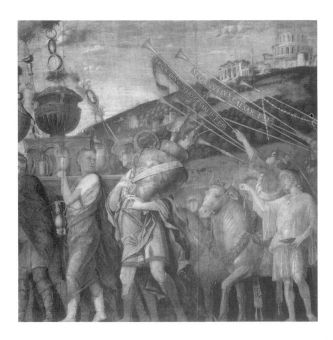

Plate 109 ANDREA MANTEGNA, *The Vase-Bearers*, 1495–1505, from
The Triumph of Caesar series, canvas IV, Hampton Court Lower
Orangery, reproduced by gracious permission of
Her Majesty the Queen.

terms of chronology points towards a date close to the *Madonna della
Vittoria* in the Louvre and the Santa Maria in Organo altarpiece in
Verona, now in the Castello Sforzesco in Milan.[24] However, apart
from the above-mentioned case of Parentino, it seems that the
cycle was not known outside Mantua prior to the 1501 festival,
which was almost a kind of solemn official preview. As early as
1502 Pomponio Gaurico records Giulio Campagnola's copies from
Mantegna's *Triumph* and, the following year, the engraver Jacob of
Strasbourg published a series of engravings of the *Triumph of
Caesar* based at least in part on motifs from Mantegna's *Triumph*.
In 1504 Benedetto Bordon sought a licence to publish a *Triumph of
Caesar*, while during the first decade of the century copies were
made of Mantegna's *Triumph* for the Château de Gaillon.[25] Finally,
in 1508, Titian published his *Triumph of Faith*, which grafts on to
the slow steady rhythm of the Mantuan model a more dramatic

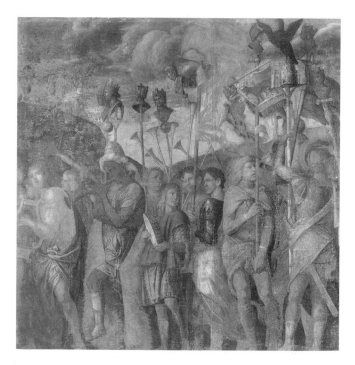

Plate 110 ANDREA MANTEGNA, *The Standard-Bearers*, from *The Triumph of Caesar* series, canvas VIII, Hampton Court Lower Orangery, reproduced by gracious permission of Her Majesty the Queen.

pace, a less consistently developed syntax, and a new emotive fire. As the years went by, interest in the *Triumph of Caesar* seems to have receded to within the city of Mantua, with the rather sentimental verses by Benivole da Pietola and the mandatory mention in Equicola, from when the cycle was completed by an addition which changed the meaning of the whole: the great canvas by Costa in the National Gallery in Prague does not in fact illustrate an episode from the triumph of Caesar but a recent ceremonial occasion at the court of the second Federico Gonzaga.

Only the praise of Vasari secures fame outside the region for the *Triumph* as a sampler of reliable archaeological data:

in this painting we can see grouped and cleverly arranged in the Triumph the ornate and beautiful chariot, the figure of a man cursing

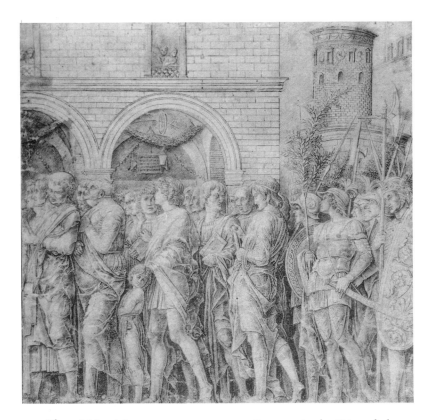

Plate 111 After ANDREA MANTEGNA, *Senators in the Triumphal Procession*, 1500–5, copy of a preliminary drawing for *The Triumph of Caesar* series, Graphische Sammlung, Albertina, Vienna.

the victorious leader, the victor's relations, the perfumes, incense and sacrifices, the priests, the bulls crowned for sacrifice, the prisoners, the booty captured by the troops, the ranks of the squadrons, the elephants, the spoils, the victories, and the cities and fortresses represented in various chariots, along with a mass of trophies on spears, and with helmets and armour, headgear of all kinds, ornaments and countless pieces of plate.[26]

Of all the possible readings of Mantegna's text, Vasari chooses the one most strictly dictated by the author's passion for the antique and by the verifiable sources for the complex background to the work: Appian, Plutarch, Flavius Josephus and, closer in time,

Valturius's *De re militari*, Flavius Blondus's *Roma triumphans*, as well as his friend Giovanni Marcanova's '*librum nostrum quem de dignitatibus Romanorum, triumpho et rebus bellicis composuimus*' (our book which we have written about the ranks accorded to the Romans, triumphs and matters of war).[27]

Vasari was however less inclined to acknowledge the other side of Mantegna's *Triumph*, its *tableau vivant* sense of spectacle, comparable to the great entrance parades customary for the more prestigious representatives of noble families: at her wedding Isabella d'Este rode triumphantly into Mantua on a chariot decorated by Ercole de' Roberti.[28] The close family network linking Ferrara, Mantua and Bologna must eventually lead us to consider the historical possibility that Mantegna, in his mature phase, is consciously vying with the fiery poetry of that leading figure of the Ferrara school, and not necessarily only in matters of ceremonial decoration. We cannot expect to find much evidence to prove this contact, with Mantegna now more than confident in his style, but the *Triumph of Caesar*, so solemnly 'sempiternal' and 'glorious', as the *Polyphilus* would have it, is certainly shot through with a subtle psychological flaw, a shadow of agonizing melancholy, and at the same time it betrays a few sudden breaks of rhythm which make one suspect that Mantegna's certainty and his faith in a firm and stable world were not unshakeable: the most explicit example of this is the sudden collapse of the arms-bearer on the right of the canvas showing the trophies of captured arms. In this case I would not rule out the possibility of de' Roberti's influence, from the negative triumph in the predella for San Giovanni in Monte in Bologna.

The shamelessly naturalistic foreground details, the ancient and modern decorative richness, a few clumsy gestures and unexpected psychological reactions make the *Triumph of Caesar* more topical, suggesting a derivation from some other figurative source, this time no longer a contemporary one. The obvious candidate is the *Judaean War* painted on the walls of the Sala Grande of the Scaligeri Palace in Verona, where Altichiero 'showed ... his genius and judgement and inventiveness, having considered everything which should be considered important in a war ...', while Jacopo Avanzi 'painted ... two beautiful triumphs with such great artifice and in such a "good manner" that Gerolamo Campagnola states that Mantegna praised them as most exceptional paintings'.[29] The testimony of Vasari–Campagnola becomes plausible in the light of the cycle's reputation in the fifteenth century as recorded in Francesco Corna's *Fioretto de le antiche cronache di Verona*; here the Sala Grande is described as

being 'all painted with great figures / from the histories of Titus and Vespasian / and so rich with paintings and gilding, / with such lifelike figures / that there is nothing like it in all Italy'. The precious fragments of those decorations which have been preserved still do not really help us to imagine Mantegna's excitement, but we can also consult a fifteenth-century drawing from the *Triumph of Titus and Vespasian* which is strongly Mantegnesque in its way. The arrangement of the main buildings corresponds to the Vienna drawing with the senators, and even has the same curious spectators in the windows, while the 'temple of Jove' seems to have inspired the Colosseum in the background of Mantegna's canvas with the vase-bearers and trumpeters (no. IV). The shaggy dog and the naughty children turn up again in the prisoners' canvas (no. VIII), but how much more would Mantegna have been moved by the ingenuity of actually doing something that was still an unspoken ambition for him; a number of figures in the Jerusalem triumph are in modern dress (modern for Altichiero and Avanzi, of course), and this makes our distance from that magnificent spectacle contract quite ver-tiginously, and even disappear altogether.

By the end of the century such a disarming concession was un-thinkable, but it opened the mind of a painter drawn to antiquity as something more than just a theme of philological research to several possible compromises, which can be glimpsed most clearly in the episode from the life of Cornelius Scipio now in the National Gallery in London.[30] Interpretation of this late monochrome by Mantegna, often wrongly judged to be of poor quality and not an original, is facilitated by the large amount of information we have about it. The painting was commissioned from Mantegna by Francesco Corner through Cardinal Marco Corner, his brother. The letter of 15 March 1505 in which the cardinal asks Francesco Gonzaga if he can use his court painter is signed 'Marcus Cardinalis Cornelius', which be-trays how a simple transposition of the Venetian surname was the inspiration for the classical masquerade on which the iconographic choice of Cornelius Scipio is based. The iconographic theme is speci-fically derived from Appian, an author already favoured by Mantegna for other reasons, but a frieze dedicated to Scipio Africanus could never have been planned without reference to other historical sources (Livy and Polybius) and to the interest shown in this highly virtuous nobleman in Petrarch's Latin works (*Africa* and *De viris illustribus*). However, it is worth noting that the real star of the painting is the Vestal Virgin Claudia Quinta, who demonstrated her innocence against her malicious detractors by refloating with her bare hands

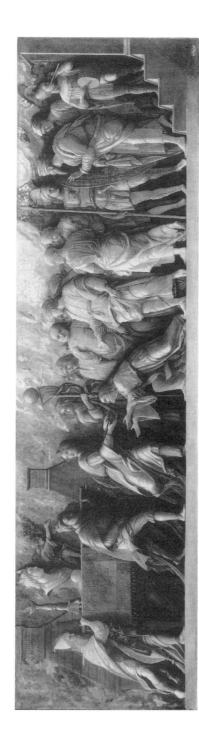

Plate 112 ANDREA MANTEGNA, *Introduction of the Cult of Cybele at Rome (The Triumph of Scipio)*, reproduced by courtesy of the Trustees of the National Gallery, London.

the ship bearing the effigy of the goddess Cybele, which had run aground in the Tiber (the iconographic theme is better known from Garofalo's enchanting version now in the Pinacoteca Nazionale in Rome, and the ancient version in the Canonici collection in Ferrara). As a feminine *exemplum virtutis* the episode is given plenty of room in Ovid's *Fasti*, and from there it passes into Petrarch's *Triumphs* and Boccaccio's *De claris mulieribus*: a pedigree that is both classical and romantic – Mantegna and his patrons could not have wished for anything better.

Mantegna's clever direction of the characters on his stage serves further to underline the link between the past history of the Cornelii and the present reality of the Corners: it seems logical to identify the young man in the centre with the turban as Scipio Africanus in conversation with his fellow consul Licinius Crassus, while the figure opposite the kneeling girl should be identified as Scipio Nasica, the cousin of Scipio Africanus, sent by the Senate to receive the goddess. The two tombs in the form of truncated pyramids in the left half of the frieze bear inscriptions identifying them as the tombs of Gnaeus Cornelius Scipio, father of Nasica, and Publius Cornelius Scipio the Elder, father of Scipio Africanus. The topical touch is reserved for the two figures directly behind the African, whose facial features are sharply defined: it is plausible to suggest that these represent important members of the Corner family, not necessarily the two brothers Marco and Francesco, who were not yet thirty at the time; the simple logic of analogy would lead one to expect them to be members of the previous generation, corresponding to the names evoked by the tomb inscriptions: first Zorzi Corner, father of Marco and Francesco, head of the family and brother of Caterina Corner, queen of Cyprus, to whom the whole of the Corner Camerino seems to be referring through its examples of feminine virtue.

The name of Caterina Corner acts as a catalyst for checking the relative chronology of the painting, which, in absolute terms, was finished in August 1506, before Mantegna's death, and delivered to its rightful owner in January 1507. I think one should remember firstly that 1506 is precisely the year marked on the back of the Vienna *Laura* at the head of a famous piece of writing, which goes on: 'on the first of June this was done by the hand of Master Zorzi of Chastel fr . . . the colleague of Master Vincenzo Chaena at the request of signor Giacomo.' A few months later, on the altar to the 'German nation' in the left-hand aisle of the Church of San Bartolomeo in Venice, the *Madonna of the Rosary* was installed, finished by Albrecht Dürer in the space of five months ('*quinquemestri*

spatio'), precisely the same period of time which Mantegna had just spent carefully putting the finishing touches to the Corner frieze. We know this for certain from an exchange of letters between Pietro Bembo and Isabella d'Este in January 1506 which mention both Mantegna's painting for the Corners and a painting by Giovanni Bellini for the *marchesa* of Mantua. Bellini for his own part throws light on Mantegna's position in relation to modernizing phenomena in the figurative tradition of the early Cinquecento. In 1505 Bellini had delivered the San Zaccaria altarpiece in Venice, and between 1506 and 1507 Dürer had judged him the best painter in Venice, and Marin Sanudo had called him 'the most excellent painter in Italy'. He landed the task of picking up the Corner Camerino project on the death of his brother-in-law Mantegna, with the *Continence of Scipio*, now in the National Gallery in Washington, and what emerged was a clear tribute to Mantegna himself (and particularly to his *Triumph of Caesar*), but with a new softness of line which Mantegna had not discovered and adopted in time. A literary manual of this new-found sensitivity, which was not confined to painting, had been published meanwhile: Bembo's *Asolani* (March 1505) set in the court of Caterina Corner. The picture we get from its pages does not fit what we know of the Gonzaga court; it shows quite different interests, different topics of conversation, indirectly different figurative tastes.[31] Its protagonists are young Venetians, who will not tolerate any classicizing travesties, even ones as easily deciphered as the *Arcadia*; they talk only of their own burning emotional experiences. If he had ever been able to peruse the *Asolani*, Mantegna would have found this private candour shockingly inconsistent with his impassive archaeological dream.

The *Studiolo* of Isabella d'Este: Mantegna, Bellini, Perugino

The great wealth of new information relating to Isabella's *studiolo* gathered by Egon Verheyen, Silvie Béguin, Phyllis Williams Lehmann and Clifford M. Brown allows us to tackle without too much hesitation this project, which was such a symbol of courtly culture in the later Quattrocento and the early years of the next century.[32] There is still no systematic catalogue of the lengthy correspondence on the matter, but a glance through the material brought to light by the pioneering efforts of Alessandro Luzio and Rodolfo Renier shows clearly how constantly determined Isabella d'Este was to be culturally

up to the minute and to find the right iconographic themes and painters for the avant-garde sanctioned by the literary elite of the day. As a participant and an acknowledged leading light in this avant-garde, her involvement was total, as was her adherence to courtly styles and values, to the point where she failed to notice their widespread blossoming quickly beginning to fade; she eventually found herself marginalized by the new wave of intellectual fashions (and by the new ideological unification) and saw her star set amid the venomous polemics and slanderous horoscopes of Aretino.

There is mention of a *studiolo* in the castle for the young bride of Francesco Gonzaga as early as November 1491, just over a year and a half after their marriage, but the original decoration by Luca Liombeni seems merely to have depicted the exploits of the Gonzaga family.[33] A few months later, on 4 March 1492, Giacomo Calandra assures Isabella that Mantegna will contribute to the decoration of the *studiolo* and finally, in July 1497, the first painting is fixed in place (most probably the so-called *Parnassus*). By this date Isabella already seems to have made contact with other painters for completion of the project, namely with Giovanni Bellini (letter from Alberto da Bologna of 26 November 1496) and Perugino (letter to Lorenzo da Pavia of 3 April 1497). These cannot be random choices, even though Isabella was only just twenty years old; the archives provide daily evidence of her quick intelligence and her breadth of information, allowing no margin for improvisation; we need some historical research to reconstruct by deduction the motives for her orientation and her clever commissioning strategy.

The Gonzagas were in touch with the Bellini family from at least 1493 and, although it was not made much of at the time, Gentile, Giovanni and Niccolo Bellini were of course Mantegna's brothers-in-law.[34] It was natural that Isabella should be well informed about Giovanni Bellini's public works in Venice through her contact with the Corner family and her correspondents in Venice, and she would have recognized his official success in being asked to take up the work in the Sala del Maggior Consiglio and the Scuola Grande di San Marco (1492). Later on she would certainly have heard about his private works as well, these being much more in line with her taste for collecting. In a letter to her friend Cecilia Gallerani in Milan dated 26 April 1498, Isabella reveals that she had been looking at 'some fine portraits by the hand of Giovanni Bellini' which she would like to compare with an example of Leonardo da Vinci's portraiture: it is hard to say whether this was to confirm for herself her established preference, or because she suspected that a new star

of portraiture had risen over the horizon, and wished to obtain early information on him; speaking plainly, Gallerani replied that, as to Leonardo's greatness, 'there is none like him.'[35] But Isabella was not satisfied with such acclaimed figurative qualities unless sanctioned by a literary eulogy, and in Bellini's case the problem was a difficult one. It was not possible to use Pietro Bembo's sonnet 'O imagine mia celeste e pura', because it was from the early years of the sixteenth century, but news may have reached the *marchesa*'s ears of the poetic compositions in praise of the painter which Niccolo Liburnio later published with his collected works, in 1502, under the charming title of *Opere gentili et amorose*.[36] This suspicion is based on the fact that Liburnio dedicated his second literary collection (the 1513 *Selvette*, recorded as being in the *marchesa*'s inventory of books) to Isabella herself.

There is no need to linger over Mantegna, having mentioned Francesco Gonzaga's gift of a house and Giovanni Santi's *Cronaca* in the opening pages of this chapter, but it is important to reflect on the choice of Perugino. The gazetteer of the Urbino *Cronaca* can help us here, since Isabella probably used it as a guide.[37] Of the two contemporaries, Leonardo and Perugino, only the latter is a 'divine painter', an opinion generally shared at least until the cartoons for Leonardo's *Sant'Anna* and the *Battle of Anghiari*. Other Florentines of the moment (Ghirlandaio, Filippino Lippi and Botticelli) slip through without special mention, apart from the early work of the younger Lippi, and only with Luca Signorelli do we again get qualifying attributes ('Luca Signorelli of rare talent'), and this is not just because of the demands of the rather babbling versification. The prestigious commission given to Signorelli for a fresco in the Sistine Chapel was perhaps still strong in Santi's memory, but it must have had less effect on the impatient mind of Isabella d'Este. We can see that current opinion favoured Perugino over Signorelli from the point when the latter was summoned to his most demanding project: his frescoes in the Duomo at Orvieto (San Brizio Chapel) which, as we know, were first offered to Perugino, who declared himself unavailable. Even Venice, not the most welcoming place for painters from other regions, gave the young Umbrian master excellent references. The documents gathered by Canuti and reassessed by Ballarin confirm that he was in the city in the summer of 1494 and the autumn of 1495, for a project of great importance, in the same Sala del Maggior Consiglio in the Ducal Palace, already mentioned with regard to Bellini.[38] I do not think there could be a more enviable sign of prestige for a Quattrocento painter who had grown up in a time

when Italy still revolved largely around the small courts, the trading cities, the great religious centres and the universities. It also serves to show clearly how figurative culture, beyond corporate constraints, adapts to the latest innovations, fashions, formal motifs and intellectual customs imposed by the court *literati*, who constantly fluttered around the centres of the circuit, and perhaps also around the most promising publishing centres. The dominance of Perugino should be read in this light from its northern reaches (Pavia, Cremona, Bologna, and of course Venice) to its southern frontiers (the altarpiece commissioned by Oliviero Carafa for the Duomo at Naples, half-way through the first decade of the sixteenth century) and we are fortunate in being able to follow its development almost 'live', as it were, through contemporary sources.

Possibly the most intriguing document is the series of couplets written by the notary Pier Domenico Stati on the contract for the high altar of the Church of Santa Maria Nova in Fano (21 April 1488), a paean of praise, recalling certain medieval inscriptions dedicated to great architects or sculptors: '*Pictor in Italia tota qui primus haberis / Petreque qui primus pictor in orbe manes /...Optimus et primus pictor iam Petrus in orbe...*' (Pietro, that are thought the best painter in all Italy / and are still the best painter in the world /... Pietro, best and foremost painter in the world).[39] Less strange, in that it is less absolute, but certainly the more significant for being relative, is the well-known passage informing Ludovico Moro as to the best painters to contact in Florence for certain works to be carried out at the Certosa in Pavia:

> Sandro Botticelli, an excellent painter both on panel and wall: his things have a virile air and are done with the best method and complete proportion. Filippino Lippi, son of the very good painter Fra Filippo Lippi: a pupil of the above-mentioned Botticelli and son of the outstanding master of his time. His things have a sweeter air than Botticelli's; I do not think they have as much skill. Perugino, an exceptional master, and particularly on walls. His things have an angelic air and very sweet. Domenico Ghirlandaio, a good master on panel and even more so on walls. His things have a good air and he is an expeditious man and one who gets through much work. All these masters have made proof of themselves in the chapel of Pope Sixtus V, except Filippino. All of them later also in the Spedaletto of Lorenzo il Magnifico, and the palm of victory is pretty much in doubt.[40]

The only real rival to Perugino was Filippino Lippi, and they were in fact both employed for the Certosa in Pavia. Outside Florence,

however, the comparisons were all in favour of Perugino, despite Filippino's bridgeheads at Genoa and Bologna; this we learn from Maturanzio's praise for the San Pietro altarpiece in Perugia (1495–9) and from a letter from Agostino Chigi to his father about an altarpiece for Sant'Agostino in Siena (7 November 1500).[41] Isabella could therefore feel quite justified in insisting that Bellini and Perugino, however reluctant they might be, contribute a painting to the *studiolo*: along with Mantegna, they were universally acknowledged to be the top painters in the figurative arts of the fifteenth century. The *studiolo* seems to be the first case of figurative debate at a national level since Giotto's supraregional success, in a country that was still quite happy to be politically fragmented. People were less complacent about the linguistic differences, and there was hot debate already raging among scholars about possible arrangements for unification, at least on the level of language used in the courts, and this debate was also opening the way for artists.

From our point of view Leonardo's lack of popularity is surprising. He was a victim of the cultural marginality of the Milanese court, particularly after the death of Beatrice d'Este, as well as of his own commitment to technical and scientific projects rather than to literature, and of the scarcity of works circulating under his name.[42] Even the *Last Supper* at Santa Maria delle Grazie in Milan was hardly seen by his contemporaries as the first masterpiece of the modern manner, a clear forerunner of Michelangelo and Raphael, and his few portraits tended for the most part to be jealously guarded. This helps to explain how Camillo Lunardi's *Speculum lapidum*, which came out in Venice in 1502 with a dedication to Cesare Borgia, could fail to number Leonardo among the great painters of the day, even though he was about to contact Borgia and put himself at his service (albeit as a military architect). Preference is shown instead for the painters chosen by Isabella, with a certain leaning still towards Mantegna:

> Who could be greater with the brush than Giovanni Bellini of Venice and Pietro Perugino, who paint pictures of men and animals and all things so well that they seem to lack only breath? Zeuxis was the most famous among the ancients . . . And Protogenes and Apelles . . . Our land of Italy has a very famous man of no less repute, who has been awarded the gilded order of a soldier for his excellence, Andrea Patavino known as Mantegna who opened all the rules and reasons of painting to posterity, and not only surpassed all with the brush, but also with the pen and charcoal in the wink of an eye draws true images of the ages of men and different animals, and pictures of the

habits, ways and gestures of different nations, so that they almost seem to move. I think this man is not only better than any modern painter but even surpasses any ancient one.[43]

That same year, 1502, Isabella d'Este re-established contact with Perugino through Francesco Malatesta and gave up hope of the painting by Bellini which she had been counting on for so long; it seems that the two facts were linked, since both letters, to Francesco Malatesta and to Michele Vianello concerning Bellini, are dated 15 September. Only a few days earlier the second of Mantegna's paintings had been placed in the *studiolo* (probably *Minerva Expelling the Vices*), judging by the fact that the necessary glaze had arrived from Venice only on 31 July. Mantegna was still to work on a third painting (or at least on the model) of the kingdom of Comus, but Isabella was not sure how much longer she could rely on this painstaking and diligent old man of seventy, even though he had just produced one of his greatest masterpieces with his *Minerva*. The finely animated head of the centaur, surrounded by downy seaweed, or the group of cherubs in flight, with their unconsciously Raphaelesque sense of proportion, the crumbling mountains, anthropomorphic clouds and the unhealthy swamp vegetation would alone be sufficient proof that Mantegna is still poetically capable of bearing comparison with the best. We have already seen the excellence of the finished Corner frieze, and the hand which crushed the fringed sash around the waist of the Ca' d'Oro *St Sebastian* with such fierce diligence seems no less refined and sensitive.[44] The painting has never enjoyed much critical success, but it should be borne in mind that the face was not finished by Mantegna himself. The complex austerity of the drapery, with its sharp folds frozen in place, seems to be Mantegna's figurative riposte to Perugino's emotional maceration, a lucid response conceived wholly within the question of style, which few people were prepared at the time to accept or appreciate; the rift between them was becoming so deep as to threaten the moral and allegorical content of the *studiolo*.

The Studiolo of Isabella d'Este: problems of iconography

(A) My poetic invention, which I wish to see you paint, is the Battle of Love (Lascivia) and Chastity, that is to say, Pallas and Diana fighting against Venus and Love. Pallas must appear to have

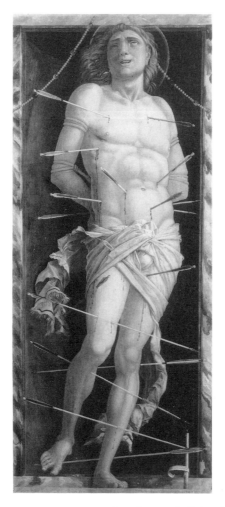

Plate 113 ANDREA MANTEGNA and assistant, *St Sebastian*, 1506, Ca'
d'Oro, Venice (from the collection of Pietro Bembo).
Photo: Soprintendenza per i Beni Artistici e Storici di Venezia.

almost vanquished Love. After breaking his golden arrow and
silver bow, and flinging them under her feet, she holds the blind-
folded boy with one hand by the veil which he wears over his
eyes, and lifts her lance to strike him with the other. The issue
of the conflict between Diana and Venus must appear more
doubtful. Venus's crown, garland and veil will only have been

slightly damaged, while Diana's raiment will have been singed by the torch of Venus, but neither of the goddesses will have received any wounds. Behind these four divinities, the chaste nymphs in the train of Pallas and Diana will be seen engaged in a fierce conflict, in such ways as you can best imagine, with the lascivious troop of fauns, satyrs and thousands of little Loves. These last will be smaller than the god Cupid, and will carry neither gold bows nor silver arrows, but darts of some baser material, either wood or iron as you please.

(B) In order to give full expression to the fable and adorn the scene, the olive tree sacred to Pallas will rise out of the ground at her side, with a shield bearing the head of Medusa, and the owl, which is her emblem, will be seen in the branches of the tree. At the side of Venus, her favourite myrtle tree will flower.

(C) To heighten the beauty of the picture, a landscape should be introduced with a river or sea in the distance. Fauns, satyrs and cupids will be seen hastening to the help of Cupid – some flying through the air, others swimming on the waves or borne out on the wings of white swans, but all alike eager to take part in the Battle of Love. On the bank of the river or on the shore of the sea, Jupiter will be seen in his character as enemy of chastity, changed into a bull that carries off the fair Europa. Among the gods attending on him, Mercury will appear flying like an eagle circling over Glaucera, the nymph of Pallas, who will bear a small cistus engraved with the attributes of the goddess. Polyphemus, the one-eyed Cyclops, will be seen chasing Galatea, Phoebus in pursuit of Daphne, who is already changing into a laurel. Pluto carrying off Persephone to the infernal realm, and Neptune about to seize Coronis at the moment she is metamorphosed into a raven.

(D) If you think these are too many figures, you can reduce the number, as long as the chief ones remain – I mean Pallas, Diana, Venus and Love – but you are forbidden to introduce anything of your own invention.

These were Isabella d'Este's instructions attached to her contract with Perugino of 19 January 1503 for the painting which was finally delivered only in 1505; the instructions were also accompanied by a drawing showing all the details which, unfortunately, has not yet been traced.[45] For greater clarity the text is reproduced here, with some retouching of the paragraphs, to distinguish what belongs to the 'poetic invention' in its 'main basis' (A and C) from what should be understood as merely subsidiary, 'for greater expression and ornament' (B), and from what comes under the optional heading of

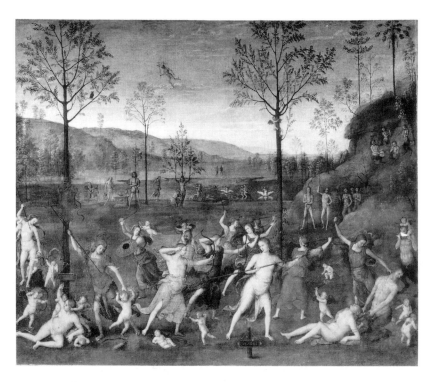

Plate 114 PIETRO PERUGINO, *Battle of Chastity against Lasciviousness*, 1505, from the *studiolo* of Isabella d'Este, Musée du Louvre. © Cliché Musées Nationaux, Paris.
Photo: Réunion des Musées Nationaux.

'charm' (C and D). We should use this lesson in humanistic iconography as a base for our attempt to understand the other paintings in the *studiolo*, by measuring how closely they adhere to its simple scheme. Obviously the *Battle of Chastity against Lasciviousness* (which Perugino casually calqued on Pollaiuolo's *Battle of Naked Figures*) comes out very well, as does Costa's so-called *Kingdom of Poetry* (or *of Music*), commissioned in late 1504 and delivered two years later; for both paintings the iconographic inspiration came from Paride da Ceresara. Mantegna's two paintings do not fit in so well with the schema, with their inextricable interlacing of 'invention' with 'expression' (in the sense of attributes to help in identifying the subject) and 'charm', and with their lack of a background to populate at will. Costa's second painting, dedicated to the god Comus

and almost certainly dated around 1511 belongs to an intermediate stage. Let us just say for now that Mantegna himself had already explored the subject of Comus, in preparing a third painting for the *studiolo*, which was never finally executed, and the drawing very probably provided Costa's inspiration for the foreground of the painting, while the crowded landscape on the left and Arion coming in from the sea, riding the waves with his companions, are all his own.[46]

We have no information as to who suggested the iconographic themes for Mantegna's contributions to the *studiolo* (including his *Comus*) and it is very likely that Mantegna took a 'poetic invention' of Isabella's for the general gist of the decoration, and made it his own. This seems to me the only way to read his letter of 13 May 1506 to Isabella: 'I have almost finished drawing Your Excellency's story of Comus which I shall pursue when my imagination moves me.' The theory is supported by Bellini's doubts, whether real or feigned, about having his painting up next to his brother-in-law's. Bellini may have been acting in bad faith, but Lorenzo da Pavia, well versed in the art world, and not just in Venice (he was also a friend of Perugino's and Leonardo's), was not. His letters are unequivocal about Mantegna's greatness of invention: 'it is true that in invention no one can come close to the excellent Master Andrea . . .' (6 July 1504); 'in invention no one can equal Master Andrea Mantegna who truly is the best and foremost, but Giovanni Bellini is excellent with colour . . .' (16 July 1504); 'I for my part can never hope to see a better draughtsman and inventor . . .' on receiving the news of Mantegna's death; in reply Isabella came out with a fairly unemotional, even perhaps a rather denigrating comment, now that she knew Mantegna's figurative and cultural legacy belonged to an era that was past: 'I am sure that the death of Master Andrea Mantegna must have upset you since you have lost someone you thought highly of' (both letters are dated 16 October 1506).[47]

The question of 'invention' should be investigated in the light of contemporary sources, for example Pomponio Gaurico's *De sculptura*. Among the many clichés the petulant twenty-year-old gathered from circles in Padua, we read that literary competence is absolutely essential for an artist, and that the sculptor must also be

> an antiquarian who knows for example why the Romans worshipped Mars in two forms, Gravidus and Quirinus, one of which was outside in the Campo, and the other inside the city in the forum, and why the Spartans showed Venus armed, the Arcadians showed her black,

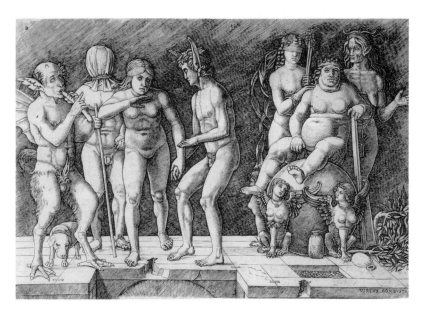

Plate 115 Assistant of MANTEGNA, *Allegory of Virtue*, 1495–1500, Bibliothèque Nationale, Estampes, Paris (Ea 32 res., C. 10763).

the Cypriots bearded with a man's sceptre and with a woman's ornaments, etc. etc.[48]

This was exactly the sort of expertise which Mantegna had gained among his 'antiquarian' friends, possibly reading *Polyphilus* by the 'antiquarian' Francesco Colonna, collecting epigraphs and drawing books, gathering ancient objects, which he would bring to life in his work as a painter who was every bit as much of an 'antiquarian' as his fellow travellers on Lake Garda: it is easy to see the features of his 'dear Faustina of ancient marble' (letter to Isabella of 13 January 1506) in the head of the Venus driven out of the garden of the Virtues.[49]

Anyone who remains unconvinced can find proof in a famous double engraving from Mantegna's workshop, prepared from a splendid drawing in the British Museum: the *Virtus combusta* or *Allegory of Virtue* (Hind, V, 22), the parentage of which has been reconstructed by careful research: starting with some lines of Pacuvius for the figure of Ignorance, blind and deformed and seated on a globe, it goes on to the *Tabula Cebetis*, a dialogue of Greek origin,

which was a great Renaissance favourite, for the remaining figures (cross-checked with a well-known painting by Leombruno, in the Pinacoteca in Brera, which interweaves the *Tabula* with the *Calumny of Apelles*).[50] However no link has yet been established between this engraving and a manuscript in the Biblioteca Nazionale in Rome containing the *Cebetis Tabulae interpretatio desultoria* by Giovanni Battista Pio with a dedication to Isabella d'Este, probably a Mantuan work dating from before Pio's move to the court of Ludovico Moro (1497), followed by his later move to the Bentivoglio in Bologna (1500). Pio's editorial career in Milan is well known (first Varro, Nonius, Festus, Apicius, Fulgentius, Sidonius, then Plautus), and is so distinctive by its obscure selections from marginal or archaic areas of classical literature that we can understand what Ercole Strozzi meant when, in 1496, he introduced him to Isabella d'Este as a potential tutor: 'You will learn more exquisite words in one month with him than in three months with anyone else.' This character turns up again in Rome, at the end of his career; at this point, in Ferrara, Mantua and Milan, his philology and love for rare texts, recondite corners of Latin, and 'exquisite vocabulary' serve to throw light on Mantegna's 'exquisite' themes.[51]

Research into the literary sources for Mantegna's works is unfortunately still in its infancy, but it is to be hoped that someone will soon manage at least to loosen the knot which binds together the engravings, the *Battle of the Sea Gods*, the passage from Pliny's *Naturalis historia* on a work by Scopas with tritons and nereids, and the decoration of the 'beautiful gate' of the temple explored by *Polyphilus* in his dream:

> full of varieties and exquisite representments, rarely ingraven and of little water monsters, as in the water itself in their right and well-disposed plemmyrules, half-men and women, with their fishie tails, some embracing one another with a mutual content, some playing upon flutes and others upon other fantasticall instruments. Some sitting in strange fashioned Chariots, and drawn in them by swift Dolphins, crowned and adorned with water lilies suitable to the furniture of the garnished seats: some with divers dishes and vessels replenished with many sortes of fruites. Others with plentiful copies, some coupled together with bands and others wrestling as they did, riding upon Hippopotamuses and other sundry and uncouth beasts, with a Chiloneal defence. Some wantonly disposed, others to variety of sports and feasts.[52]

Recent studies on the *studiolo* have lingered with particular pleasure over Mantegna's intricate iconographical details, reading

in them a surprising mixture of both medieval texts (Fulgentius's *Mitologiae*, Prudentius's *Psychomachia*, Boccaccio's *Genealogia deorum*, Petrarch's *Triumphs*) and classical texts, although these he had not always read at first hand, such as Ovid's *Fasti*, Nonnus's interminable *Dionysiacs*, and Philostratus Lemnius's *Images*, translated into Latin by Demetrius Moschus and into Italian by Mario Equicola (in the dedication to the Paris manuscript Equicola judges the *Images* to be 'worthy of your golden grotto'). There is little to add, especially for the *Parnassus*, which has been deciphered in such detail by Williams Lehmann, except to adjust the angle of vision and to try and identify how the iconography spills over from the *studiolo* into the outside world, as though these were exploits on which to base one's everyday behaviour, as were the true exploits and emblems which studded the Este–Gonzaga apartments: the sheaf of notes, the crucible, the muzzle, the candelabra, the number XXVII, etc.

The allusion to the *Parnassus* may of course be general, little more than a cliché, but there is such emphasis on the motif that it may well be part of an elegant play of references. Isabella, only recently married, was already famous as a generous patron of literature, and was described by Francesco Roello of Rimini as 'most learned, having been to Mount Parnassus and to the Pegasean fountain . . . entirely dedicated to the Muses' (which is almost the 'main basis' of the *Parnassus* still to come). But once Mantegna's splendid allegory took its place on the walls of the *studiolo* we have Galeotto del Carretto, of Casale Monferrato, sending her poetic compositions, well knowing that 'she has the whole academy of Parnassus in that illustrious city of Mantua' (15 April 1498). Even more appropriately Bernardo Bembo (father of Pietro) wrote from Verona in a letter to Francesco Gonzaga of 2 September 1502:

> . . . through Marco Cantore of your household and our city of Verona (therefore the famous Marchetto Cara) I have received the verses on Venus and her son. They have given me great pleasure because they are so delightful, and so well suited to the facts. But they would have pleased me even better if they had been about Venus and Mars showing yourself as the true image of the latter . . .

This may just be a social game, but it is not impossible that Bernardo Bembo is actually referring to Mantegna's painting; I see confirmation of this in some lines from Battista Fiera, certainly a few years later, where it is understood that the *Parnassus* Venus is Isabella

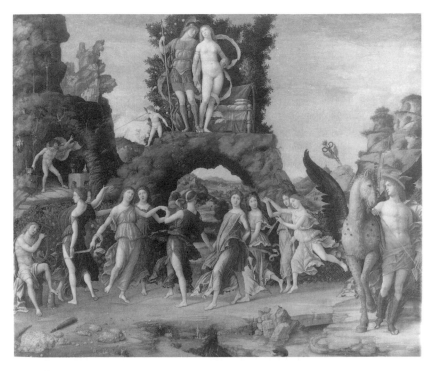

Plate 116 ANDREA MANTEGNA, *Parnassus*, 1497, from the *studiolo* of Isabella d'Este, Musée du Louvre. © Cliché Musées Nationaux, Paris.
Photo: Réunion des Musées Nationaux.

d'Este. The courtly theme of Parnassus was at its most highly developed in Calmeta's *Amoroso peregrinaggio*, which we know of from a letter Calmeta himself wrote to Isabella d'Este (5 November 1504) and from the dedication in the *Collettanee* on the death of Serafino Aquilano to Elisabetta Gonzaga, Duchess of Urbino and sister-in-law of Isabella (1504): 'this little collection of miscellaneous fragments I destine and dedicate to you', writes Giovanni Filoteo Achillini, 'so that when with your fellow goddess Emilia you ascend Mount Parnassus (whose beauty your and my fertile Poet in the first book of his Peregrinaggio Amoroso, which has not yet been published, so charmingly describes) etc.' . . .

Such was the constant osmosis between the Italian courts, a distinctive and crucial feature of contemporary cultural diffusion, that

we can apply this quotation indirectly to the Mantuan *Parnassus*, which still seems to sparkle ironically with clear springtime brightness against the troubled background of conjugal jealousy described by Francesco Gonzaga (letter of 21 February 1507): Isabella, suspecting her own lady-in-waiting Isabetta Tosabezzi of an affair with her husband, cut off the other woman's hair in her fury and struck her, shouting, 'Go on then, now play the nymph to his Lordship!'[53] Down from Olympus Mars, Venus, the Muses, nymphs, Mercury, Apollo, and the minor deities so beloved of mythologists are all circulating in the Italian courts as an inevitable part of their life and their strange penchant for classical antiquity. It is important to recall how, for the 1507 Carnival, two ambassadors from Venus came to the court at Urbino and, through an interpreter (since they could speak only the language of their planet), they scolded Elisabetta Gonzaga and Emilia Pia for their excessive coldness towards the goddess.

Recent iconographical research, following a train of thought that was at its most moderate in the work of Panofsky, has often overlooked the conventionality, possibly even the futility of these displays of allusion, and insisted on weighing areas of Renaissance culture down with an overload of philosophical (occult or scholastic) baggage, which never entered the heads of the leading figures of the time, not even Ficino's, at least not to the extent we tend to assume. Luckily Ernst Gombrich has led us to a sensitive and balanced reading of 'Botticelli's Mythologies', and it is appropriate to apply the ideas contained in that seminal essay to Mantegna's mythologies too: an intricate set of symbols and meanings which may be identified only if they are relocated within a real cultural context, or better still within the range of the artist's own reading and that of his advisers, a range which was sometimes desperately eclectic and vulgarly anthological. As if this were not bad enough, the meanings can often shift beyond their prescribed paths or respond to merely contingent demands and not those of mythologists or the first creators of the gods' names, thereby introducing disturbing factors into iconographical interpretation, which are not due to our ignorance, but to the bold exegesis of some of our humanist commentators (particularly those of the late fifteenth century).[54] The iconological delirium which has Ripa as its book of dreams (though this is nothing compared with the much more constraining nightmares of other repertoires), is a disease of later years when the courts were suffocating in an atmosphere of cultural *dirigisme*, which was not just religious or political, but more generally psychological and

moral. This was the age of manuals on correct taste, etiquette, religion, behaviour and other things, according to a purism still unknown in Isabella d'Este's time. It may come as a surprise, though not too much of one if we think about it, that the courts of late Mannerism should look back beyond late fifteenth-century models, beyond a society still full of personal fortunes, and misfortunes of course, sometimes quite independent of inheritance and breeding, and refer instead to the world of the late Gothic courts, ignoring the new openings humanism was providing, both socially and in other spheres. This goes some way to explain the historical misfortune which happened in the late fifteenth and early sixteenth centuries, years of spectacular political crisis, but not devoid of the seeds of important future innovations. In fact we need to reflect – as scholars of figurative culture have so far failed to do – on the unsuccessful religious revival which was actually initiated and dictated by courtly culture. Looking at works from the end of the century, no one would say that the *Madonna della Vittoria* in the Louvre and the Santa Maria in Organo altarpiece now in Milan could stand comparison with the *Triumph* or the *studiolo*. There is no doubt about Mantegna's personal quality, but it is important to acknowledge that only his two secular projects can reach the same status of forms symbolic of the flowering of courtly culture in Italy, and not the two religious paintings. The same goes for Mantua as for the rest of Italy, since even Savonarola's Florence could not produce a viable alternative; I could not say how likely this was in concrete terms, and the iconoclasm of reform could be seen as a negative response in desperation, if it had not been accompanied by a powerful explosion of militant graphic art of the highest level.

Beyond the ancient fables, Isabella's *studiolo* conceals a private iconological journey, to use an ambiguous fashionable term, which can be retraced only by placing in sequence the basic and most immediately obvious nuclei of those crowded iconographic schemes. The union of Venus and Mars, under the banner of celestial Love (or Anteros), generates harmony in the world, the musical rhythm of which is revealed in the dance of the Muses, the music of Apollo, singing, and therefore in poetry for music. '*Otia si tollas periere Cupidinis arcus*' (Take away leisure and Cupid's arrows are useless), we read at the feet of the combatant Minerva chasing the depraved entourage of the earthly Venus from the kingdom of the Virtues, while Justice, Strength and Temperance appear in the sky, invoked by the abandoned Virtue on the far left: '*Agite, pellite sedibus nostris / foeda haec viciorum monstra / virtutum coelitus ad nos*

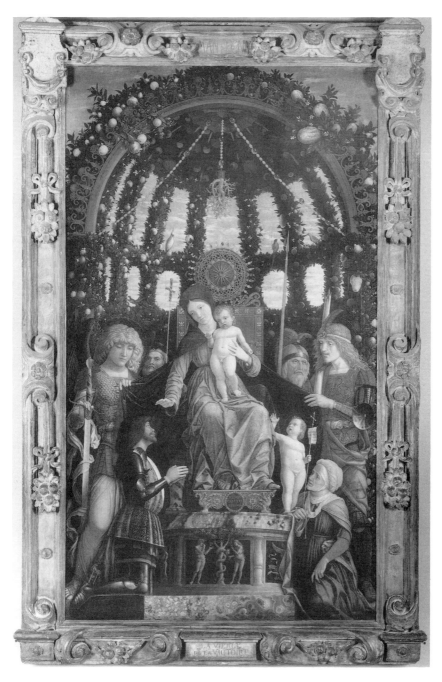

Plate 117 ANDREA MANTEGNA, *Madonna della Vittoria*, 1496,
Musée du Louvre. © Cliché Musées Nationaux, Paris.
Photo: Réunion des Musées Nationaux.

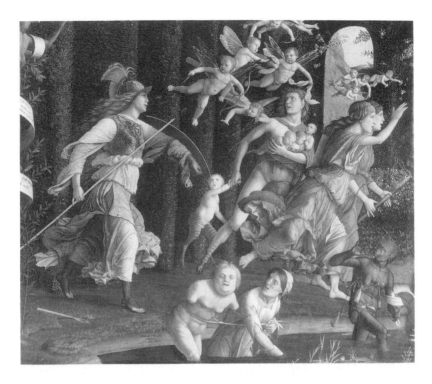

Plate 118 ANDREA MANTEGNA, *Minerva Expelling the Vices*, 1502,
from the *studiolo* of Isabella d'Este, Musée du Louvre. © Cliché
Musées Nationaux, Paris.
Photo: Réunion des Musées Nationaux.

redeuntium / divae comites' (Go, drive from our realm these vile
monsters of vice / o celestial friends of the goddess of the virtues
which are returning to us). On the right the mother of the Virtues,
kept apart behind cyclopean walls, entrusts her rescue plea to a
small card: '*et mihi virtutum matri succurrite divi*' (and come to my
aid, who am the holy mother of the virtues). We can get a clearer
picture of the meaning of this impassioned expulsion if we remem-
ber that '*Otia si tollas . . .*' is taken from Ovid's *Remedia amoris*. The
contract for Perugino's painting speaks of '*quoddam opus Lasciviae
et Pudicitiae*' (some work of Lust and Modesty) and from Isabella's
letter of intent it is clear, once again, that this is to be a defeat of
earthly Love. The meaning of Lorenzo Costa's first painting is more
ambiguous, and iconographers have spent less time over it, finding

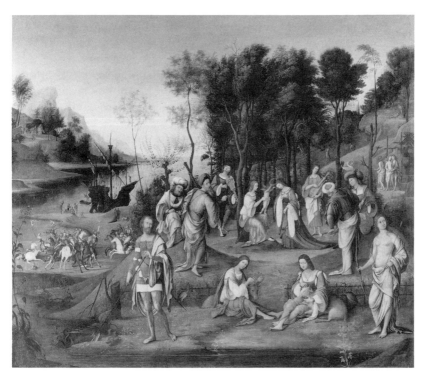

Plate 119 LORENZO COSTA, *Isabella d'Este in the Kingdom of Love*,
1506, from the *studiolo* of Isabella d'Este, Musée du Louvre. © Cliché
des Musées Nationaux.
Photo: Réunion des Musées Nationaux.

it very difficult. Here Isabella's adviser, Paride da Ceresara, is in
effect proposing a 'fable or story' which cannot be remotely 'antique'
if its real protagonist, in the centre, is to be dressed in 1506 fashion.
A schematic reduction of the reading might suggest that Venus and
Love, obviously the celestial Venus and Love-Anteros, are awarding
the prize for Victory over the Vices, and first and foremost over
earthly Love, to a young woman who must be none other than
Isabella herself, dressed as a perfect 'court lady', as Castiglione would
have said. Clearly the borders of this kingdom of music are guarded
by Diana, goddess of proclaimed chastity, and Cadmus, a minor god
who had the good fortune to marry Harmony (at least according to
the gossip in Nonnus's *Dionysiacs*). Costa's second painting again
presents a world populated by musicians presided over by Comus,

god of feasts, sitting beside the usual celestial Venus, while her earthly counterpart, cowering on the ground, is almost trampled underfoot by Apollo. In the background Janus and Mercury take on the same role assigned to Minerva in the garden of the Virtues. The thread linking the whole sequence is thus a eulogy, in five chapters, of celestial Love and its triumphs, with the ultimate prize for its disciple, who is received into the kingdom of Anteros and crowned as in an antique triumph.

We do not have to look far for the raw material on which this slightly outdated figurative expression of the lively debate going on in the courts of Italy on the subject of love is based. It is outdated because just as it was completed it was superseded by the first edition of Bembo's *Asolani*, but it is still a unique example, and this is something for which Isabella d'Este and Mantegna alone can take the credit, because the comparison between literature and art is made as no one else had yet done so rigorously, with a clear preference for art. Isabella never wrote professionally, and we remember her best for her sharp political intelligence, her openness to affectionate friendships, her impulsive sensitivities as an independent 'court lady', her insatiable curiosity, even her psychological repression, all from her fine letters, which have come down to us; but her close collaboration with Mantegna provides a channel for her to express her belief in courtly Platonism through images, with full confidence in their superior evocative and emotional power. Isabella's literary influences are the more oppressively anthological treatises on love, from Pietro Edo or Cavretto's *Anteroticorum libri* (Treviso, 1492) to Battista Fregoso's *Anteros* (Milan, 1496), clearly very close both in time and taste to the origins of the *studiolo*. Later there would also be her conversations at court with Jacopo Calandra (the son of the Calandra who arranged the *marchesa*'s collaboration with Mantegna in 1492), whom the sources record as author of a now lost treatise on love entitled *Aura*.[55]

In conclusion I feel certain that as work on the *studiolo* was coming to an end, with the painting of the kingdom of Comus, Isabella and Costa went back to Mantegna's erudite model after the topicalizing liberties of the *Coronation of Isabella* (which was delivered in 1506, a year after the publication of the *Asolani* and a few months after Isabella and Pietro Bembo first met in person).[56] This traditional choice may be explained as a revival of the old debate on Love-Anteros, encouraged by the presence of Mario Equicola who, from 1508, was in Isabella's service after many years of experience in Italian courts (from Naples to Ferrara). Equicola soon began working on his old

treatise again, or rather his *Libro de natura de Amore*, which was published only much later (1525), and was dedicated to Isabella. A book which aligns itself with the *Asolani* in its declared intention at the outset of explaining 'the nature and extent of the feelings, effects, causes and movements which come to our souls because of him (love, of course)', and yet distances itself when it seeks to discover 'what is false and what is true pleasure and happiness with the reason and authority of the most honest of the ancients . . .' And indeed there is no shortage of 'honest ancients' in the treatise; the pages are groaning with carefully chosen quotations, quite apart from the fact that the first half undertakes a thorough review of the whole of classical, medieval and contemporary bibliography. Numerous pages are also devoted to the poets of the 'stil novo', the Provençal poets and to Petrarch's *Triumphs*, a Romance tradition to which the mottoes with which the *studiolo* floor is studded were indirectly referring ('vrai amour ne se change', '*bona fe non est mutabile*'), and 'prenez sur moi votre exemple amoureux' written on one of the Mola brothers' inlays, now in the Grotta della Scalcheria. It has already been noted that the phrase is from a song by Johannes Ockeghem published by Petrucci in Venice in February 1504, but it is worth recalling that the subsequent lines seem to echo the moralism of the studiolo:

> Commencement d'amours est savoureux
> Et le moyen plain de peine et tristesse
> Et la fin est d'avoir plaisant maîtresse
> Mais au saillir sont les pas dangereux.[57]

(Love's beginning is delight, its middle full of pain and sadness, and its end to gain a pleasing mistress, but the steps are perilous to climb.)

For Isabella, as for Equicola, this lesson was to be taught through

> poetic fictions . . . because, as in sacred theology we see speculation, enigmas, figures, parables, proverbs and similes, so, in order to attract and excite the unskilled masses and secretly draw the people to the knowledge of truth, the ancients knew they needed a new generation of delights which were the fables, containing high and recondite meanings.[58]

This teaching method was moulded on the 'fables' of ancient writers and sacrificed all passions to them, so much so that the interpreter to the ambassadors from Venus who came to Urbino to pay homage

to Elisabetta Gonzaga Montefeltro may have been alluding to Isabella when he said:

> ma l'accoglienza, il senno e la virtute
> potrebbon dare al mondo ogni salute.
>
> Se non fosse il penser crudele et empio
> che v'arma incontro Amor di ghiaccio il petto,
> e fa d'altrui si doloroso scempio
> e priva del maggior vostro diletto
> voi con l'altre, a cui noce il vostro exempio.

(but warm welcome, intelligence and virtue could make the world a better place. If it were not such a cruel and wicked thought which arms your breast with ice against Love, and slaughters others so painfully and deprives them of your great love, you and others whom your example harms.)

Isabella was in fact numbered among the other women not given to a welcoming attitude in love, and the ambassadors from Venice may have been smiling beneath their masks: they were Pietro Bembo, author of the *Asolani*, and Ottaviano Fregoso, who was to receive the highest praise from Castiglione in his dedication to da Sylva in the *Book of the Courtier*.[59]

Leonardo in Mantua

On the run from Milan after the fall of Ludovico Moro, Leonardo stopped off in Mantua just long enough to draw a portrait of Isabella d'Este, as noted shortly afterwards by Lorenzo da Pavia: 'And Leonardo da Vinci is in Venice and has shown me a portrait of Your Excellency which is very like you. It is so well done, it could not be better' (letter of 13 March 1500).[60] This portrait is usually identified with a cartoon in the Louvre which has been perforated for pouncing and therefore must have been used for a painting (which has either been lost or was never finished).[61] It is likely that Leonardo left a life drawing in Mantua and took a replica with him to Venice to work on in his studio (or vice versa); having finally reached Florence he would have been at leisure to make the life-size cartoon in the Louvre. The Paris portrait has never been much praised by critics, because of the poor condition it is in and because of its obvious derivation from a heraldic pattern recognizable in a medal

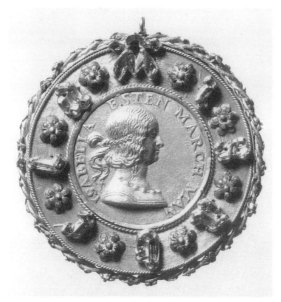

Plate 120 GIAN CRISTOFORO ROMANO, Medal with Isabella d'Este (recto), 1498, Kunsthistorisches Museum, Vienna.

by Gian Cristoforo Romano from 1498. However, it does not deserve such neglect. The most obvious comparison is with the *Mona Lisa* which, if the truth be told, does not dominate the foreground with the same authority, nor does she turn the wide arc of her shoulders so subtly and powerfully to the same minimized three-quarters pose, almost as though still hovering over the seat before settling into it. Certainly the face cannot stand comparison with the Ambrosiana *Gafurio* or the *Belle ferronière* in the Louvre, but once we have admitted the derivation, which he had no choice but to use (Isabella did not like posing for portraits), it must be acknowledged that in the new invention of Isabella's portrait Leonardo is revealing the full grandeur of his style, which will mature in the *Last Supper* at Santa Maria delle Grazie. In Venice Lorenzo Gusnasco of Pavia was right to be amazed when comparing Leonardo's drawing with Bellini's portraits, so noble and luminous but superficial by comparison. Other painters, and I refer obviously to Giorgione, would learn to make the most of this quite new, almost half-profile position, and even its sharpness of outline: see especially his *Gerolamo Marcello in Armour* (Vienna) in conversation with an unmistakably Leonardesque figure.[62]

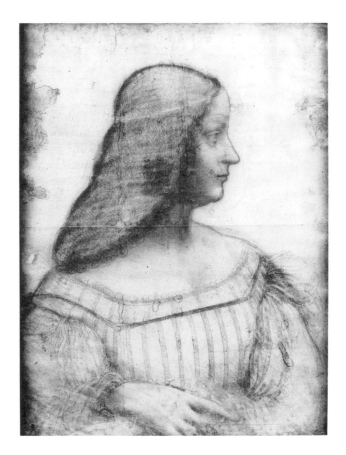

Plate 121 LEONARDO DA VINCI, Cartoon for the portrait of Isabella d'Este, 1499–1500, from Cabinet des Dessins, Musée du Louvre. © Cliché des Musées Nationaux, Paris. Photo: Réunion des Musées Nationaux (inv. MI 753).

The Paris portrait should be seen as Isabella checking for herself what Cecilia Gallerani had said in her letter about Leonardo's supremacy; by late 1499 to early 1500 Leonardo was not the same artist who had painted Moro's then extremely young mistress as the *Lady with an Ermine* (now in Cracow). A check-up of this kind could count for quite a lot, given the importance which now attached to portraits of famous people in the context of a portrait-collecting scene where comparisons and exchanges were rife. Here, as before, we find Isabella at the centre of a network which again

shows, from a different angle, the constant exchange of information going on among the Italian courts at the turn of the century.[63]

Just over a year after her marriage Isabella wrote to her sister Beatrice, wife of Ludovico Moro, asking to borrow her sculptor Gian Cristoforo Romano, 'who is making Your Excellency's portrait in marble', for a few days (Beatrice's youthful portrait is still in the Louvre, a masterpiece of careful workmanship). The request is dated 22 June 1491 and corresponds to another letter to Giorgio Brognolo in Venice (11 July) regarding the purchase of some fine marble for a portrait of herself. Because of prior engagements, Gian Cristoforo Romano's visit was postponed for several months and took place only at the end of the year, though unfortunately we do not know with what results for the portrait of the *marchesa* of Mantua. In January 1493 Isabella posed for Mantegna and promised to send the portrait to Isabella del Balzo, Countess of Acerra; from Naples the Countess of Acerra returned the compliment in advance, and Isabella d'Este thanked her on 3 April 1493, commenting with some reserve on the likeness in the portrait she had received; however, 'knowing how difficult it is to find painters who can exactly reproduce a real face', she will cherish it just as much. Meanwhile Mantegna had finished the painting promised in January, with entirely unsatisfactory results: 'he has done it so badly that it looks nothing like me; I have sent for someone from outside, who is famous for his good lifelike portraits.' That 'someone from outside' was Giovanni Santi, court painter at Urbino, who immediately went over to Mantua and was heaped with commissions in the specific area of family portraits. He did not manage to do many, because he fell ill in Mantua and died early in the autumn of 1494, but he did at least finish the portrait of the *marchesa*, and she finally sent it to her Neapolitan friend, together with a letter dated 13 January 1494: 'I am sending you via Simone da Canossa, chamberlain of the most illustrious Duke of Calabria, the panel portrait made by Giovanni Santi, painter to the most illustrious Duchess of Urbino, who they say makes very real likenesses, although I am told this one could look more like me ...'

It may seem strange so soon after the compilation of Santi's *Cronaca* to find Mantegna, who is praised therein above all others, subjected to the indignity of seeing Santi preferred to him, but the relationship between the two cannot be reduced to such a simplistic pattern. In the first place, we would need to have a precise picture, a more precise one than we can obtain today, of the position occupied by the portrait likeness in the scale of artistic values in the late fifteenth

century. Probably it did not hold a very high position, judging by
the readiness with which such products were exchanged among the
courts and by the strange pastiche Leonardo cobbled together as a
faithful image of Isabella d'Este. The improbable number of copies,
replicas and various derivations would also seem to indicate that the
recognizable portrait did not enjoy any particular figurative prestige
in the eyes of court society; it functioned instead as a documentary,
a charming souvenir, a substitute to stimulate the memory and the
feelings associated with it, nothing more. The painter from Urbino,
the modest but diligent Giovanni Santi, informed in his way about
the clarity of the Flemish painters and the tenderness of Perugino,
could never have been a proud master of 'invention'; it was only in
portraiture that he happened to surpass the 'most excellent' Mantegna,
who preferred heroic celebration to the reproduction of a likeness
in his portraits. Remembering too that in 1494 Isabella also com-
missioned a portrait of her father from Ercole de' Roberti we can see
that the portrait-painting scene at court that year, at least in Mantua,
was far from consistent, being in fact extremely open and varied.

The situation does not change much if we bring in the known
documents for 1498, except that Lombard painting seems to have
been a favourite choice. More from the letter of 26 April from
Isabella d'Este to Cecilia Gallerani: 'Having today happened to see
some fine portraits by Giovanni Bellini I have been thinking about
the works of Leonardo and would like to see them to compare them
with those I have . . .' Cecilia Gallerani sent the portrait of herself
as little more than a child with many precautions, and we do not
know what verdict Isabella reached over the two greatest painters
Italy could boast at the time (in 1498 Michelangelo was committed
to sculpture, in which he showed great promise, and Raphael was
still sweetly immature). I suspect however that the comparison idea
was little more than a pretext, since between that spring and sum-
mer Isabella worked out with Gian Cristoforo Romano the medal
that was to meet with such instant success. However, this was not
the sort of news to bandy about between Mantua and Milan before
the proper time if one wished, as Isabella did, 'never to do anything
others have already done'; Gian Cristoforo Romano may have al-
ready spoken to the *marchesa* about Leonardo's new style of por-
traiture, which was no longer just about likenesses, but about 'the
mood of the mind'. The portrait of Cecilia Gallerani was an unfor-
tunate choice, since it was not a very recent work, and it seems
strange that it was not the Louvre *Belle ferronière* which made the
journey from Milan to Mantua, being a portrait from memory based

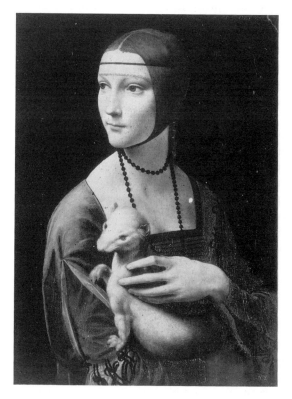

Plate 122 LEONARDO DA VINCI, *Portrait of Cecilia Gallerani (Lady with an Ermine)*, *c.*1490, National Museum Collection, Cracow.
Photo: Archivi Alinari.

on the features of Beatrice d'Este. However the medal portrait was made by taking Roman coins as a model, in line with 'antiquarian' tastes, and the only reference to Leonardo is in the soft tangle of hair clasped at the back of the neck.

In August 1498 the medal was circulating among friends (Tebaldeo in Ferrara had a copy), but meanwhile another sensitive portrait painter of the time, Boltraffio, had arrived at court, at the introduction of Isabella of Aragon, unhappy widow of Gian Galeazzo Sforza, the dispossessed grandson of Ludovico Moro. Boltraffio's job was to copy a portrait of Ferrante d'Aragona, Isabella of Aragon's brother, which belonged to the ruling family of Mantua. This copy does not survive, but we know enough about Boltraffio's portraiture to be

sure that its psychological delicacy and chromatic charm must have
been a source of amazement, even compared with the examples
of Giovanni Santi's work to be found at court.[64] This is why the
marchesa's decision to commission her own portrait, to be sent to
Isabella of Aragon who had persistently requested it, from Giovan
Francesco Maineri, 'a very shy man', is so incredible (this is late
1498). Isabella d'Este seems unable to come down in favour of
psychological portraits in the style of Leonardo, and still entrusts
her own likenesses to careful traditional painters. This observation
can perhaps give us a better understanding of how Isabella might
have preferred not expose herself to the difficult, cards-on-the-table
dialogue necessary for a portrait in the modern manner, face to face
with Leonardo, who was to pass through Mantua just a year later,
and why she might assign what appeared to be her profile to Gian
Cristoforo Romano's medal, rather than open up the secrets 'of her
mind' to Leonardo.

But she could not hold out like this for long, especially as
Leonardo's wanderings around Italy, and the diaspora of those of
his pupils from Milan who had been most implicated in Moro's
court, effectively spread his reputation as the new and disturbing
genius of painting. It would be very helpful at this point to know the
exact date of the sonnet by Niccolo da Correggio about a portrait
of a lady by Leonardo, and to be able to know for sure which of
the few portraits Leonardo painted in northern Italy this was.[65]
There is no way we can link this composition to the portrait of
Isabella with any certainty, but if the verses were written between
1500 and March 1501, we would know who the adviser was who
made Isabella change her mind and suddenly become so well disposed
towards Leonardo in a famous letter to Pietro da Nuvolara of 27
March 1501 – it would be Niccolo da Correggio himself. Another
source of information must have been Gerolamo Casio, also a poet
and jeweller, who had entrusted to Boltraffio his family altarpiece,
which is now in the Louvre but came originally from Bologna. It has
possibly never been stressed forcefully enough that the *Casio Altar-
piece*, of 1500, is among the earliest examples of a modern altar-
piece painted in Italy, despite its rather clumsy composition. The
only competition Boltraffio needed to fear was from Piero di Cosimo,
whose crystalline panel for the del Pugliese family was already, in
1493, in place over an altar in the Church of the Innocenti in Florence
(at that time such a work was little short of incredible). In 1500
Fra Bartolomeo was still stumbling over a very ambitious phase of
his *Judgement* for San Marco, also in Florence, and Raphael was

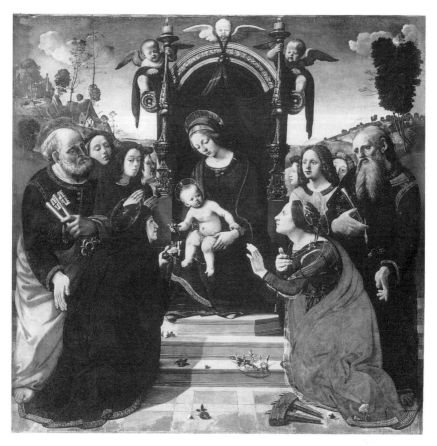

Plate 123 PIERO DI COSIMO, *Madonna and Child with Saints*, 1493,
Ospedale degli Innocenti, Florence.
Photo: Archivi Alinari.

labouring to extract a scarcely more vivid grace from two masters
he idolized, Perugino and Pinturicchio. Even Bellini's *Baptism* in Santa
Corona in Vicenza (*c.*1502) seems less confidently and airily worked
out than the *Casio Altarpiece*.[66]

So let us look at the letter of 27 March 1501 to Frate Pietro da
Nuvolara asking him to find out from Leonardo

> whether he would undertake to paint us a picture for our *studiolo*, and
> if he were pleased to do it we would leave the invention and the
> timetable up to him, but if you should find him unwilling see at least

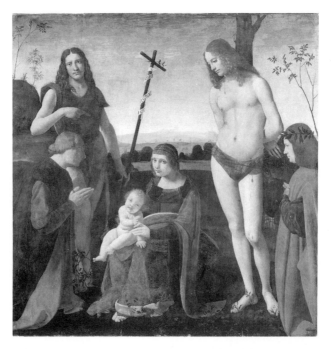

Plate 124 GIOVANNI ANTONIO BOLTRAFFIO, *Madonna and Child with
Saints and Donors*, 1550, Musée du Louvre. © Cliché Musées
Nationaux, Paris.
Photo: Réunion des Musées Nationaux.

if you can persuade him to do us a small painting of the Madonna
pious and sweet as comes naturally to him. Then you should ask him
to be so kind as to send us another sketch from our portrait (the one
he left in Mantua had been given away rather casually by Francesco
Gonzaga).

Isabella seems to be regretting not having kept better track of that
portrait, which has now become important and can be replaced only
by Leonardo himself: so much so that she is now stating her readi-
ness to make big concessions over the possible iconography of a
painting for the *studiolo* (the corresponding letter to Bellini is dated
28 June 1501 and, before Leonardo, Isabella had given such free-
dom only to Francesco d'Anichino, the famous *pietra dura* mosaicist,
with one proviso: 'that it be something representing the antique');[67]
but, more than a painting for the *studiolo*, Isabella's real wish seems

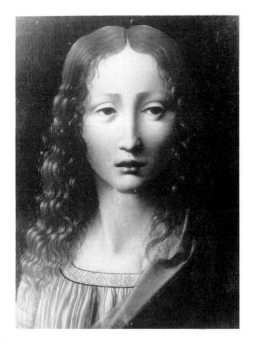

Plate 125 Lombard School, *Christ as a Young Man*, 1495–1500, Fundación Lazaro Galdiano Museum, Madrid.

to be to have 'a small painting of the Madonna pious and sweet as comes naturally to him'. We can understand what she meant from a later letter (24 May 1504) addressed directly to Leonardo, when she even gives up hope of the portrait:

> I beg you that as you wish to fulfil your obligation of honour to me you will be so kind as to convert my portrait into another figure which will be even more gracious, that is to do a young Christ aged about twelve, which would be the age he was when he debated in the temple, and painted with that gentleness and sweetness of air that is your particular skill and which you do so excellently.[68]

It is very doubtful whether Leonardo personally painted that picture for Isabella; in any case, if it ever does turn up, I do not think it could be the *Salvator mundi* known from a drawing at Windsor and a Hollar engraving.[69] If we want to imagine it I think we should use two opposite points of reference which are iconographically

more relevant than a *Salvator mundi*: namely the little known *Christ as a Young Man* in the Lazaro Galdiano Museum in Madrid, which is a Lombard work derived from an idea of Leonardo's from the last decade of the century, and Correggio's *Young Christ*, now in Washington, 'at the age he was when he debated in the temple, and painted with that gentleness and sweetness of air'; obviously Correggio based it on a Leonardo model not long after 1504, the date of Isabella's letter.[70]

There is no way that the *marchesa* of Mantua could have read Leonardo's manuscripts, but her reference to the distinctive 'sweetness and gentleness of air' found in Leonardo's works is too specific not to have come out of direct discussions and up-to-date information; we cannot ignore the fact that there is a similar assertion by one of Isabella's correspondents, Sabba Castiglione, but which would seem to have come from Isabella: 'Leonardo da Vinci, a man of the greatest genius and most excellent and famous in painting, a pupil of Verrocchio's as can be seen from his sweet air'. Later Bernardino Arluno spoke of Leonardo as 'a very sweet painter, whose paintings are still full of life to this day', and Jean Lemaire recalled in Milan 'Leonardo who has heavenly grace'. Lemaire's reference was made in 1509, and in the same year Luca Pacioli's *De divina proportione* was published in Venice, containing this psychologically significant reference to Leonardo's *Last Supper*: 'Where [the apostles] seem to be speaking to one another with actions and gestures of deep and sad amazement, so worthily did our Leonardo arrange them with his elegant hand.'[71] It is well known that Pacioli's work dates from 1497, and that Pacioli himself fled from Milan with Leonardo: this is another indication of how the master's reputation was able to grow more rapidly at a time of misfortune than it had during the years he was working enclosed in Ludovico Moro's court, where his duties were not primarily artistic ones.

Leonardo's airs had become sweet and gentle, '*mollissimum*' (very sweet – an adjective from the language of Ciceronian criticism), endowed with 'heavenly grace' and having an 'elegant hand' in the course of the 1490s in Milan, and the most important traces of this are already found in Manuscript A of the Institut de France:

> That figure is most worthy of praise which by its action best expresses the passion which animates it. The limbs should fit the body gracefully in harmony with the effect you wish the figure to produce; and if you desire to create a figure which shall possess a charm of its own, you should make it with limbs graceful and extended, without showing

too many of the muscles, and the few which your purpose requires you to show indicate briefly, that is without giving them prominence, and with the shadows not sharply defined, and the limbs, and especially the arms, should be easy ... The positions of the head and arms are numberless, and therefore I will not attempt to give any rule; it will suffice that they should be natural and pleasing and should bend and turn in various ways, with the joints moving freely so that they may not seem like pieces of wood.[72]

The fortunate reappearance of the Madrid II Manuscript, with its notes on painting covering the years 1503–5, allows us to follow the development of the themes originally worked out in Milan, and to date precisely some observations of great importance for the development of figurative culture in Florence and for the general progress of the *maniera moderna* (previously known only through Melzi's transcriptions for the *Trattato della pittura* preserved in the Cod. Vat.Urb.Lat.1270). The most important part concerns his experiments with colour and light, but there are also passages on the proper way to paint limbs and faces: 'Never put so many ornaments on your figures and other bodies in your compositions that they obscure the shape and attitude of those figures and the essence of those other bodies.' This seems to be a criticism of the archaeological overdressing found in Filippino Lippi and Perugino, who were all the rage in Florence when Leonardo returned there from Milan. '... in the limbs make the muscles which are working swell with the effort appropriate to them, and those which are not working should be left as they are ... in young figures do not strive for muscles and biceps, but gentle fleshiness with simple folds and roundness of limbs.' Both of these two statements take on a possibly polemical character when held up to Michelangelo's *David*, and they should be read with Rustici's sculptures for the Florence Baptistery in mind, since it seems that Leonardo had a hand in them. '... vary the air of faces according to the states of man: in labour, at rest, enraged, weeping, laughing, shouting, fearful and suchlike. And in addition, the limbs of the person together with his whole posture should correspond to the altered features.' With hindsight, it is clear this statement is meant to reflect the preparatory drawings for the cartoon of the *Battle of Anghiari*, and finally:

... do not try to put all the muscles in place on your figures, however much in evidence they are; they are not very obvious if the limbs they belong to are not making a great effort or exertion, and the limbs which are not being exercised should be without a show of muscles.

If you do otherwise you will have imitated a sack of nuts rather than
a human figure.[73]

The similarity of this text to the one from Manuscript A shows a
continuity in Leonardo's deliberations towards a particular grace of
posture which certainly must have clashed harshly in Florence with
Michelangelo's hypertrophied muscles in the *Doni Tondo* as well as
in the *Battle of Cascina*, and this seems to explain the sarcastic tone
of the comparison with the sack of nuts.

In the open debate about portraiture, the reference to 'expressions
of faces . . . according to the state of man' is particularly interesting,
within the emerging theme of physiognomic expression which
Leonardo had taken with him to Milan in an old and uncertain
Ficinian version and was now observing in an unexpected revival,
supported by some important published contributions.[74] For Flor-
ence, the most direct reference is the chapter '*De physiognomonia*'
in Pomponio Gaurico's *De sculptura*, published in December 1504,
but we ought to bear in mind that its appearance in Florence seems
to be rather fortuitous. The dedication by Marcantonio Placido to
the young Lorenzo Strozzi, son of Filippo il Ricco, is clearly not in
tune with the dedication by Gaurico to the ageing Ercole d'Este,
Duke of Ferrara, besides which the text is entirely northern, Veneto-
Emilian, and even the praise of four well-chosen Florentine sculptors
(Benedetto da Maiano, Michelangelo, Andrea Sansovino and Rustici)
seems to have been an afterthought for the sake of currying favour
in a different market.[75] We get a different picture if we compare
Gaurico's little treatise, and particularly his chapter on physiognomics,
to the *Quaestio de subiecto physionomiae et chiromantiae* by
Alessandro Achillini, published in 1503 in Bologna as an introduc-
tion to Bartolomeo della Rocca's *Chyromantiae et physionomiae
anastasis*, which appeared the following year, at exactly the same
time as Gaurico's work. Gaurico's assertion that he wrote the chap-
ter on physiognomics before the *De sculptura* now seems highly
suspect, since the beardless Pomponius was the brother of Luca
Gaurico, the astronomer who moved in the circles of the Bentivoglio
family in Bologna along with Achillini and della Rocca. These
wrangles over which was written first are not of much concern to us,
and anyway what mattered to the Florence of Filippino Lippi and
Piero di Cosimo, which now belonged to Leonardo, Rustici and Fra
Bartolomeo, was the important opportunity to learn of the very
scientific debate going on in the northern universities, since 'physi-
ognomy and cheiromancy are speculative sciences . . . not practical

ones.' In the north, the debate eventually touched on the delicate question of the soul, but by that time Leonardo had other things on his mind: in 1515, if he had happened to be interested in reading an Aristotelian anthology published in Pavia with the evocative title of *Infinita naturae secreta*, he would have been amused to find right at the beginning that a theme dear to his heart, which he poured into the psychological intensity of his few portraits, was still in vogue: 'And since spirits follow the body and are themselves not impassive to movements of the body (this becomes especially obvious in states of inebriation and sickness), the spirits seem to be much changed by the sufferings of the body and by adversity.'[76]

By 1515, Leonardo enjoyed wide appreciation; in Leo X's Rome, Raphael and Michelangelo were laying down the law as history painters, sculptors and architects, but on the portraiture front the model was still the one revived by Leonardo for its ease of positioning in space and for the psychological intensity and depth it achieved. This was not a new discovery: it dated back many years to Leonardo's time in Milan, and it had been such a disturbing revelation to him that he had even thought of alerting future observers with a couplet to be inscribed on a portrait's cover: 'Non iscoprire se libertà t'è cara / che'l volto mio è carcere d'amore' (Do not open if you value your liberty, for my face is a prison of love).[77]

The reference to love brings us back to Isabella d'Este, especially as the couplet probably dates from 1493, when Isabella was planning her *studiolo* dedicated to Anteros, the love which does not imprison but which liberates, which does not intimidate the soul with irrational bewilderment, which is also desire, but which seeks to lead it in holiness towards the highest spheres of heaven. The fashion for this cerebral love which does not compromise itself was already on the way out when Isabella wrote her letter to Leonardo. Less than a year later the custodians of love witnessed the scandalous explosion of the *Asolani* (March 1505, published by Aldus Manutius in Venice), a treatise on love with no archaeological myths, moral fables or other alienating devices; a treatise all about emotional phenomenology and psychological case studies, almost a confession.

A painter-musician at Isabella's court: Lorenzo Costa

To Signor Paride da Ceresara. Signor Paride, I do not know who is more irritated by the slowness of the painters: I who cannot see my Camerino finished, or you who must every day devise new ideas

which because of those painters and their strange ways are neither soon enough nor fully enough drawn for my liking, and so I have been thinking of trying out some new painters in order to get it finished in my lifetime. Since Signor Bentivoglio has been here he has offered to have a picture painted for us in Bologna by an excellent master, who would do the job quickly and so serve us well. I am asking if you would mind undertaking the further effort to devise a new composition which satisfies you, since my own satisfaction depends on yours. Once you have written the description please send it to me at once, it would be so kind of you . . .

Another letter from Isabella d'Este about her *studiolo*, and more complaints about the slowness and quirkiness of the artists chosen to decorate it; this one is dated 10 November 1504, when the worst culprit for the delays was Perugino, but in a letter not long after to Anton Galeazzo Bentivoglio, on 27 November, Isabella also recalls how Giovanni Bellini had led her quite a dance.[78] The Bolognese 'pronotario' referred to is in fact Anton Galeazzo, the second son of Giovanni Bentivoglio II, the most literate of the numerous offspring of Ginevra Sforza and also the most ostentatiously pious: Giovanni Garzoni's *De felicitate christiana* is dedicated to him as a lover of long pilgrimages to the Holy Land and Compostela, but the dedications to the first edition of Poliziano's *Stanze*, which came out in Bologna in 1494, and to the posthumous collection of the works of Codro edited by the younger Beroaldo (March 1502, again in Bologna) also refer to him.[79] We know him as a sixteen-year-old already dressed in ecclesiastical garb, from the Bentivoglio family altarpiece painted by Costa for San Giacomo, and little more than ten years later, in 1499, he appears again in the costume of a Knight of St John in Francia's altarpiece for the church of the Misericordia, now in the Pinacoteca Nazionale in Bologna. Tradition has it that in this same altarpiece the shepherd on the right has the features of Gerolamo Casio, Isabella's other correspondent in Bologna, but this identification seems unlikely. The young man crowned with oak leaves (not with laurel as Casio would have liked) has features more like those of Alessandro Bentivoglio, whom we know from the Thyssen *Concert*, where the identification seems certain.[80] Among the ten singers in the Bentivoglio choir the one in the foreground on the left is the author of the painting, Lorenzo Costa, who signs his name on the front flap of his hat; as for the date, it cannot be far off that of the exchange of letters already referred to between Bologna and Mantua concerning a new painting for the *studiolo*, which is of course the *Coronation of Isabella*. It is important to

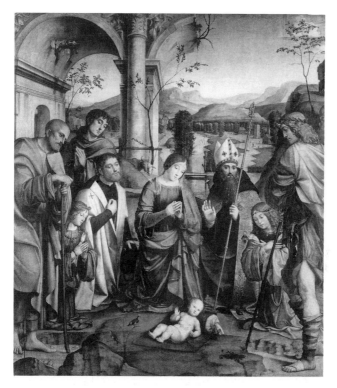

Plate 126 FRANCESCO FRANCIA, *Adoration of the Child*, Pinacoteca
Nazionale, Bologna.
Photo: Archivio Fotografico, Soprintendenza per i Beni Artistici e Storici,
Bologna.

emphasize Costa's musical skills because they may have somehow
determined this choice of painter and the iconographic theme assigned
to him, and also because they align him with that large group of
artists who were skilled lutanists and singers, as was so typical of
the courtly side of Italian figurative culture around the turn of the
century; even just assembling those Isabella was best acquainted
with we find, along with Costa, at least three stars: Leonardo,
Giorgione and Gian Cristoforo Romano. At the time of the letters
to Bologna Isabella d'Este could not have had much information
about Lorenzo Costa apart from his musical ability, except of course
from Anton Galeazzo Bentivoglio's recommendation. Unless I am
mistaken, no prints of his work had yet been published, unlike the

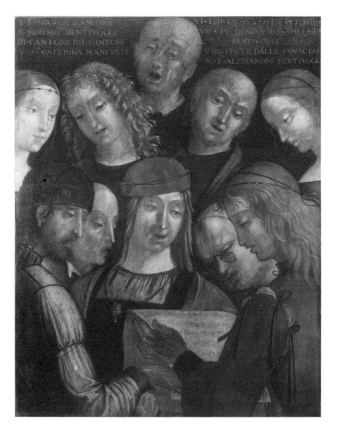

Plate 127 LORENZO COSTA, *Concerto Bentivoglio*, Thyssen–
Bornemisza Collection, Lugano, Switzerland.

work of his colleague Francesco Francia (mostly as goldsmith and
engraver); Giovanni Filoteo Achillini's eulogy in *Viridarium* may have
already been written, but it came out only in 1513.[81]

Trusting her friends in Bologna and pleased with the painting of
her personal coronation, Isabella welcomed Costa to Mantua imme-
diately after the downfall of the Bentivoglios engineered by Julius
II (early November 1506); Mantegna had only recently died, and
Costa automatically became the new court painter. This was the
beginning for him of a successful run of commissions and favourable
criticism which he could not easily have won in Bologna, as is borne
out by the experience of an example from the other side, Amico
Aspertini, who is also represented at his greatest level of achievement

in that Bolognese equivalent of the Sistine chapel which is the Oratory of Santa Cecilia near San Giacomo.[82]

Costa settled down in Mantua without difficulty and we may imagine that he took on the role of modern master as old Mantegna's glory gradually faded. The painting for the *studiolo* was a great novelty for Mantua, so chromatically pleasing and brilliant, staged according to rhythmic correspondences, which seem to take up the quest for 'silence', shot through with a fine vein of emotion, which recalls the sentiments of Sannazzaro's *Arcadia* (the great literary success of the day). We may even suspect that detailed news of a young Venetian master named Giorgione, whose reputation was growing daily, had reached Costa's ears. We know from the Vienna *Laura* how he was painting in 1506, but it is perhaps more important to remember that his reputation grew to such heights between 1506 and 1507 that the Council of the Ten decided to commission a canvas for their own audience chamber (the relevant document of 14 August is the first legal paper we have which relates to Giorgione). This is not to say that Costa could have known at first hand about his latest works, in fact it is probably out of the question, but there was someone who could have acted as intermediary, having spent his early years circulating between the courts of Mantua and Ferrara before settling finally in Venice: Giulio Campagnola.[83]

Following Costa's career at Isabella's court even over a short period, we trace a typical courtly trajectory even more explicit than that of Giorgione, Leonardo or the young Raphael himself. His output of ecclesiastical works immediately dwindles almost to nothing, in favour of a series of offerings all destined for the court, and there is also an immediate interface with contemporary literary events and therefore with the first beginnings of art criticism in Italy. On 28 June 1508 Isabella asked Gian Giacomo Calandra for some lines 'because I should like to put in the latest painting Costa has made of my portrait a fine couplet in his praise'.[84] The portrait was considered a jewel in the crown of the Gonzaga court, and was exhibited triumphantly to Francesco Maria della Rovere, the future heir to the duchy of Urbino, when he came to visit his betrothed, Eleonora Gonzaga (August 1508). He may have thought to compare it in his mind with his own portrait and the one of Elisabetta Gonzaga (now in the Uffizi) or with other well-known portraits such as the one of Emilia Pia (now in Baltimore) or the one of Eleonora Gonzaga herself made on the occasion of her betrothal in 1505 (now in Boston).[85] Of course the court of Urbino had been able to rely on Giovanni Santi's son Raphael for their own portrait requirements,

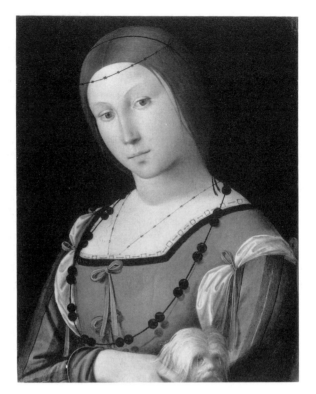

Plate 128 LORENZO COSTA, *Portrait of Isabella d'Este as Faithfulness*, Buckingham Palace, London, reproduced by gracious permission of Her Majesty the Queen.

but the contest which began with the comparison between Giovanni Santi and Mantegna was not about to end with another defeat for the Mantuan side. It may have escaped the notice of Mantua and even Urbino that Raphael had already painted the portraits of Angelo Doni and Maddalena Strozzi (now in the Pitti), since the Florentine couple did not belong to courtly society. Isabella's portrait met with even greater success in Ferrara in November: she had spoken so highly of it to her relations that she had to let them see it for themselves, and she sent a messenger to Mantua to bring it to them. I do not think it would be too unscrupulous to identify that portrait as the young woman with a puppy in her arms now in the Queen's collection at Buckingham Palace; for one thing the symbol of fidelity sits well with one of the concerns of the *studiolo*: '*bona fe non est*

mutabile' (good faith never changes). However, I think it is also only right to acknowledge that the portrait is rather disappointing. Isabella's features are hardly recognizable, apart from the chubby cheeks which she shared in common with her sister Beatrice; the eyes, mouth, and nose are basically regular, and the whole face seems to lend itself not to personal identification, but to symbolic recognition as an allegory of fidelity. Even in this light the link with the portrait in the documents is still plausible, because it was probably the same one that Francesco Gonzaga had sent to him from Mantua while he was a prisoner in Venice, along with the portrait of his daughter Eleonora. So it was probably not for its faithful reproduction of physical features that the painting was admired, but rather for the way those thoughtful and even slightly melancholy eyes allowed a psychological reading (all the texts on physiognomy from that time emphasize the eyes as the window to the soul). This was what Mantegna had always neglected in his heroic portraits, and it was an experience that Isabella had not wished to face in Leonardo's higher degree of intensity. Costa could guarantee an emotional resonance that was measured and general, a first stage in the great discovery of the phenomenology of emotions that music and poetry were showing to the Italian courts. We know from the portrait of Giovanni Battista Fiera, now in London, that he could do even better.[86]

The psychological assimilation of painting, music and poetry was familiar to the Gonzagas, particularly to the *marchese* Francesco, from Teofilo Collenuccio who, in order to justify the delays in some work at Marmirolo, had explained that 'the painter, the musician and the poet all by nature need a long time to purge themselves, particularly their heads, since most of the time they have something of the madman in them';[87] Francesco Gonzaga adapted to the situation and always remained on friendly terms with Costa, whom he remembered even in his letters from prison, willingly forgiving him even when his whims were the cause of diplomatic mishaps: 'We had commissioned from Costa our painter a portrait of Loyso', the *marchese* writes to the archdeacon of Gabbioneta on 16 March 1514, 'but he too like so many excellent minds has something of the eccentric in him. We understand that he has not been thinking about it much, and we must wait until one day he suddenly feels like it, and then I believe he will do it perfectly.' It was not a good time to insist, and the *marchese* handed the commission for the portraits of his children to be sent to Rome over to Bonsignori, who was following nobly in the Mantegnesque tradition at court. These portraits enjoyed

equally great success at the papal court, and Raffaele Riario (better known in Rome as the Cardinal di San Giorgio and as a sophisticated patron of works of art) had them copied by Raphael.[88]

We come across Bonsignori and Costa paired together in the dedicatory letter to Giovanni Battista Fiera's *Sylvae*, where, disguised as Alberti's Momus, Fiera praises the generosity of Francesco Gonzaga towards his court painters; this gives Fiera the opportunity to distinguish between the styles and preferences of the two star painters of the Mantuan court, and it is a passage of no small importance in the history of Italian art criticism before 1515 (the year when *Sylvae* was published):

> *Si molles fucos et blandimenta requiras*
> *et tibi quaeratur deliciosa Venus,*
> *en Costa tibi molliculum Charitesque ministrat,*
> *en Venerem, en comites, delicias Veneris.*
> *Seria si mavis et subnascentia rerum*
> *semina resque suam quae referant animam,*
> *non pinges – dices – quae Bossignorius audet:*
> *ille polit – dices – mollius, iste creat.*

> (If you require sweet deceit and flattery and seek delightful Venus, the tender Costa with his attendant Graces is for you, and Venus and her followers, and the delights of Venus. But if you prefer the serious and hidden seeds of things, and the things which represent the spirit, you say you do not paint what Bonsignori dares: you say the latter more gently refines, while the former is more creative.)[89]

The honours of the day were all Costa's as 'a man not only most excellent at painting but a popular and honoured courtier', so much so that he is called upon to compete with a painter employed by the king of France (in 1517 it could easily be Leonardo) for a 'nude figure or a Venus', which it seems appropriate to identify with the one in Budapest (although much work is being done to verify the dating of Costa's late works, and for now I shall not take up a position on this). Francesco Gonzaga sent the *Venus* requested by the devout king with a letter dated 30 November 1518 in which he indulges in allusions which Isabella's culture and her figurative moral code would have forbidden her to enjoy:

> With this chamberlain of my son Federico I am sending Your Majesty a painting which I commissioned specially from my painter, since I understood you wished to have an image of this kind. I know that the said picture is on its way to meet a good and great judge of corporeal beauty – particularly female beauty – and therefore send it all the more gladly.[90]

In Costa's own lifetime his critical acclaim as a delicately emotional painter began to falter, and an early sign of this shows in a sketch for a life of Raphael written by Paolo Giovio, who had nonetheless compared Costa himself to Apelles in a letter to Equicola in 1522:

> *Costa suaves hominum effigies, decentes compositosque gestus blandis coloribus pingit, ita ut vestitae armataeque imagines a nemine iucundius exprimi posse iudicentur; verum periti censores non velata magis quam nuda, graviore artis periculo, ab eo deisiderant, quod facile praestare non potest, quum certiores disciplinas ad picturae usum remissioribus studiis contentus conferre nequiverit*[91] (Costa paints delightful images of men, nobly composed of gesture with charming colours, so well that clothed and armed images are not thought to be represented more agreeably by anyone else; but skilled critics would like to see him paint things not veiled but naked, which are a harder test of art, one that he is not able to pass, since while he is happy with less demanding pursuits he cannot apply more reliable disciplines to the use of painting).

Giovio is of course speaking for Rome from Rome, a city where the archaeological classicism of the Raphael school imposed a supranational style which would eventually overthrow the last representatives of the courtly stylistic confederation (see also at the same date the even harsher judgement on Perugino, also still living); and it was not just men and their local reputations which then collapsed. With the first signs of Mannerism, as a style which tackled the nude of ancient art ('a greater test of art') with Michelangelesque boldness and could master the 'more reliable disciplines for the use of painting' (entirely formal disciplines), came the end of the courtly illusion of a chorus which was harmonious and at the same time varied in the figurative ideas it fostered. The imitation controversy between Bembo and Pio was a point of no return, and the northern courts, which had thrown in their lot with the losing side, began to suffer the obvious consequences. This point is proved by Giulio Romano's arrival in Mantua.

A sculptor, musician and poet at the court of Isabella: Gian Cristoforo Romano

The *Collettanee Grece Latine e Vulgari per diversi Auctori Moderni nella Morte de l'ardente Seraphino Aquilano* (Bologna, 1504) constitute the best catalogue of courtly society in the year 1500 (when

Aquilano's death actually took place) and it is a fact of some considerable, though not exceptional, importance that it contains a sonnet by Gian Cristoforo Romano. Among his fellow mourners are at least two other literary artists (who to different extents were stronger in one or the other profession): Gerolamo Casio and a certain 'Ercole, painter from Bologna' who may be Ercole Banci, hitherto not known at such an early date.[92] Gian Cristoforo's sonnet is not particularly charming, but it did not go unnoticed, and nor did Bramante's Milanese sonnets, which are a chip off the same block, though of a higher standard. The mention of Bramante is not out of place, since Romano first surfaces in the cultural history of late fifteenth-century Milan, along with Bramante himself and Leonardo, and from then on he seems to have reconciled his work as a fine chiseller of marble and medals with his literature and music. In 1491, when Isabella asked him for a portrait of herself, he turned out to be 'busy touring in company with other singers' and later, in 1496, he donned the costume of Acrisio, father of the hero, for the performance of Baldassare Taccone's *Danae*, which Leonardo staged for Giovanni Francesco Sanseverino, Count of Cajazzo, in the latter's house in Milan.[93] Nowadays Gian Cristoforo Romano enjoys rather limited critical acclaim as a result of Vasari's merely passing reference to him, which was perhaps worse than an outright panning, but he was accorded quite different status in his own time. It should perhaps be stated clearly at this point that, apart from his authority on the situation in Florence, Vasari is not a very reliable source for reconstructing the short-lived courtly culture which was squeezed between the giants of the Quattrocento 'who greatly added to these arts' and the triumph of Raphael and Michelangelo in the 'modern manner'. The situation was further aggravated by the fact that precisely in those formative years which concern us here, Florence had no real court, and is therefore almost excluded from the most characteristic, not to say the best, developments of the turn of the century. This absence of a court meant that things could happen in Florence that were unthinkable elsewhere (from the succession from Piero di Cosimo to Fra Bartolomeo to Andrea del Sarto, to the comparison between Leonardo and Michelangelo for the Sala del Gran Consiglio), and this was unaffected even by the period of Medici restoration. It would still have been possible for Florence to have experienced the life of a court at that point, albeit belatedly, but it was immediately compromised by the ascent to the papal throne of Giovanni de' Medici as Leo X, and the consequent transfer of the Florentine court to the palaces of the Vatican. The only real repercussion in Florence

of the 'modern manner' which then evolved in Rome was Michel-angelo's work on the tombs in San Lorenzo, and this was a term of contradiction rather than of balanced development, as we can see in the crisis of Andrea del Sarto and Pontormo's desperate struggles. Rosso Fiorentino's salvation was his trip to Rome, following a path already trodden by the Sienese Beccafumi, but, unlike Beccafumi, Rosso never sought to resettle in his native city.

These thoughts on Vasari and Florence have taken us far from the point, but they were strictly necessary in order to justify the lack of references to Vasari in these pages and the constant avoidance of Florence in the artistic itineraries we have been describing, with the exception of Leonardo (and the exception is understandable in someone who was born and raised in a tradition profoundly differ-ent from the courtly one, which was still open to adjustment but never to self-betrayal, even in its death throes). The case of Siena merits separate discussion, particularly the palace of Pandolfo Petrucci, of which there remain only a few traces, which are nonetheless highly significant; but it would not be a very pro-Florentine debate, favouring instead the Umbria–Rome area which, up to the time of Raphael and Michelangelo's monopoly of the Holy See, formed a more close-knit cultural unit than is generally believed. But let us return to our sculptor and to his fortunes in the first few decades of the sixteenth century.

We can begin with June 1506, when Cesare Trivulzio wrote from Rome to tell Pomponio Trivulzio of the discovery of the *Laocoon*:

> that statue which Pliny says was all of a piece, including the sons; Giovannangelo Romano and Michel Cristofano Fiorentino, who are the best sculptors in Rome, say that it is not made of one piece of marble, and shows around four joints, which are joined in such hid-den places, and so well mended and replastered, that they are not easy to find except for those who are very skilled in this art.[94]

If we cross the names of these two 'best sculptors in Rome' we recognize our own Gian Cristoforo Romano, from whom Julius II had commissioned several prestigious medals, and Michelangelo Buonarroti, who was at the time engaged on the tomb of Julius II.[95] The marriage of the two names counts in favour of Gian Cristoforo's authority and his association with Bramante a few years later for the sculptural decoration of the Holy House of Loreto is an even bigger point in his favour. In 1506 Gian Cristoforo Romano's refined decorative classicism had already reached its peak in the door to Isabella's studiolo (dating from just before he left for Rome) and in

the beautiful central section of the Trecchi monument in Cremona (begun in 1502). In the papal city such achievements could still be seen as the highest expression of a form of sculpture that local tradition had exploited principally for decorative purposes, and strong traces of that taste can be seen in the first blocks Michelangelo worked for the tomb of Julius II and in the Sforza and Basso tombs executed by Andrea Sansovino in Santa Maria del Popolo (the tombs bear the respective dates of 1505 and 1507, which can be taken as probable dates for the beginning of the work).

The success of Gian Cristoforo in his full maturity as a man and as a sculptor was not confined to Rome, as it is he who is praised by Pietro Bembo in a letter to Isabella d'Este from Urbino of 5 November 1508 'for his virtue and the many noble elements that are in him', praise that is evenly divided between his art and his courtliness.[96] In fact such recognition was only his due for a man who had earned a place among the characters conversing in Baldassare Castiglione's *Book of the Courtier*, and he is found there not merely as a voice defending sculpture against painting, but as an integral part of a society still generously disposed towards personal virtues.[97] His literary ability forged openings for him which would otherwise have been impossible, and, apart from his sonnet for the passionate Serafino, we have evidence of his talent in Equicola's preface to the *De natura de amore*, which is preserved in manuscript in the Biblioteca Nazionale in Turin: according to Equicola, Gian Cristoforo, 'a most excellent sculptor and a most virtuous courtier', worked on the vernacular edition of the treatise, which, as we now know, was not a translation from the Latin, but if anything an updated rewriting suggested by the maturing of the debate on language.[98] Equicola's testimony can be from no earlier than 1509 and even after the sculptor's death there are those who remember him as 'Giovan Cristoforo Romano, who, besides his other virtues and particularly his music, was in his day an excellent and famous sculptor, very sensitive and diligent', essentially third in the hierarchy of the greats after Donatello and Michelangelo (from Sabba Castiglione's *Ricordo cerca gli ornamenti della casa*). Gian Cristoforo progressed along this path and, through an epitaph by Casio, to the pages of Cesariano and Michiel, who remembers the Trecchi tomb in Cremona 'for its subtlety of foliage' and a crystal cup which was not 'very perfect, but very industrious', and which had passed from Francesco Zio's collection to Andrea Odoni's (which was not a collection to include any but the most highly qualified works). On the other hand, the Lombard Paolo Giovio did not even find room in his pages for Gian

Cristoforo Romano (instead he includes the Milanese Solari), and the sculptor's success was to fade in those few imprecise words from Vasari in 1568: 'It was the work of Paulo (Romano) Iancristoforo of Rome, who was a good sculptor, and some of his works are in Santa Maria Trastevere and elsewhere' (in the 1550 edition he was even meaner).[99]

The marks Gian Cristoforo left on Rome were certainly few, although they are found in monumental works, but it is quite interesting to follow his stay in that crowded capital, which was in the throes of revival at Julius II's instigation, especially since Isabella's sculptor immediately became involved in the very active antiquarian collecting scene. His first letter from Rome to the *marchesa* (1 December 1505) gives an enthusiast's view of the new panorama:

> I then waited to see the antiquities, and so many beautiful things have been found that I was amazed, and here many people are so excited that it is very hard to get something one would like unless one fights to be the first to see it and to pay for it without haggling, since as you may understand they fetch high prices. I must go and see a bronze panel all worked with damascened silver with ancient figures which I am told is a lovely piece: if I think Your Ladyship would like it I shall make a deal because it is something that would grace any position and you have no others like it; and I shall stay alert; I have already been informed of many things that have been excavated and others to be excavated, but if Your Ladyship comes to Rome for this Carnival I guarantee that you will be given some fine things ... I must tell Your Ladyship again what an excellent and unusual piece that *Cupid* was which Master Lodovico Brugnolo took Your Ladyship, and can surely be proved to be a great rarity and worth a great deal, and I promise by the God I worship that if it had been taken in anyone's name but Your Ladyship's it would never have left Rome. Because in the past when I was a youth I used my wits and power to keep such things for the late Cardinal Ragone and Lorenzo de' Medici because it hurt me to see Rome despoiled of such unusual things, for there are few like them ...[100]

The *Cupid* acquired for Isabella by Brognolo came from the collection of Alessandro Bonatti and, given its reputation as an original work by Praxiteles, it had been insistently sought after by the *marchesa*, who was always rather short of money, since 1498. It arrived in Mantua in February 1506, and Isabella engaged another sculptor from her circle, Pietro Jacopo the Elder, for the necessary restoration work.[101]

An equally tortuous series of events befell the second *Cupid* which Isabella found room for in her collections, which were planned as decoration for the 'grotta' directly adjacent to the *studiolo*, though this time it was a modern work. By the summer of 1496 the statue in question had already been brought to Isabella's attention as a 'putto, which is to say a Cupid, lying asleep with his head resting on one hand, intact and about IIII spans long, which is very fine; some think it is an ancient work, and some a modern one; whichever be true it is thought to be, and indeed is, most perfect...' (letter from Anton Maria della Mirandola of 27 June 1496); but Isabella had not wanted to buy it once it was proved to be a modern work, by a young sculptor who had recently arrived in Rome. After passing through a number of other hands, the *Cupid* had finally ended up at the Ducal Palace in Urbino and had been taken from there by Valentino when Montefeltro rule ended. Having made sure that her dispossessed brother-in-law would not be resentful about it, Isabella negotiated with Valentino to acquire the sculpture for her own collection, and obtained it in July 1502. The passage of the years had put quite a different light on the young man, who had been practically unknown in 1496; it was in fact Michelangelo Buonarroti, who was by now famous in Rome for his beautifully refined *Pietà*, commissioned by Jean Villier de la Grolaie, cardinal of Santa Sabina, and placed 'in the church of Santa Petronilla, in the Chapel of the king of France, near to the Sacristy of San Piero' (according to Condivi's account). The exceptional delicacy and translucence of Michelangelo's *Pietà*, which we nowadays see as relating to what Fra Bartolomeo learned in Florence, was misunderstood at the time (though not too disastrously) as adherence to the polished taste of the northern sculptors, who had been influenced by the style of Leonardo, and there was a rumour that the work was by Solari, who had replaced Gian Cristoforo Romano in the service of Ludovico Moro.[102]

I see no reason to be surprised by Isabella d'Este's insistence on acquiring statues portraying Cupid to put in the most intimate rooms of her apartment; such statues were in accordance with the iconographic theme which dominated general decor, and the fact that Michelangelo's was a sleeping *Cupid* was particularly significant. Not only is sleeping love without danger for anyone vulnerable to the wounds of his darts, but – more subtly – the meaning of his sleep ties in with Mantegna's second painting, which was delivered to the *studiolo* in that same year, 1502. The connection is justified by a comment Isabella made on a hat medallion she gave to her daughter

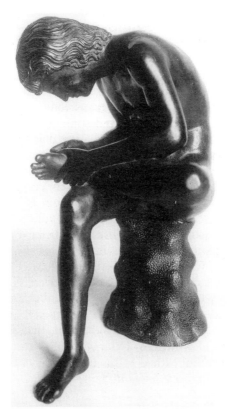

Plate 129 L'ANTICO, *Spinario*, 1501(?), Galleria Estense, Modena
(from the collection of Ludovico Gonzaga).
Photo: Soprintendenza per i Beni Artistici e Storici di Modena.

on 28 October 1512; the medal showed 'a Cupid resting within a
bower hung with ash leaves, where according to the philosophers'
words no serpents or vices may enter . . . with a motto reading *Tuta
quies*'.[103] It was a motto which Isabella could consider her own
when she shut herself in her *grotta* or her *studiolo*, surrounded by
paintings reflecting her moral and philosophical convictions and by
the varied range of her collection of works ancient and modern: the
Faustina once carved by Mantegna, the *Spinario* and the *Hercules
and Antaeus* made for her by Antico, the two *Cupids* we have
mentioned, the 'ancient . . . oil lamps' sent her from Naples by the
Marchesa di Cotrone, the precious engravings which were a gift

from the Chigi brothers in Rome, the marble head which had travelled from Rhodes to Venice and been sent to Isabella by Gian Francesco Valier.[104] Along with the works of art, of which this list gives just a taste, the collection naturally included all the curiosities of a *Wunderkammer*, as was only right at the time for a collector who was not professionally involved in archaeological research, especially one still so young when she started her collection. We must therefore think of the emerald 'found in the tomb of Tulliola' as well as 'one of those stones which breed atractylis in one night' as possible ornaments for the desk where Isabella wrote her most intimate letters, just as a fine shell is displayed on St Augustine's desk in the painting by Carpaccio in the Scuola di San Giorgio in Venice, possibly from around 1502, which is fascinating, apart from its intrinsic quality, for its portrayal of a collector not altogether unlike our *marchesa*.[105]

Gian Cristoforo Romano was close to Isabella d'Este, not just as a source of information and advice, but also for the similarity of his own art collection, which, on his death on 31 May 1512 at Loreto, included thirty-four bronze medals, eighty-seven silver medals, engraved cameos, pieces of jewellery, some possibly ancient sculptures of Pallas, Mars, Cleopatra, a *putto* playing the lyre and of course a *Cupid*. But possibly the strongest indication that Gian Cristoforo belonged to a world which by 1512 was on the wane is the book which the sculptor bequeathed to his own notary: a courtly manual of course, Pietro Bembo's *Asolani*.[106]

From moral fables to emotional reality

The 'parchment-printed' copy of the *Asolani*, a de luxe edition, is also recorded as being among Isabella d'Este's books, and appears likewise in her husband's catalogue of books, which does not match hers, being quite different in character: Isabella's library is all literary topicality, while Francesco Gonzaga's is more differentiated and practical.[107] Using a catalogue of his reading matter as a base, it would be quite fascinating to reconstruct the personality of the warrior *marchese* who collected books of dreams alongside devotional texts, with a marked preference not found in Isabella's library for illustrated works. The few overlaps are symptomatic; apart from the *Asolani*, notable ones are the writings of Equicola and Sannazzaro's *Arcadia*: the basic repertoire for a good courtier of the early sixteenth century who was either too late or unwilling to bring himself better up to date. Castiglione's *Book of the Courtier* is not there (it was published in Venice in 1528) and while this omission is quite understandable

for the *marchese*, who died in 1519, an explanation is needed for Isabella, always assuming that the book's absence is not accidental.

Another strange thing we notice is that Isabella owned a manuscript of the *Arcadia*, not one of the many available editions, and if her manuscript could be identified with manuscript V, 53, which used to be in the Biblioteca Nazionale in Turin, it would have been an unfinished version, which was widely circulated in northern Italy until Summonte's quasi-official edition (Naples, March 1504).[108] Therefore we cannot rule out the possibility that Isabella had an early preview of the work, ahead of the pirated edition in June 1502 in Venice and before Jacopo d'Atri requested some verses from Sannazzaro in the *marchesa*'s name during his distant exile in France (February 1503). The relationship between the Neapolitan man of letters and the *marchesa* of Mantua is unclear; even the only letter directly from Isabella to Sannazzaro (30 March 1507) shows only a general acquaintance, albeit a cordial one. The theft she later engineered from the poet, in 1515 (a theft of poetry naturally), at least shows how difficult the *marchesa* found it to get what she wanted from the Neapolitan writer. We do not know what our heroine thought of *Arcadia*, although it is very likely that she read it with the keenest interest; we know from other sources that the book gained instant and widespread acclaim at court, and that it came at just the right moment, after years of similar but less successful attempts. The clue to her interest turns up in the correspondence between Calmeta and Isabella in November 1504, devoted to 'precepts and observations relating to the composition of vernacular poetry'.[109] In his letter of 5 November Vincenzo Calmeta announces his demanding new work 'which without searching for Greek words I have called *Amoroso Peregrinaggio* (pilgrimage of Love)', and the tiny note of controversy could be not just against the *Polyphilus*. The theme of love rang very topically in Isabella's ear, since she was still busy with her desperate efforts to get the *studiolo* finished (her contact with Costa began in fact in 1504), but the content of that *Pilgrimage* was something quite different from the inventions of Mantegna and Paride di Ceresara; the planned work was to be

> divided into three books, mostly in prose, but with all kinds of verses to be found in the vernacular style mixed up in it, together with many styles newly formed by emulating Horace . . . since modern poets have seen fit to make the *terzetto* do the job of the *canzone*, and to express in the former, as in Latin elegy, mournful sentiments and love-laments . . . The figure of speech must be normal, but better frank and affectionate than full of fire and flourish.

So this was to be a sentimental novel in prose and verse, like the *Arcadia*, and not a mythographical and moral treatise like the *studiolo* or its literary models. Isabella's reply (of 25 November) is written with humble gratitude that he had grasped 'the importance of chapters, epistles and elegies, which has never been so well understood'.

Armed with such a reliable guide Isabella could address the whole of Sannazzaro's *Arcadia* as a literary work, but this is not to say that she was able to realize how this work of youthful mannerliness opposed so much of her less polished philosophical culture, and particularly her *studiolo*. None of the many works of art referred to in Sannazzaro's romance contain any moral message, or even the slightest veiled reference to any possible figurative metaphors of neo-Platonic theory: neither the Theocritean idylls painted on the gates of the Temple of Pales (chapter 3), nor the decorations on the vase of Elpinus, on a rather lascivious theme (chapter 4), nor the paintings in the tomb of Massilia (chapter 10), still less the 'fine vessel of maple wood, where the hand of the Paduan Mantegna, the cleverest and most ingenious artist of all, had painted many things' (chapter 11). Many things, no doubt, but none which could be compared to what Mantegna was doing in Mantua or to anything he would produce in the few years still left to him. The themes emerging from that charming romance were quite different, and they were all as good as foreign to Isabella: the extraordinary fascination with the secrets of nature and with magic (chapters 9, 10, 12), a new sensitivity in observing landscapes 'produced by nature', which reaches its culmination in the night scene in chapter 12, and finally the close analysis of 'the proud melancholy', 'the incurable sadness of mind', and 'the beating of the heart' which love and brooding bring with them (chapter 7). For a woman who found it difficult to yield to the leanings of her heart, even in her most intimate letters, all of this must have seemed indiscreet if not embarrassing. She may have felt at home in the book's musical moments, in the tender effusions of the Arcadian singers filtered through the discipline of music.

She must have found it even more frustrating to read the *Asolani* if she was looking for support for her own anti-erotic *studiolo*. This was no literary composition of uncertain constitution, but a treatise on love where as early as chapter 9 of book I, one of the protagonists (Perottino) expresses himself nonchalantly thus:

> Love is not the son of Venus, my worthy ladies, though he is so designated in the poets' fables who, nevertheless differing even among themselves in this very lie, make him the son of diverse goddesses,

as if anyone could have various mothers; yet he was begotten not by Mars or Mercury or Vulcan either, or any other God; but in our minds by those base progenitors, the excessive lust and heavy indolence of men, is born the offspring of our sensuality and vice,

and so on, without acknowledging any kind of love more celestial than this. Persevering through to chapter 18, one meets a fine example of an iconographic reading of Cupid which is absolutely contemporary and intensely psychological, with no reference whatsoever to ancient myths. Still further on, in chapter 22 of book II, the same metaphorical image that Perottino had so cleverly debunked is further brought down by Gismondo, a fortunate lover:

> And yet Perottino will say that lovers are blind: but he is blind himself since he does not see what there is to see, and deludes himself, not when he sees – for what does not exist, nay, what cannot exist, cannot be seen – but when he describes a naked boy with wings and fire and arrows, like some new-fledged chimera, and feigns, as it were, to gaze in one of those glasses where men are accustomed to show marvels.[110]

The enchanting world of classical myths 'with beautiful meanings' was crumbling under the blows of a new science of love concerned first and foremost with the 'inequalities, the dissensions, the delusions which Love pours and mixes in his servants' minds with such painful incongruity' (I, 12), and next with the delights of happy lovers and the complex problems of an etiquette of love which had been the speciality of a new generation of ladies who stepped into the limelight as Isabella reached thirty; ladies able to 'untie the knottiest questions and to judge them when untied' (II, 2) and who, in the *Asolani* and elsewhere, are acknowledged to be 'naturally more inclined . . . and more amenable to Love's assaults' (I, 30), and venture more boldly into the game of the relationship between the sexes. This was certainly not the case for Isabella, whose famous reputation for unassailable virtue dogged her all her life, as did gossip about her frigidity towards her husband, who was infected with syphilis. At some point in the book Isabella may nevertheless have succumbed to emotion and dreamed of the modern fable of the Queen of the Fortunate Isles, in whom she may have recognized herself (III, 18), while going back over the subtle joys of the lover's song (II, 25 and 26), or identifying her ambition of invincible natural elegance, without ostentation, in the feminine image which runs through chapter 23 of book II:

seeing his lady with her companions tread the happy meadow grass; or stroll along green banks by limpid streams; or in soft breezes walk the willing seashore's sandy spine, on which she writes warm verses to her watching lover; or in some smiling garden pluck dewy roses from their stems, a gift perhaps intended for the one who sees her; or as she dances, move her artless, well-knit person in time to the resounding instruments, now winning admiration with her stately steps, now charming everyone with her enchanting turns and lithe delays, now with her quicker motions striking the beholder's eye like some onrushing sun.

This was possibly how Isabella appeared at the wedding of her brother Alfonso in 1502, when she triumphed over all the women there 'in beauty and good looks and grace and all things' (and the term 'grace' is the one which will turn up in the art treatises);[111] the bride herself was almost overshadowed by her in the eyes of all present although she was none other than the beautiful Lucrezia Borgia.

Spending time with avant-garde men of letters and reading contemporary texts made Isabella aware of a reality which the 'inventions' of Mantegna and less modern literary figures (even Equicola) had hidden from her behind their display of humanism, deluding her with the wonderful charm of a solemn and nobler classical world. In the end she distanced herself from the inadequacy of Mantegna's painting, which was 'lapidary' in more ways than one, compared with the moving private experiences and the newly awakened sensitivity which love poets and musicians had been clandestinely trading in at her court. Costa's painting with its modern theme seems to be an iconographic response to this profound discovery, with its scholars and singers crowning the *marchesa*, who has arrived in the kingdom of Love, but the most genuine response is found in his peculiar softness of line, his generous curves and slowly evolving rhythms, the pure and velvety glaze of the colours, in the living landscape, which, unlike Mantegna's *Garden of the Virtues*, comes across as a possible equivalent of the opening scene of the *Arcadia*, where 'the tall and spreading trees brought forth by nature on the shaggy mountains' take pride of place over the 'cultivated trees, pruned and thinned by cunning hands, in ornamental gardens'.[112]

The encounter between Pietro Bembo and Isabella, several times postponed, finally took place in June 1505, when Costa's painting was still being installed, and they soon struck up a friendship on their common ground of music and poetry. The first letter Bembo wrote Isabella (from Venice, 1 July 1505) enclosed

ten sonnets, and two *strambotti* [satirical poems] which have devi-
ated rather from their rules . . . I also wish that Your Ladyship would
recite and sing some poetry of mine as I remember how sweetly and
gently Your Ladyship sang the others on that happy evening . . . For
that will be enough to make the audience like it and appreciate it
through the beautiful and charming hand and the pure sweet voice of
Your Most Illustrious Ladyship.[113]

We cannot yet identify the contents of Bembo's enclosure, and besides
we know that Bembo himself, many years later, censured his own
writing for music as having been tailored to facile fashionable tastes.
Certainly there is no trace of a *strambotto* in the official published
corpus of his work (and this is not the only censorship Bembo – by
this time a cardinal – was to exercise over his own youthful senti-
ments). But here we are not so much interested in Bembo's works
of poetry as in how surprising it is that while the *studiolo* closed the
door on such amorous and more generally emotional experiences,
they may have crept back in through the *grotta* in the form of works
of literature and live solo singing.[114]

Our best-qualified authority on this process is still Baldassare
Castiglione, a highly competent musician, and from him we can
learn how well Marchetto Cara, the most popular musician at the
Gonzaga court sang, with both Isabella and Francesco Gonzaga. In
a famous passage from the *Book of the Courtier* the comparison
between Bidone d'Asti, who sang for Leo X, and Marchetto seems
to put them almost on a par, but this is not how it would have
seemed to contemporary readers, and it is worth remembering that,
while Marchetto Cara was included in the passage from the first
version onwards, Bidone d'Asti appeared only later, to usurp the
place of Alexander Agricola.[115] 'The singing of our own Marchetto
Cara', therefore, 'is just as moving, but its harmonies are softer; his
voice is so serene and so full of plaintive sweetness that he gently
touches and penetrates our souls and they respond with great delight
and emotion' (I, 37). This model of controlled sentiment must have
been the basis for the development of Isabella's own singing skill,
which, ten years after Bembo's letter, still enchanted Trissino.

The figurative arts were carried along on the same tide of emotion
which brushed the Italian courts from the years just before 1480,
but which shortly after that point swelled and teemed with charming
sentimental riches as a result of the marked revival of interest in love
poetry and the unstoppable psychological investment by the new
generation in Arcadian escapism. Artists, and particularly painters,

found they had to adapt by trying to convey within a now established canon of images (both for myth and for sacred works) an emotional experience which the artists themselves had already glimpsed in the pathetic iconography of Gerson and so much of late Gothic religious sentimentality, but which the austere demands of classicizing archaeological humanism had stamped out. It was hard, slow work and we modern observers can spot few signs of it, since there is no record of the survival of the 'International' tradition in the bosom of the Quattrocento, its deathbed recovery on an emotional level in pictures stripped of any contemporary clothing. The shrewdness of form in Perugino, who is the first protagonist of this change, consists in quickly abandoning the authoritative dignity of the Florentine models he had learned from in Verrocchio's workshop and in reclothing in vaguely archaeological garb – never very chronologically or geographically specific – the sinuous figures of the late Gothic era, the honeyed, rather childish, religious sentiments which came in at the end of the fifteenth century, the trailing rhythms with easy, chirping rhymes of all those outmoded cloaks, mantles and tunics which could be replaced with humanist equivalents. The updating operation took less than a generation and gathered such momentum in the course of the 1480s that by the end of the Quattrocento any opposition was dramatically quenched. Of the old generation Andrea Mantegna was perhaps the extreme case of resistance; the only person who can stand beside him – though not entirely equal – would be Foppa, who paid the price of failing to adapt by being squeezed out of the Milanese court (and anyway he had no chance to stage a revival, when the crunch came, against the inexhaustible 'invention' of his colleague in Mantua). Giovanni Bellini had a better idea of how to tighten up his act, and was better aware of the deeper and healthier aspects of this cultural and moral watershed, which came when he was no longer in the first flush of youth. Protected by his deep-rooted Aristotelian beliefs, he saw the powerful surfacing of the emotions as another area for his descriptive analysis of natural phenomena and produced the greatest and most brilliantly balanced masterpieces of the close of the century. Leonardo was much more disturbed and fired with desperation, and put all his efforts into the rational explanation of the movements of the heart and in the graphic rendering of this disturbing experience, through his work in anatomy, physiognomy and technical codification. The newly discovered realities were almost impossible for the senses to grasp and threatened his ordered empirical constructions. The portrait was not a pure physiognomical anatomy; it now required some

subtle sign of a direct relationship between painter and painted, a dialogue which could not be reconstructed with any amount of 'exquisite words'; landscape could not be tied down to a topographical and meteorological theme once the observer's state of mind was projected on to this natural reality, even if he was not an Arcadian shepherd. Figurative art asked its exponents to reproduce the miraculous non-material metaphor of music, a consonance not easily translatable into signs or words, a psychological leap beyond the boundaries of the secret preserve they had kept to themselves.

If Leonardo ever came across Giorgione, as is not necessarily impossible, he would have been all the more convinced that 'painting could be superior to poetry' (it was certainly superior to the sentimental poetry of the time), but once again, 'since its exponents do not know how to speak its reason', he would have pitied it for 'having been so long without good representatives'.[116] We still share Leonardo's regret: there is no source of direct testimony from the artists who were part of that decisive break. Reading between the lines of Leonardo leads us instead to discover a person on the defensive against that blow, trying to exorcize it with the artless reasoning of a man 'without education'. However long the list of educated and musical artists, and I think we can now see the reason for such preferences, none managed to leave us a trace of their own private response; this is a sign of their still low standing in society compared with the lofty importance of history; a not dissimilar fate also befell professional musicians of the time, who had only just set up a written tradition and their own musical publishing industry.[117] By contrast it was often recalled how 'Petrarch . . . having heard of his brother's death, was heard to sing', and that Poliziano himself died singing and playing the lute; even the death of Ercole d'Este, Isabella's father, passed into history accompanied by the music of the court minstrels (letter from Agostino Silla to the *marchesa* of 24 January 1505).[118]

Research continues, and there is every chance that further investigations will mitigate our disappointment on this score, especially as there seems to be at least a possibility of coming very close to that delicate and exclusive relationship which was now the rule between patrons and artists in certain social circles (public commissions of a religious nature are quite another – though not entirely opposite – question). We have not taken Giorgione's name in vain, because we know how his reputation reached Mantua and aroused the curiosity and collector's zeal of Isabella d'Este.[119] As soon as the great Venetian painter died the *marchesa* tried to purchase from his heirs 'a night

painting, very beautiful and unusual' (letter to Taddeo Albano of 25 October 1510). The purchase turned out to be impossible, although there were two 'nights': 'from what I have been told, neither of them is for sale at any price, since they had them painted in order to enjoy them themselves' (Taddeo Albano to Isabella, 8 November 1510). We know what kind of enjoyment they got from the moving testament of Gabriele Vendramin, another collector of Giorgione's work, drawn up on 3 January 1548 (but remember that Vendramin was born in 1484, only ten years after Isabella d'Este). The will is very famous, but I think it is worth reproducing one more time the words of a man ready for death to come and take him, but still concerned about his collection as one of the more important reasons for his life on earth:

> I do not wish to miss saying that all these things, both for their excellence and rarity and for the many years of effort which went into acquiring them, and especially since it was these things which gave me a little peace and repose of mind from all the mental and physical exertions I underwent in my family business, are therefore so pleasing and dear to me that I am bound to beseech and exhort those to whom the above-mentioned objects shall pass to be careful that they do not get lost.[120]

After the farewells to life, accompanied by music and song, this is a farewell softened by a last loving look at his collection: two paintings by Giorgione, two portraits by Giovanni Bellini, numerous contemporary drawings including two by Raphael, others from a now closed chapter of late Gothic (Jacopo Bellini and Michelino da Besozzo), and finally a number of paintings by 'western artists'.[121] Gabriele Vendramin was by this time a survivor of the age in which he had taken his place on the Venetian stage and played his part; the ideas currently in vogue in Venice and elsewhere, especially Rome, were quite different. In the four years between the making of the will and his death (17 March 1552) we may hope that he never heard of Michelangelo's irritating verdict on Flemish painting, which we find on record in Francisco de Hollanda's *Tratado*, also from 1548. The will and this ferocious slating are only apparently contemporary: at a time when archaeological and secular mannerism reigns supreme, Gabriele Vendramin is remembering a more free and profound figurative sensibility, while Michelangelo is a menacing foretaste of how the Counter-Reformation was to exploit that emotional tendency, once it was exposed and vulnerable.

Exeunt fabulae

The death of Andrea Mantegna, at a ripe old age for the time, did not put an end to his fame, which lived on the same as ever in the poetic compositions of those who had been his friends in life, and those who continued to see him as the symbolic representative of the figurative arts in Mantua, even after the arrival of Giulio Romano. We can even detect, in the texts closest to his last years and immediately after his death, an attempt to update the painter's image in terms of the new psychological and sentimental manner. This seems to be the only way of interpreting Falcone Sinibaldi's description, inspired by a painting of Mantegna's showing Atalanta and Hippomenes: 'The painter Mantegna produced living beings . . . and the painter showed a race . . . a man panting to the finish, and a girl panting there . . . the man gazes astonished at the face of the girl he desires.' Not even in the famous portrayal of the *Occasio* in the Ducal Palace did Mantegna ever achieve such vibrant and psychologically detailed invention; nuances of feeling and more subtle reflections are beyond the scope of his impassive or extreme physiognomic portrayal. Of course, particularly in his last years, the very abundance of repeatedly exasperated facial contortions suggests that the idea of communicating emotion had occurred to Mantegna and found him unprepared. Giovanni Battista Fiera's verses '*Ad Marium fratrem*' also raise some puzzling questions when they praise a Gonzaga building as

> . . . *tectum augustum pariis insigne columnis*
> *conspicuumque nitens docta speciosius arte*
> *Mantyniae Cous merito cui surgat honore*
> *pictor Aristidesque animi formator anheli.*

> (. . . a majestic house distinguished with its marble columns and brightly shining with the learned art of Mantegna, to whom let the painter of Cos [i.e. Apelles] rise to honour him as he deserves, and Aristides, who gave shape to the breathing spirit.)

Both Mantuan texts are not above suspicion as academic exercises, like Casio's eulogies in the *Libro de Fasti*, and it is perhaps more appropriate to look for clues in less learned documents, which were not designed first and foremost for a literary audience.[122] For example it is strange that the brilliant and comical Fra Mariano Felti, writing from Florence to Francesco Gonzaga (29 January 1513), should recall among the jewels in the *marchese*'s collection the

'*Triumph of Petrarch* by Andrea Mantegna glory of Mantua'.[123] Since it has been established that Mantegna also painted a series of triumphs from Petrarch, it is important to uncover this reference to it as superior to the *Triumphs of Caesar*, at a time when Petrarch's literary success was universal. In 1514 a letter from Michiel to the painter and goldsmith Guido Celere acknowledges that Michelangelo could be compared to Mantegna with only the smallest margin of suspicion that the Florentine might actually win the day, and Folegno again compares him to Buonarroti and Raphael.[124] This always very generalized praise is heaped on Mantegna over and over again even in the more authoritative and important works of Castiglione and Ariosto.

The list of *eccellentissimi* in chapter 37 of book I of the *Book of the Courtier* is bound to be suspect to some degree, whether one chooses to accept the date of the literary framework (1507), or a more recent date based on the first proper edition of the dialogue (*c*.1516) or a still later one based on the date of publication (1528). Alongside Leonardo, Raffaello, Michelangelo and Giorgione, all much younger than him, Mantegna's name always sounds a false note: in 1507, not long after his death, he must surely have been eclipsed by the fame of Perugino and Bellini; in 1516, and even more so in 1528 (nearly a century after he was born), it was clear to all the experts that his sun had set, and it was clearest of all to Castiglione, who knew more than any other writer about the problems of modern art. His place in this Parnassus can be justified only as political opportunism, given Castiglione's official reconciliation with the Mantuan court following Francesco Gonzaga's death, and his own Mantuan roots.[125] In the eighth edition of the *Orlando Furioso* (XXXIII, 2), to be dated 1532, the obligations ensuring Mantegna's presence alongside Leonardo, Bellini, the Dossi, Michelangelo, Sebastiano del Piombo and Titian are still the constraints of good relations with the Mantuan court and of northern regionalism, but they cannot long survive.[126] Giovio, another lover of the north, had already dropped Mantegna's name in favour of Costa's, and in Vasari the undeniable limitations which confine Andrea Mantegna to the artists of Part II of the *Lives* and not Part III surface at last: '. . . he had a rather rigid and mean way of painting drapery, and a rather dry manner.'[127] After this waning of his fortunes his 'symbolic' rehabilitation was obviously bound to be the work of a Lombard, and this of course was Lomazzo.

Parallel with this main stream of the survival of Mantegna's fame runs another, rather unpredictable, one, preserving and spreading

the Mantuan master's name outside Italy and benefiting from indirect words of praise attributed to Michelangelo by Francisco de Hollanda; in the list of the best painters to be admired in Italy in his time Michelangelo did in fact happen to recall that 'the Palace of the Duke in Mantua where Andrea painted the triumph of Julius Caesar is most impressive; even more so are the stables painted by Giulio the pupil of Raphael.' The entirely secular and contemporary anthology contained in those pages is certainly the work of Francisco and not of Michelangelo, but this reference to Mantua is important because it may still have influenced Juan de Arfe for his strange catalogue of the great Italian masters: 'Pollaiuolo, Baccio and Raphael, / Mantegna, Donatello and Michel'.[128] In this company of Florentines Mantegna was by now little more than a fading myth (this was 1585), a historically rather insubstantial name for anyone not familiar with the history of Italian art: already more than one reader of Cieco d'Adria's *Pentimento amoroso*, in 1575, must have wondered who this 'Andrea Mantegna, most noble shepherd' was, who had made 'a fine drinking vessel of beech, not yet used'.[129]

The blurring of the precise outline of the figure of Mantegna runs parallel with the gradual fading of Isabella d'Este's reputation as an arbiter of artistic and literary culture. In reality much else disappeared from the historical horizon of Italy under the blows of defeat at Agnadello (1509) and Ravenna (1512), but here we must confine ourselves to seeing the fatal unbalancing of the Italian courts at work in the slow but steady decline of the *marchesa*'s authority and in her isolation from the swelling tide of the Roman manner, soon to become the Italian and European manner, both in the figurative and literary arts. These seem to have been the years of her greatest personal fame, and the cleverness she showed in maintaining the government of the marquisate during her husband's imprisonment in Venice (1509–10) earned her the esteem of the emperor and the king of France, as well as their private reproaches, surpassed only by Julius II's ferocious abuse. Such subtle defensive tactics had never before been seen on the Italian political scene, combining cultural prestige, personal charisma, gifts which were not ostentatious but always appropriate, complex games of pretence and compromise, deceptions and intrigues.

The elegant astuteness of her political ideas was of the old school and seems more like something from a manual written at the time of Lorenzo the Magnificent than from an age when French troops were really crossing the Alps into Italy, followed by the imperial forces, to settle questions which went beyond the tiny confines of

the old Italian states. Isabella would never be a female version of 'The Prince'; she would always be a 'court lady', on the lines of the charming profile drawn by Castiglione in book III of the *Book of the Courtier*. Her new political manoeuvrings, first for her imprisoned husband, then for her family in Ferrara under threat from Julius II, and finally for the uncertain return of her nephew to the Milanese throne, distracted the *marchesa*'s attention too often, and dragged her all over Italy for a series of personal meetings which she thought could make up for the troops-based politics which had never been an option for her or her husband, just as they had never had inexhaustible financial resources. News of her literary and figurative interests dwindled, but did not dry up completely; it is difficult, however, to reconstruct a definite outline of them, because the elite in Rome, where Isabella was pretty much a stranger, was now clearly holding all the aces.

In 1511 she received from Rome some poetry composed on the death of her dog Aura, a final frivolous and demeaning example of the solidarity of courtly culture, but by the following year a series of embarrassing scandals broke, which showed her up as a protectress of literary figures who were no longer on the crest of the wave, or who were about to face a tough descent from the highest peaks of Parnassus. It is quite possible that the astounding satire of November 1512 entitled *Epistola eloquentissimi oratoris ac poetae clarissimi D. Marii Aequicolae in sex linguis* may have come to her attention, especially as it concerned three people who were very close to her: firstly Equicola himself, then Giacomo Calandra and lastly Giovanni Battista Pio, from whom, towards the end of the fifteenth century, Isabella d'Este had learned so many 'exquisite words'. The Roman *Epistola* made mincemeat of such pedantic language, both for its Apuleian Latin and for its Boccaccesque or Polyphilesque vernacular. The linguistic myths to which Isabella had subscribed, either by her own hand or through her secretaries, were here exploded by an anonymous genius, who mimicked and distorted them at the same time as affected and ineffectual exercises in literary folly. This was not the only assault launched from Rome against the official representatives of the culture shared and promoted by Isabella, and should be seen in conjunction with the *Dialogus in lingua mariopionea* (1512–13), the crude antagonism of Tebaldeo towards Equicola, equivocally involving Isabella herself, and Accursio's *Osci et Volsci* dialogue, aimed at Giovanni Battista Pio.[130] This whole angry furore was dominated from the end of 1512 to the beginning of the following year by the debate on imitation between Bembo and Giovan

Francesco Pico and, with regard to the themes which have most concerned us here, by the *De Venere et Cupidine expellendis*, again by the younger Pico (December 1513), who was, as we know, the losing champion in the clash with Bembo.[131]

Gombrich has already compared this little poem with the Minerva painting in Isabella's *studiolo*, but it is worth adding some further observations in order to establish precisely how radically the relationship of the Roman intellectuals to the 'classical fables' had altered, and how a traditional neo-Platonist like Pico (who occupies the same ground as Isabella) ended up looking pathetically unequal to the moment. The letter dedicating the poem to Lilio Gregorio Giraldi describes the Belvedere Garden in the Vatican as it was at the height of Julius II's pontificate, with a splendid collection of recently discovered classical statues, certainly displayed without any thought of communicating some fine moral or philosophical meaning. These statues were collected for their beauty or for their historical renown; they could almost be seen as the object of some kind of secular worship. It was this danger that troubled Pico, but it is also precisely why we now see this exhibition as a nascent model for the first philological archaeology and for our own historical museology. There was no sacred or ritual aura surrounding these masterpieces of classical antiquity, and their charm was of a kind that Giovan Francesco Pico did not approve: he was planning to write a treatise *De amore divino*; it was in fact the same charm which Aretino promised Federico Gonzaga in a letter of 6 October 1527, describing a *Venus* by Jacopo Sansovino as 'so truthful and so vivid that she will fill the mind of every beholder with desire'.[132]

The literary, and more particularly the spoken, language which had been a password in the Italian courts was not the only target for ferocious and impudent attacks by Ciceronian humanists; doubt was cast upon the ancient fables themselves once people were advised not to read those late classical texts which had allowed moral metaphors in humanist clothing to find their way almost into the sixteenth century. Fulgentius, with a commentary by Pio, had appeared in Bologna in 1500 under the auspices of the Bentivoglio family, but in the same year, also in Bologna, Beroaldus's commentary on Apuleius had relegated the same Fulgentius

> among the common and lesser writers . . . I do not approve of his erudition, just as it is neither suitable nor plausible among erudite men . . . and seems not genuine but comical. I praise the talent of the writer who strives for the side of bravery to lift the curtain of the fables and to disclose the poetic mysteries.

This scant praise was understandable within the Bolognese milieu, where the rule for intellectuals of the same court was 'anything for a quiet life', but in Rome in 1513 at the height of Cardinal Adriano da Corneto's *De sermone latino* criticism of Sidonius, Fulgentius, Marziano Capella was unequivocal and quite blatantly opposed to the Bolognese world, which still revelled in such things: 'so that whoever reads these things which were omitted in imitation of bad authors, may understand those perfect founders of Latin clarity, and study and emulate them'.[133] Of course Apuleius, whom Isabella had just read in Boiardo's translation, was also condemned, precisely because it was an ambiguous text 'which in our time it is more the curious than the learned who are keen to follow and emulate'.[134]

At this point the Ciceronian polemic did not confine itself to rigorist proposals in favour of unadulterated Latin ('let us strive to settle like bees on the choicest flowers'), but went beyond its linguistic brief into the domain of erudition, reducing it to mere curiosity if applied to any but golden texts. An irreconcilable conflict then began in Rome – but we shall see how it immediately struck a chord in Mantua – between the Ciceronians (and the new philological archaeology of Raphael and his better-qualified colleagues, Fra Giocondo, Andrea Fulvio and a few others) and the confused aims of the omnivorous mythologists (among whom we can find another collaborator of Raphael's, Fabio da Ravenna).[135] The fantasies of the mythologists, nowadays so beloved of iconologists, were to become the oneiric counterpart of the more historically serious archaeological research, a field which had not yet been much open to personal ruminations, but which was soon drowned in the overblown volumes of the most systematic iconography.

An early document from Mantua on the perplexities surrounding the profusion of fables gathered by the most experimental and adventurous scholars is to be found in the excellent dialogue '*De Iusticia pingenda*' by Battista Fiera, whom we have already met (the dialogue appears in the collection of *Hymni divini* which Fiera dedicated from Mantua to Leo X in 1515).[136] Born in around 1465, Battista Fiera was not likely to feel involved in the controversy in Rome under the new Medici pope, but he could at least accept the invitation offered to study ancient sources and literary discipline more seriously. His formative period in Pomponio Leto's Rome was not out of key with these demands, and distanced him from the unbridled Apuleians and from the fabulists. The most Fiera could do, using the Virgilian texts that were not suspect, was attempt to reconcile the most important classical myths with the truths of the Christian religion. Placed as it

is outside the more heated debates and the gravest philological disputes, his dialogue is of largely symptomatic value as evidence of the bewilderment now felt by anyone who had believed for years in the profound truth concealed within the myths: like Mantegna himself, whom the dialogue pits against the cruel Momus, the exacting and hair-splitting son of Night, whose name also crops up in the dedication to the *Epistola in sex linguis* referred to above.

The *De Iusticia pingenda* ostensibly takes place in Rome at the time when Mantegna was working on the chapel of Innocent VIII in the Vatican, but it cannot have been written before Mantegna's death (he would never have allowed a friend to put him in such a radical position); it may date from a year or two after the painter's death, when his image, even in Mantua, had lost a little lustre. The crux of the debate turns pessimistically on the injustice of the world and on death as the final sign of equality and therefore of superior equity, but the beginning of the dialogue is given over to a lively picture of the muddles iconographers get into: 'Really, if these philosophers aren't crazy, or as others will have it, near-divine, then there's no accounting for such contradictory opinions!' This is Mantegna's first quip, in desperation at finding no consensus among philosophers as what the most appropriate attributes would be for an allegorical image of Justice. All of them disagree and contradict each other, tying the painter in tangled intricacies ('*involucra*'). 'Intricacy, you call it?' retorts Momus. 'Say nonsense rather. They are all out of their wits, all except Epicurus.' Then follows Mantegna's pathetic account of the misfortunes caused by his excessive professional seriousness and by his own cultural habits: 'Since I'm the sort of painter who is careful to the last detail, and as I heard so many conflicting accounts of Justice, I decided I ought to consult the philosophers.' The eager quest the painter embarks upon ends up with disastrous and confusing consequences; Justice is seen variously as 'one-eyed . . . seated . . . one-handed . . . standing . . . with eyes all over her . . . covered with ears' and with many incompatible attributes; Battista Mantovano's negative hypothesis, that it is impossible to give Justice a human persona, survives. Momus agrees with the Christian philosopher, though not because of his moral reasons but because of the wild dissension among the others: 'How can you represent Justice both with one eye and many eyes; and how can you depict her with one hand only, and yet measuring, and at the same time weighing and simultaneously brandishing a sword?' Finding it impossible to paint the philosophers' visible Justice, Mantegna obviously also has to give up on the theologians' abstract idea of

justice, of which we get a solemn and grotesque scholastic definition ('I have often listened to the theologians' words . . . but doubt that I have yet understood them fully'). Fiera arrives on the scene in person to move the debate from the level of grand definitions to the everyday choices of moral philosophy, and we quickly reach the declaration that 'Death levels us all, the lowest and the highest: so sacred and stern is Justice.' From this hard truth a new iconography emerges which makes no reference to classical fables or to scholastic definitions, but which relates to the tragic experience of everyone: 'Now, Mantegna, I would no longer consider you a painter, but rather a very great philosopher and a consummate theologian, had you not portrayed Death instead of Justice.'[137]

In 1515 Isabella was almost forty and was nearing the deadline she had set herself for the beginning of her old age (letter to Ludovico Brognolo of 7 November 1502).[138] She was still 'strong and cheerful', as people were to see her at Pesaro on her way to Rome for the second time (1525), and she remained above all 'a woman with her own opinions', to the embarrassment of her husband, who was beginning to feel ashamed of 'having . . . the kind of wife who always wants to do as she thinks and pleases'.[139] Their relationship eventually became more and more strained, and Isabella, squeezed out of the political administration of the marquisate, reclaimed her own sphere of activity with a series of trips which finally took her as far as Rome, which she had hitherto been acquainted with only from her son's report (he was being held hostage by Julius II) and from those whom she had instructed to watch over him (Isabella stayed there from October 1514 to March 1515, with a brief interlude in Naples). It was a good opportunity to take stock of the modern manner (in the still freshly painted Sistine chapel, or in the Stanze, where work was still in progress), but the *marchesa*'s curiosity seems not to have focused on the most recent works: 'my life has been to go and look at all the antiquities every day, and every day they seem to me more marvellous', Isabella wrote to Capilupi on 10 November 1514, and we find no such enthusiastic comments in her correspondence regarding contemporary works. In fact Isabella's greatest joy in Rome was her triumph as 'a court lady', and even in Venice, where she was not much loved, Marin Sanudo was forced to admit that she had 'kept the place in a festive mood', while reports in Mantua celebrate 'her most genteel actions and ways . . . in flattering each one according to his station', or else 'her most noble ways, and due ceremonies'. Isabella triumphantly showed her elegant social training in a casual and natural way, embodying

for all who saw her that 'certain disdain which covers up great skill and makes it look as though what one does and says is done effortlessly and almost without thinking' (*The Book of the Courtier* I, 26). She was more likely to be found in St Peter's 'adoring the holy face and the lance' than in the apartments of the Vatican or the Sistine Chapel, and in fact it is quite likely that, faced with the latest figurative innovations, she would have done as her brother Alfonso d'Este Duke of Ferrara did in July 1512:

> He took great pleasure in seeing all the rooms of Pope Alexander which are very fine ... he had a great desire to see the ceiling of the great chapel which Michelangelo was painting ... he stayed up there with Michelangelo and could not get his fill of those figures ... they tried to take him off to see the Pope's chamber and the rooms Raphael is painting, but he did not want to go.[140]

It seems strange to us that the Duke of Ferrara could, in 1512, find the rooms of the Borgia apartment 'very fine' (they were painted by Pinturicchio fifteen years earlier in very traditional style), then casually pass on to chat with the formidable Michelangelo on the scaffolding in the Sistine Chapel and then pass up the chance to be among the first to admire Raphael's new decorations for the apartment of Julius II. It seems equally strange that Isabella showed no trace of interest in these masterpieces which were radically revolutionizing the Italian figurative tradition, burning all bridges with the past, and laying down with unprecedented boldness a new rationale of form, style and personality in figurative art, as against the rationale of iconographic content and expensive materials such as gold and ultramarine blue. It may seem strange, but it is important not to be inordinately surprised: the old tastes and tradition were still holding out, as the pictorial decoration of Santa Maria del Popolo in Rome shows; Raphael and Michelangelo were still just two artists serving the pontiff, and their intellectual worth was not really recognized even by those who shared with them, though more with Raphael than with Michelangelo, in the favour of Pope Leo X. Just to read the preface to book III of Pietro Bembo's *Prose della volgar lingua* we discover that, in 1516 at least, painting, sculpture and architecture are 'very minor arts' compared with 'writing, which is such delightful and noble work, that no art can be completely beautiful and clear without it'. The social and intellectual advancement of the artist was struggling through a difficult phase, and neither Isabella d'Este nor her brother felt obliged to behave very differently from their uncle Borso when he fell out with Francesco del Cossa; the

cynicism shown by Isabella in acquiring the *Faustina* which had belonged to Mantegna tells us something about the limited social status artists had achieved for themselves by then. For Isabella in Rome the legendary Raphael was nothing more than 'Raphaelle de Zoanne de Sancto da Urbino', a 'good master' who she had previously heard was a good portrait painter; he was not yet the great archaeologist and expert on Vitruvius he was ultimately to become in the eyes of Roman intellectual society.

'A woman with her own opinions', Isabella returned to Mantua enchanted by the splendid welcome that the Curial aristocracy had extended her and by the classical antiquities that she had hitherto never seen in such abundance, but she also came back convinced that her *studiolo* had not suffered even the tiniest loss of prestige for not containing decorative works of gratuitous thematic content, however sublime, but a detailed treatise *De amore divino* like the one Gian Francesco Pico was finishing in 1516.[141] When she moved the paintings and furnishings of the *studiolo* from the Castello to the Corte Vecchia it did not occur to her to make any changes, even though she was aware of her brother Alfonso's parallel enterprise using Bellini, Titian, Dosso ('ancient fables' again, along the lines of Demetrius Moschus's translation of Philostratus, but not really with 'fine meaning').[142] It is interesting to note that in making the necessary adjustments and filling the gaps Isabella still relied on artists who were tied to the northern tradition of the early years of the century.[143] The flooring of the new apartment was commissioned from Tullio Lombardo, a sculptor who had made a great effort to adapt his work to the graceful new ideas proposed by the modern painters, enlivening with subtle psychological charm even his most reverent tributes to classical models. In taking this path he had found comfort in the choices Gian Cristoforo Romano had made, and in the development of Antico, whose late busts in the seminary in Mantua seem by their great and noble sensitivity to align him with the psychological portraiture of the Veneto-Lombard school. The new pictorial decorations, and particularly the ceiling of the so-called Scalcheria, however, were entrusted to Leombruno, the adoptive son of the painter who had done all the early work on the decoration of the *studiolo* at the beginning of the 1490s. The bright ceiling of the Sala Maggiore is full of disparate Roman allusions, apparently inspired by Leombruno's recent visit to Rome in 1521 (the year before he painted the ceiling), but it is intriguing to note the lack of coherence in these allusions, which might have been understandable in a work from the turn of the century, closer to

the Borgia apartment than the orderly and highly cultured interiors of the Villa Madama in Rome. Even the iconographic content seems disorganized, possibly because the current instigator of the work, probably Equicola, was feeling less faithful than he once had to the ancient fables so miserably derided in Rome.[144] The lunettes of hunting scenes are completely new, but as a measure of the speed of cultural innovation around Isabella d'Este's city, even independently of Giulio Romano, it should be remembered that the matching lunettes by Parmigianino at Fontanellato date from before 1524.

Isabella d'Este's farewell contribution to the figurative arts of her time was the two allegories by Correggio in the Louvre, painted as the finishing touch to the *studiolo*: the *Triumph of Virtue* in the guise of Venus-Minerva and the *Torment of the Vices*, where Virtue would in fact never triumph.[145] Supervised more closely than Leombruno, Correggio produced two paintings in complete iconographical harmony with the rest of the paintings in the *studiolo*, but with these two canvases the modern manner, defined as delicate grace of line, controlled suppleness of movement and smooth chromatic composition, suddenly relegated the works by Mantegna, Perugino and Lorenzo Costa to the past. However, we cannot assume that the reasons behind the choice of Correggio were not dependent on that bygone age. There certainly exists a letter from Veronica Gambara praising Correggio (3 September 1528), but I do not think she was telling Isabella d'Este about an unknown. Antonio Allegri started out in Mantua, between Mantegna and Costa, and was somehow involved in a phase of Leombruno's career which still needs clarification.[146] Moreover, it is worth remembering that, although Correggio's first important commission was the San Francesco altar in his native city, his second was the organ shutters for the Basilica of San Benedetto Po, a few miles from Mantua. The existence of documents for Correggio's relationship with the Mantuan area in the second decade of the century could lead one to suspect that Isabella knew the Camera di San Paolo in Parma, painted for the Abbess Giovanna da Piacenza at the end of the second decade of the century.[147] If this is so, that fascinating collection of inventions and fables was bound to ensure that the *marchesa* would engage Correggio to work on her *studiolo*. It mattered little to her that the painter was equally happy to paint the loves of Jupiter, an 'enemy of chastity', for Federico Gonzaga. Her own estrangement from her libertine son, who had grown up at Julius II's court, was now something that she, as well as every member of her court, was resigned to, and anyway she believed that the didactic content of a painting was more

important than its execution, and that therefore the personality of the artist was of secondary importance. She refused to acknowledge that the times, the political situation and the artistic myths had changed and upset the undisputed hierarchy she had known as a young woman; year by year her friends and fellow principals of that happy time were dying around her: Elisabetta Gonzaga Montefeltro in 1526, Emilia Pia in 1528 – and the death of the latter must have made a particularly strong impression on her, as well as convincing her that she was still in the right. The idea of 'Lady Emilia . . . dying without any of the sacraments of the Church' could certainly have seemed immoral to someone who had tried to keep a distance from the disturbing religious upheavals of the time, but Isabella could not have failed to be moved to think that her friend from Urbino had died 'discussing a passage of the *Book of the Courtier* with Count Ludovico'.[148] In May 1528 the *Book of the Courtier* was a brand-new title, which described 'like a painted portrait' the tranquil court of Urbino in early March 1507. But we have to read only the first pages of dedication to Miguel da Sylva to realize that the bright springtime, the court, the culture, the whole courtly utopia, had all disappeared for ever along with their most admirable protagonists.

NOTES

1 P. Kristeller, *Andrea Mantegna* (London, 1901), pp. 486–7.
2 Francesco Gonzaga had not yet seen Mantegna's papal chapel at first hand; he visited it only in March 1496 (A. Luzio, 'Isabella d'Este e i Borgia', *Archivio Storico Lombardo*, 9 December 1914, p. 488).
3 C. Cottafavi, *Ricerche e documenti sulla costruzione del Palazzo Ducale ecc.* (Mantua, 1939), p. 35 (reprinted from *Atti e memorie della Reale Accademia Virgiliana di Mantova*).
4 Kristeller, *Andrea Mantegna*, pp. 481–3.
5 Contact between Naples and Mantua could have been made through the traditional exchange of portraits among relatives (Isabella d'Este, wife of Francesco Gonzaga, was the daughter of Eleonora of Aragon and Ercole d'Este), but there were plenty of works on public display (F. Bologna, 'Ricordi di un Cristo morto del Mantegna', *Paragone* (March 1956), pp. 56–61). For the particular quotation from the *Arcadia* see O. Kurz, 'Sannazzaro and Mantegna', in *The Decorative Arts of Europe and the Islamic East. Selected Studies* (London, 1977), pp. 277–83 (the page numbering corresponds to that of vol. II of *Scritti in onore di Riccardo Filangieri*, 1959). Another important point of contact between Neapolitan and Mantuan circles is found in Isabella d'Este's correspondence with Pontano regarding a monument to Virgil,

'solo con la laura in testa, et col manto all'antica, cum l'habito togato, col groppo in su la spalla, overo col habito senatorio, che è la vesta et il manto sopra come se dice vulgarmente ad arme a collo, come ben sapra ritrovare M. Andrea Mantinia, senza cosa alcuna in mano … cum le scarpe all'antiqua' (with just a laurel wreath on his head and his cloak draped in the antique manner, with a toga knotted on the shoulder, or in senatorial dress, which is a toga and cloak tied over it baldric-wise, as is said in the vernacular, as Andrea Mantegna will certainly know how to do it, without anything in his hands and with shoes of an ancient kind). Pontano's suggestions were conveyed by Jacopo d'Atri in a letter to Isabella d'Este of 17 March 1499, and they relate generally to a famous drawing in the Louvre, inv. RF 239: see A. Luzio and R. Renier, *La coltura e le relazioni letterarie di Isabelle d'Este Gonzaga* (Turin, 1903), p. 399.

6 J. Schlosser Magnino, *La letteratura artistica* (Florence, 1964), pp. 112–13; M. Baxandall, *Painting and experience in fifteenth century Italy. A Primer in the Social History of Pictorial Style* (London, 1974); R. Dubos, *Giovanni Santi ecc.* (Bordeaux, 1971), pp. 45–78.

7 In fact the problem began as one of 'courtly language' defined as contemporary with the events which interest us here. Only recently has it been observed that 'courtly theory' went beyond the narrow confines of the linguistic question to cover a very precise and individual cultural position. The definition is now widely used, but it is still a good idea to go back to the studies which most clearly state the historical dimensions of the phenomenon: G. Folena, *La crisi linguistica del Quattrocento e l'Arcadia di I. Sannazzaro* (Florence, 1952); C. Dionisotti, introduction to P. Bembo, *Prose e rime* (Turin, 1960; new enlarged edition, 1966); P. V. Mengaldo, 'Appunti su Vincenzo Calmeta e la teoria cortigiana', *Rassegna della Letteratura Italiana* (September–December 1960), pp. 446–69; C. Dionisotti, 'Niccolo Liburnio e la letteratura cortigiana', *Lettere Italiane* (January–March 1962), pp. 33–58; P. V. Mengaldo, 'La lirica volgare del Sannazzaro e lo sviluppo del linguaggio poetico rinascimentale', *Rassegna della Letteratura Italiana* (September–December 1962), pp. 436–82; C. Dionisotti, 'Fortuna del Petrarca nel Quattrocento', *Italia Medioevale e Umanistica* (1974), pp. 60–113.

8 G. Fiocco, 'Felice Feliciano amico degli artisti', *Archivio Storico Tridentino* (1926), pp. 189–90. Fiocco transcribes from the Veronese manuscript, dated 1463, which I have been unable to check; of importance for Mantegna, see also the part of the dedication ignored by Fiocco: '*Quae cuncta in hunc usque diem per civitates Italiae diversis in locis agrorum reperta tibi Andreae amico incomparabili dedicavi, cum quia te huiusmodi antiquitatis investigandae promptissimum amantissimumque percepi. Tum quoniam nihil est apud me potius et antiquius quam te fieri quam doctissimum atque omnibus in rebus praeclaris consummatum virum evadere*' (This collection of all I have

discovered to this day in sundry cities of Italy I have dedicated to thee, Andrea, my incomparable friend. Partly because I know well that thou art a great lover and student of antiquity; partly because for me there was nothing worthier and more important than that thou shouldst become as learned as possible and shouldst be deemed a man experienced in all noble things) (quoted from the Marciano manuscript, dated 1464, fo. 28r; the text appears in translation in G. Mardersteig, *Felice Feliciano veronese. Alphabetum Romanum*, Verona, 1960, p. 19). On Feliciano and the culture of the 'antiquarians' see A. Momigliano, 'Ancient History and the Antiquarian', *Journal of the Warburg and Courtauld Institutes* (July–December 1950), p. 290; C. Mitchell, 'Archaeology and Romance in Renaissance Italy', in *Italian Renaissance Studies. A Tribute to the late Cecilia M. Ady*, ed. E. F. Jacob (London, 1960), pp. 455–83; *idem*, 'Felice Feliciano Antiquarius', *Proceedings of the British Academy* (1961), pp. 197–221; R. Weiss, *The Renaissance Discovery of Classical Antiquity* (Oxford, 1973), pp. 148–9; G. Gianella, 'Il Feliciano', in *Storia della cultura veneta. Del primo Quattrocento al Concilio di Trento*, vol. I (Vicenza, 1980), pp. 460–77.

9 See the letter from Rome of 31 January 1489 in G. Paccagnini, *Andrea Mantegna* (Milan, 1961), p. 60.

10 Kristeller, *Andrea Mantegna*, pp. 472–3.

11 G. Muzzioli, *Mostra storica nazionale della miniatura*, exhibition catalogue (Rome, 1953), pp. 379–80 (index no. 601); D. Fava and M. Salmi, *I manoscritti miniati della Biblioteca Estense di Modena*, vol. II (Milan, 1973), pp. 44–8 (Latin manuscript a L.5.15).

12 F. Colonna, *Hypnerotomachia Polyphili*, ed. G. Pozzi and L. A. Ciapponi (Padua, 1964), vol. I, p. 51 (English sixteenth-century translation by RD, *The Strife of Love in a Dream*, New York, 1976).

13 Letter of 7 July 1507 to her sister-in-law Elisabetta Gonzaga Montefeltro, Duchess of Urbino, quoted in A. Luzio, 'Isabella d'Este e la corte sforzesca', *Archivio Storico Lombardo*, 28 (1901), pp. 157–9.

14 This letter of 24 October 1476 has been reprinted in C. M. Brown, 'Gleanings from the Gonzaga Documents in Mantua. Gian Cristoforo Romano and Andrea Mantegna', *Mitteilungen des Kunsthistorischen Instituts in Florenz* (1973), pp. 158–9.

15 For the Ambrosiana drawings cf. A. Schmitt, *Disegni del Pisanello e di maestri del suo tempo*, exhibition catalogue (Venice, 1966), pp. 46–52 (paras 29–33 with an attribution to a Milanese artist around 1460; the suggestion is plausible, but one would like to see a more precise solution to the problem, as it seems to be of great importance for Foppa and perhaps also for Spanzotti); for the *Pattern-book of Mantegna's Drawings* in Berlin cf. A. Martindale, *Andrea Mantegna. I Trionfi di Cesare* (Milan, 1980), p. 146, figures 149–52. Mantegna would certainly have used sketchbooks and models, given the workshop tradition in which he had been trained, but the case is

proved by the relationship between a few details from the Eremitani frescoes in Padua and the drawings of his father-in-law, Jacopo Bellini (A. Moschetti, 'Le iscrizioni lapidarie romane negli affreschi del Mantegna agli Eremitani', *Atti del Reale Istituto Veneto di scienze, lettere ed arti* (1929–30), pp. 227–39). Felice Feliciano also collected drawings; cf. G. Mardersteig, 'Nuovi documenti su Felice Feliciano da Verona', *La bibliofilia* (March 1939), pp. 106–8: this includes Feliciano's will of 1466, which refers to antique medals and to drawings and paintings on paper 'by several excellent masters'.

16 For the Vienna drawings see Martindale, *Andrea Mantegna*, p. 68, n. 70.

17 For Parentino in Padua see A. di Nicolo Salmazo, 'Bernardino Parenzano e le storie di S. Benedetto del chiostro maggiore di S. Giustina', in *I Benedettini a Padova e nel territorio padovano attraverso i secoli*, exhibition catalogue (Padua, 1980), pp. 89–120 (with bibliography). Parentino had also been an antiquarian since privately collecting a small sylloge of inscriptions found in Istria, and he kept near him a model-drawing from a sarcophagus, showing a battle between Romans and barbarians, which had previously been in the collection of Giovanni Ciampolini in Rome. Since the sarcophagus probably arrived in Mantua only with Giulio Romano's collection, it is not out of the question that the drawing may have been made by Mantegna himself on his return from Rome. For the Istrian epigraphs see M. P. Billanovich, 'Una miniera di epigrafi e di antichità. Il chiostro maggiore di S. Giustina a Padova', *Italia Medioevale e Umanistica* (1969), particularly pp. 224–43 (but the whole article is important for its wealth of antiquarian information, for the details of Parentino's biography and the corrections to a previous contribution by Wazbinski which was full of irritating imprecisions). To Billanovich's question (p. 274) on who might have mediated between Parentino and the illustrator of the *Polyphilus* for the drawing from the Roman friezes which used to be in San Lorenzo, I should be tempted to answer that there is a good chance that it was Mantegna, back from working in Rome. Still on the Istrian epigraphs see also M. P. Billanovich's second offering: 'Bernardino Parenzano e le origini di Capodistria, *Italia Medioevale e Umanistica* (1971), pp. 252–65.

18 Billanovich, 'Una miniera', pp. 280–2. The precise details of the Parentino–Mantegna–*Polyphilus* relationship illustrated here are meant, as far as possible, to help reinforce the Casella–Ciapponi–Pozzi theory placing Francesco Colonna as Venetian, as against the Roman theory supported by M. Calvesi, *Il sogno di Polifilo prenestino* (Rome, 1980) (but already anticipated in *L'Europa Letteraria* in 1965). Anyone wishing to take up this debate in its entirety should also, to be fully informed, take into account, M. Billanovich, 'Francesco Colonna, il Polifilo e la famiglia Lelli', *Italia Medioevale e Umanistica* (1976), pp. 419–28; G. Pozzi and G. Gianella, 'Scienza antiquaria e

letteratura. Il Feliciano. Il Colonna', in *Storia della cultura veneta*, vol. I, pp. 459–98. I refrain from entering the debate surrounding the literary question, which is not my field, but I must say something about the illustrations. In the first place we must get rid of Donati's unsustainable suggestion (1957) that central Italian culture, and particularly Benozzo Gozzoli, have something to do with the illustrations of the *Polyphilus*. These woodcuts, so clear and polished, belong in every detail to the Venetian illustrative tradition, modelled first on Mantegna and Bramante and brought to maturity towards the end of the century in the context of the achievements of the Lombardo family in sculpture and the Bellinis in painting: this is supported by the harmony between the *Polyphilus* plates and the fine set of canvases by Giovanni Mansueti, including the *Cure of Benvegnudo di San Polo's daughter* at the Gallerie dell'Accademia in Venice; the picture comes from the Scuola di San Giovanni Evangelista and cannot date from before 1496: see A. Ballarin, 'Una nuova prospettiva su Giorgione; la ritrattistica degli anni 1500–1503', in *Giorgione*, Proceedings of the International Study Congress for the fifth centenary of his birth, 29–31 May 1978 (Castelfranco, 1979), pp. 237–8. Another indication is that the plaque showing the famous *Education of Love* in two copies, neither of them very fine, at the Victoria and Albert Museum in London and the Ca' d'Oro in Venice is not the work of the Florentine Bertoldo but of the Venetian Camelio, and this also therefore goes against the central Italian thesis; see J. Pope-Hennessy, 'Italian Bronze Statuettes', *Burlington Magazine* (January 1963), p. 23. It is a shame that twenty-five years after Donati's incorrect suggestion research into Venetian book illustration should be so undeveloped; but see what I have said in 'La Bibbia di Lotto', *Paragone* (July–September 1976), dedicated to Francesco Arcangeli, pp. 82–4. It is an even greater shame that none of the new lovers of iconography has followed up the brilliant suggestions made by F. Saxl, 'Pagan Sacrifice in the Italian Renaissance', *Journal of the Warburg and Courtauld Institutes* (April 1939), pp. 359–63.

19 The metaphorical lexicon of the *Polyphilus* should be included in any history of the literature of art, all the more so because it is chronologically contemporary with Calmeta's notable efforts at criticism, as already pointed out by Mengaldo, 'Appunti', pp. 451–3 and 463–6. The 'critical' language of the *Polyphilus* is indirectly clarified by Castiglione (who did not like the text) in a passage from the *Book of the Courtier* which has still not been sufficiently exploited by art historians: 'Sometimes I should like our courtier to take certain words in some other meaning than their own and, transposing them appropriately, as it were graft them like shoots of a tree on to a happier trunk, making them more lovely and graceful, and almost bring things closer to the sight of one's eyes, and, as it were, put them within reach of the hands, giving delight to whoever listens or reads' (34;

Count Ludovico di Canossa is speaking; Castiglione translated as *The Book of the Courtier* (Harmondsworth, 1967), from which quotations are taken.

20 This definition was worked out for the Roman amphitheatre in Verona (see Weiss, *The Renaissance Discovery*, p. 117). Still valuable half a century on are the insights into the 'desperate and subtle dogmatism' of Mantegnesque archaeology made famous by Roberto Longhi in the 'Lettera pittorica a Giuseppe Fiocco' of 1926, which can be found in *Saggi e ricerche, 1925–1928* (Florence, 1967), pp. 77–98.

21 Unless otherwise indicated the figurative and documentary material used here is taken from Martindale, *Andrea Mantegna*. The book is an example of professionalism in a field which is an easy target for amateurs; some hints were already present in A. Luzio and R. Paribeni, *Il Trionfo di Cesare di Andrea Mantegna* (Rome, 1940), and in E. Battisti, 'Il Mantegna e la letteratura classica', in *Arte, pensiero e cultura a Mantova nel primo rinascimento in rapporto con la Toscana e con il Veneto*, Proceedings of the VIth International Congress of Renaissance Studies (Florence, 1956), p. 39.

22 For the description of the Mantuan spectacle, see G. Campori, *Lettere artistiche inedite* (Modena, 1866), pp. 2–5; for the archaeological curiosities at Ferrara it should be remembered that Ercole d'Este had commissioned a translation of Biondo's *Roma instaurata* from Nicolo Leoniceno; cf. D. Mugnai Carrara, 'Profilo di Nicolo Leoniceno', *Interpres*, 2 (1979), pp. 178–9. For the Paradise festival in Milan see E. Solmi, *Scritti vinciani* (Florence, 1976), pp. 407–18 (the piece appeared originally in the *Archivio Storico Lombardo* of 1904).

23 On the fifteenth-century circulation of Petrarch's *Triumphs* see Dionisotti, 'Fortuna del Petrarca', pp. 68–91; for the specific case of Mantua see also C. Furlan, 'I Trionfi della Collezione Kress ecc.', *Arte Veneta* (1973), pp. 81–90.

24 The altarpiece in the Louvre had only just been completed on 6 July 1496 (Kristeller, *Andrea Mantegna*, pp. 490–1); the Verona altarpiece follows immediately but smacks of workshop contributions (ibid., p. 492).

25 The episode concerning Benedetto Bordon is not entirely clear, particularly as Jacob of Strasbourg's edition would not be a logical progression; but research into Benedetto Bordon, the engraver, is only just beginning and may have some surprises in store; cf. M. T. Casella and G. Pozzi, *Francesco Colonna. Biografia e opere* (Padua, 1959), vol. II, p. 157; however, it seems unlikely to me that the illustrations to the *Polyphilus* can be attributed to Bordon.

26 G. Vasari, *The Lives of the Painters* (London, 1963). Later we shall see another exceptional case of the success of the *Triumph of Caesar*, recorded by Francisco de Hollanda.

27 I quote from Cod. Lat.a L.5.15, fo. 5r, in the Biblioteca Estense in Modena (Marcanova, *Quaedam antiquitatum fragmenta*); unfortun-

ately the book on public offices and triumphs has not survived. We
should remember that Blondus's *Roma triumphans* was transcribed
for Marcanova (Biblioteca Marciana, Cod. Lat. X, 23, which is of the
same series as Lat. X, 21 and 22, partly in Feliciano's hand); addi-
tions and decorations by the same Feliciano can be recognized in one
of Valturius's incunabula (1472), now in the Vatican Library (Rossiano
1335); cf. Mitchell, 'Felice Feliciano', pp. 207 (n. 1) and 208.

28 A. Venturi, 'L'arte ferrarese nel periodo d'Ercole I d'Este', *Atti e
Memorie della R. Deputazione di Storia Patria per le Provincie di
Romagna* (1887–8), pp. 412–13.

29 G. L. Mellini, *Altichiero e Jacopo Avanzi* (Milan, 1965), pp. 26–8;
S. Pettenati, 'Vetri a oro del Trecento padano', *Paragone* (January
1973), p. 79, n. 9.

30 F. Saxl, 'Jacopo Bellini and Mantegna as Antiquarians', in *idem, A
Heritage of Images* (Harmondsworth, 1970), pp. 57–70; A. Braham,
'A Reappraisal of the "Introduction of the Cult of the Cybele at
Rome" by Mantegna', *Burlington Magazine* (July 1973), pp. 457–63;
C. M. Brown, 'Andrea Mantegna and the Cornaro of Venice', ibid.
(February 1974), pp. 101–3; G. Knox, '*The Camerino* of Francesco
Corner', *Arte Veneta* (1978), pp. 79–84.

31 The only artistic product referred to at length in the *Asolani* is
Perottino's handkerchief, a gift from his beloved: 'it was woven from
the finest threads and edged all round with gold and silk and in the
centre was some animal painted charmingly in the Greek manner:
it showed much care in it of mastery of hand and eye.' Dionisotti,
commenting on the passage (at the end of book I), wonders if this
may not be a reference to the grotesques which came into fashion at
this time; I am afraid this is not possible, both because of the scarcity
of grotesques in northern Italy before 1506–7, and because of the
allusion to the 'Greek manner', when grotesques were a typically
Roman decorative motif. We may have to think of it as a practical
object embroidered with motifs which the Venetians recognized as
being of Greek origin (cf. Bembo, *Prose e rime*, p. 378, n. 1). There
is an English translation of the *Asolani* (Bloomington, 1954), from
which the quotations are taken.

32 E. Verheyen, *The Paintings in the Studiolo of Isabella d'Este at Mantua*
(New York, 1971); *Lo Studiolo d'Isabelle d'Este*, exhibition cata-
logue, ed. S. Béguin (Paris, 1975); other contributions on the *studiolo*,
connected with this exhibition, in *Laboratoire de Recherche des Musées
de France. Annales* (1975) and in *Revue du Louvre* (July–August 1975);
P. Williams Lehmann, 'The Sources and Meaning of Mantegna's
Parnassus', in P. Williams Lehmann and K. Lehmann, *Samothracian
Reflections* (Princeton, 1973), pp. 57–178 (but the essay dates from
1968); C. M. Brown, 'The Grotta of Isabella d'Este', *Gazette des
Beaux-Arts* (May–June 1977), pp. 155–71; (February 1978), pp. 72–
82, written in collaboration with A. M. Lorenzoni; C. M. Brown,

' "Lo insaciabile desiderio nostro di cose antiche": New Documents on Isabella d'Este's Collection of Antiquities', in *Cultural Aspects of the Italian Renaissance. Essays in honour of Paul Oskar Kristeller*, ed. C. H. Clough (New York, 1976), pp. 324–53.

33 For these early days the information collected in G. Gerola, 'Trasmigrazioni e vicende dei Camerini di Isabella d'Este', *Atti e Memorie della Reale Accademia Virgiliana di Mantova*, 21 (1929), pp. 254–60, is still important.

34 For the intricate round of correspondence between the Gonzagas and the Bellinis see: W. Braghirolli, 'Carteggio di Isabella d'Este Gonzaga intorno ad un guadro di Giambellino', *Archivio Storico dell'Arte*' (1888), pp. 276–8; J. M. Fletcher, 'Isabella d'Este and Giovanni Bellini's Presepio', *Burlington Magazine* (December 1971), pp. 703–12; C. M. Brown, 'Giovanni Bellini and Art Collecting', ibid. (June 1972), pp. 404–5.

35 A. Venturi, 'Nuovi documenti su Leonardo da Vinci', *Archivio Storico dell'Arte* (1888), p. 45.

36 Dionisotti, 'Niccolo Liburnio', p. 49, n. 4.

37 The lines used here are readily found in Baxandall, *Painting and Experience*, p. 108.

38 Ballarin, 'Una nuova prospettiva', p. 237, n. 1.

39 F. Battistelli, 'Notizie e documenti sull'attività del Perugino a Fano', *Antichità Viva* (September–October 1974), pp. 67–8.

40 Baxandall, *Painting and Experience*, p. 24.

41 P. Scarpellini, 'Le fonti critiche relative ai pittori umbri del Rinascimento', in *L'umanesimo umbro*, Acts of the IXth Congress of Umbrian Studies, Gubbio, 22–3 September 1974 (Perugia, 1977), pp. 624–5.

42 On this suspect Milanese provincialism see the unequivocal evidence collected by me in 'La pala sforzesca', *Quaderni di Brera*, 4 (Florence, 1978), pp. 14–15 and 22, n. 22.

43 E. Garin, 'Giudizi artistici di Camillo Lunardi', *Rinascimento* (June 1951), pp. 191–2; I do not think that the Milanese Leonardo, engraver of semi-precious stones, mentioned by Lunardi, can be identified with Leonardo da Vinci; the identification is put forward again in *idem*, 'Il problema delle fonti nel pensiero di Leonardo', in *La cultura filosofica del Rinascimento italiano* (Florence, 1961), p. 397. Mantegna and Bellini, but not yet Perugino, are praised by Jacopo Filippo Foresti in the Venetian edition of the *Supplementum chronicarum* (1503); C. Dionisotti, 'Tiziano e la letteratura', in *Tiziano e il manierismo europeo*, ed. R. Pallucchini (Florence, 1978), p. 261.

44 The Venice *St Sebastian* is without doubt the one which Mantegna left unfinished when he died (13 September 1506); later Michiel notes it as being in Pietro Bembo's collection in Padua: J. Morelli with M. Michiel, *Notizia d'opere di disegno*, ed. G. Frizzoni (Bologna, 1884), p. 50; the pessimistic comment on the scroll round the candle, '*Nihil nisi divinum stabile est, caetera fumus*' (Nothing except the

divine is solid, the rest is smoke), seems to me to be the influence of the *Polyphilus* again, but it certainly ties in well with the times of the plague of 1506 (Battisti, 'Il Mantegna e la letteratura classica', pp. 46 and 51). For the sake of completeness I would also mention the puzzling article by M. Levi d'Ancona, 'Il Mantegna e la simbologia: il S. Sebastiano del Louvre e quello della Ca' d'Oro', *Commentari* (January–June 1972), pp. 44–52.

45 Verheyen, *The Paintings in the Studiolo*, pp. 26–7.

46 It is obviously inconceivable that Costa could have begun the painting before Mantegna's death, since all the evidence suggests that Mantegna had been entrusted with this subject; for the subsequent years a plausible connection seems to be the re-establishment of contact with Francia, in late 1510, which was then suddenly retracted (cf. A. Luzio, 'Federico Gonzaga ostaggio alla corte di Giulio II', *Archivio della R. Società Romana di Storia Patria*' (1886), pp. 564–5). The margins for doubt are due to our limited knowledge of Costa's years in Mantua, and the confused monograph by Ranieri Varese is no help in the matter. It has recently been repeated that Mantegna's sketch would be found under Costa's painting, but this is quite out of the question. The X-rays shown at the Paris exhibition in 1975 were far more revealing than the catalogue itself suggested: the painting was made with very washed out and lifeless colours, with a prevailing tone towards lead grey; on this base the painter went back and redid all the vegetation, which therefore shows up as having a greater thickness of chromatic material than the rest. Such an obvious imbalance must always have made observers suspect reworkings, though they are not very extensive: the greatest damage is found near the Celestial Venus's legs on the left, behind the back of the female nude embracing a heron in the centre, and in the bottom right-hand corner.

47 Kristeller, *Andrea Mantegna*, pp. 496, 493, 494, 500.

48 P. Gaurico, *De sculptura* (1504), ed. A. Chastel and R. Klein (Geneva and Paris, 1969), p. 55.

49 Kristeller, *Andrea Mantegna*, p. 496.

50 For the engraving cf. J. A. Levenson, K. Oberhuber and J. L. Sheenan, *Early Italian Engravings from the National Gallery of Art* (Washington, 1973), pp. 222–7 (index by Levenson and Sheenan); for the literary sources cf. E. J. Dwyer, 'A Note on the Sources of Mantegna's *Virtus combusta*', *Marsyas* (1970–1), pp. 58–62. The publication fortunes of the *Tabula Cebetis* in Latin began in 1495–6, and in Mantua the Bolognese edition of 12 May 1497 (Benedictus Hectoris) may have been known in a Latin translation by Ludovico Odasi of Padua under the editorship of Filippo Beroaldo; among the other writings in this collection it is worth pointing out the dialogue between Mercury and the Virtues (thought to be by Lucian) which was to inspire Dosso for his famous Viennese painting showing Jove colouring the wings of butterflies. It cannot be ruled out that the *Virtus combusta*,

like the Minerva canvas in the *studiolo*, is linked to some musical compositions attributed to Isabella d'Este, and a sonnet by Niccolo da Correggio; cf. C. Gallico, 'Poesie musicali di Isabella d'Este', in *Collectanea Historiae Musicae*, vol. III (1963), pp. 109–15; the codex containing Isabella's compositions is dated 1495; C. Dionisotti, Nuove rime di Niccolo da Correggio', *Studi di Filologia Italiana* (1959), p. 180. For the relationship with the painting by Leombruno in Brera cf. Battisti, 'Il Mantegna e la letteratura classica', p. 35.

51 C. Dionisotti, *Gli umanisti e il volgare fra Quattro e Cinquecento* (Florence, 1968), pp. 80–7.

52 The only certain date for the chronology of the *Battle of the Sea Gods* is the copy from Dürer's hand dated 1494; I see confirmation that this is not an early engraving in the relationship between the heads of the fighters in the left half of the engraving and the head of the centaur in the *Minerva Expelling the Vices* in the *studiolo* (cf. Levenson, Oberhuber and Sheenan, *Early Italian Engravings*, pp. 188–93); this would confirm the already suspected dependence on Francesco Colonna (of Venice) for the quotation included in the text (see *Hypnerotomachia Polyphili*, vol. I, p. 52; vol. II, p. 87). I was led to suspect a relationship with Pliny's text by an illumination by Pietro Guindaleri(?) in the Gonzaga *Pliny* now in the Biblioteca Nazionale in Turin: cf. A. Bovero, 'Ferrarese Miniatures at Turin', *Burlington Magazine* (August 1957), pp. 261–5; U. Meroni, *Mostra dei codici gonzagheschi*, exhibition catalogue (Mantua, 1966), pp. 66–7 and 80–1; however, the illumination (in Cod. I, 22.3, fo. 5r) illustrates the beginning of book IX, whereas the passage on the relief of the sea gods is in book XXXVI, 4.

53 The material gathered here can be found in V. Cian, 'Una baruffa letteraria alla corte di Mantova (1513). L'Equicola e il Tebaldeo', *Giornale Storico della Letteratura Italiana* (July–December 1886), p. 389, n. 1; *idem, Un decennio della vita di M. Pietro Bembo (1521–31)* (Turin, 1885), p. 90; Luzio and Renier, *La coltura e le relazioni letterarie*, p. 382; A. Luzio 'Isabella d'Este ne' primordi del papato di Leone X e il suo viaggio a Roma nel 1514–1515', *Archivio Storico Lombardo* (1906), p. 101; V. Calmeta, *Prose e lettere edite e inedite*, ed. C. Grayson (Bologna, 1959), p. xxxiv; Battisti, 'Il Mantegna e la letteratura classica', pp. 42–3.

54 E. H. Gombrich, 'Botticelli's Mythologies. A Study in the Neo-Platonic Symbolism of his Circle', in *idem, Symbolic Images. Studies in the Art of the Renaissance* (London, 1972), pp. 31–81 (but remember that the first edition of this essay was 1963). Since the efforts of Williams Lehmann mentioned above, the iconography of Mantegna's *Parnassus* can be considered decoded, but it is important to go back to the debate which preceded this solution to understand the problems and dangers of iconographic research outside a precise historical context. The most serious disaster was the salacious interpretation of

the painting proposed by E. Wind, *Bellini's Feast of the Gods. A Study in Venetian Humanism* (Cambridge, Mass., 1948), p. 8; here was proof that Wind had completely failed to understand the *studiolo* project, especially as he took each of the paintings in isolation from the whole and, on his misunderstanding of Mantegna's first canvas, tried to imagine that even the *Festino degli dei* in Washington (painted by Bellini for Alfonso d'Este's *studiolo*) could have been meant for Isabella. From the debate which rightly ensued it is worth recalling at least the contribution of E. Tietze-Conrat, 'Mantegna's Parnassus. A Discussion of a Recent Interpretation', *Art Bulletin* (June 1949), pp. 126–30; later, in 1963, Gombrich also weighed in with some plausible new ideas (now in *Symbolic Images*, pp. 82–4). In conclusion I repeat my own conviction that the Warburgian divergence between Panofsky and Saxl is much more serious than is obvious, and that the Panofsky–Wind line is much shakier than the Saxl–Gombrich line.

55 A bibliography on treatises on love in the late fifteenth century and the spread of a very casual form of neo-Platonism would now need to be quite enormous, and not always necessary; to give a bare minimum, see for greater clarity E. Verheyen, 'Eros et Anteros. L'Education de Cupidon et la prétendue Antiope du Corrège', *Gazette des Beaux-Arts* (May–June 1965), pp. 323–32; C. Dionisotti, 'Appunti su Leone Ebreo', *Italia Medioevale e Umanistica* (1959), pp. 415–21; M. Pozzi, introduction to the reprint of *Trattati d'amore del Cinquecento*, ed. M. Zonta (Bari, 1975), pp. v–xv.

56 For the iconography of the second Costa painting cf. Wind, *Bellini's Feast of the Gods*, pp. 46–8; C. M. Brown, 'Comus, dieu des fêtes', *Revue du Louvre*, 19 (1969), pp. 31–8; J. Schloder, 'Les Costa du Studiolo d'Isabella d'Este', ibid. (July–August 1975), pp. 230–3.

57 F. Luisi, *La musica vocale nel Rinascimento* (Turin, 1977), p. 18.

58 The didactic fables of the ancient poets are also stressed by Bembo (*Asolani* I, xii) and Leone Ebreo; see the long extract quoted in A. Gentili, *Da Tiziano a Tiziano* (Milan, 1980), p. 20. On Equicola and his late treatise there have been recent contributions from: D. de Roberti, 'La composizione del "De natura de amore" e i canzonieri antichi maneggiati da Mario Equicola', *Studi di Filologia Italiana* (1959), pp. 189–220; I. Rocchi, 'Per una nuova cronologia e valutazione del "Libro de natura de Amore" di Mario Equicola', *Giornale Storico della Letteratura Italiana* (October–December 1976), pp. 566–85; M. Aurigemma, 'Il gusto letterario di Mario Equicola', in *Studi di letteratura e di storia in memoria di Antonio di Pietro* (Milan, 1977), pp. 86–106; M. Pozzi, 'Mario Equicola e la cultura cortigiana', *Lettere italiane* (April–June 1980), pp. 149–71.

59 Bembo, *Prose e rime*, pp. 662–3 ('Stanze di M. Pietro Bembo, recitate per giuoco' 27 and 28).

60 A. Luzio, 'I ritratti di Isabella d'Este', in *idem, La Galleria dei Gonzaga venduta all'Inghilterra nel 1627–28* (Milan, 1913), p. 200; the

same essay, in a shorter version, had already appeared in *Emporium* (May 1900), pp. 344–59.

61 R. Bacou, *Cartons d'artistes du XVe au XIXe siècle*, exhibition catalogue (Paris, 1974), pp. 13–14.

62 C. Pedretti, 'Ancora sul rapporto Giorgione–Leonardo e l'origine del ritratto di spalla', in *Giorgione*, pp. 181–5; Ballarin, 'Una nuova prospettiva', pp. 229–30 and 239–40, nn. 8 and 9.

63 Unless otherwise indicated the facts used here are gathered from Luzio, 'I ritratti di Isabella d'Este', pp. 183–238. A precious testimony on the use of portraits has been preserved in the so-called 'rules of the company of friends' published by Dionisotti in the 2nd edn of Bembo, *Prose e rime*, p. 700 (the friends are, besides Bembo, Vincenzo Querini, Trifon Gabriele and Niccolo Tiepolo, and the text can be dated 1503–5).

64 In the *studiolo* exhibition in Paris in 1975 there was a fine portrait of a lady which used to be thought to be of Isabella d'Este, and for which the problem of attribution, whether Lombard or Venetian, was much discussed (*Le Studiolo d'Isabelle d'Este*, p. 6, index 8, judges it to be of a Venetian school and recalls Gronau's attribution to Costa, which was supported by Adolfo Venturi). The answer to this quest is in fact to be found in Milan, since this is an important work by Boltraffio, and it is only the damage to the colouring of the face which has prevented the link being made between it and a famous drawing in the Ambrosiana in Milan. The editors of the 1975 catalogue missed out the attribution to Lorenzo Lotto, which recognizes the very high quality and the Lombard leanings of the painting: F. Arcangeli, 'Una Maddalena di Lorenzo Costa', *Paragone* (September 1954), p. 51.

65 Dionisotti, 'Nuove rime di Niccolo da Correggio', p. 173.

66 For recognition of the importance of Boltraffio in the Leonardesque diaspora after 1499 I must again refer to Ballarin's evidence, which gives a similar picture in many ways to my own research ('Una nuova prospettiva' pp. 231 and 241, n. 19).

67 Letter to Giorgio Brognolo of 17 April 1496 (cf. C. M. Brown and A. M. Lorenzoni, 'Isabella d'Este e Giorgio Brognolo nell'anno 1496', *Atti e Memorie dell'Accademia Virgiliana di Mantova* (1973), pp. 105 and 121).

68 Venturi, 'Nuovi documenti su Leonardo', pp. 45–6; it must be remembered that a portrait could also be 'pietoso' (pious), and it is strange that the adjective should be used, in 1505, for a work by Bonsignori (Luzio, 'I ritratti d'Isabella', p. 192).

69 The problem of this *Salvator mundi* is summed up in J. Snow-Smith, 'The Salvator mundi of Leonardo da Vinci', *Arte Lombarda* (1978), pp. 69–81; it should be stated that the unpublished work, which appeared for the first time here, has none of the necessary characteristics for attribution as a genuine Leonardo.

70 A brief index of the Washington painting, formerly Kress, is to be found in C. Gould, *The Paintings of Correggio* (London, 1976), p. 277.

71 *Scritti d'arte del Cinquecento*, ed. P. Barocchi (Milan and Naples, 1971–7), vol. III, p. 2922 (for Sabba Castiglione); C. Pedretti, 'The Original Project for S. Maria delle Grazie', *Journal of the Society of Architectural Historians* (March 1973), p. 31 (for Bernardino Arluno); Solmi, *Scritti vinciani*, p. 180 (for Jean Lemaire); *Scritti d'arte del Cinquecento*, vol. I, p. 64 (for Luca Pacioli).

72 Leonardo da Vinci, *Scritti scelti*, ed. A. M. Brizio (Turin, 1966), pp. 228–9 (manuscript A, fo. 109v) (translation from *The Notebooks of Leonardo*, ed. E. MacCurdy (London, 1938), pp. 266–7).

73 C. Pedretti, *Le note di pittura di Leonardo da Vinci nei manoscritti inediti di Madrid*, VIII Da Vinci Lecture (Florence, 1968), pp. 41, 43, 44, 47, 50; besides Pedretti see also A. M. Brizio, 'Correlazioni e rispondenze fra il ms 8937 della Biblioteca Nacional di Madrid e il ms A dell'Institut de France', *L'Arte* (December 1968), pp. 106–11. The fundamental role of Leonardo in the years around the turn of the century has been much clarified by J. Shearman, 'Leonardo's Colour and Chiaroscuro', *Zeitschrift für Kunstgeschichte* (1962), pp. 13–47; J. S. Ackerman, 'On Early Renaissance Colour Theory and Practice', in *Studies in Italian Art and Architecture 15th through 18th Centuries*, ed. H. A. Millon (Rome, 1980), pp. 25–36. Although my main intention in these pages is to rediscover pre-Vasari literature of art, at this point we cannot overlook the sensitivity of Vasari's reading of precisely those most psychologically vibrant of Leonardo's masterpieces: *The Last Supper*, the *Battle of Anghiari* and the cartoon for *Sant'Anna*. Where found, translation is from *Leonardo on Painting*, ed. Martin Kemp (New Haven, 1989).

74 'You will write about physiognomy', it says on a drawing at Windsor (19018r): cf. K. Clark and C. Pedretti, *The Drawings of Leonardo da Vinci in the Collection of Her Majesty the Queen at Windsor Castle*, vol. III (London, 1969), p. 10 (in the relevant reproduction the writing can be found on the first line on the left).

75 The problem of the Florentine edition has not aroused any particular interest among modern editors of Gaurico (A. Chastel and R. Klein), but it does merit investigation; C. Dionisotti's *Machiavellerie* (Turin, 1980), p. 184, shows that this is an area of research worthy of attention.

76 P. Zambelli, ' "Aut diabolus aut Achillinus" ', Fisionomia, astrologia e demonologia nel metodo di un aristotelico', *Rinascimento* (1978), pp. 61–4, 72 and 79.

77 Leonardo da Vinci, *Scritti scelti*, p. 98 (Forster, III, fo. 10v).

78 A. Luzio, 'Isabella d'Este e Giulio II (1503–1505)', *Rivista d'Italia'* (December 1909), pp. 863–4.

79 On the Bentivoglio see C. M. Ady, *The Bentivoglio of Bologna. A Study in Despotism* (London, 1937), and the section by I. Walter in the *Dizionario biografico degli Italiani*, vol. VIII (Rome, 1966), pp. 600–2. For the *Stanze* dedication see G. Ghinassi, *Il volgare letterario nel Quattrocento e le Stanze del Poliziano* (Florence, 1957), p. xi.

80 C. C. Malvasia, *Le pitture di Bologna, 1686*, ed. A. Emiliani (Bologna, 1969), pp. 216–17. For the Thyssen Concert see D. von Hadeln, 'Das Bentivoglio-Konzert von Lorenzo Costa', *Pantheon* (1934), pp. 338–40.

81 M. Baxandall and E. H. Gombrich, 'Beroaldus on Francia', *Journal of the Warburg and Courtauld Institutes* (1962), pp. 113–15; for the quotation from Achillini see A. Venturi, 'Lorenzo Costa', *Archivio Storico dell'Arte* (July 1888), p. 250. Francia the goldsmith is also celebrated in Camillo Lunardi's *Speculum lapidum* (Garin, 'Giudizi artistici di Camillo Lunardi', p. 191).

82 The Oratory of Santa Cecilia is much appreciated even by today's critics, but had yet to be read in the colourful courtly context of the Bentivoglio family's Bologna; Aspertini's return to the city after his forays to Rome had a strong vitalizing effect, often stressed by Longhi in his writings on Ferrara and Bologna, and this is a question which needs to be clarified in its specific circumstances. The controversy between Aspertini and the art historians of the Longhi school is therefore still wide open, contrary to the recent excessively premature assertions, unfortunately in Longhi's own old journal itself, *Paragone* (September 1980), p. 38. At the Longhi congress in September 1980 in Florence I attempted to reassess Ezio Raimondi's pages on Codro and Bolognese literary society with reference to Aspertini, but here I shall just point out some of the figurative evidence which has not yet been properly explored. In Francesco de Nanto's corpus of engravings, the *Baptism of Christ* was certainly inspired by a drawing of Aspertini's, but I am sure that the quest does not end with just this one piece of evidence (see the acute observations made by F. Zava Boccazzi, 'Tracce per Gerolamo da Treviso il giovane in alcune xilografie di Francesco de Nanto', *Arte Veneta* (1958), p. 73, figure 76). The already well-known links between Aspertini and graphic publishing production could be extended if we brought into the debate the frontispiece to the *Canzoni nove* published in Rome in 1510 by Andrea Antico and Giovanni Battista Columba. It is only a very short step from here to the mysterious – though not too mysterious – I B with the bird. In the storerooms at the Museo Civico in Como lies a masterpiece by Aspertini, which has been seen until now only in a bad reproduction in M. Gianoncelli, *L'antico museo di Paolo Giovio in Borgovico* (Como 1977), p. 33; the necromantic dialogue between philosophers (Albertus Magnus and Duns Scotus) is important for obvious reasons and for other more elusive ones, involving Filippino's

Carafa Chapel fresco and those at the Casa Panigarola, now in the Brera. So there is no shortage of work to be done by willing and alert Aspertini scholars, especially as there already exists a strong philological and documentary base, established by the most important contributions which followed on from Longhi's initial work. See P. Pray Bober, *Drawings after the Antique by Amico Aspertini. Sketchbooks in the British Museum* (London, 1957); C. Volpe, 'Alcune schede per l'Aspertini', *Arte Antica e Moderna* (April–June 1960), pp. 165–9; M. Calvesi, *Gli affreschi a Santa Cecilia in Bologna* (Bologna, 1960); L. Grassi, 'Considerazioni e novità su Amico Aspertini e Jacopo Ripanda', *Arte Antica e Moderna* (January–March 1964), pp. 47–65; M. G. Ciardi Dupre, 'La scultura di Amico Aspertini', *Paragone* (November 1965), pp. 3–25; D. Scaglietti, 'La cappella di Santa Cecilia', in *Il tempio di S. Giacomo a Bologna* (Bologna, 1967), pp. 133–46; *idem*, 'La maturità di Amico Aspertini', *Paragone* (July 1969), pp. 21–48; P. Venturoli, 'Amico Aspertini a Gradara', *Storia dell'Arte* (October–December 1969), pp. 417–39; F. Arcangeli, *Natura ed espressione nell'arte bolognese-emiliana*, exhibition catalogue (Bologna, 1970), pp. 32–8 and 161–78; C. M. Brown, 'The Church of Santa Cecilia and the Bentivoglio Chapel in San Giacomo Maggiore in Bologna', *Mitteilungen des Kunsthistorischen Instituts in Florenz* (1968), pp. 301–24.

83 A. Luzio, 'Giulio Campagnola, fanciullo prodigio', *Archivio Storico dell'Arte* (May 1888), pp. 184–5; K. Oberhuber, in Levenson, Oberhuber and Sheenan, *Early Italian Engravings*, pp. 390–413. Remember that in the first years of the sixteenth century, Costa too was apparently interested in engraving (J. A. Levenson, ibid., pp. 489–91).

84 Unless otherwise indicated the facts on Costa come from Venturi, 'Lorenzo Costa', pp. 241–56 and from Luzio, 'I ritratti di Isabella', pp. 204–9.

85 J. Shearman, 'Raphael at the Court of Urbino', *Burlington Magazine* (February 1970), pp. 72–8. The whole article is of fundamental importance for court portraiture at the beginning of the sixteenth century, and some of the research clues implicit in it could do with developing (in particular the strange lack of acclaim for Raphael's early portraits should be examined in depth).

86 For the Buckingham Palace portrait see Luzio, 'I ritratti di Isabella', pp. 208–9. 'The portrait of Madame. . . . the *marchesa* of Mantua and of her Lady . . . daughter . . . by Lorenzo Costa, sent to Venice to Lord Francesco, when he was imprisoned in a tower' are recorded by Marcantonio Michiel in 1525 among the objects in the collection of Gerolamo Marcello at San Tomà, along with the Giorgione–Titian *Venus*, a *Diana* by Palma, a *St Jerome* and a portrait by Giorgione, a *Madonna* by Bellini and a portrait by Titian (*Notizia d'opere di disegno*, pp. 168–71).

87 Kristeller, *Andrea Mantegna*, p. 489: letter of 23 May 1494.
88 Luzio, 'Isabella d'Este ne' primordi del papato di Leone X', pp. 135–6; *idem, La reggenza di Isabella d'Este durante la pringionìa del marito (1509–1510)* (Milan, 1910), p. 21.
89 C. Dionisotti, 'Battista Fiera', *Italia Medioevale e Umanistica* (1958), pp. 417–18.
90 The quotation on the courtly Costa is from Equicola (the *Commentarii mantuani*, 1521) as related by Martindale, *Andrea Mantegna*, p. 187. For the *Venus* which was sent to France, and other information on Costa's years in Mantua, cf. C. M. Brown and A. M. Lorenzoni, 'Lorenzo Costa in Mantua. Five Autograph Letters', *L'Arte* (December 1970), pp. 102–16. I have already referred to the limitations of the recent monograph on Costa and it remains only for me to mention the useful discussion of the volume in P. Venturoli, 'Lorenzo Costa', *Storia dell'Arte* (January–June 1969), pp. 161–8. The latest person to make a contribution is P. Tosetti Grandi, 'Lorenzo Costa "Civis Mantuae et bononiensis" ', *Università di Padova. Annali della Facoltà di Lettere e Filosofia*, 4 (1979), pp. 269–99.
91 *Scritti d'arte del Cinquecento*, vol. I, p. 17; the letter from Giovio on Costa–Apelles is recalled in S. C. Vial, 'Mario Equicola in the Opinion of his Contemporaries', *Italica* (December 1957), p. 220, n. 55.
92 A. d'Ancona, 'Del secentismo nella poesia cortigiana del secolo XV', in *Studi sulla letteratura italiana de' primi secoli* (Ancona, 1884), pp. 151–61.
93 On Gian Cristoforo Romano one should still see A. Venturi, 'Gian Cristoforo Romano', *Archivio Storico dell'Arte* (March 1888), pp. 49–59; (April 1888), pp. 107–18; (May 1888), pp. 148–58. More recent contributions by J. Pope-Hennessy, *La scultura italiana. Il Quattrocento* (Milan, 1964), pp. 99–101; Brown, 'Gleanings from the Gonzaga Documents', pp. 153–8. The personality of this sculptor is deeper and more significant than would appear from the brief bibliography and the few bits of information gathered here. For the *Danae* performed in Milan, cf. E. Povoledo, 'Origins and Aspects of Set Design in Italy', in N. Pirrotta, *Li due Orfei: Music and Theatre from Poliziano to Monteverdi* (Cambridge, 1982).
94 Venturi, 'Gian Cristoforo Romano', pp. 149–50.
95 R. Weiss, 'The Medals of Pope Julius II (1503–1513)', *Journal of the Warburg and Courtauld Institutes* (1965), pp. 172–6; for the tomb of Julius II see of course C. Tolnay, *The Tomb of Julius II* (Princeton, 1954), pp. 30–1.
96 Cian, *Pietro Bembo e Isabella*, p. 113.
97 It should be remembered that Gian Cristoforo plays the diminished role only in the final edition of the *Book of the Courtier* (P. Floriani, 'I personaggi del "Cortegiano"', *Giornale Storico della Letteratura Italiana* (April–June 1979), pp. 172–3).
98 R. Renier, 'Per la cronologia . . . del "Libro de natura de amore" ',

Giornale Storico della Letterature Italiana (July–December 1889), p. 227.

99 For Sabba Castiglione cf. *Scritti d'arte del Cinquecento*, vol. III, p. 2920; for Michiel see the Frizzoni edition of the *Notizia d'opere di disegno* (pp. 92–157, 181); for Cesariano refer to Schlosser Magnino, *La letteratura artistica*, p. 252. It is interesting to note that just at the moment when Vasari decreed silence over Gian Cristoforo Romano, the sculptor's name turns up again in Spain in Lazaro Velasco's *Vitruvius*. Obviously the source is Cesariano: cf. E. Battisti, 'Note su alcuni biografi di Michelangelo', in *Scritti in onore di Lionello Venturi*, vol. I (Rome, 1956), p. 325, n. 3. The Vasari quotation comes at the end of the 'Vita di Paolo romano e maestro Mino scultori' (*Le vite de' piu eccellenti pittori, scultori e architettori*, Milan, 1963–6, vol. II, p. 489).

100 Venturi, 'Gian Cristoforo Romano', p. 149, n. 1.

101 Luzio, 'Isabella d'Este e Giulio II', pp. 856 and 872–3.

102 For the negotiations regarding the lost *Cupid* by Michelangelo cf. ibid., pp. 854–5 and A. Luzio, 'Isabella d'Este e i Borgia', *Archivio Storico Lombardo*, 30 March 1915, p. 677; 22 November 1915, p. 460. For the episode one should now read M. Ferretti, 'Falsi e tradizione artistica', in *Storia dell'Arte Einaudi*, vol. X, pp. 127–9; but the entire chapter is of the utmost interest relative to the themes addressed here. The anecdote regarding the false attribution of the St Peter's *Pietà* is recounted by Vasari in the 'Life of Michelangelo Buonarroti'.

103 A. Luzio and R. Renier, *Il lusso di Isabella d'Este marchesa di Mantova* (Rome, 1896; reprinted from *La Nuova Antologia*), pp. 67–8.

104 For Isabella's collecting see, of course, Brown, ' "Lo insaciabile desiderio nostro di cose antiche" ', pp. 324–53; *idem*, 'The Grotta of Isabella'. It has been hitherto impossible to identify with certainty a *Spinario* belonging to Isabella's collection, but it must have been very like the one now in Modena, which is believed to have belonged to the Gonzaga collections. For the important personality of Antico the best sources are again the solid research carried out by the positivist school of art history (H. J. Hermann, 'Pier Jacopo Alari-Bonacolsi, genannt Antico', *Jahrbuch der Kunsthistorischen Sammlungen des allerhöchsten Kaiserhauses*, vol. 28, 5 (1910), pp. 201–88). Fortunately the recent identification of the busts in the seminary in Mantua has put an end, once and for all, to the distortion of Antico's reputation as confined to producing collectable statuettes. The superb examples from Mantua, particularly those of obviously later date, chart Antico's closeness to the new psychological approach of the 'modern manner', cf. A. H. Allison, 'Four New Busts by Antico', *Mitteilungen des Kunsthistorischen Instituts in Florenz* (1976), pp. 213–24.

105 Luzio and Renier, *Il lusso di Isabella*, pp. 36 and 39–40.

106 Venturi, 'Gian Cristoforo Romano', pp. 157–8.

107 Luzio and Renier, *La coltura e le relazioni letterarie*, pp. 435–45. Unless otherwise indicated, the facts regarding Isabella d'Este's literary contacts all come from this rich source.

108 For the history of the *Arcadia* in manuscript I shall simply refer to Alfredo Mauro's note as an appendix to J. Sannazzaro, *Opere volgari* (Bari, 1961, pp. 415–27; English translation of Sannazzaro, *Arcadia and Piscatorial Eclogues*, Detroit, 1966).

109 Calmeta, *Prose e lettere*, pp. 47–56.

110 The drop in interest in humanistic mythology is no less clearly visible in Calmeta's summary for Ludovico Moro of Ovid's *Ars amandi*: 'It is a waste of time telling fables and stories / for someone who wants to get straight to the emotions: / if you are drowning in the sea you need help in a hurry' (Calmeta, *Prose e lettere*, p. 98, lines 19–21).

111 The quotation is taken from a letter from the Marchesa di Cotrone to Francesco Gonzaga (Luzio, 'Isabella d'Este e i Borgia', p. 543); we gather that this precious and elusive personal 'grace' was an unmistakable gift of the *Marchesa*'s from another letter, this time from Jacopo d'Atri to Isabella herself (6 October 1495), which tells of Charles VIII's curiosity about the physical and intellectual qualities of Francesco Gonzaga's young wife; there is a reference to the 'good grace (beyond beauty) which is most important' (Luzio, 'I ritratti di Isabella d'Este', p. 233). From this personal and customary use, the term went on to be promoted to a higher role by Castiglione and Giovio, and eventually reached the pages of Vasari.

112 For the discovery of the landscape of Arcadia and its ideological significance, see my *Studi sul paesaggio* (Turin, 1978), pp. 58–61 (in the notes I have put together an essential bibliography on the subject).

113 Cian, *Pietro Bembo e Isabella*, p. 101.

114 Baldassare Castiglione celebrated in Latin couplets Isabella d'Este singing the passionate lament of the abandoned Dido (*Aeneid* IV. 651–8); further desperate appeals of the unhappy queen (ibid., 305ff) were set to music by Filippo da Lurano, as recorded in book VIII of the *frottole* published by Petrucci in Venice in 1507 (cf. Luisi, *La musica vocale nel Rinascimento*, pp. 372–4 and 380–2).

115 W. H. Kemp, '*Some notes on Music in Castiglione's "Il Libro del Cortegiano"* ', in *Cultural Aspects of the Italian Renaissance*, pp. 354–69.

116 From *Trattato della pittura* (Biblioteca Vaticana, Cod. Urb. Lat. 1270, fo. 28r), reproduced in *Scritti d'arte del Cinquecento*, vol. I, p. 245.

117 A bibliography on the importance of music and song in the late Quattrocento could take up several pages and would show a phenomenon of very significant extent in determining the development of a general ideology of escapism from the tiresome difficulties of the present towards a harmonious paradise of the emotions; apart from those I have already occasionally quoted, I would draw attention to

the contributions which seem most significant and helpful to research in the figurative arts: E. E. Lowinsky, 'Music in the Culture of the Renaissance', *Journal of the History of Ideas* (1954), pp. 509–53; P. O. Kristeller, 'Music and Learning in the early Italian Renaissance', in *Studies in Renaissance Thought and Letters* (Rome, 1956), pp. 451–70; E. Winternitz, 'The Inspired Musician. A Sixteenth-Century Musical Pastiche', *Burlington Magazine* (February 1958), pp. 48–55; N. Pirrotta, 'Music and Cultural Tendencies in 15th-century Italy', *Journal of the American Musicological Society* (Summer 1966), pp. 127–61; E. E. Lowinsky, 'The Musical Avant-garde of the Renaissance or the Peril and Profit of Foresight', in *Art, Science and History in the Renaissance*, ed. C. S. Singleton (Baltimore, 1967), pp. 113–62.

118 For Petrarch see M. Savorgnan and P. Bembo, *Carteggio d'amore (1500–1501)*, ed. C. Dionisotti (Florence, 1950), p. 66 (the whole correspondence is a basic document for the interweaving of emotional relationships, musical experience and literary experience: Bembo is working on the *Asolani*; obviously the best indicator of the true temperature of the relationship is Savorgnan's burning letters, which were not revised and arranged); for Poliziano see Pirrotta, 'Music and Cultural Tendencies, p. 141 (which relies on the testimony of Bembo and Giovio); for Ercole d'Este see L. Lockwood, 'Music at Ferrara in the Period of Ercole I d'Este', *Studi Musicali* (1972), p. 112.

119 A. Luzio, 'Isabella d'Este e due quadri di Giorgione', *Archivio Storico dell'Arte* (1888), pp. 47–8.

120 S. Settis, *Giorgione's Tempest: Interpreting the Hidden Subject* (Cambridge, 1990). The idea of works of art being able to soothe the spirit was familiar to Francesco Gonzaga, from whom we get this sensitive comment (13 June 1494) on the gift of a farm to Francesco Bonsignori: 'to reward him for the ingenious art of his painting, which can include a vast arc of lands in a small space and portray the forms and lineaments of animate things in such a way that all they would need to be living bodies is breath and movement; to which he invites us the more willingly since the painting itself delights us greatly and we are more often relaxed and consoled by looking at his work when our mind is caught up in various preoccupations, worries and cares' (Luzio, 'I ritratti d'Isabella d'Este', p. 191). The particular way of enjoying a work of art described here is based on the model of the enjoyment of music as a therapeutic experience, as previously defined by Ficino; equally close to the milieu which interests us is the testimony of a letter from Beatrice d'Este to her sister Isabella in 1493; the letter requests the loan of the musician Jacopo da Sansecondo 'so that my illustrious lord consort may obtain some recreation in this mild perturbation of tertian fever he is suffering': A. Luzio and R. Renier, *Mantova e Urbino. Isabella d'Este ed Elisabetta Gonzaga*

nelle relazioni familiari e nelle vicende politiche (Turin and Rome, 1893), pp. 107–8.

121 Gabriele Vendramin's collection is of course described in Morelli (Michiel), *Notizia d'opere di disegno*, pp. 214–23.

122 Battisti, 'Il Mantegna e la letteratura classica', pp. 27 and 54.

123 Luzio, 'Federico Gonzaga ostaggio', pp. 509–82.

124 The two texts are pointed out in E. Battisti, 'La critica a Michelangelo prima del Vasari', *Rinascimento* (June 1954), pp. 122 and 126; the letter from Michiel is reproduced in Morelli (Michiel), *Notizia d'opere di disegno*, pp. 252–4.

125 For the importance of the Castiglione passage see also Dionisotti, 'Tiziano e la letteratura', pp. 263–4.

126 P. Barocchi, 'Fortuna dell'Ariosto nella trattatistica figurativa', in *Critica e storia letteraria. Studi offerti a Mario Fubini* (Padua, 1970), pp. 388–9.

127 Vasari, *Lives*, part III.

128 A. M. Bessone Aureli, *Dialoghi michelangioleschi di Francisco d'Olanda* (Rome, 1953), p. 87; for Juan de Arfe see Battisti, 'Note su alcuni biografi di Michelangelo', p. 325, n. 3.

129 E. Carrara, *La poesia pastorale* (Milan, 1908), p. 346.

130 Dionisotti, *Gli umanisti e il volgare*, pp. 111–30; these excellent pages by Dionisotti could usefully be accompanied by some earlier bibliographical references: Cian, 'Una baruffa letteraria alla corte di Mantova', pp. 387–98; R. Sabbadini, 'Una satira contro Battista Pio', *Giornale Storico della Letteratura Italiana* (1896), pp. 185–6; A. Campana, entry under 'Accursio Mariangelo', in *Dizionario biografico degli italiani*, vol. I (Rome, 1960), pp. 126–7.

131 For the debate between Bembo and Pico, apart from Dionisotti, *Gli umanisti e il volgare*, see G. Santangelo, *Le epistole 'De imitatione' di Giovanfrancesco Pico della Mirandola e di Pietro Bembo* (Florence, 1954) and E. Battisti, 'Il concetto di imitazione nel Cinquecento italiano', in *idem, Rinascimento e Barocco* (Turin, 1960), pp. 175–92 (though the essay is from 1956). As for the *De Venere et Cupidine*, see E. H. Gombrich, 'The Belvedere Garden as a Grove of Venus', in *idem, Symbolic Images*, pp. 104–7.

132 Gombrich, 'Botticelli's Mythologies', p. 213, n. 112.

133 For this aspect of the debates, which are only superficially linguistic, see again Dionisotti, *Gli umanisti e il volgare*, pp. 87–110.

134 For Isabella's reading of Apuleius see Luzio and Renier, *La coltura e le relazioni letterarie*, pp. 16–17. The broad and experimental curiosity of the *marchesa* of Mantua as a reader obviously allowed her many escape routes from the world of 'exquisite words'; I would not wish the tendency focused upon here for greater clarity to reduce to absurdly schematic narrowness a figure who has far greater possibilities than there is room to illustrate in this essay. Suffice it to call to

mind, in support of this, her partisan discussions on the French paladins and her real passion for the *Orlando furioso*. We can see strong evidence of her keen intelligence and her self-confidence as a modern writer in the contacts she made on her travels, and it is not without interest to note that a Tuscan such as Bibbiena was so delighted by our *marchesa*'s accent that he imitated in writing her Mantuan/Ferrarese babble (see the letter of 3 January 1511 printed in Luzio, 'Federico Gonzaga ostaggio', p. 518).

135 This is not the place to linger over Raphael's studies of Vitruvius or over the rightly famous letter he wrote with Castiglione to Leo X: these are in fact mature evidence of how Raphael adapted to the victory of the Ciceronians in the debate over imitation, and are therefore outside the scope of this research. It is important, however, to underline the presence alongside Raphael of Fabio Calvo, from Ravenna, whose path in life crossed with those of Isabella d'Este and her son Federico at least twice. The strange tutor to Federico Gonzaga of whom Maddalena Tagliapietra informed Isabella d'Este in a letter of 18 June 1512 must be none other than Calvo: 'a Master Fabio of Ravenna, a man aged 50 . . . Learned in Latin literature, very learned in Greek, he is currently translating a Greek book on medicine into Latin . . .' (cf. ibid., p. 539); Master Fabio was already tutor to Federico on 19 October 1511, and this is an important clue in reconstructing his hazy biography (the information is missing from V. Fontana, *Elementi per una biografia di M. Fabio Calvo Ravennate*, ed. V. Fontana and P. Morachiello (Rome, 1975), pp. 45–61). Fabio Calvo liked to call himself 'an overambitious . . . antiquarian', and another point missed by those who have most recently studied him is that he is to be found making an iconographical reading of a relief of the myth of Proserpine for the Gonzaga collections. As one might have guessed, the reading by the 'antiquarian' from Ravenna was just the sort of thing Mantegna and Isabella liked (see the letter from Angelo Germanello to Federico Gonzaga of 22 July 1523, reprinted in Brown, ' "Lo insaciabile desiderio nostro de cose antiche" ', p. 342).

136 B. Fiera, *De Iusticia pingenda*, ed. J. Wardrop (London, 1957; this precious London edition is unfortunately very difficult to obtain as only 200 copies were printed); for the author, see Dionisotti, 'Battista Fiera', pp. 401–18.

137 Unless I am mistaken, this short and important Latin dialogue has been entirely overlooked by art historians; the only reference to it, and a vague one at that, seems to be in Battisti, 'Il Mantegna e la letteratura classica', p. 23.

138 Luzio, 'Isabella d'Este e i Borgia', p. 692 (the letter concerns the pawning of some jewels): '. . . I would never allow myself to be deprived of them in the flower of my youth; because if I could enjoy them for those ten or twelve years I would certainly not enjoy them once I was nearing old age.'

139 Luzio, 'Isabella d'Este ne' primordi del papato di Leone X', pp. 108–9; but see also the beautiful but offended letter from Isabella to her husband of 12 March 1513 (in Luzio, 'Isabella d'Este e la corte sforzesca', pp. 164–5).

140 Luzio, 'Federico Gonzaga ostaggio', pp. 340–1. For the accounts of Isabella d'Este in Rome see of course Luzio, 'Isabella d'Este ne' primordi del papato di Leone X', pp. 99–180 and 454–89.

141 For the not particularly avant-garde iconography of Raphael's Stanze see E. H. Gombrich, 'Raphael's Stanza della Segnatura and the Nature of its Symbolism', in *idem, Symbolic Images*, pp. 85–101; similar observations could be advanced with regard to the almost neo-Romanesque iconography of the Sistine Chapel ceiling.

142 Rather than refer to more recent adventurous interpretations of Alfonso d'Este's *studiolo*, I believe it is still preferable to read F. Saxl, 'A Humanist Dreamland', in *idem, A Heritage of Images*, pp. 89–104.

143 For these works see Gerola, 'Trasmigrazioni e vicende dei Camerini di Isabella d'Este', pp. 264–72.

144 There is certain proof that Equicola was employed as an iconographical consultant, just as it is certain that his inventions were far from purist; see Luzio and Renier, *La coltura e le relazioni letterarie*, pp. 70 (n. 1) and 77–8: '. . . in the chamber where your lordship will sleep there are four tondi with one large one in the middle . . . and I thought I would have Victory painted in one for you, Virtue in the next, Bellona or War in the next, and Hope in the last, with Fame in the middle. In the four others which are a little larger and elongated I will have painted three noble acts by ancient figures showing loyalty, and in the last one your lordship as I shall see fit, and this chamber shall be called the chamber of faithfulness' (Mario Equicola to Federico Gonzaga, 17 February 1522). What emerges from this testimony is the decline into generality of the philosophical foundation on which the iconography of Isabella's *studiolo* was based. This is not simply a Mantuan phenomenon, and reflects both the new value accorded to formal qualities in figurative art rather than to its didactic content, and the real crisis closing in on the last representatives of Ficinian neo-Platonism, which was soon to suffocate them. Add to this the obvious limits of Equicola's intelligence, which became ever clearer to non-Mantuan critics as the years went by; the most symptomatic example is the decline in the writer's prestige in the *ottava rima* of the *Orlando furioso* (cf. Vial, 'Mario Equicola', p. 2).

145 For Correggio's paintings see, apart from the general bibliography on the *studiolo*, Verheyen, 'Eros et Anteros', pp. 321–39 (which examines the *Education of Love* in London and *Venus and Cupid Sleeping* in Paris, almost certainly painted for Isabella); *idem*, 'Correggio's Loves of Jupiter', *Journal of the Warburg and Courtauld Institutes* (1966), pp. 160–92 (where the famous series of lascivious paintings by Correggio for Federico Gonzaga is examined in opposition to

Correggio's moral paintings for Isabella, which are exactly contemporary: there is no more certain proof of 'modern' indifference to mythological content); L. Soth, 'A Note on Correggio's Allegories of Virtue and Vice', *Gazette des Beaux-Arts* (November 1964), pp. 297–300; *idem*, 'Two Paintings by Correggio', *The Art Bulletin* (December 1964), pp. 539–44 (the same paintings in Paris and London already studied by Verheyen, whose comments on Soth's article are contained in a letter in the same journal (December 1965), pp. 542–3); S. Béguin, 'Remarques sur les deux allégories de Corrège du Studiolo d'Isabelle d'Este', *Revue du Louvre* (July–August 1975), pp. 221–6.

146 The problem surfaced forcefully in 1958 with the publication of a fascinating panel showing St Helen and four saints in a private collection in Brescia; Longhi solved the problem in favour of Correggio, but the links between that painting and the altarpiece in the Church of San Martino in Mantua, which has already been plausibly attributed to Leombruno, are still very close. The issue is an important one, by virtue of the names involved, and should not be too hastily dismissed, as Gould recently did: see R. Longhi, 'Le fasi del Correggio giovine e l'esigenza del suo viaggio romano', *Paragone* (May 1958), pp. 41–2; reprinted in *idem, Cinquecento classico e Cinquecento manieristico. 1951–1970* (Florence, 1976), pp. 67–8. On Leombruno see M. Pasetti, 'Lorenzo Leombruno in un documento del 1499', *Civiltà mantovana* (1978), pp. 237–44 (brings forward Leombruno's date of birth to *c*.1477 and consequently allows for possible variations in the reciprocal exchange between Leombruno and Correggio, who was born in 1489).

147 For the San Benedetto Po organ shutters see P. Pelati, *Il Correggio e il Cenobio di Polirone in un contratto inedito del 1514* (San Benedetto Po, 1974); for the chamber of the Abbess of Parma and its valuable iconography see E. Panofsky, *The Iconography of Correggio's Camera di San Paolo* (London, 1961).

148 Luzio and Renier, *Mantova e Urbino*, p. 283 (letter from Gianmaria della Porta to Eleonora Gonzaga della Rovere, Duchess of Urbino).

Index

Note: **Emboldened** references denote works illustrated